ALSO AVAILABLE FROM CCNM PRESS

Principles and Practices of Naturopathic Clinical Nutrition
Jonathan Prousky, ND

Principles and Practices of Naturopathic Botanical Medicine
Paul Saunders, ND, PhD

Naturopathic Standards of Primary Care
Shehab El-Hashemy, ND

Healing Diabetes
Michael Friedman, ND and Alexander McLellan, ND

Healing Cancer
Abram Hoffer, MD and Linus Pauling, PhD

Healing Arthritis
Stephen Reed, MD and Penny Kendall-Reed, ND

Healing Children's Attention and Behavior Disorders
Abram Hoffer, MD

Healing Schizophrenia
Abram Hoffer, MD

Naturopathic Nutrition
Abram Hoffer, MD and Jonathan Prousky, ND

New Naturopathic Diet
Penny Kendall-Reed, ND and Stephen Reed, MD

Naturopathic First Aid
Karen Barnes, ND

FUNDAMENTALS *of*

Naturopathic
Endocrinology

Complementary and Alternative Medicine Guide

MICHAËL FRIEDMAN, ND
Preface by DENIS WILSON, MD

CCNM
PRESS

Second printing, 2008.

The author would like to thank all the colleagues and students who have contributed content to this book, reviewed the contents, and edited sections: Sumita Bhutani, ND; George Savastio ND; Beth Devlin ND; Darrow Hand ND; Heather Zwicky PhD, National College of Naturopathic Medicine; Michael Aikin PhD, Kaiser Permanente; NCCAM Review Board of NIH; Andre Barkhuizen MD, Oregon Health Sciences University; Denis Wilson MD; Judyth Moulson; Subhuti Dharmananda; Sarika Tandon; Alexander McLellan ND; Warren Levin MD, Ron Amon PhD; Paul Goettlich; Paul Saunders PhD; Helfgott Research Institute; Juan Uyunkar (Shaman from the Amazon jungle); and Great Smokies Diagnostic Laboratory.

This book is dedicated to the Earth, which has given us life and the magnificent plant medicines that sustain us. May this book help people be healthy, and increase the awareness of the connection between increases in many chronic illnesses and the environmental impact of human activities. The author does in no way support or encourage animal experimentation.

Cataloguing in Publication Data Available
ISBN HC 1-897025-02-5

Edited by Bob Hilderley.
Design and type by Sari Naworynski.
Printed and bound in Canada by Tri-Graphic Printing, Ottawa, Ontario.

Printed on ancient forest friendly paper, totally chlorine free (TCF), processed chlorine free (PCF), using post-consumer recycled fiber (PCR).

Published by CCNM Press Inc., 1255 Sheppard Avenue East, Toronto, ON M2K 1E2 www.ccnmpress.com

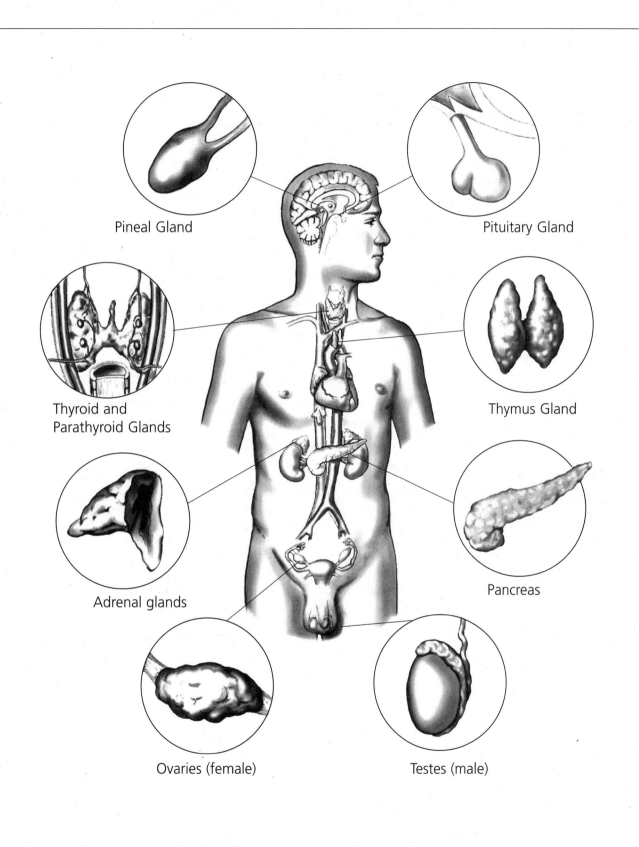

Pineal Gland

Pituitary Gland

Thyroid and
Parathyroid Glands

Thymus Gland

Adrenal glands

Pancreas

Ovaries (female)

Testes (male)

CONTENTS

CLINICAL HANDBOOK

SELECTED CLINICAL STUDIES AND LITERATURE REVIEWS

The human body is designed to heal itself. In fact, it is so good at repairing itself that people usually only recognize a health problem as a medical condition if the body isn't able to recover on its own. The common cold, for example, is something that the immune system can easily handle. We consider it a normal part of life and not a real medical concern. At the other extreme, there are illnesses that cause permanent damage to the body: for example, strokes cause paralysis and Type I diabetes destroys the pancreas. These are conditions from which the body rarely ever recovers. There are still other conditions that are too severe for the body to overcome on its own, yet not so severe as to have caused permanent damage. In this middle ground, we find reversible illnesses.

Restorative medicine is the art and science that can help the body overcome such illnesses. It can often help people recover from a variety of 'incurable' diseases. This is accomplished simply by assisting or recalibrating the body's built-in mechanisms, rather than circumventing them.

For example, imagine that while driving down the road you accidentally bumped your gearshift into a lower gear. Immediately, your car would slow down and the engine would sound louder and make a high-pitched sound. To correct the problem, would you put in earplugs to avoid the annoying sound and press harder on the gas to make up for the reduced speed? Or would you help by shifting your car back into the right gear? Stepping on the gas would only make the sound louder. You'd need stronger earplugs; you would also be putting more of strain on your engine. These are side effects of a strategy that would only create more problems for your car. However, helping the car back into gear would cause the speed and sound of your car to return to normal. Your engine would last longer, you'd get better gas mileage, and you'd get many other unforeseen benefits (more time to enjoy life and less time in the car repair shop, to name two). These are side benefits of a strategy that is actually restoring the function of your car to normal.

Restoring health is also fundamentally different than treating symptoms — as so many doctors have been trained to do. Let's say you have a splinter that is causing you a lot of pain. You could take a pain pill and cover the splinter with a bandage. However, when the pill wears off, you would probably still have the splinter, and over time it might get infected.

However, you could get a pair of tweezers and pull the splinter right out. You could wash it with an antiseptic, keep a bandage on it, and you'd be fine. If the splinter is buried more deeply, you might need to get a needle and try to poke through the skin to get the splinter out. Every time you hit the splinter with the needle, you might feel the exact same splinter pain you've been having — it might even be worse for a flash. That's because you are touching the exact problem, the splinter. But once it's out, it's out.

When doctors don't touch the problem and just treat the symptoms, they have very little chance of making the symptoms worse — but little chance of correcting the problem. In restorative medicine, when a treatment touches the exact problem a patient is having, it can temporarily worsen the exact symptoms the patient is complaining about. Nevertheless, the symptoms can then improve and disappear completely and permanently. Usually, the symptoms don't get worse before they get better, but in more severe cases, the symptoms can sometimes worsen before improvement is noticed.

The human body is very complex and has a lot of inertia. Inertia is the momentum that keeps the body doing what it is already doing. As a result, it takes outside forces, such as poor diet, lack of exercise, lack of sleep, excess stress and other factors, to make a healthy body sick. Likewise, it often takes time, effort, energy, and resources to make a sick body healthy. This effort and energy may take the form of watching what we eat, removing stress from our lives, and taking the time to exercise. Or we might need to buy the medicines and substances we need to get better, and then take them as we are instructed to do.

The endocrine system has many more facets than what we are taught about in medical school. Treating sick patients symptomatically often does not address the complications of this delicate system.

Denis Wilson, MD
Founder of Wilsons Temperature Syndrome

INTRODUCTION

undamentals of Naturopathic Endocrinology is a textbook and a clinical reference book for students of naturopathic medicine and all clinical practitioners with an interest in endocrine disorders. The purpose of the book is to apply the philosophy of naturopathic medicine to the endocrine system — in other words, to apply naturopathic methods of understanding, diagnosing, treating, and preventing disease to a wide range of endocrine-related disorders.

This book will enable students of naturopathic medicine to enter their clinical training with increased confidence in understanding and treating disorders of the endocrine system. At the same time, it will save the student much time and frustration by foregoing the need to 'reinvent the wheel'. Instead of starting from scratch with each new condition, the student can draw upon the substantial knowledge and clinical experience accumulated in these pages, as well as quickly call up the many scientific references provided from recent literature in medical journals, naturopathic and botanical medicine publications, and endocrinology textbooks.

Practicing physicians, nurses, and other healthcare professionals will also find this book a useful reference. The book covers the basic principles and therapies involved in treating the most ubiquitous endocrine disorders, such as thyroid dysfunction and diabetes. This information makes it very useful as a clinical companion in the office.

Not all diseases are discussed in the text, nor are all medicines currently used in naturopathic practice, for the art, science, and philosophy of naturopathic medicine are evolving so quickly that it is impossible to make a complete and current summary of the practice. New hormones and new functions of known hormones are continually being discovered. In addition, research

> *Fundamentals of Naturopathic Endocrinology* is designed to be a textbook for professors and students of naturopathic medicine, a desk reference for clinicians treating patients with endocrine disorders, and a convenient resource for all healthcare professionals wanting to read more about naturopathic endocrinology research.

into naturopathic approaches to medicine and naturopathic treatment is in a stage of rapid growth.

This book assumes the reader has a solid background in biochemistry and pathophysiology and thus only reviews these subjects before turning to diagnostic and therapeutic information. *Fundamentals of Naturopathic Endocrinology* does not aim to replace standard endocrinology textbooks but rather to complement them. This book is unique because it is very much a cooperative effort between naturopathic and medical doctors, NDs and MDs. The work of prominent medical doctors, such as Abram Hoffer, John Lee, and Alan R. Gaby, is published alongside the work of respected naturopathic doctors, such as Gregory S. Kelly.

The book is also unique in offering three levels of information. It is, in turn, a textbook, a clinical reference, and a reader. It is divided into three sections: a textbook of naturopathic endocrinology based on current research; a clinical handbook of naturopathic protocols to diagnose and treat the most common endocrine disorders; and a selection of key clinical studies and research reports written by leading medical doctors and scientists. In addition, case studies from clinical practice illustrate the principles outlined in the text.

Michaël Friedman, ND

Naturopathic medicine is a primary healthcare system based on the recognition that the human organism has an incredible self-healing capacity. Naturopathic medicine supports this self-healing potential using an eclectic mix of traditional therapies. The therapies used by naturopathic doctors include clinical nutrition, botanical medicine, traditional Asian medicine, homeopathic medicine, acupuncture, physical medicine, hydrotherapy, and lifestyle counseling. In its own way, each therapy supports the self-healing efforts of the body. The naturopathic physician selects appropriate modalities to use on a given individual patient based on traditional knowledge, modern research, and clinical experience. This practice of medicine is at once founded on the healing wisdom of many centuries and a distillation of current scientific research. This makes naturopathic medicine truly a mix of art and science.

Fundamental Principles of Naturopathic Medicine
- First, do no harm
- Support the self-healing potential of the body
- Address the fundamental causes of disease whenever possible
- Treat the whole person through individualized treatment
- Teach the principles of healthy living and preventive medicine

Naturopathic Medical Tradition

Naturopathic medicine developed from the ancient Greek medical tradition founded by Hippocrates, the father of Western medicine, based on the premise that the body has an inherent ability to heal, referred to in Latin as *Vis Medicatrix Naturae* (Healing Power of Nature). The human being was considered by the ancient Greek physicians to be a dynamic creation of body, mind, and spirit that was more than the sum of its parts.

These premises inform the founding of the naturopathic medical profession at the turn of the 20th century by a group of European and American physicians dedicated to the practice of botanical medicine, home-opathy, spinal manipulation, hydrotherapy, and nutritional therapy. Their vision was to educate a profession of medical practitioners who could synthesize the techniques, observations, and practices of many healing modalities. A name was needed for this profession: naturopathy, a neologism from the Latin for nature and the Greek for suffering, was chosen. While naturopathic medicine thrived in the early 20th century under the influence of such notable physicians as Dr Benedict Lust and Dr Henry Lindlahr, the profession was eclipsed by surgical and pharmaceutical technological therapies. Naturopathic medical training was revived in the 1950s by Dr John Bastyr, after whom Bastyr University is named.

Today there are five colleges of naturopathic medicine in North America: Bastyr University in Seattle, Washington; National College of Naturopathic Medicine in Portland, Oregon; Southwest College of Naturopathic Medicine in Tempe, Arizona; Bridgeport University College of Naturopathic Medicine in Bridgeport, Connecticut; and The Canadian College of Naturopathic Medicine in Toronto, Ontario.

Together these institutions have an enrollment of more than 2,000 students. The curriculum is standardized and there is an accrediting body, The Council of Naturopathic Medical Education (CNME), which is recognized by the United States Department of Education. Graduates write international (Canada and the United States) licensing exams, which are known as the Naturopathic Physicians Licensing Exams (NPLEX). Upon passing NPLEX, they are eligible to practice in jurisdictions where naturopathic medicine is regulated.

Recently, naturopathic medicine has been given many alternative names — alternative, complementary, integrative, and holistic, to name a few. Regardless of the term used, one or more modalities of naturopathic medicine are now used by an estimated 42% of the North American population. Visits to natural healthcare practitioners exceed visits to primary care physicians by more than 200 million visits a year. North Americans spend more than an estimated $30 billion a year on these services.

A common misunderstanding about the practice of naturopathic medicine is that it is not 'scientific'. The naturopathic doctor is believed to be interested

in diet and lifestyle factors only, not in the medical condition, and recommends treatments that have no evidence of efficacy. Nothing could be further from the truth. For the patient's safety, the naturopathic doctor must establish a diagnosis based on medical history, physical examination, and standard laboratory tests. The diagnosis yields the information needed to select the appropriate naturopathic treatment. Once the etiology, pathogenesis, and pathophysiology of a condition are understood, the doctor can then recommend steps to restore normal physiological function. These therapeutic protocols are evidence-based in scientific literature and clinical practice, as the many references to peer-reviewed articles and refereed medical journals in this book testify.

Holistic Perspective

Naturopathic medicine approaches the patient from a holistic perspective. The role of the naturopathic physician is to support the self-healing ability of the whole being, in contrast to the symptom management we see in conventional surgical and pharmaceutical medicine, where each organ in the body has its own specialist.

The fundamental difference between these medical practices is the focus. Holistic medicine looks at the body as a whole, not as a collection of organs functioning independently. Holistic medicine is interested in understanding how, when one system is not working properly, it causes other problems in the body. There is a myriad of possible interactions within the human body. The physician must consider the "trees" and the "forest" at the same time.

Thus, a successful treatment for an endocrine illness, such as endometriosis, must consider not only the reproductive tract but also the liver since it functions in the degradation of the hormone produced in the reproductive tract. Someone who treats osteoporosis should consider all the organs involved in calcium metabolism — the skin, liver, kidney, thyroid, parathyroid, and gastrointestinal tract. By supporting the health of the organs not only will the osteoporosis improve but many other health complaints will often improve as well. The health of the individual may improve to the extent that other potential diseases are prevented.

Another example is allergies. We do not develop allergies simply because we are deficient in antihistamines. We develop allergies for a host of reasons. Perhaps it is due to omega-3 oil deficiency in the mast cell membranes. Maybe the liver is not able to detoxify foreign substances properly, irritating the immune system. A dysbiosis in the intestinal tract may be irritating the gastrointestinal lymphoid tissue. Therefore, a successful treatment for allergies may involve

Holistic Remedies

Holistic remedies are designed to re-establish balance in the body. This is achieved by a synergy of ingredients acting broadly throughout the organism, guiding it gently (and often slowly) back to equilibrium. In contrast, contemporary therapeutic thinking often considers only rapid and intensive effects on isolated parameters. These effects are often compared to reference drugs that are isolated substances designed for a single effect. No drug ever has a single effect, as evidenced by the long list of side effects of most pharmaceutical medications. Herbal medicines are often considered worthy of use in the West only when they compare favorably to such reference drugs. Yet herbal medicines by their very nature often work very differently than their pharmaceutical counterparts. Herbal medicines have been documented to work in ways similar to pharmaceutical drugs at times, but also as nutritive agents that support new healthy tissue growth, as anti-oxidants that prevent tissue damage, and as tonics that support glandular function by providing precursor molecules, to name a few. Hence, they are well suited to a holistic medical approach, but difficult to study in randomized controlled trials that are designed investigate the activity of an isolated active ingredient in a limited time frame.

treating the liver, improving digestion, and balancing the immune system.

Holistic concepts may actually help explain the therapeutic variability always seen in human clinical trials of both herbs and pharmaceutical medications. Contemporary medicine focuses on the diagnosis of disease, seeking medicines that chemically counter the pathologic results of the condition. Clinical trials of such medicines are conducted on large groups of people lumped together by the fact that they all suffer from the same diagnosis. We have already seen with the above examples, such as the possible causes of allergies, why this may be a problem. No investigation is made into the cause of the disease, only its manifestations. Success in these trials is measured by how well the medicine is seen to counter the pathologic change or its symptoms, quickly and effectively, in a significant proportion of the studied population. Variability in results from person to person is usually considered to be due to such factors as individual variations in the number of receptor sites, enzyme systems, liver detoxification pathways, etc.

From the holistic viewpoint, there are no disease entities, only individuals suffering the results of an imbalance of ordering principles. The same disease,

such as allergies, could result from any number of causes. Treatment would be very different in each case, and a medication that would be effective at curing the disease in all patients is inconceivable. All that could be hoped for (and this is often the case in modern Western pharmaceutical medicine) is to control the symptoms. Thus, the antihistamine is considered efficacious for allergies, yet side effects are common, and there is no mitigation in the disease state, as evidenced by the fact that the medication must be consumed regularly and indefinitely. Conventional Western medical reductionism and specialization may be hindering our ability to understand the use of herbal medicines as agents whose clinical effects demonstrate their ability to re-establish health.

Traditional Chinese medicine, Indian (Ayurvedic) medicine, and the Eclectic tradition of Western herbalism have classified disease in ways that are very different from Western conventional medicine, based on seeing patients as individuals, each with a unique manifestation of a disease state. Many of the drugs of the modern pharmaceutical compendiums were derived from medicines used by these ancestors. However, by isolating and concentrating ingredients, or making molecular changes to naturally derived medicines to ensure patent rights, the synergy of multiple ingredients acting in concert may be lost — and the side effects and toxicities of modern pharmaceuticals may be gained.

This is not to say there is not a time and a place for modern pharmaceutical interventions; however, it is time for these approaches to share the stage with holistic approaches.

This book is a humble attempt to examine the endocrine system from a holistic perspective and to demonstrate that natural medicine has an integral and valuable role in promoting the health and balance of the endocrine system.

May we all better understand the art of medicine, the science of the human organism, and the need for compassion and understanding.

Case Study
Multiple Endocrinopathy: Patient Suffering from Diabetes, Hypothyroidism, Polycystic Ovary Disease, and Adrenal Insufficiency

My first patient with endocrine disorders had been suffering for more than 20 years when she was referred to our practice. When I first saw her as a patient, I was skeptical that dietary and herbal remedies could have such a profound restorative effect on her illness. This patient inspired me with confidence in naturopathic medicine, not as an adjunctive treatment for endocrine patients, but as an effective main treatment. Since treating this patient successfully with naturopathic treatments, I have been satisfied to see many of my patients recover their health, but also disappointed by my lack of ability to restore other patient's health for reasons I don't understand.

Julie was first treated at The Canadian College of Naturopathic Medicine, and this case was first presented in my endocrinology course at the University of Bridgeport. The case was subsequently published in The Journal of Orthomolecular Medicine. *This case clearly illustrates the interconnection between endocrine disorders and naturopathic treatments.*

Introduction
Julie was the first diabetic patient I treated in my practice as a naturopathic doctor. When she came to my office, she was 54 years old and had been suffering from diabetes and multiple secondary diabetic complications for 25 years. As a result, Julie had developed 19 distinct clinical pathologies, primarily endocrine related, that required immediate attention. Over the years she had been prescribed a copious variety of pharmaceutical drugs, totaling 20 different drugs for her 19 conditions. Despite the amount of medicines she took, her illnesses were progressing to a dangerous level.

The magnitude of her serious health problems seemed almost impossible to reverse, but she was not an ordinary person. Julie had developed a remarkable inner strength and utmost determination to obtain emotional and physical health, something that she had never felt before. Her childhood was scarred with abuse: emotional, physical, and sexual. At the age of 19, she started to suffer from depression and was treated with eight electroconvulsive therapies. Since then, she has been hospitalized eight times for psychiatric episodes. At age 44, she was diagnosed with a personality disorder. At the age of 53, she became homeless.

Diagnosis
I checked Julie's blood pressure. It was 200 systolic over 100 diastolic, a dangerously high level. This was far higher than normal (120/80), despite the fact that she was taking three pharmaceutical drugs to regulate her blood pressure. She was at immediate risk for a heart attack, and in conjunction with extremely high blood sugar levels, she was also in danger of a diabetic coma and renal failure in the near future.

High levels of sugar and the presence of the protein microalbumin were found in the urine. The kidneys ensure that water is secreted, while substances like microalbumin are kept within the body through the filtration system of the glomerulus. Damaged kidneys from long-term assault of high blood sugar and blood

pressure cause the glomerulus filtration to break down. It was clear from the presence of microalbumin in her urine that Julie had the beginnings of renal disease.

Blood sugar control with the use of pharmaceutical drugs was clearly not effective enough, evidenced by an extremely high level of glycosylated hemoglobin (blood test that measures long-term blood sugar control). It was apparent that the secondary complications due to hyperglycemia would only get worse. And it was getting worse. She had the textbook list of secondary complications: kidney, heart, eye, nerve, and circulatory disease.

High blood sugar can cause all of these complications. High blood sugar leads to high blood pressure. High blood pressure leads to heart and kidney damage. In turn, kidney damage causes further hypertension. At the same time, the hyperglycemia continues to produce free radicals, initiating a cascade of chemical reactions destroying tissues throughout the body.

It was clear that the pharmaceutical drugs she had been taking were not addressing her problems effectively. This was indicated by the fact that her blood pressure was 200/100 mmol/Hg and her blood sugar was 22 mmol/L, despite the fact that she had been taking oral hypoglycemic drugs intermittently for 20 years. The drugs Julie had taken had caused many secondary problems and side effects that eventually caused her to discontinue using them. As a result, she experienced flu-like symptoms, diarrhea, edema, and fatigue. She preferred to let her high blood sugar levels persist rather than to deal with the additional discomforts she faced while taking the pharmaceutical drugs Glucophage and Glyburide.

Julie had suffered from edema, which is fluid build-up in the body and legs. There are multiple causes for edema in diabetic patients. Edema often occurs when a patient's kidneys are not adequately removing water from the body. Diabetic patients often have kidney problems, and edema is a common consequence. However, in Julie's case, edema was caused by the drug Glyburide, which she took to lower her blood sugar. The Glyburide she had taken had caused a condition called SIADH (Symptom of Inappropriate Antidiuretic Hormone Secretion). As soon as Julie stopped taking Glyburide, her edema subsided and, surprisingly, her blood sugar did not increase. One of the main reasons for taking oral hypoglycemic drugs in adult onset diabetes is to prevent hyperglycemia-induced kidney disease among other complications. She currently had kidney disease and was taking Glucophage, an oral hypoglycemic drug that only instigates further kidney damage.

Treatment

I treated Julie with an aggressive program of natural medicines. To lower her blood sugar as quickly as possible, I prescribed botanicals, mineral supplements, and diet.

Botanicals

I gave her herbs that nourish the pancreas, liver, and adrenal glands — the three organs responsible for the metabolism of blood sugar. Her treatment consisted of traditional herbs that have been used around the world in the treatment of diabetes. These herbs included jambul, milk thistle, devil's club, globe artichoke, and nopal. These herbs were given in equal proportions in alcohol extracts. The dosage prescribed was 40 mL of tincture daily.

Treatment Program

The herbs prescribed and the organs they treated were as follows:

- Pancreatic Support: *Syzygium jambolana, Oplopanax horridum*
- Liver Support: *Silybum marianum*
- Adrenal Support: *Eleutherococcus senticosus*
- Nervine Support: *Hypericum perforatum*
- Kidney Support: *Solidago canadensis*
- Eye Support: *Vaccinium myrtillus*

Syzygium jambolana (jambul seed) is an Ayurvedic medicine that has been used for thousands of years in India to treat diabetes and its secondary complications. Jambul not only helps with lowering blood sugar but also with the secondary complications. It has been found to increase formation of the essential enzymes superoxide dismutase and glutathione, which serve as powerful antioxidants in preventing denaturation of proteins found in hyperglycemia.

Oplopanax horridum (devil's club), a Native American herb from the Pacific Northwest, is traditionally used for hyperglycemia, digestive problems, and a host of other conditions. Native Americans used it for almost all conditions. It has immune-supportive and antiviral properties. It also functions as an adrenal and a pancreatic tonic.

Silybum marianum (milk thistle) is an extremely potent liver tonic herb that decreases the free radical formation by supporting cytochrome P450 system of the liver. It has been recently hypothesized that the liver plays a crucial role in the regulation of hyperglycemia because it produces hepatic insulin sensitizing substrates (HISS) that help the effect of insulin

receptor sites throughout the body. Although modern science has not always been aware of this fact until recently, traditional herbal medicine in Eastern Europe used milk thistle in the treatment of diabetes long before modern science came to the understanding of the relationship between the liver and HISS.

Nopal opuntia (prickly pear cactus) can be found in the desert regions of the Southwestern United States and Central America. Traditionally, nopal is both eaten as a food and as a medicine. One of its medicinal uses is for the treatment of diabetes. Nopal is not only effective in controlling diabetes, but it also controls the secondary problems associated with diabetes, such as high cholesterol and triglycerides. Numerous studies have documented a significant improvement in patients' cholesterol and triglyceride levels within 24 hours of drinking nopal juice in high doses.

Cyanara scolymus (globe artichoke) contains inulin, a compound that buffers the effects of high blood sugar. It also tonifies and nurtures the liver, a crucial organ for the maintenance of healthy blood sugar levels.

In addition, *Hypericum perforatum* (St John's wort), a nervine, was used to restore nerve function. *Solidago canadensis* (goldenrod) was used to help kidney function. *Vaccinium myrtillus* (billberry) was prescribed not only as a hypoglycemic but also as a tonic for the eyes to treat the glaucoma.

Mineral Supplementation

Mineral supplementation included a multi-mineral formula that was specifically tailored to aid in blood sugar metabolism. This included a daily dose of 600 mcg chromium, 45 mg zinc, and 150 mcg selenium.

Diet

Her diet was considered good in the conventional medical paradigm. However, this paradigm did not consider food allergens as a significant factor in the treatment of diabetes. She was very prone to food allergies due to her past history of digestive disorders and extreme dysbiosis. Studies have found that removing food sensitivities lower blood sugar levels dramatically. Thus, a hypoallergenic diet was prescribed. Within 3 months of this diet, she had consistent fully formed stools for the first time in her life.

Results

After one year of taking this herbal formula, along with following a strict diet, receiving acupuncture treatments, and eliminating these pharmaceutical drugs, Julie's blood sugar was under excellent control. She had a 71% decrease in fasting blood sugar and a 44% reduction in glycosylated hemoglobin.

This meant that the amount of sugar molecules attaching to the red blood cell byproducts had decreased by 44%; consequently, the saturation of sugar affecting the different tissues in the body went down by 44%. This translates into a significant reduction in cardiovascular risk, kidney disease, eye disease, and nerve disease. Julie's mortality risk was significantly altered.

The treatment time was approximately one year. It took several months for the blood sugar to fall to 18 mmol/l. The blood sugar consistently fell below 10 mmol/l after one year of treatment. These levels were below any level that she had achieved in the previous 15 years, even with the daily use of Metformin 500 mg b.i.d. and Glyburide 5 mg b.i.d. The effectiveness of St. John's wort in treating the neuropathy took about 2 months. When she discontinued this herb, the symptoms came back, but with much less severity.

The patient is now in much better emotional and physical health than she has ever been. She enrolled full time in a school to become a healthcare practitioner and currently lectures on homelessness.

This herbal regime is an example of naturopathic medicine designed to improve the vitality of all the organs involved with blood sugar metabolism. This paradigm is quite different from the allopathic approach, in which pharmaceutical drugs are prescribed, not to foster health of an organ, but to stimulate or inhibit biochemical pathways within the body.

The real test of the curative aspect of these herbs would be evident a year later. By supporting the health and vitality of the body, Julie's blood sugar was in better control a year later even after discontinuing all medicines. This is quite a different result than with the use of conventional medicine. When she used drugs, her dosage and types of drugs kept on increasing throughout her life, while her health continually declined. The second evidence that these herbs were strengthening the organs is that these same herbs were used effectively to treat patients who had high insulin levels, low insulin levels, hyperglycemia, and hypoglycemia.

Due to the success of this naturopathic treatment in alleviating Julie's diabetes and secondary complications, I received a grant to conduct a 15-month clinical trial for the use of herbal medicine in the treatment of blood sugar metabolism. The results of the study showed that 88% of patients with hyperglycemia were able to lower the blood sugar by one third, while at the same time the patient who had too much insulin was able to lower it by 25%, and patients with reactive hypoglycemia had a 44% decrease in hypoglycemic symptoms. This was yet another confirmation that herbs are powerful healing agents.

BASICS OF NATUROPATHIC ENDOCRINOLOGY

The textbook section of this book is designed for a core course in naturopathic endocrinology or for an elective complementary and alternative medicine course in the subject at a traditional healthcare or medical school. After briefly reviewing the anatomy of the endocrine system, disorders of each endocrine gland are studied in depth. Quick reference guides at the beginning of each chapter and quick review questions at the end highlight the most important information. Comprehensive monographs on nutritional and botanical agents present current evidence-based research, and the extensive list of references not only supports the credibility of the information delivered but also offers directions for further research. Within the chapters, readers are also directed to the Selected Clinical Studies and Literature Reviews section of this book for supplementary recommended reading.

The Basics of Naturopathic Endocrinology section is thus a complete course resource, complemented by a set of recommended readings that can be assigned for classroom discussion or independent study. The text and the reader sections culminate in the Clinical Handbook section, designed for use by new clinicians and experienced doctors throughout their career.

Physiology Review

The endocrine system involves all the organs and their supporting tissues that are involved in secreting hormones into their respective capillaries that eventually travel through the blood and cause specific effects on target tissues of the body. Hormones are chemical agents that cause a specific effect on target tissues outside the initial place they are produced. Hormones work along with the nervous system to integrate and harmonize various physiological functions, such as growth and reproduction, related activity and homeostasis (a tendency to stability in the normal body states or internal environment).

ENDOCRINE TISSUES

Endocrine tissues or glands are distinguished from exocrine glands in that they have no ducts. Some endocrine secretory cells are located in non-endocrine organs (such as the enteroendocrine glands of the gastrointestinal tract), interstitial cells of the testes, secretory neurons in the brain (such as the hypothalamus), or may exist as microscopic islands (such as the beta cells of the Langerhans of the pancreas). The remaining endocrine tissues exist as an entity, namely the pituitary gland, pineal gland, thyroid glands, parathyroid glands, thymus, adrenal glands, ovaries, and testes.

Other Hormone-Secreting Organs

Endocrine activity also involves certain organs that have crucial functions outside this role.

Kidneys: For example, the kidney not only secretes renin involved in blood pressure, but also erythropoietin that stimulates red blood cell corpuscles.

GI Tract: The gastrointestinal tract is involved in production of hormones regulating digestion.

Placenta: The placenta secretes human chorionic gonadotropin (HCG), estrogen, progesterone, lactogen, and growth-stimulating hormone.

Heart: The heart secretes atrial natriuretic peptide (ANP) involved in sodium excretion and inhibits smooth muscle contraction.

HYPOTHALAMUS

Intimately involved with the endocrine system is the hypothalamus, controlled by secretory neurons that control the release of hypophyseal hormones from the pituitary gland. These include follicle-stimulating hormone (FSH), leuteinizing hormone (LH), thyroid-stimulating hormone (TSH), adrenocorticotropic hormone (ACTH), growth hormone (GH), prolactin, oxytocin, and antidiuretic hormone (ADH). These hormones tell their respective organs to produce estrogen, progesterone, testosterone, thyroxin, and adrenal cortical hormones.

RECEPTORS

Endocrine hormones typically act to control intracellular functions by first combining with hormone receptors on the surfaces of cells or inside the cells. Binding of the hormone with the receptor turns on a cascade of reactions within the cell to accomplish a particular goal. These hormone receptors are very large proteins, and each cell may have in the order of 2,000 to over 100,000 hormone receptors, depending on the cell's function. Receptors are understandably highly specific for a single hormone. This allows one hormone to act on a particular target tissue with minimal cross reactivity.

Amazingly, the number of receptors in a target cell is in constant flux. For example, the binding of a hormone with its corresponding receptor causes the number of receptors to change. In "down-regulation" the number of receptors is reduced, causing a decreased responsivesness to the hormone. In "up-regulation," the number of receptors is increased with a corresponding increase in hormone sensitivity. This phenomenon is responsible for many of the clinical effects seen with medical intervention, including some of the tolerance that develops to longer-term pharmaceutical treatments (and thus the need to adjust dosages) and the drug withdrawal symptoms commonly experienced when a drug or hormone treatment is discontinued. It may also help us to explain how therapies that balance the endocrine system can lead to long-term changes and bring patients to a new plateau in their wellness.

Endocrine System Interactions

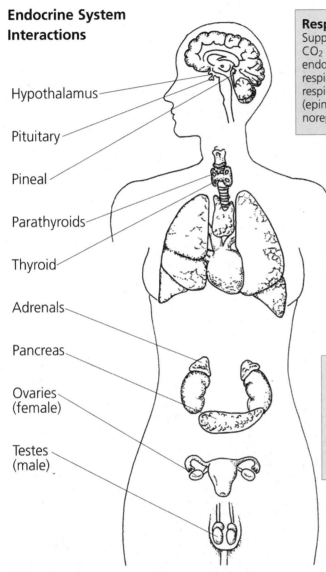

Hypothalamus

Pituitary

Pineal

Parathyroids

Thyroid

Adrenals

Pancreas

Ovaries (female)

Testes (male)

Respiratory System
Supplies O_2 and eliminates CO_2 generated by endocrine cells; stimulates respiration and dilates respiratory passageways (epinephrine and norepinephrine).

Digestive System
Provides nutrients and substrates to endocrine cells; secretes insulin and glucagon (pancreas); produces and releases angiotensinogen (liver); stimulates constriction of sphincters and depresses activity along digestive tract (epinephrine and norepine-phrine); coordinates secretory activities along tract (digestive tract hormones).

Muscular System
Adjusts muscle metabolism and supports skeletal muscle growth; regulates calcium and phosphate levels. Some endocrine tissues protected by muscles.

Urinary System
Stimulates kidney cells to release renin and erythropoietin when local blood pressure declines and to produce calcitriol; governs rates of fluid and electrolyte reabsorption in kidney.

Lymphatic System
Stimulates lymphocytes to provide defense against infection and to assist in repair; provides anti-inflammatory glucocorticoids; stimulates development of lymphocytes.

Cardiovascular System
Stimulates heart to secrete ANP; regulates production of red blood cells (erythro-poietin); elevates blood pressure, heart rate, and contractile force (epineph-rine). Hormones distributed by circulatory system.

Skeletal System
Regulates skeletal growth, calcium mobilization (parathyroid hormone and calcitonin), closure of epiphyseal plates at puberty, and adult bone mass. Endocrine tissues in brain, chest, and pelvic cavity protected by skeletal system.

Integumentary System
Stimulates sebaceous gland activity, develop-ment of mammary glands (PRL); alters dermal blood flow (adrenal hormones), release of lipids from adipocytes, and melanocyte activity (MSH); influences hair growth, fat distribution, and apocrine sweat gland activity. Superficial endocrine tissues protected.

All Systems
Regulates growth and development, metabolic rates, and substrate utilization.

Reproductive System
Regulates sexual devel-opment and function; stimulates uterine and mam-mary gland smooth muscle contractions (oxytocin).

Nervous System
Controls adrenal medullae; secretes ADH and oxytocin; affects neural metabolism; regulates fluid and elec-trolyte balance; influences reproductive hormones. Hypothalamic hormones directly control pituitary and indirectly control secre-tions of other endocrine tissues.

Endocrine Tissues and Hormones

Endocrine Tissue	Hormone
Anterior Pituitary	Growth Hormone (GH) Adrenocorticotropin Hormone (ACTH) Thyroid-Stimulating Hormone (TSH) Follicle-Stimulating Hormone (FSH) Luteinizing Hormone (LH) Prolactin
Posterior Pituitary	Antidiuretic Hormone (ADH) Oxytocin
Pineal	Melatonin
Thyroid Gland	Thyroxine (T-4), Triiodothyronine (T-3) Calcitonin
Parathyroid Glands	Parathormone (PTH)
Adrenal Glands (medulla)	Adrenaline and Noradrenaline
Adrenal Glands (cortex)	Cortisol Aldosterone DHEA
Pancreas	Insulin Glucagon
Ovaries	Estrogens Progesterone
Testes	Testosterone
Hypothalamus *Although not considered an endocrine gland, the hypothalamus exerts control over the pituitary via neuro-hormones.*	Corticotropin-Releasing Hormone (CRH) Growth Hormone-Releasing Hormone Growth Hormone-Inhibiting Hormone Gonadotropin-Releasing Hormone (GnRH) Thyrotropin- Releasing Hormone (TRH) Prolactin Inhibiting Factor (Dopamine)

Site of Action	Action
Most cells of the body	Stimulates cell growth
Adrenal Glands (cortex)	Stimulates adrenal cortex to release cortisol and aldosterone
Thyroid Gland	Causes thyroid to secrete thyroid hormones
Ovary/Testes	Promotes growth of follicles within the ovary (female), sperm formation (male)
Ovary/Testes	Stimulates estrogen/progesterone release (female), testosterone (male)
Breast tissue	Encourages breast development, milk production in pregnancy
Kidneys, blood vessels	Causes kidneys to retain water, increases blood pressure
Uterus/Breast tissue	Induces contractions during labor, milk expulsion
Brain, immune system	Governs sleep/wake cycle
Most cells of the body	Increases metabolism, chemical reactions
Bone cells	Increases calcium deposition
Gut, kidney, bone	Increases calcium in the blood
Many cells and tissues	Initiates fight-or-flight response
Many cells and tissues	Stress response affects metabolism, immune system, blood vessels
Kidneys, sweat glands	Promotes sodium/water retention, increases potassium loss
Immune system, brain	Precursor to androgens, promotes immune and mood balance
Most cells of the body	Promotes entry of sugar into cells, fat deposition
Liver, fat, muscle	Increases glucose production and release into the blood
Sex organs, uterus, bone, brain	Involved in sexual development (female), menstruation, builds uterine tissue, bone metabolism
Sex organs, uterus, bone, brain	Involved in sexual development (female), menstruation, uterine secretion, pregnancy
Sex organs, brain	Involved in sexual development (male), libido, muscle development
Anterior Pituitary	Stimulates release of ACTH
Anterior Pituitary	Stimulates release of GH
Anterior Pituitary	Inhibits release of GH
Anterior Pituitary	Stimulates release of LH and FSH
Anterior Pituitary	Stimulates release of TSH
Anterior Pituitary	Inhibits release of Prolactin

FEEDBACK MECHANISMS

Control of hormone secretions is accomplished by an internal control system. In most instances, a feedback mechanism is employed. The majority of feedback loops work as a negative feedback. In negative feedback, the endocrine gland has a natural tendency to over-secrete its hormone. The hormone then stimulates the target tissue to perform a function. Thus, the important factor is not the rate of secretion of the hormone but the rate that the target function is performed.

When the target organ's activity rises to an appropriate level, feedback is released to the endocrine gland to slow further secretion of the hormone. For example, the pituitary gland (endocrine gland) secretes thyroid-stimulating hormone, which acts on the target organ, the thyroid gland, to stimulate production of the thyroid hormones T3 and T4. The pituitary then monitors the circulating levels of thyroid hormones. When these levels are deemed by the pituitary to have reached appropriate levels, the release of TSH by the pituitary is curtailed. If the target organ (in this case the thyroid gland) were not to be able to produce adequate amounts of thyroid hormones, a healthy pituitary would secrete more and more TSH until the thyroid gland responded.

Endocrine Disorders

Endocrine disorders can be attributed to any malfunction of endocrine tissue. There are many ways that an endocrine system can go astray. The endocrine tissues can either secrete too much or too little hormone, or the peripheral tissues can't process the hormones. The causes can be quite varied — infections, tumors, trauma, and lifestyle factors. These endogenous factors can disrupt the endocrine system. Exogenous factors, such as chemicals in the environment, can also cause a host of complications in the endocrine system. These endocrine disrupters are found in high levels in non-organic foods cultivated with pesticides, in our water supply, and in the air we breath.

PITUITARY DISORDERS

These disorders include pituitary insufficiency resulting in the failure of the pituitary to release or produce adequate amounts of growth hormone, prolactin, corticotrophin, thyrotropin, leuteinizing hormone, or follicle-stimulating hormone. Excessive hormone production can also occur, caused by growth-hormone-secreting pituitary tumors and glycoprotein-secreting pituitary tumors.

PINEAL DISORDERS

Pineal disorders as recognized by conventional medi-cine are quite rare. They consist of tumors that are benign (pinealocytoma) and aggressive pineal cell tumors (pineoblastoma, pineal germinoma, pineal teratomas). Pineal cysts are most often not treated, unless they are large enough to cause hydrocephalus or visual symptoms.

Although not recognized conventionally, melatonin deficiency and excess is a relatively common condition that can be the root of many symptoms. The pineal gland is responsible for melatonin production. If it is underactive in producing melatonin, this can cause various symptoms, such as insomnia and stress. If it is overactive, the result can be seasonal affective disorder (SAD).

BLOOD SUGAR METABOLISM DISORDERS

Disorders of blood sugar metabolism involve problems with either the pancreas producing too little or too much insulin, the insulin receptor sites becoming deficient, or decreased function of the adrenal glands or liver. The most common blood sugar disorders are diabetes Type I, diabetes Type II, and hypoglycemia. The secondary complications to diabetes range from increased cardiovascular risk to end-stage renal disease.

LIPIDS METABOLISM DISORDERS

Disorders of lipid metabolism involve problems associated with either overly high or overly low levels of fats in the body. The most common disorder of lipid metabolism in the modern affluent world is high levels of lipids (cholesterol and triglycerides) due to excessive eating of high-fat foods and low levels of physical activity. Although much more rare, some people suffer from excessively low levels of lipids usually due to malabsorption of fats due to digestive disorders.

THYROID METABOLISM DISORDERS

Thyroid disorders are usually related to hyperfunction or hypofunction of the thyroid gland, resulting in hyperthyroidism or hypothyroidism. Secondary complications to hypothyroid are weight gain, fatigue, and cardiac complications; secondary complications to hyperthyroid are atrial fibrillation, weight loss, and anxiety. Chronic fatigue syndrome, fibromyalgia, and Wilsons temperature syndrome are disorders suspected of being related to decreased peripheral thyroid hormone conversion or thyroid resistance.

The parathyroid glands are found next to the thyroid, and when over activated, lead to excessive levels of calcium in the body, resulting in symptoms ranging from hypertension and headache to depression and kidney disease.

Note on the Thymus Gland

Below the thyroid along the neck descending down to the thoracic cage is the thymus gland. Traditionally, the thymus was considered solely an organ involved in developing the immune system of children. Although still not totally accepted into the conventional medical textbooks as an endocrine organ, it is involved in the endocrine system.

The thymus has epithelial cells that synthesize over 30 different polypeptides or thymus hormones. Much research still needs to be done in understanding the full functions of these hormones. One of the most important of the largest thymus hormones is thymopoietin. It induces the differentiation of thymus cells within the thymus to produce thymocyte cells. It is also believed to be involved in the disease process formation of myasthenia gravis.

ADRENAL METABOLISM DISORDERS

Adrenal disorders, like most endocrine disorders, are usually associated with hyperfunction or hypofunction. Adrenal hyperfunction can lead to hyperaldosteronism, resulting in hypertension, and adrenal insufficiency, resulting in severe fatigue. Naturopathic medicine recognizes adrenal insufficiency in a much more wider diagnostic parameter than conventional medicine.

REPRODUCTIVE HORMONE DISORDERS

Reproductive endocrinology is associated with any reproductive hormone level change. Common conditions include impotence, hirsutism, and infertility. It also covers healthy and normal changes of hormone levels associated with changes of maturation, such as puberty and menopause.

Endocrine Disruptors

Besides endocrine disorders caused by the internal environment, the endocrine system has to deal with "endocrine disruptors" that come from the external environment in the form of chemicals, such as pesticides and dioxins, found in our foods, our water, and the air we breathe.

Globally, it has been estimated that 20,000 people are killed yearly from direct exposure to pesticides; more than 500,000 illnesses yearly are due to pesticide use. Pesticide residues are found in air, soil, and water. They are found as well in most humans and animals. The majority of pesticides used are organophosphates and carbamate. They are used in schools, business offices, churches, apartment buildings, grocery stores, farms, and, homes on a regular basis.[1]

Pesticides in chronic low-dose exposure adversely affect the nervous system and cause cell-mediated immune deficiency, allergy, and autoimmunity. After symptoms occur in the immunological and neurological areas, problems in endocrine function may also occur. Chlorinated products, for example, act as weak estrogens and affect reproduction. These compounds have been associated with female infertility, miscarriages, and possible male infertility. Organophosphate (OP) pesticides have also been associated with male infertility with increased LH production (possibly secondary to testicular damage) and reduced numbers of morphologically healthy spermatozoa.[2] Hexachlorocyclohexane (HCH) alters melatonin synthesis from the pineal gland and thus affects sleep. DDE (the breakdown product of DDT) can accumulate in the adrenal gland and cause atrophy.[3] According to a study by the Environmental Protection Agency (EPA), 93% of autopsies conducted in 1982 indicated the presence of DDE. Organophosphates also seem to affect calcium metabolism. Agricultural workers exposed to OP pesticides have significantly decreased bone formation compared to healthy controls.[4]

North Americans accumulate harmful levels of dioxins in their bodies mostly through the ingestion of food. Some segments of the population, such as nursing babies and people who eat a diet high in animal fat or foods contaminated because of their proximity to dioxin release sites, are exposed to higher than average levels of dioxin. Dioxins accumulate in the fatty tissue in meat, fish, and dairy products. When people consume these foods, they also consume dioxins. The ingestion of dioxin in common foods has resulted in widespread low-level exposure in the general population. Others members of the population, such as Vietnam War veterans and some chemical plant workers, have accumulated additional dioxins because of their exposure to Agent Orange or other dioxin-contaminated chemicals in the workplace.

The World Health Organization (WHO) has studied the effect of abnormal levels of dioxin on the endocrine system, noting several serious disorders in animal and human studies.

Dioxin is not the only chemical that disrupts endocrine function. When the EPA measured the volatile organic compounds in adipose tissue of autopsies in the United States, a wide array of endocrine disruptors was discovered.

Exposure to chemicals has an impact on virtually every aspect of clinical endocrinology.

Effect of Dioxins on Endocrine System
- Endometriosis
- Genital malformations (females)
- Altered glucose tolerance
- Decrease in sperm count
- Decreased testes size
- Decreased testosterone levels

Prevalence of Foreign Chemicals in Human Fat Tissues [5]
- Benzene 96%
- PCB 83%
- Toluene 91%
- Chlorobenzene 96%
- Styrene 100%
- Ethyl benzene 96%
- DDT 55%
- DDE (breakdown product of DDT) 93%
- 2,3,7,8 TD Dioxin (Agent Orange) 76%
- Dioxin 100%

→ Selected Clinical Studies and Literature Reviews

To read more about exogenous endocrine disruptors, refer to the *Selected Clinical Studies and Literature Review:* Paul Goettlich, *Environmental Chemicals and Endocrinology,* pp. 362.
Samuel S. Epstein, *"Trade Secrets": The Latest in a Long Line of Conspiracies Charges,* pp. 366.

References

1. Coburn T, Dumanosk D, Myers JP. Our Stolen Future. Boston, MA: Little Brown, 1996.

2. Juhler RK, Larsen SB, Meyer O, et al. Human semen quality in relation to dietary pesticide exposure and organic diet. Arch Environ Cntam Toxic 1999;37:415-23.

3. Chowdhury AR, Gautam AK, Venkatakrishna-Bhatt H. DDT (2,2 Bis9 p-Chlorphenyl)1,1,1-trichlorethane-induced structural changes in adrenal glands of rats. Bull Environ Contam Toxic 1990;45:193-96.

4. Compston JE, Vedi S, Stepen AB, et al. Reduced bone formation after exposure to organophosphates. The Lancet 1999;354:1791-92.

5. Crinnion ND. Environmental medicine, Part 4: Pesticides — biologically persistent and ubiquitous toxins. Alternative Medicine Review 2000 Oct;5(5).

Pathophysiology Review

The pituitary is a small gland located below the brain in the skull base, in an area called the *sella tursica*. The pituitary gland is often called the master gland because it controls the secretion of all the major endocrine hormones. These compounds have broad ranging effects on metabolism, fluid control, growth, and sexuality.

The pituitary gland is divided into a larger anterior region (adenohypophysis) and a smaller posterior region (neurohypophysis). The gland is connected by the pituitary stalk to the hypothalamus, located directly above the pituitary gland. Because of the close proximity of the pituitary gland to the major intracranial nerves and blood vessels and its overall control of the endocrine systems, pathologies of the pituitary can cause a wide spectrum of symptoms, both hormonal and neurological.

PITUITARY HORMONES
Thyroid Stimulating Hormone (TSH)

TSH stimulates the thyroid gland to release thyroid hormones (T2, T3, T4). Thyroid hormones affect almost all cells of the body, controlling basal metabolic rate and playing a crucial role in growth. Excess TSH is the cause of secondary hyperthyroidism. TSH deficiency causes secondary hypothyroidism, which can result in short height with short extremities.

Growth Hormone (GH)

This hormone is a peptide produced and secreted by the anterior pituitary gland. GH is stimulated by growth hormone-releasing hormone (GHRH) and is inhibited by somatostatin. The pituitary produces more GH than any other hormone. GH does not exert all its effect directly. Many of its effects are caused by insulin-like growth factor (I-GH), also known as somatomedin-C.[1]

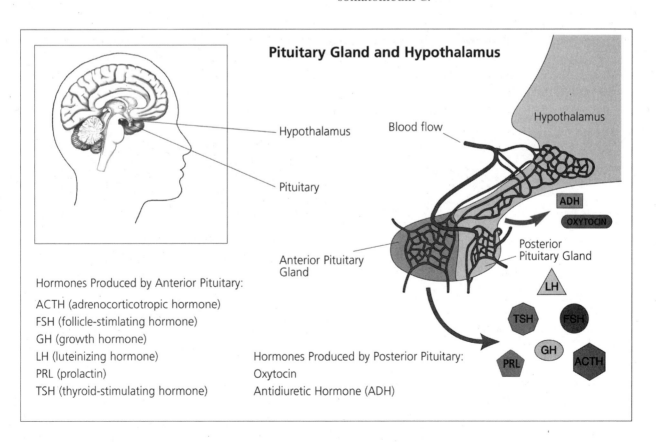

Pituitary Gland and Hypothalamus

Hypothalamus

Pituitary

Blood flow

Hypothalamus

ADH

OXYTOCIN

Anterior Pituitary Gland

Posterior Pituitary Gland

LH

TSH FSH

GH

PRL ACTH

Hormones Produced by Anterior Pituitary:

ACTH (adrenocorticotropic hormone)
FSH (follicle-stimlating hormone)
GH (growth hormone)
LH (luteinizing hormone)
PRL (prolactin)
TSH (thyroid-stimulating hormone)

Hormones Produced by Posterior Pituitary:
Oxytocin
Antidiuretic Hormone (ADH)

Quick Reference: Pituitary Disorders

Pituitary Disorder	Major Signs and Symptoms	Key Laboratory Tests	Conventional Therapies	Naturopathic Therapies
Pituitary Deficiency:				
Hypothyroidism	Fatigue	Low TSH	T4: 1-1.25 mg q.d.	T3: 30 mcg b.i.d. or Armour 1-6 grains T4: 1-1.25 mg q.d.
Adrenal	Fatigue Insufficiency pressure	Low ACTH Low blood	Hydrocortisone 20 mg AM and 10 mg PM	Hydrocortisone 20 mg AM and 10 mg PM Licorice solid extract
Hypogonadism (male and female)	Infertility Impotence No menses	Low L Low FSH Low estrogen, testosterone, progesterone	Depo-testosterone 300 mg intramuscularly ever 3 weeks Testosterone patch: 6 mg q.d. Estradiol patch: 0.05-0.1 mg b.i.d.	Bio-indentical hormone therapy
Diabetes insipidus	Polyuria Excessive thirst	ADH deficiency	Desmopressin 0.1 ml intranasally 1-2 times q.d.	Desmopressin 0.1 ml intranasally 1-2 times q.d.
Growth Hormone Insufficiency	Low body mass and stature	Low GH Low IGF-1 (somatomedin)	0.30 GH mg/kg/week	0.30 GH mg/kg/week Amino acid therapy
Pituitary Excess:				
Prolactinoma	Enlarged breasts in men Infertility in men and woman Milk in breasts (when not lactating)	High levels of GH	Bromocriptine, 2.5 mg t.i.d. Surgery	Vitex agnus Vitamin B-6 Magnesium Adaptogens
Acromegaly	Enlarged hands and feet Sleep apnea Hypertension . Diabetes	High levels of GH	Surgery The dopamine agonist drugs, bromocriptine and cabergoline, improve symptoms but are not very effective in lowering growth hormone and IGF-1 levels to normal (< 10%).	Vitex agnus Vitamin B-6 Magnesium Adaptogens
Cushing's Disease	Weight gain Muscle mass loss Easy bruising	High levels of ACTH	Surgery	Vitex agnus Adaptogens
Hyperthryoidism	Anxiety Heart palpitations	High TSH	Surgery	Vitex agnus Adaptogens

Note: Many naturopathic therapies for hormone deficiency are similar to conventional therapies. In cases of pituitary excess, specific naturopathic approaches would use dosing of Vitex agnus castus (chasteberry) from 20-200 mg t.i.d. and adaptogenic herbs 500 mg – 3 grams t.i.d. However, in severe cases surgery might still be needed.

GH is the principal hormone regulating growth. It stimulates not only muscle and bone growth, but also the growth of internal organs. It has anabolic activity, stimulating bone and muscle growth in childhood. GH also functions to raise blood sugar levels by gluconeogenesis and works as an antagonist of insulin.

GH naturally decreases by 14% per decade after age 20. When the hormone is secreted in excess, it causes gigantism (acromegaly). Excessive GH replacement therapy has been shown to cause cardiac hypertrophy, carpal tunnel syndrome, diabetes, and musculoskeletal tissue disorders.

Deficiency causes dwarfism when it occurs during growth. In adults, GH deficiency is also linked to decreased life expectancy, cardiovascular disease, and bone loss. Deficiency is caused by chronic stress, cortisol, progesterone, serotonin antagonists, obesity, hyperthyroidism, and hyperglycemia.

Adrenocorticotropic Hormone (ACTH)

ACTH triggers the adrenal cortex to release glucocorticoid steroids (cortisol and cortisone) and mineralocorticoids (11-Deoxycortiocsterone and aldosterone). ACTH deficiency causes secondary hypoadrenocorticism (Addison's disease). ACTH excess causes hyperadrenocorticism (Cushing's disease).

Leuteinizing Hormone (LH) and Follicle-Stimulating Hormone (FSH)

These hormones control reproduction. LH promotes ovulation and progesterone production in females and testosterone production in males. FSH promotes ovum formation and estrogen production in females and spermatozoa formation in males.

In females, a deficiency of LH is associated with PMS, while a deficiency of FSH is associated with PCOS. A deficiency of both LH and FSH is the cause of amenorrhea of pituitary origin. Conversely, excess LH is seen in PCOS, while excess FSH contributes to PMS. The most common cause of a combined excess of LH and FSH is menopause. In males, LH deficiency causes hypogonadism, while FSH deficiency is associated with infertility.

Prolactin (PRL)

This hormone stimulates secretion of breast milk by stimulating the mammary glands. It also suppresses ovulation and stimulates the thymus gland.

Excess prolactin is associated with a high estrogen/progesterone ratio, infertility, galactorrhea, and polycystic ovary syndrome (PCOS). Insufficient prolactin is associated with deficient lactation.

Anti-Diuretic Hormone (ADH)

Also known as vasopressin, this hormone promotes water retention by increasing the kidney's reabsorption of sodium at the distal renal tubules. ADH promotes the production of concentrated urine.

A deficiency of ADH causes diabetes insipidus. Excess ADH causes hypervolemia and hypertension.

Hypopituitarism (Pituitary Insufficiency)

Pituitary insufficiency is defined as failure of the gland to make one or more of the following anterior pituitary hormones: growth hormones (GH), prolactin (PRL), adrenocorticotropin (ACTH), thyrotropin (TSH), leuteinizing hormone (LH), or follicle-stimulating hormone (FSH).

Hypopituitarism can be caused by factors that disrupt normal pituitary function. These include pituitary, hypothalamic, or parasellar disease, which causes displacement, infiltration, or destruction of the gland. Examples include meningiomas, craniopharyngiomas, optic nerve gliomas, nasopharyngeal tumors, and pineal dysgerminomas.

If damage is located at the pituitary stalk, all the anterior pituitary hormones (TSH, LH, FSH, GH, and ACTH) decrease, while prolactin (PRL) rises. This rise in prolactin results from the loss of the inhibitory effect of hypothalamic dopamine on the lactotrophs.

Associated Hypopituitary Conditions
- Hypothyroidism
- Adrenal insufficiency
- Hypogonadism (men and women)
- Diabetes insipidus
- Growth hormone insufficiency

SIGNS AND SYMPTOMS

Non-specific symptoms, such as fatigue and weight loss (and other symptoms of adrenocortical insufficiency), are often due to ACTH deficiency. Physical characteristics, such as pubic and axially hair loss in women, with serum sodium levels being low, are also indicative of low ACTH release by the pituitary. Morning cortisol values lower than 10 ug/dl or ACTH stimulated values less than 20 ug/dl are considered indicative of secondary adrenal insufficiency.

Hypothyroidism is primary when the thyroid is not working, as in thyroiditis or Hashimoto's disease. However, in secondary hypothyroidism, thyroid hormone deficiency is secondary to loss of hormones

CLINICAL STUDY

Growth Hormone Deficiency

Growth hormone secretion naturally decreases in the second decade of life and gradually decreases until at the ago of 60, 15% of GH levels occur as opposed to the second decade of life.[2] Growth hormone deficiency not only has been treated in children but now also is recognized in the treatment of adults. Side effects of GH therapy include carpal tunnel syndrome, cardiac hypertrophy, edema, joint pain, and hyperglycemia.

A study of 237 hypopituitary adults with GH deficiency was conducted in Sweden. Patients were surveyed before and after taking 3 years of GH therapy. Patients started off at mean dose of 13 mg per day and the mean maintenance dose was 37 mg per day. Research end points measured included visits to the doctor and number of days in hospital. In patients who took the GH therapy, all end points improved significantly after 12 months. Overall, quality of life improved, as did the amount of physical activity and the patients' satisfaction with their level of physical activity.[3]

Although quite controversial, healthy aging adults who had no GH deficiency, as defined by conventional pathology measures, were given GH injections. The objective of GH therapy was to optimize health rather than treat an illness. Combining GH injections with lifestyle changes resulted in improvements not only in feeling of well-being but also in objective lab measures. Insulin sensitivity, lipid profiles, and other arteriosclerosis risk factors, as well as immune profiles, were improved. Other end points were lean muscle mass increase, decrease of fat body composition, increased energy, lower cholesterol, increased bone density, and improved short-term memory.[4]

In another study the use of supraphsyiological doses of GH was administered to 30 healthy physically active adults mean age 25.9 years. No significant change in intracellular water was detected; however, there was an increase in fat free mass by 5.3%, indicating the anabolic effects of GH.[5]

However, these injections are prohibitively costly (USD $500 to $1500 dollars per month) to most people because this treatment is not covered by most private or state health insurance coverage, unless deemed medically necessary. Nevertheless, it has become a popular therapy among the wealthy and performed by 'anti-aging' physicians.

secreted by the pituitary of hypothalamus. The signs and symptoms of secondary hypothyroidism are usually milder than primary hypothyroidism. In some cases, massive pituitary tumors may not result in obvious signs of hypothyroidism. TSH ranges may be only mildly lowered, with T3 in the normal range and with normal to low T4 levels.

The single most important hormone deficiency to identify is cortisol because cortisol deficiency can be life threatening.

CONVENTIONAL MEDICAL TREATMENT

This would include the use of growth hormone injection. It has been successfully done for the last 30 years. Currently, growth hormone therapy is available from recombinant DNA therapy rather than human cadavers. The injections are administered subcutaneously with a weekly dose totaling 30 mg/kg per week.

NATUROPATHIC MEDICAL TREATMENT AND PREVENTION

In addition to standard growth hormone injections, amino acid therapy is recommended to help stimulate human growth hormone level. The use of argi-nine intravenously has demonstrated to be effective in increasing growth hormone levels. Orally 5 g and 9 g of arginine caused a significant GH response. However, at higher doses, such as 13 g, digestive side effects occurred with no further increase of GH stimulation. The rise in GH concentration occurs within 30 minutes and peaks at 60 minutes after oral ingestion.[6]

Hyperpituitarism (Pituitary Excess)

CUSHING'S SYNDROME AND DISEASE

The normal function of cortisol in healthy subjects is to increase glucose production, inhibit protein synthesis, increase lipolysis, increase protein breakdown, and modulate immunological and inflammatory responses. ACTH is stimulated by corticotropin-releasing hormone (CRH). Cortisol suppresses the release of ACTH and CRH. Because of the wide variability of cortisol secretions in a 24-hour period, frequent saliva hormone testing during the course of a day can be helpful rather than a single blood draw to measure cortisol levels.

Cushing's syndrome is a non-specific name for excessive serum glucocorticoids. The two main causes include exogenous glucocorticoid ingestion (e.g., patients taking steroid medications, typically for inflammatory states) and pituitary dysfunction, which causes a condition that is known as Cushing's disease.

Cushing's disease is caused by excess ACTH in 80% of cases. Of these ACTH dependent cases of

Cushing's, 85% are caused by a pituitary disorder (typically a benign adenoma) that affects ACTH production. The remaining 15% are caused by ectopic ACTH producing tumors, such as malignant tumors of the lungs.

CONVENTIONAL MEDICAL TREATMENT

Surgery is often recommended if Cushing's disease is caused by benign adenoma of the pituitary.

NATUROPATHIC MEDICAL TREATMENT AND PREVENTION

Specific therapy for benign adenoma is the use of *Vitex agnus* and adaptogenic herbs. Clinical studies have only been done on horses, although it has been used successfully in human clinical practice as well. The successful treatment of equine Cushing's syndrome in decreasing pituitary adenoma is one of the best examples of treating a disease using a naturopathic approach.[7]

PITUITARY TUMORS

Pituitary tumors usually make two or more hormones at the same time. In some cases, significant hormones are produced than can end up causing characteristics of several endocrine pathologies simultaneously. Symptoms depend on the type and location of the tumor and whether the tumor causes hormone excess, hormone deficiency, or pressure on the brain and central nervous system. Thus, one type of pituitary tumor may produce symptoms that are very different from those produced by another type of growth. In addition, some tumors may begin by causing the release of excess hormone and then later result in a hormonal deficiency as normal pituitary cells are suppressed, thereby confounding a proper diagnosis.

Gonadotropinoma

Gonadotropinomas secrete the glycoproteins LH and/or FHS, which may lead to an excess of these hormones. Although they do not always cause endocrine disturbances, these tumors usually cause neurological problems because of their size.

Thyrotropinoma

Whenever patients have high levels of T3 and T4 and a detectable TSH level, a TSH-secreting tumor should be suspected. The conventional treatment includes pituitary ablation. Bromocriptine, a drug that is used to suppress TSH secretion, is usually not that effective.

Not all patients with pituitary tumors and elevated TSH have thyrotropinomas. Patients with long-term untreated hypothyroidism can cause a pseudo tumor as a compensation for the pituitary producing high levels of TSH for the low function of the thyroid gland. For this reason, no patients should go under surgical intervention of pituitary masses without first checking the TSH and T4 levels simultaneously.

Signs and symptoms of thyrotropin adenomas include weight loss, increased appetite, heart palpitations or irregular heartbeat (superventricular tachycardia, atrial fibrillation), tachycardia (rapid heart rate), heat intolerance and increased sweating, tremor, frequent bowel movements, fatigue and muscle weakness, exertional intolerance and shortness of breath, oligomenorrhea (decreased menstrual flow), nervousness and irritability, other mental disturbances, sleep disturbances (including insomnia), changes in vision, photophobia, eye irritation, diplopia or exophthalmos, lower extremity edema (swelling), sudden paralysis, and impaired fertility.

HYPERPROLACTINEMIA

Hyperprolactinemia is a common disorder characterized by excess PRL production by the anterior pituitary. Causes of elevated levels of serum prolactin are pituitary tumors, such as pituitary adenoma. Other causes include interferences with the hyopthalamic pituitary pathway, such as caused by tumors, trauma, or surgery, as well as pharmacological agents that interfere with dopaminergic input to the pituitary gland cause elevated prolactin. These drugs are Phenothiazines, Tricyclic antidepressants, Apha-Methyldopa, Metoclopramide, Cimetidine, and estrogens. In prolactin-secreting pituitary adenomas, monoclonal cell populations autonomously produce prolactin. Generally, the most important physiological states in which prolactin is found to be elevated in healthy adults are pregnancy and lactation.

Symptoms and Signs

Symptoms include anxiety, depression, irritability, and weight gain. In women, since excess PRL causes an increase in the estrogen/progesterone ratio, menstrual cycle irregularities, amenorrhea, anovulation, infertility, and ovarian cysts (PCOS) are possible. Hyperandrogenism and insulin resistance are also symptoms of elevated progesterone/estrogen ratio. In men, excess PRL is associated with low libido and erectile dysfunction.

Prolactin Stimulation

Prolactin can be stimulated by the following deficiencies:

- Deficiency of cortisol, T3, T4
- Deficiency progesterone, Somatostatin.

Prolactin can be stimulated by the following excesses:

- Stress (stimulates B-endorphins)
- TRH
- Melatonin
- Secretin
- B endorphins

Functional hyperprolactinemia can also be assessed by measuring basal body temperature charting. This charting would show an absence of increased body temperature indicating anovulation because, during ovulation, body temperature normally increases. [8]

CONVENTIONAL MEDICAL TREATMENT

The dopamine agonist, bromocriptine mesylate, is the initial drug of choice for treating hyperprolactinemia. It lowers the prolactin level in 70% to 100% of patients. However, side effects are common and may include drowsiness, digestive disturbances, headache, and insomnia.

Radiation treatment is another option; however, its benefits in routine treatment have not been shown to outweigh the risks. Radiation is, therefore, typically reserved for rapidly growing tumors.

Surgical care is indicated in patient drug intolerance, tumors resistant to medical therapy, patients who have persistent visual-field defects in spite of treatment, and patients with large cystic or hemorrhagic tumors.

NATUROPATHIC MEDICAL TREATMENT AND PREVENTION

Bio-identical Hormones and Clinical Nutrition

Naturopathic treatment of hyperprolactinemia includes the use of nutrients (such as vitamin B-6 and magnesium) that promote dopamine synthesis, since dopamine is the main inhibitor of prolactin. If an elevated estrogen/progesterone ratio is detected, this can be treated with nutrients that promote estrogen metabolism, and/or with bio-identical progesterone replacement.

Dopamine is the key modulator of prolactin and acts as an inhibiting factor. Progesterone also is used because it opposes PRL-induced excess estrogen.

Botanical Medicine

Botanicals that are known to inhibit PRL, such as chasteberry (*Vitex agnus castus*), are indicated. Animal studies confirmed that vitex agnus works comparatively as well as dopamine agonists, such as lisuride, by significantly inhibiting TRH-stimulated prolactin secretion of rat pituitary cells. Because of its dopaminergic effect, vitex can be considered an efficient alternative to drugs in slight hyperprolactinemia.[9]

Vitex at a dose of 20 mg vs placebo was administered to 52 women with luteal phase defects due to latent hyperprolactinemia. The treatment group had a statistically significant reduction in prolactin, luteal phase was normalized, and progesterone levels normalized. Two women got pregnant during the study while taking vitex. No side effects in the study were noted.[10]

Lifestyle

Stress management, aerobic exercise in moderation, and avoidance of hypoglycemic episodes are also indicated.

References

1. McDermott MT. Endocrine Secrets. Philadelphia, PA: Hanley and Belfus Inc, 1998.

2. Powell D. Endocrinology and Naturopathic Therapies. Seattle, WA, Bastyr University, 2004.

3. Svensson J, Mattsson A, Rosen T, Wiren L, Johannsson G, Bengtsson BA, Koltowska Haggstrom M. Swedish KIMS National Board. Three-years of growth hormone (GH) replacement therapy in GH-deficient adults: Effects on quality of life, patient-reported outcomes and healthcare consumption.Growth Horm IGF Res. 2004 Jun;14(3):207-15.

4. Rudman D, Feller AG, Nagraj HS et al. Effects of human growth hormone in men over 60 years old. New Eng. J. of Med 1990;323:1-6.

5. Ehrnborg C, Ellegard L, Bosaeus I, Bengtsson BA, Rosen T. Supraphysiological growth hormone: Less fat, more extracellular fluid but uncertain effects on muscles in healthy, active young adults. Clin Endocrinol (Oxf). 2005 Apr;62(4):449-57.

6. Collier SR, Casey DP, Kanaley JA. Growth hormone responses to varying doses of oral arginine. Growth Horm IGF Res. 2005 Apr;15(2):136-39. Epub 2005 Jan 26.

7. Harmany Equine Clinic, Ltd, Washington, Virginia 22747, USA. The role of nutritional therapy in the treatment of equine Cushing's syndrome and laminitis. Altern Med Rev. 2001 Sep;6 Suppl:S4-16.

8. Powell D. Endocrinology and Naturopathic Therapies. Seattle, WA: Bastyr University, 2004.

9. Sliutz G, Speiser P, Schultz AM, Spona J, Zeillinger R. Agnus castus extracts inhibit prolactin secretion of rat pituitary cells. Horm Metab Res. 1993 May;25(5):253-55.

10. Milewicz A, Gejdel E, Sworen H, Sienkiewicz K, Jedrzejak J, Teucher T, Schmitz H. Vitex agnus castus extract in the treatment of luteal phase defects due to latent hyperprolactinemia. Results of a randomized placebo-controlled double-blind study. Arzneimittelforschung 1993 Jul;43(7):752-56.

Pathophysiology Review

Located at the roof of the posterior portion of the third ventricle of the brain, the pineal gland is an endocrine organ with diverse roles. It has access to a rich supply of blood, and its hormonal products affect virtually every organ system in the body. The principle cellular components of the pineal gland are pinealocytes, which are arranged into cords or follicles separated by connective tissue septa.

The pineal gland is innervated by the sympathetic nervous system, via the superior cervical ganglion. This innervation is essential for the rhythmic metabolism of indolamines, such as tryptophan and serotonin and their derivatives, as well as the pineal gland's endocrine functions. Besides sympathetic innervation, the pineal gland also receives axons from the brain, entering through the stalk. There is strong evidence to suggest parasympathetic, commissural, and peptidergic innervation as well.[1]

MELATONIN SYNTHESIS

Melatonin is the primary substance secreted by the pineal gland, which modulates the adrenal (HPA) axis during clinical illness, the serotonergic system in psychiatric disease, and the body's general response to stress.

Melatonin is the major neuroendocrine modulator of annual and circadian biorhythms in the body, and has a far-reaching biological influence over most of the autonomic, hormonal, and behavioral functions of the human organism. With its unique ability to pass through all blood barriers in the body, melatonin acts as the central hub of physiological function, orchestrating the complex internal processes of the body in conjunction with various external stimuli. This role has resulted in melatonin being coined the "connecting chemical" — a potent hormone that conjoins the mind, the body, and the environment.

Melatonin is synthesized within the pineal gland

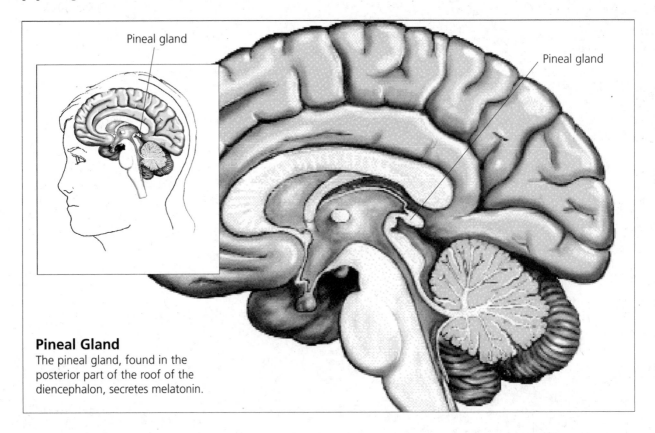

Pineal Gland
The pineal gland, found in the posterior part of the roof of the diencephalon, secretes melatonin.

Quick Reference: Major Pineal Disorders

Pineal Disorder	Major Signs and Symptoms	Key Laboratory Tests	Conventional Therapies	Naturopathic Therapies
Melatonin Deficiency	Insomnia Stress	Low melatonin Elevated estrogen/ progesterone ratio	None	Melatonin Vitamin B-6 Lifestyle/Light
Melatonin Excess	Seasonal Affective Disorder	Lowered estrogen/ progesterone ratio Low thyroid and adrenal function Hypotension	None	Thyroid and adrenal support Lifestyle/Light

from tryptophan.[2] The secretion pattern is generated within the suprachiasmatic nucleus (SCN). Synthesis occurs upon exposure to darkness, with the increased activity of serotonin-N-acetyltransferase. By the action of hydroxyindole-O-methyltransferase (HIOMT), N-acetylserotonin is converted to melatonin. Melatonin is then rapidly secreted into the vascular system and, possibly, into the cerebrospinal fluid.[3]

Peripheral tissues, such as the retina and the gut, are also known to synthesize melatonin.[4]

Melatonin production in humans begins at the age of approximately 3 months. Peak nocturnal levels occur between the ages of 1 and 3 years. Secretion levels decline as the individual develops sexual maturity, and drop 80% by the time adulthood is reached, diminishing even further with age.[5]

Melatonin secretion levels are low during the day and high at night, peaking at about 2:00-3:00 a.m. for most healthy individuals. This circadian rhythm makes melatonin one of the best markers for circadian rhythm disruption available at this time.

DIURNAL AND CIRCADIAN RHYTHMS

(Reprinted, with adaptations, by permission of Great Smokies Laboratory)
Melatonin's diurnal rhythm is synchronized by the light-dark cycle, and is strongly affected by day length, artificial illumination, electromagnetic energy, exercise, and other social and environmental influences. Melatonin rhythms also reflect the biological process of aging, with secretion levels peaking in childhood and gradually diminishing over an individual's life span. Operating much like an internal aging clock, melatonin exerts regenerative and integrative influences that may explain the age-dependent decrease in immune function that can lead to malignancy, senescence, and eventually death.

Light-Dark Cycles

Melatonin is synthesized and secreted during the dark phase of the day. The secretion rhythm is endogenous (internally generated), and generally persists in the absence of time cues, assuming a period that deviates only slightly from 24 hours. Thus, it is a true circadian rhythm.[6,7]

Melatonin secretion is related to the length of the night. The longer the night, the longer the duration of the secretion. If humans are kept strictly in darkness for 14 hours per day over a period of one month, the duration of melatonin secretion expands to cover almost the entire dark period. Conversely, if a subject is exposed to light for 14 hours per day, the duration of secretion shrinks to 10 hours, accompanied by concomitant changes in body temperature and sleep.[8]

Light Exposure

Light exposure of the retina alters the amount of serotonin metabolized to melatonin, via the neural pathways that connect the retina to the pineal gland.[9] The individual's visual system must be intact for proper synchronization of the melatonin rhythm. Blind persons commonly exhibit a pronounced lack of circadian rhythm, with free-running cycles generated internally despite the presence of other external time cues in their environment.[10,11]

Exposure to sufficient levels of light at night can rapidly reduce melatonin production.[12] One investigator found that after human subjects were exposed to one hour of light at midnight using 3000, 1000, 500, 350, and 200 lux intensities, melatonin levels dropped by 71%, 67%, 44%, 38%, and 16%, respectively.[13]

The spectrum of light that most dramatically inhibits melatonin secretion is green band light (540 nm), which corresponds to the rhodopsin absorption

spectrum in humans.[14] This observation is of considerable importance, not only to understand the physiological effects of melatonin, but to regulate circadian rhythms effectively, a crucial component in the treatment of seasonal affective disorder (SAD) and other health problems.[15]

Electromagnetic Energy

Laboratory studies with rats have consistently shown that exposure to electromagnetic fields can disrupt pineal function and circadian secretion patterns of melatonin.[16-19] One study on humans who used electric blankets concluded that periodic exposure to even low frequency electric or magnetic fields can significantly affect pineal gland function.[20] In an interesting study on electric power, pineal function, and breast cancer, investigators postulated that higher rates of breast cancer in industrialized nations may be due to increased light-at-night (LAN) and electromagnetic fields (EMF) suppressing human melatonin production.[21] Many modern occupations and conditions — including living near a power line — can significantly increase EMF exposure.[22,23]

Seasonal Variations

Seasonal changes can affect melatonin secretion patterns by advancing or delaying secretion phase shifts.[24,25] The exact nature of these variations is still not clearly understood, although factors such as length of photoperiod, temperature, and effect of seasonal changes on individuals may all be contributing factors.[26]

Effect of Drugs

Antidepressants and other psychotropic drugs affect the synthesis and release of melatonin. Some monoamine oxidase-inhibiting drugs such as clorgyline and tranylcypromine seem to enhance plasma melatonin levels, while others, such as deprenyl, register no significant change.[27-30]

Tricyclic antidepressants that influence monoamine uptake and beta-adrenoceptors trigger a decrease in plasma melatonin in rodent experiments; however, human patients treated with the tricyclic desipramine show either no change, or a notable rise, in nighttime melatonin levels.[27,30] Although tricyclics and fluvoxamine are both associated with increases in melatonin secretion in humans, fluoxetine (commonly known as Prozac) reportedly lowers blood melatonin levels.[31]

One group of researchers conjectured that sleep disruption associated with some nonsteroidal anti-inflammatory drugs (NSAIDS), such as aspirin, ibuprofen, and acetaminophen, may be a result of decreased prostaglandin production, which can suppress melatonin secretion.[32] Both ibuprofen and indomethacin significantly reduce melatonin plasma levels and delay the nocturnal rise of the circadian rhythm.[33,34]

ß-blockers can also significantly alter melatonin levels. Hypertensive patients undergoing chronic beta-adrenoreceptor blocker treatment with propranolol and ridazolol showed considerably diminished melatonin secretion.[35] Propranolol hydrochloride also induced a noticeable decrease in serum melatonin levels in schizophrenic patients.[36]

Exercise

Research suggests that daytime exercise can increase melatonin levels. While some studies report that the increase occurs during or immediately after physical activity,[37-39] others point to a delayed rise that takes place in the second half of the dark phase.[40] One group of researchers found that nighttime exercise effectively blunts the nocturnal melatonin surge.[41] And, in a unique study undertaken by Swiss researchers, daily 1-hour morning walks outdoors were shown to phase advance the onset and/or offset of melatonin secretion, and were twice as effective as low dose artificial light therapy in relieving the symptoms of SAD.[42]

Melatonin Deficiency and Excess

A deficient production of melatonin can result in anxiety and mood disorders, lowered basal body temperature, insomnia, elevated estrogen/progesterone ratio, and immune suppression associated with cancer. Excess melatonin is associated with seasonal affective disorder (SAD), lowered estrogen/progesterone ratio, low thyroid and adrenal function, and hypotension.

Melatonin Associated Disorders

Because melatonin has a pivotal role in regulating body temperature, the sleep/wake cycle, female reproductive hormones, and cardiovascular function, the effect of disrupted secretion rhythms is widespread, manifesting in a variety of physical and psychological disorders.

- Anxiety, stress, depression
- Seasonal affective disorder
- Sleep disorders
- Delayed sleep phase syndrome
- Immunological disorders
- Cardiovascular disease
- Cancer

BEHAVIOR CHANGES AND MOOD DISORDERS

Abnormalities of melatonin circadian function have been closely linked to a variety of behavioral changes and mood disorders. Determining the circadian secretion rhythm of melatonin can assist the clinician in diagnosing the type of mood disorder.

In general, studies have reported decreased nocturnal melatonin levels in patients suffering from depression.[43-45] One investigation of major depression in children and adolescents found that melatonin levels were significantly lower in depressed subjects with psychosis than in depressed subjects without psychosis.[46] Subnormal levels of melatonin accompanied by a delayed circadian rhythm have also been reported in patients with panic disorder.[45]

In a fascinating study on geomagnetic storms and depression, British researchers found that male hospital admissions with a diagnosis of depression rose 36.2% during periods of geomagnetic activity as compared with normal periods. The investigators hypothesized that this increase may have been caused by a phase advance in the circadian rhythm of melatonin production.[47]

In seasonal affective disorder (SAD), melatonin secretion tends to be elevated. Since full spectrum light reduces the rate of melatonin secretion, light therapy can be very effective in treating patients with SAD.[48-49]

BODY TEMPERATURE REGULATION

In humans, melatonin is closely connected with changes in body temperature. The most striking example is the reciprocal relationship found in circadian profiles, where the lowest body temperature correlates closely with the peak level of melatonin. The ovulatory rise in temperature during the menstrual cycle is also associated with a decline in melatonin secretion levels. There is a possible causal relationship between the two phenomena, since exogenous melatonin can acutely depress body temperature in humans.[50]

Melatonin's effect on body temperature may be one of the keys of its ability to enhance sleep. Body temperature follows a circadian rhythm, rising during the day and falling at night. The daily temperature variation in the human body is only about 1 degree, but this small difference has a dramatic influence on sleep. In general, a falling body temperature induces sleep, while a rising body temperature provokes wakefulness. It has been demonstrated that an individual will fall asleep most quickly and stay asleep the longest when lights are out, and the body temperature undergoes its most rapid decline.[51]

SLEEP DISORDERS

Patients with delayed sleep phase insomnia cannot sleep until the early hours of morning, and often end up sleeping through much of the day. This condition has been treated successfully with exposure to bright light in the early morning to induce phase advances of the clock. An evening dose of 5 mg of melatonin at 11:00 p.m. has also been shown to advance sleep time significantly.[52] A combination of both methods — timed application of bright light in the morning and a dose of melatonin in the evening — seems to be the most effective therapy for treating melatonin rhythm disturbances.

Melatonin has not only been shown to advance sleep time, but to increase sleep duration as well.[53] It is also effective in reducing the symptoms of jet lag.[54] One study examined the effectiveness of melatonin in treating the sleep disorders in 100 children, who had a wide variety of physical problems including blindness, mental retardation, autism, and central nervous system diseases. Melatonin therapy was found to benefit over 80% of these children, and was lauded as a "safe, inexpensive, and very effective treatment of sleep-wake cycle disorders."[55] In general, smaller doses of melatonin appear to be just as effective as larger doses in inducing and sustaining sleep.[56]

Patients with sleep disorders are often given a prescription for a benzodiazepine, a family of drugs that includes Dalmane, Doral, Halcion, ProSom, Restoril, Valium, Xanax, and many others. Although these medications can be very effective, particularly in cases of anxiety-related insomnia, they have many limitations and adverse side affects, including anxiety, depression, and memory loss (anterograde amnesia).[57-59] Melatonin enhances REM and slow-wave sleep patterns with little or no adverse reactions.

CANCER

There is good evidence for photoperiod dependence and/or melatonin responsiveness in the initiation and evolution of certain cancers, particularly hormone-dependent cancers. Administration of melatonin significantly improved survival time and quality of life in patients with brain metastases due to solid neoplasms.[60] When used after first-line chemotherapy (cisplatin) for treating non-small cell carcinoma (NSC) of the lung, melatonin also successfully prolonged the survival time for patients with metastatic NSC lung cancer.[61]

Because of its powerful oncostatic effects and its estrogen-blocking ability, melatonin demonstrates particular promise in the treatment of breast cancer. Numerous studies have reported an inverse correlation between melatonin levels and the growth of

estrogen-receptive positive tumors.[62-66] Used in conjunction with tamoxifen to modulate cancer endocrine therapy, melatonin shows marked ability to modulate estrogen receptor expression and inhibit breast cancer cell growth. Moreover, researchers surmised that melatonin may induce objective tumor regressions in metastatic breast cancer patients refractory to tamoxifen alone.[67]

IMMUNE SYSTEM

When properly administered, melatonin has general stimulatory effects on immune system functions; its positive anti-cancer effects may stem from this strengthening of the immune response.[68] One theory is that melatonin acts as an anti-stress hormone via the brain opioid system, with consequent up-regulation of the immune system.[69,70]

Many researchers believe that T-derived cytokines are the main mediators of the immunological effect of melatonin. Specific high affinity binding sites for 125I-melatonin have been discovered on T-helper-type 2 lymphocytes in the bone marrow and in various lymphoid tissues.[71,72]

MULTIPLE SCLEROSIS

Multiple Sclerosis (MS) is the most common of the demyelinating diseases of the central nervous system. The clinical course and prognosis of the disease is variable, although it typically tends to progress in a series of relapses and remissions. In most cases, a patient with MS undergoes a slow and steady deterioration of neurological function.

Recently, the pineal gland has been implicated in the pathogenesis and clinical course of MS. When melatonin levels decline, an exacerbation of MS symptoms is seen.[73,74] Remission effects in MS are thought to relate to the stimulatory influence of melatonin on the immune system.

In one study, 32 MS patients were randomly selected from patients consecutively admitted to a neurology service in a hospital for exacerbations of their symptoms. Nocturnal levels of melatonin and the activity of the pineal gland were monitored over the course of each patient's illness. The study revealed a progressive decline in melatonin levels over the duration of the illness. Since patients with chronic progressive MS had a lower mean melatonin level compared to those with a relapsing-remitting course of the disease, an analysis of melatonin levels may be crucial for understanding the pathophysiology of MS and, specifically, the course of its progression.[75]

Antioxidant Activity

Free radicals, especially the hydroxyl radical, can be extremely damaging to cells. Melatonin has both water and fat soluble properties, making it one of the only known antioxidants in nature that can protect all parts of a cell. Since melatonin has the unique ability to navigate any body barrier with ease (including the blood-brain barrier and the placental barrier[76]), it can protect virtually every cell in the body.

Recent evidence suggests that melatonin plays a critical role in free radical scavenging activity, preserving macromolecules, such as DNA, protein, and lipid, from oxidative damage.[77,78] In fact, melatonin has been proven more powerful than both glutathione and mannitol in neutralizing hydroxyl radicals and may protect cell membranes more effectively than vitamin E.[79,80] Remarkably, it is 500 times more efficient at protecting cells from radiation than dimethyl sulfoxide (DMSO).[81]

CARDIOVASCULAR DISEASE

A decrease in melatonin causes increased nighttime sympathetic activity, which in turn appears to increase the risk for coronary disease. One study found that patients with coronary heart disease had nocturnal melatonin levels five times lower than in healthy controls. Investigators surmised that lower levels of melatonin may act to increase circulating epinephrine and norepinephrine, which have been implicated in damage to blood vessel walls. Atherogenic uptake of LDL cholesterol is accelerated by these amines at pathophysiological concentrations.[82]

Research conducted on laboratory rodents has shown that melatonin treatment exerts the beneficial effect of increasing the HDL/total LDL cholesterol ratio, perhaps by enhancing endogenous cholesterol clearance mechanisms.[83] Specific binding sites for the melatonin agonist 2-[125I] iodomelatonin have been discovered in the heart (and lungs) of various animals.[84] In addition, melatonin seems to inhibit platelet aggregation. Platelet aggregation plays a significant role in the progression of cardiovascular disease.[85]

OVULATION AND PREGNANCY

Recently, melatonin has stimulated the interest of researchers for its potential use as an oral contraceptive. Researchers have established a negative correlation between melatonin and sex steroids, independent of gonadotrophin activity.[86] Increased secretion of melatonin in winter appears to suppress or inactivate the hypothalmic-pituitary-gonadal reproductive axis, which in many species results in a limited, seasonal period of

reproduction.[87] This natural form of contraception occurs via the hypothalamic GnRH pulse generator. It is postulated that a melatonin/ovarian steroid contraceptive could re-activate this anovulation mechanism in humans, and one melatonin-based contraceptive is already undergoing Phase III clinical trials.[88] Long-term use of such a contraceptive could reduce the risk of breast cancer by preventing the proliferation of epithelial breast cells caused by continuous ovulatory cycles.[89]

Significant increases in melatonin have been noted in women during the luteal phase of ovulation.[90] In animal studies, pharmacological doses of melatonin caused no harmful effects on developing embryos, suggesting that the administration of melatonin may be safe during pregnancy.[91]

CONVENTIONAL MEDICAL TREATMENT

The pineal gland and melatonin levels are generally not treated by conventional means, unless a rare pineal tumor is detected.

NATUROPATHIC MEDICAL TREATMENT AND PREVENTION

MELATONIN DEFICIENCY
Lifestyle
Melatonin production is increased by darkness; therefore, artificial light (or any type of electromagnetic radiation), after sundown should be minimized. Daytime exercise and light exposure will promote a regular circadian rhythm of melatonin.

Clinical Nutrition
Vitamin B-6 (Pyridoxal-5-Phosphate): Vitamin B-6 is a cofactor in melatonin synthesis from L-tryptophan.

L-Tryptophan: L-tryptophan is a precursor amino acid to serotonin and melatonin.

5-Hydroxy-Tryptophan (5HTP): 5HTP is intermediate in the tryptophan to serotonin/melatonin pathway.

Melatonin: Bio-identical hormone replacement can be administered.

MELATONIN EXCESS
Lifestyle
SAD is common in temperate climates, especially those with a high level of cloud cover. Therefore, regular daytime exposure to light (2500 lux/20 min per day in the morning) has been shown to improve the symptoms of SAD. Normal circadian rhythms should be promoted by following natural day/night light patterns and avoiding, if possible, night shift work. As stress can potentiate melatonin secretion, stress reduction and management of stress are important to the improvement of SAD.[92]

Clinical Nutrition
Cravings for sweets and other high glycemic foods are common with SAD, but these foods should be avoided. Although these simple carbohydrates may lift the mood temporarily, their consumption is often followed by a blood sugar drop (hypoglycemia), which puts extra strain on the adrenal glands. In addition, weight gained as a result can aggravate SAD. Caffeine and other stimulants are in the same category, and alcohol exacerbates SAD by acting as a depressant. Furthermore, supplements or medications that increase melatonin may exacerbate SAD. Support of thyroid and adrenal function typically improves the symptoms of SAD.[93]

References

1. Moller M. Fine structure of the pinealopetal innervation of the mammalian pineal gland. Microsc Res Tech 1992;21(3):188-204.

2. Axelrod J. The pineal gland: A neurochemical transducer. Science 1974;184:1341-1348.

3. Reiter JR. The pineal gland. In: Becker KL (ed.). Principles and Practice of Endocrinology and Metabolism. Philadelphia: JB Lippincott Company, 1990:104-09.

4. Pang SF, Dubocovich ML, Brown GM. Melatonin receptors in peripheral tissues: A new area of melatonin research. Biol Signals 1993;2(4):177-80.

5. Waldhauser F, Ehrhart B, Forster E. Clincal aspects of the melatonin action: Impact of development, aging, and puberty, involvement of melatonin in psychiatric disease and importance of neuroimmunoendocrine interactions. Experientia 1993;49:671-81.

6. Bojkowski C, Arendt J. Factors influencing urinary 6-sulphatoxymelatonin, a major melatonin metabolite, in normal human subjects. Clin Endocrinol 1990;33: 435-44.

7. Wever RA. Characteristics of circadian rhythms in human functions; melatonin in humans. J Neural Trans 1986;(suppl 21):323-74.

8. Wehr TA. The durations of human melatonin secretion and sleep respond to changes in daylength (photoperiod). J Clin Endocrinol Metab 1991;73:1276-80.

9. Kral A. The role of the pineal gland in circadian rhythms regulation. Brastisl Lek Listy 1994; 95:295-303.

10. Sack RL, Lewy AJ, Blood ML, Meith LD, Nakagawa H. Circadian rhythm abnormalities in totally blind people: Incidence and clinical significance. J Clin Endocrinol Metab 1992; 75(1):127-34.

11. Czeisler CA, Shanahan TL, Klerman EB, Martens H, Brotman DJ, Emens JS, et al. Suppression of melatonin secretion in some blind patients by exposure to bright light. N Engl J Med 1995;332(1):6-11.

12. Reiter RJ. Neuroendocrine effects of light. Int J Biometeorol 1991;35(3):169-75.

13. McIntyre IM, Norman TR, Burrows GD, Armstrong SM. Human melatonin suppression by light is intensity dependent. J Pineal Res 1989;6:149-56.

14. Reiter RJ. Action spectra, dose response relationships and temporal aspects of light's effects on the pineal gland; the medical and biological effects of light. Ann NY Acad Sci 1985;453:215-30.

15. Oren DA, Brainard GC, Johnston SH, Joseph-Vander-pool JR, Sorek E, Rosenthal NE. Treatment of seasonal affective disorder with green light and red light. Am J Psychiatry 1991;148(4):509-11.

16. Reiter RJ, Anderson LE, Buschbom RL, Wilson BW. Reduction of the nocturnal rise in pineal melatonin levels in rats exposed to 60-Hz electric fields in utero and for 23 days after birth. Life Sci 1988;42:2203-06.

17. Wilson BW, Chess EK, Anderson LE. 60-Hz electric-field effects on pineal melatonin rhythms: Time course for onset and recovery. Bioelectromagnetics 1986;7:239-42.

18. Wilson BW, Anderson LE, Hilton DI, Phillips RD. Chronic exposure to 60-Hz electric fields: Effects on pineal function in the rat. Bioelectromagnetics 1981;2:371-80.

19. Welker HA, Semm P, Willig RP, Commentz JC, Wiltshchko W, Vollrath L. Effects of an artificial magnetic field on serotonin N-acetyltransferase activity and melatonin content of the rat pineal gland. Exp Brain Res 1983;50:426-32.

20. Wilson BW, Wright CW, Morris JE, Buschbom RL, Brown DP, Miller DL, et al. Evidence for an effect of ELF electromagnetic fields on human pineal gland function. J Pineal Res 1990; 9(4):259-69.

21. Stevens RG, Davis S, Thomas DB, Anderson LE, Wilson BW. Electric power, pineal function, and the risk of breast cancer. FASEB J 1992;6(3):853-60.

22. Levallois P, Gauvin D, St-Laurent J, Gingras S, Deadman JE. Electric and magnetic field exposures for people living near a 735-kilovolt power line. Environ Health Perspect 1995;103(9):832-37.

23. Sobel E, Davanipour Z, Sulkava R, Erkinjuntti T, Wikstrom J, Henderson VW, et al. Occupations with exposure to electromagnetic fields: a possible risk factor for Alzheimer's disease. Am J Epidemiol 1995;142(5): 515-24.

24. Hofman MA, Skene DJ, Swaab DF. Effect of photoperiod on the diurnal melatonin and 5-methoxytryptophol rhythms in the human pineal gland. Brain Res 1995;671:254-60.

25. Laakso ML, Porkka-Heiskanen T, Alila A, Stenberg D, Johansson G. Twenty four hour rhythms in relation to the natural photoperiod: A field study in humans. J Biol Rhythms 1994;9:283-93.

26. Macintosh A. Melatonin: Clinical monograph. Quar Rev Nat Med 1996; Spring:47-59.

27. Murphy DL, Garrick NA, Tamarkin L, Taylor PL, Markey SP. Effects of antidepressants and other psychotropic drugs on melatonin release and pineal gland function. J Neural Transm Suppl 1986;21:2291-309.

28. Murphy DL, Tamarkin L, Sunderland T, Garrick NA, Cohen RM. Human plasma melatonin is elevated during treatment with the monoamine oxidase inhibitors clorgyline and tranylcypromine but not deprenyl. Psychiatry Res 1986;17(2):119-27.

29. Murphy DL, Garrick NA, Hill JL, Tamarkin L. Marked enhancement by clorgyline of nocturnal and daytime melatonin release in rhesus monkeys. Psychopharmacology 1987; 92(3):382-87.

30. Golden RN, Markey SP, Risby ED, Rudorfer MV, Cowdry RW, Potter WZ. Antidepressants reduce whole-body norepinephrine turnover whle enhancing 6 hydrox-ymelatonin output. Arch Gen Psychiatry 1988;45(2):150-54.

31. Childs PA, Rodin I, Martin NJ, Allen NH, Plaskett L, Smythe PJ, Thompson C. Effect of fluoxetine on melatonin inpatients with seasonal affective disorder and matched controls. Br J Psychiatry 1995;166(2):196-98.

32. Murphy PJ, Badia P, Myers BL, Boecker MR, Wright KP Jr. Nonsteroidal anti-inflammatory drugs affect normal sleep patterns in humans. Physiol Behav 1994;55(6):1063-66.

33. Surrall K, Smith JA, Bird H, Okala B, Othman H, Padwick DJ. Effect of ibuprofen and indomethacin on human plasma melatonin. J Pharm Pharmacol 1987;39(10):840-43.

34. Ritta MN, Cardinali DP. Effect of indomethacin on monamine metabolism and melatonin synthesis in rat pineal gland. Horm Res 1980;12(6):305-12.

35. Rommel T, Demisch L. Influence of chronic beta-adrenoreceptor blocker treatment on melatonin secretion and sleep quality in patients with essential hypertension. J Neural Transm Gen Sect 1994;95(1):39-48.

36. Hanssen T, Heyden T, Sundberg I, Alfredsson G, Nyback H, Wetterberg L. Propranolol in schizophrenia. Clinical, metabolic, and pharmacological findings. Arch Gen Psychiatry 1980;37(6):685-90.

37. Ronkainen H, Vakkuri O, Kauppila A. Effects of physical exercise on the serum concentration of melatonin in female runners. Acta Obstet Gynecol Scand 1986;65(8):827-29.

38. Theron JJ, Oostuizen JM, Rautenbach MM. Effect of physical exercise on plasma melatonin levels in normal volunteers. S Afr Med J 1984;66(22):838-41.

39. Bullen BA, Skrinar GS, McArthur JW, Carr DB. Exercise effect upon plasma melatonin levels in women: Possible physiological significance. Can J Appl Sport Sci 1982;7(2):90-97.

40. Monteleone P, Maj M, Franza F, Fusco R, Kemali D. The human pineal gland responds to stress-induced sympathetic activation in the second half of the dark phase: Preliminary evidence. J Neural Transm Gen Sect 1993;92(1):25-32.

41. Monteleone P, Maj M, Fusco M, Orazzo C, Kemali D. Physical exercise at night blunts the nocturnal increase of plasma melatonin levels in healthy humans. Life Sci 1990;47(22):1989-95.

42. Wirz-Justice A, Graw P, Kraauchi K, Sarrafzadeh A, English J, Arendt J, Sand L. Natural' light treatment of seasonal affective disorder. J Affect Disord 1996;37:109-20.

43. Arendt J. Melatonin — a new probe in psychiatric investigation? Br J Psychiatry 1989; 155:585-90.

44. Brown RP, Kocsis JH, Caroff S, Amsterdam J, Winokur A, Stokes P, Frazer A. Depressed mood and reality disturbance correlate with decreased nocturnal melatonin in depressed patients. Acta Psychiatr Scand 1987;76(3): 272-75.

45. McIntyre IM, Judd FK, Marriott PM, Burrows GD, Norman TR. Int J Clin Pharmacol Res 1989;9(2):159-64.

46. Shafii M, MacMillan DR, Key MP, Derrick AM, Kaufman N, Nahinsky ID. Nocturnal serum melatonin profile in major depression in children and adolescents. Arch Gen Psychiatr 1996;53(11):1009-13.

47. Kay RW. Geomagnetic storms: association with incidence of depression as measured by hospital admission. Br J Psychiatry 1994 164(3):403-09.

48. Dahl K, Avery DH, Lewy AJ, Savage MV, Brengelmann GL, Larsen LH, et al. Dim light melatonin onset and circadian temperature during a constant routine in hypersomnic winter depression. Acta Psychiatr Scand 1993; 88(1):60-66.

49. Danilenko KV, Putilov AA, Russkikh GS, Duffy LK, Ebbesson SO. Diurnal and seasonal variations of melatonin and serotonin in women with seasonal affective disorder. Arch Med Res 1994;53(3):137-45.

50. Badia P, Myers B, Murphey P. Melatonin and thermal regulation. Melatonin: Biosynthesis, physiological effects and clinical applications. Boca Raton, FL: CRC Press, 1992.

51. Campbell SS, Broughton RJ. Rapid decline in body temperature before sleep. Chronobiol Int 1994;11(2):126-31.

52. Dahlitz M, Alvarez B, Vignau J, English J, Arendt J, Parkes JD. Delayed sleep phase syndrome response to melatonin. Lancet 1991; 337:1121-24.

53. Dollins AB, Zhdanova IV, Wurtman RJ, Lynch HJ, Deng MH. Effect of inducing nocturnal serum melatonin concentrations in daytime on sleep, mood, body temperature, and performance. Proc Natl Acad Sci USA 1994; 91:1824-28.

54. Petrie K, Dawson AG, Thompson L, Brook R. A double-blind trial of melatonin as a treatment for jet lag in international cabin crew. Biol Psychiatry 1993;33:526-30.

55. Jan EJ, O'Donnell ME. Use of melatonin in the treatment of paediatric sleep disorders. J Pineal Res 1996;21(4):193-99.

56. Zhdanova IV, Wurtman RJ, Lynch HJ, Ives JR, Dollins AB, Morabito C, Matheson JK, Schomer DL. Sleep-inducing effects of low doses of melatonin ingested in the evening. Clin Pharmacology and Therapeutics 1995; 57:552-58.

57. Kales N. Benzodiazepene hypnotics and insomnia. Hosp Practice 25 1990;(suppl 3):7-21.

58. Carskadon MA, ed. Encyclopedia of sleep and dreaming. New York, NY: Macmillan, 1993:703.

59. Carskadon MA ed. Encyclopedia of sleep and dreaming. New York, NY: Macmillan, 1993:563.

60. Lissoni P, Barni S, Ardizzoia A, Tancini G, Conti A, Maestroni G. A randomized study with the pineal hormone melatonin versus supportive care alone in patients with brain metastases due to solid neoplasms. Cancer 1994;73(3):699-01.

61. Lissoni P, Barni S, and Ardizzoia, Paolorossi F, Crispino S, Tancini G, et. al. Randomized study with the pineal hormone melatonin vs supportive care alone in advanced nonsmall cell lung cancer resistant to first-line chemotherapy containing cisplatin. Oncology 1992;49:336-39.

62. Tamarkin L, Almedia OF, Danforth DN Jr. Melatonin and malignant disease. Ciba Found Symp 1985;117:284-99.

63. Danforth DN Jr, Tamarkin L, Mulvihill JJ, Bagley CS, Lippman ME. Plasma melatonin and the hormone-dependency of human breast cancer. J Clin Oncol 1985;3(7):947-948.

64. Danforth DN Jr, Tamarkin L, Lippman ME. Melatonin increases oestrogen receptor binding activty of human breast cancer cells. Nature 1983;305:323-25.

65. Tamarkin L, Danforth D, Lichter A, DeMoss E, Cohen M, Chabner B, Lippman M. Decreased nocturnal plasma melatonin peak in patients with estrogen receptor positive breast cancer. Science 1982;216:1003-05.

66. Lemus-Wilson A, Kelly PA, Blask DE. Melatonin blocks the stimulatory effects of prolactin on human breast cancer cell growth in culture. Br J Cancer 1995;72(6):1435-40.

67. Lissoni P, Barni S, Meregalli S, Fossati V, Cazzaniga M, Esposti D, Tancini G. Modulation of cancer endocrine therapy by melatonin: A phase two study of tamoxifen plus melatonin in metastic breast cancer patients progressing under tamoxifen alone. Br J Cancer 1995;71:854-56.

68. Cutando A, Silvestre FJ. Melatonin: Implications at the oral level. Bull Group Int Rech Sci Stomatol Odontol 1995;38:81-86.

69. Maestroni GJ. The immunoneuroendocrine role of melatonin. J Pineal Res 1993;14(1):1-10.

70. Armstrong SM, Redman JR. Melatonin: A chronobiotic with anti-aging properties? Med Hypotheses 1991;34(4):300-09.

71. Poon AM, Liu ZM, Pang CS, Brown GM, Pang SF.

Evidence for a direct action of melatonin on the immune system. Biol Signals 1994; 3(2):107-17.

72. Maestroni GJ. T-helper-2 lymphocytes as a peripheral target of melatonin. J Pineal Res 1995;18(2):84-9.

73. Sandyk R. Multiple sclerosis: The role of puberty and the pineal gland in its pathogenesis. Int J Neurosci 1993;68:209-25.

74. Sandyk R. The pineal gland and the clinical course of multiple sclerosis. Int J Neurosci 1992;62:65-74.

75. Sandyk R, Awerbuch GI. Relationship of nocturnal melatonin levels to duration and course of multiple sclerosis. Int J Neurosci 1994;75: 229-237.

76. Shida CS, Castrucci AML, Lamy-Freund MT. High melatonin solubility in aqueous medium. J Pineal Res 1994;16:198-201.

77. Poeggeler B, Reiter RJ, Tan DX, Chen LD, Manchester LC. Melatonin, hydroxyl radical-mediated oxidative damage, and aging: a hypothesis. J Pineal Res 1993;14(4):151-68.

78. Reiter RJ. The role of the neurohormone melatonin as a buffer against macromolecular oxidative damage. Neurochem Int 1995; 27(6):453-60.

79. Reiter RJ. Interactions of the pineal hormone melatonin with oxygen centered free radicals: A brief review. Braz J Med Biol Res 1993;26:1993.

80. Reiter RJ, Melchiorri D, Sewerynek E, Poeggeler B, Barlow-Walden L, Chuang J, et al. A review of the evidence supporting melatonin's role as an antioxidant. J Pineal Res 1995;18:1-11.

81. Vijayalaxmi BZ, Reiter RJ, Sewerynek E, Meltz ML, Poeggeler B. Melatonin protects human blood lymphocytes from radiation induced chromosomal damage. Mutation Research 1995;346(1):23-21.

82. Brugger P, Marktl W, Herold M. Impaired nocturnal secretion of melatonin in coronary heart disease. Lancet 1995;345:1408.

83. Chan TY, Tang PL. Effect of melatonin on the maintenance of cholesterol homeostasis in the rat. Endocr Res 21(3):1995:681-96.

84. Pang CS, Brown GM, Tang PL, Cheng KM, Pang SF. 2-[125I]iodomelatonin binding sites in the lung and heart: A link between the photoperiodic signal, melatonin, and the cardiopulmonary system. Biol Signals 1993; 2(4):228-36.

85. Cardinali DP, Del Har MM, Vacas MI. The effects of melatonin in human platelets. Acta Physiol Pharmacol Ther Latinaom 1993;43: 1-13.

86. Garcia-Patterson A, Puig-Domingo M, Webb SM. Thirty years of human pineal research: Do we know its clinical relevance? J Pineal Res 1996;20(1):1-6.

87. Cavallo A. The pineal gland in human beings: Relevance to pediatrics. Int J Pediatr 1993; 123(6):843-51.

88. Silman RE. Melatonin: A contraceptive for the nineties. Eur J Obstet Gynecol Reprod Biol 1993;49(1-2):3-9.

89. Cohen M, Small RA, Brzezinski A. Hypotheses: Melatonin/steroid combination contraceptives will prevent breast cancer. Breast Cancer Res Treat 1995;33(3):257-64.

90. Brun J, Claustrat B, David M. Urinary melatonin, LH, oestradiol, progesterone excretion during the menstrual cycle or in women taking oral contraceptives. Acta Endocrinol 116(1):145-49.

91. McElhinny AS, Davis FC, Warner CM. The effect of melatonin on cleavage rate of C57BL/6 and CBA/Ca preimplantation embryos culture in vitro. J Pineal Res 1996; 21(1):44-48.

92. Miller AL. Epidemiology, etiology, and natural treatment of seasonal affective disorder. Altern Med Rev. 2005 Mar;10(1):5-13.

93. Miller AL. Epidemiology, etiology, and natural treatment of seasonal affective disorder. Altern Med Rev. 2005 Mar;10(1):5-13.

Pathophysiology Review

The endocrine tissue found in the pancreas islets form the basis of blood sugar control. Alpha (A) cells in the periphery of the islet tissue secrete glucagon, a polypeptide hormone that increases blood sugar. It binds to glycogen receptors on the liver and induces the enzymatic breakdown of glycogen to glucose. Glucagon also functions in the formation of glucose from the amino acids in the liver through a process called gluconeogenesis.

Adjacent to the alpha cells are the beta cells. They constitute 70% of the islet cells and function to lower blood sugar with the secretion of insulin that is essential for the uptake of glucose from the blood into the majority of the body's cells.

Virtually all cells use insulin in order to absorb glucose, except for the tissues found in the retina, nerves, and kidney. Insulin is the facilitator that allows sugar to enter the cells by increasing the number of proteins that transport glucose across cell membranes into muscle cells, adipocytes, white blood cells, and certain other cells. Insulin also increases the synthesis of glycogen from glucose in liver cells. However, in the tissues where insulin is not required for the entry of glucose into the cell, the excess glucose that freely enters the cells is broken down into sugar alcohols (polyols). When in excess, these sugar alcohols are the cause of secondary complications of diabetes found in the retina, nerves, and kidneys.

The effects of insulin are numerous, including mediating storage of carbohydrates, proteins, fats, and proteins. It is also used in facilitating cellular growth and in enhancing liver, adipose, and muscle metabolism.

Decreased insulin secretion or decreased numbers of insulin receptors are the main causes of impaired glucose intolerance.

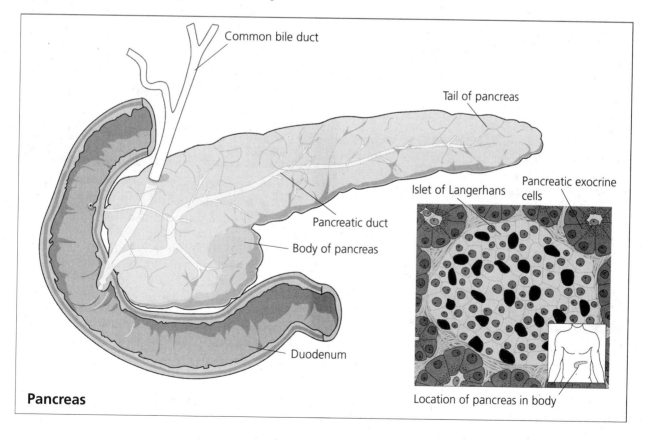

Common bile duct

Tail of pancreas

Pancreatic duct

Body of pancreas

Duodenum

Islet of Langerhans

Pancreatic exocrine cells

Location of pancreas in body

Pancreas

Quick Reference: Major Blood Metabolism Disorders

Blood Metabolism Disorder	Major Signs and Symptoms	Key Laboratory Tests	Conventional Therapies	Naturopathic Therapies
Diabetes Type I	Weight loss	High glucose High glyc, hemoglobin High fructosamine levels	Insulin	Insulin
Diabetes Type II	Obesity	High glucose High glyc hemoglobin High fructosamine levels	Sulfonylurea Biguanides	Botanical medicine, low glycemic diet, chromium, vanadium sulfate, exercise
Hyperinsulinemia	Acanthosis nigracans (darkening of the skin) Obesity	High insulin levels, possibly high glucose levels	Biguanides	Botanical medicine, low glycemic diet, chromium, vanadium sulfate, exercise
Reactive Hypoglycemia	Irritable when missing meals	none	none	Chromium, vanadium sulfate, botanical medicine

Hypoglycemia

Hypoglycemia is defined as low blood glucose values that are less than 50 mg/dl (2.8 mmol/l). Whipple's triad describes the three essential aspects of hypoglycemia: low plasma glucose, symptoms associated with hypoglycemia, and symptomatic resolution when blood sugar is returned back to normal.

SIGNS AND SYMPTOMS

The adrenergic symptoms related to hypoglycemia are related to catecholamine levels. These symptoms include diaphoresis (sweating), palpitations, apprehension, anxiety, headache, and weakness. The lack of blood sugar supply to the brain will cause neuroglycopenic symptoms and result in confusion, irritability, abnormal behavior, 'spaciness', and possibly even convulsions and coma.

CONVENTIONAL MEDICAL TREATMENT

Conventional treatment for reactive hypoglycemia as defined above is limited because often it is not considered a real condition. Conventional medicine does recognize reactive hypoglycemia by a stricter definition of serious pathologies, however:

- Alimentary hypoglycemia caused by previous gastrointestinal surgery and peptic ulcer disease.
- Hormonal causes, such early onset of diabetes Type II, hyperthyroidism, cortisol, epinephrine, thyroid hormone, glucagon, and growth hormone deficiency.
- Endocrine conditions, such as insulinoma, or insulin receptor autoantibodies.

NATUROPATHIC MEDICAL TREATMENT AND PREVENTION

Conventional treatment for the above conditions would be dealt with by treating the underlying cause.

Before making a comprehensive treatment plan for hypoglycemia, the functions and control of blood sugar need to be considered. A holistic perspective will give much better results. By strengthening the health of the same organs involved in treating diabetes Type II, good results can be achieved.

Botanical Medicine

Gymnema sylvestre: Used in India for over 2000 years, this herb contains a compound gymnemic acid that has shown to support the beta cells of the Langerhans. It is a good herbal remedy for diabetes and hypoglycemia. Use of *Gymnema sylvestre* is helpful for high or low blood sugar.[2]

KINDS OF HYPOGLYCEMIA

Fasting Hypoglycemia

Fasting hypoglycemia when very severe usually indicates an organic cause.

Organic Causes

Pancreatic disorders
Liver disease
Pituitary-Adrenal disorders
CNS disease
Non-pancreatic neoplasms
Idiopathic hypoglycemia of childhood

Exogenous Causes

Iatrogenic: insulin, oral hypoglycemic drugs, antihistamines, angiotensin converting enzyme (ACE) inhibitors, pentamidine, alcohol, salicytes, ackee nut.[1]

Postprandial and Reactive Hypoglycemia

Postprandial hypoglycemia, also called reactive hypoglycemia, is a non-severe form of hypoglycemia that is not caused by a pathology, but rather by a lack of optimum function of the organs that regulate blood sugar.

Reactive hypoglycemia is by far the most common form of hypoglycemia. It has such a variety of symptoms that they are often misdiagnosed and overlooked. Symptoms range from feeling irritable upon missing a meal to drastic mood swings during PMS. Low blood sugar causes people to feel hungry in between meals. People will often crave foods that are both sweet and high in carbohydrates. However, after eating these foods patients still don't feel well; they become sluggish and tired.

Pseudohypoglycemia

Pseudohypoglycemia is a false positive laboratory reading of hypoglycemia that happens due to chronic leukemia, hemolytic anemia, or polycythemia. The mechanism for the false positive in leukemia is due to the glucose utilization by leucocytes in the blood sample after it has been drawn from the patient.

Siberian ginseng and Panax ginseng: Adaptogens, such as Siberian ginseng and Panax ginseng, are also very useful for sustaining healthy blood sugar levels.

Glycyrrhiza glabra: Licorice root inhibits the half-life of life of cortisol by inhibiting its peripheral breakdown.[3] Licorice is an excellent remedy for hypoglycemia due to adrenocorticoid insufficiency.

Clinical Nutrition

Alpha lipoic acid: This potent antioxidant neutralizes free radicals and enhances the effectiveness of vitamin C and E, as well as sustaining blood sugar levels.[4]

Low Glycemic Diet: A low-carbohydrate, moderate-protein, and moderate-fat diet focused on natural whole foods is a solution to hypoglycemia. A diet that consists of mainly refined foods, especially sweets, combined with deficient exercise, gets people into trouble in the first place, so a program based on whole foods, not more refined food products, is the best long-term solution. In addition, more frequent meals and/or snacks through the day is helpful in keeping blood sugar stable.

Over-consumption of simple or refined carbohydrates can lead to a number of health-related concerns, including the development of hypoglycemia. This is often associated with hyperinsulinemia, which is caused by a hypersecretion of insulin by the pancreas. In other words, people can develop elevated insulin levels presumably in an effort to compensate for the spikes in blood sugar caused by consumption of these simple carbohydrates. This can lead to a subsequent drop in blood sugar (hypoglycemia) and to insulin resistance, in which the cells of the body become insensitive to insulin. Insulin resistance may eventually lead to diabetes, in which the blood sugar levels are elevated above the normal range.

A diet to control hypoglycemia must consider the glycemic index. The glycemic index of foods is a system of classifying foods according to the degree to which they raise blood glucose levels. It compares the blood glucose level following consumption of equal portions of various foods and ranks the foods relative to a standard (usually glucose or white bread).

The glycemic index is *not* a measure of the amount of carbohydrate in a particular food. For example, orange juice has a higher glycemic index than apple juice, while apple juice has higher carbohydrate levels. The body's insulin responses tend to follow the rank order of the glycemic response. Highest glycemic foods include not only sweets and deserts, but also many starchy foods, such as white bread, breakfast cereals, and potatoes. Lowest glycemic index foods include legumes, dairy products, most non-starchy fruits and vegetables, meat, fish, and poultry.

Meals and snacks should also be balanced themselves in terms of the three macro-nutrients. A ratio of approximately 20% to 30% protein, 30% to 45% fat, and 25% to 50% complex carbohydrate will

ensure that blood sugar is not raised too high at meals and therefore should not drop to the hypoglycemic range postprandially. This diet is based on human evolutionary history and physiology. It reflects what the fact that humans evolved over millions of years as hunter/gatherers, eating a diet that is low on the glycemic scale, and 'grazing' as opposed to having regular meals. Of note is that hypoglycemia and type II diabetes are more prevalent in people who made a rapid switch from hunter/gatherer to modern diets, such as the Native Americans.

→ Glycemic Index of Common Foods

For more information on a low glycemic diet and an analysis of the glycemic index of common foods, see the *Clinical Handbook: Diagnostic and Therapeutic Protocols*, pp. 184.

Side Benefits of Low Glycemic Diets

Other benefits from this diet may be seen, such as weight loss, improved lipid profile (reduction of triglycerides and high HDL levels), and blood pressure reduction. Of course, hypoglycemia symptoms should improve, and the cravings for sweets and caffeine should diminish. As the load is lessened on the adrenals, energy levels and overall mood may improve as well. As the insulin sensitivity is re-established, the body is better able to handle small amounts of high glycemic foods (in other words, cheating is less likely to lead to symptoms).

Lifestyle

Stress: Stress plays a role in improper carbohydrate metabolism. Stress causes cortisol levels to rise, which can lead to decreased utilization of blood glucose and increased obesity and reactive hypoglycemia. If stress is persistent, the adrenals can become fatigued, which is also a major contributor to hypoglycemia. Because the adrenal response is triggered by low blood glucose, hypoglycemia exacerbates adrenal fatigue, as do simple carbohydrates (especially sweets and alcohol) and stimulant consumption. Therefore, managing stress, avoiding all stimulants, and supporting the adrenals will improve hypoglycemia symptoms.

Liver Support and Detoxification: The liver also plays a role in glucose metabolism, responsible for converting stored glycogen to glucose if blood sugar drops too low. Therefore, liver support and detoxification may improve the tendency to hypoglycemia by strength-ening the ability of the liver to respond to low blood sugar. Thus, reducing toxic load on the liver by eating pesticide-free foods and by avoiding chemical exposures (including over-medicating) can improve the stability of blood glucose levels.

Exercise: Exercise has a number of benefits in the management of hypoglycemia. Exercise balances blood glucose by optimizing glucose uptake at the cellular level. Therefore, hyperinsulinemia is less likely to develop in a fit person. In addition, regular exercise balances the stress hormones and supports the adrenals, both of which help to maintain balanced blood sugar.

→ Selected Clinical Studies and Literature Reviews

For more information on the value of exercise in managing hypoglycemia, see J.K. Ojha, H.S. Bajpat, and R.M. Shettiwar, "Effect of Yogic Practices and Pterocarpus Extract on Insulin Dependent Diabetes," in *Selected Clinical Studies and Literature Reviews*, pp. 267.

Diabetes Mellitus

DIAGNOSIS

Approximately 50% of diabetics are undiagnosed. Some patients may have no overt symptoms other than 'spaciness', thirst, fatigue, and excess urination. Because the metabolic changes leading to diabetes can often be found 10 years or more before it manifests clinically, information about insulin resistance is of critical importance for prevention of increased cardiac risk, dyslipidemia, hormonal imbalances, and increased mortality rates.

Genetics

If the mother has diabetes mellitus, there is a 2.1% risk the child will have it. If the father has diabetes mellitus, the risk is 6.1% for the child. Monozygotic twins have a 20% to 50% chance if one parent has diabetes. Susceptibility to Type I diabetes is associated with certain proteins coded by the HLA region of the histocompatibility complex.

Oral Glucose Tolerance Test

Oral glucose tolerance test is the confirmatory test for diabetes, in which 75 gm of anhydrous glucose is dissolved in water. However, rarely is this test necessary in clinical practice since the measurement of elevated fasting plasma glucose done on two separate days should suffice in the diagnosis of diabetes.

CLINICAL STUDIES
Jambul Seed, Prickly Pear Cactus, Devil's Club, Milk Thistle, and Globe Artichoke

One clinical trial using 650 mg of herbal capsules 3 times a day consisting off jambul seed, prickly pear cactus, devil's club, milk thistle, and globe artichoke resulted in lowered fasting blood sugar levels by 33% in the majority of adult onset diabetics, while also raising blood sugar levels in patients with reactive hypoglycemia.[5]

Hypoglycemic Score

Hypoglycemic patients were able to lower their hypoglycemic score index by 67% after 6 weeks administration of this formula. The hypoglycemic score is calculated by assigning a numerical value to the intensity and frequency of the following symptoms:

1. Dizziness when standing up suddenly
2. Loss of vision when standing suddenly
3. Craving sweets
4. Headaches relieved by eating sweets
5. Feeling shaky or jittery
6. Irritability if a meal is missed
7. Heart palpitations after eating sweets
8. Need to drink coffee to get started in the morning
9. Impatient, moody, nervous
10. Feeling faint
11. Forgetfulness
12. Calmer after eating
13. Poor concentration

Results

Since hypoglycemic patients often have a hard time coping with their hunger between meals when the blood sugar drops, they are likely to eat often. Most of the hypoglycemic patients who took herbs during the study had decreased appetite between meals; thus, patients were also able to lose weight. The study showed that herbs, when formulated holistically to address all the organs involved in blood sugar metabolism, not only are effective in addressing problems of high blood sugar but also in low blood sugar. Thus, it was shown that many of the herbs that were used traditionally to treat diabetes are also effective in treating low blood sugar levels, reinforcing the theory that some herbs have a regulating effect.

→ Selected Clinical Studies and Literature Reviews

For a study of the correlation between mineral levels and abnormal glucose tolerance, see George M. Tamari and Zoltan Rona, "Hair Mineral Levels and Their Correlation with Abnormal Glucose Tolerance," in *Selected Clinical Studies and Literature Reviews*, pp. 260.

Fasting Levels

Fasting levels can be obtained after there has been no caloric intake for 8 hours. In a healthy person, the level will be equal or lower than 110 mg/dl. Impaired glucose homeostasis would be above this number, and diabetes is diagnosed at greater or equal to 126 mg/dl (7.0 mmol/l). If a blood sugar test is done at any time of the day, including after a meal, and is higher or equal to 200 mg/dl (11.1 mmol/l), it indicates diabetes.

Hemoglobin A1c and Fructosamine

A comprehensive dysglycemia metabolic profile would also include hemoglobin A1c and fructosamine. Hemoglobin A1c measures long-term blood sugar control over a 2 to 3 month period, while fructosamine determines it over a period of 2 to 3 weeks. Imbalances of DHEA, cortisol, and IGF-1 are contributing factors to the clusters of conditions caused by dysglycemia, due to their influence on blood sugar control. In general, insulin resistance is associated with low DHEA levels especially in men.[6-8] However, in women, insulin resistance is usually associated with adrenal hypersecretion and polycystic ovary syndrome. Typically, these subset of patients will have high levels of DHEA and cortisol.[9]

Somatomedin-C

High levels of somatomedin-C are associated with hyperglycemia. Most effects of growth hormone are mediated by IG-F. IG-F is made by the liver and various other organs,as a response from growth hormone. Somatomedin-C feeds back to the pituitary and suppresses growth hormone levels. Unlike growth hormone, somatomedin-C has a long half-life and thus is a better diagnostic tool.

Physical Exam

Physical exam can often reveal insulin resistance, paying close attention to truncal obesity, especially to patients who look like apples walking on toothpicks.

Contributing Factors for Diabetes
- Greater than 120% desirable body weight
- Imbalances of DHEA, cortisol, and IGF-1[10]
- Sedentary lifestyle, high consumption of refined sugars
- Eating at fast-food restaurants, drinking soft drinks
- Nitric oxide deficiency[11]
- Delivered a baby weighing more than 9 pounds, or gestational diabetes
- Low birth weight[12]

Type I: Insulin Dependent Diabetes Mellitus (IDDM)

In type I diabetes or insulin dependent diabetes mellitus (IDDM), the beta cells in the pancreas are being destroyed, which results in decreased insulin production. The primary step in the pathogenesis of diabetes mellitus is the activation of host T lymphocytes against specific antigens present on the patient's beta cells. These activated cells orchestrate a slow destruction of the beta cells. The histology of the pancreas shows an inflammatory infiltrate of mononuclear cells.

Type I diabetes can occur at any age, though it usually develops before age 30. Type I patients tend to be thin. They are prone to develop diabetic ketoacidosis and hypoglycemic coma from excessive exogenous insulin injections.

CAUSAL MECHANISMS

Genetics
Traditionally, Type I diabetes has been considered to be caused by a genetic factor that results in the destruction of the beta cells of Langerhans. However, this does not seem entirely true.

Viral Infections
Infections may be the cause of diabetes mellitus. It was first reported in a Scandinavian study that two children developed diabetes mellitus after the mumps. In a study done in London over a 10-year period, scientists tracked the seasonal incidence of the onset of diabetes Type I. Virtually all reported cases of Type I developed in the fall and winter, the highest level being in October. Onset peaks at age 5 and 11, which epidemiologists attribute to the time children undergo radical environmental changes as they move from home to school and are exposed to a high amount of viruses. Suspected triggers for Type I diabetes include coxsackie b4 virus, mumps, and other unidentified diabetagenic viruses.[13]

Cow's Milk
Foods have also been linked to Type I diabetes. Cow's milk ingested in the first 6 to 8 weeks of infancy has been speculated as causing an autoimmune response to the milk by a process called molecular mimicry. The body produces antibodies against an antigen, such as bovine albumin peptide in cow's milk, which mimics the pancreatic cells of the body. As a result, the white blood cells attack the pancreas. Review of the medical literature indicates that ingestion of cow's milk increases the risk of Type I diabetes by a factor of 1.5.[14]

CONVENTIONAL MEDICAL TREATMENT

A specialized team consisting of an endocrinologist and a naturopathic physician can give pharmacological advice, counseling on behavioral modifications, and nutritional recommendations.

Type I Intensive Therapy
For intensive care in Type I patients, it is recommended to test the blood four to eight times per day to assess blood sugar control before and after eating. The patient is asked to count the exact amount of carbohydrates ingested or use the diabetic exchange system to make exact estimates on insulin adjustments.

The availability of self-blood monitoring (SMBG), along with multiple-dose insulin regimens, and the evolution of the diabetes treatment has made significant improvement in glycemic control. Improved glycemic control in Type I patients has been shown to reduce the risk of long-term diabetic complications. The Diabetes Control and Complication Trial (DCCT) showed a 34% to 76% reduction in clinically meaningful retinopathy in Type I diabetic patients using intensive diabetes monitoring compared to patients who did not.[15]

Nocturnal Hyperglycemia in Type I
The risk of secondary complications is caused by high blood sugar at any time, regardless of day or night. One way to stabilize blood sugar during the night is to split the insulin dose into one dose before dinner and one before sleeping. The latter injection will cause insulin levels to peak at 5:00 or 6:00 in the morning. The levels will maintain through the night, and nocturnal hyperglycemia can thus be avoided.

HORMONAL CONVERSATIONS

One way to understand the relationship between blood sugar metabolism and the endocrine disorder we call diabetes is to look at the 'conversation' between hormones that goes on daily within the body of an ordinary person, John Doe. We can imagine this as a play, with various hormones and organs playing their roles on the stage of John Doe's endocrine system.

Cast of Characters:

Insulin: the hormone that instigates sugar absorption (decreases blood sugar).

Glucagon: a hormone that increases blood sugar.

Cortisol: a counter-regulatory hormone of insulin (increases blood sugar).

Epinephrine: a counter-regulatory hormone of insulin (increases blood sugar).

Pancreas: the organ that secretes insulin.

Adrenal glands: an organ that secretes stress hormones such as cortisol and epinephrine.

Act 1, Scene 1: It's early morning and John Doe, a non-diabetic, is still fast asleep. His blood sugar is 70 mg/dl. When his alarm clocks goes off, John's blood sugar rises as cortisol and epinephrine kick into his system.

Act 1, Scene 2: When John arrives at work, he is blamed for something that wasn't his fault. He gets angry and frustrated and his blood sugar increases again with a surge of stress hormones from the adrenal glands. Later in the morning, John sits in his car and plays a Ram Dass relaxation tape. The stress hormones stop surging. His blood sugar levels goes down.

Act 2, Scene 1: By lunchtime, John's blood sugar has dropped further to 50 mg/dl. He eats lunch and tops it off with some chocolate ice cream. His blood sugar rises to 100 mg/dl. His pancreas responds by secreting insulin. His blood sugar decreases as the sugar enters his cells. The blood sugar keeps decreasing until the body tries to rebalance levels with glucagon, which again increases the blood sugar.

Act 2, Scene 2: After work, John meets a beautiful woman and his blood sugar goes up as the adrenal glands secrete more stress hormones. As John continues the adventures of daily life, his blood sugar level rises and falls as the hormones continue their counter-regulatory dialog over and over again.

Coda: People with diabetes mellitus are missing something in their hormonal conversation. Their ability to produce or use insulin is diminished. The hormones that tell the body to increase the blood sugar may be working, but the insulin that brings blood sugar down does not respond. Glucagon responds to low insulin levels but it does not respond to low blood sugar levels. This is why the one-way conversation of the counter regulatory hormones can be quite dangerous in a diabetic. Glucagon will keep on increasing blood sugar by responding to low insulin levels, rather than responding to the high blood sugar levels, which can eventually lead to a coma.

Diabetic Therapy: The goal of diabetic therapy is to restore the communication in the body between these systems. This can be achieved by strengthening the pancreas to produce more insulin, by restoring peripheral metabolism of insulin, or by taking exogenous insulin.

Troubleshooting the Insulin Regime

Diabetics may often have difficulty in keeping the blood sugar in range. Certain foods, especially high glycemic foods (foods that easily increase blood sugar), exercise, and physiological or emotional stress can temporarily increase blood sugar.

If the patient is taking insulin and hyperglycemia is still occurring, it is important to look at these contributing factors:

- Accuracy of the self-monitoring blood glucose test
- Pharmakinetics of insulin (abdomen>arms>thighs)
- Diet
- Stress
- Use of corticosteroids
- Menses

NATUROPATHIC MEDICAL TREATMENT AND PREVENTION

Patients can often decrease insulin requirements with the use of herbal medicine. However, there are only a few reported cases of completely eliminating exogenous insulin with the use of natural medicine. While it is widely believed that all patients will eventually require insulin for glucose control and survival, rare anecdotal reports indicate otherwise with the use of IV hydrogen peroxide, niacinamide, and neuropeptide injections upon diagnosis.

Clinical Nutrition

Niacinamide: Niacinamide (also called nicotinamide) has been shown in animal and human studies to help prevent the development of Type I diabetes. There

have been six clinical, double-blind, placebo controlled studies performed on the use of niacinamide on patient's suffering from Type I within 5 years of diagnosis. Out of these six studies, three have demonstrated a positive effect in terms of remission, lowering insulin requirements, and increasing beta cell function. Some of the recently diagnosed Type I patients were able to go into complete remission with niacinamide. The main difference between the trials that proved to be positive and those that proved to be negative was that in positive trials subjects were older and had higher fasting C-peptide levels. The theoretical mode of action of niacinamide acts as an antioxidant and inhibits macrophage and interleukin 1 mediated beta cell damage.[16]

→ Selected Clinical Studies and Literature Reviews

For more information on naturopathic treatment and prevention of insulin resistance, see Gregory S. Kelly, "Insulin Resistance: Lifestyle and Nutritional Interventions," in *Selected Clinical Studies and Literature Reviews,* pp. 241.

Hemopathic Medicine

Autohemotherapy: Molecular mimicry happens in a variety of autoimmune disorders that are triggered by infections and other antigens, such as chronic prostatitis, adrenal disorders, and thyroiditis. Autohemotherapy is a treatment used commonly in Europe by clinicians as a tool in treating autoimmune disorders. This process involves taking the patient's serum and homeopathically potentiating it. Then the modified blood is reinjected in the patient, and it is speculated that the patient synthesizes antibodies against the original antibodies. The use of neuropeptide injections has some of the most promising evidence of help with autoimmune diseases.

Lifestyle

People who are under stress have increased cortisol levels, which will increase blood sugar. Many people do not realize when they are stressed, but often their bodies are. Stress of any type, including psychological, will cause higher cortisol and blood sugar levels. An anxious mind will reflect in the physical form. Lifestyle counseling and meditative practices, such as yoga, have shown to decrease stress.

Type II: Non Insulin Dependent Diabetes Mellitus (NIDDM)

In the United States, about 5.2% of the population (13 million people) has diabetes; 90% of all cases are non-insulin dependent diabetes (NIDDM). Unlike Type I patients, who are always deficient in insulin, Type II patients may have insulin resistance, decreased insulin production, or increased insulin production to compensate for the insulin resistance. Type II diabetes is usually associated with obesity, a sedentary lifestyle, and a high sugar diet (as in syndrome X). Although often undiagnosed and ignored by the medical community, hyperinsulinemia is often a precursor of NIDDM. Ketoacidosis (hyperglycemic comas) seldom occurs in NIDDM.

CAUSAL MECHANISMS

There are many proposed explanations of the mechanisms involved in developing NIDDM.

High Sugar, Low Fiber Diet

The modern Western diet — high in refined sugars and fats but low in fiber — can contribute to the cause of reactive hypoglycemia. The intake of refined sugar can lead to a rapid rise in blood sugar levels, causing the pancreas to secrete insulin sometimes at a level that can result in hypoglycemia. The adrenals then secrete epinephrine and other stress-hormones to increase blood sugar back to normal. If patients continually assault their bodies with this diet, it may result in both pancreatic and adrenal exhaustion.

Obesity

Obesity is a significant factor in NIDDM, which tends to be hypertrophic and android. Hypertrophic cells are enlarged fat cells. Serum insulin levels and triglycerides regulate the deposition of fat tissue on the abdomen. Gluteo-femoral adiposite deposition is usually regulated by corticosteroids and estrogen.

Fat tissue in itself is very metabolically active, more than conventionally considered. A study at Harvard medical school found that adipocytes secrete a variety of active hormones, such as tumor necrosis factor, leptins, interleukin 6, fatty acids, and resistin. Resistin is thought as a chemical that induces insulin resistance since it positively correlates with insulin sensitivity. However, current research still finds the evidence as premature, since the serum resistin level of Type II patients are decreased in fasting rather than increased. Adipose tissue, once considered a passive depot of fat, might actually be an active endocrine gland, playing a role in metabolic regulation, preventing harmful accumulation of lipids in other tissues, and the secretion of metabolically active hormones.[17]

Glucose Oxidation

Another postulated mechanism in NIDDM is a problem in oxidative metabolism of glucose. Glucose metabolism is regulated by pyruvate-dehydrogenase and inhibited by isomers of pyruvate-dehydrogenase kinase. Increased levels of pyruvate-dehydrogenase kinase may cause insulin-resistance in NIDDM patients and increased fatty acid oxidation. Recent studies have found that obesity can cause an insufficient down regulation of pyruvate-dehydrogenase-kinase-mRNA in people with insulin-resistance; this leads to increased levels of pyruvate-dehydrogenase-kinase, which impairs glucose oxidation and thus results in increased fatty acid oxidation.[18]

Other Disorders

Insulin-resistance is associated with various other disorders, including polycystic-ovary disease, liver malfunction, and cirrhosis. The oxidation of hepatic cell membranes, which occurs in cirrhosis, causes a decrease in liver function that is associated with the development of diabetes.

Increased abundance of insulin, insulin-like growth factors, and hybrid 1 receptors are found in muscles of obese patients.[19-20] An increase of in-vivo insulin insensitivity has been found in both obese and hyperinsulinemic patients. Hyperinsulinemia is an independent risk factor not only for NIDDM, but also for atherosclerosis.

HISS

Glucose homeostasis is regulated both by the pancreas and the counter-regulatory responses of the adrenal gland and liver. The hormones involved include glucagon, catecholamines, growth hormone, and cortisol. The role of the liver in NIDDM has been demonstrated, in both animal and human studies. Receptors on hepatic parasympathetic nerves release nitric oxide, which causes the release of Hepatic Insulin Sensitizing Substance (HISS). HISS sensitizes skeletal muscle to absorb insulin. Animal studies have shown that the blockade of nitric oxide release causes a secondary blockade of HISS, which results in insulin resistance.[21]

Low Birth Weight

Low birth weight is a contributing factor for NIDDM. Decreased fetal nutrition can lead to abnormal development of pancreas and adipose tissue, leading to hyperglycemia in adults.[22] Nitric-oxide deficiency is a risk factor for both NIDDM and insulinemia.[23] Levels of serum-chromium in adult diabetics have been found to be much lower than in non-diabetic subjects. However, no correlation between rate of glycemia and serum chromium levels has been found in diabetics.[24]

Herbicides

Exposure to herbicides during the Vietnam War, especially Monsanto's defoliant Agent Orange (dioxin), may be associated with the development of diabetes. Agent Orange was sprayed on trees to reduce cover for North Vietnamese soldiers. About 2.6 million people served in Southeast Asia between 1962 and 1975. About 8% to 11% now have diabetes. Since diabetes increases with age, the percentage will undoubtedly rise. In 1991 the U.S. Congress passed the Agent Orange Act, which established a system for evaluating the effects on its soldiers. About 8,500 Vietnam veterans have been financially compensated, many for diabetes-related health damages under this Act.

Other diseases designated as associated with herbicides include chloracne (a skin condition), soft tissue sarcoma, Hodgkin's disease, multiple myeloma, respiratory cancers, prostate cancer, and Non-Hodgkin's lymphoma. Spina bifida in the children of veterans is also considered grounds for compensation from the Agent Orange Act. Agent Orange is not only found in tissues of soldiers from the Vietnam war, but, according to an EPA study in 1982, it is also found in the tissue of 76% of the general American public.[25]

CONVENTIONAL MEDICAL TREATMENT

Insulin

Insulin is one type of pharmacological agent used in NIDDM. Eighty percent of the cell membranes in the body become highly permeable to glucose within seconds of insulin binding to its receptors; rapid entry of glucose ensues, which is used in the formation of substrates for metabolism. Thin diabetic patients respond quite well and have decreased microvascular complications. The disadvantages of using insulin in NIDDM patients is that they can have hypoglycemic episodes that can lead to a coma, or they can have increased risk of macrovascular complications. The use of insulin can cause weight-gain, which is a problem in perpetuating insulin resistance itself. Only a minority of patients can take insulin since it is usually not effective in obese patients.

Sulfonylurea

Sulfonylurea is another pharmacological agent used in NIDDM that works by stimulating insulin secretion from the beta cells of the pancreas. Following long-term

use, it may also affect extra-pancreatic functions, such as increased peripheral sensitivity to insulin and a decreased hepatic glucose production. Sulfonylureas have the advantage that there are multiple formulations available that are relatively inexpensive.

Their effectiveness was demonstrated in a study with Glimepiride: 5,000 patients with Type II diabetes had a decrease of 43-74 mg/dL more than placebo. The administration of Glimepiride also decreased HbA1c values by 1.2-1.9%. The disadvantage of sulfonylurea use is that after initial success, sulfonylureas are completely ineffective in 30% of patients. Adequate control in the long-term use of sulfonylureas only occurred in about 20-30% of patients. Sulfonylureas are contraindicated in liver, kidney, and thyroid disease.

Primary and secondary failure can occur with all oral agents used in the treatment of NIDDM. One study showed that the rate of deaths due to heart attack was 2.5 times greater in patients who had used sulfonylureas for the treatment of glycemia than the group treated with diet alone. Currently, there are warning labels for cardiac death on all Sulfonylureas and Metformin. However, the UK study found no correlation between increased cardiovascular death and sulfonylurea use.[26]

Metformin

Metformin is the drug of choice for obese NIDDM patients. A biguanide, Metformin is a pharmacological agent developed within the last few years whose mechanism is believed to potentiate insulin and increase insulin receptor sites, independent of pancreatic function. It also leads to weight-loss, which may be another contributing factor in its mechanism.

The effectiveness of metformin has been demonstrated in pharmacological studies. In one study, 228 patients had an HbA1c value of 9.43%; after 3 months of treatment it decreased to 8.7%; after 6 months to 8.3%; after 9 months to 8.72%. Notice the slight rise in HbA1c value after long-term administration of metformin. Metformin is often prescribed following secondary failure of sulfonylureas; however, many physicians find this to be rarely effective.

The most common side effect of Metformin is diarrhea. It also decreases absorption of vitamin B12 and folic acid. Patients with diabetic neuropathy may have symptoms associated with both diabetes and a vitamin B12 deficiency due to the use of Metformin. Metformin is contraindicated in kidney disease. It is important to determine whether the hyperglycemia or the pharmacological agent will present more problems to a patient with diabetic nephropathy. A rare fatal complication of Metformin is lactic acidosis.[27-29]

Alpha-glucosidase Inhibitors

A pharmacological agent used in the treatment of NIDDM is an alpha-glucosidase inhibitor. It works in the small intestine by delaying postprandial glucose absorption by inhibiting the enzyme glucosidase.

In a study of 1,027 patients given alpha-glucosidase inhibitors, a significant decrease in blood sugar levels was found. However, one-third of the patients could not take the drug for one year due to gastrointestinal side effects. Thus, it has marginal clinical relevance. The disadvantage of this drug is that it is costly and has many side effects.[30]

Cautions, Contraindications, and Side-Effects

Pharmacological drugs have been demonstrated to be effective in decreasing glycosylated-hemoglobin and in the complications of diabetes. However, great improvement still needs to be made in the ability of patients to achieve tight control of blood-sugar levels. Due to the amount of side effects, the use of oral pharmacological agents should be assessed when administering drugs to NIDDM patients. Both hyperglycemia and NIDDM pharmacological agents may cause tissue-damage; for example, kidney damage can be caused by hyperglycemia or by the use of sulfonylureas and biguanides. Thus, it is important to determine which is more damaging to the patient, hyperglycemia or drug therapy.

There is also suspicion that the sulfonylureas are toxic to the pancreas. Sulfonylureas are contraindicated in patients with liver, thyroid, and kidney disease. These three organs are all involved in diabetes, the liver having its function in producing receptor sites, the thyroid having its function in preventing excessive weight gain, and the kidneys in maintaining blood pressure control. When kidney function is impaired by hyperglycemia or pharmaceuticals, there is a progressive deterioration of blood pressure control, which is important for diabetics. In the UK study, patients were divided into a tight blood pressure control group and a group with less tight control of their blood pressure. The average blood pressure in the tight control group was 144/82 and in the less tight control group 154/87. Some of the tight control group needed three to four pharmacological agents to achieve this blood pressure level. The tight blood pressure control group had a decrease in almost all microvascular complications: a 25% decrease in diabetic related endpoints; a 32% decrease in deaths related to diabetes; a 44% decrease in strokes; and a 39% decrease in microvascular endpoints. The tight control group had a significant difference compared

to the less tight control group in along-term perspective of the patient's life.

There are many reported hypoglycemic deaths due to the use of oral hypoglycemics. Other adverse effects include jaundice, decreased RAI-uptake of the thyroid, weight-gain, chronic hyperinsulinemia, severe insulin resistance, and perhaps beta cell exhaustion.

SIADHS (syndrome of inappropriate anti-diuretic hormone secretion) can also occur in the use of sulfonylureas. This side effect is manifested by water-retention and hyponatremia. Since many diabetic patients have edema due to nephropathy, pharmacological agents must be ruled out as another cause of the edema in these patients. One patient of mine, who had diabetic nephropathy, lost all edema in her legs after discontinuing Glyburide (a sulfonylurea drug) and using a combination of herbs – jambul, devil's club, globe artichoke, milk thistle, and nopal.

Despite the use of pharmaceutical drugs for Type II diabetes in the last 30 years, less than 25% of NIDDM patients have been able to achieve normal glycosy-lated hemoglobin levels, regardless of the mode of treatment. Elevated glycosylated hemoglobin and poor glycemic control are associated with increased mortality. Thus, if mortality due to diabetes is to be decreased, advances in more effective treatments are necessary.[31]

NATUROPATHIC MEDICAL TREATMENT AND PREVENTION

Clinical Nutrition
Low Glycemic Diet: The diet restrictions and allowances described for treating hypoglycemia apply to hyperglycemia.

Hypocaloric Diet: Weight loss studies with the use of hypocaloric diets have shown not only decreased cholesterol-rich particles in serum, but also, interestingly, increased serum levels of alpha-tocopherol simultaneously. Caloric-restriction, at least in rodents, will

CLINICAL TRIALS
Combination Diet, Drug, and Herb Therapies
UK Prospective Study
In the UK Prospective Study, levels of glycemic control and its relationship to secondary complications were assessed. The study evaluated 4,075 newly diagnosed patients with NIDDM. All the patients were put on a low fat, high complex carbohydrate, and high fiber diet. These patients were then divided into two groups: diet therapy alone, and diet therapy plus one pharmaceutical agent (monotherapy). After 9 years of analysis, the group that used pharmaceutical agents plus diet were two to three times as likely to achieve 7.0% HbA1c values than patients on diet therapy alone.

The target level of the study was to be below 7.0% HbA1c or less than 7.8 mmol/L (140 mg/dL). They analyzed the HbA1c values of these patients after 3, 6, and 9 years. After 9 years, 8% of patients treated with diet were able to achieve this level; 24% were able to achieve this with diet and sulfonylurea pharmacological agents; and 42% were able to achieve this with diet and insulin. Insulin is effective in Type II patients when they are thin and insulin deficient. However, only 10% of NIDDM patients are thin.

Conclusions
1. This suggests that therapies with diet only are not nearly as effective as those that use combinations of pharmaceutical agents and diet.
2. However, the study was seriously flawed by the diabetic diet used. A diabetic diet that is conventionally prescribed by dietitians is much less strict than a naturopathic diet that forbids eating foods with higher glycemic index of 50. The glycemic index is a numerical score from 0 to 100 indicating from lowest to highest the effect of increasing blood sugar. The intensive group had an 11% decrease in glycosylated hemoglobin, which was associated with a 12% decrease in diabetic related endpoints, mostly due to a baseline microvascular decrease; a 10% decrease in diabetic related deaths; a 6% decrease in all mortality; and a 25% decrease in microvascular endpoints, mostly due to a decrease in retinal photocoagulation. An 11% decrease in HbA1c levels showed a marked decrease in diabetic complications in NIDDM. They found that even a 1% decrease in HbA1c values marked a significant difference between the control and intensive group in secondary complications. However, due to the side effects of pharmacological agents, the intensive group had a higher risk of hypoglycemic episodes.
3. This study also demonstrated that over time the ability to control blood sugar levels progressively deteriorates. After 3 years, only 50% of patients were able to achieve levels of HbA1c under 7.0% with a monotherapy; and after 9 years, only 25% were able to achieve this level.
4. The study found that with good glycemic control, patients were able to achieve a decrease in microvascular complications, but not a decrease in macrovascular complications. This study has been criticized for underestimating the benefits of decreased macrovascular complications due to the limits of the effective therapies available.[32]

decrease insulinemia. Some foods, such as daily fish intake, not only caused weight loss compared to controls, but also showed 38% decrease of triglycerides and an increase of HDL by 24%. In this particular study performed at the University of Australia, the effects of fish intake had no statistical effect on glucose or insulin levels.

Green Tea: Studies have shown that the use of green tea extract rich in catechin polyphenols and caffeine decreases obesity by increasing fat oxidation and metabolism. It appears that the thermogenic effects are due to ingredients other than just the caffeine.

Lifestyle
Contributing lifestyle factors to obesity are poor diet and lack of exercise. Obesity may also be associated with suboptimal thyroid function, including Wilsons temperature syndrome.

Other Combination Therapy Studies
Other studies have found that combination drug therapy is more effective than monotherapy. For example, a study using Metformin and Troglitazone further decreased fasting and postprandial plasma glucose concentrations by 18% in comparison to monotherapy.

Furthermore, clinical trials of glucose adaptogenic herbs indicate patients who use pharmacological agents and natural therapeutics in combination have significantly decreased fasting blood sugar levels compared to patients who use pharmacological agents alone. For example, jambul (*Syzygium jambolana*) not only lowers blood sugar but also decreases secondary complications. Prickly pear cactus (*Nopal opuntia*) is also very effective. In a trial of 29 subjects including 8 healthy subjects, 14 obese subjects, and 7 diabetic subjects, glycemia decreased a mean of 63.4 mg/dl 93.5 mmol/l) in diabetics and 3.86 mg/dl (.21 mmol/l) in non diabetics, an insignificant change.

Botanical Medicine
Several herbs have been demonstrated in clinical studies to be effective for treating Type II diabetes and supporting the glands and organs of the endocrine system. For many years, physicians have been successfully using these herbs to reduce insulin levels. The use of chromium, vanadium sulfate minerals, and fish oils are adjunctive treatments that are also helpful in reducing insulin levels.

BOTANICAL MONOGRAPHS

Among the most effective herbs for treating Type II diabetes are milk thistle (*Silybum marianum*), gymnema (*Gymnema sylvestre*), nopal (*Nopal opuntia spp.*), jambul (*Syzygium jambolana*), globe artichoke (*Cynara scolymus* L.) and devil's club (*Oplopanax horridus*). Monogarphs describing their pharmacology and clinical applications are provided here.

Milk Thistle (*Silybum marianum*)
Silybum marianum is currently the most researched herb in the treatment of liver disease (with over 450 published peer review papers). The active constituent of silybum is silymarin, a mixture of flavonolignans consisting chiefly of silibin, silidianin, and silichristine. Silibin is the most active of the three and is largely responsible for the benefits attributed to the silymarin complex.

Pharmacology: Silybum exerts a protective and restorative effect on the liver. The hepato-protective effects include anti-oxidation,[33] anti-lipid peroxidation,[34] enhanced detoxification, and protection against glutathione depletion.[35] Silybum inhibits the enzyme lipoxygenase, thereby inhibiting the formation of the hepato-destructive leukotrienes.[36] In damaged livers silymarin has been shown to increase protein synthesis, which might account for its hepatorestorative action. Silymarin has been shown in animal studies to possess antifibrotic activity.[37] Animal and in-vitro studies have shown silybum to possess antidiabetic,[38] antitumor,[39] anti-atherosclerotic, and antinephrotoxic activity.

Clinical Applications: A number of studies have shown that silymarin may be valuable in the prophylaxis and treatment of diabetes and its complications. In treatment with the milk thistle flavonoid silymarin, fasting blood glucose levels, mean daily blood glucose levels, and daily glucosuria and HbA1c levels were all reduced. In addition, fasting insulin levels and mean exogenous insulin requirements were reduced. Silymarin may reduce the lipoperoxidation of cell membranes and insulin resistance, significantly decreasing endogenous insulin overproduction and the need for exogenous insulin administration. Silymarin also decreased basal and glucagon-stimulated C-peptide levels.[40] In treatment with silibin, there was a highly significant reduction in RBC sorbitol, though no effect on fasting blood glucose, and an improved nerve conduction velocity, though not statistically significant.[41] Silibin may be a potent aldose reductase inhibitor and may be valuable in the prophylaxis and treatment of diabetic

complications. In the treatment of rats, silibin prevented the onset of diabetic neuropathy, possibly by inhibiting excessive protein mono-ADP-ribosylation.[42]

Silymarin may also reduce lipo-oxidation of hepatic cell membranes and help reverse insulin resistance. Silibin, which is one of the three flavolignans in silymarin, was studied on patients with NIDDM. The sorbitol red blood cell (RBC) level for 14 patients with NIDDM averaged 72.5 mmol/g; this was two times higher than the control group that didn't have diabetes. In this study, 231 mg of silibin was administered for 4 weeks to the NIDDM patients: their sorbitol RBC level dropped to 39.53 mmol/g. The study also found slightly improved nerve conduction velocity in the silibin group. Silibin, a potent aldose reductase inhibitor, is valuable in the prophylaxis and prevention of complications in diabetes.

Milk thistle is also effective in the treatment of neuropathy. Silibin is a flavonoid, which is a mono-adenoid di-phosphate-lipoxyl-transferase inhibitor. It helps to prevent protein ADP ribosylation. ADP ribosylation causes an increase in P-like substance that causes an immunoreactivity level that is found in diabetic neuropathy. In the treatment of diabetic rats, silibin was found to prevent the increase of ADP ribosylation in Schwann cells.[43]

The adrenal gland has a function in the regulation of insulin called the Somogyi phenomenon. In response to hypoglycemia, epinephrine, norepinephrine, and cortisol are secreted by the adrenal gland. In diabetic rats, a short-term diabetic state lowered the activity of their adrenal cortex. Thus, sub-clinical adrenal hypofunction should be assessed in NIDDM patients.

Contraindications: Silybum is virtually free of toxicity and can be used during pregnancy and lactation. In animals, silymarin was shown to be non-toxic when administered at high doses for short periods. Long-term administration to rats also demonstrated an absence of toxicity. Silybum can stimulate liver and gallbladder activity and can therefore produce a transient laxative effect. Mild allergic reactions have been noted.

Dosage/Toxicity: Since silymarin is not water soluble, administration as an infusion is not recommended. The standard dose of silybum is based on its silymarin content (70-210 mg capsules t.i.d.). A higher dosage will likely yield better results. Several animal and human studies have shown that silymarin bound to phosphatidylcholine yields better absorption and clinical effect (dose 100-200 mg b.i.d).[44]

Gymnema (*Gymnema sylvestre*)

Gymnema sylvestre is a member of the Asclepiadaceae family. It has been used in Ayurvedic medicine to treat madhu meha or "honey urine." Gymnema came to be known as a gurmar or "destroyer of sugar" because Ayurvedic physicians observed that chewing a few leaves suppressed the taste of sugar. It has been used in India for the treatment of diabetes for over 2,000 years.

The medicinally active parts of the plant are the leaves and the roots. Plant constituents include two resins (one soluble in alcohol), gymnemic acids, saponins, stigmasterol, quercitol, and the amino acid derivatives betaine, choline, and trimethylamine.

Pharmacology: The important active ingredient in *Gymnema sylvestre* is an organic acid called gymnemic acid." This is a triterpene glycoside that suppresses sweetness in humans. From this glycosidic fraction, six triterpene glycosides—gymnemosides a, b, c, d, e, and f — were isolated. There are four triterpenoid saponins and six known gymnemic acids found in G. sylvestre. However, the principal constituents are gymnemic acid and gymnemasaponin. Gurmarin is a polypeptide isolated from the leaves that consists of 35 amino acid residues, including three intramolecular disulfide bonds. It has a molecular weight of 4,000 and is inhibitory to neural responses to sweet taste stimuli.

Clinical Applications: *Gymnema sylvestre* is a stomachic, diuretic, refrigerant, astringent, and tonic. Its antidiabetic activity is due to a combination of mechanisms. Recent pharmacological studies have shown that gymnema acts on both the taste buds in the oral mucosa and the absorptive surface to the intestines. The structure of the taste buds that detect sugar in the mouth is similar to the structure of the tissue that absorbs sugar in the intestines. The active ingredient, gymnemic acid, acts on both these sites.

Gymnemic acid is made up of molecules whose atom arrangement is similar to that of glucose molecules. Those molecules fill the receptor locations on the taste buds for a period of one to two hours, thereby preventing the taste buds from being activated by any sugar molecule present in food. Similarly, the glucose-like molecules in the gymnemic acid fill the receptor locations in the absorptive external layers of the intestine, thereby preventing the intestine from absorbing the sugar molecules. Therefore, gymnemic acids from the leaves suppress the elevation of blood glucose level by inhibiting glucose uptake in the intestines. The leaves also contain chlorophyll, xanthophylls, carotene, phytol, and lime salts. *Gymnema sylvestre* has also been found to reduce the bitter taste of certain foods.

Gymnema increases the activity of enzymes responsible for glucose uptake and utilization, and inhibits peripheral utilization of glucose by somatotrophin and corticotrophin. Extracts of this plant have also been found to inhibit epinephrine-induced hyperglycemia. Gymnema has even been shown to regenerate insulin-producing beta cells of the pancreas, leading to an enhancement in the production of endogenous insulin, further controlling blood sugar. Gymnema inhibits adrenocortical activity and prevents the normal hyperglycemic response of the anterior pituitary gland, which acts in turn by inhibiting peripheral glucose metabolism induced by somatotropin and corticotropin hormones. The extracts from gymnema leaves have been shown to suppress the intestinal smooth muscle contraction, decrease O2 consumption, inhibit the glucose evoked-transmural potential, and prevent increased blood glucose levels. Studies indicate that the component of gymnema inhibits the increase in the blood glucose level by interfering with the intestinal glucose absorption process.[45]

Gymnema is antiviral. It increases oxygen uptake, blood pressure, and secretions of liver and pancreas. The leaves have been found to stimulate the heart, uterus, and circulatory system. It raises urine output. As an agent to promote weight loss, gymnema may help control appetite and carbohydrate cravings.

Gymnema also increases the blood's capacity to take up oxygen, resulting in higher physical and mental performance and increased energy levels. This is beneficial for keeping in shape and staying active. The leaves are used for stomach ailments, constipation, water retention, and liver disease. The leaves are also noted for lowering serum cholesterol and triglycerides.[46]

Dr Baskaran and Dr Ahamath, at the Department of Biochemistry, Post-Graduate Institute of Basic Medical Sciences in Madras, India, investigated the therapeutic properties of an extract from the leaves of Gymnema sylvestre in controlling hyperglycemia in 22 Type II diabetic patients on conventional oral antihyperglycemic agents. Gymnema sylvestre (400 mg/day) was administered for 18 to 20 months as a supplement to the conventional oral drugs. During supplementation, the patients showed a significant reduction in blood glucose, glycosylated hemoglobin, and glycosylated plasma proteins. Conventional drug dosage could be decreased. Five of the 22 diabetic patients were able to discontinue their conventional drug and maintain their blood glucose homeostasis with Gymnema sylvestre alone. These data suggest that the beta cells may be regenerated/repaired in Type II diabetic patients on Gymnema sylvestre supplementation. This is supported by the appearance of raised insulin levels

CLINICAL TRIALS

Gymnema sylvestre Therapy for Diabetes

Clinical trials have shown that Gymnema sylvestre is useful for treating both insulin-dependent diabetes mellitus (IDDM) and non-insulin dependent diabetes mellitus (NIDDM). The first scientific confirmation of gymnema's use in diabetes came almost 70 years ago when it was demonstrated that the leaves reduced urine glucose in diabetics. Four years later, it was shown that gymnema had a blood glucose lowering effect when there was residual pancreatic function, but was without effect in animals lacking pancreatic function, suggesting a direct effect on the pancreas.

Another study showed that in diabetic rats, fasting blood glucose levels returned to normal after 60 days of gymnema with oral administration. The therapy led to a rise in serum insulin to levels closer to normal fasting levels. In diabetic rat pancreas, gymnema was able to double the islet number and beta cell number.[47]

In 1981, it was demonstrated that oral administration of the dried leaves of gymnema brings down blood glucose and raises serum insulin levels. In 1988, a study showed a normalization of glycosylated hemoglobin and plasma proteins (indicators of long-term glucose control) from gymnema administration. In 1990, it was shown that administration of gymnema extract to diabetic animals was accompanied by a regeneration of beta cells in the pancreas. This brought about glucose homeostasis through increased serum insulin levels provided by repair/ regeneration of the pancreas.

A study was conducted on both Type I and II diabetics given a standardized gymnema extract, from the leaves, for a period of 2 years: 27 patients with IDDM who were on insulin therapy were administered 400 mg/day of gymnema for 6 to 30 months. Insulin requirements were decreased by about one-half and the average blood glucose decreased from 232 mg/dL to 152 mg/dL. Glycosylated plasma protein levels also decreased. Gymnema appeared to enhance endogenous insulin by regeneration of the residual beta cells in IDDM. Serum lipids also returned to normal levels with gymnema therapy, which may help prevent cardiovascular disease. Most impressively, an increase in C-peptide levels was found, which is a strong indication of restoration of insulin production.[48]

in the serum of patients after gymnema supplementation. Additionally, gymnema significantly improved cholesterol, triglyceride, and free fatty acid levels that were elevated.[49]

Some authors are speaking of the "adaptogenic" nature of gymnema, since it increases the body's ability to adapt to the presence of sugar. The increase in longevity noted above was ascribed to "cardiotonic and adaptogenic characteristics produced by increasing resistance and immunity in diabetic animals." It would have to be a characteristic of a true adaptogen to "normalize" function, not just prolong life. Recently, researchers have reported gymnema prevents death due to hypoglycemia in rats injected with beryllium nitrate. That gymnema prevents both rises and falls in blood sugar and causes no significant change in normal blood sugar levels and appears to be in full harmony with the concept of an adaptogen.

In other animal studies, gymnema has been found to double the number of insulin-secreting beta cells in the pancreas and return blood sugar to almost normal. Most cases have shown it to lower blood sugar to normal levels and not to a point below normal, as seen with many other antidiabetic drugs. However, studies conducted in India as early as 1930 showed that the leaves could cause hypoglycemia in experimental animals.

The anti-sweet peptide, gurmarin, purified from the leaves of *Gymnema sylvestre*, is highly specific to sweet taste so that responses to various sweeteners are all suppressed. Gurmarin acts on the apical side of the taste cell, possibly by binding to the sweet taste receptor protein.[50]

In a very thorough animal study, gymnema greatly reduced the blood glucose levels in alloxan-induced diabetic rabbits. It was thought gymnema effects were mediated through stimulation of insulin release resembling what was observed with sulfonylureas, or through inhibition of intestinal absorption of glucose as observed with the biguanides, or through stimulation of one of the insulinogenic signals promoting insulin release.[51]

Gymnema reversed the glycogen and protein depletions and lipid accumulation in the diabetic animals. The theory that gymnema works by increasing the levels of circulating insulin was supported by observations of altered enzyme activities in the liver, kidney and muscles. Most of the insulin-dependent enzymes (hexokinase, glycogen synthetase, glyceraldehyde-3-phosphate dehydrogrenase, and glucose-6-phosphate dehydrogenase) were significantly more active in the gymnema-treated animals than in control diabetic animals. It also increased the activity of enzymes affecting the utilization of glucose by insulin-dependent pathways: phosphorylase, gluconeogenic enzymes, and sorbitol dehydrogenase. Pathological changes in liver and kidney were reversed by the treatment. The study reports in great detail findings supporting the notion that gymnema corrects the metabolic derangements in diabetic rabbit liver, kidney, and muscle tissues.[52]

Other studies have found similar normalizing effects of various enzymes and chemicals of the kidney, heart, liver and brain, including hexuronic acid, hexoses, hexosamines, non-amino polysaccharides, hyaluronic acid, heparin sulfate, chondroitin sulfates, and sialic acid.

In another study utilizing alloxan diabetic rabbits and one human patient, gymnema brought down the fasting blood glucose levels, together with serum cholesterol and triglyceride levels, while improving serum protein levels. The hypoglycemic action took several weeks to develop. Oral administration in normal rats apparently has no significant effect, but only in rats made hyperglycemic experimentally (alloxan, anterior pituitary-treated, tolbutamide, adrenaline).[53]

While gymnema does not lower blood sugar levels in normal subjects, it does appear to prevent a rise in blood sugar levels in normal subjects. This result has been attributed to a pancreotropic effect due to sensitization of beta cells of islets of Langerhans for secreting larger amounts of insulin in response to glucose. In addition, it markedly inhibited somatotropin- and corticotropin-induced elevations in blood sugar levels.[54]

An interesting finding in clinical tests showed that healthy people with normal insulin levels showed no lowering of blood sugar levels or hypoglycemic effects after taking the herb.

Dosage/Toxicity: *Gymnema sylvestre* in tea form offers the best results. It has been determined that a daily dose of 200 mg is optimal in order to utilize its effectiveness in the area of weight management. The typical therapeutic dose (for treatment of hyperglycemia), standardized to contain 24% gymnemic acids, is 400-600 mg daily. In adult-onset diabetics, ongoing use for periods as long as 18 to 24 months has proven successful. In reducing the symptoms of glycosuria, the dried leaves are used in daily doses of 3-4 grams for 3 to 4 months. Because it acts gradually, gymnema extract should be consumed regularly with meals for several days/weeks and can be taken for months/years with no significant side effects.

Drug Interactions: Patients taking gymnema may require dosage adjustments of other antidiabetic

drugs. However, in some cases, it may make the treatment more effective. Some patients do develop hypoglycemia when taking gymnema along with other medications. This is because improved insulin production and release during gymnema therapy may decrease the need for other medication, and thus low blood glucose levels, unless the dosage of conventional oral medication or insulin is lowered.

Some of the effects of gymnema may be enhanced by MAOI antidepressant medications, fenfluramine, salicylates, and tetracyclines. Its actions may even be decreased by concomitant use of oral contraceptives, epinephrine, phenothiazines, marijuana, and thyroid hormones. Gymnema has diuretic action that increases the renal excretion of sodium and chloride, and may potentiate the hyperglycemic and hyperuremic effects of glucose elevating agents. Patients using diuretics may require dosage adjustments of antidiabetic drugs.

Certain medications, including antidepressants (St. John's wort) and salicylates (white willow and aspirin), can enhance the blood sugar-lowering effects of *Gymnema sylvestre*, whereas certain stimulants such as ephedra (Ma Huang) may reduce its effectiveness. The antidiabetic ability of this herb may be decreased by concomitant use of acetazolamide, oral contraceptives, corticosteroids, dextrothyroxine, epinephrine, ethanol, glucagon, guanethidine, and marijuana. The antidiabetic effects may also be decreased when used in conjunction with phenothiazines, rifampin, thiazide diuretics, and thyroid hormones.

The antidiabetic action of gymnema may be enhanced when it is used with allopurinol, anabolic steroids, chloramphenicol, clofibrate, fenfluramine, guanethidine, MAOI, phenylbutazone, probenecid and phenyramidol. This action of gymnema may also be enhanced when used in conjunction with salicylates, sulfinpyrazone, sulfonamides, and tetracyclines. The ability of gymnema to increase insulin production and secretion may be antagonized by heparin.[55]

Adverse Reactions: At typical recommended doses, dietary supplements containing gymnema are not associated with significant adverse side effects. Mild gastrointestinal upset may occur if gymnema is taken on an empty stomach; therefore, consumption with meals is recommended. Caution is urged, however, with extremely high doses, which may have the potential to induce hypoglycemia in susceptible individuals. It can also alter the bitter and sweet taste sensation.

Nopal (*Nopal opuntia spp*)

Also known as prickly pear and beaver tail, nopal is native to arid and semi-arid areas of North America and South America. Nopal has no leaves, except at the start of new growth. These leaves are actually stems called cladodes that grow one on top of another in an irregular, beaver-tail pattern. It has spiny, thickened stems that form the plant and produce yellow, orange and red rose-like flowers in the spring. These flowers mature into prickly pears, which are yellow, orange, red, or purple. The fruits are sweet, with numerous hard seeds. They survive under a ferocious variety of climates and can regenerate themselves. The pads are skinned, diced, and prepared in Mexican salads and tacos.

Pharmacology: In patients with NIDDM, studies have shown that nopal significantly reduced glucose and fasting insulin serum concentrations. Nopal lowered blood sugar when orally administered to animals with induced states of moderate hyperglycemia. Nopal does not significantly modify fasting glucose levels and insulin serum concentrations in healthy individuals; however, it reduces the elevation of glucose and insulin serum concentrations after an oral glucose load.

The mechanism of nopal is unknown; however, one study suggested it was associated with gastric distension and enterohormones. In another study, the mechanisms of cellular sensitivity to insulin in addition to dietary fiber was suspected, because blood sugar was reduced in the absence of an oral carbohydrate load; this study further showed that serum insulin concentration diminished after taking nopal, thus ruling out an enhancement of insulin release. A different study ruled out the involvement of insulin antagonist hormones, like glucagon, cortisol and growth hormone.

In addition to the diabetic effect, nopal reduced LDL cholesterol, total cholesterol, and triglycerides when taken before each meal for 10 days. The triglyceride levels were decreased in obese and diabetic patients, but not in healthy subjects with low triglyceride levels.[56]

Nopal contains vitamin B, vitamin C, calcium, iron, potassium, B-carotene, and the carbohydrates: hexoses, pentoses, cellulose hemicellulose, and mucilage. Nopal is high in fiber, protein, and amino acid composition.

Clinical Applications: Nopal is hypoglycemic, hypolipidemic, anti-microbial, vulnerary, demulcent, and nutritive. It is used for gastritis and peptic ulcers, high cholesterol, enlargement of the prostate gland, and diabetes. Externally, it is used for dry, itchy scalp and wound healing.

Drug Interactions: Since nopal has no effect in lowering blood sugar, it is highly unlikely that hypoglycemia

might occur; however, hypoglycemia drugs might need to be decreased.

Dose: 100 grams of nopal stems grilled, or 3 tablespoons of prickly pear fruit concentrate daily.

Jambul (*Syzygium jambolana*)

Jambul is native to southern Asia, India, Indonesia, and Australia. The seed is hard, oval, and red brown to brown. Jambul fruit is eaten as a preserve; it tastes faintly astringent and aromatic, like a ripe apricot. The fruit contains volatile oil, fixed oil, resin, tannins, and gallic acid, as well as phenols, tannins, triterpenoids, glycosides, volatile oils, and alkaloids (jambosine).

Pharmacology: Animal studies have shown a pronounced hypoglycemic effect. It also has an anti-inflammatory effect in animals. The method of action may be independent of pancreatic function; it may alter the conversion of carbohydrates to glucose.[57]

Clinical Applications: Jambul is astringent, carminative, hypoglycemic, anti-spasmodic, and stomatic. The seed is considered to be one of the most powerful hypoglycemic agents in the Ayurvedic repertory. In India, as little as one teaspoon per day of ground seed was a traditional treatment for NIDDM. Externally, the astringent action is useful for nosebleeds and wounds.

Dose: 0.3-2 g infusion, 1:1 in 25% alcohol, 2-4 ml t.i.d.

Globe Artichoke (*Cynara scolymus L.*)

Globe artichoke is a perennial plant found in the Mediterranean region and South America. Constituents of the flower heads are 12% sugar (inulin), 3% protein, tannin, cynarin, vitamins A, B1, B2, B3, C, caffeic acid, flavonoids (rutin), and sesquiterpenes lactones.

Pharmacology: Inulin is a polymer of fructose that is not digested and does not increase blood sugar. It decreases postprandial hyperglycemia. In research, 20 g caused only a mild rise in blood sugar, which was significantly lower than the same dose of fructose. Inulin, which may be broken down to fructose in cold weather or winter months and converted back in summer months, activates the complement pathway and promotes chemotaxis of neutrophils, monocytes, and eosinophils. It also may stimulate interferon. Cynarin (15% content in roots) stimulates bile and has a direct effect on liver function. It is broken down into caffeic acids, which act on the liver. The bitters may also contain small amount of caffeic acid.

Clinical Applications: Globe artichoke is attributed with tonic, choleretic, cholagogue, diuretic, laxative, anti-galactic, alterative, and aphrodisiac qualities. It stimulates liver cells to regenerate; and is also hepatoprotective. It supports the kidneys and has a hypoglycemic effect in diabetes.

Traditionally, it was used for arteriosclerosis, hyperlipidemia, and diabetes. In France, it was used for gallstones, obesity, and rheumatism. Globe artichoke is indicated for arteriosclerosis, jaundice, dyspepsia, anorexia, liver insufficiency, chronic albuminuria, post-operative anemia, gallbladder, and biliary disease, chronic liver disease and impairment, and kidney disease. It increases excretion and decreases synthesis of total cholesterol.[58] It helps to prevent gallstone formation.[59]

Contraindications: Theoretically, globe artichoke is contraindicated for biliary tree blockage and colic, which may be due to active gallstones.

Dose: 1-4 g dried leaves t.i.d. or up to 15-30 ml of tincture per day.

Devil's Club (*Oplopanax horridus*)

Devil's club constituents possibly include saponins and inulin. In North America, Southwest natives believed regular use could prevent cancer.

Pharmacology: Devil's club attracted medical attention in 1938 when Dr Brocklesby (MD) discovered that a patient was stabilizing diabetes with an infusion of devil's club. In lab tests conducted by Brocklesby and Large in 1938, devil's club showed no apparent toxicity. The hypoglycemic effect of devil's club extract is especially significant in view of the longstanding controversy over the use and toxicity of present antidiabetic drugs. Experiments done on rabbits demonstrated that an extract of the herb would substantially reduce blood sugar without any toxic side effects.

Clinical Applications: Devil's club is used for arthritis, rheumatism, stomach pains, constipation, and especially for the prevention and treatment of diabetes. The bark can be burnt and applied to cuts. A paste can be made out of the root powder and applied as a poultice to decrease pain and swelling from insect bites and stings.

Dose: 1-2 g t.i.d.

Contraindications: None known.

→ Selected Clinical Studies and Literature Reviews

For the therapeutic effect of the Ayurvedic herb *C. tamala* in diabetes, see Hari M. Chandola and Surendra N. Tripathi, "Hypoglycemic Response of *C. tamala* in Diabetes," in *Selected Clinical Studies and Literature Reviews*, pp. 271.

For a study of the application of Ayurvedic medical principles to understanding and treating the progression of diabetes, see H.M. Chandola, S.N. Tripathi, and K.N. Udupa, "The Role of Psychosomatic Constitution (Prakriti) in the Progression and Prognosis of Diabetes Mellitus and Response to Treatment," in *Selected Clinical Studies and Literature Reviews*, pp. 276.

Hyperglycemia Toxicity

Beta cell death resulting from hyperglycemia in diabetes Type II can cause insulin dependent diabetes in some cases. Hyperglycemia causes pancreatic beta cell damage in itself. From preliminary animal studies, it appears that beta cells fail to respond appropriately to glucose when glucose levels are kept above 120 mg/dl. By this mechanism, uncontrolled Type II diabetes can eventually turn into Type I. This is another example of how a pathology (hyperglycemia) can actually reinforce the illness itself by destroying the cells that counteract hyperglycemia. It is interesting to note that illnesses can often create feedback loops that are self-perpetuating.

The fasting glucose homeostasis is controlled by a balance between glucose utilization by peripheral tissues and hepatic glucose production. Non-diabetics are able to have fasting insulin levels that are sufficient to suppress hepatic gluconeogenesis through the production of glucagon. But insulin resistance and insulin deficiency found in Type I diabetes have no effective feedback loop for gluconeogenesis, and thus the liver will contribute to hyperglycemia.

The fasting glucose homeostasis is controlled by a balance between glucose utilization by peripheral tissues and hepatic glucose production. Non-diabetics are able to have fasting insulin levels that are sufficient to suppress hepatic gluconeogenesis through the production of glucagon. But insulin resistance and insulin deficiency found in Type I diabetes have no effective feedback loop for gluconeogenesis, and thus the liver will contribute to hyperglycemia.

Secondary Diabetes

Diabetes can be secondary to liver disease, due to the liver's role in producing hepatic insulin sensitizing substrate. Diabetes can also be secondary to other diseases, such as pancreatectomy, hemochromatosis, cystic fibrosis, and chronic pancreatitis. Endocrinopathies, such as acromegaly, pheochromocytoma, Cushing's syndrome, primary aldosteronism, and glucagonoma, are all potential causes of diabetes as well.

CLINICAL TRIALS
Milk Thistle and Secondary Diabetes

Milk thistle has been shown to be an effective treatment for patients with diabetes secondary to cirrhosis. In a trial done in Italy, 30 diabetic patients were given a regime of conventional therapy and 600 mg daily of silymarin, while 30 other patients were given only conventional therapy. After 4 months, the group who using 600 mg daily of silymarin had decreased fasting glucose levels, decreased glucosuria, decreased HbA1c values, and decreased fasting insulin levels, with a decreased exogenous insulin requirement. The control group had increased insulin levels after the study and stabilization of exogenous insulin needs. This study demonstrated that silymarin decreased endogenous insulin overproduction and decreased exogenous insulin requirements in patients with liver disease. Milk thistle stimulates protein synthesis, resulting in the regeneration of hepatic cells and new liver tissue.[60]

Iatrogenic Diabetes

Antihypertensive drugs, thiazide diuretics, glucocorticoids, estrogens, psychoactive medications, and pentamidine all can be causes of impaired glucose tolerance. Virtually all non-controlled diabetic patients end up on antihypertensive drugs due to diabetic-induced high blood pressure, and many will need thiazide diuretics due to congestive heart failure initiated by the hypertension. Antihypertensive and thiazide diuretics drugs intensify insulin resistance, thereby further intensifying diabetic illness.[61]

NATUROPATHIC MEDICAL ALTERNATIVES

Botanical Medicine

Rauwolfia serpentina: Antihypertensive pharmacological alternatives do exist. For example, *Rauwolfia serpentina* can lower blood pressure very well without affecting glucose intolerance. In Ayurvedic medicine, this herb has been used in the treatment of insomnia and schizophrenia since 1,000 BC. In China, it had also been used

for thousands of years in the treatment of a Chinese pathology called 'liver fire rising'. Pharmacology studies indicates that it blocks the adrenergic transmitter vesicles, which take up and store the amines, resulting in depletion of norepinephrine, dopamine, and serotonin, and a consequent decrease in blood pressure.

Syndrome X

This condition of impaired glucose intolerance is often the precursor of Type II diabetes. Like Type II, it results from genetic, lifestyle, nutritional, and environmental factors. Syndrome X is associated with truncal obesity and accelerated fat deposition due to evolutionary adaptations from feast or famine conditions. In the modern Western world of food security, the body is often in the feast condition and is rarely ever in the famine condition. Patients with syndrome X will have insulin resistance, hyperinsulinemia, hypertension, and related dyslipidemias. Hyperinsulinemia results from ineffective insulin response and perhaps nitric oxide deficiency.[62] Syndrome X can be effectively treated with natural medicines and lifestyle factors.

Acute Complications in Diabetes

Diabetics need to be concerned about chronic complications and acute complications of diabetes. In general it is the chronic complications that do most of the damage. Chronic complications result from high glucose levels (hyperglycemia) reacting with different tissues of the body. Acute complications result from some extreme abnormality of blood sugar, causing either severe hyperglycemia or low blood sugar (hypoglycemia). The initial symptoms of acute hyperglycemia will involve excess urination (polyuria), excess thirst (polydipsia), fatigue, and blurry vision.

Hyperglycemia may result in a coma due to the high level of glucagon stimulation, which is a response to low serum insulin levels. Hyperglycemic comas are either diabetic ketoacidosis (DKA) or nonketotic hyperosmolar coma. Hypoglycemic coma results when the patient takes excess insulin relative to what the body needs during eating or exercise.

DIABETES KETOACIDOSIS

Any disorder that affects the balance between insulin and counter-regulatory hormones can initiate diabetic ketoacidosis. Most patients already have been diagnosed with diabetes before they are diagnosed with DKA. Usually, only older people will have DKA without any prior diagnosis. Eighty percent of DKA occurs in people with diagnosed diabetes, resulting from inadequate insulin or current stress or illness.

DKA usually occurs in Type I patients and rarely in Type II patients. Symptoms include rapid respiration, acetone odor on breath, and diffuse abdominal pain. Metabolic acidosis of pH < 7.35, blood sugar levels of more than 250 mg/dl, and ketones in urine or blood are diagnostic of DKA.

The most common causes of DKA are infections, myocardial infarctions, and emotional stress. Even localized infections, such as urinary tract infections, including prostatitis, can trigger DKA. Prescription drugs, such as corticosteroids and pentamidine, or hormonal changes can also be also be triggers. The deficiency of insulin and the counter regulatory hormones (glucagons, epinephrine, growth hormone, and cortisol) results in gluconeogenesis in the liver and breakdown of fat (lipolysis), which is the basis of fatty acid breakdown that converts into ketones. The high levels of ketones cause metabolic acidosis.

The prognosis for a young healthy diabetic who is adequately managed is excellent. However, when the patient is old or weak and has other current illnesses (especially infection), or if the acidosis is very severe, there is significant mortality. If patients with DKA have fallen into a coma or hypothermia, prognosis is poor. In the hospital, electrolytes, bun, creatinine, glucose urinalysis, and electrocardiogram should be ordered. Treatment will mainly consist of IV fluids and insulin bolus of 10-20 units IV, followed by a continuous infusion of 5-10 units per hour.

NON-KETOTIC HYPEROSMOLAR COMA

The NKH coma usually only occurs in the elderly. Altered mental status is the main reason that these patients are brought to the hospital. The patient's blood sugar is consistently very high and alkaline. However, the most distinguishing feature is extreme dehydration caused by frequent urination. Symptoms include polydipsia, polyuria, and severe dehydration. Laboratory diagnostics reveal hyperglycemia equal or above to 600 mg/dl, hyperosmolarity >320 mOsm/L, arterial pH equal to or over 7.3, and the absence of ketones. Mortality rates are much more severe than DKA, ranging from 20% to 80%. Rehydration is of utmost importance.

HYPOGLYCEMIA

Hypoglycemia in a diabetic is primarily caused by incorrect dosage of insulin or hypoglycemic drugs. It is considered an acceptable complication of drug therapy. However, other factors need to be considered; for example, menstruating women can experience hypoglycemia due to the rapid fall in estrogen and

progesterone. Other contributing disorders to hypoglycemia in diabetics include organ failure, hormonal deficiencies, B cell tumor, and hypoglycemia of infancy and childhood.

C-peptide connects the A and B chains of insulin. It is used to diagnose patients differentially with insulinoma versus factitious hypoglycemia. In hypoglycemic coma induced by an overdose of insulin medication, C-peptides may be lower than normal, while insulin levels are increased. If C-peptide is high, endogenous insulin is produced in high amounts, either from anti-hyperglycemic prescription drugs, such as sulphonylureas, that stimulate the pancreas to produce more insulin or an insulin-secreting tumor. To differentiate between these causes, drug urine tests must be done.

Chronic Complications in Diabetes

AGE PRODUCTS
The two basic mechanisms of secondary complications of diabetes are the polyol pathway and non-enzymatic protein glycosylation. In non-enzymatic protein glycosylation, high amounts of circulating sugars start to attach to proteins, forming a compound called Amadori. After weeks to years, the Amadori product undergoes an irreversible conversion to form a complex compound called advanced glycosylation end (AGE) products.

AGE products are found throughout the body but in high levels in connective tissues, blood vessels, the matrix of the renal glomerulus, and the phospholipid component of low-density lipoproteins (LDL). High levels of AGE are associated with structural alterations within the body, including increased vascular permeability, loss of vascular elasticity, reduced clearance of lipoproteins, and altered enzyme function. This reduced clearance of lipoproteins is one of the main contributing factors to the high cardiovascular mortality found in diabetic patients.

AGE products are atherogenic and one of the main contributors to accelerating atherosclerosis in diabetics. Treating hypertension in long-term uncontrolled diabetics can be a very difficult challenge. It is not uncommon for these patients to be on three antihypertensive drugs and still not have adequate control.

NATUROPATHIC MEDICAL ALTERNATIVES

Hypertension drugs can decrease insulin sensitivity, so whenever possible natural medicine should be used in place of prescription antihypertensives.[63] Vitamin E and lipoic acid are two supplements that will help prevent protein glycosylation, thereby indirectly decreasing atherosclerotic hypertension. Many of these patients would benefit greatly from IV EDTA chelation therapy.

DIABETIC RETINOPATHY
Hyperglycemia will eventually cause the retinal cells to have an accumulation of sorbitol through the polyol pathway, which causes an increase in osmosis. The high levels of sorbitol are not easily able to diffuse out of the cell in which it is produced. This causes a high osmotic swelling, in which water will enter the cell. Due to the buildup of water pressure in the cell, valuable antioxidants, such as glutathione and myoinositol, are pushed out and thereby free radical damage occurs within the eye. This causes diabetic retinopathy.

The progression of diabetic retinopathy may actually begin without any overt symptoms. Eye exam will initially reveal visible lesions. Micro-aneurysms on the terminal capillaries of the retina form quite similarly to balloons. They inflate but burst very easily. The increased fragility and weakness of the capillaries start to leak proteinaceous fluid, thereby causing hard exudates. The leaking of red blood cells form hemorrhages. In itself this process does not cause visual impairment. New capillaries do not form and the condition is thus coined non-proliferative retinopathy.

This differs from proliferative retinopathy, in that the retinal vessels further deteriorate to the point of ischemia. The resultant ischemia causes new vessels to compensate for the lack of blood flow to the retina. Unfortunately, these vessels are very weak and tend to burst easily, causing hemorrhage into the preretinal areas or vitreous, causing significant vision loss. Diabetic macular edema occurs when fluid from abnormal vessels leaks into the macula. Retinal detachment is a medical emergency and needs to be treated by eye surgeons as soon as possible.

Progression of Diabetic Retinopathy	
Name of condition	*Eye Exam*
Nonproliferative diabetic retinopathy	Retinal micro-aneurysms
Proliferative diabetic retinopathy	New vessels on the disc
High risk proliferative retinopathy	New vessels with vitreous as hemorrhage
Diabetic macular edema	Hard exudates < 2 disc

NATUROPATHIC MEDICAL ALTERNATIVES

Conventional therapies for diabetic retinopathy are primarily control measures to stop the hemorrhage by laser therapy. However, chronic diabetic retinopathy is very well treated with natural medicine. It is done by inhibiting the sorbitol pathway and saturating the eyes with antioxidants. Retinal hemorrhage is harder to treat naturally but can have its impact and at times cured with the use of high doses of antioxidants.

Naturopathic treatment of diabetic retinopathy involves the administration of high doses of antioxidants, including super oxide dismutase and glutathione IV, as well as herbs that decrease diabetic complications, such as jambul and milk thistle. Blue light therapy has shown to be helpful in eliminating edema.

Aldose reductase inhibitors, such as quercetin and milk thistle, are valuable tools in preventing sorbitol production. Diabetic rats that have been given aldose reductase inhibitors have higher concentrations of glutathione reductase than diabetic rats that do not have aldose reductase inhibitors. Botanicals, such as jambul and milk thistle, have been found to increase the production of antioxidants, such as glutathione reductase and superoxide dismutase.[64]

Case Study
Diabetic Retinopathy

While conventional medicine is typically used to treat diabetic hemorrhage in the eye, naturopathic treatments have proven to be effective. A man in his mid-fifties with diabetic hemorrhage in the right eye visited our office for treatment. The right eye was 20/50.

We prescribed the following nutritional and botanical therapy:

Ambrotose: 1/4 tsp t.i.d.
Bioflavonoids: 500 mg t.i.d.
Vitamin C: 500 mg t.i.d.
Digestive Enzymes: 1 per meal
Dioscorea: 500 mg t.i.d.
Vitamin E: 400 IU t.i.d.
Bilberry: 500 mg t.i.d.
Glutathione: 5 mg sublingually t.i.d.

Within two and a half months, there was no more hemorrhage, and the right eye was 20/20.

DIABETIC NEUROPATHY

Diabetic neuropathy and retinopathy both have something in common: accumulation of sorbitol. Nerve damage (neuropathy) is an easily treatable condition when one understands its pathology. The polyol pathway functions in the capillaries of the retina as in the Schwann cells of the nerves.

The most common type of neuropathy is distal symmetrical polyneuropathy, which involves loss of vibration in the toes and loss of ankle reflexes. This can be found on a routine physical exam. Many drugs inhibit the absorption of vitamin B-12 and can cause vitamin deficiency-induced neuropathy that must be differentiated from hyperglycemia-induced neuropathy. Symptoms include numbness and paresthesias that may cause severe burning and prickling sensations. Neuropathy and vascular disease account for the high incidence of diabetic foot amputations. Pathological examination shows axonal destruction due to the complications of sorbitol buildup.

Mononeuropathies come on with a sudden onset and leave usually spontaneously. They may affect the third, fourth, sixth, and seventh cranial nerve. Truncal neuropathy in the T4 -T12 area also exists. The pain is constant, unrelenting, worse at night, and is often confused with cardiac or gastrointestinal disease.

Diabetic neuropathy, like all illnesses, can cause depression. Diabetic neuropathic cachexia involves neuropathy along with symptoms of anorexia and depression. Autonomic neuropathy, including both sympathetic and parasympathetic nerves, can cause a variety of problems, including resting tachycardia, postural hypotension, bladder dysfunction, and lack of peristalsis in the stomach (gastroparesis).

NATUROPATHIC MEDICAL ALTERNATIVES

Allopathic medicine has no effective treatment for diabetic neuropathy. Steroids and antidepressants have been tried with poor results. Natural medicine, however, has much to offer patients with diabetic neuropathy.

Clinical Nutrition

Vitamins: High doses of pyridoxine (100 mg) and vitamin B-12 (1000 mcg) can improve nerve function. Vitamin E at doses of 800 IU or higher along with lipoic acid (300 mg) will inhibit protein glycosylation. Quercitin at 2 g daily will inhibit the polyol pathway and give great benefit.

Botanical Medicine

St. John's Wort: One teaspoon of St. John's wort tincture t.i.d. has been shown to relieve neuropathy and prevent progression of the neuropathy. St. John's wort is a nervine herb that can strengthen the health of the nerves. Patients usually respond within a week to the above protocol. Essential oil of geranium has also proven to be effective in decreasing neuropathy pain.

Essential Oils

Essential or volatile oils are aromatic oils extracted from plants. The pharmacopoeias of the late Middle Ages through the 19th century contained several essential oils, and they are still used in medicine today. Eucalyptus oils, camphors, and menthols are active ingredients in over-the-counter medicines; several volatile oils are used in dentistry as solvents and analgesics. These extracts are common ingredients in perfumes, toiletries, and soaps. They are also used as flavors. The chemistry of these oils and their principal components is relatively well understood, and many of the components have been synthesized.

Essential oils are volatile hydrocarbons produced by plants, which account for most of their characteristic smell; their function in nature is largely unknown. Their use by humans traces vaguely into antiquity, where the oils were contained in various unguents. Steam distillation provided the first practical source of the oils and came into widespread use in the 16th century, at which time pharmacies distilled their own oils. The alchemists' retorts and reflux devices were often charged with herbs and spices, from which they gained returns of <0.5% of a volatile oil. The industry grew as the technology improved, with the main activity in the pharmacies and perfumeries.

In the 19th century, the chemistry of the various component oils was the subject of extensive study, and

CLINICAL TRIALS

Geranium Oil

Clinical studies have shown that using the essential oils of geranium and clove topically can temporarily decrease neuropathy pain. One research trial compared three strengths of geranium oil (100%, 50%, and 10%) with a mineral oil placebo and Zostrix, a capsaicin ointment. Subjects with post-herpetic neuralgia and moderate or greater pain were recruited. The patients completed pain assessments at times 0, 2, 5, 10, 15, 20, 30, 45, and 60 minutes following medication.

Results

Treatment with geranium oil produced a highly significant reduction in pain ($p \leq 0.002$) compared to treatment with the placebo.

The reduction in pain produced by geranium oil appears to increase as its concentration increases ($p \leq 0.003$). The observed increase is roughly linear, but a formal dose-response function cannot be defined because of the subjective nature of pain intensity.

These conclusions were true both for spontaneous pain and for evoked pain.

The response of an individual patient to treatment with geranium oil was similar for spontaneous pain and evoked pain ($p \leq .008$): those who experienced relief with one kind of pain also experienced relief with the other.

The trial demonstrates that patients with neuralgia experience less spontaneous pain when treated with 100% and 50% geranium oil than when treated with a placebo, $p \leq 0.002$. The averaged pain relief across all evaluated patients increased with increasing dosage of geranium oil, $p \leq 0.003$. The same conclusions hold for the evoked pain (allodynia), $p \leq 0.0002$.

Approximately one third of the patients had major relief, with little or no pain remaining; another third had some relief, such as reduction from severe to moderate pain; and the remaining third did not experience any benefit from geranium oil. There were no significant adverse events from the use of geranium oil. Only four patients of 30 had any adverse reactions, all mild, which were either a transient rash that resolved within the hour, or a burning sensation in the eyes that resolved within minutes.

Generally, users of geranium oil have reported that relief is experienced within 5 minutes and lasts for between 45 minutes and 6 hours, depending on the type and severity of the neuropathy.

Healthcare professionals have reported that geranium oil is useful for the following conditions:[66]

- Shingles (Herpes zoster)
- Post-Herpetic Neuralgia (PHN)
- Diabetic Peripheral Neuropathies
- Reflex Sympathetic Dystrophies (RSD)
- Spinal Compression Pain, including Sciatica
- Causalgias
- Radiculopathies
- Phantom Limb Pain
- Fibromyalgia
- Bell's Palsy
- Trigeminal Neuralgias
- Myofacial Pain

assays for these components were developed for quality control. The high point of use and appreciation of essential oils appears to be the first half of the 20th century. Guenther published a definitive series of monographs (*The Essential Oils*, Vol 1-6, 1948-1952) that is still in print. Recently, aromatherapy has gained fashion and there is a revival of interest in the naturally derived oils of various plants.

The most common chemical structure of the essential plant oils is an unsaturated hydrocarbon of general form $C_{10}H_{16}$, known as terpenes. Oxygen-containing compounds of the general formula $C_{10}H_{16}O$ or $C_{10}H_{18}O$ are the second most common class of constituents. The backbone of the terpenes can be divided into two isopentane chains C_5H_8, which are joined end-to-end in several configurations. Since the terpenes are six hydrogens short of saturation, they always contain a combination of double bonds and/or rings adding to three. Differentiation through isomerism, substitutions, ring-closures, and addition of functional groups gives rise to the thousands of individual components described to date. Moreover, many of these are convertible into each other, so some components are always present as mixtures. Enzymatic conversion has also been demonstrated, so the pharmacology in vivo is quite complicated.

Biological activity of the essential oils has been studied for numerous types. Early uses included antihelminthic activity of American wormseed oil, antibacterial activity of wintergreen, antitussive and analgesic activity for eucalyptus oil and menthol, and the many uses of camphor. Numerous over-the-counter (OTC) remedies for colds, sores, halitosis, coughs, and sore throats still use plant-derived essential oils as active ingredients. For example, Listerine contains eucalyptol 0.091% w/v, thymol 0.063% w/v, and menthol 0.042% w/v. The coumarins are a type of essential oil and their use as thrombolytic agents dates from the early 20th century. Bergaptine is a photoactive compound used in tanning lotions. Pyrethin, the active ingredient in insecticides from chrysanthemums, is derived from a bicyclic terpene D^3-carene by oxidation.

Geraniol, the chief constituent of rose and geranium oil, is easily converted into the monocyclic alcohol a-terpineol, the chief constituent of the oil of hyacinth, and into linalool, which as acetate constitutes the characteristic component of lavender oil. Longer chains of terpenes give rise to many common compounds, including squalene, the carotenoids, such as b-carotene $C_{40}H_{56}$, and cholesterol. [67]

DIABETIC NEPHROPATHY

Diabetic nephropathy is the leading cause of end-stage renal disease. It goes through a very predictable pattern of five stages.

Cardiovascular disease and mortality are a great risk for patients suffering from diabetic renal disease. In a study of NIDDM in Pima Indians, it was found that diabetics who had albumin in the urine (indicating renal disease) had 3.5 times greater risk for cardiovascular disease and overall mortality than the ones who had no albumin in the urine. Nephropathy leads to systemic hypertension because of hyperlipidemia and a decreased clearance of atherogenic advanced glycosylation end products.[68]

Diabetic patients have a fourfold chance of having both macrovascular and microvascular disease. Smoking, dyslipidemia, insulin resistance, homocysteine levels, emotional stress, and lack of general antioxidants due to the oxidation of LDL and low levels of vitamin E all need to be considered when treating diabetic patients with high cardiovascular risk factor.

The clinical signs of ischemic heart disease in diabetic patients are different than in other patients. This is one reason that thyroid hormone therapy has to be used cautiously with diabetics, due to its potential of increasing cardiac blood flow. Diabetic patients often will have a silent ischemia. It makes it more difficult to diagnose. Patients may have no pain but just nausea or sweating.

CONVENTIONAL PHARMACEUTICAL TREATMENT

ACE Inhibitors

ACE inhibitors are the drugs of choice in diabetic hypertension patients. ACE inhibitors have shown to reduce progression to renal failure by 50% in Type I patients in stage 4 diabetic nephropathy. However, diabetics may develop severe complications with the use of antihypertensive drugs, including altered symptoms of hypoglycemia from beta-blockers, intensified fluid retention from sympathetic inhibitors, and worsened hyperglycemia from diuretics. [69]

Lipid-lowering Therapy

Lipid-lowering therapy improves cardiac outcomes in diabetic patients. A study in Scandinavia on the use of statin drugs and diabetic cardiac outcome was assessed. The Scandinavian study was performed on over 4,000 patients. There was a 55% reduction in major cardiovascular events, including myocardial infarction, in patients treated with simvastatin. However, statin drugs have a history of causing liver disease.[70]

PROGRESSION OF RENAL DISEASE IN INSULIN-DEPENDENT DIABETES

Stage	Onset	Lab	Risk Factors	Treatment
1. Early Hypertrophy and Hyperfunction	Initial diagnosis	Increased glomerular filtration rate	Hyperglycemia Hypertension Stress, Homocysteine Hypoantioxidant Pharmaceuticals Protein Diet, Smoking Insulin Resistance	*Decrease:* hyperglycemia hypertension *Replace:* kidney toxic pharmaceuticals with natural medicine if possible. *Increase:* antioxidants, herbal kidney support, ACE inhibitors
2. Renal Lesions	3 years after diagnosis	Increased glomerular filtration rate	As above	As above
3. Incipient Nephropathy	7-15 years after diagnosis	Glomerular filtration rate beginning to decline Albumin found in urine more than 0.03 gm/daily	As above	As above
4. Clinical Diabetic Nephropathy	10-30 years after diagnosis	Glomerular filtration rate continues to decrease Urinary albumin continues to increase	As above	As above
5. End-stage Renal Disease	20-40 years after diagnosis	Glomerular filtration rate very low Increased serum creatinine	As above	As above, dialysis

(Adapted from Selby JV, Fitzsimmons SC, Newman JM, et al. The natural history and epidemiology of diabetic nephropathy: Implications for prevention and control. JAMA 1959;263:1954-59)

NATUROPATHIC MEDICAL TREATMENT AND PREVENTION

Traditional Chinese Medicine

Red Yeast: Lipid levels can be very well treated with the traditional Chinese medicine red yeast that contains over nine statin compounds. Unlike its pharmaceutical counterpart, it contains only one statin isolate, and has no known history of causing liver disease.

Acupuncture: Acupuncture lowers blood pressure. Studies have shown that its hypotensive effects can last a year after the treatments have been finished, while pharmaceuticals never can be stopped.

Clinical Nutrition

Inositol Hexanaicinate: Inositol hexanaicinate works well in lowering lipid levels.

B Vitamins: Homocysteine levels also should be checked because high levels can injure the endothelial cells of the vascular system, resulting in increased platelet utilization and the formation of atherosclerotic disturbances, resulting in hypertension. One study found that men with very high levels of homocysteine were three times more likely to have a myocardial infarction, even while taking in consideration lipid levels.[71] Homocysteine can be lowered with the simple addition of vitamins B-12 (1000 mcg), B-6 (50 mg), and folic acid (1 mg).

Botanical Medicine

Snakeroot (*Rauwolfia serpentina*): *Rauwolfia serpentina* is a very reliable herbal treatment to lower severe hypertension. It is also an excellent remedy for anxiety and insomnia that often accompanies a hypertensive patient. However, like most prescription drugs for hypertension, some patients do complain of feeling tired when on Rauwolfia.[72]

Hawthorne Berry (*Crataegus oxycanthus*): Moderate hypertension can be safely treated with hawthorne berry. It is extremely high in flavonoids that help limit atherosclerosis, has the ability to help regulate tension, low or high, and is able to strengthen the heart muscle, as evidenced by clinical trials on the analysis in the ejection of the heart.[73,74]

DIABETES IN PREGNANCY

Gestational diabetes is diagnosed in pregnancy and limited to pregnancy. Up to 8% of pregnancies in the world develop it. The high levels of circulating hormones, such as cortisol and progestins, have shown to decrease insulin receptor binding. Human chorionic gonadotropin and human placental lactogen decrease post receptor effects of insulin. The immediate risks of gestational diabetes to the mother include increase hypertension and preeclampsia; the later risk is developing diabetes itself. The risk to the fetus is fetal macrosomia (increased fetal size).[75] The postulated mechanism for this is due to the high levels of fuels, such as glucose, amino acids, lipids, and insulin.

Pregnancy is a complex metabolic state. There is a dramatic alteration in hormone levels, including increased levels of cortisol, progesterone, prolactin, estrogen, and human chorionic gonadotropin. Needless to say, there is also an increased demand of fuel from the fetus. This makes it very difficult for the mother to keep up with all the hormonal changes.

From 20 weeks onward into pregnancy, insulin resistance is common. In normal pregnancy, maternal secretion of insulin increases in late second and third trimesters to compensate for insulin resistance. Glucose not only alters pregnancy but triglycerides, cholesterol, and free fatty acids are also increased in the blood, as commonly found in insulin resistance.[76]

Congenital abnormalities from diabetes in the early era were about 33%, but now with the drug treatment and insulin only 1.6% to 2% of diabetic pregnant women have children with congenital abnormalities. Glucose control is critical. Optimally, pre-meal glucose should be less than 100 mg/dl with the 2-hour postprandial value not exceeding 130 mg/dl. Home glucose monitoring should be done at least four times a day. Mothers who achieve very tight control, as documented with normal glycosylated hemoglobin levels, have the same chance of fetal abnormalities as non-diabetic pregnant women. [77]

NATUROPATHIC MEDICAL ALTERNATIVES

Oral hypoglycemic drugs are contraindicated in pregnancy. However, the use of minerals, such as chromium, and herbs, such as jambul, along with a diet avoiding refined carbohydrates, should be recommended. There have been no studies that I know of that have actually studied the effects of herbal hypoglycemics during pregnancy. Historically, most of the hypoglycemic herbs have not been contraindicated in pregnancy. In my opinion, they are considered safe.

GENERAL INFECTIONS

Patients with undiagnosed high blood sugar may come into the office for the treatment of an infection. Infections are more likely in diabetic patients due to glycosylation of tissues that causes irritation and increases susceptibility to infection. Diabetics have an abnormal white blood cell defense, in which polymorphonuclear white blood cells have a decreased ability to perform chemotaxis, a reduced ability to degranulate, and a decreased production of free radicals that destroy infections. This makes diabetics more prone to infections, chiefly Staphylococcus, Streptococcus, and Candidiasis.

FOOT INFECTIONS AND AMPUTATION

Diabetics are especially prone to foot infections. As many as 25% of all diabetics will develop severe foot problems at some point in their lifetime. Half of all amputations in the United States result from diabetes. Diabetic foot infections are generally more severe and more difficult to treat than infections in nondiabetics. This is due to impaired microvascular circulation, neuropathy, anatomical alterations, and impaired immune capacity in diabetic patients. Most moderate-to-severe soft-tissue diabetic foot infections are polymicrobial (i.e., due to gram-positive, gram-negative, aerobic, and anaerobic pathogens).

Early detection and prompt attention by checking for signs of infection will significantly decrease the risk of serious complications. Although one would think that the vascular insufficiency is the main cause of diabetic foot ulcerations, it is actually the neuropathy. It is speculated that uneven pressure on the plantar side of the foot leads to microtrauma to the tissues, which allows the bacteria to enter and start reproducing. The patient will have no pain due to the neuropathy and thus continues to walk on it, further aggravating the condition. This eventually results in deep soft tissue and/or bone infections.

CONVENTIONAL PHARMACEUTICAL TREATMENT

NATUROPATHIC MEDICAL ALTERNATIVES

Antibiotic Therapy

Antibiotic therapy often includes broad-spectrum antibiotics capable of covering the most common pathogens found in diabetic infections. Therefore, antibiotic therapy is nearly always active against staphylococci and streptococci, with broad-spectrum agents indicated if gram-negative or anaerobic organisms are likely. In infected foot tissues, the levels of most antibiotics are often sub-therapeutic. The duration of therapy ranges from a week (for mild soft tissue infections) to more than 6 weeks (for osteomyelitis).

Side Effects: Antibiotic therapy, especially broad-spectrum antibiotics, can, however, disrupt the normal flora of the gastrointestinal tract and vagina, leading to other symptoms, such as diarrhea, yeast infections, and thrush. In addition, other more serious opportunistic infections of the GI tract can occur, such as C. Difficile. This infection causes frequent diarrhea, cramping, and mucous in the stool. It has been associated with deaths due to opportunistic infection in hospitals. Broad spectrum antibiotic use is also associated with allergic reactions in humans, an increase in antibiotic resistant bacteria, and disruption of the immune system. Some antibiotics have been shown to disrupt oxidative phosphorylation in the cell mitochondrion, leading to fatigue. Of course, there are situations when antibiotic treatment is necessary. However, the treatments below can lessen or eliminate antibiotic use.

There are many natural medicine alternatives to pharmaceutical antibiotics. Simple natural treatments can go a long way in preventing and treating diabetic foot ulcers.

IV Oxidative Therapy

IV Oxidative treatment is the use of ozone gas topically on the skin or by autohemotherapy. Autohemotherapy is the process of taking blood out, ozonating it, mixing it with heparin to prevent clogging, and then putting the blood into the body. The ozone gas acts as a potent antimicrobial oxidant.

Hydrotherapy

Hydrotherapy will also make sure tissues are being nourished by strong blood flow.

Botanical Medicine

Horse Chestnut (*Aesculus hippocastanum*): This herb has a long folk history in venous support. It helps healthy circulation in the legs. It helps to control venous pressure, maintain vascular integrity, decrease damaging connective tissue within the vein, and prevent lipid peroxidation.[78]

Green Tea: Adding 3 cups of green tea a day to the diet will significantly increase capillary strength.

Clinical Nutrition

Inositol Hexaniacinate: This supplement is also effective in peripheral vascular disease, including threatened foot amputations, gangrene, atherosclerosis, and hypertension.[79]

General Infections

Like antibiotics, the natural treatments listed here should show symptomatic improvement within 2 days and need to be continued until 5 days after all symptoms have subsided.

Organism	Infection	Natural Treatment
Streptococcus	Cellulitis	IV Oxidative therapy
Staphylococci	Arthritis	IV Oxidative therapy
Candida	Thrush, urinary tract infection	Thyme essential oil, garlic
Klebsiella sp.	Urinary tract infection	Uva ursi, thyme essential oil, mannose, buchu

Ozone Treatment

Ozone treatment is an excellent way to treat serious conditions like this, especially when antibiotics fail. In one case, a 54-year-old diabetic with foot ulcer and osteomyelitis was told by his family doctor that his foot needed to be amputated. He opted instead for auto-hemotherapy and ozone therapy (limb bagging with ozone). After 10 treatments, he was cured.

Case Study
Diabetes and Infection

A 48-year-old woman visited our office complaining of fatigue and 'spaciness'. She had no history of any chronic health concerns. Upon physical exam, she was obese, had mild edema, and no flank pain. Considering her physical body type, insulin resistance and NIDDM is suspected. Considering her spaciness, it may be due to some blood sugar irregularity, her mild edema, and her debilitating fatigue. An infection is suspected. The lab results revealed a urinary tract infection, hyperinsulinemia, hyperglycemia, and hyperlipidemia.

The following three treatment programs were prescribed, with good results.

Program 1:
Uva ursi, 1 teaspoon, with three drops of thyme essential oil every 2 hours for 3 days. This successfully treated the urinary tract infection.

Program 2:
Syzygium jambolana, Gymnema sylvestre: 700 mg capsules, 3 capsules, 3 times a day. Dietary elimination of all simple carbohydrates. Her blood sugar dropped 30% within 8 weeks.

Program 3:
Inositol hexaniacinate, 1 gram, 3 times a day for 3 months. Cholesterol and triglyceride levels were normalized after 3 months.

Case Studies
Use of Jambul, Nopal, Globe Artichoke, Milk Thistle, and Devil's Club for People Suffering from Dysglycemia

Methods: Starting in September 1998, we tested a herbal formula on 20 patients suffering from dysglycemia. The encapsulated formula contained the herbs jambul, devil's club, milk thistle, nopal, and globe artichoke. I will refer to it as the Jambul Combo. Ten patients with NIDDM were given the formula for a 3-month period. One patient with Type I/II was given the herbs for 3 months. One patient with Type I was given the formula for a 3-month period. One patient with hyperinsulinemia was given the herbs for 3 months, and seven patients with sub-clinical hypoglycemia were given the formula for 6 weeks.

Most participants in the study were also taking pharmacological agents. One NIDDM patient and the hypoglycemia patients were not on any pharmaceutical treatments during the study period.

Criteria: Five people were disqualified after the study for not matching the above criteria. Patients who had a weight change of more than 5 pounds within the 3 months were not included in the final data. Patients who had made dietary, lifestyle, and/or prescription drug changes were also disregarded. Patients who had not taken prescribed herbal dosages were disqualified at the end of the study.

Setting: Five outpatient clinics in Canada, the United States, and India, supervised by medical doctors and licensed naturopathic physicians.

Results:

Patient #1
Condition: Diabetes Type II
Onset of Diabetes: 6 years
Pharmacological Treatment: Metformin 500 mg b.i.d. and Diamicron 160 mg b.i.d. The patient had poor

CLINICAL TRIAL
Neuroinfected Diabetic Feet

A study at the National Institute of Angiology and Vascular Surgery in Havana examined the effect of various treatments on patients suffering from neuroinfected diabetic feet. Group one patients (15) we treated exclusively with ozone treatments, group 2 patients (13) were treated with simple cane sugar syrup (a traditional Cuban remedy for infections), and group three patients were treated exclusively with antibiotics. Treatments were analyzed to determine if they prevented amputation or if amputations was needed as the final resort.[80]

Treatment	No Amputation	Amputation
Group 1 (ozone therapy)	93.8%	6.2%
Group 2 (cane sugar)	81.3%	18.7%
Group 3 (antibiotics)	66.7%	33.3%

blood sugar control with the medicine before the study. She had taken chromium with little result.
Natural Medicine: Jambul combo three pills t.i.d.
Fasting Blood Sugar and Other Indications:
Average for the week of May 23, 1999 was about 16mmol/l (288mg/dl).
Average on June 1st was 15.9 mmol/l (286 mg/dl).
Average on June 7th was 13.6 mmol/l (245 mg/dl).
Average on June 14th was 12.2 mmol/l (220 mg/dl).
Average on June 21 was 12.3 mmol/l (221 mg/dl).
Average on June 27 was 9.5 mmol/l (171 mg/dl)
After 3 months, the patient averaged about 11.2mmol/l (201.6mg/dl). She had noticed effects of the treatment within two weeks. Her glycosylated hemoglobin HbA1c value was 10.2%, and after 3 months of treatment was 9.8%. She maintained her pharmacological treatment during the study.

Patient #2
Condition: Diabetes Type II
Onset of Diabetes: 10 years
Pharmacological Treatment: For NIDDM, Humulin 44 AM and PM, Toronto AM, and six units of insulin PM. History of diabetic treatment before the study was 9 years of oral hypoglycemics and 1 year of insulin. During this time the patient developed hypertension, angina, chronic renal failure (60% failure in both kidneys).
Natural Medicine: Jambul combo one pill t.i.d., and 600 mcg of chromium. A goldenrod tincture was prescribed for kidney support.
Fasting Blood Sugar and Other Indications: Fasting blood sugar level before the study was 2.2 mmol/l (220mg/dl). After 3 months, levels dropped to 8.8 mmol/l (158 mg/dl). Glycosylated hemoglobin was 7.9% before the study and after 3 months was 7.8%. Blood sugar levels were reduced while she decreased the dosage of her pharmaceutical drugs. Patient's insulin levels lowered to 42 Humulin and 4 Toronto. After the study, the patient needed three injections daily, instead of the five, as needed previously. The patient also experienced less back pain, which allowed her to start walking again, something she was unable to do before due to the severity of pain caused by her kidney damage. Her creatinine level decreased from 138 to 115 mmol/l.

Patient #3
Condition: Diabetes Type II
Onset of Diabetes: 25 years
Pharmacological Treatment: For NIDDM, Metformin 500 mg, 2 pills b.i.d., Glyburide 5 mg, b.i.d. These pharmaceutical drugs were discontinued upon starting

the study. This patient was able to achieve normal blood sugar levels while on the drugs. However, due to the severe side effects of the pharmaceutical agents, specifically leg edema and flu-like symptoms, she had discontinued the drugs.
Natural Medicine: Jambul combo three pills t.i.d.
Fasting Blood Sugar/Other Indications: Fasting blood sugar on waking averaged around 15 mmol/l (270 mg/dl). She maintained this level for several weeks without the use of any treatment. Within several days of taking the herbs, her fasting blood sugar level went down to 9 mmol/l (162 mg/dl). She had no leg edema or flu-like symptoms. Glycosylated hemoglobin was normal before the study, and after, it was 7.0%. The patient was near the American Diabetic Association recommendation target range of glycosylated hemoglobin without using the pharmacological agents sulfonylurea and biguanide due to her use of Jambul combo. The patient had no kidney pain at the end of the study.

Patient #4
Condition: Diabetes Type II
Onset of Diabetes: 25 years
Pharmacological Treatment: For NIDDM, insulin for the past 25 years.
Natural Medicine: Jambul combo, two pills b.i.d., and 400 mg of lipoic acid and golden rod tincture for kidney support. (Note at this dose, lipoic acid has no effect on fasting blood sugar levels.)
Fasting Blood Sugar/Other Indications: Fasting blood sugar levels averaged around 158 mg/dl (8.8 mmol/l). After 3 months, levels averaged around 100 mg/dl (5.56 mmol/l), which is a completely normal blood sugar level. Her diabetic nephropathy had decreased and the edema and blood streaks in her legs were gone at the end of this study. Exogenous insulin requirements decreased by half.

Patient #5
Condition: Diabetes Type II
Onset of Diabetes: 2 years
Pharmacological Treatment: For NIDDM, Glyburide 5 mg b.i.d.
Natural Medicine: Jambul combo 3 pills t.i.d.
Fasting blood sugar/Other indications: Before the study fasting blood sugar levels were around 12 mmol/l (216 mg/dl) and after the study were 10 to 12 mmol/l (180-216 mg/dl). The patient also had an increase in Glyburide from two pills two times per day to two pills three times a day, again with no effect. The patient did not respond to natural therapeutics or pharmacological agents. It is interesting to note that this patient

was thin, while all the other patients in this study were obese.

Patient #6

Condition: Hyperinsulinemia
Onset of Hyperinsulinemia: 2 years
Pharmacological Treatment: Metformin 2 pills b.i.d.
Natural Medicine: Jambul combo 3 pills t.i.d.
Fasting Insulin Levels/Other Indications: Before the study, the patient's fasting insulin level was 36.8u/ml. After 3 months of taking the herbal formula, her levels dropped to 28.7 u/ml. Within 2 weeks, she had noticed symptomatic relief. A rash that she attributed to the hyperinsulinemia had subsided. She stated that she felt better within a few weeks of taking the herbal formula.

Patient #7

Condition: Diabetes Type I
Onset of Diabetes: 2 years
Pharmacological Treatment: Insulin.
Natural Medicine: Jambul combo 3 pills t.i.d.
Fasting Blood Sugar/Other Indications: Fasting blood sugar levels were completely normal before the study. After the study, no decrease of daily exogenous insulin requirements were noticed. Before the study, the patient required higher insulin doses after rigorous exercise. Afterwards, an increase in insulin injections was not needed after rigorous exercises.

Patient #8

Condition: Sub-clinical Hypoglycemia
Onset of Sub-clinical Hypoglycemia: 15 to 20 years
Pharmacological Treatment: None.
Natural Medicine: Jambul combo three pills t.i.d.
Fasting Blood Sugar/Other Indications: Before the study, fasting blood sugar levels averaged 2.2 mmol/l (40 mg/dl). After the study, fasting blood sugar levels rose to 4.4 mmol/l (80 mg/dl). There was a significant decrease in hypoglycemic hunger and the patient's frequent need to eat. The patient also noted a significant decrease in sugar cravings. The patient had taken 500 mcg of chromium daily for the previous 6 months. She had not noticed any significant changes with the past use of chromium.

Patient #9

Condition: Diabetes Type II
Onset of Diabetes: 15 to 20 years
Pharmacological Treatment: Insulin
Natural Medicine: Jambul combo one pill t.i.d. During the last week of the study, the dosage was increased to two pills t.i.d.
Fasting Blood Sugar and Other Indications: Before

insulin therapy the patient's fasting blood sugar level was 200 to 240 mg/dl (11.1-13.3 mmol/l). Fasting glucose level on insulin therapy was between 150 and 160 mg/dl (8.3 -8.8 mmol/l). Fasting glucose after three months on the herbal formula was (7.4 mmol/l) 133 mg/dl.

Patient #10

Condition: Subclinical Hypoglycemia
Onset of Subclinical Hypoglycemia: 10 years
Pharmacological Agents: None
Natural Medicine: Jambul combo 3 pills t.i.d.
Fasting Blood Sugar and Other Indications: After 3 weeks of taking jambul combo, the patient did not need to eat as often, did not feel jittery when missing a meal, and noticed an overall improvement in how she felt. She had taken chromium before but never noticed any significant changes. The patient lost 2 pounds a week while taking the herbal formula.

Patient #11

Condition: Reactive Hypoglycemia
Onset of Reactive Hypoglycemia: 8 years
Pharmacological Treatment: None
Natural Medicine: Jambul combo three pills t.i.d., 500 mg of vitamin C daily, and vitamin B-12 injections monthly.
Fasting Blood Sugar and Other Indications: Before the study, the patient had to eat 6 meals a day to avoid hypoglycemic symptoms. Hypoglycemic Index before the study was 26; after the study, it was 8. The patient reported significant improvements over the course of the study in feelings of shakiness, irritability upon missing meals, heart palpitations after eating sweets, dependence on coffee in the mornings, mood disturbances, fatigue after eating, general feelings of faintness, poor concentration, and forgetfulness. The only symptom that did not improve was food cravings. Before the study period, the patient noticed waking headaches relieved by food. After the study, she experiences only two waking headaches per week.

Patient #12

Condition: Diabetes Type I/II
Onset of Diabetes: 4 years
Pharmacological Treatment: GE NPH Insulin 20 units at bedtime, fast-acting Humalog insulin at breakfast, 15 units lunch, 15 units supper. Progression of diabetes before study: started with hypoglycemics (sulfonylurea) for one year then switched to insulin.
Natural Medicine: Jambul combo three pills t.i.d.
Fasting Blood Sugar and Other Indications: Patient's

blood sugars before the study ranged from 4-15. After the study, they were stabilized at a range from 4-10. Before the study, the patient's high reading would last for a day or more; after the study, he would only get one high reading in a day. He also experiences less tiredness since taking Jambul. His insulin levels have decreased 5 units each at noon and bedtime. Before taking Jambul, the patient's insulin levels were increasing with time.

Patient # 13
Condition: Subclinical Hypoglycemia
Onset of Subclinical Hypoglycemia: 6 years
Pharmacological Treatment: None
Natural Medicine: Jambul combo three pills t.i.d.
Fasting Blood Sugar and Other Indications: Initially, the patient reported increased hunger, which disturbed her as she was trying to lose weight. She was instructed to reduce the dose to two pills, three times a day. Following this, she found a marked improvement in her energy levels, so much so that she quit smoking during the study period. Initially, her hypoglycemic score was 28; after the study, it was 13. She experienced significant decreases in irritability, headaches, and shaky feelings. The only symptoms not improved were related to memory, concentration, forgetfulness, and sugar cravings. No other side effects were reported.

Patient #14
Condition: Subclinical Hypoglycemia
Onset of Subclinical Hypoglycemia: 10 years
Pharmacological Treatment: None
Natural Medicine: Jambul combo three pills t.i.d. She also took a multi B-vitamin, magnesium, vitamin E, and deglycyrrhizinated licorice to treat her other conditions.
Fasting Blood Sugar and Other Indications: Patient's hypoglycemic score before the study was 28; after 6 weeks, it dropped to 13. She noted a decrease in dizziness, impaired vision when standing, sugar cravings, palpitations, and tiredness after eating. Her concentration problems were not affected by the treatment. She reported improvement in fibromyalgia pain, but this may be due to other factors. No side effects reported.

Conclusion
The Jambul combo was an effective treatment in 5 out of 6 patients with NIDDM after 3 months. Most NIDDM patients noticed effects within 2 months. The treatment was effective in all 5 obese NIDDM patients. The only NIDDM patient who did not respond to natural therapeutics was thin. He also did not respond to pharmacological treatments. One patient with hyperinsulinemia noticed a significant decrease in fasting insulin after 3 months of taking the herbal formula.

One patient with Type I/II noticed a decrease in fasting blood sugar levels after 2 months of taking the herbal treatment. One patient with Type I noticed no decrease in fasting blood sugar after taking Jambul combo for 3 months.

Six patients with hypoglycemia noticed a decrease in hypoglycemic score within 6 weeks. The Jambul combo was an effective treatment in 13 patients out of 15. It was not effective in one NIDDM and one Type I patient. Most patients reported decrease in diabetic complications and the progression of the illness itself.

Side Effects
One patient noticed an initial increase in hunger after taking Jambul, but it went away after a week upon lowering the dosage to two pills, three times a day. Lowering of dosage may be coincidental or not. One patient noticed gastric acidity upon taking the herbal formula more than 15 minutes apart from a meal.

Notes of Reference to Pharmacological Drugs
Oral hypoglycemic drugs, such as sulfonylureas, have no long-term effect in blood sugar control for about 20% to 30% of NIDDM patients. In a study of Glucophage used by 228 patients, glycosylated hemoglobin levels of patients started at 9.43, after 6 months went down to 8.30, and after 9 months went up to 8.72.

Overview of Diabetes Biochemistry and Case Studies

1. Red Blood Cells and Lipid Peroxidation

Lipid peroxidation

RBC membrane lipids

Malondialdehyde

1) Alpha-tocopherol nicotinate 300 mg t.i.d. after meal for 3 months ⟶ leads to:

 increased ↑ blood viscosity

 increased ↑ viscoelasticity

 decreased ↓ erythrocyte deformation

 decreased ↓ lipid peroxidation & MDA

Free oxygen radicals formed in high doses in hyperglycemia can induce lipid peroxidation in cells, and malondialdehyde (MAD) is formed during oxidative degeneration. MAD is an accurate indicator of lipid peroxidation levels.

 The use of alpha-tocopherol nicotinate (vitamin E and niacin) 300 mg t.i.g. indicated that microangiopathy and retinopathy were decreased in diabetic patients based on physical exam. Laboratory testing also indicated improvements in rheology. Alpha-tocopherol nicotinate blocks lipid peroxidation, and the formation of malondi-aldehyde.

2. Pathways in Diabetic Retinopathy

Treatment Overview

1) ⊣ Inhibit protein glycosylation

2) — Stabilize collagen

3) ↓ Decrease capillary permeability

4) ↓ Decrease polyols

5) ↑ Increase antioxidants

6) ↓ Decrease advanced glycosylation endproducts

Treatment Overview

1) Vitamin E 3200 I.U.
 Antioxidant ↓ decreases platelet aggregation
2) Jambul S.O.D. ↑ increases glutathione
3) Reishi ↑ increases N.O.
4) Quercitin, milk thistle ↓ decreases sugar alcohols
5) Anthocyanins ↑ increases capillary strength
6) Green tea ↑ increases capillary strength
7) Lipoic acid ↓ decreases glycosylation
8) *Vaccinun myrtilus* ↑ eye support
9) Ozone therapy ↑ increases antioxidants
 ↑ increases O_2 to tissues

3. Diabetic Nephropathy Case Studies

Case 1:

10 years Type II

9 years oral hypoglycemics

1 year insulin

hypertension 190/100, chronic renal failure 60% failure

Jambul Combo, One pill t.i.d., 600 mcg of chromium t.i.d., goldenrod tincture 1 tspn t.i.d.

Fasting blood sugar:	Before	After
	220 mg/dL	158 mg/dL
Creatinine:	Before	After
	138 mmol/L	115 mmol/ L

This patient was able to start walking again. Her kidney pain decreased by 90%, and her blood pressure was reduced by 40 points systolic due to renal improvements after taking the herbs.

Case 2:

25 years Type II

15 years oral hypoglycemic drugs

hypertension, diabetic nephropathy

 PX: Jambul Combo 6 pills t.i.d., Joe Pye weed combo, acupuncture points KI3, KI7, diet

Fasting blood sugar:	Before	After
	300 mg/dl	120 mg/dl
Microalbumin:	Before	After
	3080 mmol/l	2775 mmol/l

4. Capillary Effects of Anthocyanins in Human Connective Tissue Metabolism

Breakdown of blood-retinal barrier and vascular permeability are first observable alterations in diabetic retinopathy. Progression of retinopathy is limited by anthocyanins, and studies indicate restoration of capillary damage.

Arteriole

capillaries

Venule

Research Study

600 mg anthocyanins per day for 2 months in 12 Type II Diabetics

Significant ↑ increase in biosynthesis of connective tissue especially polymeric collagen and structural glycoproteins

Anthocyanins

1) ↑ increased synthesis of connective tissue

2) Repair leaking capillaries, increasing the mucopolysaccharides of the connective ground substance, by fixing the altered mucopolysaccharide pericapillary tissue

Hyperglycemia

⟶ Free radicals

Anthocyanins ⊥

⟶ Capillary damage

Breakdown of blood-retinal barrier and vascular permeability, the first observable alteration in diabetic retinopathy due to free radicals.

Overview of Diabetes Biochemistry and Case Studies

5. Nitric Oxide Deficiencies and Secondary Complications of Diabetes

Nitric Oxide deficiency (treatable with Reishi mushroom)

↓

Leukocyte activations, platelet aggregation

↓

Ischemia

Nitric oxide production

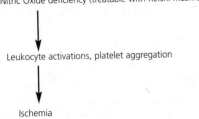

$NADPH + H^+$ → Reishi mushroom, oxygen therapies → $NADP^+$

L-Arginine → nitric oxide synthase → L-Citruline

Nitric oxide

6. Nitric Oxide Production

▸ Participates in a bewildering variety of biological processes
▸ Exists for 6-10 seconds and then is converted by oxygen and H_2O into nitrates and nitrite
▸ Prevents platelet aggregation
▸ Relaxes smooth muscle (works in similar manner to nitroglycerin)
▸ Decreased levels are found in liver disease, and are a risk factor for NIDDM and insulinemia
▸ Deficiencies or excesses can profoundly influence the body
▸ Reishi mushroom, oxygen therapy stimulates the production of nitric oxide

7. Transport of Glucose Into Cells with the Use of Insulin (througout most of the body tissues)

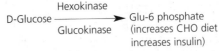

Hexokinase
D-Glucose ⟶ Glu-6 phosphate (increases CHO diet increases insulin)
Glucokinase

▸ Glucose cannot diffuse directly into cell without the entry of glucokinase or hexokinase
▸ Hexokinase — found in most tissue
▸ Glucokinase — found in liver

8. Transport of Glucose into Cells Independent of Insulin (throughout specific tissues)

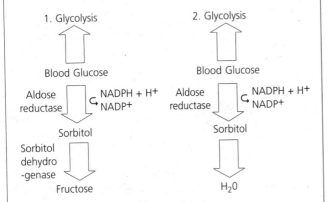

1. Glycolysis
⇑
Blood Glucose

Aldose reductase ⟶ NADPH + H⁺ / NADP⁺
⇓
Sorbitol

Sorbitol dehydro-genase
⇓
Fructose

2. Glycolysis
⇑
Blood Glucose

Aldose reductase ⟶ NADPH + H⁺ / NADP⁺
⇓
Sorbitol
⇓
H_2O

1) Liver, seminal vesicles contain sorbitol dehydrogenase, which is able to break down the extra glucose, in diabetics and convert it to fructose.

2) Lens, nerve, kidney do not contain sorbitol dehydrogenase and thus extra glucose in diabetics is converted into sorbitol. The sorbitol accumulates in the tissues, and causes osmotic swelling due to the influx of water and causes cellular damage.

9. AGE Nephropathy

Sugar and amino acid ⟶ AGE (advanced glycosylation end products)

▸ Accelerate atherosclerosis, cross linking of protein
▸ Platelet aggregation
▸ Defective vascular relaxation
▸ Abnormal lipoprotein metabolism
▸ Toxic to kidneys, increases oxidized LDL and free radicals
▸ Aminoguanidine, found naturally in goats rue, a strong base found in urine and a normal product of protein metabolism) nucleophilic — binds other chemicals, and formation of AGE inhibits their action — decreases neuropathy, decreases retinopathy, decreases nephropathy

Overview of Diabetes Biochemistry and Case Studies

10. Aminoguanidine helps clear out AGE
(advanced glycosylation end products)

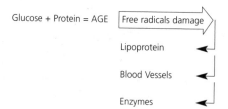

Glucose + Protein = AGE Free radicals damage

Lipoprotein

Blood Vessels

Enzymes

Function

Glucose in high levels in the blood starts forming an irreversible compound called advanced glycosylation end products (AGE). AGE acts as free radicals circulating throughout the body causing cellular death. Antioxidants are necessary in order to quench the free radicals before causing cell death.

The AGE products cause structural alterations of the blood vessels and the phospholipid component of LDL low-density lipoproteins. This causes increased vascular permeability of membranes, loss of vascular elasticity, altered enzyme function, and reduced clearance of lipoproteins. AGE are usually cleared by a healthy kidney, but not cleared well in Diabetic nephropathy. The buildup of AGE is a main cause of accelerated atherosclerosis and death in diabetics.

Vitamin E and lipoic acid are both effective in decreasing glycosylation of the glucose to the protein. The aminoguanidines are found naturally in the body and in the herb goat's rue and are effective in clearing out AGE.

11. Glucose ⟶ Glycolysis

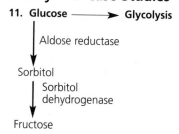

Aldose reductase

Sorbitol

Sorbitol dehydrogenase

Fructose

Function

Glucose is normally metabolized in glycolysis. In specific tissues it is metabolized into sorbitol, and the sorbitol is then changed into fructose.

However, in diabetics when the system is overwhelmed with glucose, excess glucose is converted into sorbitol, and the sorbitol dehydrogenase is insufficient. A buildup of sorbitol results, causing problems in specific tissues that rely on the aldose reductase pathway, such as the eye, kidneys, and nerves. Quercitin, xanthones, bioflavonoids, and milk thistle have all demonstrated inhibition of aldose reductase enzymes, proving themselves as some of the best tools in treating secondary diabetic complications.

12. Flow of Fluid in the Eye and Anatomy

The normal cell contains sodium and potassium in equilibrium

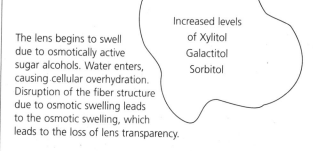

NA, K
Normal Cell

The cells in the diabetic lens begin filling up with sugar alcohols

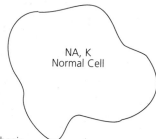

Increased levels of Xylitol Galactitol Sorbitol

The lens begins to swell due to osmotically active sugar alcohols. Water enters, causing cellular overhydration. Disruption of the fiber structure due to osmotic swelling leads to the osmotic swelling, which leads to the loss of lens transparency.

13. Flow of Fluid in the Eye and Anatomy

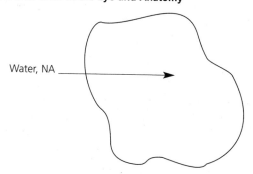

Water, NA

The lens continues to swell. Water and sodium enter the lens cells as the lens promotes the entry of sodium ions and water. Essential nutrients and antioxidants are pushed out. The reduced levels of antioxidants cause oxidative damage to the eyes.

Jambul and milk thistle seeds increase natural levels of superoxide dismutase and glutathione peroxidase. Replenishing the dietary intake of antioxidants and inositol is also helpful in treating diabetic cataracts.

This process occurs not only in the pathogenesis of cataract formation, but also in the nerves as well.

Overview of Diabetes Biochemistry and Case Studies

14. Flow of Fluid of Eye and Anatomy

Due to cellular over-hydration, amino acids, glutathione, myo-inositol, essential nutrients and antioxidants, as well as potassium, start leaving the cell

In the nerve, myo-inositol is pushed out by the high levels of sorbitol, as it is in the eye lens. This depletion of myo-inositol decreases conduction velocity of the nerve. Myo-inositol supplementation prevents both the depletion of this element and prevents the reduction of nerve velocity.

15. High Levels of Sorbitol Found in Nerve Tissue of Diabetics

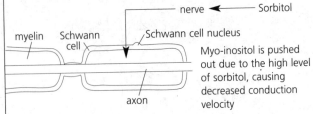

nerve ◄——— Sorbitol

myelin Schwann cell Schwann cell nucleus

axon

Myo-inositol is pushed out due to the high level of sorbitol, causing decreased conduction velocity

Myo-inositol supplementation prevents both myo-inositol depletion and reduction in nerve conduction velocity. Myo-inositol is corrective even in cases of hyperglycemia.[1] Insulin therapy during hyperglycemia is not able to increase nerve conduction, nor increase myo-inositol levels.

[1]Green DA, DeJasus PU, Winegrad AI: Effects of insulin and dietary myo-inositol on impaired peripheral motor nerve conduction velocities in acute streptozotocin diabetes. *J. Clin. Invest.* 1975,55:1326-1336.

16. The Eye: A Case Study of Diabetic Glaucoma

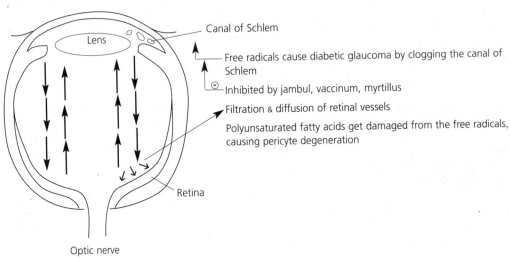

Lens

Canal of Schlem

Free radicals cause diabetic glaucoma by clogging the canal of Schlem

⊖ Inhibited by jambul, vaccinum, myrtillus

Filtration & diffusion of retinal vessels

Polyunsaturated fatty acids get damaged from the free radicals, causing pericyte degeneration

Retina

Optic nerve

Diabetic Glaucoma Case Study

Before *After 9 months*
27 mmol 1Hg ————————➤ 15mmol/Hg
PX: jambul, antioxidant, *Vaccinum Myrtillus*
Diabetic glaucoma reversed after
9 months with 1) jambul
 2) *Vaccinia myrtillus*
 3) antioxidants

Overview of Diabetes Condition

17. The Effects of Vitamin E and Lipoic Acid on AGE

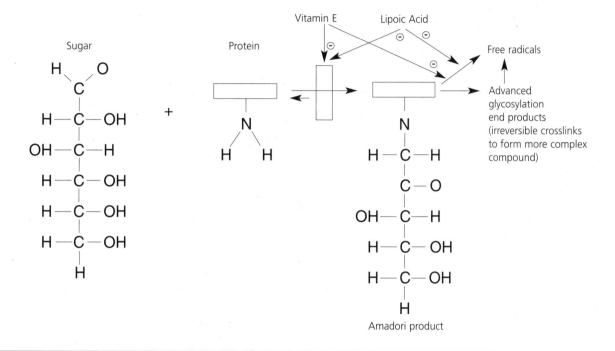

18. The Effects of Sorbitol on the Nerve, and How Lens Cataract Formation Occurs

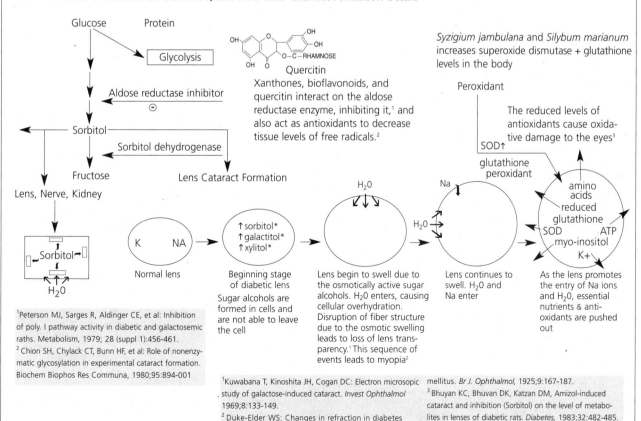

Quercitin
Xanthones, bioflavonoids, and quercitin interact on the aldose reductase enzyme, inhibiting it,[1] and also act as antioxidants to decrease tissue levels of free radicals.[2]

Syzigium jambulana and *Silybum marianum* increases superoxide dismutase + glutathione levels in the body

The reduced levels of antioxidants cause oxidative damage to the eyes[3]

Normal lens

Beginning stage of diabetic lens
Sugar alcohols are formed in cells and are not able to leave the cell

Lens begin to swell due to the osmotically active sugar alcohols. H_2O enters, causing cellular overhydration. Disruption of fiber structure due to the osmotic swelling leads to loss of lens transparency.[1] This sequence of events leads to myopia[2]

Lens continues to swell. H_2O and Na enter

As the lens promotes the entry of Na ions and H_2O, essential nutrients & antioxidants are pushed out

[1]Peterson MJ, Sarges R, Aldinger CE, et al: Inhibition of poly. I pathway activity in diabetic and galactosemic raths. Metabolism, 1979; 28 (suppl 1):456-461.
[2] Chion SH, Chylack CT, Bunn HF, et al: Role of nonenzymatic glycosylation in experimental cataract formation. Biochem Biophos Res Communa, 1980;95:894-001

[1]Kuwabana T, Kinoshita JH, Cogan DC: Electron microsopic study of galactose-induced cataract. *Invest Ophthalmol* 1969;8:133-149.
[2] Duke-Elder WS: Changes in refraction in diabetes mellitus. *Br J. Ophthalmol*, 1925;9:167-187.
[3] Bhuyan KC, Bhuvan DK, Katzan DM, Amizol-induced cataract and inhibition (Sorbitol) on the level of metabolites in lenses of diabetic rats. *Diabetes*, 1983;32:482-485.

Overview of Diabetes Complications

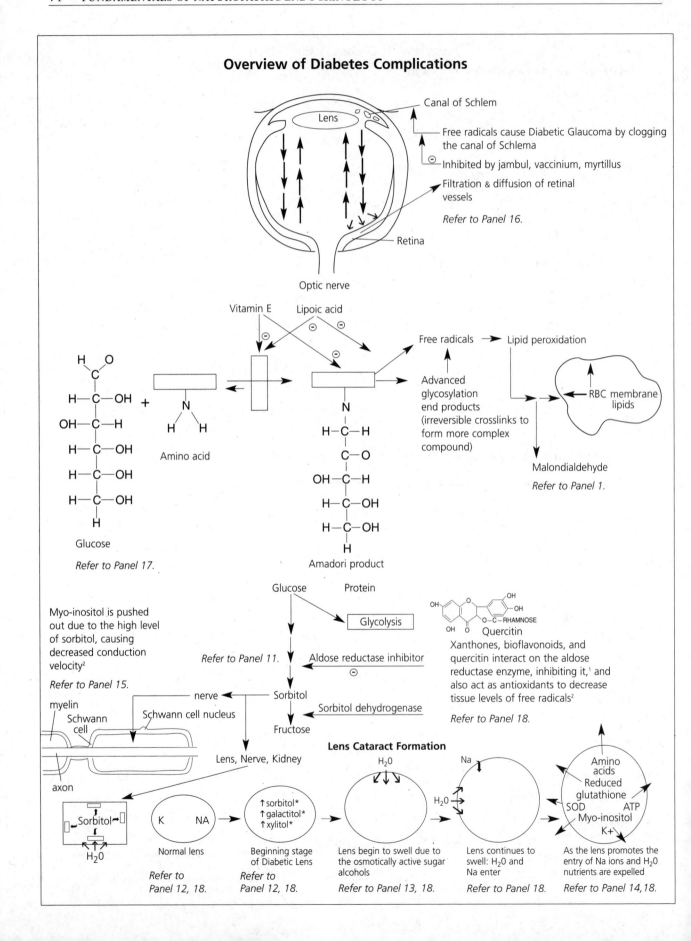

Canal of Schlem

Lens

Free radicals cause Diabetic Glaucoma by clogging the canal of Schlema

⊖ Inhibited by jambul, vaccinium, myrtillus

Filtration & diffusion of retinal vessels

Refer to Panel 16.

Retina

Optic nerve

Vitamin E Lipoic acid

Free radicals → Lipid peroxidation

Amino acid

Advanced glycosylation end products (irreversible crosslinks to form more complex compound)

RBC membrane lipids

Malondialdehyde
Refer to Panel 1.

Glucose

Refer to Panel 17.

Amadori product

Myo-inositol is pushed out due to the high level of sorbitol, causing decreased conduction velocity[2]

Refer to Panel 15.

myelin
Schwann cell
Schwann cell nucleus

axon

Glucose Protein

Glycolysis

Refer to Panel 11.

Aldose reductase inhibitor ⊖

nerve ←

Sorbitol

Sorbitol dehydrogenase

Fructose

Lens, Nerve, Kidney

Quercitin

Xanthones, bioflavonoids, and quercitin interact on the aldose reductase enzyme, inhibiting it,[1] and also act as antioxidants to decrease tissue levels of free radicals[2]

Refer to Panel 18.

Lens Cataract Formation

H_2O

Na

Amino acids
Reduced glutathione
SOD ATP
Myo-inositol
K+

H_2O

Sorbitol

H_2O

K NA

Normal lens

Refer to Panel 12, 18.

↑sorbitol*
↑galactitol*
↑xylitol*

Beginning stage of Diabetic Lens

Refer to Panel 12, 18.

Lens begin to swell due to the osmotically active sugar alcohols

Refer to Panel 13, 18.

Lens continues to swell: H_2O and Na enter

Refer to Panel 18.

As the lens promotes the entry of Na ions and H_2O nutrients are expelled

Refer to Panel 14, 18.

Case Study
Interview with a Survivor of a Diabetic Coma

This interview took place at the University of Bridgeport in Spring 2000 as part of an endocrinology class with a patient suffering from diabetes Type I who explains how an illness can be used as a tool for personal discovery.

Q. What symptoms did you start noticing, physically or emotionally, before you were diagnosed with diabetes?
A. I was in Poland and started to get night sweats. My girlfriend at the time would wake up in the middle of the night and want to turn the heater off in the room, but there wasn't a heater in the room. I was pumping off so much heat. And then I noticed that I craved sweets. I started to space out often during the day, lost a little weight, and it wasn't until later when I was traveling through Europe, living sort of an itinerant lifestyle, not so good for the body, that I noticed I had to go to the bathroom a lot.

Q. Traditional Chinese Medicine views diabetes as a condition called Kidney yin deficiency. The symptoms match yours exactly. Symptoms of Kidney yin deficiency include excess urination, excess heat, hot sweats at night, and losing weight.
A. It got worse and worse until I couldn't sleep at night. I had to get up three or four times during the night to urinate. Then, I started drinking copious amounts of water. By the time I was back in Poland, I had lost about 40 pounds, was getting tremors. It became really hard to concentrate my thoughts, and I started to get cramping in my legs all the time.

Q. What was your eyesight like?
A. Toward the end it became like tunnel vision. I was losing my peripheral vision. All I wanted to do was sleep or drink water or eat sugar. Craving sugar for energy, because I had no energy. I thought I had cancer so I thought I was going to die. I made peace with people in my life and accepted it, because for some reason I just didn't want to go to the doctor in Poland. I was really poor and stubborn. When I returned from Poland, I went to the hospital, had my blood checked and went home. Soon the phone rang: "You better get in here right away"! My blood sugars were about 700 mg/dL when I got checked in. I walked to the hospital from my house, and halfway there I almost passed out in a snow bank, because I could hardly see. I was losing all control of my body. I drank a liter of Gatorade, which was more sugar, and then I trudged off to the hospital. By this time I was losing consciousness. They threw me into a wheelchair, and I passed out. I remember waking up the next day with all of these tubes in me.

Q. When did you regain consciousness, after how many hours?
A. A couple of hours later I regained consciousness. I was aware that I was inside my body, but I had no control of it, it was shut down. That was a really interesting time for me. I had an out-of-body experience where I was floating over the bed looking down at my body and all of these doctors. That really changed my perspective of life and what goes on. I had read about things like that in the Tao Te Ching and different religious texts, but I had never really had an experience, which was a big difference.

Q. What happened when you came out of the coma? How did you feel on the physical level? Was your eyesight changed after having such high blood sugar?
A. I felt physically clear, like it was a new life. I felt reborn, almost, like I had come really close to death and I remember feeling relieved. I realized too at that point that it is just the body that dies, it is not whatever is inside the body that dies. It changed my perspective of death as well. I no longer had to really fear it anymore.

Q. What kind of life were you living before you had the diabetes, as opposed to how it changed after the coma?
A. Before I took my body for granted; it was very strong. I worked out and ate whatever I wanted. I ate a lot of meat. In a sense, I was using my body as a sort of laboratory. I slowly realized that it wasn't helping my mind, body, or life. I felt like I had been given a second chance and I didn't want to blow it. I became involved in Tai Chi and Chi Gung, different yoga systems, Vipassana meditation, and I started to change my diet to a plant-based vegetarian diet that I adhere to until this day. I feel really glad and much better, lighter, more clear in my mind and more focused.

Q. Did you ever notice any signs of illness before diabetes?
A. Well, I noticed even as a child that I had hypoglycemia, and I would end up overeating processed carbohydrates and dairy, and I think that really affected everything. By the time I was 20 or 21 my body couldn't take those things anymore. When I came out of the hospital, they put me on this huge diet to build my weight up again. It was all animal protein and milk. My body could take it for a few months, but after that I got sick again because I was developing allergies to wheat and dairy. There was a lot of research showing that almost everyone with Type I diabetes has a high rate of albumin allergy to milk.

I do great when I stay away from dairy. That stuff really wrecks me. I had some dairy over Christmas and

I got a sinus infection easily. It's really great where I work now, we do wheat grass; I find that it is amazing. We also have a lot of sprouted things. Anything that has been sprouted has a lot more potency, and it's a living food so it's bioactive so to speak, whereas a lot of foods that has been cooked are dead. They don't have a lot of life force in them. Supposedly as a diabetic I am not to eat that much fruit, but I find if I eat fruit, I am fine, as long as I don't eat a lot of junk food and fatty foods and hydrogenated foods. Apples, peaches, plums, pears, and the non-sweet fruits, like cucumbers, pepper, olives, avocados, and kumquats, are great because they have beneficial fat in them, which is good for diabetics and most people actually. I've been blessed. I probably would have been in politics if I hadn't gotten sick. The whole journey led away from that route and now I'm really interested in medicine and nutritional health and meditation, prayer, just living as sacred a life as possible.

Q. I've had a few patients also state their biggest gift in life is having their illness.
A. Yes, it's great that it happened early in my life, and not when I'm 80 and on my deathbed.

Q. Have you had any lingering effects from the periods of high blood sugar?
A. No, they checked a few years ago to see about neuropathy, and they found that the response in my fingers and toes was normal. I do a lot of yoga and I am a pretty active person. I have heard there is a high rate of impotence in diabetic persons, and I don't want that. I like having sex so, its little things like that. Once in a while I get tingling in my fingers and my hands, but I had that before. As a kid my hands would always go to sleep.

My eyesight has actually improved in the last year or two because I have been doing the yogic exercises for the eye. I am looking at reducing my prescription for my glasses. The only thing I find is that when my blood sugar is a little bit off, it definitely affects my whole nervous system, my nerve transmitters, and my thoughts.

Q. Is there anything else you would like to add about your diabetes?
A. I'm happier, more centered, and grateful to be alive.

References

1. McDermott M.T. Endocrine Secrets. Philadelphia, PA: Hanley and Belfus Inc, 1998.

2. Shanmugasundaram KR, Panneerselvam C, Samudram P. Possible regeneration of the islets of Langerhans in streptozotocin-diabetic rats given Gymnema sylvestre leaf extracts. J Ethnopharmacology. 1990 Oct;30(3):268.

3. Heikens. E. Fliers, E. Endert, M. Ackermans, G. van Montfrans. 1995. Liquorice-induced hypertension-a new understanding of an old disease: Case report and bried review. Neth J Med 4795;255-62.

4. Jacob S, et al. Enhancement of glucose disposal in patients with type 2 diabetes by alpha lipoic acid. Arzneimittelforschung April;160(16):2377-81.

5. Friedman M. Clinical study: Adaptogenic herbs in the treatment of blood sugar disorders. Toronto, ON: Naka Inc, 1998.

6. Yamauchi A, Takei I, Nakamoto S, Ohashi N, Kitamura Y, Tokui, et al. Hyperglycemia decreases dehyroepiandrosterone in Japanese male with impaired glucose tolerance and low insulin response. Endocr J 1996;43(3):285-90.

7. Nestler JE, Beer NA, Jakubowicz DJ, Beer RM. Effects of a reduction in circulating insulin by metformin on serum dehydroepiandrosterone sulfate in nondiabetic men. J Clin Endocrinol Metab 1994;78(3):549-54.

8. Buffington CK, Pourmotabbed G, Kitabchi AE. Case report: Amelioration of insulin resistance in diabetes with dehydroepiandrosterone. Am J Med Sci 1993;306(5):320-24.

9. Buffington CK, Givens JR, Kitabchi AE. Enhanced adrenocortical activity as a contributing factor to diabetes in hyperandrogenic women. Metabolism 1994;43(5):584-90.

10. Buffington CK, Givens JR, Kitabchi AE. Enhanced adrenocortical activity as a contributing factor to diabetes in hyperandrogenic women. Metabolism 1994;43(5):584-90.

11. Sadri P, Lautt W: Blockade of hepatic nitric oxide synthase causes insulin resistance. American Journal of Physiology 1999 July;277(1pt1):G101-8998.

12. Vaag A, et al: Is low birth rate a risk factor for the development of NIDDM? Ugeskriept Laeger 1998 April;160(16): 2377-81.

13. McDermott J. Endocrine Secrets. Philadelphia, PA: Hanley and Belfus Inc, 1998.

14. Gerstein HC. Cow's milk exposure and type 1 diabetes mellitus: A critical review of the clinical literature. Diabetes Care 1994;17:13-19.

15. Anonymous. Tight blood pressure control and risk of microvascular complications in Type 2 Diabetes: (UKPDS 38). UK Prospective Diabetes Group. BMJ 1998 Sept 12; 317(7160):703-13.

16. Anderson HU, et al. Nicotinamide prevents interleukin-1 effects on accumulated insulin release and nitric oxide production in rat islets of Langerhans. Diabetes 1994;43:770-77.

17. Lafontan M. Fat cells: Afferent and efferent messages define new approaches to treat obesity. Annu Rev Pharmacol Toxicol. 2005 Feb 10;45:119-46.

18. Majer M, et al. Insulin down regulates pyruvate dehydrogenase kinase (PDK) mRNA: Potential mechanism contributing to increased lipid oxidation in insulin-resistant subjects. Molecular Genetics and Metabolism 1998 Oct;63(2):181-86.

19. Xie H, Laut W. Insulin resistance of skeletal muscle produced by hepatic parasympathetic interruption. American Journal of Physiology 1996 May;270(5pt1):e858-63.

20. Levi-Ran A: Myogenic factors accelerate later disease: Insulin as a paradigm [review]. Mechanisms of Aging and Development 1998 May 1;2(1):95-113.

21. Sadri P, Lautt W: Blockade of hepatic nitric oxide synthase causes insulin resistance. American Journal of Physiology 1999 July;277(1pt1):G101-8998.

22. Vaag A, et al: Is low birth rate, a risk factor for the development of NIDDM? Ugeskriept for laeger, 1998 April;160(16):2377-81.

23. Sadri P, Lautt W: Blockade of hepatic nitric oxide synthase causes insulin resistance. American Journal of Physiology 1999 July;277(1pt1):G101-8.

24. Vechi C, Tucci P, Galvin P: Chromium and diabetes: relationship to serum levels of cholesterol, triglycerides and lipoproteins. Medical hypothesis 1980 Nov; 6(11):1177-89.

25. Crinnion WJ. Environmental medicine, part 4: Pesticides - biologically persistent and ubiquitous toxins. Altern Med Rev. 2000 Oct;5(5):432-47.

26. Laakso, M. Hyperglycemia and cardiovascular disease in type II diabetes. Diabetes 1999 May;48(5):937-42.

27. Swis Locke AL, Khuu Q, Viaole E, Wu E, Lopez J, Kwan G, Noth RH. Safety and efficacy of Metformin in a restrictive formularity. American Journal of Management Care 1999 Jan;5(1):62-68.

28. Melchior WR, Jaber LA: Metformin: An antihyperglycemic agent for treatment of type II diabetes. Ann Pharmacotherapy 1996 Feb; 30(2):158-64.

29. Inzucchi SE, et al. Efficacy and metabolic effects of Metformin and trigladazone in type II diabetes mellitus. New England Journal of Medicine 1998 March 26;338(13):867-72.

30. Scorpiglrione N, Bellfiglio M, Carinch F, Cavalier D, Dekurtis A, Franciosi M, Mari E, Sacco M, Tagnoni G, Nicolucci A. The effectiveness and safety and epidemiology of the use of Ascarbose in the treatment of patients with type II diabetes mellitus: A model of medicine based evidence. European Journal of Clinical Pharamcology 1999 June;55(4):239-49.

31. Anonymous. Intensive blood glucose control with sulfonylureas or insulin compared to conventional treatment and risk of complications in type II diabetes. UK Prospective Diabetes Study Group. Lancet 1998 Sept 12;352(9131):837-53.

32. Anonymous. Intensive blood glucose control with sulfonylureas or insulin compared to conventional treatment and risk of complications in type II diabetes. UK Prospective Diabetes Study Group. Lancet 1998 Sept 12;352(9131):837-53.

33. Von Schonfeld J, Weisbrod B, Muller MK. Silibin, a plant extract with antioxidant and membrane stabilizing properties, protects exocrine pancreas from cyclosporin A toxicity. Cell Mol Life Science 1997;53:917-20.

34. Flora K, Hahn M, Rosen H, Benner K. Milk thistle (Silybum marianum) for the therapy of liver disease. Am J Gastroenterol 1998;93:139-43.

35. Luper S. A Review of Plants Used in the Treatment of Liver Disease: Part 1. Alternative Medicine Review 1998;3:410-421.

36. Wagner H, Horhammer L, Munster R. The chemistry of Silymarin (silybun), the active principle of the fruits of Silybum marianum. In: Brown DJ (ed.). Herbal Prescriptions for Better Health. Roseville, CA: Prima Health, 1996;151-58.

37. Luper S. A review of plants used in the treatment of liver disease: Part 1. Alternative Medicine Review 1998; 3:410-21.

38. von Schonfeld J, Weisbrod B, Muller MK. Silibin, a plant extract with antioxidant and membrane stabilizing properties, protects exocrine pancreas from cyclosporin A toxicity. Cell Mol Life Sci 1997;53(11-12):917-20.

39. Lahiri-Chatterjee M, Katiyar SK, Mohan RR, et al. A flavonoid antioxidant, Silymarin, affords exceptionally high protection against tumor promotion in the SENCAR mouse skin tumorigenesis model. Cancer Res 1999;59(3):622-32.

40. Velussi M, Cernigoi AM, De Monte A, et al. Long-term (12 months) treatment with an anti-oxidant drug (Silymarin) is effective on hyperinsulinemia, exogenous insulin need and malondialdehyde levels in cirrhotic diabetic patients. J Hepatol 1997;26(4):871-79.

41. Zhang JQ, Mao XM, Zhou YP: [Effects of silibin on red blood cell sorbitol and nerve conduction velocity in diabetic patients]. Chung Kuo Chung Hsi I Chieh Ho Tsa Chih 1993; 13(12):725-26, 708.

42. Gorio A, Donadoni ML, Finco C, et al. Endogenous mono-ADP-ribosylation in retina and peripheral nervous system. Effects of diabetes. Adv Exp Med Biol 1997;419:289-95.

43. Gorio A, Donadoni ML, Finco C, et al. Endogenous mono-ADP-ribosylation in retina and peripheral nervous system. Effects of diabetes. Adv Exp Med Biol 1997;419:289-95.

44. Gorio A, Donadoni ML, Finco C, et al. Endogenous mono-ADP-ribosylation in retina and peripheral nervous system. Effects of diabetes. Adv Exp Med Biol 1997;419:289-95.

45. Shimizu K, Ozeki M, Tanaka K, Itoh K, Nakajyo S, Urakawa N, Atsuchi M. Suppression of glucose absorption by extracts from the leaves of Gymnema. J Vet Med Science, 1997 Sep;59(9):753.

46. Bishayee A, Chatterjee M. Hypolipidemic and antiatherosclerotic effects of oral Gymnema sylvestre R.Br. leaf extract in albino rats fed on a high fat diet. Phytother Res 1994;8:118–20.

47. Shanmugasundaram KR, Panneerselvam C, Samudram P. Possible regeneration of the islets of Langerhans in streptozotocin-diabetic rats given Gymnema sylvestre leaf extracts. J Ethnopharmacology. 1990 Oct;30(3):268.

48. Shanmugasundaram ER, Rajeswari G, Baskaran K, et al. Use of Gymnema slvestre leaf in the control of blood glucose in insulin-dependent diabetes mellitus. J Ethnopharmacol 1990;30:281-94.

49. Baskaran, K. Antidiabetic effect of a leaf extract from Gymnema sylvestre. J. Ethnopharmacology. October 30, 1990;296.

50. Miyasaka, A. Electrophysiological characterization of the inhibitory effect of a novel peptide gurmarin on the sweet taste response in rats. Brain Res 1995, April 3;676(1):63-68.

51. Loubatieres, A. The mechanism of action of the hypoglycemic sulphonamides: A concept based on investigations in animals and in man. Diabetes 1957;6:408-417.

52. Gupta SS. Experimental studies on pituitary diabetes Part II: Comparison of blood sugar level in normal and anterior pituitary extract-induced hyperglycemic rats. Indian J of Med Research 1962;50:708-714.

53. Gupta SS. Experimental studies on pituitary diabetes Part II: Comparison of blood sugar level in normal and anterior pituitary extract-induced hyperglycemic rats. Indian J of Medical Research 1962:51:716-725.

54. Gharpurey KG. Gymnema sylvestre in the treatment of diabetes. Indian Medical Gazette 1926:61:155.

55. Chopra R, J. Bose N, Chatterjee P. Gymnema sylvestre in diabetes mellitus. Indian Journal of Medical Research 1928:16:115-20.

56. Cardenas Medellin ML, Serna Saldivar SO, Velazco de la Garza J. Use of nopal dietary fiber in a powder dessert formulation. Arch Latinoam Nutr. 2002 Dec;52(4):387-92.

57. Prince PS, Kamalakkannan N, Menon VP. Antidiabetic and antihyperlipidaemic effect of alcoholic Syzigium cumini seeds in alloxan induced diabetic albino rats. J Ethnopharmacol. 2004 Apr;91(2-3):209-13.

58. Lupattelli G, Marchesi S, Lombardini R, Roscini AR, Trinca F, Gemelli F, Vaudo G, Mannarino E. Artichoke juice improves endothelial function in hyperlipemia. Life Sci. 2004 Dec 31;76(7):775-82.

59. Saenz Rodriguez T, Garcia Gimenez D, de la Puerta Vazquez R. Choleretic activity and biliary elimination of lipids and bile acids induced by an artichoke leaf extract in rats. Phytomedicine. 2002 Dec;9(8):687-93.

60.Velussi M, Cernigoi AM, De Monte A, et al. Long-term (12 months) treatment with an anti-oxidant drug (Silymarin) is effective on hyperinsulinemia, exogenous insulin need and malondialdehyde levels in cirrhotic diabetic patients. J Hepatol 1997; 26(4):871-79.

61. McDermott MT. Endocrine Secrets. Philadelphia, PA: Hanley and Belfus Inc, 1998.

62. Sadri P, Lautt W. Blockade of hepatic nitric oxide synthase causes insulin resistance. American Journal of Physiology 1999 July;277(1pt1):G101-08.

63. McDermott MT. Endocrine Secrets. Philadelphia, PA: Hanley and Belfus Inc, 1998.

64. Prince PS, Menon VP, Pari L. Hypoglycaemic activity of Syzigium cumini seeds: Effect on lipid peroxidation in alloxan diabetic rats. J Ethnopharmacol. 1998 May;61(1):1-7.

65. Tager M, Dietzmann J, Thiel U, Hinrich Neumann K, Ansorge S. Restoration of the cellular thiol status of peritoneal macrophages from CAPD patients by the flavonoids silibinin and silymarin. Free Radic Res. 2001 Feb;34(2):137-51.

66. Greenway, F. Frome, B. Engels, T. McLellan, A. Temporary relief of post herpetic neuralgia with topical geranium oil: American Journal of Medicine Nov 2003;115:586-87.

67. Schnaubelt Medical Aromatherapy. Healing with Essential Oils. Berkeley, CA: Frog Ltd,1998.

68. McDermott MT. Endocrine Secrets. Philadelphia, PA: Hanley and Belfus Inc, 1998.

69. McDermott MT. Endocrine Secrets. Philadelphia, PA: Hanley and Belfus Inc, 1998.

70. Pyorala k, Pederson TR, Kjekshus J, et al. Cholesterol lowering with simvastatin improves prognosis of diabetic patients with coronary heart disease. A sub group analysis of the Scandanavian Simvstatin Survival Study (4S). Diabetes Care 1997;20:614-20.

71. Tyagi SC, Rodriguez W, Patel AM, Roberts AM, Falcone JC, Passmore JC, Fleming JT, Joshua IG. Hyperhomocysteinemic diabetic cardiomyopathy: Oxidative stress, remodeling, and endothelial-myocyte uncoupling. J Cardiovasc Pharmacol Ther. 2005 Mar;10(1):1-10.

72. Okano H, Masuda H, Ohkubo C. Effects of 25 mT static magnetic field on blood pressure in reserpine-induced hypotensive Wistar-Kyoto rats. Bioelectromagnetics. 2005 Jan;26(1):36-48.

73. Ficarra P, Ficarra R, Tommasini A, et al. High performance liquid chromatography of flavonoids in Crataegus oxycantha. Il Farmaco Ed pr 1983;39:148-57..

74. Petkov V: Plants with hypotensionsive, antiattheromatous and coronadilating action. Am J Chin Med 1979;7:197-236.

75. Kalhoff RK. Impact of maternal fuels and nutritional state on fetal growth. Diabetes 1991;40;18-24.

76. Freinkel N, Phelps RL, Metzger BE. The mother in pregnancies complicated by diabetes. In: Rifkin H, Porte D (eds).: Diabetes Mellitus: Theory and Practice. 4th ed. New York, NY: Elsevier, 1990:634-50.

77. Frienkel N, Ogata E, and Metzger B: The offspring of the mother with diabetes. In: Rifkin H, Porte D (eds): Diabetes Mellitus: Theory and Practice. 4th ed. New York, NY: Elsevier, 1990:651-60.

78 Greeske K, et al. Horse chestnut seed extract—an effective therapy principle in general practice: Drug therapy of chronic venous insufficiency. Fortschr Med 1996 May 30;114(15):196-200.

79. Welsh A, Eade M. Inoslitol hexanicotinate for improved nicotinic acid therapy. Int Record Med 1961;174:9-15.

80. Pavlovskaya E, et al. Effectiveness of ozone therapy in the process of diabetes treatment. Abstracts: 2nd International Symposium on Ozone Applications. Havana: Ozone Research Center/ National Center for Scientific Research, 1997.

LIPIDS METABOLISM DISORDERS

Pathophysiology Review

Endocrine function and lipid metabolism are interwoven in innumerable ways and more connections are being discovered on a regular basis. For example, human growth hormone (hGH) lowers total cholesterol, while increased cortisol levels have the opposite effect. Menopause is known to decrease HDL, while LDL levels rise. Hyperlipidemia is a standard screening test for thyroid dysfunction. Recently, Gerald Reaven at Stanford University discovered that hyperinsulinemia (Metabolic Syndrome X) raises triglycerides and LDL levels, thereby increasing cardiovascular risk. Clearly, consideration of endocrine function is important in assessing any dyslipedemia.

FUNCTIONS OF LIPIDS

Lipids are fat-soluble substances that have many essential roles in the body. They are integral constituents of all cell membranes in the body.

- Protection of the body from the entry of water-soluble substances on the skin
- Prevention of evaporation of water from the body
- Nerve conduction

- Neurotransmitter production
- Digestion of dietary fats
- Transportation and storage of energy rich compounds
- Molecular basis of the steroid hormone molecules

Four Common Lipids
- Cholesterol
- Cholesterol ester Phospholipid
- Triglyceride
- Unesterified fatty acid

LIPOPROTEINS

Lipoproteins transport water-insoluble lipids from one site of the body to the other. Lipoproteins surround lipids with a coating of water-soluble proteins and phospholipids. Apoproteins are located on the surface of lipoproteins, which function as molecular structures that can bind to receptors in peripheral tissues.

Lipoprotein Functions and Apoprotein Mechanisms

Lipoprotein	Function	Apoprotein	Mechanism
Chylomicrons	Transport dietary cholesterol from the small intestine to muscles and fat tissue	Apoprotein C-II	Used as a cofactor for lipoprotein lipase, which removes triglycerides from chylomicrons and VLDL
VLDL	Transports triglycerides produced from the liver to fat and muscle tissue	Apoprotein C-II	Used as a cofactor for lipoprotein lipase, which removes triglycerides from chylomicrons and VLDL
LDL	Transports liver-produced cholesterol to the rest of the body	Apoprotein B	Binds to peripheral and hepatic receptors for LDL
HDL	Transports cholesterol from peripheral tissue back to the liver	Apoprotein A	Binds to peripheral receptors for HDL

Quick Reference: Lipids Metabolism Disorders

Primary Lipid Metabolism Disorder	Major Signs and Symptoms	Key Laboratory Tests	Conventional Therapies	Naturopathic Therapies
Familial Hypercholesterolemia	Tendon xanthomas	Very high cholesterol: 800-1200 mg/dl	HMG Co A reductase inhibitors, bile acid resins Gemfibrozil, niacin	High fiber diet, decreased saturated fats, increased omega oils, niacin, red yeast, botanical medicines
Familial Hypertriglyceridemia	Non specific symptoms	Very high triglycerides, normal cholesterol	Gemfibrozil, HMG Co A reductase inhibitors, niacin	High fiber diet, decreased saturated fats, increased omega oils, niacin, red yeast, botanical medicines
Polygenic Hypercholesterolemia	Non specific symptoms	High cholesterol	HMG Co A reductase inhibitors, bile acid resins Gemfibrozil, niacin	High fiber diet, decreased saturated fats, increased omega oils, niacin, red yeast, botanical medicines
Familial Dysbetalipoproteinemia	Planar xanthomas on palms and soles of feet	High cholesterol, high triglycerides, abnormal apoprotein E phenotype	Gemfibrozil, HMG Co A reductase inhibitors, niacin	High fiber diet, decreased saturated fats, increased omega oils, niacin, red yeast, botanical medicines
Familial Combined Hyperlipidemia	Non specific symptoms	High cholesterol, high triglycerides, high Apoprotein B	HMG Co A reductase inhibitors, bile acid resins, Gemfibrozil, niacin	High fiber diet, decreased saturated fats, increased omega oils, niacin, red yeast, botanical medicines

Secondary Lipid Metabolism Disorder

Diabetes Mellitus	Non specific symptoms	Very high cholesterol	HMG Co A reductase inhibitors, bile acid resins, Gemfibrozil, niacin	High fiber diet, decreased saturated fats, increased omega oils, niacin, red yeast, botanical medicines
Hypothyroidism	Fatigue Low body temperature	Very high cholesterol	HMG Co A reductase inhibitors, bile acid resins, Gemfibrozil, niacin, Synthroid	High fiber diet, decreased saturated fats, increased omega oils, niacin, red yeast, botanical medicines, Armour, T3, T4
Wilson's Temperature Syndrome	Fatigue Low body temperature	High cholesterol	HMG Co A reductase inhibitors, bile acid resins, Gemfibrozil, niacin	High fiber diet, decreased saturated fats, increased omega oils, niacin, red yeast, botanical medicines, T3 therapy
Nephrotic Syndrome	Edema	High cholesterol, high triglycerides	HMG Co A reductase inhibitors, bile acid resins, Gemfibrozil, niacin, steroids	Salt restriction, high fiber diet, decreased saturated fats, increased omega oils, niacin, red yeast, botanical medicines
Obstructive Liver Disease	Jaundice	High cholesterol, high triglycerides	Surgery	Salt restriction, high fiber diet, decreased saturated fats, increased omega oils, niacin, red yeast, botanical medicines, milk thistle

Four Major Lipoproteins
- Chylomicrons
- Very Low Density Lipoproteins (VLDL)
- Low Density Lipoproteins (LDL)
- High Density Lipoproteins (HDL)

VLDL AND LDL METABOLISM

The liver produces very low-density lipoproteins (VLDL) in order to have cholesterol transported in a manner that can move through the blood. Very low-density lipoproteins contain cholesterol and triglycerides in the middle, encoated with three apolipoprotein structures that are surface molecules to be recognized by lipoprotein lipase. The apolipoproteins consist of Apo E, Apo B 100, and Apo CII. Lipoprotein lipase breaks down Apo E and Apo CII, leaving Apo B 100.

With the aid of lipoprotein lipase found in the endothelial walls of vessels, VLDL is then converted into LDL, where the cholesterol can be either used as substrates for steroid synthesis or for bile acids. The rest is deposited in extra hepatic tissue or oxidized in the arterial walls, becoming the precursor of plaque formation.

In general, we must try to decrease the oxidation of LDL and help with the elimination via bile acid secretion. Most people's LDL is high due to genetic, lifestyle, and other inheritance factors. It is often due to a secondary cause, such as hypothyroidism and insulin resistance.

LDL receptors are made in the endoplasmic reticulum and further processed in the golgi apparatus where they are excreted. The cholesterol synthesized with HMG CoA reductase enzyme is then either stored with the aid of the enzyme cholesterol acyltranferase, or exported into the plasma for the formation of cell membranes, steroid synthesis, or bile acids.

HDL METABOLISM

The liver has a central role in cholesterol balance. The liver is the main organ in both the production of cholesterol and the breaking down of cholesterol. HDL (high density lipoprotein) particles are produced in the liver and released into the blood. The function of HDL particles is to carry excess cholesterol from the cells back to the liver. The cholesterol returned to the liver can be reused or excreted in the bile.

Since HDL particles take cholesterol from the cells and remove it, it has earned the name "good" cholesterol. Higher levels of HDL in the blood are associated with less risk of cardiovascular disease. HDL levels are increased by exercise and decreased by excess insulin release. Just as there are genetic conditions in which people overproduce LDL, there are also some people who have a disposition to produce high levels of HDL. These people have very low rates of heart disease even into old age, and this seems to be unaffected by dietary fat intake.

Lipids Testing

Screening measures for clinical dyslipidemia can be performed in a non-fasting state. However, if the total cholesterol is > 240 mg/dl, or the HDL is < 35, a new blood draw and retesting are required in a fasting state.

Some values are measured, while others are calculated. LDL cholesterol and HDL is calculated by dividing triglycerides by 5, which provides the VLDL level. Then the VLDL is subtracted from the HDL to get the LDL. This calculation works for everyone except for patients with dysbetalipoproteinemia, due to its extreme high levels of triglycerides over 400 mg/dl. It is important to note that when ordering blood tests for lipids, exercise and diet will decrease LDL cholesterol.

RISK LEVELS AND FACTORS

The National Institutes for Health in the United States has developed a public screening guide to risk levels and risk factors for total cholesterol levels, as well as goals for HDL- and LDL-cholesterol. It examines 100 risk factors, including diabetes, LDL, HDL, smoking, lack of exercise, estrogen use, obesity, age, family history, hypertension, and gender. HDL under 30 mg/dl, smoking more than 10 cigarettes a day, and blood sugar over 126 in a fasting state are all considered significant risk factors.

Normal Distribution for Plasma Lipids and Lipoprotein Cholesterol

Age	Cholesterol mg/dl	Triglycerides mg/dl	VLDL mg/dl	LDL mg/dl	HDL mg/dl Male	HDL mg/dl Female
0-19	under 180	10-140	5-25	50-170	30-65	30-70
20-29	under 200	10-140	5-25	60-170	35-70	35-75
30-39	under 220	10-150	5-35	70-190	30-65	35-80
40-49	under 240	10-160	5-35	80-190	30-65	40-95
50-59	under 240	10-190	10-40	80-210	30-65	35-85

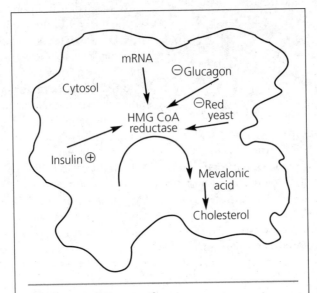

Cholesterol Formation

This chemical reaction with HMG-CoA begins in the cytosol, where HMG-CoA reductase is used as the main enzyme converting mevalonic acid into cholesterol. Insulin acts as a positive stimulus for this pathway, while glucagon and red yeast act as inhibitors.

Liver's Central Role in Cholesterol Balance

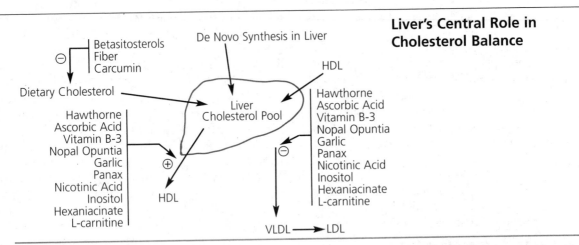

- The liver is the main organ in both the production and breakdown of cholesterol. Cholesterol in the form of high density lipoproteins (HDL) is brought to the liver. In patients with hypercholesterolemia, it is important that HDL levels are increased.
- Most natural medicines that have been shown to decrease cholesterol also help in increasing HDL, while simulaneously lowering LDL (low density lipoproteins). Many natural medicines increase levels of HDL, such as garlic, reishi mushroom, hawthorne berry, opuntia cactus, *Panax ginseng*, ascorbic acid, and niacin. Niacin has been shown to increase HDL by 33% as opposed to Lovastatin that increases it only by 7%.
- Cholesterol excretion from the body is in the form of bile acids and bile salts produced by the liver. Fiber, such as psillium husks, oatmeal, and opuntia cactus, is an effective method to help the body naturally excrete cholesterol and to reduce the 25% normally reabsorbed into the small intestine.

Risk Levels

Total cholesterol of 240 mg/dl or higher: A person found to have a total cholesterol level 240 mg/dl or higher should undergo further evaluation and further lipo-protein analysis, regardless of other risk factors.

HDL-cholesterol less than 35 mg/dl: A person found to have an HDL-cholesterol level less than 35 mg/dl should undergo further evaluation and further lipo-protein analysis, regardless of other risk factors.

Total cholesterol between 200 and 239 mg/dl: A person with total cholesterol between 200 and 239 mg d/l with two or more risk factors should be referred to further medical care. The value of good nutrition and regular physical activity should be reinforced.

Total cholesterol below 200 mg/dl: A person with total cholesterol below 200 mg/dl should undergo a regular cholesterol check every 5 years. The potential benefits of healthy eating habits, weight reduction (if overweight), and regular physical activity should be emphasized.

Risk Factors

- Coronary heart disease
- Heart attack (myocardial infarction)
- Angina pectoris
- Coronary bypass surgery
- Abdominal aortic aneurysm
- Blockage of arteries to legs
- Transient ischemic attacks
- Blockage of carotid artery
- Cigarette smoking
- High blood pressure
- Diabetes
- Heart attack of first-degree relative (mother, father, siblings) – if a male before age 55 or female before age 65
- Male 45 years or over
- Female 55 years or over

Primary Genetic Dyslipidemias

There are five primary, genetically-inherited dyslipidemias.

Dyslipidemia	Lab Values
Familial hypercholesterolemia	Very high levels of cholesterol
Familial combined hyperlipidemia	High levels of cholesterol and triglyceride
Familial dysbetalipoproteinemia	High levels of cholesterol and triglyceride
Polygenic hypercholesterolemia	High levels of cholesterol
Familial hypertriglyceridemia	Very high levels of triglyceride

FAMILIAL HYPERCHOLESTEROLEMIA

Familial hypercholesterolemia is a problem with either a completely defective or absent LDL receptor. There are two separate genetic types. Homozygous hypercholesterolemia results in cholesterol levels from 800 to 1200 mg/dl. These patients die usually from coronary artery disease by the age of 20. Heterozygous patients have much lower levels of cholesterol, usually under 300 mg/dl, and die from coronary artery disease by age 50. Triglycerides will usually be normal. Tendon xanthomas are characteristic of this condition.

FAMILIAL COMBINED HYPERLIPIDEMIA

Familial combined hyperlipidemia will result in both high levels of cholesterol and triglycerides. Patients are susceptible to premature coronary artery disease. This illness is due to excessive hepatic production of apoprotein B.

FAMILIAL DYSBETALIPOPROTEINEMIA

Familial dysbetalipoproteinemia will result in both high levels of cholesterol and triglycerides. It is caused by impaired apoprotein E, which results in abnormal clearance of VLDL by the liver. Xanthomas in the crease of their palms and soles of their feet are characteristic of this disorder. Familial dysbetalipoproteinemia has an abnormal apoprotein E. Thus, it binds poorly to hepatic receptors and it impairs the circulating LDL remnants. Apoprotein E is used to bind to the hepatic receptors. This will impair the clearance of circulating VLD. These patients will often have xanthomas in the crease of their palms and soles of their feet. It is very characteristic of this disorder.

POLYGENETIC HYPERCHOLESTEROLEMIA

Polygenetic hypercholesterolemia is due to several inherited genetic defects in cholesterol metabolism. This is the most common cause for elevated fats. These people will have mild to moderate serum cholesterol elevation. This will often be found within the context of insulin resistance and truncal obesity in syndrome X. Polygenetic hypercholesterolemia is due to several inherited genetic defects in cholesterol

metabolism. These people will have mild to moderate serum cholesterol elevation. Polygenic means that it affects many genes. Often you will see these type of patients within that context of syndrome X, with high lipids, high circulating insulin or insulin resistance, and truncal obesity.

FAMILIAR HYPERTRIGLYCERIDEMIA
Familiar hypertriglyceridemia is due to an excessive hepatic triglyceride synthesis. The difference between combined hyperlipidemia and familiar dysbetalipoproteinemia is both high cholesterol and high triglycerides, while familiar hyperlipidemia has an increase of apoprotein B receptors, and the dysbetalipoprotein has a normal Apo B but an abnormal Apo E. Familial hyperlipidemia will have elevated Apo B receptors.

Secondary Dyslipidemias
Secondary dyslipidemias are all secondary causes of serum lipid elevations from other illnesses. Diabetes mellitus, hypothyroidism, nephrotic syndrome, renal disease, and obstructive liver disease can contribute to dyslipidemias.

Iatrogenic causes include beta blockers and diuretics, progestins, androgens, estrogens, retinoids (such as Accutane, an analog of vitamin A), corticosteroids, anti-convulsant medications, Cyclosporin, and HIV drugs. Many of the drugs used in treating secondary complications of diabetes, such as beta blockers and diuretics, are helpful in treating the hypertension and edema, but cause other secondary complications of diabetes, such as dyslipidemia. Cardiovascular disease is the highest significant risk for a diabetic.

Cardiovascular Disease
The following conditions put people at increased risk for cardiovascular disease and dyslipidemia.[1]
- Family history of cardiovascular disease
- Diabetes
- Obesity
- Insulin resistance
- Hypertension
- Thyroid disorders
- Stress
- Chronic illness, including chronic fatigue
- Diets high in meat and saturated fats
- Diets low in essential fatty acids
- Lack of exercise
- Prescription drugs: oral contraceptives, Accutane, glucocorticoids, diuretics
- Hormone imbalances: estradiol, cortisol, melatonin, insulin
- Renal disease

ATHEROSCLEROSIS
Atherosclerosis is a complex disorder arising from the combined interaction of hormones, lipids, and cell proliferation, involving many cells, including arterial medial smooth muscle cells, endothelial cells, and macrophages. Atherosclerosis occurs when fat deposits form on the walls of major arteries throughout the body, particularly on the walls of coronary arteries. The process actually seems to develop in childhood with fatty streaks (atheromas) developing into fat debris at about age 25.[2]

The highest risk factor for atherosclerosis is LDL cholesterol. Patients who have highest risk factors for cardiovascular disease ideally need to bring down the LDL level to under 100 mg/dl. Patients who have moderate risk factors need to get it under 130 mg/dl.

HYPERCHOLESTEROLEMIA
High cholesterol levels are a significant risk factor for cardiovascular disease. For each 1% reduction in cholesterol, it is estimated that there is a 2% reduction in risk of coronary artery disease.

Cholesterol is synthesized in virtually all human tissues and therefore is found throughout the body. Higher concentrations are found in tissues that have essential roles in metabolism of cholesterol, such as the liver, adrenals, ovaries, and testes. The cytosol (the area) within the cell takes HMG-CoA, the building block for cholesterol, into a chemical reaction that converts mevalonic acid into cholesterol. The main enzyme necessary for this reaction involves the HMG Co A reductase. Lipitor and other drugs under the classification of statin drugs inhibit this pathway. Statin drugs are named after a compound synthesized

Hypercholesterolemia Causes
In treating high cholesterol levels, it is important to determine the cause. Causes of elevated serum cholesterol can be found in a variety of illnesses and conditions.

Lipoproteineimia	Nephrotic Syndrome	Hypothyroidism
Wilsons Temperature Syndrome	Oral Contraceptives	Normal Pregnancy
Acute Intermittent Porphyria	Cholestasis Intra and Extra Hepatic	

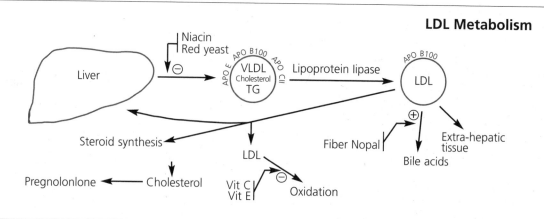

LDL Metabolism

- The liver produces very low density lipoproteins (VLDL) in order to have cholesterol transported in a manner that can move through the blood. VLDL molecules have cholesterol and triglycerides in their centers, encoated with three Apo lipoprotein structures that are surface molecules to be recognized by lipoprotein lipase.
- The Apo lipoproteins consist of Apo E, Apo B 100 and Apo CII. Lipoprotein lipase breaks Apo E and Apo CII, leaving the remaining Apo B 100. With the aid of lipoprotein lipase found in the endothelial walls of vessels, VLDLs are then converted into LDLs, where the cholesterol can either be used as substrates for steroid synthesis or for bile acids. The rest is deposited in extra hepatic tissue or becomes oxidized in the arterial walls, becoming the precursors of plaque formation.
- In patients with hypercholesterolemia, the formation of bile acids needs to be supported, while simultaneously inhibiting the deposition and oxidation of LDL.

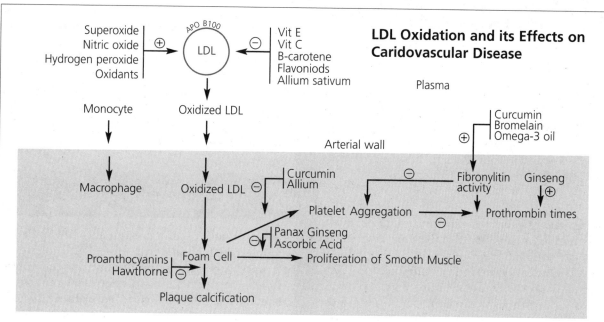

LDL Oxidation and its Effects on Caridovascular Disease

- Superoxide, nitrous oxide, hydrogen peroxide, and other oxidants cause LDL to become oxidized, which, in turn, causes a cascade of reactions leading to the formation of plaques. Antioxidants, such as vitamin E, vitamin C, B carotenes, flavonoids, and garlic, inhibit this pathway. This figure illustrates each specific point in the pathway that is inhibited or initiated by the different natural medicines shown.

from fungus that inhibits HMG Co A reductase. Insulin acts as a positive stimulus to increase the formation of cholesterol, while catabolic hormones, such as glucagon, inhibit this pathway.

In patients with hypercholesterolemia, it is important that HDL levels are increased. The formation of bile acids needs to be supported, while simultaneously inhibiting the deposition and oxidation of LDL. A holistic approach needs to be considered, in which the cholesterol formation by HMG Co A is not the only concern.

HYPOCHOLESTEROLEMIA

Patients with low levels of cholesterol are relatively rare in the Western world, but hypocholesterolemia is found in a variety of serious conditions as well. Just as in treating patients with hypercholesterolemia, a holistic approach needs to be taken and the root causes need to be addressed.

- ❖ Liver disease
- ❖ Malabsorption ex. Inflammatory Bowel Disease
- ❖ Malnutrition
- ❖ Hyperthryoidism
- ❖ Anemia
- ❖ Abetaliproteinemia

Statin Drugs

CONVENTIONAL
PHARMACEUTICAL TREATMENT

HMG CoA reductase inhibitors, more commonly known as statins, are the most common prescription for dyslipedemia. However, the voluntary withdrawal of cerivastatin (Baycol) from the U.S. market on August 8, 2001, by the manufacturer, in agreement with the Food and Drug Administration, has prompted concern. This drug, when removed from the market, had resulted in 31 deaths from rhabdomyolysis (muscle symptoms with marked CK elevation).[3]

Side Effects: In general, it is estimated that 5% of patients taking statins will experience general muscle aches and joint pain. Some of these patients will go on to develop rhabdomyolysis, a serious condition in which death may occur due to kidney failure. This is believed to occur because the statins, while blocking cholesterol synthesis in the liver, may also block the synthesis of nutrients important to cellular respiration in the mitochondrion, especially ubiquinone (Co-enzyme Q10).[4] However, 100 mg CoQ10 supplementation prevents plasma reduction of CoQ10 levels while taking statin drugs.

Whether this happens with red yeast extract is not known. However, many compounds that naturally occur and are taken as a whole plant do not have the same side effects of taking one isolated compound. For example, red yeast contains numerous different types of statins and antioxidants and flavanoids.

It is also estimated that up to 2% of all patients receiving statin therapy will develop elevated liver enzymes (hepatic transaminases), a blood marker of hepatotoxicity. This may progress to liver failure. Patients taking statins should therefore have their liver enzymes checked every 3 to 6 months.

Because of these side effects and adverse reactions, the FDA recommends prescribing cholesterol medications and statins only when cholesterol levels are markedly elevated or in those who have significant other risks of developing (or already have) coronary heart disease. Even when statins are prescribed, only 40% of people treated with cholesterol drugs actually achieve target goals within the United States national guidelines.

Finally, it must be noted that a number of medications, such as glucocorticoids, diuretics, and thiazides, have been shown to affect lipid levels negatively. For some patients, their statin prescription is deemed necessary only to manage the side effects of these other medications.

Coumadin and Natural Medicine

Conventional doctors will usually forbid the use of Siberian ginseng, vitamin E, and ginger while taking Coumadin because of its ability to lower levels of prothrombin. Coumadin is one of the most dangerous drugs; however, when administered in conjunction with natural medicines, lower doses of Coumadin can be used. By simply adding high levels of vitamin E at levels of 3200 E, one would be able to monitor the prothrombin time and adjust or eliminate Coumadin dosages.

NATUROPATHIC PREVENTION
AND TREATMENT

The aim of naturopathic treatments of dyslipidemia is to lower LDL cholesterol, raise HDL cholesterol, and support the organs, specifically the liver, involved in lipid metabolism. Lipid disorders can be effectively treated with natural medicine, especially if one takes in consideration all the different pathways of cholesterol metabolism. It is also important to note that most of the prescription drugs currently used for dyslipidemia originate from natural medicines. Patients will normally have a minimum 20% to 30 % decrease

in cholesterol and triglycerides, usually within 6 weeks with the use of a comprehensive program in natural medicine.

LOWERING LDL

The liver's production of LDL (low density lipoproteins) is the body's way of sending cholesterol to the rest of the body for deposition. In patients with high cholesterol, the formation of LDL needs to be inhibited. Botanical medicine and clinical nutrition are helpful in limiting this pathway.

Botanical Medicine

Nopal *(Opuntia streptacanthae)*: This herb is effective not only in the treatment of diabetes but also with hyperlipidemia. One study on healthy and diabetic subjects found that nopal intake before every meal for 10 days reduced body weight, as well as total cholesterol and triglycerides. Nopal also increases liver apolipoprotein receptors while decreasing LDL cholesterol in guinea pigs. The mechanism of action may be similar to bile acid sequestrants.

In another trial of 29 subjects who were administered nopal, including 8 healthy subjects, 14 obese subjects and 7 diabetic subjects, total cholesterol decreased a mean of 31 mg/dl in 26 out of 29 cases, and decreased in all nine cases with values higher than 240 mg/dl (6.2 mmol/l). Triglycerides also diminished in obese and in diabetic patients, while no changes occurred in healthy subjects with lower triglyceride levels. This is another example of how herbs seem to have their own intrinsic wisdom. In this case, nopal lowered triglyceride levels only when needed. The highest reductions were seen in subjects with highest triglyceride levels. In obese subjects, the mean initial value of 162 mg/dl decreased to 43.8 mg/dl. In the diabetic group, the mean value of 376 mg/dl was reduced to 93.5 mg/dl.[5-6]

Excessive cholesterol in the form of LDL will be partly excreted in bile, and thus a high fiber diet, supplemented with nopal, will support the elimination of these bile acids into stools.

Traditional Chinese Medicine

Hong Qu: A pulverized strain of rice called red yeast has been consumed for over 2,000 years as a culinary ingredient and a medicine to improve blood circulation. It contains over nine different statin compounds inhibiting HMG Co A reductase. In four studies with patient bases between 70 and 446, it has shown to decrease total cholesterol by 16.4% to 25.9%. Red yeast does not damage the liver, unlike prescription drugs containing statin.[7]

Clinical Nutrition

Vitamin B-3 (Niacin): Nicotinic acid has been shown to decrease LDL cholesterol by about 23% and lipoprotein A by 35%. The decrease of lipoprotein A is significant because it has been shown that high levels are correlated with premature coronary artery disease. This is a unique aspect of nicotinic acid since allopathic drugs, such as Lovastatin, increase these levels.[8-9]

Unlike many cholesterol drugs that have shown to reduce life expectancy, niacin has been shown to increase life expectancy. The Coronary drug project conducted in the 1970s showed that long-term death rate for patients treated was only reduced with niacin. Negative risk factors include HDL over 60 mg/dl. Thus a high HDL can outweigh the risk of high LDL.

About 20 to 30 minutes after first taking niacin, patients will notice harmless skin flushing. Occasionally, patients also notice nausea and liver enzyme increase. However, most reports of high levels of liver enzymes were found only in people taking sustained release. Sustained release is a preparation of niacin that is absorbed slowly in order to prevent flushing. *The Journal of the American Medical Association* has reported cases in which 52% of people using sustained release had elevated liver enzyme increase, while no cases of liver damage were found with niacin in itself.

There haven't been any reports of damage with inositol hexaniacinate (INH), another form of nicotinic acid, even at levels of 4 g daily. Patients may choose to take inositol hexanaicinate instead of niacin.[10]

CLINICAL STUDIES

Lovastatin vs. Niacin

In a study reported in *The Annals of Internal Medicine*, Lovastatin (prescription statin drug) and vitamin B-3 (niacin) were evaluated for their effect on LDL cholesterol. The results indicated that while Lovastatin produced a greater effect on LDL cholesterol, niacin was able to produce better over all results when all the lipid parameters were measured.

The 33% increase in HDL cholesterol found with the niacin group versus the 7% found with the Lovastatin group was indicative of the greater benefit of niacin, since HDL level is a more significant indicator for coronary heart disease than total cholesterol. Lipoprotein A is an independent risk factor for coronary heart disease, especially with patients with high LDL. The niacin group showed a 35% decrease while Lovastatin had no effect. This study correlated well with another previous study in which niacin at 4 g per day reduced lipoprotein A levels by 38.[11]

Lovastatin vs. Niacin Cholesterol Reductions in Percentages

Group	Week 10	Week 18	Week 26
LDL Cholesterol			
Lovastatin	26	28	32
Niacin	5	16	23
HDL Cholesterol Increase			
Lovastatin	6	8	7
Niacin	20	29	33
LP (A) Lipoprotein Reduction			
Lovastatin	0	0	0
Niacin	14	30	35

Inositol Hexaniacinate: Inositol hexaniacinate (INH) consists of six molecules of nicotinic acid (niacin with an inositol molecule in the center). It reaches maximum serum levels 10 hours after ingestion. As with niacin it decreases lipid deposition, decreases VLDL synthesis in the liver, resulting in a decrease in LDL, total cholesterol, and triglycerides. It also increases HDL by inhibiting its breakdown and further inhibits cholesterol synthesis in the liver. Studies have found INH to be more effective than niacin in its hypocholesterolemic action. Significant hypocholesterolemic effect took place at doses as low as 400 mg, 3 to 4 times a day.[12]

L-carnitine: This enzyme has been shown to be particularly effective in patients with fatty liver. This is a condition in which the liver is not able to handle effectively the metabolism of cholesterol, thus increasing an excessive amount of VLDL production.[13]

Beta-sitosterols: Liver function must be working at its optimal level when treating patients with dyslipidemia. Dietary cholesterol is the only pathway where exogenous cholesterol goes to the liver. Beta-sitosterols found in soy and red yeast extracts, fiber, and curcumin inhibit the absorption of cholesterol in the small intestine, thereby inhibiting the formation of chylomicron remnants.[14]

Bile Acid Resins: Approximately 25% of cholesterol is secreted in the bile every day and is reabsorbed in the intestines. Bile acid resins will support the excretion of cholesterol. However, they will also decrease all the fat vitamins: D, A, K, E and folic acid. The decreased absorption of vitamin D will consequently result in decreased calcium absorption.

The combined use of niacin or nicotinic acid with HMG-Co A reductase inhibitor may increase the likelihood of developing rhabdomyolysis and myopathy. HMG-Co A reductase inhibitors, such as statin drugs, decrease vitamin B-12 and folate absorption and deplete CoQ10 (a necessary cofactor in cardiovascular health.) CoQ10 supports all the cells of the body, especially cells that require a lot of energy, such as heart muscle.[15]

Antioxidants: Superoxide, nitrous oxide, hydrogen peroxide, and other oxidants cause LDL to become oxidized, which in turn causes a cascade of reactions leading to the formation of plaques. Monocytes, a type of WBC that attach to the oxidized LDL in the endothelial wall of the artery, are called macrophages. These macrophages eat up the LDL and form foam cells (lipid laden macrophages), which in turn cause platelet aggregation. Antioxidants, such as vitamin E, vitamin C, B carotenes, flavonoids, and garlic, have shown to inhibit this pathway.[16]

Other Supplements: Curcumin (turmeric), a common Indian spice, has been shown to inhibit platelet aggregation by decreasing thromboxane and increasing prostacyclin.[17] Capsicum, bromelain, Omega 3 oils, and garlic have shown to increase in fibrolytic activity. Siberian ginseng and vitamin E increase prothrombin time, thus inhibiting the ability for the body to produce plaques.[18]

Calcium Caution: Lipids are negatively charged ions and so is the phosphate PO4- and chondroitin sulfate, which is inside the endothelial tissue. Calcium, a positive ion, can make these two negative ions connect

and thus increase the chance of forming plaques in arteries. This is one reason that calcium should not be taken in megadosages.

MONOGRAPH

Inositol Hexaniacinate

(*Reprinted by permission of* Alternative Medicine Review, *1998;3(3). Copyright © Thorne Research, Inc. All rights reserved.*)

Inositol hexaniacinate (IHN) is the hexanicotinic acid ester of meso-inositol. This compound consists of six molecules of nicotinic acid (niacin) with an inositol molecule in the center. Pharmacokinetic studies indicate the molecule is, at least in part, absorbed intact, and hydrolyzed in the body with release of free niacin and inositol. It appears to be metabolized slowly, not reaching maximum serum levels until approximately 10 hours after ingestion.[19]

Mechanisms of Action: The mechanisms of action of inositol hexaniacinate are believed to be the same as those for niacin. These include a decrease in free fatty acid mobilization; a decrease in VLDL synthesis in the liver, resulting in a decrease in LDLs, total cholesterol, and triglycerides; inhibition of cholesterol synthesis in the liver; an increase in HDL levels by decreasing its catabolism; and fibrinolysis.

Clinical Indications:

Hyperlipidemia: Studies report significant lipid-lowering effects of IHN at doses of 400 mg 3-4 times daily. Welsh and Eade found IHN more effective than niacin in its hypocholesterolemic, antihypertensive, and lipotropic effects.[20-21]

Raynaud's Disease: A review of the literature reveals numerous positive studies on the use of IHN in Raynaud's disease. The typical dosage is 1 g daily for several months. The mechanism of action appears to be more than just a transient vasodilation, involving lipid-lowering and fibrinolysis. This explains the need for long-term administration.[22-23]

Intermittent Claudication: The use of niacin esters for the treatment of intermittent claudication secondary to atherosclerosis has been examined extensively. Significant improvement has been reported by several investigators at dosages of 2 g twice daily, typically for at least 3 months. While arterial dilation may be a factor, it has been postulated that reduction in fibrino-

gen, improvement in blood viscosity, and resultant improvement in oxygen transport are involved in the therapeutic effects.[24-26]

Other Peripheral Vascular Diseases: IHN appears to have application in the treatment of other conditions resulting from peripheral vascular insufficiency, including threatened amputation from gangrene, restless legs syndrome, stasis dermatitis, atherosclerosis-related migraines, and hypertension.[27]

Dermatological Conditions: IHN has been used for the treatment of various dermatological conditions with mixed results. Included were lesions of scleroderma, acne, dermatitis herpetiformis, exfoliative glossitis, and psoriasis. IHN appeared to help four out of five patients with dermatitis herpetiformis. The one patient with sclerodermal skin lesions was reported to have improved significantly on 1200 mg IHN daily. The results with other skin conditions have been less promising. It appears the dermatological problems most benefited by IHN are those related to vascular insufficiency.[28]

Dosage: Recommended dosage for lipid-lowering and improving conditions related to peripheral vascular insufficiency ranges from 1500 mg to 4 g daily, in divided dosages of two to three times daily.

Deficiency: Although the inositol hexaniacinate complex is not an essential nutrient, niacin is vital to cellular metabolism, principally through its role in the coenzymes, nicotine-adenine dinucleotide (NAD) and nicotine-adenine dinucleotide phosphate (NADP), in oxidation-reduction reactions. There are certain population fractions that may be deficient, requiring niacin supplementation to prevent pellagra. These groups include alcoholics and the elderly.

Toxicity: Numerous toxic reactions, both acute and chronic, have been reported from the use of high-dose niacin. Reactions to niacin range from acute symptoms of flushing, pruritis, and GI complaints to chronic symptoms of hepatotoxicity, hyperuricemia, and impaired glucose tolerance. On the other hand, no adverse effects have been reported from the use of inositol hexaniacinate in dosages as high as 4 g daily. Despite the lack of reported adverse reactions, use of IHN in patients with known liver disease probably should be avoided. In addition, if high doses (2 g or greater daily) are being administered, liver enzymes should be monitored every 2-3 months for at least the first 6 months.[29] Although no adverse reactions

between inositol hexaniacinate and other nutrients or drugs have been reported, due to its fibrinolytic effect it should be used with caution in conjunction with other blood thinners.

RAISING HDL

Most natural medicines that have been shown to decrease cholesterol also help in increasing HDL, while simultaneously lowering LDL.

There are many natural medicines that increase HDL, such as garlic, reishi mushroom, hawthorne berry (*Crataegus oxycanthus*), nopal (*Opuntia streptacanthe*), Panax ginseng, garlic, ascorbic acid, and niacin.[30-33]

The excretion of cholesterol from the body itself is in the form of bile acids and bile salts that are produced from the liver. This pathway can be supported with the use of Panax ginseng, globe artichoke, curcumin, and dandelion root.

Cholesterol in the bile is excreted into stool matter. Normally 25 % is reabsorbed into the small intestine. Natural fiber, such as psyllium husks, oatmeal, and nopal, has shown to be effective in further helping the body to excrete cholesterol.

Minor Hypertension

Hypertension of any sort can be well treated with herbal medicine. For minor hypertension, herbal combinations, such as the following, work very well with no side effects.

Formula for Minor Hypertension
- Hawthorne Berry
- Motherwort
- Valerian

Hawthorne berry (*Craetagus oxycanthus*): Hawthorne berry helps not only with hypertension but also hypotension due to its adaptogenic effects. It tones the heart. Hawthorne berry is a rich source of bioflavonoids, which are also important in preventing lipid peroxidation of LDL.[34]

Motherwort (*Leonurus cardiaca*): Motherwort is also a tonic for the heart and effective in minor to moderate hypertension. It also can be used as a beverage, eaten fresh in salads, or made into salad dressings.

Valerian (*Valerian officinalis*): Many patients with hypertension will also be suffering due to stress. Valerian is an ideal herb for hypertension because it is a smooth muscles relaxant of the arterial walls. It, too, can be consumed safely as a beverage.[35]

Moderate to Severe Hypertension

Severe hypertension can be also very well treated with herbal medicine. Unlike the herbs mentioned in moderate hypertension, these herbs should not be taken as foods. High doses should not be taken.

Formula for Severe Hypertension:
- Snakeroot
- Jamaican dogwood
- False Hellebore
 Dose: 20 drops two times a day

Snakeroot (*Rauwolfia serpentia*): The root contains 155 reserpine-rescinnamine groups of alkaloids called reserpine.[36] The genus name was named after a German botanist, Dr Rauwolfia. Serpentia refers to the long tapering snakelike roots of the plant. For thousands of years, Rauwolfia has been used in Ayurvedic medicine to treat a variety of disorders, ranging from hypertension and insomnia to insanity. In 1952, scientists isolated the compound alkaloid reserpine from the root for use in Western medicine. Currently, there are several drugs with this alkaloid, including Reserpine, Novoreserpine, and Serpasil.[37]

Jamaican dogwood (*Piscidia Erythrine*). This herb is a smooth muscle relaxant, similar to valerian, that can be very useful in treating hypertension by relaxing the smooth muscle of the vascular system.

Case Study
Lipids and Thyroid Metabolism Disorder

A 54-year-old female presented with hyperinsulinemia, diabetes, and hyperlipidemia. Her chief purpose for coming to our office was to lower her cholesterol with natural medicines. Physical exam revealed obesity and a temperature of 97.1°F, indicating an underactive thyroid. TSH levels were normal, indicating Wilsons temperature syndrome. A holistic therapy was prescribed to lower her lipids in order to restore healthy thyroid function first because the Wilsons temperature syndrome was the root cause of her high lipids and obesity.

Jambul and Devil's Club Extract: 1 teaspoon, t.i.d. to balance blood sugar and insulin levels
Kelp: 5 g daily to help with thyroid function
Lifestyle: Regular exercise also to help with thyroid function
Inositol Hexaniacinate: 1 g t.i.d. to lower lipid values

Case Study
Improvement of Essential Hypertension after EDTA Intravenous Infusion Treatment

Compiled by James A. Jackson, MT (ASCP)CLS, PhD, BCLD1, Professor and Chair, Clinical Sciences Department, The Wichita State University, Wichita, Kansas; and Hugh D. Riordan, MD, The Center for the Improvement of Human Functioning International, Inc., Wichita, Kansas.
Reprinted by permission from the Journal of Orthomolecular Medicine *1995;7(1).*

This white male patient was first seen at the Center in 1985 for treatment of angina and essential hypertension. He was 51 years of age with a long history of essential hypertension. He was told at about age 18 that he had "high blood pressure" with a systolic blood pressure of 180 mm/Hg. No treatment was prescribed at that time. The history also revealed that both his mother and father died at age 69 of myocardial infarction.

While in his twenties, he became a private pilot and passed three separate FAA flight physical examinations. On each examination a comment was made that "his blood pressure was a little high." Later, on a physical examination with a different physician, his blood pressure was 170/100 mm/Hg and he was diagnosed with essential hypertension. His medication consisted of daily doses of 120 mg of Inderal(R) "diazide capsules" and 3 SLOKr tablets. He failed his next FAA flight physical because of his essential hypertension and the medication being taken. He continued on medication over a period of 15 years with fluctuations in his blood pressure.

When first seen at the Center, his blood pressure was 140/85 with medication; 180/100 without medication. He was given an initial intravenous infusion of EDTA, which consisted of 3.0 g EDTA 15 g ascorbic acid buffered in sodium ascorbate (Bronson Pharmaceuticals), 800 mg magnesium chloride, 40.0 mg procaine, and 1000 units of heparin delivered in 500 ml of sterile, deionized water. Pre- and post-chelation 24 hour urine samples were collected, and aluminum, cadmium, lead, mercury, manganese, chromium, copper, iron, zinc, calcium, and magnesium levels measured.

The lead level was of particular interest, as several published studies demonstrated a relationship of lead levels and hypertension.[38-39] His pre-chelation urine lead level was 14.0 mg/24 hours. The post-chelation urine lead level was 91 mg/24 hours. The Center considers a 5-fold increase in urine lead excretion after chelation an indication of increased body load of lead. He was then started on a series of 30 EDTA intra-venous infusions administered at approximately weekly intervals over a period of 7 months. Each treatment was transfused over a period of 3-5 hours.

Other post-chelation urine studies were performed over a period of time and showed urine lead level of 39, 40, and 50 mg/24 hours, respectively. Complete blood counts, urinalysis, and chemistry profile were done throughout the treatment and showed no adverse effects of the treatment.

The patient slowly decreased his medication during the EDTA treatment and stopped them completely at the last chelation (March 14, 1986). His blood pressure at the last chelation was 124/84 mm/Hg. He has not taken any blood pressure medication since the last chelation treatment. He also decided to take another flight physical to renew his private pilot license. He passed without any problems.

References

1. McDermott MT. Endocrinology Secrets. Philadelphia, PA: Hanley and Belfus Inc., 1998.

2. Ross R. Factors influencing atherogenisis. In: Hurst JW, Schlant RC, Rackley CE, Sonnenblick EH, Wenger NK (eds). The Heart, Arteries and Veins. New York, NY: McGraw Hill, 1990:106-11.

3. Braun RN, Halhuber MJ, Hitzenberger G. Information regarding adverse drug effects and treatment indications ("package inserts") exemplified by cervistatin (Lipobay) Wien Med Wochenschr. 2003;153(3-4):80-82.

4. Meletis J. Interactions between Drugs and Natural Medicines. Sandy, OR: Eclectic Medical Publications, 1999.

5. Fernandez ML, Trejo A, McNamara C. Pectin isolated from prickly pear (Opuntia sp.) modifies low density lipoprotein metabolism in cholesterol in guinea pigs. New York, NY: Publication of the American Institute of Nutrition, 1990:1283.

6. Frati-Munari F, Raul T. Effect of Nopal (Opuntia sp.) on serum lipids, glycemia, and body weight. Arch. Invest. Med Mex 1983;14:117.

7. Wang J, Chi J, et al. Multicentre clinical trial of serum lipid lowering effects of Monasscus purpurues (red yeast) rice preparations from traditional Chinese medicine. Curr Theory Res 1997; 58(12);964-78.

8. Carlson L, Hamsten A, Asplund A. Pronounced lowering of serum levels of lipoprotein Lp(a) in hyperlipidaemic subjects treated with nicotinic acid. J Intern Med 1989;226:271-76.

9. Wang J, Chi J, et al. Multicentre clinical trial of serum lipid lowering effects of Monasscus purpurues (red yeast) rice preparations from traditional Chinese medicine. Curr Theory Res 1997; 58(12);964-78.

10. Welsh A, Eade M. Inositol hexanicotinate for improved nicotinic acid therapy. Int Record Med 1961;174:9-15.

11. Illingworth D, et al. Comparative effects of lovastatin and niacin in primary hypercholesterolemia. Arch Intern Med 1994;154,1586-95.

12. Welsh A, Eade M. Inositol hexanicotinate for improved nicotinic acid therapy. Int Record med 1961;174:9-15.

13. Tanaka Y, Sasaki R, Fukui F, Waki H, Kawabata T, Okazaki M, Hasegawa K, Ando S. Acetyl-L-carnitine supplementation restores decreased tissue carnitine levels and impaired lipid metabolism in aged rats. J Lipid Res. 2004 Apr;45(4):729-35.

14. Cicero AF, Minardi M, Mirembe S, Pedro E, Gaddi A. Effects of a new low dose soy protein/beta-sitosterol association on plasma lipid levels and oxidation. Eur J Nutr. 2004 Oct;43(5):319-22. Epub 2004 Jan 26.

15. Langsjoen et al. Usefulness of coenzyme Q10 in clinical cardiology: A long term study. Mol Aspects Med 1994;15 Suppl;S165-S175.

16. Faustino RS, Clark TA, Sobrattee S, Czubryl MP, Pierce GN. Differential antioxidant properties of red wine in water soluble and lipid soluble peroxyl radical generating systems. Mol Cell Biochem. 2004 Aug;263(1-2):211-15.

17. Park SD, Jung JH, Lee HW, Kwon YM, Chung KH, Kim MG, Kim CH. Zedoariae rhizoma and curcumin inhibits platelet-derived growth factor-induced proliferation of human hepatic myofibroblasts. Int Immunopharmacol. 2005 Mar;5(3):555-69.

18. Bakaltcheva I, Gyimah D, Reid T. Effects of alpha-tocopherol on platelets and the coagulation system. Platelets. 2001 Nov;12(7):389-94.

19. Harthon L, Brattsand R. Enzymatic hydrolysis of pentaerythritoltetranicotinate and meso-inositolhexanicotinate in blood and tissues. Arzneim-Forsch 1979;29:1859-62.

20. Welsh AL, Eade M. Inositol hexanicotinate for improved nicotinic acid therapy. Int Record Med 196;174:9-15.

21. El-Enein AMA, Hafez YS, Salem H, Abdel M. The role of nicotinic acid and inositol hexaniacinate as anticholesterolemic and antilipemic agents. Nutr Reports Int 1983;28:899-911.

22. Holti G. An experimentally controlled evaluation of the effect of inositol nicotinate upon the digital blood flow in patients with Raynaud's phenomenon. J Int Med Res 1979;7:473-83.

23. Aylward M. Hexopal in Raynaud's disease. J Int Med Res 1979;7:484-91.

24. O'Hara J. A double-blind placebo-controlled study of Hexopal in the treatment of intermittent claudication. J Int Med Res 1985;13:322-27.

25. O'Hara J, Jolly PN, Nicol CG. The therapeutic efficacy of inositol nicotinate (Hexopal) in intermittent claudication: A controlled trial. Br J Clin Practice 1988;42:377-83.

26. Tyson VCH. Treatment of intermittent claudication. Practitioner 1979;223:121-26.

27. Seckfort H. Treating circulatory problems with inositol nicotinic acid ester. Med Klin 1959; 10:416-18.

28. Seckfort H. Treating circulatory problems with inositol nicotinic acid ester. Med Klin 1959; 10:416-18.

29. Seckfort H. Treating circulatory problems with inositol nicotinic acid ester. Med Klin 1959; 10:416-18.

30. Turner B, Molgaard C, Marckmann P. Effect of garlic (Allium sativum) powder tablets on serum lipids, blood pressure and arterial stiffness in normo-lipidaemic volunteers: A randomised, double-blind, placebo-controlled trial. Br J Nutr. 2004 Oct;92(4):701-06.

31. Frati-Munari F, Raul T. Effect of Nopal (Opuntia sp.) on serum lipids, glycemia, and body weight. Arch. Invest. Med Mex 1983;14:117.

32. Farvid MS, Siassi F, Jalali M, Hosseini M, Saadat N. The impact of vitamin and/or mineral supplementation on lipid profiles in type 2 diabetes. Diabetes Res Clin Pract. 2004 Jul;65(1):21-28.

33. El-Enein AMA, Hafez YS, Salem H, Abdel M. The role of nicotinic acid and inositol hexaniacinate as anticholesterolemic and antilipemic agents. Nutr Reports Int 1983;28:899-911.

34. Wang SL, Li YD, Zhao Q. Effects of Crataegus pinnatifidae, Astragalus memoranaceus and Acanthopanax senticosus on cholesterol metabolism in the guinea pig. Zhong Xi Yi Jie He Za Zhi. 1987 Aug;7(8):483-84, 454.

35. Fields AM, Richards TA, Felton JA, Felton SK, Bayer EZ, Ibrahim IN, Kaye AD. Analysis of responses to valerian root extract in the feline pulmonary vascular bed. J Altern Complement Med. 2003 Dec;9(6):909-18.

36. Lopez-Munoz F, Bhatara VS, Alamo C, Cuenca E. Historical approach to reserpine discovery and its introduction in psychiatry. Actas Esp Psiquiatr. 2004 Nov-Dec;32(6):387-95.

37. Pirkle J, et al. The relationship between blood lead levels and blood pressure and its cardiovascular risk implications. Am. J. Epi. 1985;121:246-58.

38. Batuman V, et al. Contribution of lead to hypertension with renal impairment. N. Engl. J. Med. 1983;309:17-21.

THYROID AND PARATHYROID METABOLISM DISORDERS

THYROID
Pathophysiology Review

The thyroid gland covers the anterior surfaces of the second to fourth tracheal rings. It comprises a right and left lobe, separated in the middle by an area called the isthmus. It is surrounded with a fibrous capsule. The posterior layer contains four parathyroid glands.

The thyroid consists of loose tissue in the formation of grape-like clusters with many blood vessels. Microscopic analysis reveals follicle walls that are surrounded by cuboidal epithelial cells. The follicle cells produce a glycoprotein called thyroglobulin. With the incorporation of dietary iodine, thyroglobulin is further processed to form a variety of thyroid hormones, most importantly triiodothyronine, commonly referred to a T3, and thyroxine (tetraiodothyronine), commonly referred to as T4.

Hyperthyroid secretion of thyroid hormones results in excessive metabolism. Insufficient secretion of thyroid hormones will result in deficient metabolism.

Congenital thyroid insufficiency is manifested by dwarfism and mental retardation.

T3 AND T4 HORMONES

T3 is produced in small amounts from the thyroid, but, most significantly, it is converted in the liver and kidneys from T4. T4 secretion is controlled by the pituitary secretion of TSH (thyroid-stimulating hormone). Like many other endocrine systems, its regulation works by a negative feedback loop. Increase of TSH will result in an increase formation of thyroxine. A high thyroxine level will cause the TSH to decline.

T3 is the most active thyroid hormone. However, both T3 and T4 have the same function: they increase oxygen availability in virtually all tissues. T3 also functions in maintaining metabolic rate, growth, and development.

PARATHORMONE

The parathyroid glands lie posterior to the thyroid. It

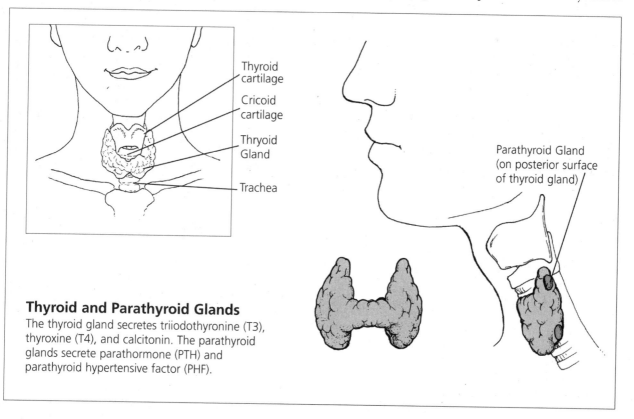

Thyroid cartilage

Cricoid cartilage

Thryoid Gland

Trachea

Parathyroid Gland (on posterior surface of thyroid gland)

Thyroid and Parathyroid Glands

The thyroid gland secretes triiodothyronine (T3), thyroxine (T4), and calcitonin. The parathyroid glands secrete parathormone (PTH) and parathyroid hypertensive factor (PHF).

Quick Reference: Major Thyroid Metabolism Disorders

Thyroid Metabolism Disorder	Major Signs and Symptoms	Key Laboratory Tests	Conventional Therapies	Naturopathic Therapies
Hypothyroid	Fatigue Lethargy	FT4 low, TSH high	T4	T4, T3, Armour, SR T3, botanical medicines, iodine, selenium
Subclinical Hypothyroidism (e.g.,Hashimoto's)	Fatigue Lethargy	FT4 normal, TSH high	T4	T4, T3, Armour, SR T3, botanical medicines, iodine, selenium
Wilsons Temperature Syndrome	Fatigue Lethargy	Low basal body temperature, normal TSH	None	WT3 therapy, botanical medicines, iodine, selenium
Hyperthyroidism (e.g., Graves', TMG, thyroid adenoma)	Heart palpitations Weight loss	FT4 high, TSH low	Tapazole, irradiation of thyroid	Botanical medicine
Subclinical Hyperthyroidism	Heart palpitations Weight loss	FT4 normal, TSH low	No treatment or Tapazole	Botanical medicine

Note: Naturopathic therapies will also include detoxification of heavy metals, which have been linked to thyroid disease, treating the digestive system for allergic food response, and treating the autoimmune aspect of the disease.

is a highly vascular tissue that secretes parathormone. Parathormone maintains calcium levels through out the body by stimulating osteoclastic activity (bone breakdown), freeing calcium ions. Reduced parathormone will result in low calcium levels manifesting as muscle stiffness, cramps, spasms, and convulsions.

Up to 30% to 40% of essential hypertension may be due to excessive parathyroid hypertensive factor (PHF), another hormone produced by the parathyroid gland.[1]

IODINE

The trace mineral iodine is an integral component of the thyroid hormones. Found primarily in sea life, iodine is absorbed into the body through the consumption of sea vegetables and seafood, such as fish and shellfish, and iodized table salt. Other foods, such as beans, nuts, seeds, and vegetables (peppers, spinach, chard, summer squash, turnip, onion, garlic), are good sources, provided that the soil contains sufficient quantities of iodine. Dairy and eggs will contain appreciable quantities of iodine depending on the dietary sources provided to the animals in question.

Concern about iodine deficiency leading to goiter resulted in the fortification of table salt with iodine in 1924 in the state of Michigan. Today, consumption of one gram of iodized salt provides 76 µg of iodine, while sea salt also contains iodine but in lesser amounts. Some bakers may add iodine to dough as a stabilizing agent, rendering up to 150 µg per slice.

Iodine is absorbed quickly through the skin or intestinal tract. On average, 30% is absorbed by the thyroid gland, depending on need, where it is incorporated into thyroid hormones. Iodine is also found in the salivary glands, breasts, choroid plexus, and gastric mucosa. Excess iodine is excreted in the urine or the sweat, tears, and bile.

There have been no reported cases of iodine toxicity from naturally occurring sources in food or water. The RDA of iodine is 150 µg for an adult male.

Iodine deficiency has been known to cause hypothyroidism. It has been associated with increased cholesterol levels, atherosclerosis, fibrocystic breast disease, and breast cancer. Iodine deficiency can also be devastating to the developing brain, causing a mental retardation known as cretinism. Most developed countries, therefore, screen for hypothyroidism at birth.

Toxic amounts of concentrated iodine taken orally can cause metallic taste, burning mouth, increased

salivation, headache, edema, acne, and gastric upset. Prolonged use can cause thyroid gland hyperplasia, thyroid adenoma, and hypothyroidism. Topically, iodine may stain skin, irritate tissues, and cause iodine burns in concentrations of 7% or more. Elemental iodine in the form of potassium iodide has been pre-scribe in very high doses such as 50 mg per day, with excellent results in terms of decreasing need of T4 in hypothyroid patients, and decreasing hypothyroid symptoms.[2] However doses at this high dose can potentially cause side effects such as skin outbreaks and palpitations and aggravations of thyroid nodules. In one study, potassium iodide, along with T4 ther-apy, inhibited and prevented the growth of thyroid benign nodes in approximately 66% of patients.[3]

→ Selected Clinical Studies and Literature Reviews

For a comprehensive review of iodine deficiency research and thyroid disorders, see Guy E. Abraham , Jorge D. Flechas, and John C. Hakala, "Orthoiodosup-plementation: Iodine Sufficiency of the Whole Human Body," in *Selected Clinical Studies and Literature Reviews*, pp. 306.

Laboratory Tests

MEASUREMENTS
Standard laboratory measures have been established for thyroid disease.

T3 and T4
This measure is a defining feature of the diseases. T3 and T4 levels are elevated in hyperthyroid and reduced in hypothyroidism.

Iodine Uptake
Radioactive iodine is utilized to allow monitoring of uptake, by measurement of radioactive emissions at the neck in the region of the thyroid gland. In gen-eral, iodine uptake is increased in hyperthyroid cases, due in part to the larger amount of thyroid tissue and the higher production of the iodine-based T3 and T4, and iodine uptake is reduced in hypothyroidism. Clinical values for iodine uptake usually keep pace with those for T3 and T4 production.

BMR
Basal metabolic rate is raised in hyperthyroid cases and lowered in hypothyroid cases. Because metabolic rate is influenced by T3 and T4 levels, the BMR meas-urement closely follows the T3 and T4 measures.

TSH
Thyroid-stimulating hormone is released from the pituitary in a feedback loop with T3/T4 levels in nor-mal individuals. TSH levels are usually reduced in hyperthyroidism and elevated in hypothyroidism.

TESTS
TSH Assay
The best test for thyroid function to rule out thyroid pathology is TSH (thyroid stimulating hormone). TSH is a highly sensitive assay. When TSH is high, the patient will have primary hypothyroidism. Low TSH levels indicate primary hyperthyroidism. If TSH is normal, it excludes any conventional primary thyroid pathology.

However, this does not take into account secondary thyroidism from the hypothalamus, or pituitary gland, subclinical hypothyroidism, Wilsons temperature syn-drome, or thyroid resistance. These conditions will usually have other symptoms that would suggest the need for further diagnostic work or clinical history.

When treating hypothyroid patients with exoge-nous hormones, TSH levels should be within normal range. However, one should not adjust dosage based on merely TSH values because it is much more impor-tant to adjust thyroid hormone supplementation based on clinical results. It should be low when thy-roid hormone therapy is used to suppress thyroid function as in benign nodules, thyroid malignancy, or Wilsons temperature syndrome.

Free Thyroid Hormone Assay
This the best test to order. Free T3 and T4 are unbound and bioactive. Free thyroid hormone levels are abnor-mal in thyroid dysfunction. If total thyroid levels are abnormal, it is possible that the thyroid may be function-ing fine, due to the fact that most thyroid hormones are bound to proteins: 99% of T4 and 98% of T3 are bound to the carrier proteins thyroid binding globulin (TBG), albumin, and pre-albumin. Factors that will increase binding capacity are pregnancy, estrogen, and increased levels of conjugated TBGs. Factors that decrease bind-ing are androgens and congenital TBG deficiency.

Blood Tests
Thyroid-stimulating immunoglobulin blood test is used to diagnose Grave's disease. Anti-thyroid perox-idase and antithyroglobulin antibodies are used to diagnose Hashimoto's thyroiditis.[4]

Calcitonin
Calcitonin levels are measured to diagnose medullary carcinoma of the thyroid. This is a very rare condition and need not be ordered on a routine thyroid test.

Thyroid Scan

A thyroid scan is good to rule out thyroid nodules. Thyroid scan presents diffuse trace uptake in Grave's disease and non-diffuse in toxic multinodular goiter. Discrete uptake in a single area presents as solitary toxic adenoma.

RAI

The difference between a thyroid scan and radioactive iodine uptake diagnostic testing is that RAI gives a quantitative status of thyroid gland, while the scan portrays a two-dimensional representation used to differentiate between isolated nodules and uniform distribution of the pathology. Radioactive iodine isotopes are used to distinguish causes of hyperthyroidism.

→ Selected Clinical Studies and Literature Reviews

For a full discussion of thyroid hormone metabolism and naturopathic treatments of thyroid disorders, see Gregory S. Kelly, "Peripheral Metabolism of Thyroid Hormones: A Review," in *Selected Clinical Studies and Literature Reviews*, pp. 285.

Thyrotoxicosis

Thyrotoxicosis refers to high levels of T4 and T3. It does not mean that the thyroid is toxic or symptomatic. Hyperthyroidism is a cause of thyrotoxicosis.

Thyrotoxicosis Symptoms
- Palpitations
- Jitters
- Insomnia, irritability
- Weight loss (occasionally, weight gain due to excess eating)
- Heat intolerance
- Fatigue
- Brittle hair
- Light flow during menses
- Warm, moist skin
- Hyperdefecation

Hyperthyroidism

The three main types of hyperthyroidism are Graves' disease, thyroid multinodular goiter, and toxic adenoma.

GRAVES' DISEASE

The most common cause of hyperthyroidism is Graves' disease, an autoimmune disorder in which antibod-ies destroy TSH receptors. Ophthalmopathy and pretibial myxedema are found in this condition. Graves' disease patients, as well as all hyperthyroid patients, can develop eyelid retraction and a distinctive stare. However, true ophthalmopathy is unique to Graves' disease and its proposed etiology is due to thyroid antibodies that cross-react with antigens in fibroblasts and adipocytes posterior to the eye.

TOXIC MULTINODULAR GOITER

Toxic multinodular goiter develops autonomic function and secretes thyroid hormone within the nodules.

TOXIC ADENOMA

Toxic adenoma presents itself with a benign tumor that leads to excessive activation of TSH receptors. Rare cases of hyperthyroidism are TSH pituitary adenomas.

CONVENTIONAL MEDICAL TREATMENT

Conventional treatment of hyperthyroidism includes propylthiouracil (PTU), radioiodine (RAI), and surgery. PTU blocks conversion of T4 to T3. RAI is the conventional treatment of choice for Graves' disease. Patients treated with radioactive iodine will no longer be hyperthyroid, but usually will be hypothyroid for life.

NATUROPATHIC MEDICAL TREATMENT AND PREVENTION

Hyperthyroidism, if not an immediate medical emergency, can often be successfully treated with a naturopathic approach. Patients treated effectively with natural medicine will have their thyroid restored to health, not partially destroyed by conventional radioactive treatment. For this reason, a naturopathic approach should almost always be tried first.

Botanical Medicine

Motherwort (*Leonurus cardiaca*): In the Middle Ages, motherwort was a remedy of choice for nervousness due to emotional excitement. The alkaloids in motherwort, specifically leonurine, act as a central nervous depressant and hypotensive. It is recommended as an adjuvant therapy for hyperthyroidism.[5]

Bugleweed (*Lycopus virginicus*): This herb is used as a vascular sedative, especially indicated for a rapid

pulse with a weak heart. It usually takes one week for effect. Pharmacology studies have shown that it cancels out gonadotropin hormone effect on anterior pituitary in animal studies. Diverse effects on the pituitary thyroidal system, as well as on the pituitary gonadal system, have been confirmed. In one animal study there was a pronounced decrease in T4 ,T3 and TSH levels within 24 hours. It inhibits iodine metabolism, inhibits release of thyroxine from the thyroid, decreases pulse rate, and decreases blood pressure.[6]

Clinical Nutrition

Soy: Short-term administration of dietary soy has a small but measurable effect on thyroid hormone levels increasing the T4/T3.[7]

Brassicas: Cabbage, cauliflower, and other brassica family vegetables have been known to be antithyroid in high dosages. In animal studies, boiled extracts showed maximum inhibition of thyroid peroxidase activity followed by cooked and raw extracts. Excess iodide was able to counteract its effects but not neutralize it.[8]

Traditional Chinese Medicine

The Chinese concept of hyperthyroidism is that there is usually an underlying deficiency of QI (vital energy) and yin (feminine energy), with an excess of heat, especially in the heart meridian. Although the concepts are totally different from Western medicine, traditional Chinese medicine has significant success in managing hyperthyroidism through a variety of herbs, in which TSH levels can be increased successfully.

Ayurvedic Medicine

Ayurvedic medicine interprets the hyperthyroid symptoms of nervousness, hypersensitivity to heat, palpitations, fatigue, increased appetite, and weight loss as caused by an imbalance of all three doshas, especially the pitta (fire doshas). The main herbs used are kanchanar guggul, triphala, and trikatu. Guggul is helpful for all thyroid conditions, hyper and hypo.

→ Selected Clinical Studies and Literature Reviews

For a full discussion of successful Chinese herbal treatments for thyroid disease, see Subhuti Dharmananda, "Treatments for Thyroid Disease with Chinese Herbal Medicine," in *Selected Clinical Studies and Literature Reviews*, pp. 317.

Hypothyroidism

Clinically serious low thyroid function will exhibit oral temperature as low as 93°F on rising from sleep, with symptoms of sluggishness and mild depression.

CAUSAL FACTORS

The two most common causes of hypothyroidism are chronic lymphocytic thyroiditis (Hashimoto's disease), an autoimmune form of thyroid condition, and iatrogenic causes due to radioactive iodine.

Autoimmune Disease

Autoimmune disorders, such as chronic lymphocytic thyroiditis, are the most common cause of thyroid problems in the United States. Also known as Hashimoto's disease, chronic lymphocytic thyroiditis commonly begins between the ages of 30 and 50. It affects women more often than men (8:1) and often causes a goiter. Approximately 20% of patients have symptoms of hypothyroidism when first diagnosed, while for the majority, hypothyroid symptoms will follow the goiter. Other forms of autoimmune disease may exist concomitantly with Hashimoto's thyroiditis, such as Addison's disease, rheumatoid arthritis, systemic lupus erythematosus, Sjögren's syndrome, and pernicious anemia.

Iatrogenic

Treatments for hyperthyroidism, such as thyroidectomy, Iodine 131 therapy, and antithyroid drugs, are common causes of hypothyroidism. Other prescribed agents that may block thyroid hormone synthesis include lithium carbonate, oral hypoglycemic agents, 6-mercaptopurine, P-aminosalicylic acid (PAS), amiodarone (antiarrhythmic, antianginal), tricyclic antidepressants, and interferon. Drugs associated with altered peripheral conversion of T4 to T3 include dexamethasone (corticosteroid), propylthiouracil, lopanic acid (radiographic contrast agent), amiodarone, and propanolol (beta blocker).[9]

Secondary Hypothyroidism

Pituitary disease can be caused by tumors, surgery, radiation therapy, or Sheehan's syndrome. Each of these causes a decrease in pituitary gland size and functioning. When the pituitary gland gets smaller as the result of tumors, surgery, or radiation, it cannot produce enough thyroid-stimulating hormone (TSH). Sheehan's syndrome occurs when there is necrosis (cell death) of the pituitary gland, typically related to childbirth in women.

Tertiary Hypothyroidism

Just as the pituitary gland releases TSH to tell the thyroid gland to produce thyroid hormone, there is a hormone released from the hypothalamus that tells the pituitary gland to release parathyroid hormone. Although it is rare, there is sometimes a problem with the hypothalamus, in which thyrotropin-releasing hormone is not released. This can be caused by radiation to the brain, trauma to the head, or other conditions that affect the hypothalamus.

Peripheral Hypothyroidism

Decreased conversion of T4 to T3, excess reverse T3, or thyroid hormone resistance can result in a peripheral hypothyroidism, in which the thyroid gland is functioning normally but the cells experience a lack of active thyroid hormone.

Other Pathologies

Certain diseases that affect the connective tissues in the body (for example, sarcoidosis, amyloidosis, and scleroderma) can affect the thyroid gland as well. When these diseases reach the thyroid gland, they add tissue (typically connective tissue) that is different from thyroid gland tissue, which ends up taking the place of the thyroid gland tissue. The connective tissue that replaces the thyroid gland tissue does not have the ability to produce thyroid hormone.

Congenital Disease

Although it is rare, approximately 1 in 5,000 babies are born with a malfunctioning thyroid gland or no thyroid gland at all.

Postpartum Thyroiditis

Fluctuating thyroid function after childbirth is common (5% to 10% of patients in some studies) and was first described in the 1970s. Thyroid inflammation may occur several months after childbirth, resulting in the development of clinical hyperthyroidism. In some patients, the hyperthyroid phase will be associated with significant damage to the thyroid as a consequence of the inflammation, and hence the hyperthyroid phase will be followed by the development of hypothyroidism.

Organophosphate Pesticides

Organophosphate pesticide levels correlate with endocrine pathologies. Organophosphate pesticides have been shown to decrease TSH levels, free T4, and free T3. They also increased adrenocorticotropic hormone and cortisol levels. Hexachlorobenzene (HCB), a commonly used pesticide, is highly lipophilic and accumulates in fat tissue. In a study performed at the Environmental and Respiratory Unit in Spain, it was found there was a negative association between serum HCB concentrations and total T4 levels (a decrease of .32 microg/dl per each unit, 1 ng/ml). These results suggest there is an effect on thyroid function. It could also be a contributing factor to peripheral metabolism of thyroid hormones. The importance of eating organic foods cannot be overemphasized for endocrine health.[10]

Toxic Metal Exposure

Exposure to toxic metals, such as cadmium, mercury, and lead, can result in altered thyroid hormone metabolism. Researchers have concluded that heavy metal toxicity damages antioxidant enzyme systems that protect cell membranes from lipid peroxidation. Increased lipid peroxidation in the presence of heavy metals can affect thyroid gland function and peripheral conversion of thyroid hormones.[11]

Stress

Low thyroid function often is triggered after trauma or grief and may act as a coping mechanism for a stressful situation. In critical illnesses and stressful situations, drugs and chemicals can alter the functions of neurotransmitters, which consequently affect pituitary hormone secretion. Even changes in serum cortisol within normal range can cause significant alterations in thyroid hormone levels.[12]

Nutrition

Fasting or deficiency of vitamins (riboflavin, niacin A, E), minerals (Se, I, Fe, Zn, K), or amino acids (cysteine, tyrosine) can lead to hypothyroidism.[13] Conversely, excess consumption of certain foods, known as goitrogens, can induce hypothyroidism. These include brassicas (cabbage, kale, brussel sprouts, mustard, cauliflower), rutabagas, peanuts, turnips, peaches, pears, spinach, and soy.[14]

Lifestyle

Aerobic exercise, full spectrum light, and stress management all seem to support proper thyroid function and peripheral conversion. Conversely, stress, sleep deprivation, and excess alcohol intake appear to impair thyroid hormone function.[15]

SIGNS AND SYMPTOMS

Subclinical hypothyroidism refers to patients who exhibit typical hypothyroid symptoms of cold intolerance and fatigue. They have normal levels of thyroxine, while slightly elevated TSH levels. Patients can

also have normal thyroid tests and exhibit hypothyroid symptoms; this is identified as Wilsons temperature syndrome.

Common signs of moderate to severe hypothyroidism include hypertension, bradycardia, coarse hair, periorbital swelling, yellow skin due to elevated beta carotene, delayed relaxation of deep tendon reflexes, and, surprisingly, carpal tunnel syndrome.

Physical exam will reveal an enlarged but firm consistency of the thyroid. Although less common, there can also be a variety of other concomitant symptoms, such as megacolon, cardiomegaly, and congestive heart failure. There is one documented case in which a heart transplant was not needed after simply taking thyroid hormone replacement alone.

Post-partum hypothyroidism occurs transiently after pregnancy, accounting for 5% to 10% of patients, while 20% of women over age 50 years have subclinical hypothyroidism indicated by normal levels of T3, and T4, and mild elevated TSH. Subclinical hypothyroid needs to be treated not only for symptomatic relief but also due to its close association with hypercholesterolemia and cardiac abnormalities.

Hypothyroid Symptoms
- Fatigue
- Cold intolerance
- Depression
- Weight gain
- Weakness
- Joint aches
- Constipation
- Dry skin
- Hair loss
- Menstrual irregularities

Testing

There is only one diagnostic test needed in screening for primary thyroid disease — TSH levels. TSH is the single most sensitive indicator of thyroid function in the non-stressed state. Thyroid antibodies, an indicator of autoimmune thyroid disease, help to predict clinical hypothyroidism. However, currently there is no lab test for peripheral function of thyroid hormones, except symptoms and low body temperature. Many patients who have Wilsons temperature syndrome will exhibit adrenal insufficiency and low blood pressure commonly found in chronic fatigue syndrome and fibromyalgia syndrome.

Deficiencies Leading to Hypothyroidism by Impairing T3 to T4 Conversion

Trace Minerals:	Selenium, iodine, iron, zinc
Vitamins:	Vitamin A, B2, E
Amino Acids :	Cysteine, tyrosine
Energy Compounds:	Glucose ATP, NAD, NADH-O_2
Nutrition	Fasting, starvation, anorexia, protein or calorie malnutrition, lack of hydrocarbons lack of fats (severe deficiency)
Hormones:	GH, TSH, insulin, FSH, melatonin, prolactin
Environmental:	Pesticides

Excesses Leading to Hypothyroidism

Trace Minerals:	Cadmium, lithium, copper (impair T3-T4 conversion)
Nutrition:	High soy diets (impair T3-T4 conversion)[16, 17]
Hormones:	Estrogen dominance[18] Stress hormones: catecholamines, ACTH, cortisol, vasopressin, angiotensin II, glucagon, rT3
Medications:	Beta-blockers, propyl-thiouracil PTU, theophylline, clomipramine, amiodarone, chemotherapeutic agents, Phenytoin, röntgen contrast products[19]
Toxins:	Alcohol Digestive toxins: cholera, botulinum, candida, cyanide, thiocyanate[20]

CONVENTIONAL MEDICAL TREATMENT

Often Armour thyroid (desiccated bovine thyroid tissue) or Synthroid is prescribed. However, the use of a holistic approach, with an understanding of the effects of the peripheral metabolism of thyroid hormones, may reduce or eliminate the need for drugs.

NATUROPATHIC MEDICAL TREATMENT AND PREVENTION

Botanical Medicine

Ashwagandha (*Withania somnifera*): Studies have been conducted to investigate the effects of ashwagandha on thyroid and liver function. Mice given high doses (1.4g/kg) of the root extract showed significant increases in serum levels of T3 and T4. Furthermore, the extract was shown to reduce hepatic lipid peroxidation significantly while increasing the activity of superoxide dismutase and catalase. These results indicate that ashwagandha stimulates both thyroid and hepatic antioxidant activity.[21-23]

Kelp: Seaweed therapy (kelp) at 5 g per day seems to help relieve many of the symptoms of iodine remineralization and strengthens the thyroid gland. Clinically, it is useful. TSH may respond after 2 to 4 months with 5 g per day. It is also helpful in patients with thyroidectomies and as an adjunctive treatment with thyroid hormone replacement. It contains weak hormone activity with the compound di iodotyrosine.[24] Di iodotyrosine is the building block for T3 and T4 production.

→ Selected Clinical Studies and Literature Reviews

For a study of thyroid dysfunction and the use of seaweed therapy, see Ryan Drum, "Thyroid Function and Dysfunction," in *Selected Clinical Studies and Literature Reviews*, pp. 336.

Clinical Nutrition

Tyrosine: This amino acid attaches to iodine atoms to form active thyroid hormones. Low plasma tyrosine levels have been associated with hypothyroidism, low blood pressure, low body temperature, and restless leg syndrome.

Iodine: Anywhere between 150 mcg to 50 mg daily can be prescribed. Hypothyroid symptoms can often decrease quickly with the use of this element.[25]

Selenium: Selenium is used for the formation of selenocysteine. This trace mineral has been shown to have strong effects on peripheral thyroid function because it is the cofactor for hepatic 5'- deiodinase. Selenium has been found to influence metabolism of thyroid hormones positively. In a randomized clinical trial of 24 critically ill patients, parenteral supplementation of 500 mcg of sodium selenite b.i.f. for week 1, then 500 mcg daily for 2 weeks, and 100 mcg for week three, free T3 levels were restored. Selenium supplementation also has been shown to decrease thyroid peroxidase levels in Hashimoto's disease.[26,27]

Triiodothyronine (SR-T3): One specific thyroid hormone, sustained release triiodothyronine (SR-T3), has gained popularity in the complementary and alternative medical community in the treatment of fatigue, with a protocol (WT3) pioneered by Dr Denis Wilson. The WT3 protocol involves the use of SR-T3 taken orally by the patient every 12 hours according to a cyclic dose schedule determined by patient response. The patient is then weaned once a body temperature of 98.6°F has been maintained for 3 consecutive weeks. The symptoms associated with this protocol have been given the name Wilsons Temperature Syndrome (WTS).

Although there have been clinical studies historically using T3 in patients who are euthyroid based on normal TSH values, the use of T3 in clinical practice, specifically the WT3 protocol, has gained significant popularity in the alternative medicine community. This treatment has created a controversy in the conventional medical community, however, especially with the American Thyroid Association, because it is not based on a measured deficiency of thyroid hormone. However, just as estrogen and progesterone are prescribed to regulate menstrual cycles in patients who have normal serum hormone levels, the WT3 therapy can be used to regulate metabolism despite normal serum thyroid hormone levels. SR-T3 prescription is based exclusively on low body temperature and presentation of symptoms.

Decreased T3 function exerts widespread effects throughout the body. It can decrease serotonin and growth hormone levels and increase the number of adrenal hormone receptor sites. These effects may explain some of the symptoms observed in WTS. The dysregulation of neuroendocrine function may begin to explain such symptoms as alpha intrusion into slow wave sleep, decrease in blood flow to the brain, alterations in carbohydrate metabolism, fatigue, myalgia and arthralgia, depression, and cognitive dysfunction.[28] Low body temperature, depression, and chronic fatigue indicate a hypometabolic state not unlike that of hypothyroidism.[29-30] WT3 therapy may well re-establish normal functions.

Wilsons Temperature Syndrome

The hallmark symptoms of Wilsons temperature syndrome (WTS) – fatigue, anxiety, depression, headaches, insomnia, and muscle aches — are indistinguishable from chronic fatigue syndrome (CFS),

except that WTS requires low body temperature as diagnostic of WTS. WTS patients suffer from a wide range of debilitating symptoms, including persistent or relapsing fatigue, muscle aches, insomnia, cognitive dysfunction, and an overall lack of well-being. These symptoms resemble those of conventionally recognized hypothyroidism and of CFS.[31-33]

CFS is characterized by persistent or relapsing debilitating fatigue that has continued for at least 6 months in the absence of any other definitive diagnosis. The source of the fatigue is unknown and the illness is not alleviated with bed rest. Symptoms vary from person to person and fluctuate in severity. CFS patients function significantly below their pre-illness capabilities. Their quality of life is considerably affected. Although patients experience the illness, the symptoms do not have outward identifying physical manifestations.[34]

Although WTS does not require the strict definition of fatigue lasting for more than 6 months, it still appears that in most cases the definition is indistinguishable from CFS, except that WTS includes patients who have mild fatigue and it does not require other symptoms to be present at the same time. CFS includes fever as one potential symptom, while WTS requires low body temperature.

LOW BODY TEMPERATURE

Many patients who have low body temperature do not suffer from WTS. Low body temperature in itself is not diagnostic of WTS, without a minimum of one accompanying symptom. However, low body temperature appears as a biological marker that consistently and predictably changes during the progression from illness to health.

Although not always noted clinically, CFS patients often self-report low average body temperatures. This low body temperature has been attributed by some researchers to circadian rhythm disruption.[35] However, other researchers have found normal mean core body temperatures in CFS patients. It is possible that the subset of CFS patients who suffer from low body temperature weren't represented in this study. Alternatively, because CFS patients experience circadian dysrhythmia as demonstrated by their disrupted sleep patterns and salivary cortisol levels, it is possible that the results in this study were affected by the time of day that the study was performed, rather than the mean average of temperatures taken throughout the day.[36-37]

CHRONIC FATIGUE SYNDROME AND FIBROMYALGIA SYNDROME

CFS shares many features with fibromyalgia syndrome

CLINICAL STUDY
T3 Treatments for Euthyroid Hypometabolism

The use of T3 for patients suffering from euthyroid hypometabolic states was first described in the early 1950s. Euthyroid hypometabolism was described as a group of symptoms very similar to CFS, including fatigue, lethargy, irritability, headaches, and musculoskeletal pain with the absence of any known underlying cause, including normal TSH levels. Studies performed by Kurland, Sonkin, Title, and Morton reported the efficacy of synthetic T3 (liothyronine sodium) in eliminating the symptoms of hypometabolism.

One such study performed by Sonkin prescribed thyroid therapy for 88 patients suffering from euthyroid hypometabolism. He scored the symptoms of each patient for the following symptoms before and after thyroid therapy. The following results indicated that T3 was effective in alleviating euthyroid hypometabolism.[38-40]

Complaint	Total	Positive Responses
Fatigue	88	51
Myofascial Pain	63	46
Depression	39	20
Headache	4	3
Nervousness	2	0
Insomnia	3	1

Psychiatric research in the use of T3 on euthyroid patients has indicated that people need a decreased dose of antidepressants when taking T3, and that it is also a rapid, safe, and effective way of treating depression that fail to respond to tricyclics.[41-42] This might be the mechanism in which WTS patients notice decreased depression from the WT3 protocol.

(FMS).[43] The predominance of pain or fatigue is the primary means of distinguishing between these two syndromes. Precedence for the use of T3 to treat CFS can be found in recent successful FMS studies. One study found that 75.32% of FMS patients experienced decreased tender point sensitivity as measured by algometry after treatment with 75-150 mcg T3 in conjunction with other lifestyle changes, including unspecified increases in aerobic activity, diet changes, and nutrient supplementation.[44]

Other studies found that supraphysiologic doses of T3 produced significant improvement in all measured parameters. These included algometer measurement of tender point sensitivity, American College of Rheumatology measurement of pain distribution, Visual Analog Scale measurement of symptom

intensity, Fibromyalgia Impact Questionnaire scores, and Zung's Depression Inventory scores. Mean heart rate elevations were noted during treatment as opposed to placebo phases, but there was no report of tachycardia or symptoms of thyrotoxicosis.[45-46]

The Center of Disease Control (CDC) hypothesizes that CFS might be caused by an initial trigger, such as a stress in the form of an infectious agent, toxin or illness, that can cause a hit and run situation in which once the trigger has happened, the body shifts into a hypo-metabolic state.[47] The hypothesis that a subtle thyroid defect might be a secondary response from the initial trigger of stress has not been fully explored, but it has been well documented that the conversion of T4 to T3 decreases under periods of physical injury, as well as chronic or acute illness.[48-49] However, even after the initial injury to the body has passed, the body sometimes has not yet fully recovered.

CLINICAL STUDIES

T3 Treatments

A 2001 study published in *The New England Journal of Medicine* shows that mood, neuropsychological function, and cognitive abilities were much improved in patients who had taken T3 as opposed to T4 (levothyroxine). Although the participants in the study were hypothyroid, the important aspect in the study was that the patients were already taking exogenous T4 and thus had euthyroid TSH and T4 blood values, but still had hypothyroid cognitive symptoms that were resolved with T3 therapy. It was concluded that T3 had much more of an impact in human physiology than once traditionally thought.[50-51]

THYROID RESISTANCE

Not only is it possible that a problem with conversion of thyroid hormone might occur, but there is evidence that thyroid resistance might well be a secondary response to the initial trigger causing CFS. Although the concept of euthyroid fatigue was recognized in conventional medicine in the 1950, it is not until recently that it is gaining acceptance again in the medical literature. Current medical literature is identifying euthyroid patients who exhibit hypothyroid symptoms as thyroid resistance. Thyroid resistance shares many of the same symptoms as CFS, including headaches, anxiety, fatigue, and recurring sore throats.

One postulated mechanism for thyroid hormone resistance found in WTS/CFS might be due to a dysregulation in the type I interferons (IFN-alpha/beta) pathway. This results in a sustained upregulation of 2('),5(')-oligoadenylate synthetases (2-5OAS). Patients treated with IFN-alpha/beta therapy usually com-

plain of severe fatigue as a limiting side effect, perhaps due to the same effect. The 2-5OAS, IFN-alpha/beta instigates the expression of three closely related proteins. The amino acid sequences of the 2-5OASL proteins display 96% identity with the partial sequence of the thyroid receptor interacting protein (TRIP). It is hypothesized that the 2-5OASL proteins are TRIPs mechanism of suppressing the TR transactivation and/or possibly destroying the thyroid receptor by the proteasome. This is perhaps how CFS/WTS patients might have normal TSH values yet have a clinical hypothyroid state in CFS/WTS.[52]

One other mechanism of thyroid resistance found in CFS might be due to a chronic consumptive coagulopathy, which itself might be associated with chronic infections, such as mycoplasmids, and other microbes. It is suggested that supraphysiological doses of thyroid hormone or anti-coagulants and anti-infective agents might be effective treatments options. Current research has not found any clear association between an infectious agent and CFS.[53] However, based on a multi-causal model, it is possible that some infectious agent might be a contributory cause for a certain subset of patients, or that it might be a trigger for CFS even after the infection is gone.[54]

Immune system defect might be involved in a certain amount of CFS patients. There is evidence of inappropriate cytokine response.[55] The etiological cause is still not known. However, it is hypothesized that it might be due to decreased thyroid function. Thyroid resistance has been associated with increased infections, such as chronic sore throats.[56]

Stress stimulates the hypothalamic-pituitary-adrenal axis (or HPA axis), which leads to increased levels of cortisol. Increased levels of cortisol inhibit thyroid function.[57] Some CFS studies have found cortisol levels to be lower than healthy controls.[58] However, since studies have not found conclusively that cortisol replacement is an effective treatment, cortisol deficiency as the main causative factor for CFS seems not promising. Low thyroid function has shown to affect cortisol levels.[59] Some researchers have found that hypothyroidism increases cortisol levels and others have found that it decreases cortisol levels.[60]

In conclusion CFS/WTS might have a variety of causative factors that compromise immune system by stress or other insults that come from viruses, bacteria, toxins, or other triggering agents that upset the body's normal functioning. After the initial insult to the body, CFS/WTS symptoms remain, perhaps due to thyroid hormone resistance or peripheral thyroid hormone conversion problems.

Regardless of the mechanism, WT3 therapy seems to restore metabolism to most patients.

Case Study

WTS Protocol for CFS

We performed an in-house study in which 11 patients diagnosed with CFS were given the WTS protocol. Each patient was given a physical exam and multi-chemistry panel to rule out any other medically identifiable causes of fatigue. We asked patients to evaluate symptoms of CFS numerically before and after treatment. Treatment was considered complete when the patient was able to maintain a body temperature of 98.6°F. The table below presents the results. A value of '10' represents greatest severity of symptoms, while '1' represents the least severity. A value of '0' represents absence of symptoms. Each patient required a different amount of time to achieve normalization of body temperature. Recovery time varied between 3 weeks and 12 months.

Patient	Before or After Rx	Fatigue	Headaches	Anxiety	Insomnia	Myalgia	Patient Mean	Patient Temp
1	Before	10	10	8	10	0	7.6	97.9∞ F
	After	4	5	2	2	0	2.6	98.6
2	Before	10	0	7	0	10	5.4	96.9
	After	0	0	1	0	1	0.4	98.6
3	Before	9	0	5	7	7	5.6	97.7
	After	0	0	5	3	1	1.8	98.6
4	Before	10	0	10	10	10	8	97.6
	After	3	0	2	3	1	1.8	98.6
5	Before	8	9	6	8	0	6.2	97.8
	After	1	2	3	0	0	1.2	98.6
6	Before	10	7	9	7	6	7.8	96.9
	After	0	0	0	0	0	0	98.6
7	Before	10	10	0	10	10	8	97.7
	After	0	1	0	0	0	0.2	98.7
8	Before	8	2	3	6	9	5.6	98.4
	After	2	0	2	6	3	2.6	98.6
9	Before	8	2	6	2	5	4.6	97.5
	After	2	1	5	2	3	2.6	98.6
10	Before	10	10	7	9	7	8.6	96.5
	After	0	0	4	2	2	1.6	98.6
11	Before	8	4	9	9	8	7.6	96.9
	After	4	4	7	4	2	4.2	98.6
Mean	Before	9.18	4.91	6.36	7.09	6.55	6.82	
	After	1.45	1.18	2.82	2.00	1.18	1.73	

A statistical analysis of these results, conducted by Michael Aikin (PhD) at Kaiser Permanente, revealed the following:

Factor	Mean Change	SE P-value (Adjusted for Baseline)
Fatigue	-7.7	.49 0.00
Headache	-3.7	.51 0.00
Anxiety	-3.5	.69 0.001
Insomnia	-5.1	.61 0.000
Myalgia	-5.3	.35 0.000

After the treatment is discontinued, normally 3 to 6 months after initiation of treatment, the majority of CFS patients report significant and continued improvement in their symptoms. Most patients experience complete resolution of their CFS symptoms persisting years after treatment has been discontinued. Based on clinical observations, many patients are completely freed of fatigue, depression, muscle aches, and other complaints related to CFS.

In addition, if it is demonstrated that return of oral temperature to 98.6°F correlates closely with restoration of good health in a high percentage of CFS patients, this may indicate that body temperature in itself is a useful biological marker that can be reset to normal. Since many patients who have low body temperature do not have CFS, we do not propose that it in itself is diagnostic of CFS, but rather that it is a biological marker that consistently and predictably changes during this progression.

MONOGRAPH

SR-T3 Protocol

(*Reproduced from WTSmed.com, with adaptations, by permission.*)

In the clinical setting, T3 therapy is not used to correct a measurable thyroid hormone deficiency, but rather to recalibrate metabolism and body temperature patterns.

Dr Denis Wilson developed the SR-T3 treatment protocol over a 2-year period via empirical observations of treating patients with intractable fatigue. He subsequently treated more than 5,000 people over a period of 4 years. The Wilsons temperature syndrome (WTS) web site (www.WTSmed.com), established in 1997, provides information to the general public regarding Wilsons temperature syndrome. The web site designates at least 250 doctors in the United States (as well as others in Australia, Canada, Finland, New Zealand, Russia, and the United Kingdom) on its list of "Wilsons Temperature Syndrome Treating Physicians." Currently, there is an estimated 1,000 American doctors who use the therapy for fatigue and other WTS symptoms.

Unique Features

The unique features of the Wilson protocol that distinguish it from conventional T3 therapy are that it uses a sustained release form of T3, as opposed to Cytomel, and it is cyclic in its administration, with the dose and cycle-length adjusted according to patient symptomatic response. The subjects are treated with Liothyronine compounded in a hydrophilic matrix system, employing hydroxypropyl-methylcellulose (HPMC) designed to be taken every 12 hours. The liothyronine is synthetically made and does not differ from any standard pharmaceutical preparation of T3, except that it is compounded with the sustained release agent methylcellulose. Clinical observation using SR-T3 shows that prolonged exposure to T3 changes patient susceptibility to the drug, necessitating alterations in dose. For example, the first cycle SR-T3 may require 90 mcg of T3 b.i.d. to obtain a normal temperature, while the second cycle may require only 45 mcg of T3 to achieve the same temperature. Body temperature is used in determining dosage and cycle length.

The original protocol used liothyronine sodium (Cytomel), but undesirable side effects (e.g., irregular heartbeat and occasional atrial fibrillation) prompted exclusive use of SR-T3. The SR-T3 produced fewer and milder side effects.

However, a significant number of patients still suffer from some symptoms, including increased awareness of heartbeats, heart palpitations, increased heart rate, irritability, shakiness, fatigue, and headaches. These effects are usually successfully treated with a "test dose" of T4. A test dose of T4 is a small dosage (.0125-.025 mg) of Levothyroxine taken to dampen the effects of T3 therapy through competitive inhibition of T3 by T4. T4 has 25% the potency of T3, and administration of T4 usually decreases or eliminates the side effects of T3 therapy within 45 minutes.

The clinical experience of numerous physicians suggests that T3 compounded in a hydrophilic matrix system (sustained release system) in capsules taken every 12 hours provides a predictable, well-tolerated means to influence body temperature patterns and alleviate the debilitating symptoms experienced by WTS patients. Once symptoms improve or resolve, patients are able to wean off SR-T3 therapy. Patients often report no return of symptoms after the treatment has been discontinued. Some patients do relapse, but a very short cycle of SR-T3 will bring them back to normal.

Long-term Success

The use of T3 outside of the WT3 protocol has not been shown to normalize body temperature. Dr Wilson's clinical experience indicates that long-term success in resetting metabolism and alleviating symptoms using the cyclic SR-T3 therapy proposed for this study seems to be related to holding body temperatures close to 98.6°F for a specified set of time. Patients whose body temperatures have been successfully raised to or near 98.6°F show sustained positive responses after the treatment is discontinued. Patients whose oral temperatures are not successfully raised to that level seem to retain less benefit from the treatment.

It is known that exogenous T3 suppresses T4 levels due to negative feedback inhibition of TSH. It is speculated that T4 suppression is an important effect of the Wilson protocol that is essential to its effectiveness. Often more than one cycle of SR-T3 therapy may be needed to increase body temperature to near-normal values. In many cases, one or more cycles reaching a maximum dose of SR-T3 (90 mcg b.i.d.) fails to raise the patient's temperature to normal. The temperature may reach normal on a subsequent cycle at a lower dose. In such cases, we speculate that greater T4 suppression is achieved with each successive cycle until the body temperature reaches normal. Serial measurements of serum free T4 may help to elucidate this proposed mechanism.

It is speculated that T4 suppression from repeated

cycles of SR-T3 therapy results in lower serum levels of T4 and RT3, and therefore less competitive inhibition of T3. This suppression may increase from cycle to cycle, increasing T3 expression with each cycle. Increased expression of T3 may result in greater T4 suppression until body temperature is finally normalized and the metabolism is "re-calibrated." Once temperature is normalized, decreased SR-T3 is needed on subsequent cycles to maintain normal body temperature. Clinical evidence thus far indicates that patients can safely discontinue the sustained-release T3 therapy and maintain benefits once oral body temperature are held at 98.6°F for a specified set of time. More information can be found at this free site www.wtsmed.com/eManual.

After the treatment is discontinued, normally 3-6 months after initiation of treatment, the majority of WTS patients report significant and continued improvement in their symptoms. Many patients experience complete resolution of their WTS symptoms persisting years after treatment has been discontinued. Based on clinical observations, many patients are completely freed of fatigue, depression, muscle aches, and other complaints related to WTS.

Clinical Studies

Most studies on thyroid hormone supplementation have been done using Levothyroxine. There is current controversy over the effects of thyroid hormone supplementation on osteopenia. Most studies indicated no effect,[61-62] while one study of long-term suppressive dose of T4 did show a increase in bone loss.[63]

Clinical studies using supraphysiological doses of T3 ranging from 93.75 to 105 mcg daily in euthyroid fibromyalgia over an 8-month period indicated no change in serum calcium and phosphorous, nor in bone densitometry vs. placebo. However, there were higher levels of urinary N telopeptides. Liver function tests were no different vs placebo at 4- month follow-up; serum creatinine and calcium were also normal, indicating no change in muscle mass. Mean heart rate significantly increased from 68.5 bpm in placebo vs 83.94 bpm in T3 patients during the study. No patients developed tachycardia. There was no significant difference in diastolic or systolic blood pressure in T3 or placebo group. Serial EKG indicated no significance except that the placebo QT intervals shortened within the normal range during T phases.[64]

Adverse reactions to liothyronine sodium are generally due to therapeutic over-dosage, and thus are characterized by the typical symptoms of hyperthyroidism (e.g., tachycardia, irritability, nervousness, and increased bowel motility). In rare instances, allergic skin reactions have been observed in patients taking liothyronine sodium.

Most patients on sustained-release T3 do not experience any cardiac manifestations; however, a small percentage report increased awareness of heartbeat/palpitations and/or increased pulse rate. Dr Wilson noted that the patients most likely to experience these phenomena were individuals who had previously experienced heart flutters or PVCs prior to starting treatment with sustained-release T3.[65]

Physicians who use the WT3 protocol have noticed that cardiac support with CardiaCare Plus, containing the botanicals night blooming cactus (*Cereus grandiflorus*), lilly of the valley (*Convallaria officinalis*), motherwort (*Leonurus cardiaca*), and lemon balm (*Melissa officinalis*), aids in patient comfort by decreasing the amount of palpitations and preventing tachycardia.

Case Study
SR-T3 Protocol

A 43-year-old businessman came to the office complaining of severe fatigue, difficulty in sleeping, and headaches. All tests were normal, but his temperature averaged a degree lower than normal during the day. He was started on a cycle of T3 therapy consisting of 7.5 mcg p.o. b.i.d. and was instructed to increase the dose by 7.5 mcg/dose/day if he was without complaints until his average temperature got to 98.6° F by mouth.

He was also instructed to call the office if he developed any complaints and to return to the office after 2 weeks. At the 2-week visit, the patient related that he was taking 90 mcg b.i.d. and his temperature was still not up. Since his temperature did not change at all during the first cycle and he had noticed no difference at all in the way he felt since starting the treatment, he was instructed to try weaning off the T3 therapy by 7.5 mcg/dose/day if he remained without complaints. This was done so that the next part of the treatment would not be unnecessarily delayed. He was able to decrease the dose every day without complaints.

The patient was then started on a second cycle, with the same instructions as the first cycle. This time his temperature went up to 98.6° F on 75 mcg b.i.d. His symptoms began to improve, but after about 3 days, his temperature dropped again. The dose was increased to 82.5 and his temperature returned to normal. After about a week on that dosage, his temperature started to go down again and some of the recent clinical improvements were lost. The dose was increased to 90 mcg/dose, and his temperature went up again, restoring some of his clinical improvement.

His temperature went down again after an undetermined time (he wasn't recording his temperature three times a day as instructed). Since he had been showing a definite response to each recent increase and was without complaints, he was increased above the usual maximum dose of 90 mcg b.i.d. to see if the temperature of 98.6° F could be captured with one or two more increases. The temperature responded and dropped again on the 97.5 mcg dose. Then his temperature went up and stayed normal on 105 mcg b.i.d. and did not drop again.

He was maintained at 105 mcg b.i.d. for at least 3 weeks to help make sure that his temperature was indeed stable. During that 3-week period of time, he did not take his medicine at the correct time for a few days, and he began to experience headaches and felt tired and edgy. His temperature log revealed that his temperature had become slightly unsteady. His temperature was ranging more widely across his 3 daily temperatures. He was then given a T4 test dose of half a .025 mg tablet (.0125 mg) of levothyroxine, and within 45 minutes his complaints resolved completely. Anxious to see if he might be able to capture his temperature with a smaller dose of T3 on the third cycle, he was weaned off the second cycle.

The patient demonstrated unsteady T3 levels in the second cycle with the T4 test dose. He wondered how successful the T3 therapy was going to be for him (even though he had gotten a fairly good response to treatment so far). He tried weaning down with a 7.5 mcg decrease dose of the T3 every 2 days, but with the third decrease his temperature started to decrease. At this point it became clear that he would require one or two more cycles of the treatment to resolve his symptoms. We decided to decelerate the weaning process to every 4 days. He then was able to decrease his dose without a drop in temperature. He was instructed to remain off the medicine for 10 days after cycle 2 in order to let his T3 levels steady down as much as possible.

On the next cycle, he was able to capture 98.6° F on 60 mcg b.i.d. His symptoms were nearly resolved. After a few weeks, he was instructed to decrease his dose of T3 to see if he could capture his temperature with less medicine on a subsequent cycle for complete resolution of his symptoms. He decreased the dose by one decrement every 4 days without any drop in his temperature. On the fourth cycle, his temperature was captured with 15 mcg b.i.d., and his symptoms resolved completely. He was later able to wean off the T3 and remain improved even after the T3 had been discontinued. His temperature remained normal as well.

PARATHYROID
Pathophysiology Review

The parathyroid glands consist of two pairs of small button-shaped tissues located superior and inferior to the posterior aspect of the thyroid gland. Like most endocrine tissue, these glands are highly vascular. They secrete parathyroid hormone (PTH) that increases plasma calcium levels. PTH induces osteoclastic activity (bone breakdown), freeing calcium ions. PTH also promotes the synthesis of 1,25-dihyroxy vitamin D, the active form of vitamin D. Thus, PTH increases calcium absorption in the GI tract and decreases calcium loss in the urine.

LOW PTH LEVELS

PTH levels are modulated via a negative feedback loop by serum calcium ion levels. Normal muscle activity and blood clotting depend on normal calcium levels in the plasma. Reduced parathyroid function lowers calcium levels and, below certain levels, causes muscle stiffness, cramps, and convulsions. Reduced parathormone also contributes to rickets, a disorder of immature bone that is centralized in the epithelial growth plates; osteomalacia, a disorder of mature bone in which mineralocorticoids and newly formed osteoid bone protein matrix is inadequate; and osteoporosis, a disorder that weakens the mature bone, especially in post-menopausal women, leading to bone fractures.

BONE REMODELING

Bone remodeling is done by osteoblasts and osteoclasts. Osteoclasts are giant cells that attach to bone surfaces, where they secrete acid and proteolytic enzymes to dissolve the underlying bone, leaving a resorption pit. Osteoblasts do the opposite. They move and secrete osteoid, which secretes subsequently mineralized calcium and phosphate crystals, forming a compound called hydroxyapatite.

Bone contains 99% of body calcium stores. Of the remaining 1%, most is intracellular, while a small amount is extracellular. One percent of this skeletal calcium is freely exchangeable with the extracellular fluid. Normal serum calcium is regulated by the bone, kidney, liver, skin, thyroid, and parathyroid.

PTH, 1,25 dihydroxy vitamin D, and calcitonin provide the main control of serum calcium. 1,25 dihydroxy vitamin D is manufactured in the kidney (after dietary vitamin D-2 and skin produced vitamin D-3 is converted from the liver). Evidence also exists to suggest that estrogens, androgens, growth hormone, insulin, and prolactin levels influence renal vitamin D synthesis. Calcitonin is produced by the parafollicular C cells

Quick Reference: Major Parathyroid Metabolism Disorders

Parathyroid Metabolism Disorder	Major Signs and Symptoms	Key Laboratory Tests	Conventional Therapies	Naturopathic Therapies
Hyperparathyroidism	Commonly asymptomatic Muscle weakness, kidney stones	Serum calcium Serum phosphorus Serum PTH MRI	Surgery	Magnesium supplementation (750 mg q.i.d. or to bowel tolerance), avoiding excess phosphorus intake. Fluid intake should be increased to avoid kidney stone formation.
Hypoparathyroidism	Often asymptomatic Paresthesias Mood disturbances Muscle tetany Monitor for hypercalcemia	Serum calcium Serum phosphorus Serum PTH	Calcium and Vitamin D supplements	Supplementation with calcium, vitamin D, and magnesium supplementation (750 mg q.i.d. or to bowel tolerance) while avoiding excess phosphorus
Osteoporosis	Often asymptomatic	DEXA bone density scan	Calcium, vitamin D, HRT, various medications	Multi-vitamin mineral treatment

of the thyroid gland. Calcitonin opposes osteoclastic bone resorption and increases renal phosphate and calcium excretion. Thus, the net effect of calcitonin is to decrease serum calcium levels.

Osteoporosis

(Parts of this section are reprinted from Great Smokies Diagnostic Laboratory by permission)

The World Health Organization has declared osteoporosis the second largest medical problem, next to cardiovascular disease.[66] Osteoporosis is the most common bone disorder in America.[67] More than 25 million Americans, primarily women, are candidates for developing osteoporosis.[68] The disease leads to 1.5 million fractures per year.[69] More than 50% of healthy American women aged 30 to 40 are likely to develop vertebral fractures as they age due to osteoporosis.[70] In the United States, a third of all women 60 and older have spinal compression fractures. Such fractures cause varying degrees of pain, deformed spine, and height loss. They are associated with loss of appetite, heartburn, bloating, and difficulty in breathing.[71] In the United States, more than 300,000 hip fractures occur each year due to osteoporosis.[72] Half of the patients with hip fractures cannot walk independently afterward, frequently developing other complications, such as pneumonia or blood clots. Other metabolic bone and joint diseases and disorders (osteoarthritis, rheumatoid arthritis, cancer, endocrine disorders, Paget's disease, and amenorrhea) account for an additional 12 million cases of accelerated bone loss per year.

Summary of Calcium and Phosphate Control

Parathormone (PTH)	1,25 dihydroxy Vitamin D	Calcitonin	Calcium	Phosphate
Increases serum calcium and decreases phosphate	Increases serum calcium and phosphate	Decreases serum calcium and phosphate	Increases calcitonin Decreases PTH and phosphate	Increases PTH Decreases calcium

Unfortunately, treatment is only partially successful (at best) once progressive bone weakening has occurred. It is important to identify women in danger and those who are currently losing bone at an accelerated rate so that effective treatment can begin when the therapeutic burden is prevention instead of reversal of bone loss.

Excluding chronic alcoholics, fewer men than women develop osteoporosis. Men generally have greater bone mass, consume more calcium, and exercise more than women of similar age. Until a woman is in her early 20s, she synthesizes more bone than is resorbed. Eventually, aging shifts this balance, and most women over age 30 slowly lose bone. Although both men and women slowly lose bone as they age, some women lose bone much more rapidly around menopause. It has been assumed that menopause initiates this more rapid bone loss. Preventive measures, such as exercise, diet, and nutritional supplements, are known to help prevent and partially reverse the effects of osteoporosis. If preventive measures are to be initiated prior to the onset of rapid bone loss, they must be considered by young women in their 30s and 40s.

CAUSES OF OSTEOPOROSIS

Bone is a dynamic tissue, continually formed and resorbed. Osteoporosis results when the normal cycle of bone remodeling is interrupted. In normal remodeling, osteoclasts carve out cavities in the bone surface, which are filled by osteoblasts to form new bone. In bones affected with osteoporosis, new bone formation does not keep up with bone removal, leaving the bone progressively brittle. As bone is lost, the skeleton continues to have a normal composition, but it becomes porous, hyper-mineralized, and more fragile. A woman may lose 30% to 50% of her cortical bone thickness over a lifetime.[73]

Osteoporosis is a complex disease with genetic and environmental factors. Genetic traits, such as Caucasian or Asian ancestry or a family history of osteoporosis, significantly increase the potential for developing osteoporosis. Gender is important, too, as women are four times more likely than men to develop the disease. Fair-skinned, slender, and small-boned women who have a close relative with the disease have the greatest risk. The extent to which genetic influences on peak bone mass can be modified by lifestyle changes remains an important question for research studies.[74-76]

Significantly, lifestyle choices affect bone health for all women. These modifiable factors include diet and nutrition, physical activity, excessive alcohol consumption, and cigarette smoking.

Physiologic states and disease comprise a third category of factors.

LABORATORY TESTS

Measurements of bone mass assess the short-term likelihood of fractures. However, few tools have been available to assist healthcare professionals in identifying bone resorption before it has become excessive. Plain radiographs are usually inadequate in diagnosing bone mass. Static markers of bone mass, such as photon absorptiometry, do not provide information on the dynamics of bone formation and resorption. Bone biopsies provide this information but are too invasive for routine use.

Tests to distinguish abnormal clinical entities of abnormal calcium metabolism include the basics: CBC, ESR (erythrocyte sedimentation rate), serum calcium, phosphate, alkaline phosphatase, creatinine, TSH, serum testosterone, and 24-hour urine, calcium sample, and creatinine. Other tests recommended include single photon absorptiometry, dual photon absorptiometry, and DEXA dual energy x-ray absorptiometry.

Photon Absorptiometry

Bone loss can be estimated by photon absorptiometry.[77] A single measurement is employed to determine bone mass; two or more measurements over time are required to determine bone loss rates. Because of the relatively small changes in bone mass and the precision of the bone mass measurement methods, serial bone mass measurements may take an unacceptably

CLINICAL STUDIES

Relationship of Biochemical Markers to Osteoporosis

Many studies have investigated the relationship of pyridinium markers to osteoporosis. In one, the urinary excretion of Pyd crosslinks was compared with iliac crest biopsy in a group of elderly women with untreated osteoporosis.[80] The crosslinks relative to creatinine correlated closely with bone resorption with osteocalcin, a specific marker of bone formation and osteoporosis.

In another study, elderly women with femoral fractures associated with osteoporosis were compared with age-matched controls.[81] Women with fractures and osteoporosis excreted higher levels of crosslinks. The molar ratio of Pyd to D-Pyd did not differ appreciably among the three groups. Patients with recent fractures showed higher excretion of both markers than those without recent fractures, indicating that accidental bone fractures also increase crosslink excretion.

long period of time.[78] Photon absorptiometry is static and does not reflect the activity of the bone remodeling cycle.[79]

Photon absorptiometry does provide an excellent tool for identifying women who are in immediate danger of developing fractures. It has limited value, however, in predicting those who will lose bone, develop osteoporosis, or are more likely to suffer fractures in the future. A woman already undergoing accelerated bone loss may have a normal bone scan if, for example, she started with a higher than normal bone mass due to increased calcium intake and exercise.

Biochemical Markers

Biochemical markers are dynamic measures of bone turnover, providing information on the pathogenesis of bone diseases and on the rate of bone turnover. Various assays (bone alkaline phosphatase, osteocalcin, and procollagen peptide) have been developed during the past decade to measure bone formation. Bone resorption has been evaluated by a number of urinary excretion assays, including hydroxyproline, galactosyl hydroxylysine, pyridinoline, and deoxypyridinoline. Of these, the pyridinium crosslinks have been found to be more accurate and show a higher discrimination power than other assays.[82]

Pyridinium crosslinks are products of a unique series of reactions during the maturation of collagen fibrils, leading to the formation of pyridinium and deoxypyridinium. Bone collagen contains both Pyd and D-Pyd. Release of these components from bone undergoing resorption constitutes the main source of both crosslinks in urine.[83] Both Pyd and D-Pyd occur only in extracellular collagen. Pyd is a major cross-link

CLINICAL STUDIES
Biochemical Markers and Other Bone Disorders

Arthritis

Several studies support collagen crosslinks as valuable markers of arthritic disease activity.[95-97] Seibel studied the excretion of collagen crosslinks in patients with rheumatoid arthritis, with osteoarthritis, and in normal controls.[98] The levels of Pyd and D-Pyd relative to creatinine increased significantly in both groups of patients, an indication of increased bone resorption. Patients with advanced osteoarthritic disease had higher levels of Pyd than those with less pronounced joint damage.

In another study, significantly increased excretion rates of Pyd and D-Pyd were found with disease activity and bone loss in patients with rheumatoid arthritis, concluding that these collagen crosslinks may be useful markers of bone and cartilage turnover in patients with rheumatoid arthritis.[99]

Metabolic Bone Disease

One study measured the urinary excretion of Pyd crosslinks in normal adults and in patients with metabolic bone disease.[100] There was a three-fold increase in patients with primary hyperparathyroidism and a 12-fold increase in patients with Paget's disease compared to controls. Excretion increased two to three times as much, due to menopause. When Paget's disease was treated with bisphosphonates to inhibit bone resorption without altering bone formation over a short time span, the level of crosslinks declined to the normal range. The data indicate that urinary D-pyd crosslinks reflect specifically collagen degradation during bone resorption.

Another study also analyzed urinary concentrations of Pyd and D-Pyd relative to creatinine in patients with metabolic bone disorders and reported significantly elevated values in patients with Paget's disease of the bone, primary hyperparathyroidism, and osteomalacia.[101] Furthermore, there was a significant correlation between the concentrations of crosslinks and urinary hydroxyproline, although the variations in the latter were large.

Researchers have found that biochemical markers of bone turnover were increased when Paget's disease activity is high. This study suggested that urinary Pyd measurement would improve the detection of Paget's disease during low periods of disease activity.[102]

Cancer

Metastatic disease in bone is of concern to patients with a history of cancer, including breast carcinoma. In a preliminary study, urinary collagen crosslinks were measured in groups of patients with breast cancer, patients with bone metastases, and controls with no evidence of metastatic disease.[103] Values for both Pyd and D-Pyd were significantly greater in the group with metastases than in healthy volunteers. Excretion of the crosslinks correlated with elevated serum levels of phosphatase activity as well.

Alcoholic Bone Disease

Chronic alcohol consumption leads to various bone pathologies, possibly due to decreased consumption of calcium and vitamin D, reduced osteoblastic function, and increased bone turnover. One study found that chronic ethanol feeding in rats led to decreased excretion of D-Pyd but not Pyd, thus increasing the ratio of Pyd/D-Pyd.[104] The research implicates a reduction of the absolute rate of bone resorption and the inhibition of mature crosslinks with chronic consumption of ethanol.

in the collagen of bone as well as connective tissues (tendon and cartilage, but not skin), while D-Pyd is located primarily in bone and serves as a specific marker of this tissue.

Research supports these indicators as excellent, sensitive, and specific indicators of bone loss due to osteoporosis.[84,85] Presence in the urine of higher than normal amounts of Pyd and D-Pyd indicate a rapid rate of bone loss.[86-88] The markers are also highly useful in treatment monitoring as biochemical markers, such as Pyd and D-Pyd, have a beneficial ratio between change/precision when compared with bone mass measurement.[89]

The ability to measure urine crosslinks led to their application in clinical studies. The good correlations between pyridinium crosslink excretion and bone turnover rates measured by radioisotope methods or histomorphometry provide direct validation of the urinary markers.[90]

Pyridinium crosslinks appear to be independent of diet.[91] Both Pyd and D-Pyd are specific markers of bone resorption in various bone-related disorders. Crosslink excretion is greatly increased in patients with Paget's disease, primary hyperparathyroidism, osteomalacia, and osteoporosis, and these assays are especially useful in monitoring therapy.[92,93]

A high rate of bone turnover in an untreated post-menopausal woman indicates that bone loss is likely to be rapid. Nearly all women will show high bone turnover in the first few years after menopause, but about a third will continue to have high turnover 10 to 20 years after menopause. Many clinicians believe such women are destined to suffer extensive bone loss and should be targeted for aggressive therapy to block bone resorption.[94]

DIAGNOSIS

Diagnosis of osteoporosis is made by evaluating a 'T' score and a 'Z' score. A 'T' score compares a patient's bone mass to a young, normal subject. For example, -2 indicates 2 standard deviations below normal. A 'T' score -1 to -2.5 indicates osteopenia, and below -2.5 indicates osteoporosis.

A 'Z' score is a comparison of patients' bone mass to age matched normal subjects. The 'Z' score is a measure of the standard deviations above or below the mean value. A 'Z' score will indicate the patients bone mass is appropriate for age, or if there are other variables that might be associated with the excessively low bone mass.

The differential diagnosis of osteoporosis includes a thorough exam for other calcium metabolism disorders. This includes osteomalacia, osteogenesis imperfecta, hyperparathyroidism, hyperthyroidism, hypogonadism, Cushing's syndrome, multiple myeloma, rheumatoid arthritis, and renal failure.

CONVENTIONAL MEDICAL TREATMENT

Pharmacological agents for osteoporosis fall into two categories. They either inhibit bone resorption or stimulate bone formation. Bone resorption inhibitors include estrogen, phosphates, and calcitonin. Bone formation stimulators include sodium fluoride, androgens, parathyroid hormone, and growth hormone.

Other conventional treatment of osteoporosis includes estrogen replacement therapy (ERT), calcium supplements, and weight-bearing exercise. ERT inhibits bone resorption in postmenopausal women and has been shown to reduce the incidence of osteoporotic fractures by about 50%. Although the conventional approach reduces the incidence of osteoporosis, many women cannot or will not use ERT because of the risks and side effects associated with it.

NATUROPATHIC MEDICAL TREATMENT AND PREVENTION

Non-pharmacological measures for preventing osteoporosis are calcium 1000 mg/day for pre-menopause, and calcium 1500 mg/day post menopause, vitamin D 400 IU/day, exercise, smoking cessation, limiting alcohol and caffeine, and the use of natural medicines in restoring all the organs involved in calcium metabolism, which includes the digestive tract, kidneys, liver, skin, thyroid, and parathyroid.

A number of different vitamins and minerals in addition to calcium play a role in maintaining healthy bones, but, unfortunately, Americans often consume inadequate amounts of these nutrients. Additionally, hormone therapy may be more effective when ovarian hormones other than estrogen are taken into consideration.

Clinical Nutrition

Calcium: Calcium has been known for its ability to impact bone formation positively. Now, evidence suggests it also slows down bone resorption.[105-107] Research indicates a calcium-rich supplement containing microcrystalline hydroxyapatite concentrate has been useful in preventing bone thinning and increasing cortical bone thickness.[108]

Magnesium: The typical American diet often contains less than two-thirds of the RDA for magnesium. Deficiency is common in women with osteoporosis and appears to be associated with abnormal bone mineral crystal formation. Magnesium is necessary for the absorption of calcium and plays a part in the conversion of vitamin D to its active form. A two-year study found nearly 75% of 31 women taking 250-750 mg of oral magnesium showed bone density increases of 1% to 80%.[109]

Vitamin K: Vitamin K is a cofactor in the synthesis of osteocalcin, a unique bone protein that attracts calcium to bone tissue. Inadequate vitamin K levels impair normal bone mineralization. Serum vitamin K levels in individuals with osteoporosis were found to be 74% lower compared to a healthy control group.[110] Age-related dietary changes, reduced efficiency of absorption, and use of antibiotics that destroy vitamin K-producing intestinal flora may all contribute to vitamin K deficiency.

Boron: Evidence suggests that boron may promote synthesis of compounds related to bone health, including estrogen, testosterone, DHEA, and vitamin D, and may play an important role in maintaining bone mass. One study showed that 3 mg of boron per day decreased urinary calcium excretion by 44% and increased levels of estradiol (the most biologically active form of estrogen in the body) to that found in women receiving estrogen replacement therapy.[111]

Manganese: In a study of 14 women with osteoporosis, blood levels of manganese were 75% lower than those of age-matched controls.[112] Manganese deficiency has also been found to produce osteoporosis in animals. Studies suggest that manganese is a necessary mineral for bone mineralization.

Vitamin D: In many patients with osteoporosis, there is an impairment in renal conversion of vitamin D to its most active form. This may result from deficiencies in estrogen, magnesium, or boron.

Folic Acid: Folate is important in the metabolism of homocysteine, a metabolic intermediate that may affect osteoporosis by interfering with collagen crosslinking, resulting in a defective bone matrix. Increased levels of homocysteine have been found in postmenopausal women. The beneficial effect of folic acid appears to occur even in women who have no apparent deficiency of the vitamin.[113]

Other Nutrients: Additional studies suggest that vitamin B-6, vitamin C, zinc, copper, silicon, and strontium play roles in maintaining bone mass. Due to poor food choice and processed food, many of these nutrients are lacking in the American diet. A comprehensive nutritional supplement program that provides all of the vitamins and minerals involved in bone health may be valuable in preventing and treating osteoporosis.

Exercise

Exercise plays an important role in prevention and treatment of osteoporosis. Weight-bearing exercise strengthens bones, increases bone mass, and increases a person's reaction time and stability, thus decreasing the likelihood of a bone-breaking fall. Walking, running, tennis, aerobics, and weightlifting are effective at building and maintaining bone mass. Swimming may increase bone density while strengthening the cardiovascular system.

Hormonal Therapy

Estrogen: Estrogen replacement therapy inhibits bone resorption and reduces the incidence of osteoporotic fractures. However, ERT also increases the risk of certain forms of cancer. While the increased risk of endometrial cancer is prevented by the concomitant use of a progestogen, there is evidence that ERT may also cause breast cancer. However, it has been shown that one of three naturally occurring forms of estrogen, known as estriol, may actually prevent breast cancer.

A combination estrogen medication called Tri-estrogen (containing 80% estriol, 10% estrone, and 10% estradiol) may present a safer alternative to standard ERT in the management of postmenopausal osteoporosis.

Progesterone: Progestogens have been shown to reduce bone loss. Natural progesterone may be significantly safer and more effective than progestogens. One study of postmenopausal women receiving progesterone demonstrated increased bone density in all subjects. Over several years, average bone mass increased by 15.4%. Height loss was stabilized, and no new osteoporotic fractures occurred.[114]

Progesterone appears to enhance new bone formation in contrast to estrogen, which merely inhibits resorption of old bone. Unlike estrogen, progesterone is not carcinogenic, and there is evidence that progesterone actually prevents certain female cancers.

Testosterone and DHEA: Although testosterone and dehydroepiandrosterone (DHEA) are considered

male hormones, they are produced in substantial amounts by the ovaries. Each of these hormones has been shown to enhance new bone formation. Ovariectomized women, as well as some women with intact ovaries, may develop testosterone deficiency. In such cases, testosterone therapy may be of benefit. Serum levels of DHEA tend to decline around the time of menopause. A further fall in levels occurs around age 70 as the adrenal gland loses its capacity to produce the hormone. Administration of DHEA may help to prevent or reverse osteoporosis.

Other Considerations

The physician should rule out gastrointestinal problems, such as hypochlorhydria, dysbiosis, and malabsorption, which can compromise nutritional status, especially of minerals and fat-soluble nutrients such as vitamin K.

Individuals should avoid exposure to toxic metals, especially aluminum, which can bind to phosphorus in the intestine, leading to phosphorus depletion and fecal calcium excretion. Magnesium deficiency enhances the absorption of aluminum.

Certain medications such as glucocorticoids, anticonvulsants, anticoagulants, and some diuretics may result in a loss of bone tissue. Patients using these medications should be monitored for bone loss.

References

1. Tahara H. [Hypertension secondary to hyperparathyroidism] Nippon Rinsho 2004 Mar;62 Suppl 3:517-20.

2. Abraham GE, Flechas JD, Hakala JC. Orthoiodosupplementation: Iodine sufficiency of the whole human body. Reproduced in *Selected Clinical Studies and Literature Reviews*, pp. xx.

3. Grineva EN, Malakhova TV, Tsoi UA, Smirnov BI. Efficacy of thyroxine and potassium iodide treatment of benign nodular thyroid lesions. Ter Arkh. 2003;75(8):72-75.

4. McDermott MT. Endocrine Secrets. Philadelphia, PA: Hanley and Belfus Inc, 1998.

5. Kelly GS. Peripheral metabolism of thyroid hormones: A review. Altern Med Rev. 2000 Aug;5(4):306-33.

6. Winterhoff H, Gumbinger HG, Vahlensieck U, Kemper FH, Schmitz H, Behnke B. Endocrine effects of Lycopus europaeus L. following oral application. Arzneimittelforschung. 1994 Jan;44(1):41-45.

7. White HL, Freeman LM, Mahony O, Graham PA, Hao Q, Court MH. Effect of dietary soy on serum thyroid hormone concentrations in healthy adult cats. Am J Vet Res. 2004 May;65(5):586-91.

8. Chandra AK, Mukhopadhyay S, Lahari D, Tripathy S. Goitrogenic content of Indian cyanogenic plant foods & their in vitro anti-thyroidal activity. Indian J Med Res. 2004 May;119(5):180-85.

9-20. Kelly GS. Peripheral metabolism of thyroid hormones: A review. Altern Med Rev. 2000 Aug;5(4):306-33.

Reproduced in *Selected Clinical Studies and Literature Reviews*, pp. xx-xx.

21. Kohrle J, Spanka M, Irmscher K, Hesch RD. Flavonoid effects on transport, metabolism and action of thyroid hormones. Prog Clin Biol Res 1988;280:323-40.

22. Panda S, Kar A. Withania somnifera and Bauhinia purpurea in the regulation of circulating thyroid hormone concentrations in female mice. J Ethnopharmacol 1999;67:233-39.

23. Panda S, Kar A. Changes in thyroid hormone concentrations after administration of ashwagandha root extract to adult male mice. J Pharm Pharmacol 1998;50:1065-68.

24. Pohhloudek-Fabini R, Katterbach HA. On the presence of diiodotyrosine in Baltic Sea fucus. Pharmazie. 1965 Mar;20:176.

25. Abraham GE, Flechas JD, Hakala JC. Orthoiodosupplementation: Iodine sufficiency of the whole human body. Reproduced in *Selected Clinical Studies and Literature Reviews*, pp. 306.

26. Kelly GS. Peripheral metabolism of thyroid hormones: a review. Altern Med Rev. 2000 Aug;5(4):306-33. Reproduced in *Selected Clinical Studies and Literature Reviews*, pp. 285.

27. Gartner R, Gasnier BC. Selenium in the treatment of autoimmune thyroiditis. Biofactors. 2003;19(3-4):165-70

28. Russell IJ. Neurochemical pathogeneses of fibromyalgia syndrome. Journal of Muscoskeletal Pain, 1996; 2(3):61-92.

29. Karkal S. Overcoming diagnostic and therapeutic obstacles in hypothyroidism. Emergency Medicine Reports, 1990; 11(23):219-27.

30. Lam KS. et al. Vasoactive intestinal peptide in the anterior pituitary is increased in hypothyroidism. Endocrinology 1989;124(2):1077-84.

31. Lam KS, et al. Vasoactive intestinal peptide in the anterior pituitary is increased in hypothyroidism. Endocrinology 1989;124(2):1077-84.

32. Kales A, et al. All night sleep studies in hypothyroid patients, before and after treatment. J Clin Endocrinol Metab 1967;27(11): 1593-99.

33. Eisinger J, Plantamura A, Ayavou T. Glycolysis abnormalities in fibromyalgia. J Am Coll Nutr 1994;13(2):144-48.

34. Fukuda K, et al. The chronic fatigue syndrome: A comprehensive approach to its definition and study. International Chronic Fatigue Syndrome Study Group. Ann Intern Med 1994;121(12):953-99.

35. Williams G, Pirmohamed J, Minors D, Waterhouse J, Buchan I, Arendt J, Edwards RH. Dissociation of body-temperature and melatonin secretion circadian rhythms in patients with chronic fatigue syndrome. Clin Physiol 1996;16(4):327-37.

36. Fukuda K, Ishhara K, Takeuchi T, Yamamoto Y, Inugami M. Core temperature pattern and self-rated lifestyle. Psychiatry Clin Neurosci 1998;52(2):243-45.

37. Shibui K, Okawa M, Uchiyama M, Ozaki S, Kamei Y, Hayakawa T, Urata J. Continuous measurement of temperature in non-24 hour sleep-wake syndrome. Psychiatry Clin Neurosci. 1998;52(2):236-37.

38. Title CR. Effects of triodothinoine in patients with metabolic insufficiency. JAMA 1956:162: 271.

39. Kurland GS, Hamolsky MW, Feedberg AS. Studies in non-myxedematous hypermetabolism: 1. The clinical syndrome and the effects of triiodothyronine, alone or combined with thyroxine. J. Clinical Endocrinology 1955;15:1354.

40. Sonkin LS. Myofascial pain due to metabolic disorders: Diagnosis and treatment. In: Myofascial Pain and Fibromyalgia: Trigger Point Management. Rachlin ES (ed.) St. Louis, MO: Mosby,1994:45-60.

41. McIntyre RS, et al. What to do if an initial antidepressant fails? Can Fam Physician 2003;49: 449-57.

42. Joffe, R.T., et al. Predictors of response to lithium and triiodothyronine augmentation of antidepressants in tricyclic non-responders. Br J Psychiatry, 1993. 163: p. 574-8.

43. Lowe J. Thyroid status of 38 fibromyalgia patients: Implications for the etiology of fibromyalgia. Clinical Bulletin Myofascial Ther. 1997;2(1):47-64.

44. Lowe J, et al. Effectiveness and safety of t3 therapy for euthyroid fibromyalgia: A double-blind placebo-controlled crossover study. Clinical Bulletin Myofascial Ther. 1997;294:71-88.

45. Lowe JC, Reichman AJ, Yellin J. The process of change during T3 treatment for euthyroid fibromyalgia: A double-blind placebo-controlled crossover study. Clin. Bull. Myofascial Ther. 1997;2(2/3):91-124.

46. Lowe JC, Garrison RL, Reichman A, Yellin J. Triiodothyronine (T3) treatment of euthyroid fibromyalgia: A small-N replicaiton of a double-blind placebo-controlled crossover study. Clin. Bull. Myofascial Ther. 1997;2(4):71-88.

47. Primary Care Provider Education Project. Chronic Fatigue Syndrome: A Diagnostic and Management Challenge. Center for Disease Control and Prevention, 2003:3.

48. Felicetta J. Effects on illness on thyroid function tests. Postgraduate Medicine 1989;85(8):213-20.

49. Schimmel M, Utiger RD. Thyroidal and peripheral production of thyroid hormones: Review of recent findings and their clinical implications. Ann Intern Med 1977;87(6):760-68.

50. Refetoff S. Resistance to thyroid hormone: An historical overview. Thyroid 1994;4(3):345-49.

51. Bunevicius R, et al. Effects of thyroxine as compared with thyroxine plus triiodothyronine in patients with hypothyroidism. N Engl J Med 1999;340(6) 424-29.

52. Englebienne P, et al. Type I interferons induce proteins susceptible to act as thyroid receptor (TR) corepressors and to signal the TR for destruction by the proteasome: Possible etiology for unexplained chronic fatigue. Med Hypotheses 2003;60(2):175-80.

53. Garrison RL, Breeding PC. A metabolic basis for fibromyalgia and its related disorders: The possible role of resistance to thyroid hormone. Med Hypotheses 2003Aug; 61(2):182-89.

54. Primary Care Provider Education Project. Chronic Fatigue Syndrome: A Diagnostic and Management Challenge. Center for Disease Control and Prevention. 2003:3.

55. Refetoff S, Weiss RE, Usala SJ. The syndromes of resistance to thyroid hormone. Endocr Rev 1993;14(3):348-99.

56. Primary Care Provider Education Project. Chronic Fatigue Syndrome: A Diagnostic and Management Challenge. Center for Disease Control and Prevention, 2003:3.

57. Braverman LE, Utiger RD. Introduction to hypothyroidism. In: Werner and Ingbar's The Thyroid: A Fundamental and Clinical Text. Baltimore, MD: Lippincott, 1991:919-920.

58. Scott LV, Svec F, Dinan T. A preliminary study of dehydroepiandrosterone response to low-dose ACTH in chronic fatigue syndrome and in healthy subjects. Psychiatry Res 2000;97(1): 21-8.

59. Primary Care Provider Education Project. Chronic Fatigue Syndrome: A Diagnostic and Management Challenge. Center for Disease Control and Prevention, 2003:3.

60. Iranmanish A, et al. Dynamics of 24-hour endogenous cortisol secretion and clearance in primary hypothryoidsim assessed before and after partial thyroid hormone replacement. J. Clin. Endocrinol. Metab. 1990;70:155.

61. Gyulai L, et al. Bone mineral density in pre-and post-menopausal women with affective disorder treated with long-term L-thyroxine augmentation. J Affect Disord 2001:66(2-3):185-91.

62. Van Den Eeden SK, et al. Thyroid hormone use and the risk of hip fracture in women > or = 65 years: A case-control study. Journal of Women's Health, 2003:12.

63. Sijanaovic S, Karaner I. Bone loss in premenopausal women on long term suppressive therapy with thyroid hormone. Medscape Women's Health 2001.

64. Lowe JC, Reichman AJ, Yellin J. The process of change during T3 treatment for euthyroid fibromyalgia: A double-blind placebo-controlled crossover study. Clin. Bull. Myofascial Ther. 1997;2(2/3):91-124.

65. Wilson D. Personal communication. 2002;May 20.

66. World Health Organization. Osteoporosis: Both health organizations and individuals must act now to avoid an impending epidemic. Press Release WHO/58, 11 October 1999.

67. Riffee JM. Osteoporosis: Prevention and management. Amer Pharm 1992;NS32;8:61-72.

68. Stand UP to Osteoporosis. Washington, D.C. National Osteoporosis Foundation, 1995.

69. Stand UP to Osteoporosis. Washington, D.C. National Osteoporosis Foundation, 1995.

70. Riffee JM. Osteoporosis: Prevention and management. Amer Pharm 1992;NS32;8:61-72.

71. Stand UP to Osteoporosis. Washington, D.C. National Osteoporosis Foundation, 1995.

72. Stand UP to Osteoporosis. Washington, D.C. National Osteoporosis Foundation, 1995.

73. Seeman E. Unresolved issues in osteoporosis in men. Rev Endocr Metab Disord. 2001;2(1):45-64.

74. Albers MM. Osteoporosis: A health issue for women. Health Care for Women Inter 1990; 11:11-19.

75. Wark JD. Osteoporosis: Pathogenesis, diagnosis, prevention and management. Bailliere's Clin Endocrinol Metab 1993;7(1):151-81.

76. Riffee JM. Osteoporosis: Prevention and management. Amer Pharm 1992;NS32;8:61-72.

77. Wark JD. Osteoporosis: Pathogenesis, diagnosis, prevention and management. Bailliere's Clin Endocrinol Metab 1993;7(1):151-81.

78. Riis BJ. Biochemical markers of bone turnover II: Diagnosis, prophylaxis, and treatment of osteoporosis. Am J Med 1993;95(5A):17-21S.

79. Notelovitz M. Osteoporosis: Screening, prevention, and management. Fertility and Sterility 1993;59(4):707-25.

80. Anonymous. Pyridinium crosslinks as markers of bone resorption. The Lancet 1992;340:278-79.

81. Bettica P, Moro L, Robins SP, Taylor AK, Talbot J, Singer FR, Baylink DJ. Bone-resorption markers galactosyl hydroxylysine, pyridinium crosslinks, and hydroxyproline compared. Clin Chem 1992;38(11):2313-18.

82. Bettica P, Moro L, Robins SP, Taylor AK, Talbot J, Singer FR, Baylink DJ. Bone-resorption markers galactosyl hydroxylysine, pyridinium crosslinks, and hydroxyproline compared. Clin Chem 1992;38(11):2313-18.

83. Anonymous. Pyridinium crosslinks as markers of bone resorption. The Lancet 1992;340:278-79.

84. Hassager C, Colwell A, Assiri AMA, Eastell R, Russell RGG, Christiansen C. Effect of menopause and hormone replacement therapy on urinary excretion of pyridinium crosslinks: A longitudinal and cross-sectional study. Clin Endocrinology 1992;37:45-50.

85. Delmas PD. Clinical use of biochemical markers of bone remodeling in osteoporosis. Bone 1992;13:S17-21.

86. Uebelhart D, Gineyts E, Chapuy M-C, Delmas PD. Urinary excretion of pyridinium crosslinks: A new marker of bone resorption in metabolic bone disease. Bone Miner 1990; 8:87-96.

87. Delmas PD, Schlemmer A, Gineyts E, Riis B, Christiansen C. Urinary excretion of pyridinoline crosslinks correlates with bone turnover measured on iliac crest biopsy in patients with vertebral osteoporosis. J Bone Min Res 1991;6(6):639-44.

88. McLaren AM, Hordon LD, Bird HA, Robins SP. Urinary excretion of pyridinium crosslinks of collagen in patients with osteoporosis and the effects of bone fracture. Ann Rheum Dis 1992;51:648-51.

89. Riis BJ. Biochemical markers of bone turnover II: Diagnosis, prophylaxis, and treatment of osteoporosis. Am J Med 1993;95(5A):17-21S.

90. Anonymous. Pyridinium crosslinks as markers of bone resorption.The Lancet 1992;340:278-79.

91. Anonymous. Pyridinium crosslinks as markers of bone resorption.The Lancet 1992;340:278-79.

92. Anonymous. Pyridinium crosslinks as markers of bone resorption.The Lancet 1992;340:278-79.

93. Alvarez L, Guañabens N, Peris, P, Monegal A, Bendini JL, Deulogeu R, Martinez de Osaba MJ, Muõz-Gomez J, Rivera-Fillat R, Ballesta AM. Discriminative value of biochemical markers of bone turnover in assessing the activity of Paget's disease. J Bone Min Res 1995;10(3):458-65.

94. Ettinger B. An update for the obstetriciangynecologist on advances in the diagnosis, prevention, and treatment of postmenopausal osteoporosis. Current Opinion OB GYN 1993;5:396-403.

95. Gough AKS, Peel MFA, Eastell R, Holder RL, Lilley J, Emergy P. Excretion of pyridinium crosslinks correlates with disease activity and appendicular bone loss in early rheumatoid arthritis. Ann Rheum Dis 1994;53:14-17.

96. Seibel MJ, Duncan A, Robins SP. Urinary hydroxy-pyridinium crosslinks provide indices of cartilage and bone involvement in arthritic diseases. J Rheumatol 1989;16:964-70.

97. MacDonald AG, McHenry P, Robins SP, Reid DM. Relationship of urinary pyridinium crosslinks to disease extent and activity in osteoarthritis. Brit J Rheum 1994;33:16-19.

98. Seibel MJ, Duncan A, Robins SP. Urinary hydroxy-pyridinium crosslinks provide indices of cartilage and bone involvement in arthritic diseases. J Rheumatol 1989;16:964-70.

99. Gough AKS, Peel MFA, Eastell R, Holder RL, Lilley J, Emergy P. Excretion of pyridinium crosslinks correlates with disease activity and appendicular bone loss in early rheumatoid arthritis. Ann Rheum Dis 1994;53:14-17.

100. Uebelhart D, Gineyts E, Chapuy M-C, Delmas PD. Urinary excretion of pyridinium crosslinks: A new marker of bone resorption in metabolic bone disease. Bone Miner 1990; 8:87-96.

101. Alvarez L, Guañabens N, Peris, P, Monegal A, Bendini JL, Deulogeu R, Martinez de Osaba MJ, Muõz-Gomez J, Rivera-Fillat R, Ballesta AM. Discriminative value of biochemical markers of bone turnover in assessing the activity of Paget's disease. J Bone Min Res 1995;10(3):458-65.

102. Alvarez L, Guañabens N, Peris, P, Monegal A, Bendini JL, Deulogeu R, Martinez de Osaba MJ, Muõz-Gomez J, Rivera-Fillat R, Ballesta AM. Discriminative value of biochemical markers of bone turnover in assessing the activity of Paget's disease. J Bone Min Res 1995;10(3):458-65.

103. Preedy VR, Sherwood RA, Akpoguma CIO, Black D. The urinary excretion of the collagen degradation markers pyridinoline and deoxypyridinoline in an experimental rat model of alcoholic bone disease. Alcohol and Alcoholism 1991; 26(2):191-98.

104. Preedy VR, Sherwood RA, Akpoguma CIO, Black D. The urinary excretion of the collagen degradation markers pyridinoline and deoxypyridinoline in an experimental rat model of alcoholic bone disease. Alcohol and Alcoholism 1991; 26(2):191-98.

105. Shapses SA, Robins SP, Schwartz EI, Chowdhury H. Short-term changes in calcium but not protein intake alter the rate of bone resorption in healthy subjects as assessed by urinary pyridinium cross-link excretion. J Nutr 1995;125:2814-21.

106. Horowitz M, Wishart JM, Goh D, Morris HA, Need AG, Nordin BEC. Oral calcium suppresses biochemical markers of bone resorption in normal men. Am J Clin Nutr 1994;60:965-68.

107. Blumsohn A, Herrington K, Hannon RA, Shao P, Eyre DR, Eastell R. The effect of calcium supplementation on the circadian rhythm of bone resorption. J Clin Endocrinol Metab 1994;79:730-35.

108. Epstein O, Kato Y, Dick R, Sherlock S. Vitamin D, hydroxyapatite, and calcium gluconate in treatment of cortical bone thinning in postmenopausal women with primary biliary cirrhosis. Am J Clin Nutr 1982;36:426-30.

109. Vikhanski L. Med Tribune July 22, 1993.

110. Hart JP, Shearer MJ, Klenerman L, Catterall A, Reeve J, Sambrook PN, Dodds RA, Bitensky L, Chayen J. Electrochemical detection of depressed circulating levels of vitamin K1 in osteoporosis. J Clin Endocrinol Metab 1985;60:1268-69.

111. Nielsen FH.Boron - an overlooked element of potential nutritional importance. Nutr Today 1988;(Jan-Feb):4-7.

112. Raloff J. Reasons for boning up on manganese. Science News 1986;130:199.

113. Brattstrom LE, Hultberg BL, Hardebo JE. Folic acid responsive postmenopausal homocysteinemia. Metabolism 1985;34:1073-77.

114. Lee JR. Is natural progesterone the missing link in osteoporosis prevention and treatment? Med Hypotheses 1991;35:316-18.

Pathophysiology Review

The adrenal glands rest on the superior and medial side of each kidney at the 11th and 12th thoracic vertebrae. Like other endocrine glands, they are very well vascularized. Each adrenal gland comprises two different glands encapsulated as one: the adrenal cortex on the outer surface and the medulla on the inside.

ADRENAL CORTEX

The adrenal cortex has three regions — the zona glomerulosa, the zona fasciculata, and the zona reticularis — that produce mineralocorticoids, glucocorticoids, and androgens. The outer zona glomerulosa secretes hormones, such as aldosterone and other mineralocorticoids, which control fluid/electrolyte balance. The zona fasciculata secretes cortisol and other glucocorticoids, as does the zona reticularis.

The pituitary gland's secretion of ACTH stimulates glucocorticoid production, the main glucocorticoid being cortisol. The pituitary gland is, in turn, regulated by corticotrophin-releasing factor (CRF), which is secreted from the hypothalamus. Like most hormone systems in the body, these hormones are controlled by a negative feedback loop.

Cortisol has a number of physiological functions, including promoting and enhancing gluconeogenesis enzymes in the liver to keep blood glucose levels high. This is the reason that diabetic patients under high stress will need to increase drug dosages to compensate for the increased blood sugar levels. Cortisol also increases hepatic protein synthesis and protein catabolism at the same time, and stimulates hormone sensitive lipase and the release of fatty acids from adipose tissue.

ADRENAL MEDULLA

The adrenal medulla consists of secretory cells, 80% of which produce and release epinephrine (adrenaline), while the remaining 20% secrete norepinephrine (noradrenaline). These secretory cells are actually

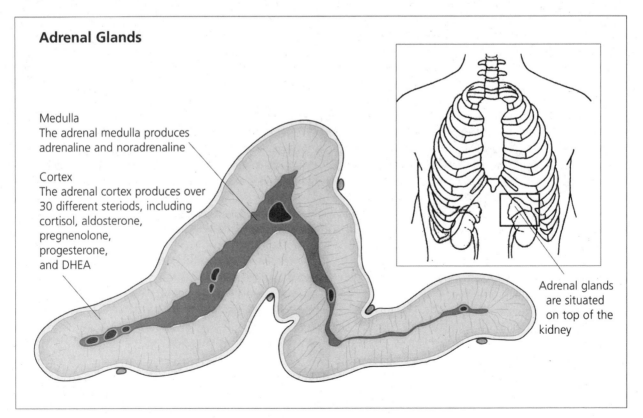

Adrenal Glands

Medulla
The adrenal medulla produces adrenaline and noradrenaline

Cortex
The adrenal cortex produces over 30 different steriods, including cortisol, aldosterone, pregnenolone, progesterone, and DHEA

Adrenal glands are situated on top of the kidney

Quick Reference: Major Adrenal Metabolism Disorders

Adrenal Metabolism Disorder	Major Signs and Symptoms	Key Laboratory Tests	Conventional Therapies	Naturopathic Therapies
Primary Aldosteronism	Hypertension	High aldosterone levels, hypokalemia, hypomagnesemia, metabolic alkalosis	Unilateral adrenalectomy	General naturopathic support; if serious, consider surgery
Pheochromocytoma	Hypertension Headaches Sweating Palpitations	High catecholamines	Surgical resection	*Rauwolfia serpentina*, general naturopathic support; if serious, consider surgery
Adrenal Insufficiency	Weakness, Fatigue Postural hypotension	Low plasma cortisol, low DHEA	Salt, sugar, steroids	Salt, adaptogen herbs, licorice solid extract, cortisol, DHEA, tyrosine

Adrenal Hormones

Adrenal Medulla

Hormone Group	Catecholamines, adrenaline (epinephrine), noradrenaline (norepinephrine)
Function	Neurotransmitters, fight or flight, increase blood pressure, catabolic, insulin resistance
Pathology	Pheochromocytoma, hyperfunctioning
Symptoms	Headaches, diaphoresis, palpitations
Therapeutic	Surgery, *Rauwolfia serpentina* (reserpine)[1]

Adrenal Cortex

Hormone Group	Glucocorticoids, cortisone, hydrocortisone (cortisol)
Function	Anti-inflammatory, gluconeogenesis
Pathology	Adrenal insufficiency
Symptoms	Weakness, fatigue, anorexia, nausea
Therapeutic	Hydrocortisone, Cortisone acetate, Glycerhhizic acid, Sarsparilla, Ginseng, Licorice Solid Extracts

Hormone Group	Androgens, testosterone, androstenedione, dehydroepiandrosterone
Function	Androgenic, anabolic, increase uric acid
Disorder	Adrenal insufficiency
Symptoms	Weakness, fatigue
Therapeutic	DHEA, pregnenolone, androstenedione, testosterone, lifestyle

Hormone Group	Mineralocorticoids, 11-deoxycorticosterone (DOC), aldosterone
Function	Increase blood pressure, increase Na/k ratio
Disorder	Primary aldosteronism (excessive aldosterone), functional hypofunction
Symptoms	Hypertension
Therapeutic	Surgery, dexamethasone, functional hypofunction: salt, licorice, Sarsparilla solid extract

modified postganglionic neurons. This embryological fact is crucial for the 'fight or flight' reaction in response to life threatening situations.

→ Selected Clinical Studies and Literature Reviews

For a discussion of the biochemistry of adrenal metabolism, see Abram Hoffer, "Dopamine, Noradrenalin, and Adrenalin Metabolism to Methylated or Chrome Indole Derivatives: Two Pathways or One?" in *Selected Clinical Studies and Literature Reviews*, pp. 345.

Adrenal Gland Dysfunction

Adrenal gland dysfunction is typically related to a maladaption to stress, as first reported by Hans Selye in the general adaptation syndrome theory (GAS).

THE GENERAL ADAPTATION SYNDROME (GAS)

In order to develop a general theory for the physiological response of humans and animals to stress, Hans Selye, former director of Experimental Medicine and Surgery at the University of Montreal, performed an integrated analysis of the effects of stress on adrenal gland function. He called his model of stress adaptation the General Adaptation Syndrome or GAS. The GAS was thought by Selye to outline how the organism adapts physiologically to stressors in its attempt to restore homeostasis.

The GAS has proven useful for many years by providing a model of how stress-induced illness arises and by giving clinicians some insight into how to manage stress related conditions in their patients. According to Selye, there are three stages of stress response: alarm phase (acute stress); resistance phase (chronic stress); and exhaustion phase (burnout).

Stress includes not only psychological stress but also any insult to the body that may tax the adrenal gland function, including chronic infections, allergies, exposure to chemical toxins, use of stimulants (such as caffeine and nicotine), poor nutrition, physical trauma, and poor sleep habits. Other contributing factors include exogenous steroid use, chronic hypoglycemia, and pharmaceutical and non-pharmaceutical drug use. For instance, many people develop adrenal exhaustion after a physical trauma, such as a car accident, after an acute exposure to toxins in the workplace, or after an extended course of corticosteroid treatment.

Alarm Phase (Acute Stress)

The alarm phase of the GAS occurs when a stress is first encountered and an alarm is sounded in the body. This alarm, sometimes called the fight or flight response, is associated with an activation of the sympathetic nervous system.

Hormonally, we see an increase in the release of cortisol from the adrenal cortex and epinephrine from the adrenal medulla. This response is a normal defense mechanism that engages when an organism is threatened, and serves a critical function by stimulating the organism to respond to the threat at hand. Once this phase is over, the body goes through a 24 to 48 hour period of recovery, during which one desires primarily to rest.

However, this response can be considered maladaptive when the hormonal release is not appropriate for the situation (e.g., in states of hyper-vigilance, chronic anxiety syndromes, post-traumatic stress disorder). Animal studies of prolonged alarm reactions associate this stage with weight loss, gastric ulcers, and immunosuppression.

Resistance Phase (Chronic Stress)

Due to the challenges of modern life, for many people the perceived stressors are not short term but chronic. In this second phase of the GAS, the organism is still reacting to a perceived stress or stresses, but some of the outwardly observable signs of stress are different. Levels of cortisol and epinephrine are still elevated. This chronic elevation results in weight gain, although the person may appear to have returned to normal functioning. However, immunity and inflammatory responses are still suppressed, and thus there is an increased susceptibility to opportunistic infections, neoplasia, arthritis, allergies, and autoimmune conditions. In addition, chronically elevated adrenal hormone levels may lead to depression, hyperlipidemia, atherosclerosis, hypertension, hyperinsulinemia, insulin resistance, diabetes, osteoporosis, and other degenerative diseases.

Exhaustion Phase (Burnout)

No matter how vital the person, chronic stress can eventually lead to the exhaustion phase, characterized by deficient glucocorticoid and mineralocorticoid production, sometimes combined with episodic pulses of excess epinephrine. This is commonly known as adrenal exhaustion.

Adrenal exhaustion is associated with decreased resistance to stress, premature aging, and, if left uncorrected, even death. Conditions that are common in people in this phase of the GAS include allergies, chronic fatigue syndrome, fibromyalgia, hypoglycemia, multiple chemical sensitivities, irritable bowel syndrome, hypotension, insomnia, hypothyroid, lack of motivation, and anxiety disorders.[2]

Adrenal Cortical Hypofunction

ADDISON'S DISEASE

Addison's disease is a failure of the adrenal cortex. It affects approximately four people in 100,000 and occurs in all age groups and among both sexes equally. Addison's disease can be triggered by acute external stressors, such as infection, trauma, toxic chemical exposure, corticosteroid withdrawal, or extreme psychological stress.[3] It is considered to be autoimmune in nature, and can affect other glands, including the thyroid and pituitary.

Symptoms

Symptoms include hyperpigmentation (mouth, areolae, perineum), weight loss, asthenia, depression, and postural hypotension causing vertigo. Extreme adrenal crisis can lead to vascular collapse with hypotension and azotemia.

Tests

Conventional tests to detect Addison's include serum cortisol, 24-hour free cortisol, and the ACTH stimulation test. Standard electrolytes may be imbalanced with an elevation of serum potassium and depression of serum sodium.

ADRENAL INSUFFICIENCY SYNDROME

Adrenal insufficiency is common in Western culture due to the high amount of psychological stress, environmental toxins, and poor nutrition, all of which deplete adrenal reserves. Other lifestyle factors in adrenal insufficiency development include inadequate amount of sleep, eating infrequently, and lack of exercise. Adrenal insufficiency can be thought of as an acute or chronic impairment of adrenal function, as opposed to the failure of the gland, as seen in Addison's disease. Therefore, it may be more difficult to diagnose adrenal insufficiency than Addison's disease. Symptoms are an important consideration, as first identified by Dr John Tintera in 1956.[4]

Tests

Lab testing may be helpful to diagnose adrenal insufficiency.

Salivary Cortisol: Salivary cortisol is likely the best single test, as saliva hormones indicate the amount of hormone inside cells and the testing is simple, noninvasive, and easy to do. The best way to use saliva testing is to measure cortisol levels at least four times per day (waking, noon, afternoon, evening), which increases the chances of detecting a failure of adrenal reserve. Testing at various times in the day can also

Symptoms and Signs of Adrenal Insufficiency

Symptom	Percentage of Patients
Excessive fatigue	94%
Nervousness/Irritability	86%
PMS	85%
Salt craving	84%
Depression	79%
Sweet craving	75%
Allergies	73%
Headache	68%
Alcohol intolerance	66%
Weakness	65%
Neck/Shoulder pain	65%
Confusion	61%
Poor memory	59%
Palpitations	57%
Poor digestion	51%
Backache	48%
Lightheadedness	47%
Constipation or diarrhea	45%
Fainting	42%
Insomnia	40%
Dermatitis	39%
Signs	
Postural hypotension	93%
Dry Skin	91%
Scanty perspiration	91%
Low basal body temp	85%
Sparse body hair	83%
Underweight	78%

be correlated with perceived energy levels throughout the circadian rhythm cycle. DHEA-S and testosterone levels can also be measured with saliva testing, and if low are also considered to be indicators of adrenal exhaustion, whereas high levels may indicate adrenal resistance phase.

Urinary Cortisol: A 24-hour urinary cortisol test can be used to monitor the output and metabolism of the corticosteroids, aldosterone, and the sex hormones. Hypoadrenia is suspected for those in the bottom one-third of the "normal" range. Because the urine is collected in one container, this test gives a 24-hour average, and therefore the highs and lows may cancel each other out in many patients. However, if metabolites of these hormones are included, ratios of these hormones to their metabolites can give a fairly accurate picture of an individual's adrenal hormone metabolism.

This is especially useful for diagnosing syndromes, such as Apparent Mineralocorticoid Excess (AME), in which cortisol is not metabolized effectively to cortisone (typically due to an altered expression of 11-b-hydroxy steroid dehydrogenase), leading to hypertension.

Urine 24-hour cortisol measurements can also be useful when performing an ACTH challenge test. In the challenge test adrenal reserve can be functionally measured by comparing 24-hour urinary cortisol before and after stimulation of the adrenal cortex with ACTH.[5]

Blood Tests: Blood tests can also be used to measure circulating hormone levels related to adrenal function. However, because of a wide variation in what is considered to be normal levels, many symptomatic patients may not show irregularities, since in most cases of adrenal fatigue, the cause is a functional lack of adrenal reserve, as opposed to outright Addison's disease.

Nevertheless, on routine blood screening we may see the following in adrenal insufficiency:
- Serum Na low normal
- Serum K high normal
- BUN high normal or elevated
- Eosinophils high
- Cortisol low/normal

Adrenal Cortical Hyperfunction
CUSHING'S DISEASE
Excess adrenocortical hormone production is known as Cushing's disease.

Cushing's Disease Symptoms
In full-blown Cushing's, signs and symptoms include:
- Redistribution of fat to face (moon facies), truncal obesity, dorsal and supracalvicular fat pads
- Hypertension
- Osteoporosis and connective tissue weakness
- Insulin resistance
- Decreased immunity
- Mood disturbances (depression, mania, anxiety)
- Poor wound healing
- Virilism in women

Tests
Cushing's can also be diagnosed by laboratory testing. Values found in Cushing's would include elevated serum or 24-hour cortisol, elevated serum sodium, low serum potassium, and lowered eosinophil levels. Several tests, such as a dexamethasone suppression test, metyrapone test, and CRH test, can help differentiate primary from secondary (pituitary mediated) disease. Imaging studies can help to identify the presence of pituitary tumors that are the most common cause of secondary Cushing's.

HYPERCORTISOLISM
As with Addison's disease and adrenal insufficiency, Cushing's disease can be seen to exist as a continuum. Cortisol is normally released in response to any stress, such as physical, psychological, infection or trauma. Since cortisol levels are usually not reduced until the stressor is removed, many people are suffering from a chronic form of low-level Cushing's called hypercortisolism.

Symptoms
Symptoms of chronic hypercortisolism may include some of the symptoms of Cushing's given above, as well as:

Cardiovascular: EKG abnormalities and myocardial hypertrophy correlate with high levels of serum cortisol. This is a mechanism by which stress can be an etiology for heart disease. Prolonged stress results in increased secretion of glucorticoids and maladaption of the adrenal cortex to stress, which may result in adrenal corticohypertrophy.

Aging: High levels of cortisol from stress have been shown to accelerate the aging process in laboratory animals, but overall the basic rhythm of corticosteroid secretion is preserved in healthy individuals even in old age. However, older patients under stress are more prone to irregularities of circadian rhythm than their younger counterparts. This tends to accelerate further the aging process.[6]

Depression: The disruption of the circadian rhythm and high serum cortisol levels have been found to co-exist in depressed patients. There is a strong correlation between cortisol rhythm and diurnal mood variation in both depressed and healthy individuals. Cortisol levels thus have a profound effect on mood, and high levels have been associated with psychiatric disturbances, including depression, bipolar disorders, and schizophrenia.[7-8]

Immune Function: T-lymphocytes serve as regulators of antigen-specific responses and are decreased with excess cortisol secretion. Cortisol also acts as an anti-inflammatory, down regulating interferon and ILK 2, causing a strong immunosuppression effect. Thus, hypercortisolism has been linked to immunosuppression.[9]

Insomnia: Deep sleep associated with REM occurs primarily when cortisol levels are decreased. Insomnia is associated with increased plasma cortisol. This is an important link in patients suffering from poor sleep and insomnia.[10-11]

Fatigue: Chronic and continual oversecretion of cortisol over time can weaken the adrenal glands and trigger exhaustion. Chronic Fatigue Syndrome (CFS) is diagnosed by consistent, debilitating fatigue for more than 6 months in absence of other definable causes. It is associated with depression, weight loss, an inability to handle stress and hypotension. Low cortisol levels and immune suppression have been found in most CFS patients.[12]

Other: High cortisol is also found in anorexia nervosa.[13] High levels can suppress thyroid function, leading to hypothyroidism and other related illnesses.[14] Excess cortisol production can also lead to a deficiency of progestin and estradiol. This can result in gynecological problems, such as irregular periods and PMS.[15]

Primary Aldosteronism (Conn's Syndrome)

Primary aldosteronism is a term to describe adrenal disorders in which excessive aldosterone is produced by the zona glomerulosa. It occurs outside of the normal renin angiotensin system. Secondary hyperaldosteronism is due to excess rennin, found in such disorders as renal artery stenosis.

Clinical Entities in Primary Aldosteronism
1. Solitary aldosterone producing adenoma (most common)
2. Bilateral hyperplasia zona glomerulosa
3. Primary AD hyperplasia
4. Adrenal carcinoma (very rare)
5. Glucocorticoid remedial aldosteronism (genetic disorder)

Lab Tests for Primary Aldosteronism
- High plasma aldosterone
- Hypertension
- Suppressed renal activity
- Low K+
- Urinary excretion of aldosterone and sodium intake

Hyperaldosteronism

Stress is the initial trigger of hyperaldosteronism. The most common manifestation of hyperaldosteronism is hypertension. Between .05% and 2% patients with hypertension suffer from hyperaldosteronism. Because stress has such a great impact on the adrenal gland, unhealthy high levels of aldosterone and stress hormones are found in the majority of hypertension patients. It occurs mostly in women in their third to fifth decade of life.

High levels of aldosterone result in the renal distal convoluted tubules stimulating reabsorption of sodium and secretion of K+ at medullary collecting ducts and secretion of hydrogen ions. The high levels of aldosterone will thus increase hypertension, metabolic alkalosis, hypokalemia, and hypomagnesemia.

Most of the symptoms of hyperaldosteronism will be related to hypokalemia (low potassium).

Hypokalemia Symptoms
- Palpitations
- Weakness
- Muscle cramping
- Paresthesia
- Headaches
- Polydipsia and polyuria

ALDOSTERONE ADENOMA

The most common form of aldosteronism is caused by a solitary aldosterone adenoma, which occurs in about 65% of patients. It is a benign epithelial tumor, in which the cells form a recognizable glandular structure. Adrenal cancer is very rare.

GLUCOCORTICOID REMEDIAL ALDOSTERONISM

Glucocorticoid remedial aldosteronism is also a very rare condition of primary aldosteronism. Its treatment consists of high levels of exogenous glucocorticoids to suppress ACTH secretion from the pituitary gland.

Pheochromocytoma

Pheochromocytoma is an adrenal medulla tumor composed of chromaffin cells that are capable of secreting

high levels of norepinephrine (NE), epinephrine (EP), and dopamine. Pheochromocytoma is relatively rare.

Approximately 90% of tumors arise within the adrenal gland itself. The remaining 10% can occur in various parts of the body: aortic bifurcation, bladder wall, and carotid artery. The symptoms of this condition will be due to high levels of epinephrine and norepinephrine, resulting in headaches, diaphoresis, palpitations, and hypertension. Pheochromocytoma is diagnosed through urinary measurement of urinary breakdown products of EP and NE.

CONVENTIONAL MEDICAL TREATMENTS

Addison's Disease
Conventional medical treatment of Addison's disease consists of hormone replacement therapy. Two common prescriptions are hydrocortisone (glucocorticoid replacement) and fludrocortisone (mineralocorticoid replacement).

Adrenal Insufficiency Syndrome
Adrenal insufficiency syndrome is generally not recognized nor treated conventionally.

Cushing's Disease
In the case of Cushing's disease, destructive techniques may be employed to decrease excess hormone production. Surgical excision of part of the adrenal cortex or radiation of adrenal tumors may be part of the treatment protocol. Steroid blocking drugs, such as aminoglutethimide, may also be used. If the onset of Cushing's is secondary to prescribed corticosteroids, dose reduction or an alternative medication may be indicated.

Primary Aldosteronism
Conventional medical treatment of primary aldosteronism includes investigation into the cause, such as adrenal adenomas, followed by surgical excision. Pharmaceutically, spironolactone is an aldosterone agonist that helps to lower the hypertension associated with primary aldosteronism.

Pheochromocytoma
Pheochromocytoma is also often treated with surgical excision of the associated adrenal medulla tumor. This may be accompanied by chemotherapeutic agents used to treat malignancy, such as vincristine, cyclophosphamide, and dacarbazine. Alpha and beta adrenergic blockers may also be employed to reduce the symptoms of excess catecholamine production.

Pharmaceutical Side Effects
Glucocorticoids, such as prednisone, hydrocortisone, and dexamethasone, are similar to natural hormones produced by the adrenal glands. They are used to treat a variety of conditions, including many inflammatory diseases, such as asthma and some forms of arthritis.

However, when patients are treated with glucocorticoids, the production of adrenal hormones may decrease because of effects on the pituitary and the adrenals glands themselves. If glucocorticoids are stopped or decreased too quickly, the adrenal glands may not begin making their own hormones again fast enough to meet the body's needs, and symptoms of adrenal insufficiency result. This condition usually occurs when these drugs are given systemically (by pills or injections), rather than topically (on the skin) or in inhaled forms. Higher doses and longer treatment increase the risk.

Abrupt cessation of treatment with glucocorticoids is the most common cause of adrenal insufficiency. Drugs that have a direct effects on the adrenal glands, decreasing glucocorticoid production, and therefore often causing adrenal insufficiency, include megestrol (hormone receptor blocker used in breast cancer), ketoconazole (antifungal), metyrapone, aminoglutethimide, and mitotane. There are also hypothesized but as yet unproven connections between a number of other classes of drugs, such as antibiotics and antihistamines, and the development of adrenal insufficiency.

There are many drugs that alter the metabolism of catecholamines. Alpha-Agonist, Ca Channel blockers, Beta blockers, and ACE inhibitors all reduce plasma and urinary concentration of the breakdown products of NE and EPI.[16] This is perhaps another mechanism found with patients who are fatigued and feel malaise on drugs for treatment of hypertension.

NATUROPATHIC MEDICAL TREATMENT AND PREVENTION

Traditional Chinese Medicine
Traditional Chinese medicine (TCM) treats the adrenal glands as part of the vital force of the kidney, stored in the "lower burner." The kidneys store the body's vital energy (Qi) and are called the "Root of Pre-Heaven Qi." The kidneys are almost always affected in chronic disease.

There are many factors that can weaken this energy source of the body, including hereditary weakness,

strong emotions (especially anxiety and fear), chronic illness, old age, and overwork. Similar factors can lead to exhaustion of the adrenal gland, to use Western medical terminology. TCM explains that people who work too much and are stressed too much can suffer exhaustion by becoming deficient in yang energy.

Symptoms of kidney conditions in TCM include a pale, swollen, and wet tongue, as well as a deep yet weak pulse. If the kidneys were deficient in yin, other symptoms would arise, such as dizziness, poor memory, and sore back. Patients suffering from a kidney deficiency in TCM terms have symptoms in adrenal insufficiency in Western terms — low back pain, fatigue, poor memory, and dizziness upon rising. Dizziness upon standing is a sign that the adrenal gland is not able to produce enough aldosterone and thus not able to compensate by increasing the blood pressure when standing.

In TCM, stress is a main etiology for causing irregular periods and an inability to produce a period. TCM has excellent results with treatments for these conditions.

Acupuncture

Acupuncture can be a very effective treatment to tonify the adrenal glands. The kidney meridian points used traditionally in TCM for tonification of the adrenals include Ki 3 and Ki 7. Traditional symptoms for which these points are indicated include frequent urination, premature aging, weak knees and weak back, fatigue, depression, and feeling chilly. These symptoms correspond well with the Western physiological effects of adrenal insufficiency.

Traditional tonification points on the spleen meridian, such as SP 9 and ST 36, are also helpful. The spleen points are concerned with digestion and absorption of nutrients, so these are particularly important for those with a weak digestive system. In adrenal insufficiency, there are often digestive disturbances, such as weak stomach (low acid production), gas, bloating, and irritable bowel syndrome (alternating diarrhea and constipation).

Conversely, if the problem is not one of deficiency but excess, traditional points to calm the mind and body, such as the An Mian points, can be used. These points were used traditionally to deal with stress and excess stimulation, as seen in adrenal hyperfunctioning.

Adaptogenic Herbs

In Western herbalism, TCM herbal formulas are called adaptogens. Adaptogenic herbs help us to support our vital force and increase resistance to stress and other factors leading to adrenal disorders. In India, they are called Rasayana herbs.[17] These herbs are known to rebuild the body and the mind, reduce aging, and improve the quality of life. They have the unique ability to be able to balance the endocrine system. "Adaptogen" is a term coined by researchers to describe this class of herbs that help the body adapt to stress. These herbs are finding an increasingly important role in today's pharmacopoeia.

Adaptogenic herbs have been shown to benefit the adrenal gland. These herbs are thought to achieve their effect primarily by supporting adrenal gland function. They are very effective in the treatment of hypoadrenalism. The adrenal glands are responsible for producing hormones that modulate the body's response to stress, such as cortisol and DHEA. The output of the adrenal glands can fall below optimal levels, especially under prolonged stress, leading to adrenal insufficiency. The adrenal glands may also hyperfunction in the resistance phase of chronic stress.

Adaptogenic herbs, therefore, support healthy adrenal function and adrenal hormone levels, whether the glands are hyperfunctioning or hypofunctioning. A balanced adrenal gland, in turn, supports the rest of the glandular systems in the body (endocrine system), promotes a healthy and balanced immune system, and helps relieve the effects of stress on mood, such as anxiety and depression.

Chronic stress can lead to a wide variety of symptoms, such as fatigue, low immunity, insomnia, dizziness upon standing, lack of motivation, irritability, and other mood disturbances. Hypoglycemic symptoms are also associated with stress, such as shakiness, irritability, lack of concentration, or headaches when meals are missed or delayed. Studies have shown that plant adaptogens help with these symptoms, as well as increasing red blood cell and white blood cell count in patients who are immuno-compromised, and improving exercise tolerance in healthy individuals.[18] Adaptogens also prevent immune system imbalances, endocrine dysfunction (such as thyroid or pituitary gland imbalances) and, by supporting immune function, help prevent infections and cancer.[19]

Adaptogens are an ideal choice for people with symptoms of chronic stress, as an adjunctive treatment for any endocrine condition or immune disorder, and as a general daily tonic.

Among adaptogenic herbs, ashwagandhi, licorice, Panax ginseng, Siberian ginseng, North American ginseng, schisandra, borage, astragalus, sarsaparilla, shatavari, wild yam, golden root, and devil's club have been shown in clinical trials and traditional use to be effective.

Definition of Adaptogens

In 1968 a Soviet research scientist and medical doctor, Dr Brekham, initiated many large-scale studies of adaptogens involving schools, factories, and even an entire town. He suggested the following definition of adaptogens:

1. The action of the adaptogen should be harmless and innocuous and cause minimal disturbance to the organism.
2. An adaptogenic agent should not be active only in a specific context or against a particular background. It must have a broad therapeutic spectrum of action.
3. The action of an adaptogen has to be nonspecific; that is to say, resistance to a wide variety of actions from harmful factors, whether of a physical, chemical, or a biological nature, has to increase. In other words, the action of an adaptogen has to be more intense as unfavorable changes occur in the organism.
4. An adaptogen has to have a normalizing or stabilizing action independent of the direction of previous changes.

Prescribing Adaptogens

As more herbs are represented in the scientific literature, we will begin to see that many more plants meet the criteria of adaptogens as described by Dr Brekham. Facing these options, how do we decide which adaptogen is the best choice for our patients.

Accessibility: Adaptogens are often prescribed for long-term use, so it is best to be sure they are readily available and affordable.

Susceptibility: The patient's area of susceptibility should be considered. Look for herbs that have an affinity for those organ systems that are affected by stresses. Also consider the specific indications if available.

Energetics: Energetics of the herb is another important factor. Even a rudimentary understanding of the Ayurvedic or Chinese systems can be helpful in this area. Remember that some herbs are more appropriate for the very young or elderly. Always look at the patient's goals and make choices based on supporting them.

Compliance: When choosing herbs for long-term use, it is especially important to enhance the probability of compliance. While availability and affordability are

factors in compliance, perhaps a more important consideration is taste. Be familiar with the taste of what your recommending and make efforts to make your herbal prescriptions as palatable as possible. This requires some degree of creativity. Many practitioners seem to fall into a habit of using one form of herb, usually capsules or tinctures. Talk with your patients about what forms they will be most likely to use. Consider the possibility of making teas from dried herbs or even chewing on roots or berries, especially if the plant was traditionally used in that manner. It is often easy to add additional herbs or essential oils to formulas, which not only improve the taste but act as synergists.

Value: Explaining the value of adaptogens can overcome any resistance from patients. Adaptogens can protect us from and strengthen us after serious illness. These herbs can help to optimize our physical and mental potential. They as the rest of the plant community are a great gift to be appreciated and used respectfully.

BOTANICAL MONOGRAPHS

Ashwagandha (*Withania somnifera*)

The Ayurvedic medical herb ashwagandha means "that which has the smell of a horse," implying that it gives the vitality and sexual energy of that animal. This aphrodisiac quality has not gone unnoticed among Western authors.

Contained in ashwagandha are the tastes of bitter, astringent, and sweet. Herbs with such multiple tastes often possess a broad spectrum of healing effects. The sweet post-digestive state or *vipaka* of ashwagandha indicates that it promotes *kapha* or earth secretions, and has an overall moistening effect. It is said to have a reducing effect on *vata* (wind) and *kapha* (earth) while being neutral to *pitta* (fire). In excess, it promotes *pitta* and accumulation of *ama* (undigested food toxins).

Adrenal Support: Recent research has shown that ashwagandha and ginseng influence hormone activity by helping support the hypothalamic pituitary axis function. Research indicates that ashwagandha helps adaptability to both physical and chemical stress. Studies also show that it can reduce vitamin C depletion and reduce cortisol depletion under times of stress. Lab results indicate that it can increase catecholamine production.[20-21]

Indications: There are many indications for the use of ashwagandha. It is listed for general debility, sexual

debility, nervous exhaustion, convalescence, problems related to aging, emaciation (particularly of children), loss of memory, muscle weakness, spermatorrhea, overwork, tissue deficiency, insomnia, paralysis, multiple sclerosis, tired eyes, rheumatism, skin afflictions, cough, dyspnea, anemia, fatigue, infertility, glandular swellings, AIDS, immune system problems, alcoholism, and lumbago.

Ashwagandha is considered to be the best rejuvenative in Ayurvedic medicine, particularly for *vata dosha* and for the muscles, marrow, and semen. It is also clarifying and nurturing for the mind and promotes deep, dreamless sleep. It is considered a good food for weak pregnant women as it stabilizes the fetus and regenerates hormones. Externally, it may be applied to wounds, sores, skin diseases, obstinate ulcers, carbuncles, and rheumatic swellings. It is excellent in conjunction with chemotherapy, because it enhances the effect of the drugs while protecting against side effects.[22-23] For cancer and serious illnesses, one or more ounces are recommended daily.

Ashwagandha may be taken as a decoction, medicated *ghee* or oil, powder, medicated wine, milk decoction, or paste. For regenerative purposes, raw sugar, honey, *pippali*, and *basmati* rice may be added. In general, 5 g of the powder in warm milk or water is recommended, taken twice daily, sweetened with raw sugar. This preparation augments the tonic and nutritive effects. It combines well with other rejuvenative tonics, such as elecampane, ginseng, gokshura, and lotus, as well as nerve tonics, such as skullcap.

Constituents: The chemistry of ashwagandha has been thoroughly studied. More than 35 constituents have been identified. Biologically active compounds are considered to be alkaloids, such as isopelletierine and anaferine, steroidal lactones, including withanolides and withaferins, and saponins, such as sitoindoside VII and VIII. The plant is also rich in iron.[24]

Actions: The root is considered to be an immune tonic, stress-protectant, antihepatatoxic, antibacterial, diuretic, antipyretic, astringent, nerve sedative, and alterative. The stem and leaves are used as antihepatotoxics, antipyretics, febrifuges, bitters, diuretics, antibacterials, antimicrobials, astringents, and nerve sedatives. The seeds are hypnotic, diuretic, and coagulant. The fruit is an immune tonic with antibacterial and alterative properties.[25]

Mechanism of Action: To date, there are no agreed-upon mechanisms for the many actions of this remarkable plant. Many pharmacological studies have been

conducted in an attempt to investigate the use of ashwagandha as a multi-purpose medicinal agent. The results of studies appear to validate its anti-inflammatory, antitumor, antistress, antioxidant, immunomodulatory, hemopoietic, and rejunenative properties. Further, it appears to exert a positive influence on the cardiopulmonary, endocrine, and central nervous systems.

CLINICAL STUDIES
Antistress Effect of Ashwagandha
Ashwagandha appears to protect against the physical ravages of stress, preventing adrenal mass increase and reducing vitamin C depletion in one study, and reducing stress-induced increases in blood urea nitrogen and blood lactic acid in another.[26] Other studies show that it reverses stress-induced increases in plasma cortisone and phagocytic index. In a comparison with Panax ginseng, it reduced weight loss more effectively in swimming-stressed mice; however, the Panax group was able to swim longer.

The above findings have been confirmed in a recent investigation using a withanolide-free aqueous extract of the roots. This extract proved to exhibit significant anti-stress activity in all measured parameters, which included hypoxia time, antifatigue effect, swimming time, swimming- and immobilization-induced gastric ulceration, swimming-induced hypothermia, auto analgesia, and biochemical changes in the adrenal glands. Preliminary acute toxicity studies indicated a good margin of safety at therapeutic doses.[27]

Endocrine Effects: Studies have been conducted to investigate the effects of ashwagandha on thyroid and liver function. Mice given high doses (1.4 g/kg) of the root extract showed significant increases in serum levels of T3 and T4. Furthermore, the extract was shown to reduce hepatic lipid peroxidation significantly, while increasing the activity of superoxide dismutase and catalase. These results indicate that ashwagandha stimulates both thyroid and hepatic antioxidant activity.[28]

A separate investigation studied the effect of a lyophilized aqueous extract on immature male Wistar rat testicular development, as well as serum testosterone and FSH levels. A notable increase in testicular weight was observed, with histological examination revealing an apparent increase in the diameter of the seminiferous tubules, along with an increase in the number of seminiferous tubular cell layers. Serum testosterone and FSH levels were decreased in the treated group. The authors concluded that a spermatogenic influence on the seminiferous tubules of

immature male rats might indicate that ashwagandha possesses a testosterone-like effect.[29]

In combination with the Ayurvedic herbs *Tinospora cordifolia, Eclipta Alba, Ocimum sanctum, Picrorrhiza kurroa,* and *shilajit,* ashwagandha was shown to cause a dose-related decrease of streptozotocin-induced hyperglycemia. This effect was not seen when any of the herbs were used alone, however, which may validate the Ayurvedic practice of using herbs in synergistic combinations. These results point to promise in using ashwagandha in endocrine dysfunction.

Anti-Inflammatory Properties: Most studies of the anti-inflammatory properties of ashwagandha have been conducted on rats using a variety of chemical markers to evaluate its efficacy in reducing artificially induced inflammation. These studies used varying amounts of the powdered root, which was compared to different reference drugs and control substances. Ashwagandha consistently altered the marker levels in a positive way, with a stronger effect than hydrocortisone in two studies. Two of these investigations showed that ashwagandha might be effective in reducing granuloma formation, at least in a rat model.

One clinical trial was performed on human subjects, using a formula (450 mg ashwagandha, 100 mg boswellia, and 50 mg each of turmeric and zinc) in the treatment of osteoarthritis. In a double-blind, placebo, cross-over study of 42 patients, the herbal formula significantly reduced both pain and disability, but produced no change in erythrocyte sedimentation rate or in radiological appearance following 3 months of treatment. One study indicates that cyclooxygenase inhibition may be the mechanism whereby its anti-inflammatory properties derive.[30]

Antitumor Properties: Ashwagandha appears to exert antitumor, radiosensitizing, and cyclophosphamide-protectant effects. Studies in this area have so far been limited to animal models, using artificially induced or transplanted tumors. It provided protection against urethane-induced tumors in mice, while reversing the adverse effects of urethane on leukocyte and lymphocyte counts, body weight, and mortality. It also inhibited growth of sarcoma in another study conducted on mice using a root tincture, although the highest used doses of one gram per kilogram were in some cases lethal. The isolated steroidal lactone withaferin A was shown to posses radiosensitizing properties in a study of Chinese hamster cells. Another study indicates that ashwagandha may reduce the leukopenia that follows cyclophosphamide treatment, possibly through the stimulation of stem cell proliferation.

Two more recent studies support the chemoprotective and chemopreventive properties of ashwagandha. The effect of an aqueous extract of ashwagandha in preventing paclitaxel-induced neutropenia was demonstrated in mice in one study. The chemotherapeutic agent paclitaxel was given to the mice at a dose of 1 mg/kg, which produced a significant decline in white blood cell (WBC) and absolute neutrophil counts as measured on days three and five. The aqueous extract of ashwagandha administered at a dose of 200 mg/kg by mouth for 4 days prior to and 12 days following paclitaxel administration significantly reduced both the decline in WBC count and neutropenia normally induced by the chemotherapeutic agent.

These findings would appear to reinforce the use of ashwagandha as an adjuvant during chemotherapy to prevent the bone marrow suppression associated with anticancer drugs. The second study appears to verify the chemopreventive effects of a hydroalcoholic extract of the root. In this experiment, Swiss albino mice were injected with a single dose of 200 micrograms of 20-methylcholanthrene in the thigh, which induced tumors in 96% of the mice. Animals that received the ashwagandha extract at a dose of 400 mg/kg one week before the injection and 15 weeks thereafter had a significant reduction in the incidence and volume of tumors, in addition to enhanced survival and delay in tumor formation. Investigation into liver biochemical parameters revealed a significant modulation of reduced glutathione, lipid peroxides, glutathione-S-transferase, superoxide dismutase, and catalase levels in treated versus 20-methylcholanthrene injected mice. These findings suggest that the chemo-protective properties of ashwagandha may be due to its antioxidant and detoxifying capabilities.[31-33]

Antioxidant Effect: The active principles of ashwagandha, sitoindosides VII-X and withaferin A, have been shown to have antioxidant effects. The effect of these glycowithanolides in mitigating the deleterious effects in rat brain frontal cortex and striatum induced by daily administration of foot-shock for 21 days was assessed in one study. Levels of superoxide dismutase, glutathione peroxidase, and catalase showed a dose-dependent increase comparable to the known antioxidant deprenyl when given orally 1 hour prior to the stressor. It was further shown to protect against lipid peroxidation induced by IV administration of lipopolysaccharides. These findings imply that ashwaghanda may have an antioxidant effect in the brain that may account for some of its therapeutic properties.

Antioxidant effects outside the brain were demonstrated in another study that investigated the free

radical scavenging capacity of a methanolic extract and its effect on DNA cleavage induced by hydrogen peroxide and ultra-violet photolysis. The extract showed a dose-dependent free radical scavenging capability with a protective effect against DNA cleavage in human fibroblasts treated in vitro with hydrogen peroxide. The authors of this study speculate that this antioxidant capacity may, at least in part, account for the antistress, immunomodulatory, cognition-enhancing, anti-inflammatory, and anti-aging effects produced clinically and experimentally by ashwagandha.[34]

Immunomodulatory Properties: The use of ashwagandha as a tonic to increase energy and prevent disease may be related to the Western concept of immune-stimulation. As an immunomodulator, ashwagandha has been shown to increase mobilization and activation of peritoneal macrophages, as well as increase phagocytosis and activity of lysosomal enzymes in rats and mice. It was also shown to enhance learning acquisition and memory retention in young and old mice. Further, it caused increases in hemoglobin concentration, red blood cell count, white blood cell count, and body weight in healthy and myelosuppressed mice. Ashwagandha has displayed remarkable cytotoxic effects, inhibiting delayed-type hypersensitivity in mice, and significantly reversed the toxin-induced suppression of chemotaxis, interleukin-1, and tumor necrosis factor secretion in macrophages of treated mice. It has been shown to increase circulating antibody titers and the number of spleen plaque forming cells with treatment of five doses of 20 mg/kg of the powdered root. However, the isolated withanolides showed an immunosuppressive activity in a separate study, which may be an indication that whole plant extracts tend to contain balancing principles that guard against an overly one-sided effect.[35]

Hemopoietic Effect: Ashwagandha exhibited a significant hemopoietic effect in mice treated with the myelosuppressive agent cyclophosphamide, increasing white cell counts and cellularity of the bone marrow. Similar increases in bone marrow cellularity were conformed in a separate study. These findings may indicate a stimulation of stem cell proliferation, which could be of use as an adjuvant in cancer chemotherapy.[36]

Rejuvenating Effects: Some interesting preliminary human trials have been conducted to assess the growth-promoting and rejuvenative effects of ashwagandha. One study compared ashwagandha alone to ashwagandha combined in equal parts with the Ayurvedic herb punarvana (*Boerhaavia diffusa*) and to two groups receiving different amounts of ferrous fumarate, as well as a control group receiving placebo. Each group of 12 healthy children ranging from 8 to 12 years of age received its daily mixture for a 60-day period. The ashwagandha was administered as powdered root dissolved in milk, which in Ayurvedic thinking should promote the tonic properties of the herb, as well as increase its ojas. This group showed significant increases in body weight, mean corpuscular hemoglobin, and total blood proteins as compared to the control group. Hemoglobin and handgrip strength increased significantly in the combined herb group compared to controls.

In another clinical trial, 3 g per day of root powder was given to 101 healthy males aged 50 to 59 years. All subjects showed significant increases in hemoglobin and red blood cell count along with improvements in hair melanin, seated posture and reports of sexual performance.[37]

Nervous System Effects: The effects of ashwagandha on the nervous systems of various mammals have been investigated. The alkaloid extract ashwagandholine has been shown to produce taming and tranquilizing effects on monkeys, cats, dogs, rats, and mice. However, the alkaloid also potentiated Metrazol toxicity in rats and mice, and barbiturate-, ethanol-, and urethane-induced hypnosis, as well as hypothermia, in mice. A separate study demonstrated a weak relaxant and anti-spasmodic effect of the alkaloid extract in countering artificially induced smooth muscle contractions in the intestinal, uterine, tracheal, and vascular muscles. Isolated extracts of the sitoindosides VII-X and withaferin seemed to affect events in the cortical and basal forebrain cholinergic signal transduction cascade. The authors of this study speculate that this might account for the putative cognition and memory enhancing effects of the herb.

A methanol extraction of the root at a dose of five micrograms per milliliter was shown in one study to activate neurite outgrowth in vitro in human neuroblastoma SK-N-SH cells. This effect was both dose- and time-dependent, and indicates that the extract may promote the formation of dendrites. The investigators postulated that this action might compensate for and assist in repair of damaged neuronal circuits in the treatment of dementia.

Cardiopulmonary Effects: The effectiveness of ashwagandha as a general tonic may result in part from its

cardiopulmonary effects, as the following studies suggest. The alkaloid extract appears to exert influence on the cardiopulmonary system, as shown in experiments conducted on dogs and frogs. A prolonged hypotensive, bradycardic, and respiratory-stimulant effect was demonstrated on dogs. These effects seem to be due to a combination of autonomic ganglion blocking action, as well as a depressant action on higher cerebral centers, along with stimulation of vasomotor and respiratory centers in the brainstem. In these studies, the alkaloids were more than twice as powerful as the whole root in producing the observed effects.

Cardioprotective effects were demonstrated in another trial using rats and frogs. Significant increases in relative heart weight as well as myocardial and hepatic glycogen were observed in treated groups. Ashwagandha treatment appeared to protect against the action of the cardio-toxic agent strophanthin-K in frog heart muscle function tests by increasing the duration of contractility in the presence of the tachycardic drug. Ashwagandha also caused significant increases in coagulation time, with a return to normal rates seen following a 7-day cessation of administration. These findings resulted in the author's observation that the herb appears to possess cardiotropic, cardioprotective, and anticoagulant properties.[38]

CLINICAL STUDIES
Pharmacology
The major biochemical constituents of ashwagandha root are steroidal alkaloids and steroidal lactones in a class of constituents called withanolides. At present, 12 alkaloids, 35 withanolides, and several sitoindosides from this plant have been isolated and studied. A sitoindoside is a withanolide containing a glucose molecule at carbon 27. Much of ashwagandha's pharmacological activity has been attributed to two main withanolides, withaferin A, and withanolide D. The withanolides serve as important hormone precursors that can convert into human physiologic hormones as needed. Ashwagandha is thought to be amphoteric; i.e., it can help regulate important physiologic processes. The theory is that when there is an excess of a certain hormone, the plant-based hormone precursor occupies cell membrane receptor sites so the actual hormone cannot attach and exert its effect. If the hormone level is low, the plant-based hormone exerts a small effect. Ashwagandha is also considered to be an adaptogen, facilitating the ability to withstand stressors, and has antioxidant properties as well. Other studies have shown ashwagandha to have an immunostimulatory effect.[39]

Licorice (*Glycyrrhiza glabra*)

Commonly known as licorice or sweetwood, *Glycyrrhiza glabra* of the Leguminosae family was named by the Greek physician Dioscorides and widely used in Europe during the Middle Ages and the Renaissance. Licorice is considered a cool or tonic herb. It has a sweet/bitter taste.

Adrenal Support: Licorice root has been used for thousands of years as an herbal tonic. Research has shown that licorice increases cortisol levels and mitigates problems with low blood pressure. Licorice, through its effects on the kidneys, also improves the body's ability to retain sodium and magnesium, thereby reducing problems with frequent urination. Blood pressure should be monitored when taking licorice due to its ability to raise blood pressure.[40-42]

Pharmacology: Two well-known constituents are the triterpenes, glycyrrhizin (glycyrrhizic or glycyrrhizinic acid) and its aglycone component, glycyrrhetinic acid (glycyrrhetic acid). The constituents also include phytoestrogenic phytosterols, flavonoids and isoflavonoids, coumarins, chalcones, polysaccharides, and volatile oil.[43]

The triterpenes are metabolized to a similar structure as the adrenal cortical hormones, which may be responsible for its anti-inflammatory action. Glycerrhizin inhibits hepatocyte damage and increases antibody production, possibly through a stimulation of interleukin. It has been found to inhibit the growth of some RNA and DNA viruses, including the herpes simplex virus. Glycyrrhizin has been used intravenously to treat chronic hepatitis in Japan.[44]

In studies on mice, it demonstrated a reduction in morbidity and mortality in response to lethal doses of influenza virus. Lower viral titers were noted, as well as a decrease in lung consolidation.[45]

Clinical Applications: Along with its adaptogenic effect on the adrenal gland, licorice is known as an anti-inflammatory, demulcent, expectorant, lightly acting laxative, and pancreatic tonic, as well as an immune stimulant with antiviral properties. Licorice is thought to work on all tissue elements with affinities for the digestive, respiratory, nervous, reproductive, and excretory systems. In the gastrointestinal tract, it generally soothes and tones mucous membranes, decreases muscle spasms, reduces inflammation, and removes mucous. Licorice is often used in combination with other herbs to mask disagreeable tastes. It is also thought to improve voice, vision, hair,

and complexion. Licorice has been used topically for herpes lesions, eczema, and psoriasis.

There has been concern voiced over a reported tendency for licorice to increase blood pressure; however, a study of prolonged ingestion of licorice found that out of 24 healthy volunteers only two experienced a notable increase in blood pressure, an overweight woman with a history of arterial hypertension and a man with a similar hypertensive history.[46] In a related case study, licorice has been noted to ameliorate postural hypotension caused by diabetic autonomic neuropathy.[47]

Cautions: Blood pressure should be monitored during the use of licorice in extended high doses, especially in cases with a history of hypertension. Licorice increases the half-life of corticosteroids by a factor of two and thus is not well indicated in combination with corticosteroids.[48]

Korean Ginseng (*Panax Ginseng*)

Another member of the Araliaceae family is *Panax ginseng*, also known as Korean, Japanese, Chinese, Oriental or 'true' ginseng. The genus name *Panax* was derived from the Latin *panacea* or "cure all." 'Red' ginseng is produced by steaming the naturally creamy white root. The steamed root is thought to be more stimulating and effective. Known as Sanchi or Ten Chi, *Panax notoginseng* is another species with actions similar to *P. ginseng*. This is a pungent, bitter, and sweet herb and tends to be warming.

Adrenal Support: Panax is reported to have a tonic effect on blood pressure and is indicated in cases of adrenal insufficiency. It has an affinity for the adrenal glands, digestive tract, male genital urinary tract, and nerves.

Pharmacology: The constituents of *Panax ginseng* include at least 13 ginsenosides, saponinglycosides, glycans, and volatile oils. The ginsenosides have been reported to have an antioxidant effect, decreasing senile dementia by protecting neural cells from overproduction of nitric acid. Trilinolein, isolated from Sanchi, has been found in vivo to reduce the risk of ischemic injury to the myocardium, and to suppress arrhythmias during ischemia and reperfusion. It increases red cell deformability and exhibits an antiplatelet effect, probably due to an increase in cyclic GMP via stimulation of nitric oxide. Trinolein also potentiates super oxide dismutase, leading to better preservation and recovery with hypoxia.[49]

Sanchi was found to have the strongest anti-tumor effect among six species of the genus. These studies were based on induced skin and hepatic cancer in mice. It was also found to be effective against the Epstein Barr virus. Panax is considered a strong antiviral that is effective in cases of hepatitis. Its strong hepatoprotective effect has been shown in vivo with disease induced by alcohol, carbon tetrachloride, chloroform, and galactosamine.[50]

Clinical Applications: Other findings in the liver include a reduction in cellular swelling, congestion, bile pigmentation, and reduced liver enzyme levels. It enhances antibody response, increases interferon production, and generally tonifies the immune system. Panax has been shown to possess an anti-tumor effect.[51]

It is considered an aphrodisiac by some and may be beneficial in cases of erectile dysfunction due to stress. Topically, it is an effective antipruritic and stimulates hair growth.

Cautions: *Panax ginseng* should not be used in cases of acute inflammatory disease or bronchitis; it should be avoided generally when the patient is experiencing symptoms of heat. It may be overly stimulating, like coffee, in those who are not weak. It has occasionally been found to produce headaches. It should be used with care in patients who are hypertensive. It is also contraindicated in women with heavy menstrual flow and those who are pregnant.

Siberian Ginseng (*Eleutherococcus senticosus*)

Eleutherococcus senticosus, commonly known as Siberian ginseng, is also a member of the Araliaceae family. "Eleutheros" means free and "kokkos" means seed from the Greek. Acanthopanax has been used interchangeably (as far as nomenclature goes) with Siberian ginseng but these two herbs are separate genera in the Araliaceae family. Eleutherococcus grows wild in eastern Russia, China, Korea, and Japan. Energetically, this herb is heating, pungent, and sweet.

Although the first recorded mention of *Eleutherococcus senticosus* as a medicinal herb was by a Russian physician en route to Peking via Mongolia as a member of the 11th-century Russian ecclesiastic mission, Siberian ginseng was not widely used medicinally until the 1950s and 1960s when Dr Brekham studied the attributes of this adaptogenic herb.

Adrenal Support: Extracts of ginseng containing eleutherosides were found to have specific binding affinity to adrenal receptor sites, including glucorticoid,

mineralcorticoid, and progestin receptors. This preferential binding affinity may be part of the mechanism of the balancing adrenal effects of adaptogenic herbs.

CLINICAL STUDIES
Soviet Tests
Many Soviet studies were done on *Eluetherococcus senticosus* (Siberian ginseng) in the 1950s, including one experiment that involved 30,000 people. These studies have shown great reductions in the number of workdays lost due to illness via reductions in influenza and other acute upper respiratory diseases, as well as a decrease in hypertension and ischemic heart disease. Siberian ginseng has also been found to improve visual acuity, in addition to promoting an increase in physical and mental endurance. It has been found to support faster healing postoperatively and to potentiate antitumor immunity through the stimulation of natural killer cell activity. This herb may also be helpful for patients receiving chemotherapy.

Animal studies have shown that subjects had less weight loss and higher white blood cell counts while given Siberian ginseng as an adjunct to antineoplastic drugs. It is thought to support immune function, and is effective in cases of nervousness and frontal headaches due to prolonged stress, especially when combined with poor eating and sleeping habits. It may help to normalize volatile blood sugar levels.

Pharmacology: Many constituents of Eleutherococcus, referred to as eleutherosides, have been found to be beneficial. Beta-sitosterol has anticancer, anti-inflammatory, antipyretic, antihyperglycemic, and antihypercholesterolemic effects. The lignans produced by this herb may offer the plant immuno protection as well protection against free radical damage. One of these lignans, syringen has been found to protect against radiation by decreasing leucopoenia, as well as having an immunostimulating and potentiating effect. Syringen has also been found to have a hypocholesteremic effect, especially on LDL. Sesamin has exhibited an anticancer effect and an immunostimulatory effect. It reduces liver enlargement due to alcohol intake. Siberian ginseng also produces precursors to lignans, such as caffeic acid and coniferlyadehyde, both of which have demonstrated anticancer activity. Isofraxiden is cytotoxic in lymphocytic leukemia in mice and is choleretic.

Applications: Siberian ginseng is one of the more stimulating of the adaptogens and, accordingly, is

often used in cases of exhaustion, debility, and depression. After the Chernobyl nuclear incident in Russia, it was used to help with the ill effects of radiation. It increases duration of muscular activity with less loss of glycogen, creatine phosphate, and protein nitrogen, while increasing mobilization of lipids. Pretreatment doubles the recovery rate of messenger and ribosomal RNA synthesis in the rat liver following severe muscle load. Overall, it prolongs the resistance phase of GAS, while reducing the alarm reaction and exhaustion stage.[52]

North American Ginseng (*Panax quinquefolius*)

The North American cousin representing the Araliaceae family is *Panax quinquefolius*. It is also referred to as *Aralia quinquefolius*, Five Fingers, Tartar root, Red Berry, and Man's Health. The American Indian name for the herb is "Garantoquen," which means like a man. *Panax quinquefolius* is generally thought to be similar to but gentler in action than *Panax ginseng*.

Adrenal Support: Extracts of ginseng containing ginsenosides were found to have specific binding affinity to adrenal receptor sites, including glucorticoid, mineralcorticoid and progestin receptors. This preferential binding affinity may be part of the mechanism of the balancing adrenal effects of adaptogenic herbs.

Pharmacology: The main constituents found in *P. quinquefolius* are steroidal saponins, including panoquilon. A small amount of volatile oil, starch, and gums are also present. The saponins are given credit for the antioxidant and, therefore, vascular protective effect of this herb.

Clinical Applications: Although the use of this herb has not been widespread, it was in the *Eclectic Pharmacopoeia*. In the eclectic literature, the indications for this herb are nervous dyspepsia; mental and other forms of nervous exhaustion from overwork. It has been used for heart and blood circulation, sugar diabetes, depressions, neurasthenia, neurosis, and psychasthenia. It is a gentle tonic to be used over a long period of time and is very comforting to the stomach. The herb is used as a physical restorative that also acts psychologically for feeling tired. American ginseng combines well with fresh pineapple juice in cases of dyspepsia.[53-55]

Cautions: American ginseng should not be taken during pregnancy.

Schisandra (*Schisandra chinensis*)

Schisandra chinensis and its Chinese cousin *Wu Wei Zi* are members of the Schizandraceae family. Both are adaptogens. *Schisandra chinensis* is a warm tonic herb and has a sour taste.

Adrenal Support: The herb has shown to counteract testosterone-induced atrophy of the adrenal in animal studies. Ingestion of the fruit of schisandra has shown to increase adrenal and spleen function in animal studies as well.

Pharmacology: As many as 30 lignans have been identified, including schizandrin, doxyschizandrin, gomsin, phytosterols, beta-sitosterols, stigmasterols, volatile oil, and vitamins C and E. Gomsin A has been found to increase metabolism of deoxycholic acid, which is an endogenous risk factor for hepatocarcinogenesis.

Fructus Schizandrae (FS) has been found to be effective against viral and chemical induced hepatitis. Study results indicated that "FS and its several components can mainly protect liver from injury induced by toxic substances, such as CCl4; they have anti-oxidant activities against oxygen free radicals; FS and four components have inducing action on liver cytochrome P-450; they also promote certain anabolic metabolism, such as serum protein biosynthesis and glycogenesis. All these activities would be of importance in the protection and repair of the injured liver cells."[56]

Clinical Applications: Schisandra is used in cases of poor liver function, hepatitis, and liver cancer. It is used as a sexual stimulant, increasing the secretion of sexual fluids in both men and women. It is thought to tone and strengthen kidney function by helping the body to balance fluid in cases of urinary frequency, thirst, and night sweats. Although it is thought of as a stimulating herb by some, acting on the CNS to enhance reflexes and stamina, it is thought by the Chinese to "quiet the spirit and calm the heart." It has been used in cases of insomnia, especially due to dream-disturbed sleep. The berries have been used in China to treat mental illness, forgetfulness, and irritability. Schisandra is considered a deep immune activator. In China, *Wu Wei Zi* is used for acute and chronic coughs with wheezing.

Contraindications: It is contraindicated in pregnancy due to its reported effect on uterine contractions.

Borage (*Borago officinalis*)

Borago officinalis, commonly known as borage, is prepared as an oil high in polyunsaturated fats. According to English herbalist John Gerard in 1597, a syrup of the flowers was used to "comfort the heart and purgeth melancholy." The Celts steeped borage leaves in wine, and the mixture was thought to increase the blood adrenaline level, thereby bolstering courage. The purple-blue hanging flowers are said to produce excellent honey. Folklore also suggests that borage can enhance psychic awareness and has been used in ritual baths to prepare for shamanic journeying. It is also thought to make people more aware of their male aspect of their personality. Borage is traditionally used to treat premenstrual complaints, rheumatism, and skin problems, such as eczema.

Adrenal Support: The energetics of borage is thought to be astringent, sweet, and cooling. Borage helps to restore the adrenal glands after internal stress of cortisone or steroid use or external stress.

Pharmacology: Borage contains potassium and calcium, along with mineral acids, saponins, tannins, and essential oil. It is high in mucilage, which, when cooked, will deposit nitre and common salt.

Clinical Applications: It is a tonic and often used after fevers as a diaphoretic and long term for convalescence. It stimulates the flow of milk in nursing mothers. Borage is useful in respiratory ailments due to its expectorant, emollient and anti-inflammatory action.

Astragalus (*Astragalus membranaceus*)

Astragalus membranaceus, a member of the Leguminosae family, is a Chinese tonic herb that has been used medicinally for thousands of years and is now gaining popularity in the West. Also referred to as *Huang Qi* in traditional Chinese medicine, astragalus is well indicated in young people as an energy tonic that helps to tonify the *Wei qi*, which helps to protect the body from "External Pernicious Influences." This seems to correspond with our modern Western view of this herb as an immune tonic. Astragalus may not be well indicated for acute illness because it "locks the gates," not allowing entrance or exit from the body, although this view is certainly not held by all herbalists.

Adrenal Support: Astragalus is a warming and sweet herb. In addition to a tonic adrenal effect, astragalus also has an affinity for the lungs and spleen.

Pharmacology: Astragalus contains glycosides, polysaccharides, choline, betaine, rumatakenin, beta-sitosterol, isoflavones, and selenium. The polysaccharides have been found to increase phagocytosis of

reticuloendothelial cells, stimulate pituitary-adrenal cortical activity, and restore depleted red blood cell formation in the bone marrow. They also stimulate the production of interferon.[57]

Clinical Applications: Astragalus is antiviral, carminative, antispasmodic, and hepatic. It improves glucose tolerance and acts as a vasodilator. In China, astragalus has been used as an energy tonic for deficient spleen qi and yang conditions. It has been used to treat wasting and thirsting conditions, as well as diarrhea, fatigue, and prolapse of the uterus. Astragalus is used to control fluids in cases of excess sweating and to reduce fluid retention. In the Western world, the focus has been on its immunomodulatory effects, specifically the stimulation of interferon, which can be useful in conditions ranging from the common cold to cancer.[58]

Shatavari (*Asparagus racemosus*)

Shatavari is the common name of the Ayurvedic herb *Asparagus racemosus* from the Liliaceae family. It translates as "she who possesses a hundred husbands." This herb is also used in states of debility of the reproductive organs and general sexual debility. Shatavari is indicated in infertility, impotence, and menopause. It increases milk and semen. Shatavari is said to aid in love and devotion.

Adrenal Support: This herb has shown to have the same effect of diminishing the damaging effects of stress on the adrenal gland as with *Panax ginseng.*[59]

Clinical Applications: As a more general adaptogen, it is used for dysentery and diarrhea due to it ability to restore fluids and soothe inflamed membranes. These properties also make it useful in cases of stomach ulcers, cough, and dehydration. It can also be used externally as an emollient for stiffness throughout the body.

Dose: It is used as a decoction with 250 mg to 3 g of the powder in milk and can be sweetened with raw sugar.

Sarsaparilla (*Smilax officinalis*)

Another member of the Lilliacea family, *Smilax officinalis* is commonly known as Sarsaparilla or Smilax. Smilax was brought from the new world to Spain in 1563 and was at first thought to be a cure for syphilis, but these claims were found to be inflated. Sarsaparilla root was used as the flavoring agent for root beer before the introduction of artificial flavorings. Energetically, it is a bitter, sweet, and cooling herb.

Adrenal Support: The natural steroidal glycosides found in sarsaparilla root enhance glandular balance, boost hormone production, and aid muscle building.

Pharmacology: The constituents include steroidal sapogenins, glycosides, essential oils, and resin.[60]

Clinical Applications: This herb continues to be used in cases of skin problems, such as eczema, psoriasis, and general pruritus. It is also used in rheumatism and gout. It is an alterative, a blood cleanser. Hormonally, it is thought to have testosterogenic action, leading to an increase in muscle bulk and libido. Sarsaparilla is also thought to have progesterogenic activity, making it useful in some cases of premenstrual syndrome and menopause. It is used widely in Mexico and by the native Amazonians to increase virility. Some practitioners use it in combination with hydrastis and echinacea in the treatment of Lyme disease. In Ayurvedic practice, it is used in combination with gentian for herpes and other venereal complaints.

Dose: For decoction, simmer 1-2 tsp of root in water and drink a cup, 3 times a day. If tincture is preferred, take 1-2 ml, 3 times a day.

Wild Yam (*Dioscorea villosa*)

Dioscorea villosa or wild yam is probably best known as a female tonic that has also been used as a poultice to treat scabies and boils.

Adrenal Support: Wild yams contain a sapogenin called diosgenin. Diosgenin is a precursor to the hormone progesterone.[61] The wild yams do not contain any hormones, but are potential precursors. Birth control pills were initially made with a chemical process using wild yam. It also contains compounds that can be made in the lab to form DHEA.

Pharmacology: It also contains steroidal saponins including diosine, diosin, dioscorin, phytosterols, alkaloids, tannins, and starch.

Clinical Applications: The main actions of *Dioscorea villosa* are considered to be anti-inflammatory, antispasmodic antirheumatic, hepatic, and diaphoretic. Wild yam is a cholagogue. Wild yam has been to relieve nausea of pregnancy in small frequent doses. It soothes diverticulosis and is helpful in the treatment of rheumatoid arthritis.

Wild yam is often used in cases of dysmenorrhea and other uterine and ovarian pain, especially when accompanied by nervousness.

Golden Root (*Rhodiola rosea*)

Rhodiola rosea, also known as golden root or arctic root, is another adaptogen found in the mountains of China, the Ukraine, and Russia. A favorite form of the herb is a tincture called nastojka, prepared by combining the fresh roots of Rhodiola with 40% alcohol and allowing the mixture to sit for one week. A teaspoonful of the resulting nastojka after breakfast, lunch, and dinner is prescribed for those experiencing sexual disturbances. In Siberia, it was taken regularly, especially during the cold and wet winters, to prevent sickness. In Mongolia, it was used for the treatment of tuberculosis and cancer.

Adrenal Support: Like many of the other adaptogens, this herb increases the body's resistance against mental and physical stress. In animal studies, Rhodiola was found to increase blood insulin levels and decrease glucagon levels.[62]

Pharmacology: The known constituents of Rhodiola include phenylpropenoids (rosavin, rhosavidin, rhodiolosid, salidrosid). Additional constituents are thyrosol and cinnamic alcohol, essential oil, anthraglycosides, beta-sitosterin, daucosterol, monoterpenes, flavonoids, and tannins.

Clinical Applications: Rhodiola has action as a nervine and has been used in cases of depression. Studies have shown an immunostimulatory effect, and it is an enhancer of long-term memory.

Rhodiola has been found useful in the treatment of arrhythmias, via the induction of opioid peptide biosynthesis. It reduces catecholamine release and cAMP in the myocardium. It is postulated that *Rhodiola rosea* extracts are anti-mutagenic due to their ability to raise the efficiency of intracellular DNA repair mechanisms.[63]

Rhodiola has also been reported to decrease the toxicity of Adriamycin in mice with metastatic carcinoma. Adriamycin can be involved in producing liver dysfunction, as usually seen by a sharp increase in blood transaminase levels. Rhodiola extract was reported to decrease this toxicity and inhibit tumor dissemination.[64]

Devil's Club (*Oplopanax horridum*)

Oplopanax horridum, commonly known as devil's club, is a member of the Araliaceae family found in northwest North America. It is a shrub with spiny stems and clusters of orange red berries that resemble a club.

Endocrine Support: *Oplopanax horridum* is often used in cases of hyperglycemia or unstable blood sugar. Oplopanax has a balancing effect on the endocrine system that makes it a good choice in the treatment of diabetes.

Pharmacology: Several antimicrobial polyenes have been isolated from devil's club. Falcarinol and falcarinadol have been found to be effective antibiotic agents against *S. aureus, B. subtilis, E. coli DC2,* and *pseudomonas,* as well as *Candida albicans.* Various combinations of these polyenes were found to be effective against *Mycobacterium tuberculosis* and isoniazid-resistant *Mycobacterium avium.*[65]

Clinical Applications: The dried, inner part of the bark has been used as medicine by the Native community for a wide variety of ailments, including diabetes, lung hemorrhages, tuberculosis, swollen glands, burns, and wounds. Oplopanax is also indicated in the treatment of chronic infections and headaches due to stress or worry. It not only acts as an adaptogen with an affinity for the adrenals but as a diuretic and carminative. It is both warming and stimulating. Since it acts as an adaptogen, its balancing effect will be beneficial in both high and low blood sugar.

Dose: Anywhere between 200 mg to 1/2 cup of dried root and boiled as a concoction.

NUTRITION DEFICIENCIES AND SUPPLEMENTS

A number of nutrient deficiencies have been associated with improper functioning of the adrenal glands and thus should be supplemented if deficient.

Supplements

Vitamin C: Necessary for cortisol and other adrenal hormone production and as an antioxidant that protects the adrenals from damage.[66]

Vitamin E: Essential to enzymatic reactions in the adrenal gland that neutralize free radicals produced during the manufacture of adrenal hormones.

Pantothenic Acid (Vitamin B-5): Part of the energy producing pathways, B-5 is necessary in high quantities in the adrenal glands because a great deal of energy is necessary in the production of adrenal hormones.[67]

Pyridoxal-5-Phosphate (Vitamin B-6): A cofactor in the enzymatic production of adrenal hormones.[68]

Magnesium: Necessary for cellular energy production, and is often depleted in patients on diuretics or who suffer from frequent urination.

Calcium: Both calcium and magnesium help to settle the nervous system and improve stress-handling capabilities.

Trace Minerals: Zinc, manganese, selenium, molybdenum, chromium, copper, and iodine are all trace minerals that are necessary for overall health and specifically to calm an overexcited nervous system that can lead to adrenal gland maladaption.

Essential Fatty Acids: Omega-3 and omega-6 fatty acids contribute to a balanced nervous system, increased focus, ability to handle stress, and adrenal gland health and recovery. Unfortunately, deficiencies of omega 3 fatty acids are common, as is over-consumption of unhealthy fats (trans and saturated).

Adrenal Diet

The diet should focus on consumption of a variety of whole, natural, and, preferably, organic foods. To control blood sugar fluctuations, each meal should combine some fat (preferably high in essential fatty acids) with protein and complex carbohydrate. Non-starchy vegetables should be eaten 6 to 8 servings per day.

Fruits and grains should probably be avoided at breakfast because these foods can lead to pre-lunch hypoglycemia. In fact, bouts of hypoglycemia should be avoided as much as possible. Eating smaller meals more frequently, while being aware of the glycemic indices of food, is necessary if hypoglycemia needs to be managed.

Salt need not be restricted, especially if hypotension is a sign. Any food sensitivities should be avoided during this phase of adrenal recovery, as well as stimulants (caffeine in any form and nicotine), alcohol, hydrogenated oils, and deep-fried foods.

Beverages conducive to adrenal recovery include good quality water, herbal teas, green tea, fresh organic vegetable juices, and alternatives to dairy (if food allergy is present), such as nut milks, rice milks, and soy milk. All stimulants should be avoided including caffeine, ephedrine, nicotine, and cocaine. Soft drinks should be avoided due to the high amounts of sugar, artificial sweeteners, or caffeine. Goat's milk and goat's milk products can be used as an alternative to dairy products if it is shown that an allergy is restricted to dairy products from cows.

MONOGRAPH

DHEA SYNTHESIS

(Reprinted, with adaptations, by permission of Great Smokies Diagnostic Laboratory)

Pregnenolone has been described as the grandmother of all steroid hormones: 150 different steroid hormones are all derived from pregnenolone. It has been linked to help with memory, mood, and the immune system. Pregnenolone is convert into progesterone or DHEA according to the body's needs.

The adrenal androgen dehydroepiandrosterone (DHEA) is used commonly by the complementary and alternative medical community in the treatment of adrenal hypofunction. DHEA is the most abundant adrenal steroid hormone in the body. Through its peripheral conversion to androgens and estrogens, it helps regulate a wide array of metabolic and endocrine function, ranging from fat catabolism to energy levels. DHEA supplementation has been associated with increased emotional well-being and immune function.

Dehydroepiandrosterone is primarily produced in the adrenal cortex from the steroid precursor pregnenolone, which is synthesized from cholesterol. Since the plasma half-life of DHEA is less than 30 minutes, over 95% of circulating DHEA is in sulfate form (DHEA-S). DHEA-S provides a readily available source of DHEA for the production of estrogens and androgens in the adrenal glands, ovaries, and testes.

DHEA is the major steroid synthesized by the adrenals of the fetus before birth. DHEA is detectable by age 7 and rises to a maximum at about age 25. Levels decline gradually thereafter, and by age 75 and over, they are only about 15% to 20% of their youthful peaks.[69-71]

Circadian Rhythm of DHEA

Salivary DHEA is considered a better indicator of adrenal function than DHEA-S. DHEA is produced solely by the adrenal glands, unlike DHEA-S, which can also be synthesized from sulfated precursors, in addition to being produced directly from DHEA.

Measuring levels of DHEA also allows a more precise analysis of the circadian secretion pattern of this hormone. Salivary DHEA reflects the unbound, biologically active fraction of the hormone in general circulation, and shows excellent correlation with DHEA free plasma levels.

Role of DHEA

DHEA serves as a metabolic intermediate in the pathway for synthesis of testosterone, estrone, and estradiol. It also affects lipo-genesis, substrate cycling, peroxisome proliferation, mitochondrial respiration, protein synthesis, and thyroid hormone function.[72-73]

DHEA AND HEALTH CONDITIONS

Stress

By inhibiting tryptophan hydroxylase enzyme activity, DHEA provided protection in rats subjected to acute sound stress. Recent studies support the use of DHEA-S as a biological indicator of stress, aging, and age-related diseases, such as neurosis, depression, psychosomatic disorders, peptic ulcer, irritable bowel syndrome, and others. Since DHEA exhibits pronounced anti-cortisol activity, normal DHEA levels may be key indicators of a patient's ability to cope with stress.

Sleep

A single high oral dose (500 mg) of DHEA administered to ten healthy young men resulted in a significant increase in REM (rapid eye movement) time during sleep. Since REM sleep is closely associated with memory storage, there is clinical value for use of DHEA in age-related dementia.[74-75] Recent preclinical research also reveals that DHEA may prevent neuronal damage and even reverse symptoms of senile dementia in Alzheimer's patients deficient in DHEA.[76]

Immune Function

The decline of DHEA levels with aging correlates with a general decline of cell-mediated immunity and increased incidence of malignancies, suggesting immuno-modulatory effects for DHEA.[77] T cells, which can recognize foreign antigens and protect the body from infection, are produced in the thymus. DHEA protects the thymus gland from glucocorticoid-induced involution.[78] DHEA has also been shown to stimulate interleukin-2 (IL-2) activity and interferon-g production in T cells isolated from human donors.[79]

Systemic lupus erythematosus (SLE) is a classical organ non-specific autoimmune disorder characterized by aberrant immuno-regulatory T cell function and B cell hyperactivity, both of which are associated with pathogenic autoantibody production. Deficient IL-2 activity is a characteristic abnormality of T lymphocytes found in SLE patients.[80] Family studies of patients with SLE showed that IL-2 deficiency could result from genetic predisposition and precede, rather than follow, the onset of clinical symptoms.[81] Serum levels of patients with SLE showed lower levels of DHEA compared to normal levels. Supplementation of exogenous DHEA to the in vitro cultures of T lymphocytes (CD4+) from SLE patients can restore IL-2 production. Low serum concentrations of DHEA down-regulate the ability of SLE T cells to secrete IL-2. Thus, deficient IL-2 production by T lymphocytes in patients with SLE is, at least in part, attributed to low serum levels of DHEA.[82-83] IL-2 deficiency of T cells occurring with low serum DHEA levels has also been reported in patients with rheumatoid arthritis (RA).[84-86]

Diet

A vegetarian diet seems to promote the production of androgens, such as DHEA and testosterone. Subjects on a high carbohydrate diet also showed a slight increase in DHEA levels.[87] When a group of South African men were switched from their customary vegetarian diet to a Western-style cafeteria diet, researchers noted a decrease in DHEA levels.[88]

Obesity

DHEA was shown to have an anti-obesity effect on developing lean and obese laboratory rodents by decreasing adipose tissue weights, hyperinsulinemia, and food intake.[89-90] A daily oral administration of 1600 mg of DHEA to healthy men over a period of 4 weeks resulted in a 31% decrease in body fat. This study also showed that oral administration of DHEA to young males resulted in lower cholesterol and low density lipoprotein cholesterol (LDL-C) levels, without affecting other lipid parameters or glucose profile.[91] In other studies, however, DHEA had no effect on obese men, nor did it influence protein metabolism or energy levels in healthy males.[92-93]

Hypertension

Excretion of DHEA is reduced in individuals with essential hypertension, compared to controls. This deficiency also causes increased conversion of deoxy-corticosterone to corticosterone, leading to the over-production of mineralocorticoid (viz. aldosterone) syndrome characterized by hypertension.[94]

Heart Attack

Researchers at Johns Hopkins demonstrated a "consistent, independent, inverse, dose-response relationship" between DHEA levels and coronary atherosclerosis in men. They suggested that DHEA-S could serve as an important, modifiable factor in the development and progression of coronary atherosclerosis.[95]

Insulin

Numerous studies show that insulin activity, DHEA levels, and glucose homeostasis are all important synergistic factors in the onset and progression of diabetes.[96-98]

Animal studies have shown that DHEA guards against and/or reduces insulin resistance, providing a benefit similar to that of exercise.[99] In general, insulin resistance and hyperinsulinemia are associated with low circulating levels of DHEA, especially in men.[100-103] In women, however, insulin resistance is often accompanied by androgen excess, with chronically elevated levels of DHEA-S.[104] Thus, hyperglycemia in women with polycystic ovarian syndrome (PCOS) often correlates with adrenal hypersecretion, and high levels of DHEA and cortisol may underlie the development of non insulin dependent diabetes mellitus in these women.[105]

Thyroid Function

A significant decrease in serum DHEA levels was recorded in patients with hypothyroidism.[106]

Menstrual Disorders

Because DHEA is a precursor of estrone and estradiol, it can greatly affect female physiology. Women with hyperprolactinemia-induced amenorrhea exhibit an increase in DHEA levels, while amenorrheal women with normal prolactin levels show no such increase. This reveals a correlation between prolactin secretion and DHEA levels.[107]

Cancer

Epidemiological studies indicate that circulating levels of DHEA are related to the etiology of certain cancers. Decreasing serum levels of DHEA and DHEA-S have been positively correlated with the development of bladder cancer and gastric cancer in some patients.[108-109] Patients with prostate cancer and lung cancer have also been shown to have significantly lower DHEA levels. In certain clinical situations, reduced DHEA levels may serve as a marker of adrenocortical tumor.[110-112]

When administered to laboratory animals, DHEA prevents growth of spontaneous and chemically-induced tumors,[113-114] although in sufficiently large doses it may exert a hepatocarcinogenic effect.

Abnormal production of androgens is characteristic of breast cancer. Controlled studies show significantly elevated serum levels of DHEA associated with post-menopausal breast cancer in women.[115] Subnormal production of DHEA, however, has been linked to breast cancer in some pre-menopausal women,[116]

and with a lower survival rate for women with post-menopausal estrogen and progesterone receptor-positive tumors.[117] Cumulatively, this evidence points to the critical need for maintaining adequate, though not excessive, androgen levels through careful testing and intervention practices.

HIV and AIDS

DHEA inhibits RNA and DNA viral expression in animal studies,[118] and also seems to suppress HIV replication. One recent investigation of HIV-positive patients showed that a reduction in serum DHEA and DHEA-S levels inversely correlates with the progression of AIDS, indicating that DHEA can provide some measure of protection against HIV infection.[119,120]

Cushing's Syndrome

Patients with hypercortisolism associated with Cushing's syndrome showed lower DHEA-S levels than controls. Although removal of the adrenal tumor restored normal cortisol levels, DHEA-S levels continued to remain low for a longer period of time.[121]

Alzheimer's Disease

DHEA levels were significantly lower in patients with early or late Alzheimer's disease compared to normal controls.[122] DHEA shows the ability to protect against oxidative stress in the hippocampal region of the brain, a critical area for memory function often damaged by Alzheimer's disease.[123]

DHEA: Summary

DHEA is a major steroid hormone linked to balancing the body's stress response, providing source material for the synthesis of sex hormones, and guarding against the degenerative conditions associated with aging. DHEA levels are evaluated in relation to the patient's age and sex.

DHEA/CORTISOL RATIO

As a maladaption to stress, a reduction in DHEA and an increase in cortisol synthesis can occur in the adrenal cortex due to mild or severe pathophysiological conditions. This maladaption of adrenocortex function is characterized by a shift in pregnenolone metabolism away from both the mineralocorticoid and androgen pathways toward the glucocorticoid pathway. These changes result in a decrease in the DHEA/cortisol ratio.

Low DHEA/cortisol ratios were recorded in patients with surgical stress, patients with depression, and patients suffering from terminal gynecological malignancy treated with cytotoxic chemotherapy

TREATMENT OPTIONS FOR ADRENAL IMBALANCES

If low cortisol:

Suspect:	Some degree of adrenal insufficiency
Consider the following options:	Lifestyle changes:

Stress reduction: (chronic stress can fatigue the adrenals): Rest, exercise, prayer, meditation, relaxation exercises

Dietary changes:

Balance blood sugar: Lower calorie, high protein, high complex carbohydrate and high fiber diet

Nutritional supplements: High-grade multivitamin and mineral. Additional vitamin C, vitamin B-5, vitamin B-6, and zinc, as indicated

Herbal Support:

"Adaptogenic" herbs: American or Korean ginseng (*Panax spp.*), Siberian ginseng (*Eleuthrococcus senticosus*), Withania (*Withania somnifera*)

Miscellaneous herbs: Licorice (*Glycyrrhiza glabra*) to prolong the half-life of cortisol, Sarsaparilla (*Smilax spp.*) is a cortisol precursor

Glandular Support:

Adrenal, pituitary, others as indicated

Hormone replacement therapy:

Cortisol, DHEA, pregnenolone, as indicated

For herbal, glandular, and hormone replacement therapy, it is important to preserve or restore circadian rhythm by dosing in morning. May give 1/3 to 1/2 of morning dose at noon. Dosing later than noon is not advised.

If high cortisol:

Suspect:	Some degree of adrenal hyperreactivity or hyperfunction, in response to environmental, physiological, or psychological stress
Consider the following options:	Lifestyle changes:

Stress reduction, rest and relaxation, prayer, meditation, regular exercise, blood sugar stabilization, sufficient sleep, elimination of food allergies and restoration of normal bowel function

Nutritional supplements:

High-grade multi-vitamin/mineral. Additional vitamin C, vitamin B-5, vitamin B-6 and zinc, as indicated. Phosphatidyl serine may re-sensitize the hypothalamus and pituitary to cortisol negative feedback.

Herbal Support:

Nervine and "calmative" herbs: St. John's wort (*Hypericum*), passionflower (*Passiflora*), valerian (*Valeriana*), skullcap (*Scutellaria*), and hops (*Humulus lupulus*)

Low dose adaptogens: Siberian ginseng (*Eleuthrococcus senticosus*), Withania (*Withania somnifera*)

In cases of high cortisol or low DHEA or low DHEA/cortisol ratio, consider using nervine and adaptogenic herbs with divided dosing throughout the day.

If low DHEA:

Suspect:	A physiological response to stress, with shifting of the steroidogenic pathway to cortisol at the expense of DHEA
Consider the following options:	Lifestyle, dietary

DHEA or pregnenolone supplementation may be warranted

Measuring testosterone and/or estradiol levels and intervene if necessary

If high DHEA:

Suspect:	An abnormal physiological response to stress, with shifting of the steroidogenic pathway to DHEA at the expense of cortisol
Rule out:	Exogenous supplementation and polycystic ovary syndrome
Consider the following options:	Lifestyle, dietary, and herbal options
	Measuring testosterone and/or estradiol levels and intervene if necessary

If low DHEA/cortisol ratio:

Suspect:	A physiological response to stress, with shifting of the steroidogenic pathway to cortisol at the expense of DHEA
Consider the following options:	Lifestyle, dietary, and herbal options
	DHEA or pregnenolone supplementation may be warranted
	Measuring testosterone and/or estradiol levels and intervene if necessary
	Support immune function, if indicated

If high DHEA/cortisol ratio:

Suspect:	An abnormal physiological response to stress, with shifting of the steroidogenic pathway to DHEA at the expense of cortisol.
Consider the following options:	Lifestyle, dietary and herbal options as outlined under low cortisol
	Measuring testosterone and/or estradiol levels and intervene if necessary

If altered circadian rhythm of cortisol:

Suspect:	Dysglycemia since cortisol will be secreted in response to a drop in blood sugar
	Disrupted sleep cycles
	Altered negative feedback of the HPA Axis
Consider the following options:	Lifestyle, diet and herbal options as outlined under LOW CORTISOL
	Assess melatonin levels and treat accordingly
	Phosphatidyl serine may re-sensitize the hypothalamus and pituitary to cortisol negative feedback
	The essential fatty acid DHA may improve cellular receptor function of the HPA axis

(stressors).[124-125] Low DHEA/cortisol ratios were also recorded in patients with anorexia nervosa.[126] An increase in DHEA-S/cortisol ratios, however, was found in patients suffering from panic disorders.

Salivary Analysis of Cortisol and DHEA

Free or unbound hormones are relatively non-polar and have a low molecular weight (less than 400 daltons), allowing them to easily diffuse from blood to saliva. Because saliva acts as a natural ultrafiltrate of blood, it is an excellent diagnostic medium for measuring the biologically active fraction of steroid hormones in the bloodstream. Numerous clinical studies have validated the use of saliva as a reliable clinical marker for assessing free hormone levels and for diagnosing HPA malfunction.

Salivary DHEA levels correlate closely with free plasma levels, representing about 0.1% of their concentration in blood plasma.[127-128] There is also an excellent linear correlation between salivary and free serum cortisol concentration.[129-130]

Because concentrations of free cortisol in the blood vary with clinical conditions, they provide the best assessment of corticoid status. However, total plasma cortisol measurements taken from blood samples can give misleading results, due to variations in plasma cortisol-binding protein capacity caused by drugs, pregnancy, congenital alterations, or stress during venipuncture. Saliva cortisol measurement avoids these possible complications, thus providing a more accurate indicator of adrenal status than plasma measurement.

Saliva testing also offers more controlled collection times, critical for accurate baseline testing of hormones that display circadian rhythms and for effective monitoring of dosage levels in hormone replacement therapy. Multiple samples may be collected by the patient at home or at work, avoiding the inconvenience and expense of repeated visits to a clinic or hospital.

DHEA TREATMENTS

Disease symptoms associated with high or low levels of DHEA and/or cortisol, particularly those that are age-related, may be significantly alleviated with a therapeutic program based on exercise, diet, stress reduction, and/or supplementation. Since both excesses and deficiencies of DHEA and cortisol have been implicated in the etiology of various illnesses, preventative and therapeutic approaches should emphasize the critical importance of maintaining proper equilibrium of these adrenal hormones.

Melatonin is the main modulator of neuroendocrine function in humans, and a substantial body of research underscores melatonin's capacity to regulate the HPA axis. Patients with hypercortisolism exhibit decreased melatonin levels with a disrupted circadian rhythm.[131] Melatonin has also been shown to greatly affect cortisol levels in post-menopausal women,[132] and interactive patterns of melatonin and cortisol secretion have been associated with behavior disorders, such as depression and alcoholism.[133] Recent laboratory evidence also reveals that melatonin stimulates production and secretion of DHEA.

Increased cardiovascular risk is associated with imbalances of both DHEA and cortisol. The Comprehensive Cardiovascular Assessment goes one step further by assessing an array of other markers for heart disease, including HDL and LDL cholesterol, triglycerides, homocysteine, C-reactive protein, and fibrinogen. Many of these markers are supported by the latest developments in advanced cardiovascular research.

Since DHEA serves as a vital source for androgen and estrogen production, abnormal levels may well be accompanied by excesses or deficiencies in sex hormones, such as testosterone and estrogen, causing potentially deleterious health consequences. The cyclical activity of ß-estradiol and progesterone can uncover key imbalances associated with a variety of menstrual and ovarian dysfunctions. Male hormone tests evaluate the circadian activity of testosterone, with implications for numerous clinical conditions, including hypogonadism, hepatic cirrhosis, lipid abnormalities, obesity, emotional disturbances, and prostate cancer.

→ Selected Clinical Studies and Literature Reviews

For further discussion of the role of DHEA in adrenal metabolism, see Alan R. Gaby, "Dehydroepiandrosterone: Biological Effects and Clinical Significance," in *Selected Clinical Studies and Literature Reviews*, pp. 354.

References

1. Batara VS, Shamrma JN, Gupta YK. Images in psychiatry. Rauwolfia serpentia: The first herbal antipsychotic. Am J Psychiatry 1997 Jul;15(7):894.

2. Selye H. The Stress of Life. New York, NY: McGraw-Hill, 1956.

3. Powell D. Endocrinology and Naturopathic Therapies. Seattle, WA: Bastyr, 2004.

4. Tintera, JW. Hypoadrenocortism. Clifton Park, NY: Adrenal Metabolic Research Society, 1956.

5. McDermott MT. Endocrine Secrets. Philadelphia, PA: Hanley and Belfus Inc,1998.

6. Van Cauter E, Leproult R, Kupfer DJ. Effects of gender and age on the levels and circadian rhythmicity of plasma cortisol. J Clin Endocrinol Metab 1996;81(7):2468-73.

7. Guéchot J, Lépine JP, Cohen C, Fiet J, Lempérière T, Dreux C. Simple laboratory test of neuroendocrine disturbance in depression: 11 p.m. saliva cortisol. Biol Psychiat 1987;18:1-4.

8. Guechot J, Fiet J, Passa P, Villette JM, Gourmel B, Tabuteau F, et al. Physiological and pathological variations in saliva cortisol. Horm Res 1982;16:357-64.

9. Maes M, Smith R, Scharpe S. The monocyte-T-lymphocyte hypothesis of major depression. Psychoneuroendocrin 1995;20:111-16.

10. Born J, Kern W, Bieber K, Fehm-Wolfsdorf G, Schiebe M, Fehm HL. Night-time plasma cortisol secretion is associated with specific sleep stages. Bio Psychiat 1986;21:1415-24.

11. Born J, DeKloet ER, Wenz H, Kern W, Fehm HL. Gluco - and antimineralocorticoid effects on human sleep: A role of central corticosteroid receptors. Amer J Physiol 1991;260(2 Pt 1):E183-E188.

12. Holmes GP, Kaplan JE, Stewart JA, Hunt B, Pinsky PF, Schonberger LB. A cluster of patients with a chronic mononucleosis-like syndrome: Is Epstein-Barr virus the cause? JAMA 1987;257:2297-2302.

13. Ferrari E, Fraschini F, Brambilla F. Hormonal circadian rhythm in eating disorders. Biol Psychiat 1990;27:1007-20.

14. Barnes BO, Galton L. Hypothyroidism: The Unsuspected Illness. New York, NY: Harper and Row, 1976:206-07.

15. Ding JH, Sheckter CB, Drinkwater BL, Soules MR, Bremner WJ. High serum cortisol levels in exercise-associated amenorrhea. Ann Int Med 1988;108:530-34.

16. McDermott MT. Endocrine Secrets. Philadelphia, PA: Hanley and Belfus Inc, 1998.

17. Rege NN, Thatte UM, Dahanukar SA. Adaptogenic properties of six rasayana herbs used in Ayurvedic medicine. Phytother Res 1999 Jun;13(4):275-91.

18. Duan P, Wang ZM. Clinical study on effect of Astragalus in efficacy enhancing the toxicity reducing of chemotherapy in patients of malignant tumor. Zhonggguo Zhong XI Yi Jie He Za Zhi 2002 July 22;(7):515-17.

19. Wang ZT, Ng TB, Yeung HW, Xu GJ. Immunomodulatory effect of a polysaccharide-enriched preparation of Codnpsis pilosola roots. Gen Pharmacol 1996 Dec 27;(8):1347-50.

20. Lakshm-Chandra M, Singh B. Scientific Basis for the Therapeutic Use of Withania somnifera (Ashwagandha): A Review. Altern Med Rev 2000:5(4):334-46.

21. Archana R, Namasivayam A. Antistressor effect of Withania somnifera. J Ethnopharmacol 1998 Jan;64(1):91-93

22. Davis L, Kuttan G. Suppressive effect of cyclophoshamide-induced toxicity by Withania somnifera extract in mice. J Ethnopharmacol 1998 Oct;62(3):209-14.

23. Prakash J, Gupta SK, Kochupillai V, Gupta YK, Joshi S. Chemopreventive activity of Withania somnifera in experimentally induced fibrosarcoma tumours in Swiss albino mice. Phytother Res 2001 May;15(3):240-44.

24. Singh B, Saxena AK, Chandan BK, Gupta BK, Bhutani KK, Anand KK. Adaptogenic activity of a novel, withanolide-free aqueous fraction from the roots of Withania somnifera Dun. Phytother Res 2001 Jun;15(4):311-18.

25. Singh B, Saxena AK, Chandan BK, Gupta BK, Bhutani KK, Anand KK. Adaptogenic activity of a novel, withanolide-free aqueous fraction from the roots of Withania somnifera Dun. Phytother Res 2001 Jun;15(4):311-18.

26. Archana R, Namasivayam A. Antistressor effect of Withania somnifera. J Ethnopharmacol 1998 Jan;64(1):91-93.

27. Archana R, Namasivayam A. Antistressor effect of Withania somnifera. J Ethnopharmacol 1998 Jan;64(1):91-93.

28. Lakshm-Chandra M, Singh B. Scientific basis for the therapeutic use of Withania somnifera (Ashwagandha): A review. Altern Med Rev 2000;5(4):334-46.

29. Lakshm-Chandra M, Singh B. Scientific basis for the therapeutic use of Withania somnifera (Ashwagandha): A review. Altern Med Rev 2000;5(4):334-46.

30. Mishra L, Singh B. Scientific basis for the therapeutic use of Withania somnifera (Ashwaghanda): A review. Altern Med Rev 2000 Aug;5(4):334-46.

31. Davis L, Kuttan G. Suppressive effect of cyclophoshamide-induced toxicity by Withania somnifera extract in mice. J Ethnopharmacol 1998 Oct;62(3):209-14.

32. Gupta YK, Sharma SS, Rai K, Katiyar CK. Reversal of paclitaxel induced neutropenia by Withania somnifera in mice. Indian J Pharmacol 2001 Apr;45(2):253-57.

33. Prakash J, Gupta SK, Kochupillai V, Gupta YK, Joshi S. Chemopreventive activity of Withania somnifera in experimentally induced fibrosarcoma tumours in Swiss albino mice. Phytother Res 2001 May;15(3):240-44.

34. Mishra L, Singh B. Scientific basis for the therapeutic use of Withania somnifera (Ashwaghanda): A review. Altern Med Rev 2000 Aug;5(4):334-46.

35. Mishra L, Singh B. Scientific basis for the therapeutic use of Withania somnifera (Ashwaghanda): A review. Altern Med Rev 2000 Aug;5(4):334-46.

36. Mishra L, Singh B. Scientific basis for the therapeutic use of Withania somnifera (Ashwaghanda): A review. Altern Med Rev 2000 Aug;5(4):334-46.

37. Mishra L, Singh B. Scientific basis for the therapeutic use of Withania somnifera (Ashwaghanda): A review. Altern Med Rev 2000 Aug;5(4):334-46.

38. Dhuley J. Adaptogenic and cardioprotecive action of ashwaghanda in rats and frogs. J Ethnopharmacol 2000 Apr; 70(1):57-63.

39. Mishra L, Singh B. Scientific basis for the therapeutic use of Withania somnifera (Ashwaghanda): A review. Altern Med Rev 2000 Aug;5(4):334-46.

40. Utsunomiya T, Kobayashi M, Pollard R, Suzuki F. Glycyrrhizin, an active component of licorice roots, reduces morbidity and mortality of mice infected with lethal doses of influenza virus. Antimicrobial Agents and Chemotherapy 1997 Mar:551-56.

41. M. Bernardi et al. Effects of prolonged licorice ingestion of graded doses of licorice by healthy volunteers. Life Sciences 1994;55(11):863-72.

42 Vierhapper H, Kiss A, Nowotny P, Wiesnagrotzki S, Monder C, Waldhausal W. Metabolism of cortisol in anorexia nervosa. Acta Endocrinol 1990;122(6):753-58.

43. Utsunomiya, T., Kobayashi, M, Pollard R., Suzuki, F. Glycyrrhizin, an active component of licorice roots, reduces morbidity and mortality of mice infected with lethal doses of influenza virus. Antimicrobial Agents and Chemotherapy 1997 Mar:551-56.

44. Utsunomiya, T., Kobayashi, M, Pollard R., Suzuki, F. Glycyrrhizin, an active component of licorice roots, reduces morbidity and mortality of mice infected with lethal doses of influenza virus. Antimicrobial Agents and Chemotherapy 1997 Mar:551-56.

45. Utsunomiya, T., Kobayashi, M, Pollard R., Suzuki, F. Glycyrrhizin, an active component of licorice roots, reduces morbidity and mortality of mice infected with lethal doses of influenza virus. Antimicrobial Agents and Chemotherapy 1997 Mar:551-56.

46. M. Bernardi et al. Effects of prolonged licorice ingestion of graded doses of licorice by healthy volunteers. Life Sciences 1994;55(11):863-72.

47. Murav'ev IA, Basso A, et al. Licorice ameliorates postural hypotension caused by diabetic autonomic neuropathy. Diabetes Care 17(11):1356.

48. Mar'iasis ED, Krsova TG, Chebotarev VV, Starokozho LE. Corticoid-Like action of Liniments based on licorice root preparations. Endocrinol. Jpn 1979 Dec;26(6):661-65.

49. Li J, Huang M, Teoh H, Man R. Panax quinquefolim saponins protects low density lipoproteins from oxidation. Life Sciences 1999;64(1):53-62.

50. Konoshima T, Takasaki M, Tokuda H. Anticarcinogenic Activity of the Roots of Panax notoginseng, Biol. Pharm. Bull. 1999;22(10):1150-52.

51. T. Konoshima T, Takasaki M, Tokuda H. Anticarcinogenic Activity of the Roots of Panax notoginseng, Biol. Pharm. Bull. 1999;22(10):1150-52.

52. Hiai S, Yokoyama H, Oura H, Yano S. Stimulation of pituitary-adrencorticortical system by ginseng saponin. J Endocrinol Metab 1978 Aug;47 920;397-400.

53. Konoshima T, Takasaki M, Tokuda H. Anticarcinogenic Activity of the Roots of Panax notoginseng, Biol. Pharm. Bull. 1999;22(10):1150-52.

54. Jiping Li, Min Huang, Hwee Teoh, Man R. Panax quinquefolim saponins protects low density lipoproteins from oxidation. Life Sciences 1999:64(1):53-62.

55. Chan P, Tomlinson B. Antioxidant effects of Chinese Traditional Medicine: Focus on trinilein isolated from the Chinese herb Sanchi (Panax pseudoginseng). J Clin. Pharmacology 2000;40:457-61.

56. Liu GT. Pharmacological actions and clinical use of fructus schizandrae. Chin Med J (Engl) 1989 Oct;102(10):740-49.

57. Duan P, Wang ZM. Clinical study on effect of Astragalus in efficacy enhancing the toxicity reducing of chemotherapy in patients of malignant tumor. Zhonggguo Zhong XI Yi Jie He Za Zhi 2002 July;22 (7):515-17.

58. Duan P, Wang ZM. Clinical study on effect of Astragalus in efficacy enhancing the toxicity reducing of chemotherapy in patients of malignant tumor. Zhonggguo Zhong XI Yi Jie He Za Zhi 2002 July;22 (7):515-17.

59. Bhattacharya SK, Bhattacharya A, Chakrabarti A. Adaptogenic activity of Siotone, a polyherbal formulation of Ayurvedic rasayanas. Indian J Exp Biol. 2000 Feb;38(2):119-28.

60. Shu XS, Gao ZH, Yang XL. Supercritical fluid extraction of sapogenins from tubers of Smilax china. Fitoterapia. 2004 Dec;75(7-8):656-61.

61. Narula A, Kumar S, Srivastava PS. Abiotic metal stress enhances diosgenin yield in Dioscorea bulbifera L. cultures. Plant Cell Rep. 2005;69:778-79.

62. Zhu BW, Sun YM, Yun X, Han S, Piao ML, Murata Y, Tada M. Reduction of noise-stress-induced physiological damage by radices of Astragali and Rhodiolae: Glycogen, lactic acid and cholesterol contents in liver of the rat. Biosci Biotechnol Biochem. 2003 Sep;67(9):1930-36.

63. Kucinskaite A, Briedis V, Savickas A. Experimental analysis of therapeutic properties of Rhodiola rosea L. and its possible application in medicine. Plant Med 2003;63:701-05.

64. Kucinskaite A, Briedis V, Savickas A. Experimental analysis of therapeutic properties of Rhodiola rosea L. and its possible application in medicine. Plant Med 2003;63:701-05.

65. Wang GS, Yang XH, Xu JD. Structures of four new triterpenoid saponins from the leaves of Oplopanax elatus Nakai. Yao Xue Xue Bao 2004 May;39(5):354-58.

66. Patak P, Willenberg HS. Medicina (Kaunas) Lithuanian 2004;40(7):614-9.

67. Bornstein SR. Vitamin C is an important cofactor for both adrenal cortex and adrenal medulla. Endocr Res. 2004 Nov;30(4):871-75.

68. Wilson JL. Adrenal Fatigue: The 21st Century Stress Syndrome. Petaluma, CA: Smart Publications, 2001.

69. Vermeulen A. Adrenal androgens and aging. In: Genazzani AR, Thijssen JH, Siiteri PK (eds.). Adrenal androgens. New York, NY: Raven Press, 1980:27-42.

70. Bonney RC, Scanlon MJ, Jones DL, Beranek PA, Reed MJ, James VH. The interrelationship between plasma 5-ene adrenal androgens in normal women. J Steroid Biochem 1984;20:1353-55.

71. Rotter JI, Wong L, Lifrak ET, Parker LN. A genetic component to the variation of dehydroepiandrosterone. Metab Clin Exp 1985;34:731-36.

72. Deslypere JP, De Bishop G, Vermeulen A. Seasonal variation of plasma dehydroepiandrosterone sulfate and urinary androgen excretion in post-menopausal women. Clin Endocrinol 1983;18:25-30.

73. Fitzgerald PA. Adrenal cortex physiology. In: Tierney Jr LM, McPhee J, Papadakis MA (eds.). Current medical diagnosis and treatment. Los Altos, CA: MA Lange Publishers, 1995:982.

74. Holboer H, Grasser A, Friess T, Wiedemann K. Steroid effects on central neurons and implications for psychiatric and neurological disorders. Ann NY Acad Sci 1994;746:345-359.

75. Freiss E, Trachsel L, Guldner J, Schier T, Steiger A, Holbsboer F. DHEA administration increases rapid eye movement sleep and EEG power in the sigma frequency range. Am J Physiol 1995;268(31):E107-E113.

76. Bologa L, Sharma J, Roberts E. Dehydroepiand-rosterone and its sulfated derivative reduce neuronal death and enhance astrocytic differentiation in brain cell cultures. J Neuro-Sci Res 1987;17:225-234.

77. Suzuki T, Suzuki N, Engleman EG, Mizushima Y, Sakane T. Low serum levels of dehydroepiandrosterone may cause deficient IL-2 production by lymphocytes in patients with systemic lupus erythematosus (SLE). Clin Exp Immunol 1995;99:251-55.

78. Maes M, Holmes E, Rogers W, Pot M. Protection from glucocorticoid induced thymic involution by dehydroepiandrosterone. Life Sci 1990;46:1627-31.

79. Meikle AW, et al. The presence of a dehydroepiandrosterone-specific receptor binding complex in murine T cells. Am J Med Sci 1992;303:366-71.

80. Suzuki T, Suzuki N, Engleman EG, Mizushima Y, Sakane T. Low serum levels of dehydroepiandrosterone may cause deficient IL-2 production by lymphocytes in patients with systemic lupus erythematosus (SLE). Clin Exp Immunol 1995;99:251-55.

81. Gordon GB, Shantz LM, Talaly P. Modulation of growth, differentiation and carcinogenesis by dehydroepiandrosterone. Adv Enzymol Regul 1987;26:255-82.

82. Suzuki T, Suzuki N, Engleman EG, Mizushima Y, Sakane T. Low serum levels of dehydroepiandrosterone may cause deficient IL-2 production by lymphocytes in patients with systemic lupus erythematosus (SLE). Clin Exp Immunol 1995;99:251-55.

83. Hedman M, Nilsson E, de le Torre B. Low blood and synovial fluid levels of sulpho-conjugated steroids in rheumatoid arthritis. Clin Exp Rheumatol 1992;10:25-30.

84. Cutolo M, Balleari E, Giusti M, Intra E, Accardo S. Androgen replacement therapy in male patients with rheumatoid arthritis. Arthritis Rheum 1991;34:1-5.

85. Hedman M, Nilsson E, de la Torre B. Low sulpho-conjugated steroid hormone levels in systemic lupus erythematosus. Clin Exp Rheumatol 1989;7:583-88.

86. Hall GM, Perry LA, Spector TD. Depressed levels of dehydroepiandrosterone sulfate in postmenstrual women with rheumatoid arthritis but no relation with axial bone density. Ann Rheum 1993;52:211-14.

87. Anderson KE, Rosner W, Khan MS, New MI, Pang SY, Wissel PS, Kappas A. Diet-hormone interactions: Protein/carbohydrate ratio alters reciprocally the plasma levels of testosterone and cortisol and their respective binding globulins in man. Life Sci 1987;40:1761-68.

88. Hill P, Wynder EL, Garbaczewski L, Walker AR. Effect of diet on plasma and urinary hormones in South African black men with prostatic cancer. Cancer Res 1982;42:3864-69.

89. Cleary MP, Zisk JF. Anti-obesity effect of two different levels of dehydroepiandrosterone in lean and obese middle-aged female zucker rats. Int J Obesity 1986;10:193-204.

90. Gansler T, Meller S, Cleary J. Chronic administration of dehydroepiandrosterone reduces pancreatic B-cell hyperplasia and hyperinsulinemia in genetically obese zucker rats. Proc Soc Exp Biol Med 1985;180:155-62.

91. Nestler JE, Barlascini CO, Clore JN, Blackard WG. Dehydroepiandrosterone reduces serum low density lipoprotein levels and body fat but does not alter insulin sensitivity in normal men. J Endocrin Metab 1988;66:57-61.

92. Berdanier CD, Parente JA Jr, McIntosh MK. Is dehydroepiandrosterone an antiobesity agent? FASEB J 1993;7:414-19.

93. Usiskin KS, Butterworth S, Clore JN, Arad Y, Ginsberg HN, Blackard WG. Lack of effect of dehydroepiandrosterone in obese men. Int J Obes 1990;14:453-57.

94. Welle S, Jozefowitz R, Statt M. Failure of dehydroepiandrosterone to influence energy and protein metabolism in humans. J Endocrin Metab 1990;21:1197-1207.

95. Herrington DM, Gordon GB, Achuff SC, Trejo JF, Weisman HF, Kwiterovich Jr. PO, Pearson TA. Plasma dehydroepiandrosterone and dehydroepiandrosterone sulfate in patients undergoing diagnostic coronary angiography. J Am Coll Cardiol 1990;16(4):862-70.

96. Falcone T, Meltzer S, Morris D. Effect of hyperprolactinemia on the androgen response to an oral glucose load. Fertil Steril 1992;58(6):1119-22.

97. Nestler JE, Clore JN, Blackard WG. Dehydroepiandrosterone: The "missing link" between hyperinsulinemia and atherosclerosis? FASEB J 1992;6(12):3073-75.

98. Ebeling P, Stenman UH, Seppala M, Koivisto VA. Androgens and insulin resistance in type 1 diabetic men. Clin Endocrinol 1995;43(5):601-07.

99. Han DH, Hansen PA, Chen MM, Holloszy JO. DHEA treatment reduces fat accumulation and protects against insulin resistance in male rats. J Gerontol A Biol Med Sci 1998;53(1):B19-B24.

100. Paolisso G, Ammendola S, Rotondi M, Gambardella A, Rizzo MR, Mazziotti G, et. al. Insulin resistance and advancing age: What role for dehydroepiandrosterone sulfate? Metabolism 1997;46(11):1281-86.

101. Yamauchi A, Takei I, Nakamoto S, Ohashi N, Kitamura Y, Tokui, et. al. Hyperglycemia decreases dehyroepiandrosterone in Japanese male with impaired glucose tolerance and low insulin response. Endocr J 1996;43(3):285-90.

102. Nestler JE, Beer NA, Jakubowicz DJ, Beer RM. Effects of a reduction in circulating insulin by metformin on serum dehydroepiandrosterone sulfate in nondiabetic men. J Clin Endocrinol Metab 1994;78(3):549-54.

103. Buffington CK, Pourmotabbed G, Kitabchi AE. Case report: Amelioration of insulin resistance in diabetes with dehydroepiandrosterone. Am J Med Sci 1993;306(5):320-24.

104. Haffner SM, Valdez RA, Mykkanen L, Stern MP, Katz MS. Decreased testosterone and dehydroepiandrosterone sulfate concentrations are associated with increased insulin and glucose concentrations in nondiabetic men. Metabolism 1994;43(5):599-603.

105. Welle S, Jozefowitz R, Statt M. Failure of dehydroepiandrosterone to influence energy and protein metabolism in humans. J Endocrin Metab 1990;21:1197-1207.

106. Foldes JL, et al. Dehydroepiandrosterone sulfate (DS), dehydroepiandrosterone (D) and "free" dehydroepiandrosterone (FD) in the plasma with thyroid diseases. Horm Metab Res 1983;15:623-24.

107. Bassi F, Giusti G, Borsi L, Cattaneo S, Giannotti P, Forti G, et al. Plasma androgens in women with hyperprolactinaemic amenorrhea. Clin Endocrin 1977;6:5-10.

108. Gordon GB, Helzlsouer KJ, Comstock GW. Serum levels of dehydroepiandrosterone and its sulfate and the risk of developing bladder cancer. Cancer Res 1991;51(5):1366-69.

109. Gordon GB, Helzlsouer KJ, Alberg AJ, Comstock GW. Serum levels of dehydroepiandrosterone and dehydroepi-

androsterone sulfate and the risk of developing gastric cancer. Cancer Epidemiol Biomarkers Prev 1993;2(1):33-35.

110. Stahl H, Schnorr D, Pilz C, Dorner G. Dehydro-epiandrosterone (DHEA) levels in patients with prostatic cancer, heart diseases and under surgery stress. Exp Clin Endocrin 1992;99:68-70.

111. Bhatavdekar JM, Patel DD, Chikhlikar PR, Mehta RH, Vora HH, Karelia NH, et al. Levels of circulating peptide and steroid hormones in men with lung cancer. Neoplasma 1994;41(2):101-03.

112. Flecchia D, Mazza E, Carlini M, Blatto A, Olivieri F, Serra G, et al. Reduced serum levels of dehydroepiandrosterone sulphate in adrenal incidentalomas: A marker of adrenocortical tumour. Clin Endocrinol 1995;42(2):129-34.

113. Hursting SD, Perkins SN, Haines DC, Ward JM, Phang JM. Chemoprevention of spontaneous tumorigenesis in p53-knockout mice. Cancer Res 1995;55(18):3949-53.

114. McCormick DL, Rao KV, Johnson WD, Bowman-Gram TA, Steele VE, Lubet RA, Kellof GJ. Exceptional chemopreventive activity of low-dose dehydroepiandrosterone in the rat mammary gland. Cancer Res 1996;56(8):1724-26.

115. Gordon GB, Bush TL, Helzlsouer KJ, Miller SR, Comstock GW. Relationship of serum levels of dehydroepiandrosterone and dehydroepiandrosterone sulfate to the risk of developing postmenopausal breast cancer. Cancer Res 1990;50(13):3859-62.

116. Secreto G, Zumoff B. Abnormal production of androgens in women with breast cancer. Anticancer Res 1994;14(5B):2113-17.

117. Mason BH, Holdaway IM, Skinner SJ, Kay RG. The relationship of urinary and plasma androgens to steroid receptors and menopausal status in breast cancer patients and their influence of survival. Breast Cancer Res Treat 1994;32(2):203-212.

118. Loria RM, Inge TH, Cook SS, Szakal AK, Regelson W. Protection against acute lethal viral infections with the native steroid dehydroepiandrosterone (DHEA). J Med Virol 1988;26:301-14.

119. Schinazi RF, et al. Effect of dehydroepiandrosterone in lymphocytes and macrophages infected with human immunodeficiency viruses. In: Kalimi M, Regelson W (eds.). The biological role of dehydroepiandrosterone (DHEA). Berlin, Germany: Walter de Gruyter, 1991.

120. Wisniewski TL, Hilton CW, Morse EV, Svec F. The relationship of serum DHEA-S and cortisol levels to measures of immune function in human immunodeficiency virus-related illness. Amer F Med Sci 1993;305:79-83.

121. Yamaji T, Ishibashi M, Sekihara H, Itabashi A, Yanaihara T. Serum dehydroepiandrosterone sulfate in Cushing's syndrome. J Clin Endocrin Metab 1984;59:1164-68.

122. Sunderland T, et al. Reduced plasma dehydroepiandrosterone concentrations in Alzheimer's disease. Lancet 1989;2:570.

123. Näsman B, Olsson T, Seckl JR, Eriksson S, Viitanen M, Bucht G, Carlstrom K. Abnormalties in adrenal androgens, but not of glucocorticoids, in early Alzheimer's disease. Psychoneuroendocrin 1995;20:83-94.

124. Ozasa H, Kita M, Inoue T, Mori T. Plasma dehydroepiandrosterone to cortisol ratios as an indicator of stress in gynecological patients. Gynecol Oncology 1990;37:178-82.

125. Fava M, Rosenbaum JF, MacLaughlin RA, Tesar GE, Pollack MH, Cohen LS, Hirsch M. Dehydroepiandrosterone-sulfate/cortisol ratio in panic disorder. Psychiat Res 1988;38:345-50.

126. Zumoff B, et al. Subnormal plasma dehydroepiandrosterone to cortisol ratio in anorexia nervosa: a second hormonal parameter of ontogenic regression. J Clin Endocrin Metab 1983;56:668-72.

127. Lac G, Lac N, Robert A. Steroid assays in saliva: a method to detect plasmatic contaminations. Archiv Int Physiol Biochem 1993;101:257-62.

128. Walker R, et al. 9th Workshop. Cardiff, 1982.

129. Vining RF, McGinley RA. The measurement of hormones in saliva: Possibilities and pitfalls. J Steroid Biochem 1987;27:81-94.

130. Tunn S, Möllmann H, Barth J, Derendorf H, Krieg M. Simultaneous measurement of cortisol in serum and saliva after different forms of cortisol administration. Clin Chem 1992;38:1491-94.

131. Soszynski P, Stowinska-Srzednicka J, Kasperlik-Zatuska A, Zgliczynski S. Decreased melatonin concentration in Cushing's syndrome. Horm Metab Res 1989;21:673-74.

132. Cagnacci A, Soldani R, Yen SS. Melatonin enhances cortisol levels in aged but not young women. Eur J Endocrinol 1995;133:691-95.

133. Levine ME, Milliron AN, Duffy LK. Diurnal and seasonal rhythms of melatonin, cortisol, and testosterone in interior Alaska. Arctic Med Res 1994;53:25-34.

MALE SEX HORMONES

(Based on information from Great Smokies Diagnostic Laboratory, used, with adaptations, by permission.)

Pathophysiology Review

Testosterone is an anabolic steroid synthesized primarily by the Leydig cells in the testes in males, the ovaries in females, and adrenal glands in both sexes. It is synthesized from cholesterol, with androstenedione, androstenediol, dehydroepiandrosterone (DHEA), progesterone, and pregnenolone acting as some of the intermediate substrates.

SECRETION RHYTHM

Testosterone production is regulated by hormonal secretions from the hypothalamus and the pituitary gland in the brain. The process begins as the hypothalamus secretes gonadotropin-releasing hormone (GnRH) in generative pulses. In response to these steady intermittent bursts of GnRH, the pituitary gland releases luteinizing hormone (LH) and follicle-stimulating hormone (FSH), which act directly on the testes.

FSH activates the Sertoli cells that produce sperm (spermatogenesis). LH stimulates the Leydig cells to secrete testosterone in a daily rhythm characterized by peak levels in the morning and low levels in the evening. Once it reaches high levels, testosterone production generates negative loop feedback to the hypothalamus to downregulate LH release and diminish further testosterone production. In this way, testosterone inhibits its own secretion.

Like most hormonal-control feedback mechanisms, this is a closed-loop system, which also operates in the opposite direction to guard against deficiencies. The healthy functioning of this feedback loop ensures a steady secretion of gonadotropins, resulting in relatively constant levels of testosterone secretion by the testes.

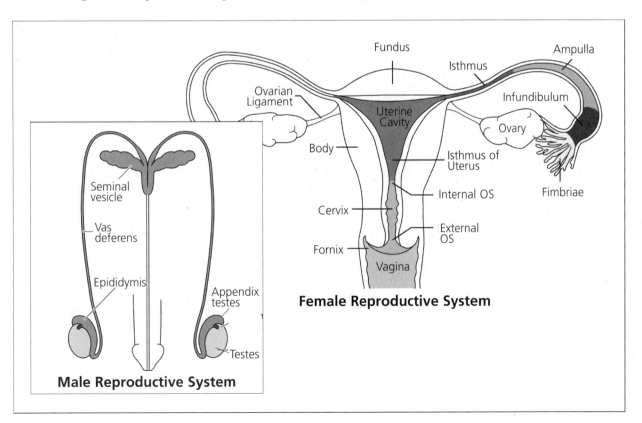

Female Reproductive System

Male Reproductive System

Quick Reference: Major Reproductive Hormone Disorders and Natural Reproductive Hormonal Changes

Reproductive Hormone Disorder	Major Signs and Symptoms	Key Laboratory Tests	Conventional Therapies	Naturopathic Therapies
Male hypogonadism	Infertility Loss of libido Erectile dysfunction	Low testosterone	Testosterone	Testosterone, detoxification of dioxins (can be cause of hypogonadism), bio-identical hormone therapy
Endometriosis	Painful menses	Not applicable	Anabolic androgenic steroids	Botanical medicine, acupuncture, Turskas formula, bio-identical hormone therapy
PMS	Painful menses	Possible high estrogen to progesterone ratio	Birth control pills	Botanical medicines, acupuncture, bio-identical hormone therapy
PCOS	Obesity	High androgens, high insulin	Birth control pills	Turskas formula, bio-identical hormone therapy
Menopause	Lack of menses	High LH	Birth control pills only if necessary	Botanical medicine (black cohosh) only if necessary
Impotence	Lack of erection Premature ejaculation	None	Viagra, or treat underlying cause, such as diabetes, vascular disease, chronic prostatitis	Botanical medicine, treat underlying cause, such as diabetes, vascular disease, chronic prostatitis, bio-identical hormone therapy
Gynecomastia	Palpable breast tissue in man	Increase ratio of estrogen to androgen	Surgery, tamoxifen	Decrease xenoestrogens in environment, bio-identical hormone therapy
Amenorrhea	Absence of menstrual period	Possibly elevated or decreased LH and FSH	Birth control pills	Botanical medicine, acupuncture, bio-identical hormone therapy
Galactorrhea	Milk-like discharge from a non gravid woman	Possible elevated prolactin	Treat root cause	Treat root cause, bio-identical hormone therapy
Hirsutism	Excessive hair in androgen dependent areas	Elevated testosterone, DHEA	Estrogen, progesterone, Clomiphene (if with infertility)	Estrogen, progesterone, bio-identical hormone therapy
Infertility	Inability to conceive	Elevated TSH, elevated FSH	Clomiphene	Acupuncture, botanical medicine, treat underlying cause, such as WT3 therapy for WTS patients (can be very effective), bio-identical hormone therapy

Note: All naturopathic therapies include exercise, diet, and lifestyle changes.

AGING

During puberty, male testosterone levels increase approximately 10 to 20 times, triggering the development of mature male genitalia and secondary hair patterns, sperm production, accelerated musculoskeletal development, and behavioral changes.

Barring specific factors that may trigger hypogonadism, such as illness, lifestyle, or environment (see section on "Hypogonadism"), the decline of testosterone production due to aging often begins in a man's forties. At age 50, it is estimated that at least half of all males have bioavailable testosterone levels that are lower than that found in healthy young men. The primary cause of this decline is chronic deterioration of Leydig cells in the testes; a 20-old man has approximately 700 million Leydig cells but by age 80 that number will be reduced to about 200 million.[1] This age-related drop in testosterone is more pronounced in patients with chronic illnesses, such as rheumatoid arthritis or those at risk of frailty or wasting conditions. In men of advanced age (over 70), dramatic drops in testosterone levels often occur in conjunction with a decline in circulating IGF-1 levels.[2]

Age-induced testosterone decline and other sex hormone alterations are associated with a gradual weakening of the male hypothalamic-pituitary-gonadal axis. Bioavailable testosterone is the portion of testosterone unbound to proteins in the blood. This unbound testosterone is freely available to impact target tissues and organs throughout the body. As testosterone levels fall, concomitant elevations in sex hormone binding globulin (SHBG) further reduce the amount of bioavailable testosterone in the body. Both the pulse secretion and bioactivity of luteinizing hormone also decrease. Aging Leydig cells will often show reduced sensitivity to stimulation by human chorionic gonadotropin hormone. In men of advanced age, increases in follicle stimulating hormone are also observed. However, one study found that 70% of men over age 50 with low bioavailable testosterone levels displayed low LH levels, suggesting that secondary hypogonadism can develop as a result of diminished HPA-axis responsiveness, which occurs with a gradual decline in testicular function.[3]

Hypogonadism

Hypogonadism, the inability of the testes to produce adequate testosterone, can arise as a result of genetic, environmental, or physiological causes. There is no strict clinical definition of the testosterone deficiency producing hypogonadism and experts note that this condition can be extremely difficult to detect through clinical symptoms alone, particularly in men of advanced age.[4] While conservative estimates place the percentage at 20% of men, those figures are likely to be low because they are based on total testosterone levels. It is noted that, based on bioavailable levels, the rate of hypogonadism could actually reach as high as 50% of men.[5]

Causes of Hypogonadism
- Congenital
- Cryptorchidism
- Chronic/systemic illness
- Surgery
- Chemotherapy
- Premature aging
- Testicular trauma
- Stress
- Klinefelter's syndrome
- Autoimmune damage
- Tobacco, alcohol and cannabis
- Sleep apnea
- Excessive heat
- Obesity
- Hypercortisolism
- Medications

Primary hypogonadism is characterized by testicular dysfunction. It can develop from congenital causes, such as Klinefelter's syndrome, which can remain undiagnosed until late in adult life. Primary hypogonadism may also be induced by various disease conditions and treatments, including chemotherapy, surgery, autoimmune damage, infections, and testicular trauma.[6]

Secondary hypogonadism can develop as a result of hypothalamic or pituitary disease, obesity, hypothyroidism, or other causes. Some conditions, such as hypercortisolemia, AIDS, and severe systemic illnesses, can trigger hypogonadism through a combination of both primary and secondary mechanisms.

SIGNS AND SYMPTOMS

Subtle clinical signs of hypogonadism may include slight gynecomastia and soft, small testes. However, researchers have noted that "the findings of physical examination in men with adult-onset hypogonadism are often normal. This underscores the need for precise evaluation of bioavailable hormone levels to ensure accurate diagnosis." Noting that low libido is "the most common predictor of low testosterone syndrome, "other clinicians at the University of St. Louis have composed a series of questions to alert their

male patients to possible low testosterone levels. While not strict guidelines for clinical diagnosis, this "low testosterone checklist" can help identify patients who may benefit from testing and treatment.

Cardiovascular Disease

Current clinical research suggests that sex hormones work in opposite ways in men and women to impact cardiovascular disease processes. Thus, while estrogen generally has a protective influence on cardiovascular health in women, high levels of this 'female' sex hormone in men are associated with an increased risk of angina, coronary artery disease, and myocardial infarction.[7,8] Conversely, though testosterone may exert a detrimental influence on cardiovascular dynamics in women, it produces strong beneficial effects on an amazingly wide array of CVD risk factors in men.[9]

A variety of physiological mechanisms may explain the associations between testosterone imbalances and the pathogenesis of coronary disease, myocardial infarction, and stroke, in addition to testosterone's ability to modulate lipid and glucose factors. Low testosterone is linked to higher levels of fibrinogen and plasminogen activator inhibitor, which play a crucial role in blood viscosity, plaque formation, and platelet aggregation. Experimental studies also show testosterone capable of triggering vasodilation of the arteries — a relaxant effect believed to have a beneficial impact on angina and other cardiovascular impairments.

Testosterone deficiency has been called the "primary event" initiating the synergistic process involving insulin resistance, diabetes, myocardial infarction, and stroke. Testosterone levels independently predict the likelihood of developing diabetes, and restoring depleted levels has been shown to improve insulin resistance.

While early studies examining the specific relationship between testosterone and cardiovascular factors in men sometimes produced inconclusive results, many investigators now believe that these inconsistencies may have stemmed, in part, from the limitations of measuring total testosterone levels in blood, rather than the more clinically significant bioavailable fraction of testosterone. The bioavailable form of testosterone is more readily available to target tissues and organs in the body, and has been shown to display a stronger negative correlation with coronary artery disease parameters than total testosterone levels.

CLINICAL STUDIES
Testosterone Levels

Research studies have demonstrated that higher levels of testosterone conferred a protective ratio against atherosclerotic coronary artery disease (ASCAD) of greater than five-fold in men. One study reported an inverse correlation between free testosterone levels and both the degree of coronary artery disease and the various risk factors for myocardial infarction. Chronically low testosterone levels, they concluded, may actually precede — and thus in part precipitate — coronary artery disease and thrombosis in men.[10]

"A normal physiological level of testosterone may protect against the development of hyperlipidaemia, hyperinsulinism, hypertension, thrombophilic tendency, obesity and increased waist-hip ratio," echoed British cardiologists in the Quarterly Journal of Medicine. "The decline of testosterone with age may partly explain the greater risk of CAD with advancing years." They emphasize the importance of identifying young men with relative hypogonadism, who are at increased risk of premature CAD. These patients may only exhibit symptoms of fatigue and depression, while "the true diagnosis is unsuspected and undiagnosed."[11] This recommendation is supported by a cross-sectional study of South African Indian men, which revealed lower testosterone levels in younger men with premature coronary artery disease.[12]

Sexual Function and Libido

Abundant clinical literature shows that testosterone levels directly and indirectly influence the fundamental components of male sexual function, including genital development, sex drive, ejaculation, penile sensitivity, and erectile function.

Male potency and libido are interdependent factors, and evidence suggests that there is a consistent, graded relationship between testosterone levels and sexual interest, particularly in men with suboptimal amounts. Researchers reported a clear relationship between testosterone levels during puberty and sexual timing and activity, with higher levels of salivary testosterone associated with a four-fold increase in sexual activity. A review of recent studies on testosterone therapy notes that testosterone boosts, in a dose-response fashion, both erectile function and sexual libido. This may be one reason why testosterone is among the most commonly used therapies for impotence in men. Experts advise, however, that this approach is best utilized only after an initial assessment of bioavailable levels of testosterone to establish clinical need.[13]

With advancing age, testicular function often declines and levels of bioavailable testosterone plum-

met, corresponding to a marked decrease in sexual function. By the time a man reaches age 50, his bioavailable levels of testosterone may be half their youthful levels.[14] Significantly, testosterone loss has been shown to precede — not simply accompany — both a drop in sexual interest and frequency of erections. [15]

Other health conditions commonly associated with impotence in men, such as diabetes, vascular dysfunction, thyroid imbalances, arthritides, and various systemic diseases, display powerful synergistic effects upon testosterone levels.[16-21] A positive correlation has also been established between testosterone levels and male fertility, with testosterone loss corresponding to oligospermic and azoospermic conditions.

Musculoskeletal Health

As an anabolic hormone, testosterone provides the important hormonal source for bone and muscle tissue growth throughout the body.

BONE GROWTH AND REMODELING

The impact of osteoporosis in men remains a severely neglected area of health care. The National Osteoporosis Foundation reports that men over 50 have a greater chance of suffering an osteoporosis-related fracture than they do of developing prostate cancer.[22] In fact, nearly one out of every three hip fractures occurs in men — and the resulting mortality — one-third of those men will die within the same year — is higher than it is in women.

Increasing evidence reveals that gonadal function — and specifically the production of testosterone — plays a central role in bone metabolism and growth. Surges in testosterone during puberty trigger the accelerated bone growth and density of bones that spurs sexual dimorphism of the human skeleton. As men age, the sex steroids continue to impact strongly the process of bone formation and resorption. Androgens may accomplish this by binding directly to androgen receptors in cells, such as osteoblasts, or by triggering an indirect effect via their aromatization to estrogen. [23]

Hypogonadism, which may occur as a result of genetics, environment, aging, or illness, can accelerate bone turnover by increasing the recruitment of osteoclasts from bone marrow. In this way, chronically low levels of testosterone can predispose men to osteoporosis. One study found that testosterone-deficient men had a five-fold greater likelihood of suffering hip fractures than controls. They called gonadal deficiency "an important and heretofore understudied" factor predisposing men to increased hip fractures, and concluded that "prevention of hip fractures in men may involve early recognition and treatment of testosterone deficiency."[24]

Numerous studies consistently show that long-term testosterone replacement therapy to combat hypogonadism improves bone mineral density and reduces bone turnover.

MUSCLE MASS AND SARCOPENIA

Testosterone displays a marked ability to build muscle tissue in the body, and may trigger its anabolic effects through a variety of physiological mechanisms. Testosterone increases nitrogen stores in the body, promotes protein synthesis, and raises circulating levels of insulin-like growth factor (IGF-1), all of which are known to enhance muscle formation.[25-27]

Numerous studies report that testosterone administration increases muscle size, strength, and lean body mass in both young and old hypogonadal men, as well as in older healthy men with low to low-normal testosterone levels. Besides conferring positive benefits on a man's well-being by ensuring optimal physical strength and stamina, this has profound clinical implications for preventing morbidity and mortality associated with frailty and wasting conditions.

CLINICAL STUDIES
Testosterone Effects
Dutch researchers point out that "loss of muscle strength resulting in frailty is the limiting factor for an individual's chances of living an independent life until death." Maintaining optimal levels of testosterone provides an important therapeutic tool to ensure mobility, function, and quality of life in men as they age.

Several recent studies have revealed testosterone's powerful role in preventing wasting conditions associated with AIDS, cancer, lung disease, cancer, and chronic infection. A team of investigators from Massachusetts General Hospital found that treating AIDS patients for testosterone deficiency resulted in a significant increase in lean body mass, which is associated with higher survival rates, as well as improved well-being, appearance and overall quality of life. The authors of this double-blind, placebo-controlled study concluded that androgen testing could be valuable in identifying men with AIDS wasting syndrome who may benefit from testosterone replacement therapy. The percentage of HIV-infected men who are hypogonadal is estimated to range from 20% to 70%.[28-29]

Mood and Cognition

Leading experts in the field of brain research have observed that "sex steroids exert profound effects on mood and mental state."[30] Many studies have established a direct relationship between decreased testosterone levels and negative mood factors, such as depression, anger, confusion, anxiety, and fatigue.[31] One study found that testosterone replacement used to restore androgen balance in hypogonadal men improved many emotional parameters, including friendliness, energy levels, and sense of well-being.[32] Significantly, these benefits were maintained over the course of a 6-month period of therapy, precluding the possibility of a short-term placebo effect.

Testing to establish baseline testosterone levels prior to replacement therapy is crucial for effectively treating sex-hormone-related mood disorders in men. Researchers stress there is a clear "threshold effect," i.e., that positive benefits on mood achieved by therapy are only realized when initially deficient hormone levels are brought into the "normal" range. Replacement therapy applied to men with normal levels, or therapy that triggers higher than normal levels, usually provides negligible clinical benefit and may even trigger potential adverse affects.

Testosterone is believed to influence strongly cognitive function in the brain, particularly visuo-spatialization skills. This relationship exhibits a curvilinear relationship: spatialization skills in men decrease as salivary testosterone levels become either too low or too high.[33-34] An increase in visuo-spatial ability gained through testosterone therapy, however, may be accompanied by a slight drop in verbal fluency ability — which some researchers relate to possible sex-based differences in physiological cognitive processes.[35]

Various mechanisms could explain testosterone's powerful effect on cognitive function: experimental studies have revealed androgen binding sites in the hypothalamus and other regions in the brain.[36] Other researchers suggest that the aromatization of testosterone to estrogen impacts both serotonin transport and 5-hydroxytryptamine 2a receptors in the forebrain, which play pivotal roles in emotion, memory, and cognition.[37]

Prostate Cancer

Testosterone and other male hormones are crucial for the healthy growth, structure, and function of the prostate gland. Research has uncovered specific androgen receptors in prostatic tissue, suggesting the important role of androgens in shaping the body's genetic expression of diseases of the prostate, as well as their course of development.[38,39] Differences in testosterone levels that occur among age, ethnic, and racial groups, as well as in those with clinical conditions, such as diabetes, have been cited as possible causes of variable incidence of prostate cancer.[40,41]

Studies on the relationship between testosterone and prostate cancer have not always yielded consistent results. However, several recent clinical trials have found high levels of free, unbound testosterone associated with an increased incidence of prostate cancer. A positive correlation has also been established between high testosterone values and metastatic relapse in prostate cancer patients who underwent radiation treatment.[42]

Certainly, the most prudent course is to prevent supraphysiologic levels through careful monitoring of bioactive testosterone, avoiding excess levels that may promote the development of prostate cancer.

CLINICAL STUDIES
Salivary Analysis for Testosterone

A wealth of current literature supports salivary analysis of steroid hormones as the "gold standard" in endocrine assessment. Saliva is a natural filtrate of blood that allows only the bioactive portion of the hormone to permeate, providing a greater correlation with clinical symptoms and conditions. This is crucial because bioavailable testosterone deficiencies may exist even when total serum levels are normal in such conditions as Klinefelter's syndrome, hyperthyroidism, liver disease, estrogen excess, and advancing age. Because serum levels of sex-hormone-binding globulin increase with age, bioavailable testosterone is a much more sensitive indicator of testosterone decline than total serum testosterone levels, and can detect much earlier testosterone decline associated with aging.[43-45]

 CONVENTIONAL MEDICAL TREATMENT

Conventional medical treatment of male hypogonadism involves excluding underlying pathologies that may be the cause. Treatment typically revolves around testosterone replacement therapy.

 NATUROPATHIC MEDICAL TREATMENT AND PREVENTION

Clinical Nutrition

Nutrients that may improve testosterone production include vitamin C, zinc, arginine, vitamin E, essential fatty acids, and Co-enzyme Q10.

CLINICAL STUDIES
Hormone Imbalances

Recent research reveals that the synergistic interplay among testosterone, DHEA, cortisol, and melatonin modulates the genetic expression and pathogenesis of many chronic and degenerative conditions, including rheumatoid arthritis and cancer.

DHEA is a precursor hormone for the production of testosterone. Researchers theorize that one of the primary functions of DHEA-S, the sulfate form of DHEA, is to serve as an allosteric facilitator of the binding of testosterone to albumin, which allows testosterone to attach to receptor sites and initiate physiological responses throughout the body. Cortisol, the body's potent glucocorticoid and anti-inflammatory, is modulated by levels of DHEA. Melatonin, produced by the pineal gland, is a powerful regenerative hormone linked to sleep cycle, immune modulation, mood regulation, anti-cancer activity, reproductive function, and antioxidant defense.

Botanical Medicine

Herbs include *Panax ginseng*, damiano (*Turnera diffusa*), sarsaparilla (*Smilax spp.*), and puncture vine (*Tribulus terrestris*).

Hormone Replacement

Hormone replacement with the adrenal hormone DHEA may be beneficial, if shown to be depleted. Bioindentical transdermal testosterone cream can be applied to the scrotum for those whose physiological levels remain below normal.

Oral doses of testosterone are not recommended because of increased detoxification in the liver ("first pass effect") and therefore concern about the potential of increased risk of liver cancer with long-term use.

FEMALE SEX HORMONES
Pathophysiology Review

Research shows that fluctuating levels of estradiol, progesterone, and testosterone play a key role in shaping the course of a woman's menstruation cycle, affecting changes in mood, sleep patterns, appetite, sexual drive, and PMS symptoms. Because hormones work together and influence each other in complex ways, an analysis of melatonin, DHEA, and cortisol can give a more complete picture of how endocrine function may be influencing female reproductive health.

ESTROGENS

Three steroid hormones — estrone (E1), ß-estradiol (E2), and estriol (E3) — are known collectively by their function as estrogens. Estradiol is the most physiologically active estrogen in non-pregnant women. Its potency is 12 times that of estrone and 80 times that of estriol. In non-pregnant women, estrogens are mainly produced in the ovaries and adrenal cortex. In pregnant women, estrogens are also produced in the placenta. ß-estradiol is produced in the ovaries; estrone is synthesized in the ovaries and adrenal cortices from ß-estradiol and androstenedione; and estriol is formed in the liver by conversion of either ß-estradiol or estrone.

During puberty, estrogens play a significant role in the maturation of such female reproductive organs as the vagina, uterus, fallopian tubes, and ovaries. Estrogens also trigger secondary sexual characteristics, namely the development of breasts and increased osteoblastic activity, resulting in characteristically feminine skeletal development.

Estrogens stimulate an increase in total body protein, promoting body development during puberty. These hormones also stimulate deposition of fat in subcutaneous tissues, particularly breasts, buttocks, and thighs. Estrogens influence development of vascular function and soft textured skin and have a minor effect on pubic and underarm hair growth. Furthermore, estrogens cause a slight retention of sodium and water by the kidneys and more pronounced retention during pregnancy.

PROGESTERONES

Progesterone is present as progesterone and 17-a hydroxyprogesterone. They exhibit similar potency. Because 17-a hydroxyprogesterone is produced in minute quantities compared to progesterone, the latter is considered the most significant progesterone. As is the case with estrogen, progesterone is produced in the ovaries and adrenal cortex in non-pregnant women, while in pregnant women it is also secreted in the placenta.

Both progesterone and estradiol are formed from cholesterol. In the luteal phase, progesterone levels increase dramatically, in spite of a portion of available steroids still being converted to estrogens. Conversion of ß-estradiol to the less potent estrone or estriol diminishes circulating ß-estradiol, and further functional degradation occurs as formation of glucuronides and sulfates in the liver takes place. Similarly, progesterone is functionally degraded to less potent steroids in the liver.

Like estrogen, progesterone plays a role in increasing the size of breasts by stimulating the development of lobules and alveoli. During the menstrual cycle, progesterone promotes secretory changes in the endometrium preparatory to the implantation of a

fertilized ovum. Progesterone also has a minor effect on the retention of sodium, chloride, and water by the kidneys.

TESTOSTERONE

In the adult female, testosterone plays an important role in maintaining lean body mass, bone density, skin elasticity, and libido. In addition, testosterone is involved in blood cell production. Low testosterone levels have been linked to increased risk for osteoporosis, decreased lean body mass, and decreased libido, and may suggest ovarian insufficiency and/or adrenal insufficiency. Elevated testosterone levels have been linked to masculinization, hirsutism, and increased risk of insulin resistance. Elevated testosterone levels have been noted in polycystic ovary disease and adrenal hyperplasia and suggest the presence of ovarian dysfunction or adrenal dysfunction.

MENSTRUAL CYCLE

The average menstrual cycle takes about 28 days (25-35 days) to complete and falls into three phases: follicular, ovulatory, and luteal phases.

Follicular Phase

In the follicular phase ovarian follicular growth, the uterine endometrium develops in preparation for the implantation of fertilized ovum. The growing follicles themselves produce high amounts of estrogen, which stimulates the uterine endometrium to proliferate and to synthesize cytosolic receptors for progesterone. Progesterone levels during this phase remain low.

The follicular phase can be divided into two stages. In the periantral stage of follicular growth, luteinizing hormone (LH) stimulates theca interna cells to produce androgens (mainly androstenedione), which diffuse through the basal lamina into the granulosa cell compartment to stimulate proliferation. The follicle grows, accumulates fluid, and forms an antrum. Estradiol levels are not high enough to diffuse into general circulation, so follicle-stimulating hormone (FSH) and LH are not inhibited.

In the antral stage of follicular growth, the combined effects of FSH and estradiol induce LH receptors on the granulosa cells. This enables them to begin producing estradiol from pregnenolone (de novo estradiol synthesis). Spillage of estradiol into the general circulation results from this increased estradiol pool and accelerated follicle growth. Subsequently, a relatively rapid increase in circulating estradiol level is seen during the last 5 or 6 days of the follicular phase.

Initially, this rise in estradiol exerts a negative feedback on FSH release. Continued high levels (about a three-fold increase) presented over a 2- to 3-day period exert a positive feedback effect, resulting in a large surge of LH and FSH. The large bolus of LH (preovulatory LH surge) released induces ovulation in about 1 day. The follicular phase lasts for about 9 to15 days, and its duration determines the period of the menstrual cycle itself, since the length of the two subsequent phases remains fairly constant.

Ovulatory Phase

The ovulatory phase involves the release of the ovum or egg (ovulation) from the follicles and lasts about 36 hours. Ovulation is probably induced when LH stimulates the production of granulosa plasminogen activator, triggering the formation of plasmin, an enzyme responsible for digesting the basal lamina, and thus the rupture of the follicle. Women generally experience an increase in the basal body temperature of 0.5° to 1.0° F following ovulation. This increase is due to the thermogenic effect of pregnanediol, a metabolite of progesterone.

After ovulation, granulosa cells proliferate in response to the preovulatory LH surge, while theca interna cells and perifollicular blood vessels invade the cavity of the collapsed follicle. Under the influence of LH, the granulosa and evasive theca cells differentiate into luteal cells.

Luteal Phase

During the luteal phase, the ruptured follicles in the ovary form a corpus luteum. Luteal cells are steroidogenic and produce large amounts of progesterone and moderate amounts of estradiol.

The increase of estrogen and progesterone during the first 4 to 5 days of the luteal phase promotes endometrium and fallopian tube secretions that allow for proper nourishment and implantation of the fertilized ovum. During this time, circulating levels of estradiol are reduced, a decrease necessary for the proper transport of the ovum through the fallopian tube into the uterus. Exposure to high levels of estrogen during this interval would lead to expulsion of the ovum or to blockage of ovum transport.

The corpus luteum has a life span of about 12 days. If fertilization and implantation do not occur, the corpus luteum degenerates (luteolysis), and its production of progesterone and estradiol rapidly declines. Since progesterone inhibits FSH and folliculogenesis, withdrawal of progesterone and estradiol during luteolysis results in deterioration of the endometrium and its shedding (menstruation). The first day of menstruation is the first day of the menstrual cycle.

The endometrium is most conducive to implantation

during the progesterone peak secretion period, about the fifth day into the luteal phase. If fertilization of the ovum occurs, secretion of chorionic gonadotropin (hCG) by the implanted blastocyst stimulates the corpus luteum to continue producing progesterone and luteolysin is prevented.[47]

Anovulation

If the preovulatory surge of LH is not sufficient, anovulation can occur. The pre-ovulatory surge of LH is linked to the positive feedback of the pre-ovulatory estrogen peak. Lack of ovulation leads to failure in the development of the corpus luteum and subsequent production of progesterone.

Infertility is defined as a year of unprotected intercourse without achieving pregnancy. Infertility occurs in about 10% of the population. The probability of anovulation or luteal phase defect causing infertility is 20% 40% and 3% to 10%, respectively. Functional infertility occurs as a result of several conditions. Rising estrogen and progesterone levels inhibit LH and FSH. Corpus luteum degenerates and becomes refractory to LH. Finally, withdrawal of progesterone (estrogen) occurs and results in endometrium deterioration and menstruation.

Polycystic Ovary Syndrome (PCOS)

Polycystic ovary syndrome is a common condition (4% to 10% of America women of reproductive age) that accounts for approximately 8% of anovulation cases. PCOS is used to describe a group of clinical presentations characterized by bilateral polycystic ovaries potentially combined with amenorrhea, anovulation, infertility, insulin resistance, truncal obesity, and hirsutism. Hormone imbalances may include hypothalamus, pituitary, ovarian, adrenal, insulin excess (Syndrome X), androgen excess, and prolactin excess.

Other endocrine disorders that can mimic PCOS include adrenal and ovarian cancers, Cushing' s disease, and hyperthyroidism or hypothyroidism.

Premenstrual Syndrome (PMS)

PMS is described as a group of symptoms that include mood swings, hypoglycemia (food cravings), depression, bloating, and other complaints occurring during the luteal phase of the menstrual cycle. With the onset of menses, the symptoms usually disappear.

Progesterone deficiency, increased estrogen, or estrogen/ progesterone imbalance can all trigger PMS. Factors associated with an increased ratio of estrogens/progesterone include a history of pregnancy, abortion, tubal ligation, hysterectomy, oral contraceptive use, and anovulatory cycles. Other fac-

tors implicated in the etiology of PMS are Western lifestyle, decreased hepatic production of estriol, excessive aldosterone production, dysinsulinemia, hyperprolactinemia, and calcium and magnesium deficiency.

PMS Symptoms

PMS symptoms have been divided into four groups:

PMS-A: Anxiety, including nervousness, irritability, and sudden mood swings.

PMS-C: Cravings, including typical hypoglycemic symptoms, such as headache, dizziness, and brain fog, which are better from eating carbohydrates.

PMS-D: Depression, as well as crying, insomnia, and poor memory.

PMS-H: Hyperhydration, resulting in bloating, edema, and weight gain.

Amenorrhea

Functional secondary amenorrhea or oligomenorrhea is defined as the failure of a woman with periodic menses to experience menstruation for 6 consecutive months. The association between high intensity athletic training and menstrual disturbances may be attributable in part to altered nutritional intake and body mass and in part to exercise- and competition-induced stress.[48] One study observed that salivary progesterone levels change with age, that lower progesterone peaks were recorded in women aged 18 to19 and 40 to 44 years, and that women experienced a gradual increase in peak progesterone levels from age 20 to 39.[49]

CLINICAL STUDIES

Luteal Phase Defects

Patients with prolonged, unexplained infertility experienced a high frequency of luteal phase defects, including pre-ovulatory progesterone peaks, interruption of progesterone secretion during the luteal phase, and high progesterone levels at the beginning of menstruation. Researchers recorded a correlation of 0.71 (10 of 14) between low progesterone levels and luteinized unruptured follicle cycles. Another study of 50 infertile women with regular menstrual cycles of normal length revealed low progesterone levels in subgroups with three menstrual patterns: cycles with luteinized unruptured follicles, cycles with an early luteinizing surge, and normal controls.

CLINICAL STUDIES

Estrogen and Cancer Risk

Dr Henry Lemon (MD) observed that women with higher levels of estriol as opposed to estrone or estradiol were more likely to be long-term survivors after breast cancer surgery. This corresponds to a great deal of laboratory research showing estriol to be anti-carcinogenic.

Epidemiological studies have also shown an inverse relationship between estriol and breast cancer. Lemon introduced the "Estrogen Quotient" (EQ), which is equal to the estriol level (urine or serum) divided by the sum of the values for estrone and estradiol. This was later refined to look at the ratio of 2-OH estrogens to 16-a-hydroxye-strone. This ratio, known as the "2/16" test, is a well-established risk factor for estrogen related reproductive cancers. The mean value is considered to be 2.0-2.3, with high values indicating protection.

Dietary factors, such as the consumption of brassicas (cabbage, kale, broccoli, cauliflower, brussel sprouts, bok choy, mustard greens), flax, and soy, have all been shown to positively influence the "2/16" ratio, as have supplements of DIM (di-indolymethane) and I3C (indole-3-carbinole). These foods and supplements appear to offer some protection to women who wish to reduce their breast cancer risk.

Some research has shown that men who consume these vegetables have close to a 50% reduction in prostate cancer risk. Future research is needed to investigate the adverse effects of estrogen ratios on male reproductive cancers.[55]

Endometriosis

A significant number of infertile women show ovarian dysfunction with endometriosis. Higher progesterone levels in late follicular and luteal phases have been associated with endometriosis.[50] A recent study of women with similar etiology found that 50% had normal progesterone cycles, while 45% showed higher progesterone levels. Among the latter, 18% of the subjects exhibited elevated levels in the follicular phase, 20% in the luteal phase, and 7.5% in both phases.[51] It has also been observed that maintaining adequate estrogen levels in post-menopausal women may be a risk factor for developing endometrial cancer.[52]

Breast Disease

Elevated estrogen levels are generally considered an increased risk factor for breast cancer, especially in women after menopause. A study of 276 British and Thai women with different levels of progesterone indicated that higher levels of progesterone might also be a risk factor for breast cancer. This hypothesis was further strengthened by another study of 362 young women.[53]

There is good evidence for photoperiod dependence and/or melatonin responsiveness in the initiation and evolution of certain cancers, particularly hormone-dependent cancers. Because of its powerful oncostatic effects and its estrogen-blocking ability, melatonin demonstrates particular promise in the treatment of breast cancer. Numerous studies have reported an inverse correlation between melatonin levels and the growth of estrogen-receptive positive tumors. Used in conjunction with tamoxifen to modulate cancer endocrine therapy, melatonin shows marked ability to influence estrogen receptor expression and inhibit breast cancer cell growth. Moreover, researchers surmised that melatonin might induce objective tumor regressions in metastatic breast cancer patients refractory to tamoxifen alone.[54]

Hypertension and Heart Disease

Estrogen replacement has been shown to improve endothelium-dependent vasodilation of coronary arteries in women with risk factors for atherosclerosis, perhaps due to its antioxidant properties. High levels of cortisol are associated with hypertension, and, interestingly, it has been found that simply having a family history of hypertension predisposes an individual to exaggerated cortisol excretion in response to stress.

One important study in Scotland explored the connection between cardiovascular risk factors and abnormal glucocorticoid activity. Researchers demonstrated a relationship between tissue sensitivity to cortisol and high blood pressure, insulin resistance, glucose intolerance, and hypertriglyceridemia.

Patients with heart diseases exhibit higher cortisol levels than do controls. Recently, Japanese scientists discovered a direct correlation between electrocardiographic abnormalities, such as myocardial hypertrophy, and elevated cortisol levels. A significant surge in cortisol levels accompanies the actual onset of myocardial infarction, with levels substantially decreasing within three days following the stress.

A decrease in melatonin causes increased nighttime sympathetic activity, which, in turn, appears to increase the risk for coronary disease. One study found that patients with coronary heart disease had nocturnal melatonin levels five times lower than in healthy controls. Investigators surmised that lower levels of melatonin might act to increase circulating epinephrine and norepinephrine, which have been

implicated in damage to blood vessel walls. Atherogenic uptake of LDL cholesterol is accelerated by these amines at pathophysiological concentrations.

Research conducted on laboratory rodents has shown that melatonin treatment exerts the beneficial effect of increasing the HDL/LDL cholesterol ratio, perhaps by enhancing endogenous cholesterol clearance mechanisms. Specific binding sites for the melatonin agonist 2-[125I] iodomelatonin have been discovered in the heart (and lungs) of various animals. In addition, melatonin seems to inhibit platelet aggregation. Platelet aggregation plays a significant role in the progression of cardiovascular disease.

Hormone Disruption Factors

Stress: Stress has been shown to decrease the production of sex steroids, which could lead to reduced libido and menstrual irregularities. Maladaption of the adrenal cortex in producing high cortisol levels is, at least in part, responsible for the reduction of sex steroid levels.

Diet: There is strong evidence that the foods consumed by women have an effect on hormone levels. Investigation into dietary habits and, in particular, vegetarian diets, has established that certain foods can modify gonadal estrogen metabolism.[56] Researchers have also speculated that early menarche recorded in girls of developed countries could be due to consumption of steroid hormones in meats.

Exercise: Menstrual irregularities (oligomenorrhea, amenorrhea, anovulation) in athletic women have been attributed to strenuous physical exercise. These patients showed increased estrogen and decreased progesterone levels in the luteal phase. This pattern could be due to an impaired metabolic clearance rate (MCR) of estradiol during physical exercise and decreased sex steroid production under stress.[57]

Cigarette Smoking: Although there is evidence of reduced fertility caused by cigarette smoking, the relationship between cigarette smoking and the anti-estrogenic effect related to infertility remains unclear. Several studies show a positive correlation. However, a recent publication suggests no significant correlation between hormone levels and smoking.[58]

Menopause

In the United States, the cessation of menstruation, menopause, normally occurs between 40 and 60 years of age. The initial symptoms include irregular menstrual cycles, anovulation, and hot flashes. A dramatic decline in the levels of progesterone and estrogen also occurs at this time. Estradiol values decline to subfunctional levels after menopause. In some women,

maintaining adequate estrogen levels after menopause may alleviate the typical symptoms of menopause, but hormone replacement therapy may increase a woman's risk of developing endometrial cancer.[59] A decrease in progesterone levels prior to menopause also results in a reduced anti-estradiol effect. The inability of a pre-menopausal woman's body to maintain the secretory activity of the endometrium leads to endometrial hyperplasia, irregular bleeding, and related conditions. The information provided by a Female Hormone Panel concerning hormone levels can provide guidance in hormone replacement therapy.

Endometrial stimulation by estrogen can lead to the development of cancer, and the risk increases in proportion to the length of time involved. The information provided by the Committee for Proprietary Medicinal Products (CPMP) concerning hormone levels can provide guidance in hormone replacement therapy. There is no way to overstate the importance of monitoring hormone therapy on a regular basis and performing physical examinations prior to beginning therapy and at least annually thereafter.

Menopausal bleeding can develop in women with or without hormone replacement therapy. Because of the increased incidence of endometrial adenocarcinoma, endometrial sampling should be performed as soon as possible. Cyclic courses of progestogens have been used to arrest heavy menopausal bleeding and reverse hyperplasia of the endometrium.

Following menopause, a decrease in estrogen levels produces several distinct changes in female physiology. For sexually active women, intercourse can become uncomfortable or painful because vaginal lubrication is reduced with the decrease in estrogen and the epithelium becomes progressively thinner, producing a condition known as atropic vaginitis. Hormone replacement therapy or the use of water-soluble lubricants can provide relief in such cases.

Lower levels of estrogens can also influence skin aging, affect memory, alter lipid metabolism, and accelerate rate of bone loss. Vasomotor symptoms, at least among women in the industrialized Western countries, include hot flashes, which can also be ameliorated by estrogen replacement.

Progesterone also decreases at this point in the female life cycle. Lower levels of this hormone have been associated with dysfunctional uterine bleeding and may play a role in osteoporosis and other age associated conditions. To reduce some of the side effects of estrogen replacement therapy, especially the increased risk of endometrial hyperplasia adenocarcinoma, progesterone is often combined in hormone replacement therapy.

For women as well as men, testosterone maintains libido. Imbalances of testosterone in postmenopausal women are associated with various forms of coronary heart disease and cardiovascular events, including myocardial infarction. In addition to influencing muscle mass and weight loss, testosterone also plays a role in the production of several other hormones.

Osteoporosis

Because estrogen controls the functioning of osteoclasts and osteoblasts in bone tissue, the hormone also influences the rate of absorption and deposition of calcium. Estrogen deprivation following menopause results in increased activity of osteoclasts that exceeds the capacity of osteoblasts to deposit needed calcium. Under these conditions, osteopenia and ultimately osteoporosis occur.

Administration of glucocorticoids has become an increasingly prevalent treatment modality in conventional biomedicine, yet prolonged use of these powerful drugs often accelerates bone loss, leading to osteopenia and increased incidence of fractures.

Both endogenous and exogenous cortisol excesses are well-established causes of osteoporosis. Increased cortisol levels have been associated with calcium malabsorption, as well as osteoporosis in oophorectomized women. Higher cortisol levels in athletes with exercise-related amenorrhea have also been correlated with significantly lower bone mineral density.[60] One investigator postulated a possible link between lower limb stress fractures in young female athletes and hypersecretion of cortisol.[61]

Melatonin is thought to regulate calcium metabolism by stimulating the activity of the parathyroid glands and inhibiting both calcitonin release and prostaglandin synthesis. Thus, a decline in melatonin levels may be an important contributory factor in the development of post-menopausal osteoporosis. One investigator has even suggested using oral doses of melatonin combined with light therapy for prophylaxis and treatment of post-menopausal osteoporosis.

CONVENTIONAL
MEDICAL TREATMENT

POLYCYSTIC OVARY SYNDROME

Typical conventional treatment of PCOS includes oral contraceptives, progestins, androgen antagonists (spironolactone), and glucocorticoids (prednisone). Limited effectiveness and significant side effects are common. Surgery (wedge resection) is typically reserved for those who fail to respond to pharmacological treatment. Adhesions that form after surgery may prevent future pregnancy.

PREMENSTRUAL SYNDROME

A number of pharmaceutical agents are typically employed for PMS, although often with limited success. Hormonally, oral contraceptives are prescribed, but, in many women, they actually aggravate existing symptoms or create new PMS symptoms. Anxiolytics, antidepressants, and lithium have been prescribed to manage the psychological manifestations of PMS, while diuretics have been prescribed for water retention symptoms. NSAIDS are prescribed for the pain of uterine cramping.

ENDOMETRIOSIS

Typical conventional treatment for endometriosis may include surgical excision of the endometrial tissue and drug therapy to suppress ovarian function. Pharmaceuticals employed include oral contraceptives, progestin, danazol, and GnRH agonists. Side effects of these medications may include PMS symptoms, hirsutism, menopausal symptoms, liver dysfunction, and deep vein thrombosis. Total abdominal hysterectomy, with or without salpingo-oophorectomy, is reserved for patients with intractable pain who have completed child bearing.

MENOPAUSE

Conventional treatment of menopause typically involves the use of hormone replacement therapy (HRT). The most commonly prescribed and studied HRT combination is estrogen in the form of equine estrogens (Premarin) and medroxyprogesterone acetate (Provera).

There has been much controversy over the risk factors associated with these types of hormone replacement strategies. Recent studies do indicate an increased risk of breast cancers with combination HRT therapy, especially after prolonged use (4 to 5 years). Conventional HRT is also associated with increased risk of gallbladder disease, asthma, uterine fibroids, hypertension, blood clots and liver disease.

NATUROPATHIC MEDICAL
TREATMENT AND PREVENTION

POLYCYSTIC OVARY SYNDROME
Diet and Lifestyle

Weight reduction and improvement of insulin resistance is critical to the treatment of PCOS, especially in

overweight and obese women. The diet should focus on removing high glycemic foods and possibly all grains. Similar treatments as for insulin resistance will benefit PCOS.

Short-term dietary intervention studies have consistently shown that weight loss can normalize reproductive fitness and hyperandrogenism and improve metabolic variables in overweight women with polycystic ovary syndrome (PCOS). Consuming fat as 30% of daily caloric intake, reduced saturated and trans fats, increased fiber, and polyunsaturated fat intake have been shown to be effective.

Lifestyle Treatments for PCOS
- Exercise moderately for 30 min/day
- Establish an energy deficit of 500-1,000 kcal/day for weight loss
- Reduce psychosocial stresses
- Stop smoking
- Consume alcohol moderately
- Consume caffeine moderately
- Use castor oil packs 3 to 5 times a week over the abdomen

Nutritional Supplements
Nutrients that reduce prolactin secretion, such as vitamin B-6, magnesium, and GLA, may benefit PCOS. Choline, inositol, and methionine (lipotrophics) assist the liver in hormone breakdown. Vitamin D-2 and calcium supplementation led to normalization of menstrual cycles within 2 months in 7 of 13 patients with PCOS. In a study of 238 patients with PCOS and ovarian dysfunction, the use of inositol offered a beneficial effect, improving ovarian function in women with oligomenorrhea and polycystic ovaries.[62]

Botanical Medicines
Botanicals that inhibit prolactin, such as chasteberry (*Vitex agnus castus*), and those with progesterogenic effects (also chaste berry) are useful in PCOS. Botanical medicines that inhibit the conversion of testosterone to DHT (the hormone that causes acne and male pattern baldness), such as saw palmetto (*Serenoa repens*), can be used to control the virilization seen with PCOS. Saw palmetto also inhibits the binding of DHT at the cellular level.[63]

In vitro studies of nettle root (*Urtica urens*) have shown it to be an up-regulator of sex hormone-binding globulin (SHBG), in part due to the lignans found in the root. Most circulating androgens are bound primarily to SHBG, and when bound, hormones, such as testosterone, are considered biologically inactive. It is believed that with PCOS, SHBG levels are decreased and androgens circulate more freely and are more active. Thus, nettle root is indicated to treat the virilization of PCOS. Flax seeds also stimulate SHBG production, in addition to stimulating ovulation, and are also indicated for PCOS. Liver cleansing and liver support herbs are indicated as well.

PREMENSTRUAL SYNDROME
Diagnosis
A wise course of treatment for PMS focuses on the root causes of the condition. Therefore, proper patient evaluation is critical.[64] The following diagnostic considerations and evaluation will aid in developing a naturopathic PMS protocol for each individual patient:

PMS Questionnaire: PMS questionnaires are available to assess the category or categories of PMS symptoms present.

Hormone Testing: FSH, LH, estradiol, progesterone, TSH.

Basal Body Temperature Chart (for at least one month): This helps to identify ovulatory cycle, follicular and luteal phase lengths, and possible menstrual cycle irregularities (such as biphasic cycles).

Differential Diagnosis: Rule out hypothyroidism, pelvic inflammatory disease, endometriosis, dysmenorrhea, and ovarian pathologies such as PCOS

Diet and Lifestyle
A diet high in meat, saturated and trans fats, simple carbohydrates, and salt all seem to increase the intensity of PMS symptoms. It has been shown that vegetarian women have less circulating free estrogen than non-vegetarian women; a diet that focuses on wholesome food with low saturated fat may, therefore, significantly reduce or even eliminate PMS symptoms.

Xanthines (found in tea, colas, coffee, and chocolate) should also be restricted as they act as xenoestrogens. Phytoestrogens have been shown to have a generally beneficial effect on PMS symptoms. Alcohol and any foods shown to cause an allergic reaction or intolerance should also be avoided, especially for the 2 weeks before the period. Regular aerobic exercise generally benefits PMS.

Clinical Nutrition

Vitamin B-6: A number of clinical studies have confirmed that vitamin B-6 helps PMS by acting as a cofactor that aids the metabolism of estrogen in the liver. Magnesium is also a cofactor in estrogen metabolism and relieves muscle (uterine) cramping. Indole – 3 – carbinole (I3C), found in brassicas, assists the liver in metabolizing estrogens.

Calcium: Calcium supplementation was studied in one clinical trial of 497 women and improvement was noted in mood, fluid retention, food cravings, and cramping.

Evening Primrose Oil: Evening primrose (*Oenothera biennis*) oil is an excellent source of GLA, an essential fatty acid, which, as a precursor to prostaglandins, helps regulate hormone cycles. Research has shown that GLA benefits PMS related depression, mood swings, fluid retention, and breast tenderness.

Vitamin E: Vitamin E supplementation has been shown to reduce the breast tenderness of PMS. The supplement 5-HTP raises serotonin levels. Low serotonin is associated with the depression and anxiety of PMS.

Botanical Medicines

Chasteberry (Vitex agnus castus): This herb has a balancing effect on progesterone and prolactin, both of which are implicated in PMS. Chasteberry has a long history in European herbal medicine as a treatment for PMS. In a one study of Vitex versus the antidepressant Prozac, it was found that Vitex was more beneficial for the physical complaints of PMS, whereas Prozac proved more beneficial for the psychological symptoms. Improvements from Vitex are usually noted within two menstrual cycles.

Milk Thistle (Silybum marianum): This herb aids liver cytochrome P450 detoxification of estrogens.

Cramp Bark (Viburnum opulus): Cramp bark alleviates menstrual cramping acutely.

Wild Yam (Dioscorea villosa): Wild yam benefits PMS by improving estrogens/progesterone ratio and acting as an antispasmodic.

Dong Quai (Angelica sinensis): Dong quai relaxes smooth muscle and reduces breast tenderness.

Dandelion (Taraxacum officinalis): Dandelion leaf reduces water retention.

Passionflower (Passiflora incarnata): Passionflower relaxes the CNS and improves restlessness, irritability, and insomnia.

Bio-identical Hormones

Bio-identical Progesterone: This is usually administered as a transcutaneous cream. It is a stronger therapy typically reserved for those women with severe or intractable PMS. Natural progesterone can also be given sublingually, vaginally, rectally as a suppository, orally, or intramuscularly. Progesterone is usually taken from the day after ovulation (day 15 approximately) until the period begins.

Synthetic progestins, such as medroxyprogesterone acetate (Provera), generally are not as effective as bio-identical progesterone in treating PMS, and their use may result in side effects, such as fluid retention, breast tenderness, and mood irregularities

Melatonin: Melatonin is another hormone that may benefit PMS if supplemented. Melatonin lowers estrogen and helps with insomnia. Therefore, taken at night before bedtime, melatonin will typically not only result in more restful sleep, but also help to normalize the circadian rhythm, including the normal rhythm of hormone secretions.

ENDOMETRIOSIS

An anti-estrogenic diet designed to minimize endogenous and exogenous estrogens is indicated.[65] Avoidance of saturated and trans fats, adequate essential fats, and avoidance of chemical pesticides, herbicides, and plastics that mimic estrogen are important. Incorporation of organic fruits and vegetables, especially those that aid in the detoxification function of the liver (such as dandelion and bitter greens, beets, brassicas, apples, cherries) is recommended.

Avoidance of sexual intercourse during menstruation is warranted, as retrograde endometrial lining flow is considered a potential etiology. Applying a warm castor oil pack to the lower abdominal area may relieve pain and increase circulation during painful periods. Exercising regularly and using relaxation techniques to lower stress will help with hormone balancing.

Clinical Nutrition

Vitamin B-6 and magnesium act as cofactors that aid the metabolism of estrogen in the liver and are indicated. Indole – 3 – carbinole (I3C), found in brassicas, also assists the liver in metabolizing estrogens. D-glucarate is available as a supplement and also supports this process.

Since a healthy balance of flora in the large intestine prevents the recycling of excess estrogens, proper fiber intake, such as supplemental ground flax seed, as well as a probiotic supplement, is also indicated. Intestinal fungal overgrowth, or the overgrowth of pathogenic bacteria, needs to be addressed if present.

Nutrients that support a healthy vascular system, such as vitamin C and bioflavonoids, may help by improving circulation.

Botanical Medicines

Botanicals that have progesterogenic effects (such as chaste berry) are useful in the treatment of endometriosis. Once again, botanicals that aid in the liver mediated detoxification of hormones are indicated. There are also reports that circulatory tonics, such as hawthorne berry (*Crataegus oxycantha*) are beneficial, possibly by reducing capillary fragility. A traditional herbal formula, known as Turska's Formula, has also shown benefit. Turska's formula contains aconite, gelsemium, bryonia, and phytolacca. Because these herbs can be toxic in high doses, this formula should be used only as directed by an experienced healthcare provider.

Bio-identical Hormones

Bio-identical progesterone, usually administered as a transcutaneous cream, is a stronger therapy typically reserved for those women with more severe symptoms. Natural progesterone can also be given sublingually, vaginally, rectally as a suppository, orally, or intramuscularly. Low dose progesterone treatment for endometriosis can be given throughout the period, stopping only on the days of menstrual flow.

MENOPAUSE

Although pre-, peri-, and post-menopausal women can experience significant changes in their health with the ending of menstruation, many of the symptoms associated with this period of a woman's life can be overcome or modulated with botanical, nutritional, and lifestyle interventions.[66] For those women who have more severe symptoms or do not respond to treatment, low dose transdermal bio-identical hormones may be considered. Menopause is not a disease, but a normal life transition, and the symptoms do for the most part diminish with time.

Effective assessment provides important information to practitioners regarding the determination of which dietary changes, nutritional supplements, or lifestyle changes may be beneficial, and whether the use of bio-identical hormone replacement is warranted and not contraindicated. Individualized treatment can be then be implemented based on patient signs and symptoms, family history, and diagnostic tests.

The essence of naturopathic treatment of menopause is to find an appropriate combination that balances the hormones and thereby improves the symptom picture for the individual patient. In other words, treatment is very much individualized depending on the case presentation.

Menopause Treatment Factors
- Personal and family history of breast, uterine, ovarian cancers, osteoporosis, cardiovascular disease, liver disease, fibrocystic breast disease, and gallbladder disease
- Severity and impact of symptoms, including vasomotor, emotional, insomnia, urinary, cognitive, musculoskeletal, and libido
- Severity of signs, including atrophic vaginitis, cardiac dysrhythmias, irregular menstruation, polymenorrhea, metrorrhagia, and menorrhagia.
- Evaluation of laboratory test/scans for LH, FSH, serum estrogen (E2), DHEA, dyslipidemia, osteoporosis, and calcium balance

Diet and Lifestyle

Phytoestrogens: Increasing phytoestrogens in the diet can help alleviate some of the symptoms of menopause. Phytoestogens are a diverse group of chemical compounds that act as hormone regulators; they have a mild estrogenic activity yet also block endogenous estrogens. In this way, they up-regulate deficiency states and down-regulate estrogen excess.

Soy is probably the best known nutritional source of phytoestrogens. Soy has been shown to reduce hot flashes, increase bone density, improve lipid profiles, and inhibit reproductive cancers.

Low-fat, Low-glycemic Diet: A diet low in saturated and trans fats, adequate in essential fats, avoiding high glycemic foods, and regular aerobic and weight bearing exercise can help prevent the negative effects of menopause on serum lipids and bone density.

Nutritional Supplements

Vitamin E (800-1200 IU/day) and evening primrose oil (2000-3000 mg/day) may be helpful in treating the vasomotor symptoms. A bone building formula containing calcium, magnesium, zinc, boron, strontium, vitamin D, and vitamin K can help treat and prevent osteoporosis. A supplement of omega-3 fatty acids and nicotinic acid or inositol hexaniacinate can

benefit serum lipid levels and therefore lower cardio-vascular risk factors. In addition, since elevated homo-cysteine is associated with menopause, supplementing with vitamin B-6, B-12, folic acid, and betaine may be indicated to prevent cardiovascular disease.

Botanical Medicines

There are a number of botanical medicines that have shown to be beneficial in treating menopausal symp-toms.

Black Cohosh (*Cimicifuga racemosa*): Traditionally, black cohosh was used by native Americans to assist in child birth, for dysmenorrhea, and for menopausal symptoms. Black cohosh improved hot flashes, heart palpitations, anxiety, insomnia, and depression asso-ciated with menopause in a number of studies. The mechanism of action appears to be similar to other phytoestrogens, as pharmacological studies have shown a weak estrogen binding activity in vitro. Black cohosh extracts have been shown to suppress LH levels and cause peripheral vasodilation in humans. Black cohosh is also known to be anti-inflammatory, hypotensive, mildly sedating, and spasmolytic.

Estrogenic and Progesterogenic Herbs*:* Many other botanicals have estrogenic or progesterogenic effects. For this reason combination products are commonly seen containing a mix of estrogenic and progestero-genic herbs. Estrogenic herbs include red clover (*Tri-folium pratense*), dong quai (*Angelica sinensis*), licorice (*Glycyrrhiza glabra*), and *Chamaelirium luteum*. Proges-terogenic botanicals include chasteberry (*Vitex agnus castus*), wild yam (*Dioscorea villosa*), and cramp bark (*Viburnum opulus*). Of these, chaste berry is the most studied and considered to be one of the most effec-tive. It acts directly on the pituitary to stimulate LH and inhibit FSH, thereby decreasing the ratios of estrogens to progesterone. It also promotes proges-terone synthesis at the corpus luteum by inhibiting pro-lactin synthesis at the pituitary.

Sympton Specific Herbs*:* Other botanicals may be pre-scribed in menopause depending on symptoms. For instance, *Chimaphila umbellata* can be used to treat cys-titis. St John's wort (*Hypericum perforatum*) can be pre-scribed if depression, insomnia, or sciatica are present. Anxiolytic herbs, such as kava kava (*Piper methysicum*), can be employed if insomnia or anxiety is present.

Bio-identical Hormones

Bio-indentical Progesterone: Replacing progesterone alone, by application of bio-indentical progesterone cream, can be used as a first line treatment of vasomo-tor symptoms. Although progesterone by itself is not as effective as estrogen, it can be useful when estrogens are contraindicated. Bio-indentical progesterone cream can also be combined with oral phytoestrogens.

Bio-identical Estrogen: If symptoms persist, or if risk modification is paramount, bio-identical estrogen cream treatment can be implemented. This is typically done using a "biest" (estradiol and estriol) or a "triest" (estrone, estradiol, estriol) product, always combined with progesterone treatment. Typical "triest" formulas from compounding pharmacies contain 80% estriol, 10% estrone, and 10% estradiol, thus promoting a healthy estrogen quotient. Dosages should be titrated by starting low and increasing until a sufficient amount is absorbed to relieve symptoms without cyclic bleed-ing. The estrogen and progesterone doses should also be cycled to mimic the premenopausal hormone cycle.

Testosterone: If testosterone is replaced, it should be cycled so as to be given on the same days as estrogen.

DHEA: DHEA, which has also been shown to benefit menopausal symptoms, would be given daily to mimic adrenal production, if supplementation is necessary.

MONOGRAPH

THREE BASIC RULES OF BIO-IDENTICAL HORMONE REPLACEMENT THERAPY (BHRT)
(Reprinted by permission of Dr John Lee, www.johnleemd.com)

The *Lancet* publication of the Million Women Study (MWS) removes any lingering doubt that there's something wrong with conventional HRT. Why would supplemental estrogen and a progestin (i.e., not real progesterone) increase a woman's risk of breast can-cer by 30% or more? Other studies found that these same synthetic HRT hormones increase one's risk of heart disease and blood clots (strokes), and do noth-ing to prevent Alzheimer's disease. When you pass through puberty and your sex hormones surge, they don't make you sick — they cause your body to mature into adulthood and be healthy. But the hormones used in conventional HRT are somehow not right — they are killing women by the tens of thousands.

The question is — where do we go from here? My answer is — we go back to the basics and find out where our mistake is. I have some ideas on that.

Over the years I have adopted a simple set of three rules covering hormone supplementation. When these rules are followed, women have a decreased risk

of breast cancer, heart attacks, or strokes. They are much less likely to get fat, or have poor sleep, or short-term memory loss, fibrocystic breasts, mood disorders, or libido problems. And the rules are not complicated.

Rule 1. Give hormones only to those who are truly deficient in them.

The first rule is common sense. We don't give insulin to someone unless we have good evidence that they need it. The same is true of thyroid, cortisol, and all our hormones. Yet conventional physicians routinely prescribe estrogen or other sex hormones without ever testing for hormone deficiency.

Conventional medicine assumes that women after menopause are estrogen-deficient. This assumption is false. Twenty-five years ago I reviewed the literature on hormone levels before and after menopause, and all authorities agreed that over two-thirds (66%) of women up to age 80 continue to make all the estrogen they need. Since then, the evidence has become stronger. Even with ovaries removed, women make estrogen, primarily by an aromatase enzyme in body fat and breasts that converts an adrenal hormone, androstenedione, into estrone. Women with plenty of body fat may make more estrogen after menopause than skinny women make before menopause.

Breast cancer specialists are so concerned about all the estrogen women make after menopause that they now use drugs to block the aromatase enzyme. Consider the irony: some conventional physicians are prescribing estrogens to treat a presumed hormone deficiency in postmenopausal women, while others are prescribing drugs that block estrogen production in postmenopausal women.

How does one determine if estrogen deficiency exists? Any woman still having monthly periods has plenty of estrogen. Vaginal dryness and vaginal mucosal atrophy, on the other hand, are clear signs of estrogen deficiency. Lacking these signs, the best test is the saliva hormone assay. With new and better technology, saliva hormone testing has become accurate and reliable. As might be expected, we have learned that hormone levels differ between individuals; what is normal for one person is not necessarily normal for another. Further, one must be aware that hormones work within a complex network of other hormones and metabolic mediators, something like different musicians in an orchestra. To interpret a hormone's level, one must consider not only its absolute level but also its relative ratios with other hormones that include not only estradiol, progesterone, and testosterone, but cortisol and thyroid as well.

For example, in healthy women without breast cancer, we find that the saliva progesterone level routinely is 200 to 300 times greater than the saliva estradiol level. In women with breast cancer, the saliva progesterone/estradiol ratio is considerably less than 200 to 1. As more investigators become more familiar with saliva hormone tests, I believe these various ratios will become more and more useful in monitoring hormone supplements.

Serum or plasma blood tests for steroid hormones should be abandoned — the results so obtained are essentially irrelevant. Steroid hormones are extremely lipophilic (fat-loving) and are not soluble in serum. Steroid hormones carry their message to cells by leaving the blood flow at capillaries to enter cells where they bond with specific hormone receptors in order to convey their message to the cells. These are called "free" hormones. When eventually they circulate through the liver, they become protein-bound (enveloped by specific globulins or albumin), a process that not only seriously impedes their bioavailability but also makes them water soluble, thus facilitating their excretion in urine. Measuring the concentration of these non-bioavailable forms in urine or serum is irrelevant since it provides no clue as to the concentration of the more clinically significant "free" (bioavailable) hormone in the blood stream.

When circulating through saliva glands, the "free" non-protein-bound steroid hormone diffuses easily from blood capillaries into the saliva gland and then into saliva. Protein-bound, non-bioavailable hormones do not pass into or through the saliva gland. Thus, saliva testing is far superior to serum or urine testing in measuring bioavailable hormone levels.

Serum testing is fine for glucose and proteins but not for measuring "free" steroid hormones. Fifty years of "blood" tests have led to the great confusion that now befuddles conventional medicine in regard to steroid hormone supplementation.

Rule 2. Use bio-identical hormones rather than synthetic hormones.

The second rule is also just common sense. The message of steroid hormones to target tissue cells requires bonding of the hormone with specific unique receptors in the cells. The bonding of a hormone to its receptor is determined by its molecular configuration, like a key is for a lock. Synthetic hormone molecules and molecules from different species (e.g., Premarin, which is from horses) differ in molecular configuration from endogenous (made in the body) hormones.

From studies of petrochemical xenohormones, we learn that substitute synthetic hormones differ in

their activity at the receptor level. In some cases, they will activate the receptor in a manner similar to the natural hormone, but in other cases the synthetic hormone will have no effect or will block the receptor completely. Thus, hormones that are not bioidentical do not provide the same total physiologic activity as the hormones they are intended to replace, and all will provoke undesirable side effects not found with the human hormone. Human insulin, for example, is preferable to pig insulin. Sex hormones identical to human (bio-identical) hormones have been available for over 50 years.

Pharmaceutical companies, however, prefer synthetic hormones. Synthetic hormones (not found in nature) can be patented, whereas real (natural, bio-identical) hormones cannot. Patented drugs are more profitable than non-patented drugs. Sex hormone prescription sales have made billions of dollars for pharmaceutical companies. Thus is women's health sacrificed for commercial profit.

Rule 3. Use only in dosages that provide normal physiologic tissue levels.

The third rule is a bit more complicated. Everyone would agree, I think, that dosages of hormone supplements should restore normal physiologic levels. The question is — how do you define normal physiologic levels? Hormones do not work by just floating around in circulating blood; they work by slipping out of blood capillaries to enter cells that have the proper receptors in them.

As explained above, protein-bound hormones are unable to leave blood vessels and bond with intracellular receptors. They are non-bioavailable. But they are water-soluble, and thus found in serum, whereas the "free" bioavailable hormone is lipophilic and not water soluble, thus not likely to be found in serum. Serum tests do not help you measure the "free," bioavailable form of the hormone. The answer is saliva testing.

It is quite simple to measure the change in saliva hormone levels when hormone supplementation is given. If more physicians did that, they would find that their usual estrogen dosages create estrogen levels 8 to 10 times greater than found in normal healthy people, and that progesterone levels are not raised by giving supplements of synthetic progestin, such as medroxyprogesterone acetate (MPA).

Further, saliva levels (and not serum levels) of progesterone will clearly demonstrate excellent absorption of progesterone from transdermal creams. Transdermal progesterone enters the bloodstream fully bioavailable (i.e., without being protein-bound). The progesterone

increase is readily apparent in saliva testing, whereas serum will show little or no change. In fact, any rise of serum progesterone after transdermal progesterone dosing is most often a sign of excessive progesterone dosage. Saliva testing helps determine optimal dosages of supplemented steroid hormones, something that serum testing cannot do.

It is important to note that conventional HRT violates all three of these rules for rational use of supplemental steroid hormones.

A 10-year French study of HRT using a low-dose estradiol patch plus oral progesterone shows no increased risk of breast cancer, strokes, or heart attacks. Hormone replacement therapy is a laudable goal, but it must be done correctly. HRT based on correcting hormone deficiency and restoring proper physiologic balanced tissue level, is proposed as a more sane, successful and safe technique.

Other Factors
Hormone imbalance is not the only cause of breast cancer, strokes, and heart attacks. Other risk factors of importance include the following:
- Poor diet. (Excess sugar and refined starches, trans fatty acids, lack of needed nutrients, such as omega-3 fats, full range of essential amino acids, vitamins, minerals, etc.)
- Environmental xenoestrogens and hormones not removed by water treatment. (Be sure that your home water filter will remove hormones.)
- Insulin resistance
- Stress
- Lifestyle problems, such as excess light at night (poor sleep, melatonin deficiency), alcohol, cadmium (cigarette smoking), and birth control pills during early teens

Men share these risks equally with women. Hormone imbalance and exposure to these risk factors in men leads to earlier heart attacks, lower sperm counts, and higher prostate cancer risk.

Conclusion
Conventional hormone replacement therapy (HRT) composed of either estrone or estradiol, with or without progestins (excluding progesterone), carries an unacceptable risk of breast cancer, heart attacks, and strokes. I propose a more rational HRT using bio-identical hormones in dosages based on true needs as determined by saliva testing. In addition to proper hormone balancing, other important risk factors are described, all of which are potentially correctable. Combining hormone balancing with correction of

other environmental and lifestyle factors is our best hope for reducing the present risks of breast cancer, strokes, and heart attacks.

Sexual Differentiation Disorders

X and Y chromosome are necessary for testicular development. Two x chromosomes are necessary for complete ovarian function. Male sexual differentiation originates from an undifferentiated gonad that is derived from epithelium, mesenchyme, and germ cells. The presence of testicular determining factor (TDF) gives rise to Leydig cells, Sertoli cells, seminiferous tubules, and spermatogonia. Testes are formed at 7 weeks. The conversion of testosterone to dihydroxytestorone by 5 alpha reductase and its binding to androgen receptors cause the external genital masculinization.

In the female, the undifferentiated gonad gives rise to follicles, granulose cells, theca cells, and ova. Ovarian development occurs in the thirteenth to sixteenth week of gestation. Lack of dihydroxy testosterone results in the maintenance of female genitalia. Both in females and males, the external genitalia arise from the urogenital tubercle, urogenital swelling and urogenital folds.

Hypospadias, a developmental anomaly in the male in which the urethra opens on the bottom of the penis, and cryptorchidism (failure of the testes to descend) have been linked to prenatal estrogen exposure in animal models. Pesticide use on farms and household gardens have been shown to possess estrogenic and other hormone-disrupting effects. Studies have shown that an increased risk of urogenital malformations have been found in the sons of pesticide appliers. A significant increased risk of cryptorchidism was found among sons of women working in conventional gardens that used pesticides in a study of 6,177 cases of cryptorchidism and 23,273 controls. The study was performed in Scandinavia.[67]

Pregnant women living close to farms where pesticides are sprayed on fields may have an increased risk of having the fetus die due to birth defects. Mothers should to their best ability avoid all pesticides and chemicals during pregnancy.[68] A detoxification before pregnancy is recommended. ADD, asthma, and allergies have been linked to pesticide exposure in foods. The importance of eating organic foods cannot be overemphasized.

Premature Puberty

The maturation of the hypothalamic-pituitary axis initiates puberty. Gonadotropin-releasing factor is secreted from the hypothalamus and tells the pituitary gland to secrete leuteinizing hormone (LH) and follicle-stimulating hormone (FSH). These hormones stimulate gonads to enlarge and to secrete sex steroids that circulate and initiate the development of secondary sex characteristics.

Organic pollutants, including pesticides and some plasticizers, can disrupt normal sexual development. DEHP is a phthalic ester that is found in food, water, and medical equipment from contact with plastic containers, plastic wrappings and containers, plastic toys and pacifiers. The daily consumption of DEHP in the United States is 5.8 mg and 2.1 mg in Japan. These high levels have been linked to the cause of premature puberty.[69]

In the United States, normal puberty occurs between 9 and 14 years. However, puberty is occurring earlier and earlier due to chemical exposure.

References

1. Morley JE. Endocrine factors in geriatric sexuality. Geriatr Sex 1991;7(1):85-93.

2. Morley JE, Kaiser FE, Sih R, Hajjar R, Perry III HM. Testosterone and frailty. Clin Geriatr Med 1997;13(4): 685-95.

3. Fink G, Sumner EH, McQueen JK, Wilson H, Rosie R. Sex steroid control of mood, mental state and memory. Clin Exp Phramacol Physiol 1998;25:764-75.

4. Tenover JL. Male hormone replacement therapy including "andropause." Endocrinol Metab Clin N Am 1998;27(4):969-87.

5. Sternbach H. Age associated testosterone decline in men: clinical issues for psychiatry. Am J Psychiatr 1998;155(10):1310-18.

6. Tenover JL. Male hormone replacement therapy including "andropause." Endocrinol Metab Clin N Am 1998;27(4):969-87.

7. English KM, Steeds R, TH Jones, Channer KS. Testosterone and coronary heart disease: Is there a link? QJM 1997;90:787-91.

8. Phillips GB, Pinkernell BH, Tian-Yi J. The association of hypotesteronemia with coronary artery disease in men. Arterioscler Thromb 1994;14(5):701-06.

9. Phillips GB, Pinkernell BH, Tian-Yi J. The association of hypotesteronemia with coronary artery disease in men. Arterioscler Thromb 1994;14(5):701-06.

10. Phillips GB, Pinkernell BH, Tian-Yi J. The association of hypotesteronemia with coronary artery disease in men. Arterioscler Thromb 1994;14(5):701-06.

11. English KM, Steeds R, TH Jones, Channer KS. Testosterone and coronary heart disease: Is there a link? QJM 1997;90:787-91.

12. Sewdarsen M, Vythilingum S, Jialil I, Desai RK, Becker P. Abnormalities in sex hormones are a risk factor for premature manifestation of coronary artery disease in South African Indian men. Atherosclerosis 83:111-17.

13. Morley JE, Kaiser FE. Sexual function with advancing age. Geriatr Med 1989; 73(6):1483-95.

14. Sternbach H. Age associated testosterone decline in men: Clinical issues for psychiatry. Am J Psychiatr 1998;155(10):1310-18.

15. Velazquez M, Bellabarba Arata G. Testosterone replacement therapy. Arch Androl 1998; 41:79-80.

16. Morley JE. Endocrine factors in geriatric sexuality. Geriatr Sex 1991;7(1):85-93.

17. Tenover JL. Male hormone replacement therapy including "andropause." Endocrinol Metab Clin N Am 1998;27(4):969-87.

18. Skakkeback N, Bancroft J, Davidson DW, et al. Androgen replacement with oral testosterone undecanoate in hpogoandal men: A double-blind controlled study. Clin Endocrinl 14:49-55.

19. Galard R, Antolin M, Catalan R, Magana P, Schwartz S, Castellanos JM. Salivary testosterone levels in infertile men. Int J Androl 1987 Aug;10(4):597-601.

20. Forsberg L, Gustavii B, Hojerback T, Nilsson AL, Olsson AM. One hundred impotent men. Scand J Urol Nephrol 1990;24:83-87.

21. Gordon D, Beastall GH, Thomson JA, Sturrock RD. Androgenic status and sexual function in males with rheumatoid arthritis and ankylosing spondylitis. Quart J Med 1986; 60(231):671-79.

22. National Osteoporosis Foundation 1997. Washington DC. www.nof.org/other/men1op.html

23. Hansen KA, Tho SPT. Androgens and bone health. Sem Repro Endocrinol 1998; 16(2):129-134.

24. Jackson JA, Riggs MW, Spikerman AM. Testosterone deficiency as a risk factor for hip fractures in men: A case-control study. Am J Med Sci 1992;304(1):4-8.

25. Morley JE, Kaiser FE, Sih R, Hajjar R, Perry III HM. Testosterone and frailty. Clin Geriatr Med 1997;13(4):685-95.

26. Velazquez M, Bellabarba Arata G. Testosterone replacement therapy. Arch Androl 1998; 41:79-80.

27. Bhasin S, Storer TW, Berman N, Yarasheski KE, Clevenger B, Phillips J, et al. Testosterone replacement increases fat-free mass and muscle size in hypogonadal men. J Clin Endocrinol Metab 1997;82:407-13.

28. Velazquez M, Bellabarba Arata G. Testosterone replacement therapy. Arch Androl 1998; 41:79-80.

29. Bhasin S, Storer TW, Berman N, Yarasheski KE, Clevenger B, Phillips J, et al. Testosterone replacement increases fat-free mass and muscle size in hypogonadal men. J Clin Endocrinol Metab 1997;82:407-13.

30. Burris AS, Banks SM, Carter CS, Davidson JM, Sherin JS. A long-term prospective study of the physiologic and behavioral effects of hormone replacement therapy in untreated hypogonadal men. J Androl 1992;13(4):297-304.

31. Burris AS, Banks SM, Carter CS, Davidson JM, Sherin JS. A long-term prospective study of the physiologic and behavioral effects of hormone replacement therapy in untreated hypogonadal men. J Androl 1992;13(4):297-304.

32. Alexander GM, Swerdloff RS, Wang C, Davidson T, McDonald V, Steiner B, Hines M. Androgen-behavior correlations in hypogonadal men and eugonadal men. Horm Behav 1997;31:110-19.

33. Moffat SD, Hampson E. A curvilinear relationship between testosterone and spatial cognition in humans: Possible influence of hand preference. Psychoneuroendocrinol 1996; 21(3):323-27.

34. Janowsky JS, Oviatt SK, Orwoll ES. Testosterone influences spatial cognition in older men. Behavioral Neurosci 1994; 108(2):325-32.

35. Van Goozen SHM, Coehn-Kettenis PT, Gooren LJG, Frijda NH, Van de Poll NE. Activating effects of androgens on cognitive performance: Causal evidence in a group of female-to-male transsexuals. Neuropsychologia 1994; 32(10):1153-57.

36. Janowsky JS, Oviatt SK, Orwoll ES. Testosterone influences spatial cognition in older men. Behavioral Neurosci 1994; 108(2):325-32.

37. Christiansen K. Sex hormone-related variations of cognitive performance in Kung San hunter gatherers of Namibia. Neuropsychobiol 1993;27:97-107.

38. Srinivasan G, Campbell E, Bashirelahi N. Androgen, estrogen, and progesterone receptors in normal and aging prostates. Microsc Res Tech 1995;30(4):293-304.

39. Brown TR. Provocative aspects of androgen genetics. Prostate Suppl 1996;6:9-12.

40. Demark-Wahnefried W, Lesko SM, Conaway MR, Robertson CN, Clark RV, Lobuaght B, et al. Serum androgens: Associations with prostate cancer risk and hair patterning. J Androl 1997;18(5):495-500.

41. Gann PH, Hennekens CH, Ma J, Longcope C, Stamper MJ. Prospective study of sex hormone levels and risk of prostate cancer. J Natl Cancer Inst 1996;88(16):1118-26.

42. Zagars GK, Pollack A, von Eschenbach AC. Serum testosterone — a significant determinant of metastatic relapse for irradiated localized prostate cancer. Urology 1997;49(3):327-34.

43. Morley JE, Kaiser FE, Sih R, Hajjar R, Perry III HM. Testosterone and frailty. Clin Geriatr Med 1997;13(4):685-95.

44. Morley JE. Endocrine factors in geriatric sexuality. Geriatr Sex 1991;7(1):85-93.

45. Tenover JL: Male hormone replacement therapy including "andropause." Endocrinol Metab Clin N Am 1998;27(4):969-87.

46. Roberts E. The importance of being dehydroepiandrosterone sulfate (in the blood of primates): A longer and healthier life? Biochem Pharmacol 1999;57(4):329-46.

47. Vuorento T, Lahti A, Hovatta O, and Huhtaniemi I. Daily measurements of salivary progesterone reveal a high rate of anovulation in healthy students. Scan J Clin Lab Invest 1989;49:395-401.

48. Ronkainen H, et al. Physical exercise-induced changes and season-associated differences in the pituitary-ovarian function of runners and joggers. J Clin Endocrin Metab 1985;60:416.

49. Lipson S and Ellison P. Normative study of age variation in salivary progesterone profiles. J Biosoc Sci 1992;24:233-44.

50. Ayers J, Birenbaum DL, Menon KM. Luteal phase dysfunction in endometriosis: Elevated progesterone levels in peripheral and ovarian veins during the follicular phase. Fertil Steril 1987;47:935-39.

51. Wingfield M, O'Herlihy C, Finn M, Tallon D, Fottrell P. Follicular and luteal phase salivary progesterone profiles in women with endometriosis and infertility. Gynecol Endocrin 1994;8:21- 25.

52. Wren B. Reproductive endocrinology. In: Hacker N and Moore J (eds.). Essentials of Obstetrics and Gynecology. Philadelphia, PA: W. B. Sanders Co., 1992.

53. Wilson D, Turkes A, Jones R, Danutra V, Read G, Griffiths K. A comparison of menstrual cycle profiles of salivary progesterone in British and Thai adolescent girls. Eur J Cancer 1992; 28A:1162-67.

54. Tamarkin L, Almedia OF, Danforth DN Jr. Melatonin and malignant disease. Ciba Found Symp 1985;117:284-99.

55. Conference of Academy of Environmental Medicine Texas, 2002.

56. Pirke KM, Schweiger U, Laessle R, Dickhaut B, Schweiger M, Waechtler M. Dieting influences the menstrual cycle: Vegetarian versus nonvegetarian diet. Fertil Steril 1986;46:1083

57. Keizer H. Exercise- and training-induced menstrual cycle irregularities (AMI). Int J Sports Med 1986;8 (suppl 3):137-74.

58. Thomas EJ, Edridge W, Weddell A, McGill A, McGarrigle HH. The impact of cigarette smoking on the plasma concentrations of gonadotrophins, ovarian steroids and androgens and upon the metabolism of oestrogens in the human female. Hum Rep 1993;8:1187-93.

59. Vining RF, McGinley RA, Maksvytis JJ, Ho KY. Salivary cortisol: A better measure of adrenal cortical function than serum cortisol. Ann Clin Biochem 1983;20:329-35.

60. Vining RF, McGinley RA, Maksvytis JJ, Ho KY. Salivary cortisol: A better measure of adrenal cortical function than serum cortisol. Ann Clin Biochem 1983;20:329-35.

61. Vining RF, McGinley RA, Maksvytis JJ, Ho KY. Salivary cortisol: A better measure of adrenal cortical function than serum cortisol. Ann Clin Biochem 1983;20:329-35.

62. Gerli S, Mignosa M, Di Renzo GC. Effects of inositol on ovarian function and metabolic factors in women with PCOS: a randomized double blind placebo-controlled trial.Eur Rev Med Pharmacol Sci. 2003 Nov-Dec;7(6): 151-59.

63. Habib FK, Ross M, Ho CK, Lyons V, Chapman K. Serenoa repens (Permixon) inhibits the 5alpha-reductase activity of human prostate cancer cell lines without interfering with PSA expression. Int J Cancer. 2005 Mar 20;114(2):190.

64. Fugh-Berman A, Kronenberg F. Complementary and alternative medicine (CAM) in reproductive-age women: A review of randomized controlled trials. Reprod Toxicol. 2003 Mar-Apr;17(2):137-52.

65. Dog TL. Conventional and alternative treatments for endometriosis. Altern Ther Health Med. 2001 Nov-Dec;7(6):50-6:quiz 57.

66. McKee J, Warber SL. Integrative therapies for menopause. South Med J. 2005 Mar;98(3):319-26.

67. Weidner IS, Henrik M, Jensen TK, Skakkebæk NE. Cryptorchidism and hypospadias in sons of gardeners and farmers. Environmental Health Perspectives 1998;106(12).

68. Shah CM, Wasserrnan CR, O'Malley CD, Nelson V, Jackson RJ. Maternal pesticide exposure from multiple sources and selected congenital anomalies. Epidemiology 1999;10(1):6066.

69. Colón I, Caro D, Bourdony CJ, Rosario O. Identification of phthalate esters in the serum of young Puerto Rican girls with premature breast development. Environmental Health Perspectives 2000;108(9).

CLINICAL HANDBOOK

Diagnostic & Therapeutic Protocols

This handbook is designed for efficient clinical diagnosis, treatment, and prognosis of most endocrine conditions. For background information about these procedures and their scientific research basis, consult the corresponding section in Basics of Naturopathic Endocrinology and the relevant papers in Clinical Studies and Literature Reviews.

Diagnosis of endocrine conditions includes physical examination, medical history, and laboratory diagnostics. A physical exam would review not only the physical symptoms of the patient, such as pain, but also physical characteristics, such as obesity. The medical history would include questions about any physical symptoms or signs that they might have had in the past. Laboratory testing will help further define the endocrine diagnoses. The information provided below is to be used as a basic reference tool in pointing to the suspected endocrine condition.

PHYSICAL EXAMINATION

Pain

On a physical exam, finding the character and location of pain originating from endocrine condition can be helpful in diagnosing further lab work follow-up.

Lower Quadrant Pain
- ❏ Ureter calculi. Kidney stones are usually caused by high levels of blood calcium from unknown reasons. About 5% is caused by hyperparathyroidism.
- ❏ Endometriosis or polycystic ovary syndrome. Patients who have these conditions usually have significant menstrual pain.
- ❏ Diabetic keto acidosis. Nausea with diffuse abdominal pain along with acetone breath are key signs of this condition.

Epigastric Pain
- ❏ Zollinger-Ellison syndrome. This condition is primarily found in the pancreas, resulting in high gastric juice formation causing burning epigastric pain.
- ❏ Adrenal insufficiency. Patients will have vague digestive complaints, including nausea associated with severe fatigue.

Chest Pain
- ❏ Osteoporosis. Bone pain due to bone loss commonly found in postmenopausal women.
- ❏ Osteomalacia. Bone pain due to bone loss due to abnormal vitamin D metabolism or phosphate deficiency.

Physical Signs

Cardiomegaly
- ❏ Carcinoid syndrome
- ❏ Hyperthyroidism. Increased thyroid hormone levels continually stimulate the heart to pump faster and harder.
- ❏ Diabetic atherosclerosis. This eventually causes high blood pressure.
- ❏ Hypothyroidism. This is associated as well with hypertension.
- ❏ Adrenal tumors. Secrete high levels of aldosterone, which results in hypertension.

Bleeding Under the Skin (Purpura)
- ❏ Cushing's syndrome
- ❏ Waterhouse-Friderichsen syndrome

Epistaxis
- ❏ Menopause
- ❏ Menstruation

Hematemesis and Melena
- ❏ Zollinger Ellison syndrome

Vaginal Bleeding
- ❏ Menopause (from the uterus)
- ❏ Dysfunctional bleeding (from the uterus)
- ❏ Hypopituitarism (from the ovaries)
- ❏ Hypothyroidism (from the ovaries)
- ❏ Stein Leventhal (from the ovaries)

Physical Characteristics

GENERAL

Obesity	Diabetes mellitus, Stein Leventhal (with hirsutism)
Truncal Fat with thin limbs	Cushing's disease Cushing's disease vs. syndrome: *Disease*: excess cortisol due to excess ACTH *Syndrome*: excess cortisol regardless of cause
Hirsutism	Cushing's adrenogenital syndrome Adrenal and ovarian tumors
Fever	Thyroiditis Hypothyroid

CHILDREN

Growth Retardation	Hypopituitarism (tumor, thick, dry, mottled sallow skin, large protruding tongue, thick lips with open, drooling mouth, broad face, upturned nose, puffy hands and feet.)

SKIN

Pigmentation	Pituitary tumors Hyperthyroidism Addison's disease (especially in exposed areas, palmar creases, points of pressure and friction, buccal mucosa, lips, vagina)
Ecchymoses	Cushing's disease
Flushing	Pheochromocytoma
Vitiligo	Addison's disease Diabetes mellitus Hypothyroid Hyperthyroid Hashimoto's thyroiditis
Dryness	Diabetes mellitus
Rough, dry, thick	Hypothyroid, Wilsons temperature syndrome
Warm, moist	Hyperthyroid Pheochromocytoma Acromegaly Hypoglycemia
Cold extremities	Addison's disease Hypothyroid Pheochromocytoma
Dry, longitudinally ridged nails	Hypothyroid
Sergent's white adrenal line	Addison's disease (lightly stroke the abdomen with blunt instrument; + = pale line appears 30 seconds after stroke, and then increases with whiteness and remains for 2-3 minutes)

Constricted Pupils
- ❏ Hypoparathyroidism

Convulsions
- ❏ Hypoglycemia (due to effects on the brain)
- ❏ Hypocalcemia (due to effects on the brain)
- ❏ Addison's disease (due to effects on supporting tissue)
- ❏ Hyperthyroidism (due to effects on the heart)

Cough
- ❏ Substernal thyroid

Diarrhea
- ❏ Zollinger-Ellison syndrome (due to effects on stomach and small intestine)
- ❏ Pancreatic cholera
- ❏ Hypoparathyroidism (due to effects on small intestine)
- ❏ Hyperthyroidism (due to effects on small intestine)
- ❏ Addison's disease (due to effects on small intestine)

Dilated Pupils
- ❏ Pheochromocytoma
- ❏ Pituitary tumors (advanced)
- ❏ Cataracts (due to diabetes)
- ❏ Exophthalmos (due to hyperthyroidism)

Dyspnea
- ❏ Hyperthyroidism (due to increased oxygen demand)
- ❏ Diabetic acidosis (due to inability to excrete carbon dioxide)

Fevers
- ❏ Pituitary tumors
- ❏ Diabetes mellitus
- ❏ Calculi
- ❏ Pregnancy

Jaundice
- ❏ Hyperthyroidism

Paresthesias, Dyschezias, and Numbness
- ❏ Tetany of hypoparathyroidism
- ❏ Diabetic neuropathy
- ❏ Pituitary tumors
- ❏ Acromegaly

Syncope
- ❏ Insulinomas
- ❏ Addison's disease
- ❏ Hypopituitarism

Tachycardia
- ❏ Fat emboli
- ❏ Hyperthyroidism
- ❏ Hyperthyroidism
- ❏ Pheochromocytomas

Tinnitus and Deafness
- ❏ Myxedema
- ❏ Diabetic neuropathy

EENT

FEATURE: SIGN	CONDITION
Face: prominent brow and jaw, enlarged nose, ears, lips	Acromegaly
Face: myxedema (dull, puffy, non-pitting edema, especially around eyes with dry skin, coarse thick hair and thin eyebrows)	Hypothyroid
Face: moon-shaped (round face with red cheeks)	Cushing's disease
Hair: fine	Hyperthyroid
Hair: coarse	Hypothyroid, Wilsons temperature syndrome
Mouth: acetone breath	Diabetes mellitus
Fast speech	Hyperthyroid
Slow, thick, hoarse voice	Hypothyroid, Wilsons temperature syndrome Thyroid Nodule

Laboratory Tests

Pituitary Panel
Low Levels of Prolactin, ACTH, GH, TSH, LH, FSH
- ❑ Pituitary insufficiency

High levels of Prolactin, ACTH, GH, TSH, LH, FSH
- ❑ Pituitary excess

Pineal Panel
Low Melatonin
- ❑ Pineal deficiency

Glucose Panel
Fasting Glucose Low
- ❑ Insulinoma
- ❑ Factitious (Insulin Injection)
- ❑ Factitious (Oral Hypoglycemics)

High Insulin
- ❑ Insulinoma
- ❑ Factitious (Insulin Injection)
- ❑ Factitious (Oral Hypoglycemics)

Elevated Fasting Insulin
- ❑ Syndrome X
- ❑ Increased cardiovascular risk
- ❑ Hyperinsulinemia/Diabetes Type II

Low Fasting Insulin
- ❑ Diabetes Type I

Elevated 2 hour Insulin
- ❑ Syndrome X
- ❑ Insulin dose adjustment needed

Elevated Fructosamine
- ❑ Diabetes Type I, Type II
- ❑ Hypothyroidism
- ❑ Renal failure

Decreased Fructosamine
- ❑ Hypoalbuminemia
- ❑ Renal disease
- ❑ Hyperthyroidism

C-peptide High
- ❑ Insulinoma
- ❑ Oral hypoglycemics

C-peptide Low
- ❑ Insulin injection

Thyroid Panel
Causes of Elevation of T4
- ❑ Hyperthyroidism
- ❑ Increased thyroxine-binding proteins
- ❑ Pregnancy, estrogens, Clofibrate
- ❑ Genetic increases of thyroxine-binding proteins
- ❑ Acute hepatitis
- ❑ Anti T4 antibodies

Causes of Decreased Total T4
- ❑ Hypothyroidism
- ❑ Decreased thyroxine-binding globulins
- ❑ Androgens
- ❑ Renal disease
- ❑ Malnutrition
- ❑ Major illness

Elevation of T3 Resin Uptake
- ❑ Hyperthyroidism
- ❑ Decreased TBG
- ❑ Renal disease

Decreased T3 Resin Uptake
- ❑ Hypothyroidism
- ❑ Increased TBG

High TSH
- ❑ Primary hypothyroidism

Low TSH
- ❑ Primary hyperthyroidism

Adrenal Panel
Adrenal Insufficiency
- ❑ Plasma cortisol low
- ❑ Urinary free cortisol decrease
- ❑ Plasma ACTH increased
- ❑ Urinary 17-KS decreased
- ❑ Serum sodium decreased
- ❑ Potassium increased
- ❑ Bun increased
- ❑ Glucose decreased
- ❑ Hematocrit increased
- ❑ Eosinophils increased

Adrenal Hyperfunctioning (Cushing's syndrome)
- ❑ Plasma cortisol increased
- ❑ Diurnal variation of plasma cortisol
- ❑ Loss of diurnal variation
- ❑ Urinary free cortisol increased
- ❑ Urinary 17-KH increased
- ❑ Dexamethasone screening test 8 a.m. cortisol greater than 5 mcg

Low DHEA
- ❑ Excessive stress shifting steroid pathway to cortisol at the expense of DHEA
- ❑ Adrenal hypofunction
- ❑ CFS
- ❑ Hyperinsulinemia
- ❑ Syndrome X
- ❑ Addison's disease

High DHEA
- ❑ Excessive stress shifting steroid pathway to DHEA at the expense of cortisol
- ❑ Adrenal hypertrophy
- ❑ PCOS
- ❑ Exogenous DHEA, pregnenolone, or progesterone supplementation

Altered Circadian Rhythm
- ❑ Disrupted sleep
- ❑ Chronic Fatigue Syndrome
- ❑ Altered negative feedback of the HPA axis
- ❑ Hypoglycemia (as a trigger to increase cortisol)

Male Hormone Profile

Low IGF-1 (Somatomedin-C)
- ❑ Aging
- ❑ Impaired pituitary function
- ❑ Liver dysfunction
- ❑ Sedentary lifestyle

Increased IGF-1
- ❑ Hyperinsulinemia, Syndrome X
- ❑ Exogenous DHEA
- ❑ Pregnenolone administration
- ❑ Excess growth hormone

Menopausal Profile
- ❑ Low estradiol
- ❑ Reduced ovarian function
- ❑ Adrenal insufficiency

High Estradiol
- ❑ Ovarian or adrenal dysfunction
- ❑ Increased Body Mass Index (BMI)
- ❑ Impaired detoxification of estradiol

Low Progesterone
- ❑ Luteal insufficiency
- ❑ Adrenal insufficiency

High Progesterone
- ❑ Exogenous progesterone or pregnenolone supplementation
- ❑ Adrenal dysfunction

Low Testosterone
- ❑ Ovarian or adrenal insufficiency

High Testosterone
- ❑ Ovarian or adrenal dysfunction

Bone Panel
- ❑ Serum calcium decreased
- ❑ Serum phosphate decreased
- ❑ Serum alkaline phosphatidase increased

Diagnosing Thyroid Disorders

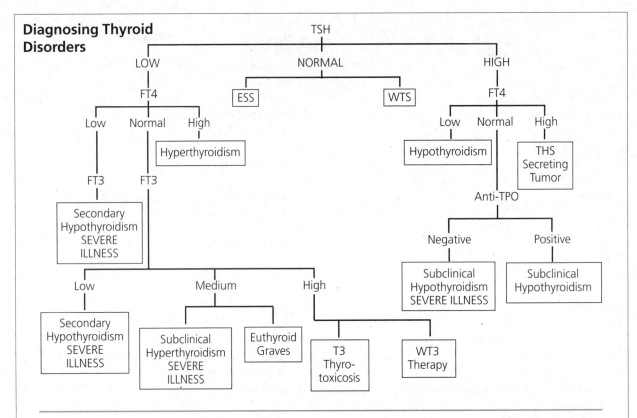

- Diagnosing thyroid conditions can be understood through a flow chart for interpreting lab tests.
- Usually, a TSH is sufficient to rule out thyroid pathologies.
- If the TSH is normal and the patient has suspected symptoms, there are two possibilities: euthyroid sick syndrome or Wilsons temperature syndrome.

- If the TSH is high, one has to go through the flow chart on the right, in which most patients are hypothyroid.
- If the TSH is low, one has to read through the flow chart on the left, in which most patients are hyperthyroid.
- As the chart indicates, non thyroidal illnesses can severely alter thyroid blood tests.

CONDITIONS

□ **Hypopituitarism:** Hypopituitarism (pituitary insufficiency) is defined as failure of the gland to make one or more of the following anterior pituitary hormones: growth hormones (GH), prolactin (PRL), adrenocorticotropin (ACTH), thyrotropin (TSH), leuteinizing hormone (LH), or follicle stimulating hormone (FSH).

□ **Cushing's Syndrome and Disease:** Cushing's syndrome can be seen to exist as a continuum. Cortisol is normally released in response to any stress, such as physical, psychological, infection or trauma stress. Since cortisol levels are usually not reduced until the stressor is removed, many people are suffering from a chronic form of low level Cushing's syndrome that we can call hypercortisolism. Cushing's disease implies a pituitary origin, typically due to excess ACTH release from a pituitary adenoma.

□ **Pituitary Tumors:** Pituitary tumors that produce hormones are called functioning tumors. Tumors that don't produce hormones are known as nonfunctioning pituitary tumors. The signs and symptoms of a functioning pituitary tumor result from excessive or insufficient hormone production, or from pressure of the tumor on surrounding tissues.

□ **Hyperprolactinemia:** Hyperprolactinemia is a common disorder characterized by excess PRL production by the anterior pituitary. Functional hyperprolactinemia is often undiagnosed because serum PRL levels often appear within normal laboratory range. In addition, pituitary microadenomas may escape detection by standard imaging techniques.

Associated Syndromes and Etiologies

Pituitary tumors are common. In autopsy studies of patients who did not have known pituitary disease, as many as 26% had a small tumor (adenoma) in the gland.

The DNA mutations that cause tumors in people with multiple endocrine neoplasia type I (MEN1) have been identified. This condition is responsible for nearly all pituitary tumors that run in families, but only about 3% of all pituitary tumors. A mutation of the MEN1 gene has recently been identified as being responsible for a protein called menin. Although patients affected by the MEN1 syndrome can develop tumors of some glands as early as their teenage years, the pituitary tumors usually occur in adults.

HYPOPITUITARISM

Signs and Symptoms

Hypopituitarism is often progressive. Although the signs and symptoms can occur suddenly, usually they tend to develop gradually. They're sometimes vague and subtle, and may be overlooked for many months or even years.

Signs and symptoms of hypopituitarism also vary, depending on which pituitary hormones are deficient.

□ Fatigue
□ Decline in energy
□ Muscle weakness
□ Nausea
□ Constipation
□ Weight loss or gain
□ Decline in appetite
□ Abdominal discomfort
□ Sensitivity to cold or difficulty staying warm
□ Visual disturbances
□ Loss of underarm and pubic hair
□ Joint stiffness
□ Hoarseness
□ Facial puffiness

- ❏ Thirst and excess urination
- ❏ Low blood pressure
- ❏ Headaches
- ❏ Loss of interest in sexual activity
- ❏ Erectile dysfunction
- ❏ Decrease in facial or body hair

- ❏ Irregular or stopped menstrual periods
- ❏ Infertility
- ❏ Inability to produce milk for breast-feeding
- ❏ Children: stunted growth, short stature, and slowed sexual development

Medical History

The cause of hypopituitarism can also be other diseases and events that damage the pituitary.

- ❏ Head injuries
- ❏ Brain tumor
- ❏ Brain surgery
- ❏ Radiation treatment
- ❏ Autoimmune inflammation (hypophysitis)
- ❏ Stroke
- ❏ Infections of the brain, such as meningitis

- ❏ Tuberculosis
- ❏ Sarcoidosis (inflammatory disease occurring in various organs)
- ❏ Histiocytosis X (abnormal cells cause scarring in numerous parts of the body, such as the lungs and bones)
- ❏ Diseases of the hypothalamus, located just above the pituitary, also can cause hypopituitarism. The hypothalamus produces hormones of its own that directly affect the activity of the pituitary.

Therapeutics

Pituitary Insufficiency Hormones, Botanicals, and Nutraceuticals

The long-term medical management of pituitary insufficiency would include some of the following prescriptions.

Deficiency	Replacement Regimen
Adrenal Insufficiency	Hydrocortisone: 20 mg AM, 10 mg PM DHEA: 100 mg *Glycerrhiza glabra* (licorice): solid extract 1/8-1 tsp b.i.d. *Smilax officinalis* (*sarsparilla*): solid extract 1 tsp q.d.
Hypothyroidism	Levothyroxine: 100-125 mg T4 or T3 5-45 mcg b.i.d. Armour: 1-6 grains q.d.
Hypogonadism, men	Depo-testosterone: 300 mg intramuscularly every 3 wks or Testosterone patch: 6 mg q.d. Full spectrum light, daylight sunlight GNRH
Hypogonadism, women	Conjugated estrogens: 0.625-1.25 mg on days 1-25 of each month or Estradiol patch: 0.05-0.1 twice weekly Full spectrum light, daylight sunlight GNRH Medroxyprogesterone acetate: 5-10 mg on days 13-25 of each month
Diabetes insipidus	Desmopressin: 0.1 ml intranasally 1-2 q.d.
Growth Hormone Insufficiency	GH injections, Regular exercise, Arginine: 3-20 g q.d., Ornithine: 3-20 g q.d. Zinc 15-100 mg q.d., High protein diet Deep sleep: Melatonin 3 mg at bed GABA: 500 mg 2-3 times per day

Laboratory Tests

❑ Assessment of anterior pituitary hormone
❑ Radiographic imaging by computed tomography or magnetic resonance imaging to assess anatomy
❑ Formal visual fields
❑ Serum levels of testosterone for men and estradiol for women, LH, FSH, T4, TSH, prolactin, GH (for children), and cortisol. The cortisol test is usually done before and after an ACTH administration test
❑ Symptoms of nocturia and polyuria may warrant a test for ADH adequacy. Secretion of ADH can be analyzed using a water deprivation test

Prognosis

If the pituitary insufficiency is functional treatment to support and nourish the gland may restult in complete reversal. If, however, hormone deficiencies persist after naturopathic treatment, then one or more hormone replacement medications is indicated. These treatments are considered as "replacement", as the dosages are set to match the amounts that the body would normally manufacture ("physiologic dose"). This type of hormone treatment is usually lifelong.

PITUITARY TUMORS

Signs and Symptoms

Since the pituitary gland controls the production of hormones throughout the body, pituitary disorders have a broad range of symptoms. Symptoms depend on the type and location of the tumor and whether the tumor causes hormone excess, hormone deficiency, or pressure on the brain and central nervous system. Thus, one type of pituitary tumor may produce symptoms that are very different from those produced by another type of growth. In addition, some tumors may begin by causing the release of excess hormone and then later result in a hormonal deficiency as normal pituitary cells are suppressed, thereby confounding a proper diagnosis.

Common symptoms of all pituitary tumors as listed below, followed by typical symptoms for the various types of tumors.

All Pituitary Tumors
❑ Headache
❑ Decreased libido
❑ Menstrual disorders
❑ Cold intolerance
❑ Excessive perspiration
❑ Decreased appetite
❑ Vision impairment, blurriness, blindness (particularly poor peripheral vision)
❑ Excessive thirst and frequent urination
❑ Growth failure
❑ Delayed or premature puberty
❑ Nausea
❑ Dry skin
❑ Constipation
❑ Fatigue
❑ Low or high blood pressure
❑ Hypernatremia (high sodium in the blood)
❑ Frequent urination (diabetes insipidus)

Prolactinoma
❑ Infertility
❑ Amenorrhea
❑ Oligomenorrhea (irregular/sparse menstruation)
❑ Decreased libido
❑ Galactorrhea (breast milk production/leakage/nipple discharge)
❑ Osteoporosis, bone fractures, breakage
❑ Impotence vaginal dryness (painful intercourse)
❑ Visual loss

Growth Hormone-secreting Adenoma
❑ Sleep apnea
❑ Hand, foot, face, or tongue growth or enlargement
❑ Swelling (soft tissue enlargement)
❑ Coarsening of facial features
❑ Change in ring or shoe size
❑ Spreading teeth, bite difficulties (overbite/underbite)
❑ Bell's palsy (facial paralysis on one side)
❑ Carpal tunnel syndrome
❑ Joint and bone aches, pains, and tenderness (including foot and tooth pain)
❑ Gigantism
❑ Excessive perspiration
❑ Oily skin
❑ Impotence

Cushing's Disease (ACTH-secreting adenoma)

- ❑ Fat build-up in the face (round or moon face), back (characteristically the upper back causing a so-called hump), and chest, while the arms and legs to become relatively thin
- ❑ Hyperglycemia/diabetes
- ❑ Weak and fragile muscles and bones
- ❑ Backache
- ❑ Flushed face
- ❑ Thin skin
- ❑ Increased bruising or bruisability
- ❑ Skin ulcers
- ❑ Hypertension
- ❑ Weight gain
- ❑ Skin striae (lines/wrinkles/stretch marks)
- ❑ Decreased fertility in men
- ❑ Mood swings
- ❑ Excess hair growth
- ❑ Osteoporosis rib and vertebral compression fractures

(TSH) Thyrotropin-secreting Adenomas

- ❑ Weight loss
- ❑ Increased appetite
- ❑ Heart palpitations or irregular heartbeat (superventricular tachycardia, atrial fibrillation)
- ❑ Tachycardia
- ❑ Heat intolerance and increased sweating
- ❑ Tremor
- ❑ Frequent bowel movements
- ❑ Fatigue and muscle weakness
- ❑ Exertional intolerance and shortness of breath
- ❑ Oligomenorrhea (decreased menstrual flow)
- ❑ Nervousness and irritability
- ❑ Other mental disturbances
- ❑ Sleep disturbances (including insomnia)
- ❑ Changes in vision, photophobia, eye irritation, diplopia, or exophthalmos
- ❑ Lower extremity edema
- ❑ Sudden paralysis
- ❑ Impaired fertility

Medical History

- ❑ While making a diagnosis, the physician needs to find out if family members have had pituitary gland tumors, hyperparathyroidism (overactive parathyroid gland), multiple kidney stones, multiple stomach ulcers, hypoglycemia (low blood sugar), or adrenal gland tumors.
- ❑ Molecular biology studies have shown that a change in the DNA of pituitary cells can cause unregulated growth of a particular cell type, resulting in a pituitary tumor.
- ❑ Multiple Endocrine Neoplasia, Type I, an uncommon type of pituitary tumor, is inherited. There is usually a family history of endocrine tumors, most commonly a parathyroid tumor, a pituitary tumor, and, less commonly, a tumor of the pancreas. This occurs in less than 4% of patients with a pituitary tumor.

Laboratory Tests

A variety of approaches are necessary to diagnose pituitary dysfunction. Even so, there are limitations because the hormones being tested for are present in very small quantities, they are often released cyclically, based on circadian rhythms, they are pulsatile, and many factors can interfere with their release patterns, such as exercise, stress, and fluctuating levels of serum binding proteins.

Hormone Tests

- ❑ Serum hormone testing can be done on the end organ or on the anterior pituitary hormones directly.
- ❑ End organ tests may include thyroid hormones (fT4, fT3, and rT3), adrenal hormones (cortisol, DHEA), sex hormones – estrogens (E1,E2,E3), progesterone, and testosterone.
- ❑ Anterior pituitary hormone tests include TSH, ACTH, FSH, LH, GH, PRL, and ADH.

Suppression Tests

The suppression test is used when a pituitary hormone is thought to be in excess. The principle of a suppression test takes advantage of normal negative feedback control of hormone secretions. A normal response to an exogenously administered drug or hormone is to suppress the gland's secretion. For example, dexamethasone normally suppresses ACTH production by the pituitary. Failure of the gland to respond or suppress constitutes an abnormal response. Another example of a pituitary suppression test is to give oral glucose and to observe serum GH response. A normal response is to suppress growth hormone after glucose ingestion. Suppression tests are available for most of the pituitary hormones, but should only be performed under certain circumstances. Suppression tests are particularly useful to detect hormone-producing tumors that are not responding to feedback control.

Stimulation Tests

A stimulation test is usually performed when a deficiency of a pituitary hormone is suspected. Since many pituitary hormones are produced episodically and random sampling in blood may give a low value in between normal episodic release, a stimulation test is required to test the ability of the pituitary to release a specific hormone. An example of a pituitary stimulation test is the use of arginine to release GH in patients with suspected growth hormone deficiency.

A rise in blood growth hormone is an expected normal response to arginine infusion; failure to respond is abnormal and proves the inability of the pituitary to release this hormone normally.

Imaging Studies

A computerized tomography (CT) or magnetic resonance imaging (MRI) scan of the brain can often detect a pituitary tumor. In children, an X-ray of the hand and wrist can measure whether bone growth is normal.

Therapeutics

In general, dopamine agonists need to be taken for life, and about 20% of patients might completely resolve after 5 years. With the use of dopamine agonists, prolactin levels will decrease and women can get pregnant. The use of the naturopathic treatments listed for hyperprolactinemia can be used as primary treatments for prolactinomas. If prolactin levels do not go down, bromocriptine should be considered.

Prognosis

Most studies indicate that prolactinomas rarely progress. Less than 5% of prolactinomas enlarge. Some patients do have spontaneous remission.

CUSHING'S SYNDROME AND DISEASE

For the diagnosis, treatment, and prognosis of Cushing's syndrome and disease, see the discussion of these disorders in the Adrenal Protocols section.

HYPERPROLACTINEMIA

Signs and Symptoms

❑ Anxiety, depression, irritability
❑ Weight gain
❑ In women, since excess PRL causes an increase in the estrogen/progesterone ratio, menstrual cycle irregularities, amenorrhea, anovulation, infertility, and ovarian cysts (PCOS) are possible. Hyperandrogenism and insulin resistance are also symptoms of elevated progesterone/estrogen ratio.

Medical History

❑ A history of acute or chronic stress (physical or psychological) is common, as stress increases pituitary PRL release.
❑ Sexual activity, pregnancy, high levels of exercise, and sleep also increase PRL.
❑ Certain medications, such as tricyclic antidepressants, methyldopa, phenothiazines, opiates, MAO inhibitors, reserpine, metoclopramide, and haloperidol, increase PRL release.
❑ Cortisol, thyroid hormones, progesterone, L-Dopa, PGE1, GABA, and the medication bromocriptine all inhibit PRL release.
❑ Primary hypothyroidism must be ruled out.
❑ Headaches and visual disturbances.
❑ Galactorrhea may indicate the presence of a prolactinoma.

Laboratory Tests

- ❑ Serum prolactin, elevated estrogen/progesterone ratio in women
- ❑ Absence of ovulatory thermal shift on a BBT chart
- ❑ FSH and LH may be suppressed

- ❑ Visual-field testing
- ❑ CT or MRI is used to identify tumors or microadenomas

Therapeutics

Hyperprolactinemia Botanicals and Nutraceuticals

Herb/Nutrient	Indication/Action	Dose
Vitamin B-6 (Pyridoxal-5-Phosphate)	Cofactor in dopamine synthesis, which is a key inhibitor or PRL	100-200 mg per day
Magnesium	Cofactor in B6 and dopamine metabolism	500 mg per day
Vitex agnus castus (Chaste Berry)	Well-studied progesterogenic effects and inhibitor of PRL secretion	180-240 mg per day of standardized extract
GLA	Stimulates PG1, which supports dopaminergic activity	200-300 mg per day
Indole-3-Carbinole (I3C)	Assists the liver in metabolizing estrogens	300 mg per day
Lipotrophic Factors	Inositol, choline, and methionine combination helps detox steroid hormones	500 mg t.i.d. with meals
GABA	Neurotransmitter found to decrease PRL secretion and counter stress	500 mg t.i.d.
Bio-identical Progesterone Cream	Corrects imbalance of estrogen/progesterone ratio	0.25-0.5 tsp transdermal cream beginning after ovulation until period begins (day 15 to day 28)

Prognosis

In idiopathic hyperprolactinemia, progression to pituitary prolactinoma seldom, if ever, occurs. When followed for longer than 7 years, 90% to 95% of microadenomas remained stable or gradually decrease prolactin secretion. One third of patients with idiopathic hyperprolactinemia may experience resolution without treatment, and we believe this number increases substantially with naturopathic approaches. Surgery often is not curative for macroprolactinomas, with a recurrence rate of as high as 40% within 5 years. Recurrence rates of hyperprolactinemia are as high as 80%, and, subsequently,

PINEAL DISORDERS

CONDITIONS

❑ **Melatonin Deficiency:** Functional deficiency of melatonin production by the pineal gland
❑ **Melatonin Excess:** Excess production of melatonin by the pineal gland

Associated Syndromes and Etiologies
Melatonin deficiency is associated with insomnia. Melatonin excess is associated with seasonal affective disorder (SAD).

MELATONIN DEFICIENCY

Signs and Symptoms

❑ Insomnia
❑ Anxiety
❑ Elevated estrogen/progesterone ratio
❑ Immune suppression
❑ Lowered basal body temperature

Medical History

❑ Evaluate history for family history of insomnia, circadian rhythm patterns, light and electromagnetic radiation exposure, stress, and head trauma.

Laboratory Tests

❑ Saliva and plasma tests are useful to detect melatonin levels. Note that the half-life of melatonin is 20-50 minutes.

Therapeutics

Lifestyle
❑ Minimize exposure to artificial light (or any type of electromagnetic radiation) after sundown.
❑ Promote a regular circadian rhythm with daytime exercise and light exposure.
❑ Meditate or practice other types of stress reduction techniques.
❑ Maintain regular habits for sleep/waking/eating, etc.

Clinical Nutrition
❑ Avoid simple carbohydrates and other high glycemic foods.
❑ Avoid caffeine and other stimulants.
❑ Avoid alcohol.
❑ Avoid cherries and cherry juice, which have been shown to increase melatonin
❑ Eat adequate protein. High tryptophan foods (turkey, chicken, soy, whole grains) support melatonin synthesis.

Melatonin Nutraceuticals

Herb/Nutrient	Indication/Action	Dose
Vitamin B-6 (Pyridoxal-5-Phosphate)	Cofactor in melatonin synthesis from L-tryptophan	100-200 mg q.d.
L-Tryptophan	Precursor amino acid to serotonin and melatonin	500 mg 1-3 q.d.
5-Hydroxy-Tryptophan (5HTP)	Intermediate in the tryptophan to serotonin/melatonin pathway	50-600 mg q.d. in divided doses
Melatonin	Bio-identical hormone replacement	1-3 mg q.d. at bedtime

MELATONIN EXCESS

Signs and Symptoms

❑ Seasonal affective disorder (SAD)
❑ Lowered estrogen/progesterone ratio

❑ Low thyroid and adrenal function
❑ Hypotension

Medical History

❑ Medical history should be evaluated for light and electromagnetic radiation exposure.

❑ Family history of depression, anxiety, bipolar, and symptoms of SAD.

Laboratory Tests

❑ Saliva and plasma tests are useful to detect melatonin levels. Note that the half-life of melatonin is 20-50 minutes.

Therapeutics

Lifestyle
❑ Aim for regular daytime exposure to light (10,000 lux/20 minutes per day in the morning).
❑ Promote normal circadian rhythms by following natural day/night light patterns.
❑ Avoid night shift work.
❑ Manage stress.
❑ Exercise daily, preferably in sunlight.
❑ Place office/workspace near large windows to maximize natural light exposure.

Clinical Nutrition
❑ Avoid simple carbohydrates and other high glycemic foods.
❑ Avoid caffeine and other stimulants.
❑ Avoid alcohol.
❑ Maintain blood sugar balance by having protein with meals.
❑ Take essential fatty acids (omega 3 from fish and flax oil).

Prognosis

Most patients with excess melatonin /seasonal affective disorder respond well to naturopathic approaches. Melatonin deficiency can improve with general naturopathic recommendations, or melatonin can be taken orally for some time until normal pineal function can be enhanced.

CONDITIONS

❏ **Type I Diabetes Mellitus:** DMI usually begins in childhood and is due to insufficient insulin production by the pancreas. The cause is viral or autoimmune disease. Insulin allows glucose to travel from the blood into the cells, where it can be metabolized. When there isn't enough insulin, blood glucose levels become elevated.

❏ **Type II Diabetes Mellitus:** DMII usually begins in adulthood and is often due to insulin resistance or improper response of insulin receptors to the insulin produced by the pancreas.

❏ **Hypoglycemia:** The symptoms of hypoglycemia come on when blood sugar levels drop too low. Symptoms go away after eating, when blood sugar levels return to normal. The diagnosis of hypoglycemia is usually based on symptoms because blood sugar levels are only low at the time patients are experiencing symptoms.

❏ **Hyperinsulinemia:** This condition is often a precursor to Type II Diabetes. Patients can develop elevated insulin levels before they develop elevated blood glucose levels. The pancreas makes and secretes excessive amounts of insulin, presumably in an effort to compensate for insulin resistance.

❏ **Syndrome X:** This syndrome refers to a metabolic syndrome of hyperinsulinemia that is associated with high blood pressure, high triglyceride levels, and low HDL levels. Predisposing factors include a family history of Type II diabetes, a diet high in carbohydrates, and a sedentary lifestyle. Truncal obesity, fatty liver, difficulty losing weight, and hypoglycemia often accompany this condition.

Diabetic Complications
❏ Diabetic Retinopathy
❏ Diabetic Neuropathy
❏ Diabetic Nephropathy
❏ Cardiovascular Disease

Associated Syndromes and Etiologies
❏ **Polycystic Ovarian Syndrome (PCOS):** This condition can lead to amenorrhea, infertility, and hirsutism in females. It is also associated with hyperinsulinemia. PCOS can be treated as a condition of insulin resistance.

❏ **Stress:** Stress has been established as an independent risk factor for Type II diabetes. Physiologically, stress causes cortisol levels to rise, which leads to increased blood glucose, hyperinsulinemia, and, over time, truncal obesity.

❏ **Adrenal Resistance:** Increased cortisol also decreases the conversion of T4 to T3, leading to decreased metabolism, resulting in increased obesity.

❏ **Hypothyroidism and Wilsons Temperature Syndrome:** These thyroid conditions lead to decreased metabolism that can cause obesity.

Signs and Symptoms

DM Type I
❏ Typical symptoms include polyuria, polydipsia, weight loss despite a normal or increased dietary intake, fatigue, and opportunistic infections, such as mycotic infections.
❏ Diabetic ketoacidosis may develop if DM type I is left untreated. Nausea, vomiting, abdominal pain, dehydration, hypotension, and even coma can result.
❏ Diabetes Type I increases risk of cardiovascular disease, neuropathy, nephropathy, cataracts, and retinal disease.

DM Type II
❏ Typically, this condition comes on insidiously over several years. Symptoms can be similar to Type I, but without the propensity to ketoacidosis.
❏ Patients are usually over 30, overweight or obese, and may have a history of hypertension and dyslipidemias.

❑ Long-term complications are similar as those mentioned for Type I, although in this case, complications, such as neuropathy, mycotic infections, or eye disease, may be the first clue to a disease state.

Hypoglycemia
❑ Tired all the time
❑ Hungry between meals or at night
❑ Depressed
❑ Insomnia, awakening with inability to return to sleep
❑ Wake up after a few hours sleep
❑ Fearful (overwhelmed by people, places, or things)
❑ Can't decide easily
❑ Can't concentrate
❑ Poor memory
❑ Worry frequently
❑ Highly emotional
❑ Moody
❑ Cry easily, or feel like crying inside
❑ Fits of anger
❑ Magnify insignificant details (mountains out of molehills)
❑ Eat candy, cake, or drink soda pop
❑ Eat bread, pasta, potatoes, rice, or beans
❑ Consume alcohol
❑ Drink more than three cups of coffee or cola drinks daily
❑ Crave candy, soda, or coffee between meals or mid-afternoon
❑ Can't work well under pressure
❑ Headaches
❑ Sleepy during the day
❑ Sleepy or drowsy after meals
❑ Lack of energy
❑ Can't get started in the morn
❑ Stomach cramps or 'nervous stomach'
❑ Allergies: asthma, hay fever, skin rash, sinous trouble, etc.
❑ Fatigue relieved by eating

❑ Suicidal thought or tendencies; feeling of hopelessness
❑ Bored
❑ Bad dreams
❑ Irritable before meals
❑ Heart beats fast (palpitations)
❑ Get shaky inside when hungry
❑ Feel faint if meal is delayed
❑ Ulcers, gastritis, chronic indigestion, abdominal bloating
❑ Cold hands or feet
❑ Blurred vision
❑ Bleeding gums
❑ Dizziness, giddiness, or lightheadedness
❑ Aware of breathing heavily
❑ Bruise easily
❑ Reduced sex drive
❑ Poor coordination (drop or bump into things)
❑ Sweating excessively
❑ Unsocial or antisocial behavior
❑ Muscle twitching or cramps
❑ Skin aches or itches
❑ Phobias (excessive fear or some thing or situation)
❑ Hallucinations
❑ Convulsions
❑ Trembling (shaking) hands

Syndrome X Symptoms
❑ Syndrome X is a pre-diabetic condition resulting from insulin resistance without necessarily elevated blood glucose levels.
❑ Truncal obesity resistant to calorie restriction, elevated triglycerides, and low HDL cholesterol are common findings.
❑ Fatigue (especially after meals with a high glycemic index or load), skin tags, Dupuytren's contracture, Peyronie's disease, osteoarthritis, hypoglycemia, and sugar cravings.

Medical History

❑ Family history of Type II diabetes
❑ Combined with a diet high in refined carbohydrates, deficient in dietary fiber, and a lack of physical exercise.

Physical Examination

❑ Truncal obesity, hypertension, skin tags, cataracts, opportunistic infections.

Laboratory Tests for Diabetes/Syndrome X

❑ Fasting plasma glucose is the typical diagnostic test for diabetes mellitus.

❑ Oral glucose insulin tolerance test (GITT) is indicated if hyperinsulinemia is suspected.

❑ Hemoglobin A1c is a useful measure of average blood glucose over a 2- to 3-month time span.

❑ Serum lipids (triglycerides, LDL, HDL, total cholesterol), lipoprotein A, and homocysteine are useful to assess cardiovascular risk.

❑ Cortisol and DHEA to assess adrenal function as increased cortisol and decreased DHEA are typical in insulin resistance.

Therapeutics

DM Type I

Niacinamide: High does of niacinamide (25 mg/kg) have suppressed autoimmune disease in recently diagnosed DM Type I. Cases of complete remission with this protocol have occurred. This protocol may cause remission of DM Type I if done within 6 months of the diagnosis. If no effect has been shown within 8 weeks, chance of cure is low. Patients should consider neuropeptide injections, a low glycemic diet, and herbs after the 6-month mark or after trying this protocol without success.

Gymnema sylvestre: 2 grams daily helps stimulate insulin production. No cases of complete remission with this approach; however, it significantly balances blood sugar levels.

Pterocarpus marsupium: 2 grams daily helps stimulate insulin production. Clinical research indicates significantly reduced need for exogenous insulin. No cases of complete remission with this approach reported; however, it significantly balances blood sugar levels.

Camal tamala: 2 grams daily helps stimulate insulin production. No cases of complete remission with this approach; however, it significantly balances blood sugar levels.

Low Glycemic Diet

The glycemic index is a numerical system that evaluates the speed in which a certain food can increase blood sugar. Foods that are high in glycemic index tend to increase blood sugar and insulin levels quickly. Foods over 50 for a diabetic should be avoided at all times, except for the occasional cheating. Patients who follow this diet, and exercise aerobically for one hour a day, will be able to have very tight blood sugar control.

Glycemic index does not necessarily correlate with the amount of carbohydrate levels. For example, orange juice has a higher glycemic index than apple juice, but apple juice has higher carbohydrate levels. Thus, a diabetic should consider glycemic index and carbohydrate levels. Foods that are high in carbohydrates, like flours, grains, tubers, and fruits, should be very limited.

Good diet and exercise alone can often work wonders in bringing down blood sugar levels. Many people say they have tried "dieting" after going to dietitians, but many diets prescribed by dietitians are often too lenient to help adequately. A very strict diet, such as the Syndrome X diet by Gerald Reaven, which excludes anything with a glycemic index greater than 50 and balances good carbohydrates with essential fats and adequate protein, is best. If patients want to eat anything with a glycemic index of over 50, they should combine it with protein and do at least a half-hour of exercise that day. A strict diet gets great results by itself, but is very difficult for many patients to maintain.

Restrictions and Allowances

The low glycemic diet typically restricts the following items:

❖ Artificial sweeteners (may raise insulin levels)
❖ Most processed grain products (breads, pasta, cornbread, tortillas, crackers, popcorn)
❖ Simple sugars/carbohydrates (sucrose, fructose, sweets, cookies, candy, ice cream, pastries, honey, fruit juice, soda pop, alcoholic beverages, etc.)
❖ Refined grains/carbohydrates (white flour products, white pasta, white rice, etc.)

And allows the following:

❖ Whole grains (brown rice, wheat, rye, barley and buckwheat)
❖ Legumes (beans, peas, peanuts, soybeans, soy products, etc.)
❖ Nuts, seeds, and nut butters
❖ Fruits are allowed but higher glycemic fruits are better if eaten with protein meals or snacks and not alone. Berries are best. No dried fruit or fruit juices.
❖ Lots and lots of non-starchy vegetables. These should be the main source of carbohydrates in the diet.
❖ Fish and chicken

Hydrogen Peroxide: IV.2cc H202 (30% solution) in 250 D5W, three times a week to kill microbial causes of diabetes type I. Needs to be done immediately after onset. Cases of complete remission with this protocol reported.

IV Antiviral Protocol (Dioxychlor and Sulfoxamine) (from Bradford Research Institute): Three times a week to kill microbial causes of diabetes type I. Clinically proven in large clinical trials for reducing viral load after 12 treatments.

Neuroeptide Injections: 1 cc every 3 weeks. Used in autoimmune disease very successfully. Animal studies indicate complete remission of DM Type I. Human studies used successfully in reversing other autoimmune diseases, such as rheumatoid arthritis.

Avoidance of Dairy Products: Antibodies to cow milk are speculated as a possible etiology for some individuals.

Recommended Vegetables

Highly Recommended Vegetables Eat as many of these as possible for the best health			Vegetables to Use in Moderation	Vegetables to Avoid
Artichoke	Collard greens	Peppers (all kinds)	Beets	Potatoes
Asparagus	Cucumber	Purslane	Carrots	Parsnip
Avocado	Dandelion greens	Plantain	Green beans	Pumpkin
Beet greens	Endive	Radish	Eggplant	Rutabaga
Bok Choy	Escarole	Seaweed	Jicima	Sweet potatoes
Broccoli	Fennel	Spinach	Peas (actually a	Corn (actually a grain)
Brussel sprouts	Garlic	Swiss chard	legume)	
Cabbage (green	Kale	Tomatillos	Squashes	
and red)	Kohlrabi	Tomatoes	New potatoes	
Cauliflower	Lettuce (avoid iceberg)	Turnips greens	Taro	
Celery	Mushrooms	Turnips	Yams	
Chicory	Mustard greens	Watercress		
Chinese cabbage	Onions	Zucchini		
Chives	Parsley			

Glycemic Index of Common Foods

Grain Products

Baguette	95	Pumpernickel bread	50	Carrots	49	Romano beans	46
Wheat bread, gluten free	90	Oat bran bread	48	Carrot juice	45	Pinto beans, *canned*	45
White bread	78	Mixed grain bread	48	Carrots, cooked	39	Garbanzo beans, *canned*	42
Waffles	76	Cake, banana, w/ sugar	47			Black-eyed peas	41
Donuts, plain	76	Sponge cake	46	**Fresh Vegetables**		Pinto beans	39
Bread stuffing	74			Pumpkin	75	Navy beans	38
Kaiser rolls	73	**Root Vegetables**		Sweet corn	55	Garbanzo beans	33
Bagel, white	72	Parsnips	97	Peas, green	48	Split peas	32
Melba toast	70	Potato, baked	85	Peas, dried	22	Lima beans	32
Tortilla, corn	70	Potato, instant	83	Green vegetables, all	30	Butter beans	31
Whole wheat bread	69	Potato, French fries	75			Kidney beans	29
Most cakes and pastries	65	Potato, boiled	73	**Legumes**		Lentils	29
Rye flour bread	64	Potato mashed	70	Broad beans	79	Soybeans	18
Hamburger bun	61	Rutabaga	72	Butter beans	54		
Cheese pizza	60	Beets	64	Lentils, *canned*	52	**Breakfast Cereals**	
Pita bread	57	Sweet potato	54	Kidney beans,	52	Puffed Rice	90
		Yam	51	Baked beans, *canned*	48	Rice Chex	89

Food	GI	Food	GI	Food	GI	Food	GI
Corn Chex	83	Agave nectar	10	Sausages	28	Vermicelli	35
Rice Krispies	82	Artificial sweeteners	>5	Nopales, prickly pear cactus	7	Fettuccini	32
Post Flakes	80	Stevia Liquid Extract	0			Spaghetti, protein enriched	27
Coco Pops	77						
Total	76	**Fruits**		**Cookies and Crackers**		**Dairy**	
Cheerios	74	Watermelon	72	Puffed crispbread	81	Yogurt, sweetened	63
Puffed Wheat	74	Pineapple	66	Morning coffee cookies	79	Ice Cream	61
Golden Grahams	71	Cantaloupe	65	Rice cakes	77	Ice Cream, low fat	50
Cream of Wheat	70	Raisins	64	Vanilla wafers	77	Chocolate milk w/sugar	34
Shredded Wheat	69	Apricots, canned	64	Graham crackers	74	Skim milk	32
Sustain	68	Apricots	57	Wheat Thins	67	Whole milk	27
Grape Nuts	67	Mangos	56	Rye crispbread	65	Chocolate milk, artificial sweetener	24
Nutri-Grain	66	Fruit cocktail, canned	55	Shortbread	64	Yogurt, artificial sweetener	14
Life	66	Bananas	54	Chocolate chip cookies	64		
Oatmeal, quick	61	Orange juice	52	Oatmeal cookies, w/o raisins	55	**Snack Foods**	
Kellogg's Just Right	59	Grapefruit juice	48			Dates	103
Bran Chex	58	Peaches, canned	47	**Beverages**		Pretzels	81
Kellogg's Mini-Wheats		Pineapple juice	46	Gatorade	95	Jelly beans	80
Muesli	56	Grapes	46	Soft drinks	68	Corn chips	74
Kellogg's Honey Smacks	55	Oranges	44	Diet soda, with caffeine	30	Life Savers	70
Oat Bran	55	Pears, canned	44	Soy milk	30	Skittles	69
Special K	54	Peaches	42	Diet soda, without caffeine	0	Mars bar	64
Bran Buds	53	Apple juice	41			Muesli bars	61
Oatmeal, regular	49	Plums	39	**Pasta**		Popcorn	55
All-Bran	42	Apples	38	Rice pasta, brown	92	Potato chips	55
Kellogg's Guardian	41	Pears	37	Gnocchi	67	Most jams and jellies	50
All Bran Fruit & Oats	39	Strawberries	32	Macaroni & Cheese	64	Chocolate bars	49
		Apricots, dried	31	Spaghetti, durum	55	Twix cookie bars	43
Sugars		Grapefruit	25	Instant noodles	47	Snickers bar	40
Maltose	105	Cherries	22	Linguini	46	Peanut M&M's	32
Maltodextrin	105			Macaroni	45	Peanuts	15
Glucose	100	**Specialty Foods**		Spaghetti, white	41		
Sucrose	64	Tofu frozen dessert	105	Ravioli, durum, meat filled	39		
High fructose corn syrup	62	Cactus jam	91	Spaghetti, whole meal	37		
Honey	58	Breadfruit	68				
Lactose	46	Taro	54				
Fructose	21	Fish fingers	38				

DM Type II

Diabetes Type II is usually due to insulin resistance, and thus the peripheral metabolism of insulin needs to be the primary focus of treatment. Secondarily, since there may be some inability of the pancreas to produce enough insulin, pancreatic tonics are also of value. Blood sugar is also controlled to a certain extent by the liver and adrenal glands. Therefore, the treatment needs to take into account each aspect of blood sugar metabolism in the individual patient.

Because obesity contributes to Type II diabetes, diet and lifestyle factors must be modified as well. Stress, which tends to contribute to or worsen most conditions, also plays a role here and must be addressed. In our experience, if patients take the necessary natural medicines, make lifestyle changes, and manage their stress effectively, most patients will be able to wean themselves off of prescription drugs completely.

DM Type II Botanicals and Nutraceuticals

Herb/Nutrient	Action	Dose
Oplopanax horridus (Devil's Club)	Helps with insulin resistance; also an adrenal tonic	1 g q.d.
Gymnema sylvestre (Gymnema, Gur-Mar)	Helps stabilize blood sugar	1 q.d.
Taraxacum officinalis (Dandelion root)	Contains inulin	1 g q.d.
Silybum marianum (Milk thistle)	Liver tonic increases Hepatic Insulin Sensitizing Substance; useful for insulin resistance	500 mg q.d.
Chromium Picolinate	Helps with insulin efficacy	600-5,000 mcg q.d., to the level that controls sugar cravings
Vanadium sulfate	Helps with insulin efficacy	600 mcg q.d.
Galega officinalis (Goats Rue)	Contains biguanides found in Glucophage; helps with insulin resistance	2 g q.d.
Nopal Opuntia (Prickly Pear Cactus)	One of the most effective herbs in lowering blood sugar and insulin resistance at high doses only	1 tablespoon of nectar (10 g) b.i.d.
Syzygium jambolana (Jambul Seed)	Aids in decreasing hyperglycemia; also increases glutathione and superoxide dismutase antioxidant levels	1-2 g q.d.

Hypoglycemia Botanicals and Nutraceuticals

Herb/Nutrient	Action	Dose
Oplopanax horridus (Devil's Club)	Adrenal tonic that has demonstrated a specific positive effect in achieving blood sugar balance	1 g q.d.
Astragalus membranaceus (Chinese Milk Vetch)	hypoglycemic	2-6 g q.d.
Glycyrrhiza glabra (Licorice root)	Prolongs the half-life of cortisol, thereby helping maintain consistency of blood glucose levels; antistress and antifatigue properties	1-2 g root t.i.d. or 250-500mg extract t.i.d. Should be used with caution in patients with high blood pressure.
Eleutherococcus senticosus (Siberian Ginseng)	Used in China for fatigue, weakness, depression, forgetfulness, and insomnia; known in the West for its adrenal and liver tonic properties	2-4 g t.i.d. or 100-200 mg of a 1:20 extract (1% eleutherosides)

Hypoglycemia Botanicals and Nutraceuticals continued...

Herb/Nutrient	Action	Dose
Silybum marianum (Milk thistle)	Liver support	70-210 mg silymarin t.i.d.
Dioscorea villosa (Wild Yam)	Used as an antispasmodic in the West; used in Chinese medicine to "brighten the eyes" and as a tonic Contains diosgenin, a precursor for cortisol, a key constituent required for blood sugar balance	500 mg t.i.d.
Chromium picolinate	Facilitates glucose uptake into cells as part of "glucose tolerance factor"	200-5000 mcg q.d.
Pantothenic acid	Helps with adrenal support	1 g q.d.

Additional Hypoglycemic Herbs

Herbal protocols support blood sugar control holistically through support of the pancreas, liver, and adrenal glands, which are the combined organs of blood sugar regulation. These herbs can naturally increase endogenous antioxidants, such as glutathione and superoxide dismutase (SOD). Thus, they can be of great benefit in treating retinopathy, neuropathy, and nephropathy, the common secondary diabetic complications associated with free radical damage.

These herbs are not drugs that lower blood sugar; rather they are aimed at strengthening the related organs so that they function better and regulate blood sugar more effectively. The effects of herbs for DM Type II can usually be seen within 1 to 8 months.

Although these herbs are most helpful for lowering high blood sugar levels, they are also helpful in patients with low blood sugar.

Adaptogenic Botanicals and Nutraceuticals

Name	Indications	Pharmacology	Dose
Allium cepa (Onion)	Hypoglycemic Antibacterial Antifungal	Competes with insulin for insulin degradation; increases half life of insulin	5-30 drops of fluid extract b.i.d.
Momordica charantia (Bitter melon)	Hypoglycemic Antibacterial Antifungal	Contains charantin (steroid) that decreases blood sugar; increases secretion and activity of insulin	5-30 drops of fluid extract b.i.d.
Trigonella foenum graecum (Fenugreek)	Hypoglycemic Digestive stimulant	Stimulates pancreas to produce more insulin	5-30 drops of fluid extract b.i.d.
Syzygium jambolana (Jambul seed)	Hypoglycemic Digestive stimulant Excellent antioxidant Helps with diabetic secondary complications	Prevents conversion of starch and CHO into sugars; increases superoxide dismutase and glutathione levels	5-30 GTT of fluid extract b.i.d.
Pterocarpus marsupium (Kino)	Hypoglycemic	Prevents toxin induced B cell damage on the pancreas; helps regeneration in the pancreas; might be contraindicated in hyperinsulinemia patients	5-30 drops of fluid extract b.i.d.

Additional Hypoglycemic Botanicals and Nutraceuticals

Name	Indications	Pharmacology	Dose
Chromium picolinate	Insulin resistance	Improves insulin efficiency, which lowers blood sugar levels	50-5000 mcg q.d.
Quercitin	Cataracts	Aldose reductase inhibitor, antioxidant; decreases the accumulation of toxic polyols	300 mg-1000 mg q.d.
Vanadium sulfate	Insulin Resistance	Improves insulin efficiency, which lowers blood sugar levels	200-800 mcg q.d.
Vitamin B12	Neuropathy	Decreases diabetic neuropathy	1000 mcg q.d.
Vitamin B6	Neuropathy	Decreases diabetic neuropathy	50-100 mg q.d.
Taurine	Hypoinsulinemia	Aids in the release of insulin	1-3 grams q.d.
L-carnitine	Insulin Resistance	Aids in mobilizing fat	1-3 grams q.d.
Lipoic acid	Insulin Resistance Diabetic Neuropathy	Decreases secondary glycosylation; excellent antioxidant	300 –1,000 mg q.d.
Grape seed extract	Complications due to poor microvascular circulation	Decreases secondary complications; excellent antioxidant	200-800 grams q.d.
Omega Oils (borage, evening primrose oil, flaxseed, fish oils)	Dyslipidemia Neuropathy (EPO)	Help decrease blood sugar	1 tablespoon q.d.
Niacinamide	Protects islet cells of the pancreas	Helps with DM Type I autoimmune process if taken within first 6 months	25 mg per kg

Hyperinsulinemia

Many patients with DM Type II and hyperinsulinemia have low body temperatures and can benefit from WT3 therapy. If the thyroid system appears to need help, WT3 therapy and/or other thyroid support can always be used. The best thing about WT3 therapy is that it doesn't have to be taken for life, unless the patient has Hashimoto's disease. The improvements are often lasting, but WT3 alone won't always normalize insulin levels. Increasing body temperature is indicative of increasing metabolism, which results in increased uptake of glucose of the cells.

Hyperinsulinemia Hormone Supplements

Hormone/ Drug	Indication	Pharmacology
Pregnenolone	Adrenal tonic	Low adrenal function is associated with hypometabolism causing weight gain
DHEA	Adrenal tonic	Low levels associated with dysglycemia
Liothyronine	WTS protocol helps with euthyroid and hypothyroidism	Low thyroid function causes weight gain and decreases insulin receptivity

Caution: Due to the increased cardiovascular risk, caution should be used when administering thyroid hormones.

Diabetic Complications

There are five aspects that need to be considered in therapy for diabetic complications.

1. Hyperglycemia needs to be controlled as well as possible.
2. Free radical production in hyperglycemia needs to be quenched.
3. The polyol pathway in which excess sugar alcohols are produced needs to be inhibited.
4. The organs that are affected, such as the eyes, kidneys, and nerves, need to be supported.
5. Protein glycosylation needs to be inhibited.

Inihibiting Polyol Pathway and Free Radical Formation
Quercitin: 2 g q.d.
Vitamin C: 2 g q.d.
IV Gluatahione: 100 mg q.d.
Grape seed extract: 100 mg q.d.

Inhibiting Protein Glycosylation and Decreasing Polyol Formation
Lipoic Acid: 200-500 mg q.d.
Quercitin: 1-2 g q.d.
Vitamin E: 400-12000 IU q.d.

Secondary Diabetic Complications Botanicals and Nutraceuticals

Herb/Nutrient	Action	Dose
Silybum marianum (Milk Thistle)	Antioxidant Reduces aldose reductase	1 g q.d.
Hypericum perforatum (St. John's Wort)	Aids in neuropathy, both internally and externally	1 g q.d.
Eupatorium purpureum (Gravel Root)	Aids in kidney function	1 g q.d.
Solidago canadensis (Canadian Goldenrod)	Aids in kidney function	1 g q.d.
Vaccinum myrtillus (Bilberry)	Aids in eye function	1 g q.d.
Syzygium jambolana (Jambul Seed)	Antioxidant	1 g q.d.
Inositol	Replenishes inositol depletion from hyperglycemia induced sorbitol osmosis causing inositol excretion	2 g q.d.
Vitamin B-6	Aids in neuropathy	100 mg q.d.
Vitamin B-12	Aids in neuropathy	1000 mcg q.d.
CoQ10	Aids in cardiac function	500 mg q.d.
Cereus grandiflorus (Night Blooming Cactus)	Aids in cardiac function	10 drops b.i.d.
Convallaria officinalis (Lily of the Valley)	Aids in cardiac function	10 drops b.i.d.
Crataegus oxycantha (Hawthorne)	Aids in cardiac function	60 drops b.i.d.
Leonurus cardiaca (Motherwort)	Aids in cardiac function	60 drops b.i.d.
Pelargonium spp. (Geranium Oil)	Topical treatment for neuropathy (pain relief immediate but temporary)	topical
Aminoguanidine	Decreases advanced glycosylation end products	300 mg b.i.d.
Alpha tocopherol nicotinate	Improves blood rheology, decreases lipid peroxidation	300 mg b.i.d.
Ganoderma lucidum (Reishi)	Increases nitric oxide	1 g q.d.
Quercitin	Reduces aldose reductase	1 g q.d.
Anthocyanins	Increases capillary strength	180-215 mg q.d.
Green Tea Catechins	Increases capillary strength	400 mg-1 g q.d.

Prognosis

- Studies have shown that only about 25% of diabetic patients on oral diabetic medicine are able to achieve good (not perfect) control of their blood sugar levels. However, many patients who are treated with naturopathic approaches involving diet, supplements, herbs, and exercise are able to maintain good sugar control while off pharmaceutical medicines for diabetes type II.
- Blood sugar can begin to decrease within 2 weeks, but it may take 6 weeks before some people notice a change. Approximately 88% of people are able to lower their blood sugar levels within 3 months of continued use, based on clinical research of herbal combinations containing jambul and devil's club.
- Patients with excessive insulin can expect about a 30% decrease in 3 months. After 2 months of daily use, most people will notice a decrease in blood sugar.
- As with pharmaceutical hypoglycemic agents, there are always some individuals who do not seem to respond.
- Fasting blood sugar should go down within 8 weeks and HBA1c value within 3 months.

Side Effects: There are no reported adverse side effects from use of diabetic herbs and nutrients.

Drug Interactions: The herbs used in DM Type II are blood sugar balancers, so there is little possibility of blood sugar going too low when pharmaceuticals are used.

Weaning Off Drugs: Once people start noticing a significant decrease in blood sugar, they might consider starting to wean themselves off any prescription drugs they may be taking for their condition. Some people may be able to start weaning after 2 weeks of being on natural medicines, while others may be able to start after 8 weeks. It is not recommended for patients to stop their prescription drugs when their blood sugars are consistently over 150 mg/dL.

Side Benefits: Diabetic herbs such as jambul and devil's club can help eliminate free radicals, which are largely responsible for the secondary complications of diabetes. Secondary complications of diabetes might get better. Vision and kidney function may improve.

LIPIDS METABOLISM DISORDERS

High lipid levels are only one of many factors of cardiovascular disease. Other factors, such as levels of antioxidants, which are necessary in preventing the oxidation of cholesterol to form plaques, might be a more important factor. Low levels of lipids are also detrimental to patients because cholesterol is required for steroid synthesis and membranes of cells.

❑ **Elevated Total Cholesterol over 200 mg/dl**

❑ **Elevated LDL Cholesterol over 150 mg/dl**

❑ **Reduced HDL Cholesterol under 35 mg/dl**

❑ **Elevated Apolipoprotein B (ApoB) over 110 mg/dl**

❑ **Reduced Apolipoprotein A1 (ApoA1) under 140 mg/dl**

❑ **Elevated Triglycerides over 190 mg/dl**

Associated Syndromes and Etiologies

❑ **Low Thyroid, Liver Disease, and Diabetes:** Other considerations in treating dyslipidemia include screening for low thyroid function, liver disease, and diabetes, all of which can contribute to the condition.

❑ **CVD:** The main concern with dyslipidemia is the increased risk of cardiovascular disease. However, other independent risk factors also should be considered in an individual patient, such as blood homocysteine, C-Reactive protein, fibrinogen, RBC magnesium, and CoQ10 levels.

Signs and Symptoms

❑ Typically, asymptomatic unless early onset familial dyslipidemia is present.

Medical History

❑ Family or personal history of diabetes, insulinemia, heart disease, stroke, transient ischemic attacks, intermittent claudication, angina pectoris, pancreatitis, hypertension, dyslipidemia, gallbladder disease, cigarette smoking, overweight or obesity.

Physical Examination

❑ Blood pressure, heart rate and rhythm, exercise stress test, earlobe crease, arcus senilis, or the presence of xanthomas should be investigated.

Laboratory Tests

❑ **Fasting Blood Lipids Test**
A fasting blood lipids test should be taken as baseline and evaluated as follows:
- ❖ Is total cholesterol high considering other risk factors (cardiovascular history, diabetes, etc.)?
- ❖ Is there a high ratio of triglycerides to HDL?
- ❖ Is the HDL:Total Cholesterol ratio adequate for CVD protection?
- ❖ Is LDL high?

- ❖ If triglycerides: HDL ratio is high (typically 4:1 or higher), then metabolic Syndrome X (hyperinsulinemia) should be considered. This patient may have truncal obesity, borderline or normal blood glucose, a history of inactivity, and a high rate of carbohydrate consumption, especially those with high glycemic index. Often there is a family history of DM Type II.

Normal Distribution for Plasma Lipids and Lipoprotein Cholesterol

Age	Cholesterol mg/dl	Triglycerides mg/dl	VLDL mg/dl	LDL mg/dl Male	HDL mg/dl Male	HDL mg/dl Female
0-19	under 180	10-140	5-25	50-170	30-65	30-70
20-29	under 200	10-140	5-25	60-170	35-70	35-75
30-39	under 220	10-150	5-35	70-190	30-65	35-80
40-49	under 240	10-160	5-35	80-190	30-65	40-95
50-59	under 240	10-190	10-40	80-210	30-65	35-85

Therapeutics

Diet and Lifestyle

Lipid Diet

Patients should be placed on a carbohydrate restricted diet, such as suggested by Gerald Reaven (45% fat, 15% to 20% protein, 35% to 40% carbohydrates). Patients who are put on a strict lipid diet can normally expect about a 5% to 20% decrease in cholesterol within a few months.

Restrict Carbohydrates: All simple carbohydrates, starchy vegetables, and, for the more extreme cases, complex carbohydrates should be restricted.

Limit Total Dietary Fat: Total dietary fat has been clearly linked with total serum cholesterol levels.

Decrease Cholesterol: Each 1 mg/1000 Kcal results in approximately a 0.1 mg/dl increase in serum cholesterol.

Limit Hydrogenated Vegetable Oils: Hydrogenated vegetable fat appears to be just as bad as animal fats in epidemiological studies.

Consume Good Fats: Omega 3, 6, 9 versus saturated animal fats.

Avoid Oxidation of Fats: Heating of fats, such as in frying, has shown to increase the degeneration of smooth muscle cells in arterial tissue.

Select Protein: Protein should be obtained from fish, skinless chicken, and nuts and seeds. Protein powder shakes are also acceptable.

Increase Fiber: Water-soluble forms of fiber (oat bran, guar gum, pectin) seem to be much more effective than water insoluble forms of fiber, such as wheat and cellulose. Regardless of the type, fiber does seem to have a minor to moderate effect in lowering cholesterol levels.

Eat Vegetarian: Not only does a vegetarian diet exclude cholesterol from the diet, but also it inhibits cholesterol absorption by competing for cholesterol binding sites. May be difficult with syndrome X though, so low fat proteins are encouraged.

Limit Coffee: In a study of 1,130 male medical students, the relative risk for cardiovascular disease was 2.49 times greater for those who drank 5 cups of coffee as opposed to those who did not, even while taking smoking, hypertension status, and serum cholesterol into consideration. Coffee increases homocysteine and decreases magnesium.

Drink Alcoholic Beverages in Moderation: In every epidemiological study, it was found that moderate drinkers had a lower cardiovascular risk than either low or high intake groups. Best choices are red wine and dark beer because of the antioxidant content.

Liver and Digestive Support

❑ For high levels of LDL, the liver (which produces and metabolizes cholesterol) and the digestive tract (which excretes cholesterol in bile) need to be supported.

❑ Supporting healthy digestion and preventing dysbiosis with probiotics, such as *Lactobacillus Acidophilus*, has been shown to improve blood lipids.

❑ Also necessary is the support of liver function with lipotrophic agents (methionine, inositol, choline), botanical medicines , and a healthy diet.

❑ Diet should focus on restriction of saturated fat and inclusion of unsaturated fat in the diet. In other words, animal fats should be avoided, and fats from nuts, seeds, and fish should be encouraged.

Lipid Lowering Botanicals and Nutraceuticals

Herb/Nutrient	Action	Dose
Niacin	Inhibits liver formation of LDL cholesterol Can be used as a detoxification agent	3 g q.d. Causes flushing (a non-toxic release of histamine), but taking it with food decreases this; taking it in 500 mg increments every 3 days (up to 3 g) can also decrease flushing.
Inositol hexaniacinate	Inhibits liver formation of LDL cholesterol	3 g q.d. Does not flush. More expensive than niacin.
Garcinia cambogia (Garcinia)	Extract lowers cholesterol, increases HDL, and curbs the appetite.	Extract containing 500 mg hydroxycitric acid t.i.d.
Commiphora mukul (Guggul)	Considered the best botanical medicine for lowering high cholesterol in Ayurvedic medicine Active ingredient guggulsterone increases the uptake of LDL cholesterol from the blood by the liver	500 mg t.i.d. of a 5% guggulsterone extract (equivalent of 25 mg guggulsterone t.i.d.)
Cynara scolymus (Globe Artichoke)	Liver support, increases HDL, decreases LDL, increases bile production	1-4 g t.i.d. (root) or 500 mg t.i.d. of 12:1 extract
Red Yeast Extract	Decreases cholesterol formation within the cell Naturally contains the HMG-CoA reductase inhibitor mevinolin found in Lovastatin Clinically effective in reducing cholesterol and triglyceride levels and free of the troubling side-effects of 'statin' drugs, such as elevated liver enzymes, lowered circulating CoQ10 levels, and serious muscle diseases	1 gram q.d.
Nopal opuntia (Prickly Pear Cactus)	Lowers lipids, lowers glucose (only if high), lowers insulin levels in hyperinsulinemia patients (excellent choice for syndrome X) High fiber content decreases cholesterol absorption	3 tablespoons (15 g) of nectar
Policosanol	A derivative of sugar cane containing 24-34 carbon alcohols that inhibit hepatic cholesterol synthesis and increase the degradation of LDL	20-40 mg q.d. has shown to be effective in studies done in Cuba; however, it has been very disappointing in clinical practice with my colleagues
Soy Protein	Lowers cholesterol	30-50 g q.d., especially in post-menopausal women
Turmeric	Increases HDL, decreases LDL, decreases oxidation of cholesterol, increases liver function and is an antioxidant	

Exercise

Exercising for at least 20 minutes three times per week at 50% to 80% of maximum heart rate is crucial to this healthy approach to lowering LDL. Exercise should be started under supervision of a physician.

Inhibiting Cholesterol Oxidation

Agents that inhibit cholesterol oxidation, an essential step in the formation of atherosclerotic plaque, may play a role in CVD prevention. Oxidation of cholesterol is essential in the creation of plaque build up.

Flavanoids: Inhibition of cholesterol oxidation is believed to account for the "French Paradox" — high saturated fat consumption without a marked increase in cardiovascular disease. Flavanoids, strong antioxidants found in red wine, may be partially responsible. However, one need not consume red wine to get these benefits. Flavanoids are also found in green tea, extra virgin olive oil, and dark pigmented berries such as blueberries, red grapes, strawberries, etc. These foods are especially recommended for those patients with a history of CVD.

Vitamins: Inhibit oxidation. Effects are immediate.
Vitamin E: 400-800 IU daily
Vitamin C: 5 g daily.

Oral EDTA: 2-4 g daily. Decreases plaque build-up. Effects are gradual over a period of months.

IV EDTA Chelation: 1.5-3 g daily. Decrease plaque build-up. Effects are gradual over a period of months.

Increasing Metabolism

For euthyroid and/or hypothyroid patients, there may be a need to increase metabolism with botanicals and nutraceuticals.

Lithyronine: (T3) 7.5 mcg incremental dosing WTS protocol

Armour: 1-6 grains daily (simpler to use than WTS protocol; however, not restorative and patients rarely get their temperature back to normal)

Herbal Support: Guggul, Blue Flag, Kelp

Tyrosine: 2 g daily

Treating Associated Low Thyroid
Since hypercholesterolemia is often a secondary effect of low thyroid function or Wilsons temperature syndrome, cholesterol levels often drop from even high levels in the 300 range down to normal range after 6 weeks of normal temperatures on WT3 therapy and/or other thyroid support. One patient had cholesterol levels in the low 300s in spite of being treated with several different cholesterol lowering drugs and following a strict diet. With proper WT3 therapy and the ensuing normalization of her body temperature pattern, her symptoms of WTS resolved. Within 1.5 months, her blood cholesterol levels had dropped below 200 for the first time in years despite the fact that she had not taken her cholesterol-lowering drugs during that 1.5-month period.

Treating Associated Cardiovascular Disease
Alongside correction of dyslipidemia, vitamin B-12, B-6, folic acid, and other nutrients that reduce the inflammatory process have a role in CVD prevention.

Prognosis

Most patients with lipid disorders respond well to a naturopathic program.

THYROID METABOLISM DISORDERS

HYPERTHYROIDISM

❑ **Graves' Disease:** The most common form of hyperthyroidism (accounting for approximately 85% of hyperthyroidism) is Graves' disease. Graves' disease is an autoimmune condition in which the thyroid TSH receptors are continually stimulated by antibodies. This causes the thyroid gland to overproduce thyroid hormone. TSH production is regulated by a negative feedback loop, so if the thyroid is overactive, the pituitary gland will produce less TSH. Patients with normal T3 and T4, and suppressed TSH are usually considered to have a subclinical hyperthyroidism. However, current research indicates patients with Graves' disease also have auto antibodies to thyrotropin receptor sites, thus resulting in TSH suppression regardless of the levels of endogenous or exogenous thyroid hormones.

❑ **Hashimoto's Disease:** Another form of autoimmune thyroiditis, Hashimoto's disease can also become hyperthyroid, although typically it causes hypothyroidism only. When Hashimoto's is associated with hyperthyroidism, it usually waxes and wanes as opposed to Graves' disease, which usually progresses.

❑ **Toxic Multinodular Goiter:** This is a third cause of thyrotoxicosis and is treated similarly to Graves' disease.

HYPOTHYROIDISM

❑ **Hashimoto's Thyroiditis:** Autoimmunity is one of the main factors contributing to low thyroid function. Chronic lymphocytic thyroiditis (Hashimoto's) is characterized by an autoimmune goiter typically followed by hypothyroidism. It affects women more than men (8:1) and begins usually between 30 and 50 years of age. Treatment usually includes thyroid hormone replacement, which suppresses the thyroid gland function and in turn the autoimmune process, but is rarely curative. The use of desiccated thyroid is controversial, as some patients are unable to tolerate it due to the antigenicity of the thyroid substance, while in others it is thought that the antigenic properties stimulate blocking antibodies and thereby reduce the autoimmune process.

❑ **Wilsons Temperature Syndrome:** This is low metabolic syndrome with the hallmark signs of low body temperature. Although patients are usually biochemically euthyroid, they have all low thyroid symptoms, which resolve with the use of T3 thyroid hormone preparation doses in a cyclic fashion.

Associated Syndromes and Etiologies
❑ **Chronic Fatigue Syndrome**
❑ **Fibromyalgia**

Signs and Symptoms

Hyperthyroidism
❑ Heart palpitations
❑ Insomnia
❑ Weight loss
❑ Fatigue
❑ Chest pain
❑ Breathing difficulties
❑ Anxiety
❑ Fever
❑ Tachycardia
❑ Insomnia
❑ Increased bowel motility
❑ Excess sweating
❑ Autoimmune manifestations: exophthalmos, periorbital edema, swollen conjunctivi, diplopia, onycholysis, and pretibial dermopathy

Hypothyroidism
Symptoms
❑ Fatigue
❑ Depression
❑ Poor concentration
❑ Intolerance to cold
❑ Weight gain

- ❑ Constipation
- ❑ Muscle cramps
- ❑ Paresthesias
- ❑ Joint pain
- ❑ Vertigo

Signs
- ❑ Fluid retention
- ❑ Menstrual irregularities
- ❑ Dry skin, hair loss
- ❑ Lateral eyebrow thinning
- ❑ Muscle weakness

- ❑ Hoarse voice
- ❑ Hypertension
- ❑ Slow deep tendon reflex (especially slow Achilles relaxation phase)
- ❑ Carotene deposits around mouth and on palm
- ❑ Low basal body temperature
- ❑ Infertility
- ❑ Increased PRL
- ❑ Normocytic anemia
- ❑ Hyponatremia
- ❑ Hyperlipidemia (especially, increased LDL and total cholesterol)

Medical History

- ❑ Family and personal history of thyroid disorders
- ❑ Exposure to excess halogens (fluoride, chlorine) and lack or excess iodine intake
- ❑ Exposure to ionizing radiation to the head or neck can affect the thyroid and pituitary

- ❑ Excess ingestion of goitrogens
- ❑ History of stress
- ❑ Heavy metal exposures
- ❑ Pregnancies
- ❑ Pharmaceutical use should also be investigated

Physical Examination

- ❑ Visual inspection of the anterior neck region for signs of masses.
- ❑ Manual palpation of the thyroid for size, tenderness, masses, nodules, consistency.

- ❑ Patients can be instructed to turn their heads or swallow. The thyroid gland moves down when swallowing.
- ❑ Auscultate the thyroid for bruits (blood flow is increased in hyperthyroidism).

Laboratory Tests

- ❑ TSH, Total T4, Free T4, and Free T3 are the most common laboratory tests to address thyroid function.
- ❑ Autoantibodies, such as anti-thyroglobulin (anti-TBG), anti-thyroid peroxidase (anti-TPO), are measured if autoimmune disease is suspected.
- ❑ Anti TSH receptor antibodies (TSH-R Ab) are present in Graves' disease.
- ❑ A radioactive iodine uptake (RAIU) scan is used to assess thyroid gland metabolism.

HYPERTHYROIDISM

Therapeutics

Once a diagnosis of hypothyroidism has been made, treatment may include phytotherapeutic agents, lifestyle changes, nutritional supplements, and hormone replacement therapy.

Priority 1: Cardiac Complaints
The first priority in treating hyperthyroid patients is to manage any cardiac complaints the patient may be having. In particular, the physician should bring the blood pressure and heart rate within normal limits. Patients with cardiovascular symptoms may benefit simply from the use of the hyperthyroid formula. *Lycopus virginacus* (bugleweed) is a cardiac sedative and cardiac tonic, while *Melissa officinalis* (lemon balm) and *scutellaria lateriflora* (skullcap) are calming nervines. However, in acute thyrotoxicosis patients will need extra assistance from cardiac and hypertension formulas. Natural approaches in very aggressive, high dosages often can be used instead of pharmaceuticals. However, in emergency situations, PTU might be needed to decrease thyroid hormone production from the thyroid and to decrease peripheral conversion of T4 to T3.

Hyperthyroid Botanicals and Nutraceuticals

Herb/Nutrient	Action	Dose
Lycopus virginicus (Bugleweed)	Thyroid alterative helpful for both hyperthyroid and hypothyroid. Reduces thyroid hormone levels in hyperthyroid animals	150 drops of a 1:3 extract
Mellissa officinalis (Lemon Balm)	Helps in decreasing anxiety and calming an overactive thyroid (demonstrated the ability to normalize TSH levels in animal experiments when combined with Lycopus virginicus)	45 drops of a 1:3 extract.
Scutellaria officinalis (Skullcap)	Nervine to calm the emotionally and physically over-stressed patient	45 drops of a 1:3 extract
Iris versicolor (Blue Flag)	Lymphatic herb. Potent detoxifier of the thyroid. Helpful for goiters and nodules	45 drops of a 1:6 extract
Tripterygium wilfordii (Thunder God Vine)	Considered in TCM to be safer and more effective than corticosteroids in treating autoimmune diseases; Chinese doctors use it for a wide range of autoimmune diseases, especially rheumatoid arthritis (the variety leigongteng is used), lupus, and hyperthyroidism	Availability in North America is limited due to toxicity issues
Niacin	Anecdotal response of thyroid normalizing action with the use of niacin, according to Dr Abram Hoffer. Two reports of decreasing Graves' ophthalmopathy after 3 months of continued use.	3 grams q.d.

Priority 2: Hyperthyroidism Control

Once cardiovascular symptoms are under control, the second priority is to work toward controlling the hyperthyroidism. The current medical paradigm believes that hyperthyroidism can only be permanently "cured" by using radioactive iodine or surgery to destroy the thyroid gland permanently. However, the use of natural medicine in the high doses will usually be able to reverse hyperthyroidism.

Hyperthyroid Botanicals and Nutraceuticals

Hyperthyroid herbs in high doses often reduces thyroid hormone levels, allowing the TSH level to come up over time as described in the tables below. However, it is possible that TSH levels may get a little worse before they improve.

Prognosis

❑ Most patients with hyperthyroid respond within a few months. The majority will have restored thyroid function within a year to the point that they are no longer hyperthyroid, even after discontinuing a hyperthyroid formula. Patients who have severe hyperthyroidism might need several years to normalize.

❑ TSH values usually increase within several months of taking hyperthyroid formula.

Drug Interactions: The use of thyroid hormone supplementation is contraindicated in hyperthyroidism.

Side Effects: In clinical practice, none have been noted.

Side Benefits: The formula is not only calming to the thyroid, but also effective for anxiety and heart palpitations.

Combination with Adaptogens: Since adaptogenic herbs are an adjunctive therapy for all endocrine conditions, it is recommended that patients take them as part of the hyperthyroid protocol.

Combination with Cardiac Support: Hyperthyroid patients often suffer from cardiac bundle branch blocks, arrhythmia, cardiac hypertrophy, and tachycardia, among other symptoms. Often hyperthyroid formula is enough to alleviate these problems. If not, these supplements are helpful in regularizing cardiac symptoms, especially the herbs containing cardiac glycosides, such as *Convallaria officinalis* and *Cereus grandiflorus*.

HYPOTHYROIDISM

Therapeutics

Hypothyroidism may be caused by a number of factors including a reduction in hormone synthesis by the thyroid gland, thyroid gland ablation (surgery/radiation), deficient TSH, and peripheral causes. Hormone synthesis is reduced in iodine deficiency, Hashimoto's disease, high intake of dietary goitrogens or pharmaceutical inhibitors of the thyroid, subacute thyroiditis, infiltrative thyroid disease, or congenital thyroid disease. Peripheral causes include deficient T4 to T3 conversion, excess rT3, and thyroid hormone resistance.

Thyroid Replacement Hormones

- Thyroid hormones are useful in hypothyroidism and Wilsons temperature syndrome. They can also decrease thyroid nodule sizes.
- However, thyroid hormone replacement can aggravate a number of conditions, so should be used cautiously. For example, adrenal cortical insufficiency (Addison's or subclinical Addison's syndrome), coronary artery disease (angina pectoris), cardiac arrhythmias, tachycardia, cardiomyopathy, anxiety disorders, diabetes mellitus Type II and syndrome X, diabetes insipidus, osteoporosis, and thyrotoxicosis can all be exacerbated with thyroid hormone replacement.
- In addition, thyroid hormone replacement should be used cautiously with stimulant herbs or pharmaceuticals and other forms of prescription medication, such as steroid hormone replacement, anticoagulants, hypoglycemic agents, antidepressants, and cardiac medications. The high-end dosages of these thyroid hormone preparations can be very cardioactive, and if not carefully done, can potentially cause tachycardia and atrial fibrillation, even in the individual with no history of cardiac symptoms. Thus, patients taking thyroid hormone replacement must be encouraged to report adverse events and educated in the symptoms of thyrotoxicosis.

Thyroid Hormone Replacement Options

- ❑ **T3 Liothyronine sustained release:** 7.5 -100 mcg b.i.d. in incremental dosages (see WTS protocol). The main advantage is that it can reset the metabolism back to normal by resetting the temperature back to 98.6°F for euthyroid and hypothyroid patients. For euthyroid patients, it is restorative, and the patient does not need any exogenous thyroid hormones after the treatment to continue feeling well. The disadvantage is that the protocol is time consuming, and some patients might have to endure unpleasant side effects for the first part of the treatment. Dr Wilson designed this protocol.

- ❑ **T3 Pure (Cytomel):** 7.5-100 mcg daily. A high dose of Cytomel once a day used for euthyroid patients suffering from fatigue and fibromyalgia is often effective in alleviating symptoms, and is easier to use. However, most people are not able to restore metabolism back to normal, nor are patients able to wean off the Cytomel without having symptoms return. Dr Lowe designed this protocol.

- ❑ **Desiccated Natural Thyroid:** Prepared from domesticated animals, one grain (60 mg desiccated thyroid) contains approximately 38 mcg T4 and 9 mcg T3. One-grain increments of desiccated thyroid can be increased once a week, as long as there are no significant cardiac effects. This almost never resets the metabolism back to normal, nor are patients able to wean off the medicine without having symptoms return. However, it is easy and simple to use.

- ❑ **T3 and T4 mixed:** 50 mcg T3, 100 mcg T4.

❏ **Levothyroxine:** 25-200 mcg. The most popular thyroid hormone replacement, levothyroxine provides a standard dose of T4, but does not include T3, and thus adequate T3 is maintained only if T4 to T3 conversion is adequate.

❏ **Natural Progesterone:** Oral micronized progesterone 200 mg a day potentiates thyroid hormone and is indicated if a patient has excessive estrogen levels in ratio to progesterone (estrogen dominance).

Thyroid Support
Thyroid botanical support (Iris Versicolor, Guggule, potassium iodide) is often useful in the treatment of Wilson's temperature syndrome, low body temperature, fatigue, arthritis, mild hypercholesterolemia, chronic lymphocytic thyroiditis (Hashimoto's disease). Thyroid support is designed to provide adjunctive support for the hypothyroid patient and may be of assistance regardless of the etiology of the condition. Thyroid support can often be used as an alternative to WT3 therapy for patients with mild to moderate Wilson's Temperature Syndrome.

❏ **Diet and Supplements:** As in any autoimmune disease, natural therapies that focus on immune system regulation are indicated. Hair mineral analysis evaluating nutritional levels can be of great value. Low levels of selenium, zinc, and iron contribute to thyroid hormone production problems. Decreasing the antigenic load by testing for and avoiding dietary antigens is indicated. Gluten sensitivity, for example, has now been associated with most autoimmune conditions, including Hashimoto's disease. Hypothyroid patients are deficient in heat and energy and should eat warming foods. A diet high in goitrogens should be avoided.

❏ **Digestion:** Ensuring healthy digestion and absorption, including an intact and functional digestive tract lining, is critical. Supplements, such as HCL, bitter herbs, and digestive enzymes with meals, support healthy digestion. If leaky gut is identified, a medium- to long-term gut repair protocol, including the treatment of dysbiosis, is indicated. Treating dysbiosis can reduce the production of endotoxins in the gut and reduce intestinal hyperpermeability, in turn helping to modulate an over active immunity.

❏ **Exercise:** The single most important lifestyle factor one can do in improving thyroid function is exercise. Aerobic exercise stimulates the peripheral production of T3 by inducing 5'-deiodinase (Type I monoiodinase), an enzyme outside the thyroid gland that converts T4 into the more active T3. Aerobic exercise of a minimum three times a week should, therefore, be prescribed.

❏ **Full Spectrum Light:** Light stimulates T4 production through its action on the pineal gland and a reduction in melatonin production.

❏ **Stress Reduction:** Thyroid malfunction is epidemic in this century, possibly due to pesticides and chemicals ubiquitously found in our environment. Chronic emotional stress can be a causative factor as well. Thus, stress management techniques and the consumption of chemical-free whole foods should be encouraged.

❏ **Aptogenic Herbs:** Adding adaptogenic herbs is often helpful in the treatment of Hashimoto's disease because they act as endocrine tonics that help mitigate autoimmune diseases. This is especially indicated if chronic stress or adrenal insufficiency is a factor.

❏ **DHEA:** DHEA, a major adrenal hormone, has been found to benefit a variety of autoimmune diseases in dosages of 100-200 mg/day. However, many clinicians prefer physiological doses, such as 10-50 mg/day in men and 5-15 mg/day in women. Lab work should be done to confirm physiological ranges with DHEA supplementation.

❏ **Detoxification:** The traditional use of detoxification has a place in the treatment of autoimmune disease. Therapies that support the liver to process endogenous and exogenous toxins have demonstrated benefits in managing autoimmune disease, including thyroiditis.

❏ **WT3:** WT3 treatment can also lower thyroid antibodies and ensure a better chance of controlling Hashimoto's disease. It is not uncommon for patients to need 100 mg/day of Synthroid before treatment with WT3 and thyroid support, but only and .025 mg/day of Synthroid, if any, after treatment. WT3 therapy not only rests but also tends to clear out and reset the thyroid system (as opposed to Synthroid or Armour). WT3 therapy can often reduce the amount of thyroid medicine needed by patients who are hypothyroid. The combination of WT3 therapy and thyroid support provides a better chance of complete recovery.

Thyroid Support Botanicals and Nutraceuticals

Herb/Nutrient	Action	Dose
Iris Versicolor (Blue flag)	Stimulates glandular secretion and removal of wastes through the lymphatic system	750 mg q.d.
Commiphora mukul (Guggul)	Naturally increases T3 levels; also effective in decreasing T3 levels in hyperthyroid patients. Considered a rejuvenative and stimulant in Ayurvedic medicine	With 2.5 guggulsterones, 750 mg q.d.
Fucus vesiculosis (Bladderwrack or Kelp)	Provides the organ with the nutrition and substrates it requires. Can increase the metabolic rate and stimulate weight loss	5 g q.d.
Selenomethionine	Decreases thyroid peroxidase antibodies	200 mcg q.d.; for faster results: 500 mcg b.i.d. week 1, then 500 mcg q.d. week 2, then 200 mcg q.d. thereafter
Tyrosine	Amino acid required for the synthesis of thyroid hormones	Up to 2 g q.d., in divided doses between meals
Potassium Iodide	Element necessary for thyroid hormone metabolism	100 mcg-50 mg q.d.

Thyroid Support Botanicals and Nutraceuticals

This formula provides nutritional support and stimulation to the thyroid gland, improving the peripheral conversion of T4 to T3. It often decreases thyroid antibodies in Hashimoto's thyroiditis, and, with long-term use, often increases thyroid hormone production in hypothyroid patients. In addition, it can increase the body temperature. Thyroid support formula, especially with high doses of selenomethionine, can bring thyroid antibodies down. Patients with mild to moderate cases of Wilson's temperature syndrome can often recover with the use of this herbal formula or WT3 — or both.

Preferably, the components of this formula are given all together. One possible option includes 225 mg *Iris versicolor*, 225 mg Guggul, 200 mg Fucus, and 80 mcg Selenomethionine 1 cap t.i.d.

WILSONS TEMPERATURE SYNDROME

Diagnostics

Wilsons temperature syndrome is a diagnosis of exclusion and is confirmed by a therapeutic trial of WT3 therapy. Thyroid blood tests have no role in diagnosing this condition other than to rule out decreased thyroid gland function.

History, physical exam, and laboratory tests can help identify other possible causes of fatigue, including anemia, chronic infections, blood sugar abnormalities, lifestyle factors, side effects of prescription drugs, toxicity, other endocrine disorders. If no more likely explanation can be identified for the patient's symptoms, WT3 therapy should be considered.

Signs and Symptoms

❏ Symptom or symptoms consistent with low thyroid system function
❏ Average body temperature that is less than 98.6°F
❏ Fatigue
❏ Depression
❏ Cold or heat intolerance
❏ No other likely explanations for symptoms

WTS Symptom Checklist for Patients

Before beginning the treatment, patients should fill out the WTS Symptom Checklist. That way, they will be able to compare their progress over time.

Patients Instructions: Use this sheet to track your progress with symptoms by rating them before, during, and after treatment. Mark these dates at the top of each column. Rate each symptom on a scale of 1 to 10 of how you feel, 10 being how you imagine a normal person to feel, and 1 being terrible.

SYMPTOM	BEFORE (DATE):	DURING (DATE):	AFTER (DATE):
Fatigue			
Headaches			
Migraines			
PMS			
Irritability			
Fluid Retention			
Anxiety			
Panic Attacks			
Hair Loss			
Depression			
Decreased Memory			
Decreased Concentration			
Decreased Sex Drive			
Unhealthy Nails			
Constipation			
Irritable Bowel Syndrome			
Inappropriate Weight Gain			
Dry Skin			
Dry Hair			
Insomnia			
Needing to Sleep during the day			
Arthritis and Joint Aches			
Allergies			
Asthma			
Itchiness of Skin			
Elevated Cholesterol			
Ulcers			
Abnormal Throat Sensations			
Sweating Abnormalities			
Heat and/or Cold Intolerance			
Low Self-Esteem			
Irregular Periods			
Severe Menstrual Cramps			
Low Blood Pressure			
Frequent Colds and Sore Throats			
Frequent Urinary Infections			

SYMPTOM	BEFORE (DATE):	DURING (DATE):	AFTER (DATE):
Lightheadedness			
Ringing in the Ears			
Slow Wound Healing			
Easy Bruising			
Acid Indigestion			
Flushing			
Frequent Yeast Infections			
Cold Hands/Feet, Turn Blue			
Poor Coordination			
Increased Nicotine/Caffeine Use			
Infertility			
Hypoglycemia			
Increased Skin Infections/Acne			
Abnormal Swallowing Sensations			
Changes in Skin Pigmentation			
Prematurely Gray/White Hair			
Excessively Tired after Eating			
Carpal Tunnel Syndrome			
Dry Eyes/Blurred Vision			
Hives			
Bad Breath			

Medical History

❑ Often a history of surgery, trauma, divorce, chronic illness

Physical Examination

❑ Dry skin
❑ Carpal tunnel syndrome

❑ Hair loss
❑ Muscle tenderness

Laboratory Tests

❑ The diagnosis of WTS is not based on any blood tests. It is not based on a T3 deficiency or rT3 excess. Like irregular periods, it is a functional impairment that doesn't show up on blood tests, but does respond to treatment (like irregular periods often respond to birth control pills). We don't know exactly how WT3 therapy resets the body temperature and metabolism; we just know that it often does.

❑ Laboratory tests can include CBC, Multi-chemistry panel, T4, TSH, ANA, and EKG. Special care should be taken to rule out conditions that can be intensified by thyroid treatment, such as cardiac arrhythmias and Addison's disease.

❑ Low progesterone levels and low testosterone levels can also be a cause of low temperatures.

Therapeutics

WT3 Therapy

The majority of patients complaining of fatigue will have low body temperatures and will be good candidates for WT3 therapy. More than 90% of patients have responded well to these treatments, as long as they did not have other concomitant illnesses, such as chronic infections.

These basic guidelines include typical patient work-up, common patient management issues, practice tips, frequently asked questions, and common misconceptions regarding the WT3 protocol. These guidelines do not completely explain the WT3 protocol. *The Doctor's Manual for Wilsons Temperature Syndrome* (available from WTS at 1-800-420-5801 and without charge on line at www.wtsmed.com) should be read in conjunction with this protocol. *The Doctor's Manual* details how to maximize the benefits while minimizing the risks of T3 therapy. It is imperative that doctors read the manual before trying to treat WTS with T3.

Treatment Options

1. *WTS herbal medicines*: The advantages of this approach is that it is simple, there is almost no chance of side effects, and improvement of symptoms usually occurs in 3 to 4 weeks.
2. *WT3 therapy*: The advantage of this approach is that there is a greater likelihood of a more pronounced and longer-lasting effect, especially in patients with severe cases. However, WT3 requires a high level of commitment and discipline (e.g., taking the medicine on time). There is also a chance of some cardiovascular side effects, such as rapid pulse or palpitations. Although some patients dramatically improve within hours or days, others feel significantly worse before feeling better.
3. *WTS medicines in combination with WT3 therapy:* The advantage of doing both at the same time is that this approach covers all the bases. WTS medicines can often reduce the chance of side effects and extend the benefits of WT3 therapy. In our experience, this method has yielded the greatest success.

WTS Medicines

WTS Medicines are herbal and nutritional supplements designed to dovetail with WT3 therapy. Candidates for WT3 therapy who have abnormalities on the work-up can often be prepared for WT3 therapy with WTS medicines. Many patients are able to recover their health through the use of WTS medicines alone. In our experience, we have found that WTS medicines can often extend the benefits and reduce the risks of WT3 therapy.

- **Healthy Foundation:** Healthy Foundation can often bring down elevated liver enzymes within 2 to 4 weeks. If appropriate, patients can also be weaned off prescription medicines that might be causing elevated liver enzymes.
- **CardiaCare:** CardiaCare and CardiaCare Plus can often bring pulse rates that are over 100 down into the 80s and can help maintain desirable pulse rates during WT3 therapy.
- **Adaptogen:** Patients with low blood pressure and orthostatic lightheadedness may benefit from adrenal support from Adaptogen. Many adrenal symptoms often improve with thyroid treatment alone. If desired, Adaptogen can be used at the end of the treatment for any remaining adrenal symptoms.
- **ThyroCare:** ThyroCare provides herbal and nutraceutical thyroid support and can help patients achieve the desired temperature. It can also be used to correct backsliding that may occur after the protocol.

Some patients prefer to try WTS Medicines, such as ThyroCare, Healthy Foundation, and Adaptogen, and add WT3 only if necessary. Others like to try the WT3 and only add WTS medicines if required (i.e., some patients need ThyroCare for help getting their temperature up or Adaptogen for adrenal support). Still others prefer to start WTS medicines and WT3 therapy at the same time. WTS medicines can often help patients become candidates for WT3 therapy when otherwise they might not be. For example, palpitations, high pulse rate, and other cardiac problems can often be normalized with CardiaCare.

WT3 Therapy Procedures

WT3 therapy involves taking incremental doses of T3, which is mixed with a sustained release agent (SR-T3). The dose is increased and then decreased until the body temperature is restored to 98.6° F. Most patients are not able to normalize their temperatures on the first cycle. The protocol involves additional cycles until the patient is able to maintain their temperature at 98.6°.

We've started calling the protocol Wilson's T3 therapy, or WT3 therapy for short, to distinguish it from different methods of using T3. Not all pharmacists compound the T3 consistently well, based on the fact that quite a few doctors and patients have noticed

better results with fewer side effects when they switched to T3 compounded by reputable pharmacies. It is important to work with an experienced pharmacy that has the right equipment, such as a V-blender, that mixes the T3 compound thoroughly and consistently.

Patient Time and Attention
This involves taking medicine every 12 hours precisely to the minute, as well as monitoring pulse rate and body temperature on a daily basis. Patients should count on the treatment requiring a minimum investment of 3 to 6 months to complete.

The patient will need to visit the treating physician about twice a month, although people with more complex cases often need to be monitored more frequently. Most patients have at least eight office visits. Experience has shown that patients who have adequate support and supervision from their doctors usually make fewer mistakes, stick with the protocol, and experience greater success.

Monitoring Temperature
When patients start with temperatures of less than 97°, it can take a while before their temperature gets into the 98.6° range. If their temperature is nowhere near normal, patients can take their temperature once a day. But as their temperature increases to 98.1° or 98.2°, it is important that they take their temperature at least twice a day. Take the average by adding two temperatures and dividing by two, or by adding three temperatures and dividing by three.

Monitoring Pulse Rate
In the morning, before taking their first dose of T3, patients should check their pulse rate, using a watch with a second hand, and count their heartbeats for 60 seconds. It is easiest to feel the pulse on the wrist or the neck. Patients should monitor their pulses closely and never increase the T3 if their pulses are over 100 or if they're having palpitations. Patients can run into trouble if they are not diligent about checking their pulse.

Timing of T3 Administration
T3 medicine needs to be taken *exactly* every 12 hours, twice a day, at the same times every day (for example, 8 a.m. and 8 p.m.). If the patient finds out after starting that another time would be more convenient, you may advise the patient to wean off the medicine and start a new cycle. It is best to choose the administration time carefully from the beginning. Side effects occur more often when patients don't take the T3 on time (to the minute). This can result in side effects or decreased benefits for up to 2 weeks.

Dose
The starting dose is 7.5 mcg of T3, twice a day (7.5 mcg in the morning, 7.5 mcg in the evening).

If their temperature remains below 98.6°, and they are without complaints, then increase the dose by 7.5 mcg every day. That means that on the second day, the dose would be 15 mcg in the morning and 15 mcg in the evening, on the third day 22.5 mcg in the morning and evening, etc.

Do not increase the dose if:
- If the patient's resting heart rate is more than 100 beats per minute or if the patient has any disturbing complaints, such as significant heart palpitations (disagreeable awareness of your heartbeat). However, the dose may be increased to treat other side effects, such as worsening migraines, panic attacks, or fluid retention.
- Temperature has reached 98.6° or higher, on average.
- Patient has reached the maximum dose of 75 mcg, twice a day, or the maximum indicated by other related conditions or circumstances.
- It's worse to have a pulse rate over 100 than it is to have a temperature over 98.6°. If the dose is increased when the resting pulse is over 100, the patient may start experiencing unwanted side effects. Having a temperature a little over 98.6° can give some extra leeway as the patients weans off the T3.

'Capture' Temperature
When the temperature reaches 98.6°, the patient can stop increasing the T3 dose. Keep an eye on the temperature because it will likely go down again. This is called compensation and is perfectly normal. When this happens, simply continue cycling up to get the temperature back up to 98.6° (unless the patient is already on the maximum dose).

When temperature averages 98.6° on the same dose of T3 for 3 weeks, the temperature has been 'captured'. When this happens, the patient should plateau at that same dose.

Plateau
If the patient's temperature is still low, even though the dose can't be increased higher (either because the patient can't tolerate a higher dose or they on the maximum allowable dose), then the patients can stay on that dose for a time and wean off in preparation for the next cycle.

With each cycle, patients often are able to increase their temperatures with lower doses than were

required on previous cycles. They may stay on a plateau for a few days or a few weeks.

Weaning

It is important to wean the T3 slowly enough that the daily average temperature doesn't drop. Some people can decrease their dose every 2 days, but others may need to slow it down to every 4 or 8 days. The danger of weaning too quickly is that the temperature can drop more than 0.2°F. It is more important for patients to monitor their temperature while they are weaning off than when cycling up, to make sure you don't lose any of the progress that they have made.

Between Cycles

Usually, patients can stay off the T3 for 2 days before starting the next cycle. If they are still having any side effects from the T3 once weaned off, they should wait until they have been free of side effects for 2 to 3 days before starting the next cycle.

If their temperature doesn't go up on the first round, it usually will on the second.

Fast Compensators

As soon as patients are given oral T3, their bodies begin to produce less. It should not be a surprise when a patient's temperature goes up to normal on a certain dose, and then drops back down again after some time on that same dose. This hormonal compensation to a 7.5 mcg b.i.d. increment of T3 can take from a few hours to 3 weeks to occur. On average, compensation will take 4 days. However, it is important to realize that compensation can be taking place even when the body temperature is not yet increasing.

Around 10% of patients are fast compensators who compensate in less than a day. They can compensate so fast that they can overcompensate. For fast compensators, it is typical for their temperatures to go down instead of up during the first day or two of T3 therapy.

Understandably, these more volatile patients are often more difficult to treat:

1. Stress that it's extremely important for them to take their medicine on time.
2. CardiaCare or CardiaCare Plus should be taken every day and as needed.
3. T4 should be taken as needed. Some fast compensators will need to take a small T4 dose as described above every day (it's important for the patient to feel comfortable and to be safe).
4. Some patients will also benefit from adrenal support from Adaptogen or Adaptogen Plus. Low

body temperature and low blood pressure due to decreased endogenous thyroid production can often lead to adrenal compensation, which is the secretion of adrenal stress hormones that increase the pulse rate and blood pressure and blood sugar levels.

Although fast compensators can be very challenging to treat, they can also be very appreciative when they succeed. They are often very willing to support and encourage other patients once they finish the treatment.

Support Procedures

Some patients following the WT3 protocol still have difficulty getting their temperatures up to 98.6. There are several procedures to support them:

1. Adding ThyroCare (a WTS Medicine), one cap, t.i.d. will often bring their temperatures up to normal.
2. Cycling up by an increment (3.75 mcg or 7.5 mcg) every 12 hours instead of each day can often help. Patients cycling up every 12 hours should be especially vigilant in taking their medicine precisely on time.
3. Some patients will have other issues that need to be addressed, such as heavy metals, toxicity, chronic infections, or chronic illnesses that continually cause a decrease in temperature.
4. The use of WT3 therapy is often done as a therapeutic trial. Occasionally, if a patient has seen no increase in temperature after three rounds, it might mean that is does not work for them. These patients can be helped in other ways that might take much longer, but are still effective. (For example, one patient had a temperature of 96.0° F and was not able to increase his temperature with T3. A hair test analysis indicated severe heavy metal toxicity, and a 9-month detoxification program eliminated most of his WTS symptoms.)

Preventing Relapse of WTS while Stopping WT3

Relapsing can be very discouraging for patient, but putting patients on a maintenance dose of the Healthy Protocol for a time almost always prevents them from relapsing. The Healthy Protocol consists of giving at least two of the following WTS medicines: ThyroCare, Adaptogen, and Healthy Foundation.

Measuring WT3 Effectiveness

It takes about 4 to 6 weeks to completely suppress TSH with Synthroid; however, T3 can do that in about a week. There's really no reason to order thyroid tests

while patients are on the treatment because the tests do not change management. However, if you do, you may find that the TSH will likely be suppressed, and the T3 count will be high and the T4 will be low. These findings are not problematic and are to be expected.

Thyroid Tests: The whole purpose of T3 treatment is to decrease the T4 level. Having low T4 is not a problem as long as patients are being supported directly with T3. It is important to remember that T4 is merely a pro-hormone for the active hormone T3, 80% of which is made from T4 in the peripheral tissues of the body.

Patients with primary hypothyroidism have high TSH levels and almost always have elevated thyroid antibodies, such as thyroglobulin and thyroid peroxidase (antimicrosomal) antibodies. Patients with antibody levels of 50 IU/mL can often come down to about 15 IU/mL after about 4 months of taking ThyroCare.

Low TSH levels and high T4 levels indicate hyperthyroidism if the patient is not taking exogenous thyroid hormones. The presence of thyroid-stimulating immunoglobulin generally indicates Graves' disease.

Benign thyroid nodules can often be decreased in size with the combined use of suppressive doses of T3 or T4 and ThyroCare, or with ThyroCare alone.

The thyroid gland is essential for maintaining blood sugar and getting insulin to the receptor sites. WT3 therapy can often bring high blood sugar and insulin levels down comparably to Glucophage. WT3 and or DiabetiCare alone can often decrease insulin levels significantly in cases of hyperinsulinemia.

Salivary Cortisol: Ordering salivary cortisol levels can be helpful but is not always necessary. Adrenal symptoms, such as low blood pressure and orthostatic light-headedness, often improve with thyroid treatment alone. One can often start the WT3 therapy and then see if any adrenal symptoms remain. Many patients with Wilsons temperature syndrome will have low DHEA levels. Adaptogen can increase cortisol and DHEA levels within 3 to 4 weeks.

DHEA: If symptoms are severe, DHEA levels should be tested. If the levels are very low, supplementing DHEA can often help patients feel better. It is important to remember that excess levels of DHEA can cause masculinizing side effects. However, if DHEA levels are low, then fairly large doses of DHEA may serve to fill the deficit rather than to create excess. Thus, when patients have low DHEA levels and there is little concern for masculinization, their DHEA levels can often be brought up to normal within about 6 weeks on 50 to 100 mg/day of DHEA.

This will often help patients feel better, and once the levels are back to normal, supplementation with Adaptogen can help the levels stay normal. The Adaptogen may have to be continued for 6 to 9 months. About 20% of patients given Adaptogen might need DHEA supplementation as well.

AST: Interestingly, AST levels may be low in some candidates for WT3 therapy. Patients with low AST levels often complain of carpal tunnel syndrome. Low AST levels can be caused by pyridoxine deficiency. Many holistic and naturopathic doctors treat CTS with pyridoxine (vitamin B-6). It appears that pyridoxine metabolism may be affected by thyroid physiology, which might be why many thyroid patients have carpal tunnel syndrome and why CTS often resolves with WT3 therapy.

WTS Symptom Checklist

It's very helpful to have the patients fill out the WTS symptom checklist and put a numerical score for every symptom they have. That way they'll be able to evaluate the progress they're making, as their symptoms resolve.

WT3 Therapy Side Effects

T3 is four times stronger and breaks down three times faster than T4. The short half-life of T3 can contribute to unsteady T3 levels. Side effects of unsteady T3 levels include: fluid retention, muscle aches, anxiety, irritability, increased heart rate, and increased awareness of heartbeat.

People who are not taking thyroid medicine can easily have pulse rates over 140 when they exercise. If a patient has a resting pulse of over 100, it is not an emergency, but it is important to start trying to bring the pulse rate down with T4 and CardiaCare. If the resting pulse rate rises above 150 consistently (though we haven't ever heard of this occurring with doctors using the protocol), you should consider sending the patient to the emergency room. Patients may exercise as long as their hearts don't pound very hard.

Patients should avoid stimulants, such as caffeine, nicotine, and decongestants, during the protocol.

Management of Side Effects

T4 or Synthroid: Being weaker and longer-lived than T3, T4 can act as an antidote to unsteady T3 levels. When released into the bloodstream, T4 occupies some of the thyroid hormone receptors and provides a predictable dampening effect within 45 minutes.

A dose of .0125 mg of T4 can be an effective treatment for side effects of T3 therapy, and that dose can

be repeated after 45 minutes if necessary. Usually, the dose of T4 needed is proportional to the dose of T3 a patient is taking. Therefore, if the patients need to repeat the .0125 mg test dose of T4, then they can take .025 mg every time they need a dose of T4 for side effects in the future when they are on the same or higher dose of T3.

CardiaCare Formulas: There are two CardiaCare Formulas (CCF) — CardiaCare (CC) and CardiaCare Plus (CC+) — that can greatly reduce the chances of cardiac side effects. It is recommended that all patients who are started on the WT3 therapy also be started on a CardiaCare Formula to be taken daily. CardiaCare liquid is preferable for patients who are sensitive to herbs as it can be titrated by drop dosages if needed. It is also well suited to help with tachycardia, and rarely causes side effects even at high doses (60 drops). CardiaCare Plus is a more concentrated version that is available in capsules. The recommended dose should not be exceeded unless in extreme cases, and then only under your close supervision. The main advantage of the CardiaCare Plus is that it offers fast relief from functional cardiac problems, such as arrhythmias, and offers relief from stubborn cardiac complaints that on rare occasion cannot be helped with the liquid CardiaCare.

There are two advantages to giving patients either version of CardiaCare at the beginning of the treatment. One is that it prevents cardiac side effects, and the other is that it gives patients access to the medicine in case cardiac side effects develop. If side effects do develop and patients call after hours, they will have the medicine on hand. All the doctor has to do then is recommend the appropriate dose. A dose of T4 and an extra dose of CardiaCare or CardiaCare Plus are almost always enough to bring the heart rate back to normal.

Patients who go a month without side effects can stop taking the CCF.

WT3 Therapy and Primary Hypothyroidism

Patients can be suffering from primary hypothyroidism and Wilsons temperature syndrome simultaneously. Treating hypothyroidism with WT3 therapy can accomplish two things. First, it can clear up the patient's WTS, presumably by clearing up the peripheral pathways of thyroid metabolism. Second, it can give the thyroid gland a rest.

This is an excellent time to treat the patient with ThyroCare. ThyroCare seems to help restore thyroid gland function. Primary hypothyroidism can often be reversed to a degree with WT3 therapy and ThyroCare. This approach can often bring down antithyroid

antibody titers dramatically in 3 months. The patient's need for thyroid hormone replacement can be diminished, even to the point of no longer needing any thyroid medicine in order to maintain a normal TSH level.

We have found that patients who have normal TSH and thyroid antibodies can often feel better and decrease their thyroid antibodies just on ThyroCare alone. With proper use of the protocol, not only is WTS reversible, but mild cases of primary hypothyroidism can be, too.

Hypothyroid patients can be shifted off of medicines containing T4 and started on T3 therapy. If necessary, patients can be transferred back onto small doses of T4 while weaning off of T3 in preparation for the next cycle. There are different ways in which this weaning can be accomplished. *The Doctor's Manual* describes the process of weaning the patient completely off the T4 in 10 days. In this case, T3 should only be taken when necessary to prevent worsening of symptoms.

Another option is to cycle the hypothyroid patient up on the T3 at the same time as they wean off the T4. This method is easier to explain to the patient and often provides satisfactory results. For example, patients can wean off their T4 doses over 3 or 4 days while starting up on the T3 therapy. A patient on 0.15 mg of T4 might take 0.1 mg of T4 and 7.5 mcg b.i.d. of T3 on the 1st day, 0.05 mg T4 and 15 mcg b.i.d. of T3 the second day, and 0 T4 and 22.5 mcg b.i.d. of T3 the third day.

When hypothyroid patients are weaning off T3 therapy, they may find that they can't go below a certain dose of T3 without their temperature dropping. At that point they can add .025 mg/day of T4 and increase it as necessary to support them while they are weaning off the T3. Once they are off the T3 for a few days, the patients can then consider transitioning off the T4 support they're taking and back onto another cycle of T3 as they did on the first cycle.

The goal is to find a maintenance dose of T3 the patients feel good on. Usually, this dose will keep their temperature close to normal. Continuing the ThyroCare can be a great help in healing the autoimmune condition of Hashimoto's thyroiditis. You can order antithyroid antibody tests approximately every 3 months. At a certain point the antibody levels may start decreasing. The TSH may also tend to stay normal even while the patient is weaning off the T3.

WT3 Therapy and Thyroidectomy

Patients who have had a thyroidectomy are excellent candidates for WT3 therapy. In some ways they are easier to treat than other patients because they're not producing any T4.

The treatment approach can be similar to the one described above for primary hypothyroidism, but the goal is simply to help the patient feel better on the thyroid medicine they must take for life. Patients who have had partial thyroidectomies might be able to restore some thyroid function with ThyroCare. In most cases, though, the patient will require daily thyroid hormone replacement.

All total thyroidectomy patients and many hypothyroid patients will need to take some form of thyroid medicine for life. Once it seems the full benefits of WT3 therapy have been obtained, patients can be transferred back from T3- to a T4-containing medicine, such as Synthroid or Armour. These medicines are once a day, ubiquitous, and less expensive. However, some patients don't feel as well on these medicines as they do on the T3 therapy, and some doctors don't mind leaving hypothyroid patients and thyroidectomy patients on T3 alone indefinitely. This is usually tolerated well — especially if patients continue taking their CardiaCare.

In fact, patients tend to tolerate T3 replacement better and better over time, as their bodies become more accustomed to it. Some patients who don't tolerate T3 well the first month usually tolerate it much better the next. This effect is improved when they take CardiaCare. In fact, some people even get to the point of being able to tolerate a once a day schedule so that it becomes a lot like taking T4 (most patients feel better on a b.i.d. schedule). Over time, some patients may also find that they don't have to be as strict about taking their T3 on time.

Patient selection criteria are important when considering patients for long-term T3 maintenance. They should be able to take the medicine reliably and correctly. They should be monitored for any cardiac complaints and osteoporosis while on indefinite use of SR-T3. They should make sure they exercise regularly to diminish the chances of developing osteoporosis. Taking 1000 mg of calcium daily is a good preventive measure as well.

Patients' cholesterol levels may run lower on T3 than on T4. And as long as patients are feeling well, and there are no indications of any problems, some doctors may be comfortable leaving certain patients on T3 for 20 or 30 years, considering how much better their lives can be on T3 than on Synthroid. The case of a boy born without any thyroid function provides an interesting point of reference. His case was reported in the *Lancet* when he was in his twenties. He was started on T3 at birth instead of T4. He developed completely normally without any endogenous or exogenous T4 in his body.

Prognosis

- Wilsons temperature syndrome, low body temperature, fatigue, arthritis, mild hypercholesterolemia, and chronic lymphocytic thyroiditis (Hashimoto's disease) can often be corrected to the point that patients no longer need treatment.
- Up to 20% of patients may find the regimen too demanding and give up. Of those who are willing to do the work and stick with the treatment you can expect the following results:
- Within 3 months, about 70% of patients will have successfully finished the treatment, and within 6 months, 90%. About 10% of patients will need more time, maybe even a year, or simply might not be good candidates for WT3 therapy.
- About 20% of patients will feel worse before they'll feel better.
- About 90% of patients will be cured of the majority of their complaints, as long as any other imbalances are also treated.
- Due to its ability to increase both metabolism and body temperature, thyroid support can also decrease mild hypercholesterolemia by itself.
- In patients with moderate fatigue, lowering thyroid antibodies with thyroid support of Thyrocare (which contains iodine and selenium) usually takes 3 months. The most common use of thyroid support is for fatigue, even in patients with normal body temperatures.
- With some combination of these approaches, we believe a significant number of people with mild or recent onset Hashimoto's can sometimes decrease antibody levels, even if they are eventually weaned off thyroid hormones.
- Anecdotal response has been found in decreasing nodule size with the use of blue flag and guggul in some patients.

Remember: People typically feel the best when their temperature is steady at 98.6° and they're off the medicine. Only some people will feel extremely well while they're at 98.6° and on the medicine.

CLINICAL PRACTICE TIPS
Patient Education and Support

It's helpful for the patient to understand the commitment of time, money, and adherence to the protocol that is required. It is also very helpful to collect a list of names and phone numbers of patients who have been successfully treated with the WT3 therapy and who would be willing to discuss their treatment with new patients. Successfully treated patients are often happy to provide this assistance. This is perhaps the best tip in this entire guide. These patients can often provide invaluable support to other patients. They have the desire, time, and personal experience to help other patients feel more comfortable with the protocol.

It would also be helpful for you to have a list of patients who were "fast compensators." Fast compensators are often the most difficult patients to treat, and they can benefit from moral support. You can also keep track of those patients who were cured of various symptoms. For example, you could have a new patient that has migraines call a patient who was cured of migraines. You can match up the circumstances of new patients with those patients who have done well with the treatment. This is an excellent way to encourage hope, determination, and compliance.

There are many patients who have completed the treatment who are willing to share their experiences with others, as recorded on the Wilsons Temperature Syndrome website (www.wtsmed.com).

Doctor Confidence

Doctor confidence is extremely important with WT3 therapy since success depends on patient compliance. Patient compliance largely depends on doctor confidence.

Some doctors say all their patients get better and some doctors say none of their patients get better. Many doctors get frustrated because they say they have tried the treatment for 6 months or a year and their patients don't get their temperatures up. But many doctors aren't adequately familiar with the protocol, and, consequently, neither are their patients. For example, doctors often don't cycle up (increase the dosage) every day. And many doctors don't know that patients can wean off T3. Some doctors think T3 has to be taken indefinitely. They don't understand why they might want to use T3 as opposed to Armour. They'll put their patients on T3 along with Armour thyroid. A lot of these patients won't get better as quickly, completely, or permanently as they would with WT3 alone. WT3 therapy and WTS medicines are designed to make patients feel completely well when off the treatment.

It's true that some doctors use the protocol correctly and still have a challenging time with it. It's possible that the first ten patients a doctor sees will be fast compensators. If doctors are following the protocol correctly and the temperatures are not going up, then they might try going up by 3.75 mcg or by 7.5 mcg every 12 hours and/or adding ThyroCare. After 3 months, if the temperature still hasn't come up, one might consider other issues (such as the patients' progesterone or adrenal levels, diet, etc.). Some patients may just need several cycles of the therapy. Out of 100 people, there will be a handful who might respond after six or nine cycles, or even a year of cycles, or more.

Exploring Options

When patients are willing to do the work and their doctor is willing to give them different options (such as the ones below), almost everybody is very happy with the results. Occasionally, you might have to try something different. Some patients just don't respond in the typical fashion.

For example, one of my patients was on Synthroid for 10 years and never felt well. Then she went to Armour thyroid and never felt well. Then she cycled up and down on T3 for 6 months and her temperature never went up. She complained that "T3 doesn't help me. T4 doesn't help me and my temperature never goes up." So we asked her, "When you're cycling up and down, is there a time when you feel good?" And she said, "I feel pretty good at 22.5." She stayed at 22.5 for 10 days. She came back and she said that she had lost 10 pounds and that it was the first time in 10 years that she felt well. She was able to stay up the whole day without complaints. She is now taking 22.5 mcg b.i.d. of T3 indefinitely.

Another technique to try on patients whose temperatures are not coming up on WT3 is to leave them on a plateau at the top of a cycle for weeks. Dr Stephen Leighton feels that this can more fully deplete rT3 and reset the system more effectively than waiting only 3 days between cycles. He feels this often helps patients capture their temperatures on subsequent cycles.

Sometimes patients respond well to the supplements before or after discontinuing the T3. It looked like WT3 therapy was not working for one patient, so she was weaned off and started on ThyroCare and Adaptogen. The supplements were enough to help her feel well. Another patient never tried the T3, but she did have a low temperature and mercury toxicity, and body temperature went up after DMSA treatment to remove the heavy metals..

One patient's temperature went up on WT3 therapy but she still didn't feel better. It turned out that she literally ate nothing but nutritional bars every day, and only ate about 10 cooked meals a year (on holidays). For her, the solution was as basic as diet.

COMMON MISCONCEPTIONS AND FREQUENTLY ASKED QUESTIONS ABOUT WTS PROTOCOL

Misconceptions

Misconception #1: WTS can be diagnosed with laboratory tests. The basis for suspected WTS is quite simple: low body temperature and any of the WTS symptoms. The diagnosis is confirmed by a therapeutic trial. TSH, T3, and RT3 blood tests have no impact on the diagnosis and treatment of WTS.

Misconception #2: WTS patients must have all of the symptoms. WTS patients do not have to have all the symptoms. They could just have fatigue. They may have weight gain or they may be very thin. Just one of the symptoms on the checklist (other than low body temperature) is required for diagnosis. For example, someone might have only hypoglycemic symptoms and T3 and/or ThyroCare will often correct it. A high cholesterol level is enough of an indication for T3 therapy because often when the temperature is raised to normal the cholesterol will normalize. When the T3 is stopped, the cholesterol often stays normal.

Misconception #3: Patients who aren't tolerating the treatment well should increase their T3 doses more slowly. That's usually not the case. Most patients who don't tolerate the treatment well are fast compensators. Fast compensators require decisive action. It's like crossing a river with a strong current. If people wade across slowly, it's easy for the current to knock them down. But if they jump quickly from rock to rock, they can get to the other side more efficiently and comfortably. Slower is not better when it comes to cycling up on T3 therapy. Going up in incremental doses on time every day is often crucial.

Misconception #4: Patients should be weaned off T3 more quickly than they increased their dose. Many times patients are weaned off the T3 too quickly. Thus, doctors often have patients go up too slowly and come down too quickly, but it should be the reverse. Patients should always try going down slowly enough that their temperatures hold without slipping. Some people can wean down an increment every two days, whereas some people need to go down every 4 or 6 days.

Frequently Asked Questions

Question # 1: Should I use Armour thyroid, should I use T3, or should I use Synthroid? Because Armour thyroid has T3 in addition to T4, it's probably one step closer to proper treatment for WTS than Synthroid. But patients treated with Armour usually don't feel 100% better, and they will not be able to get off the medicine without feeling poorly again. When treated properly with WT3 therapy, almost everyone will get to feeling 100% better and are able to remain that way even after they wean off the medicine.

Question # 2: Am I the only doctor doing this? No, there are currently more than 250 doctors on our list of treating physicians, practicing all over the world. It's estimated that more than 1,000 doctors have used the protocol for more than 50,000 patients during the past 10 years.

Question # 3: Can I get in trouble for prescribing SR-T3? Sustained release T3 is a compounded medicine that is legal to prescribe. Although Dr Wilson faced some opposition for using it in the beginning, there is now a large constituency of doctors using Sr-T3. It is extremely rare that doctors have any trouble. In fact, the opposition against Dr Wilson was largely for his use of advertising to spread the word about the treatment.

Question #4: Could my patient go to the emergency room and have a heart attack? Because the T3 is given with a sustained release agent, it's extremely unlikely that patients will have a high risk of heart attack. However, the risk is there, so it's important to order a baseline EKG before the treatment. Since we now have the CardiaCare formulas, as well as T4, the cardiac risk is much less.

Question # 5: What should I look for in an EKG? You can look for evidence of old heart attacks, frank arrhythmias, and other significant abnormalities. Using calipers, you may want to look for traces of irregularities in the heart rhythm. Such traces may indicate a tendency toward atrial fibrillation, even though at first glance the patients appear to be in normal sinus rhythm.

Question # 6: Can I treat someone with T3 if they have an abnormal EKG? Yes, but you have to be extremely careful. Unsteady T3 levels due to T3 therapy can make cardiac abnormalities more pronounced. For example, small irregular irregularities on the EKG can develop into atrial fibrillation. Patients with abnormal EKGs have been treated successfully with T3 therapy, but they require very careful management. The addition of CardiaCare Plus to the protocol has made this easier.

Finding out the patients' physical limitations can often lend perspective to the EKG findings. For

example, if patients are able to exercise and run around the block without difficulty, the concern is less. On the other hand, if patients already have palpitations and aren't able to walk up stairs because of increased pulse rates, then T3 therapy would rarely be advisable. However, patients with high cardiac risk can often improve within 4 weeks of being on CardiaCare Plus. And if they go one month without having any heart palpitations or significant arrhythmias, then WT3 therapy can be considered. CardiaCare Plus will often decrease arrhythmias within 2 weeks and can be given before and during T3 therapy. It can actually decrease tachycardia immediately or within a half hour.

Patients with increased cardiac risk can be kept on smaller maximum doses of the T3 during the first round, up to 30 mcg b.i.d., and supplemented with 0.0125 mg of T4 each day for at least the first 2 or 3 months. This more conservative treatment can help patients become acclimated to the T3, especially if they are kept on a plateau dose of T3 for 3 weeks before cycling down. If they tolerate the treatment very well, the maximum dose can be increased to 45 mcg b.i.d. The next round they might go as high as 52.5 mcg. If patients still have slight arrhythmias or abnormalities on the EKG, then it is best for them to become acclimatized to the T3 for at least 6 months before trying to go as high as 75 mcg b.i.d.

Question # 7: *Can people with high pulse rates be candidates for WT3 therapy?* One capsule of CardiaCare Plus (CC+) twice a day or 20 to 60 drops of Cardiocare liquid is usually enough to bring their pulse rates down below 80 within 3 days. If they are feeling well, they can then be started on the WT3 protocol. If their pulse rates are still high, then the CC can be increased to 60 drops four times a day or CardiaCare plus can also be increased to one capsule t.i.d. Please read the product descriptions of CardiaCare and CardiaCare Plus before prescribing.

PARATHYROID METABOLISM DISORDERS

❑ **Hyperparathyroidism:** Hyperparathyroidism typically results in excess secretion of PTH by the parathyroid gland. This can be caused by parathyroid gland hyperplasia or adenoma.

❑ **Hypoparathyroidism:** Deficient PTH production by the parathyroid gland leads to hypoparathyroidism. Thyroidectomy and other types of surgery or radiation in the area of the parathyroid glands is the most common cause of hypoparathyroidism. Idiopathic hypoparathyroidism also occurs and, in some cases, may be secondary to magnesium deficiency, GI disorders, or renal disease.

❑ **Osteoporosis:** Osteoporosis occurs when new bone formation does not keep up with bone removal, leaving the bone progressively more porous and fragile. Osteoporosis is a complex disease with genetic and environmental factors. Genetic traits, gender, diet, and lifestyle play an important role in its development.

HYPERPARATHYROIDISM

Signs and Symptoms

Hyperparathyroidism is most commonly asymptomatic. When hyperparathyroidism is of long duration, nephrolithiasis is a possible presenting symptom. Muscle weakness, anorexia, nausea, and confusion are other possible symptoms.

Medical History

❑ Family history for MEN I and II
❑ History of neck irradiation

❑ History of GI or renal disease

Laboratory Tests

❑ Serum calcium (elevated)
❑ Serum phosphorus (decreased)
❑ Serum chloride/phosphorus ratio > 33 (elevated)

❑ Serum PTH (elevated)
❑ MRI

Therapeutics

Clinical Nutrition

Mild hyperparathyroidism (asymptomatic with serum calcium below 12 mg/dl) can generally be managed nutritionally. Magnesium supplementation (750 mg per day or to bowel tolerance) while avoiding excess phosphorus intake is indicated. Calcium supplementation (1500 mg q.d.) may suppress PTH via negative feedback. Fluid intake should be increased to at least six 8-oz glasses per day of water to avoid kidney stone formation.

HYPOPARATHYROIDISM

Signs and Symptoms

Hypoparathyroidism is often asymptomatic. Symptoms of hypoparathyroidism may include neurologic manifestations, such as paresthesias, depression, dementia, and psychosis. Muscle tetany is possible and is characterized by a positive Chvostek's or Trousseau's sign.

Medical History

❑ Thyroidectomy or other types of surgery in the area of the parathyroid glands

❑ Irradiation or trauma to the neck
❑ Family history of hypoparathyroidism

Laboratory Tests

❑ Serum calcium (decreased)
❑ Serum phosphorus (elevated)

❑ Serum (decreased)

Therapeutics

Clinical Nutrition

Mild hypoparathyroidism can generally be managed nutritionally. Magnesium supplementation (750 mg q.d. or to bowel tolerance) while avoiding excess phosphorus intake is indicated. Calcium supplementation (1500-2000 mg q.d.) with 50,000-100,000 IU per day vitamin D minimizes the negative calcium balance. Patients on these high doses of vitamin D need to be monitored for hypercalcemia.

OSTEOPOROSIS

Signs and Symptoms

Osteoporosis, without complications or in the earlier stages, may be aymptomatic. Symptoms that may occur include:
❑ Stooped posture

❑ Dowager's hump
❑ Shortened stature
❑ Backache
❑ Fractures which occur easily

Medical History

Risk factors for osteoporosis include:
❑ Family history of osteoporosis
❑ History of conditions which may cause GI malabsorption of nutrients
❑ History of renal disease or liver disease
❑ History of endocrine disease including glucocorticoid excess (Cushing's disease), hyperparathyroidism, hyperthyroidism, hypogonadism, hyperprolactinemia, diabetes mellitus
❑ History of corticosteroid use, ethanol and tobacco use, use of stomach acid blocking medications, anticonvulsants, lithium, furosemide, isoniazid, and heparin
❑ Exposure to heavy metals, especially aluminum
❑ Decreased exercise and little or no weight-bearing exercise
❑ Dietary deficiencies, such as deficiencies of calcium, magnesium, vitamin C, vitamin D, vitamin K, boron, manganese, and protein
❑ Dietary excesses, such as excess phosphorus, sodium, sugar, protein, and acid ash foods

Laboratory Tests

- DEXA (Dual X-Ray Absorptiometry) evaluates bone density
- D-PYD (deoxypyridinium) and PYD (pyridinium) measure osteoclastic bone loss
- Serum calcium, phosporus, chlorine, and PTH evaluates parathyroid function
- NTx (Urinary N-telopeptide of Type I collagen) indicates osteoclastic bone loss
- Urinary calcium and sodium
- Hair mineral analysis

Therapeutics

Parathyroid Nutraceuticals

Herb/Nutrient	Indication/Action	Dose
Calcium	The main mineral found in bone Microcrystalline hydroxyappatit concentrate derived from bone has been shown to increase cortical bone thickness	1,000-1,500 mg q.d. in divided doses
Magnesium	Magnesium is also necessary for the absorption of calcium and and plays a part in the conversion of vitamin D to its active form	500-700 mg q.d. in divided doses
Vitamin D	Improves intestinal calcium absorption and decreases urinary calcium loss In many patients with osteoporosis there is an impairment in renal conversion of vitamin D to its most active form	800-1200 IU q.d.
Vitamin K	Vitamin K is a cofactor in bone mineralization by improving calcium deposition in the bone matrix	2-10 mg q.d. (caution with anti-blood clotting medications)
Boron	Evidence suggests that boron may promote synthesis of compounds related to bone health, including estrogen, testosterone, DHEA, and vitamin D, and may play an important role in maintaining bone mass	3 mg q.d.
Strontium	A mineral involved in bone formation, studies have shown increased bone density with strontium supplementation	Strontium citrate: 227 mg t.i.d.
Folic Acid	Folate is important in the metabolism of homocysteine, a metabolic intermediate that may affect osteoporosis by interfering with collagen crosslinking, resulting in a defective bone matrix	400-1000 UG q.d.
Ipriflavone (7-isopropoxy-isoflavone)	Studies have shown this soy isoflavone increases bone density when combined with calcium, vitamin D, or hormone replacement	200 mg t.i.d.
Essential Fatty Acids	Studies show that essential fatty acids from fish and EPO improve calcium absorption and deposition in bone	4 g q.d. fish oil 3 g q.d. evening primrose oil
Manganese	Studies suggest that manganese is a necessary mineral for bone mineralization	2-3 mg q.d.
Bio-Identical Hormone Replacement	Estogens, progesterone, testosterone, and DHEA have all been shown to positively affect bone density	See reproductive chapter for dosing

Clinical Nutrition

- ❏ Avoid excess simple carbohydrates and simple sugars
- ❏ Avoid excess sodium
- ❏ Avoid excess phosphorus (such as in soda pops)
- ❏ Eat a diet approximately 75% alkaline ash versus 25% acid ash
- ❏ Avoid excess caffeine and diuretics
- ❏ Incorporate foods with high calcium and magnesium content
- ❏ Maintain moderate level of protein intake
- ❏ Avoid food sensitivities as they contribute to malabsorption of nutrients

Lifestyle

- ❏ Regular weight-bearing exercise
- ❏ Regular UV light exposure (15 minutes per day sun exposure without sunscreen)
- ❏ Avoid tobacco, excess alcohol, and medications that reduce bone density
- ❏ Maintain good digestion

ADRENAL METABOLISM DISORDERS

❑ **Addison's Disease/Hypoadrenalism**

Adrenal insufficiency is common in Western culture due to the high amount of psychological stress, environmental toxins, and poor nutrition, all of which deplete adrenal reserves. Other lifestyle factors in adrenal insufficiency development include inadequate amount of sleep, eating infrequently, and lack of exercise. Adrenal insufficiency can be thought of as an acute or chronic impairment of adrenal function, as opposed to the failure of the gland seen in Addison's disease.

❑ **Cushing's Disease/Hypercortisolism**

Hypercortisolism and Cushing's disease can be seen to exist as a continuum. Cortisol is normally released in response to any stress, such as physical, psychological, infection, or trauma stress. Since cortisol levels are usually not reduced until the stressor is removed, many people are suffering from a chronic form of low level Cushing's that we can call hypercortisolism.

❑ **Conn's Disease/Hyperaldosteronism**

Primary aldosteronism (Conn's disease) is a term to describe adrenal disorders in which excessive aldosterone is produced by the zona glomerulosa of the adrenals. Secondary hyperaldosteronism is due to increased aldosterone produced due to stimuli acting on the adrenals, such as excess renin, found in such disorders as renal artery stenosis.

The following questionnaire is a tool for helping to diagnose adrenal gland dysfunction that patients can quickly complete. The answers to the questions help determine whether the adrenal glands are likely implicated as a factor in a person's health concerns. The results of the questionnaire will create a picture of how the adrenal glands are functioning in terms of their response to stress. The questionnaire is not meant to replace laboratory testing, but to be used in conjunction with the standard tests used to measure adrenal function.

The questionnaire helps to identify if a person is in the "exhaustion" phase of adrenal depletion. In the "resistance" phase of adrenal dysfunction, cortisol levels tend to be high, and this results in some slightly different symptoms. For common symptoms that help to distinguish adrenal exhaustion (low cortisol) from adrenal resistance (high cortisol), see the table below entitled "Recognizing the Stages of Adrenal Dysfunction." To help distinguish low adrenal function from low thyroid function, see the section below entitled "Recognizing Weak Adrenal vs. Weak Thyroid Patterns."

Severity of Symptoms Ranking

This questionnaire is easy to complete. Simply read each statement, decide its degree of severity, and then place the appropriate number beside each statement based on the severity ranking below.

Please rank your symptom according to the categories below and enter a number from 0-4 for each question.

　0 = Never
　1 = Occasionally (1-4 times per month)
　2 = Moderate in severity and occurs moderately
　　　frequently (1-4 time per week)
　3 = Intense in severity and occurs frequently
　　　(more than 4 times per week)

ADRENAL HEALTH QUESTIONNAIRE FOR PATIENTS

KEY SIGNS AND SYMPTOMS

1. _____ I get dizzy or see spots when standing up rapidly from a sitting or lying position.

2. _____ I urinate more frequently than others and may need to get up at night.

3. _____ I feel as though I might faint or black out.

4. _____ I have chronic fatigue.

5. _____ I have mitral valve prolapse or get heart palpitations.

6. _____ I often have to force myself on order to keep going.

7. _____ I have difficulty getting up in the morning.

8. _____ I have low energy before the noon meal (approxmately 11:00 a.m.).

9. _____ I have low energy in the late afternoon between 3:00-5:00 p.m.

10. _____ I usually feel better after 6:00 p.m.

11. _____ I often feel the best late at night because I get a 'second wind'.

12. _____ I have trouble getting to sleep.

13. _____ I tend to wake early (approximately 3:00 to 5:00 a.m.) and have trouble getting back to sleep.

14. _____ I have vague feelings of being generally unwell for no apparent reason.

15. _____ I get swelling in the extremities, such as the ankles.

16. _____ I need to rest after times of mental, physical, or emotional stress.

17. _____ I feel more tired after exercise or physical, either soon after or the next day.

18. _____ My muscles feel weak and heavy more than I think they should.

19. _____ I have chronic tenderness in my back near the bottom of my rib cage.

20. _____ I have a weak back and/or weak knees.

21. _____ I have restless extremities.

22. _____ I am allergic to many things, such as foods, animals, and pollens.

23. _____ My allergies are getting worse.

24. _____ I get bags or dark circles under my eyes, which may be worse in the morning.

25. _____ I have multiple chemical sensitivities.

26. _____ I have asthma or get regular bouts of bronchitis, pneumonia, or other respiratory infections.

27. _____ I have dermatographism

(a white line appears on my skin if I run my fingernail over it and persists for one minute).

28. _____ I have an area of pale skin around my lips

29. _____ The skin on the palms of my hands and soles of my feet tends to be red/orange in color.

30. _____ I tend to have dry skin.

31. _____ I tend to get headaches and a sore neck and shoulders.

32. _____ I am sensitive to bright light.

33. _____ I frequently feel colder than others around me.

34. _____ I have decreased tolerance for cold.

35. _____ I have Raynaud's syndrome (extremely cold hands/feet).

36. _____ My temperature tends to be below normal when measured with a thermometer.

37. _____ My temperature tends to fluctuate through the day.

38. _____ I have low blood pressure.

39. _____ I become hungry, confused, or shaky if I miss a meal.

40. _____ I crave sugar, sweets, or desserts.

41. _____ I use stimulants, such as tea or coffee, to get started in the morning.

42. _____ I crave food high in fat and feel better with high-fat foods.

43. _____ I need caffeine (chocolate, tea, coffee, colas) to get me through the day.

44. _____ I often crave salt and/or foods high in salt, such as potato chips.

45. _____ I feel worse if I eat sweets and no protein for breakfast.

46. _____ I do not eat regular meals.

47. _____ I eat fast-foods often.

48. _____ I am sensitive to pharmaceutical or nutritional supplements.

49. _____ I have taken steroid medications for a long term or at high dose.

50. _____ I have symptoms that improve after I eat.

51. _____ I tend to be thin and find it difficult to put weight on.

52. _____ I have feelings of hopelessness and despair or have been diagnosed with depression.

53. _____ I lack motivation because I do not feel I have the energy to get things done.

54. _____ I have decreased tolerance towards other people and tend to get irritated by them.

55. _____ I get more than two colds or flus per year.

56. _____ It takes me a long time to recover from illness.

57. _____ I get rashes, dermatitis, eczema, psoriasis, or other chronic skin conditions.

58. _____ I have an autoimmune disease.

59. _____ I have fibromyalgia.

60. _____ I have had mononucleosis or been diagnosed with Epstein Barr virus.

61. _____ I do not exercise regularly.

62. _____ I have a history of large amounts of stress in my life.

63. _____ I tend to be a perfectionist.

64. _____ My health is negatively affected by stress.

65. _____ I tend to avoid stressful situations for the sake of my health.

66. _____ I am less productive at work than I used to be.

67. _____ My ability to focus mentally is generally impaired.

68. _____ Stressful situations hinder my ability to focus.

69. _____ Stress causes me to become overly anxious.

70. _____ I startle easily.

71. _____ It can take me days or weeks to recover from a stressful event.

72. _____ I tend to get digestive disturbances when tense.

73. _____ I tend to get unexplained fears and phobias.

74. _____ My sex drive is very low or non-existent.

75. _____ My relationships at work and/or home tend to be strained.

76. _____ My life contains insufficient time for fun and enjoyable activities.

77. _____ I have little control over my life and I feel 'stuck'.

78. _____ I tend to get addicted easily to drugs, alcohol, or foods.

79. _____ I suffer from post-traumatic distress disorder.

80. _____ I have or have had an eating disorder.

81. _____ I have gum disease and/or tooth infections or abscesses.

The next 2 questions are for women only.

82. _____ I have symptoms of premenstrual syndrome (PMS)

83. _____ My periods are irregular and/or affected by stress.

_____ Total Score

Interpretation
Total Score:
Under 40: very slight or no adrenal fatigue
41-80: mild adrenal fatigue
81-120: moderate adrenal fatigue
Above 120: severe adrenal fatigue

Recognizing Adrenal Dysfunction Stages

The adrenal glands typically go through a number of stages when responding to stress. These stages are typically known as "alarm," "resistance," and "exhaustion." The resistance phase is a common response to chronic stress and manifests as high cortisol levels. If the chronic stress persists, the next phase is known as the exhaustion phase, and manifests as low cortisol levels. One could then think of these phases as a tendency towards either Cushing's syndrome (high cortisol) or Addison's syndrome (low cortisol).

The time it takes to go from resistance to exhaustion depends on many factors, including genetics, medical history, individual stress management skills, and nutritional status. Keep in mind that these symptoms and signs are general and may vary from person to person. It is also possible for some individuals to manifest above normal cortisol levels at some times during the day or week, and abnormally low cortisol at other times. For this reason, the table below is meant to be used along with laboratory testing.

Sign or Symptom	Exhaustion Phase Tendency (Low Cortisol)	Resistance Phase Tendency (High Cortisol)
Blood pressure	Low	High
Body weight	Difficulty putting on muscle	Truncal fat deposition
Hair	Decreased body/facial hair	Increased body/facial hair
Musculoskeletal	Arthritis	Osteoporosis
Blood sugar	Low (hypoglycemic)	High (insulin resistance or diabetes)
Skin	Dry	Acne
Sweat/Secretions	Scanty	Excessive
Cholesterol	Low total cholesterol	High triglycerides

Recognizing Weak Adrenal vs. Weak Thyroid Patterns

Both low adrenal function and low thyroid function can reduce the metabolic energy available to the body, creating the symptom of fatigue. In this way, the two are often confused. The adrenals help us manage stress and maintain homeostasis, while the thyroid establishes the basic energy setpoint. Compounding the confusion is that the two conditions tend to co-exist in a great many chronically ill patients.

One way to focus in on which gland is more in need of support is through laboratory testing for thyroid and adrenal hormone levels. In addition, symptoms listed below tend to give clues as to whether the thyroid or adrenal is weaker. Keep in mind that these symptom tendencies are based on observation and are not clearly apparent in all cases. Also, a mixed picture of both hypothyroid and hypoadrenal is not uncommon. In these cases, as a general rule of thumb, support the adrenal glands first; otherwise, increased circulating thyroid hormone may further strain the already weak adrenal glands.

Sign or Symptom	Hypothyroid Tendency	Hypoadrenal Tendency
Body temperature	Low and consistent	Low and fluctuates
Energy pattern	Generally sluggish	"Wired and Tired"
Body type	Difficulty losing fat	Difficulty gaining muscle
Blood pressure	Normal to high	Low to normal
Total cholesterol	High	Low
Facial color	Reddish	Pale
Sweating	Scanty or none	Profuse
Bowels	Irritable or hyperfunctioning	Sluggish/Constipated

Signs and Symptoms

As Hans Selye observed, "the physician, in dealing with GAS, may be faced with a patient with no clear-cut diagnostic pattern, but just vague feelings of ill health." Fortunately, there are now more tools available to help with assessment of adrenal dysfunction, an important first step to choosing from among treatment options. Patient history, physical signs, and symptoms can be the most useful methods of diagnosis.

Here is a list of the common symptoms of adrenal exhaustion and the percentage of patients who experience them.

Symptoms
❏ Excessive fatigue 94%
❏ Nervousness/Irritability 86%
❏ PMS 85%
❏ Salt craving 84%
❏ Depression 79%
❏ Sweet craving 75%
❏ Allergies 73%
❏ Headache 68%
❏ Alcohol intolerance 66%
❏ Weakness 65%
❏ Neck/Shoulder pain 65%
❏ Confusion 61%
❏ Poor memory 59%
❏ Palpitations 57%
❏ Poor digestion 51%
❏ Backache 48%
❏ Lightheadedness 47%
❏ Constipation or diarrhea 45%
❏ Fainting 42%
❏ Insomnia 40%
❏ Dermatitis 39%

Signs
❏ Postural hypotension 93%
❏ Dry skin 91%
❏ Scanty perspiration 91%
❏ Low basal body temp 85%
❏ Sparse body hair 83%

Additional Symptoms
❏ Problems waking in the morning
❏ Afternoon low energy and/or evening "second wind"
❏ Increased irritability/decreased tolerance toward others
❏ Symptoms that are worse if meals skipped and better after eating
❏ Increased susceptibility to illness and increased time to recover
❏ Decreased libido
❏ Intolerance to cold

Laboratory Tests

Lab testing may be helpful to help assess the level of adrenal fatigue, to differentiate the "resistance" from the "exhaustion" phase of adrenal dysfunction, and to monitor recovery.

❑ **Saliva Cortisol:** Saliva cortisol is likely the best single test, as saliva hormones indicate the amount of hormone inside cells and the testing is simple, non-invasive, and easy to do. The best way to use saliva testing is to measure cortisol levels at least four times per day (waking, noon, afternoon, evening), which increases the chances of detecting a failure of adrenal reserve. Testing at various times in the day can also be correlated with perceived energy levels throughout the circadian rhythm cycle. DHEA-S and testosterone levels can also be measured with saliva testing, and if low, are also considered to be indicators of adrenal exhaustion, whereas high levels may indicate adrenal resistance phase.

❑ **Urinary Cortisol:** A 24-hour urinary cortisol test can be used to monitor the output and metabolism of the corticosteroids, aldosterone, and the sex hormones. Hypoadrenia is suspected for those in the bottom third of the "normal" range.

Because the urine is collected in one container, this test gives a 24-hour average, and therefore the highs and lows may cancel each other out in many patients. However, if metabolites of these hormones are included, ratios of these hormones to their metabolites can give a fairly accurate picture of an individual's adrenal hormone metabolism. This is especially useful for diagnosing syndromes, such as Apparent Mineralocorticoid Excess (AME), in which cortisol is not metabolized effectively to cortisone (typically due to an altered expression of 11-b-hydroxy steroid dehydrogenase), leading to hypertension.

❑ Urine 24-hour cortisol measurements can also be useful when performing an ACTH challenge test. In the challenge test, adrenal reserve can be functionally measured by comparing 24-hour urinary cortisol before and after stimulation of the adrenal cortex with ACTH.

❑ **Blood Tests:** Blood tests can also be used to measure circulating hormone levels related to adrenal function. However, because of a wide variation in what is considered to be "normal" levels, many symptomatic patients may not show irregularities, since in most cases of adrenal fatigue the cause is a functional lack of adrenal reserve as opposed to outright Addison's disease.

Nevertheless, on routine blood screening we may see the following in adrenal fatigue:
- Serum Na low normal
- Serum K high normal
- BUN high normal or elevated
- Eosinophils high

Therapeutics

Lifestyle and Diet
Stress Management: Stress management is a primary consideration. Any unresolved areas of stress must be addressed. Psychotherapeutic counseling may be indicated. Stress reduction techniques, such as biofeedback, meditation, yoga, and tai chi, are also useful stress reaction modulators. Rest and relaxation should be encouraged, including rest periods during the day and getting to bed early (preferably by 10:30 p.m. or before the evening "second wind"). A moderate level of enjoyable exercise is also indicated, such that one is not more fatigued after or the next day.

Diet and Nutrition: The diet should focus on consumption of a variety of whole, natural, and preferably organic foods. To control blood sugar fluctuations, each meal should combine some fat (preferably high in essential fatty acids) with protein and complex carbohydrate. Non-starchy vegetables should be eaten 6-8 servings per day. Fruits and grains should probably be avoided at breakfast because these foods can lead to pre-lunch hypoglycemia. In fact, bouts of hypoglycemia should be avoided as much as possible. Eating smaller meals more frequently, while being aware of the glycemic indices of food, is necessary if hypoglycemia needs to be managed. Salt need not be restricted especially if hypotension is a sign. Taking 1/2 teaspoon of salt twice a day is recommended. Any food sensitivities should be avoided during this phase of adrenal recovery, as well as stimulants (caffeine in any form, nicotine, etc.), alcohol, hydrogenated oils, and deep-fried foods.

Supplements and Hormones: Botanicals, nutritional supplements, and replacement hormones can be used to support the adrenal gland and to mitigate the effects of either excess or deficient cortisol production. They play an important role in adrenal fatigue

recovery. The charts below give some typical herbs, nutritional supplements, and hormones used, and the rationale for their use in both the resistance phase and exhaustion phase adrenal fatigue.

Herbs: Adaptogenic herbs help with a variety of conditions, ranging from the body's ability to handle stress to increasing red blood cell and white blood cell count in patients who are immune compromised. They can serve as part of the treatments for fatigue, hypothyroid, hyperthyroid, Graves' disease, diabetes, hypoglycemia, chronic fatigue syndrome, adrenal hyperplasia, Addi-

son's, Cushing's, and any other endocrine conditions. They are also ideal as a general daily tonic that can support the immune system and promote health. Some adaptogens also aid in digestion, circulatory tone, and various hormonal imbalances.

Nutritional Supplements: Nutritional supplements speed recovery from adrenal fatigue, prevent some of the damage caused by adrenal dysfunction, and, by helping to improve such things as motivation, energy and mood, in many cases are necessary for recovery to occur.

Adrenal Fatigue Botanicals

Herb	Action	Dose
Eleutherococcus senticosus (Siberian Ginseng)	Commonly used to treat adrenocortical hypofunction. Acts on the pituitary to stimulate the adrenal gland, thus increasing the ability for people to handle stress and to improve mental fatigue and physical endurance. Particularly useful to treat adrenal exhaustion and to correct disruptions in the HPA (hypothalamus–pituitary-axis) after a period of exogenous steroid use	2-4 g t.i.d. or 100-200 mg of a 1:20 extract (1% eleutherosides)
Glycyrrhiza glabra (Licorice Root)	Glucocorticoid potentiator that functions by inhibiting the key enzyme that inactivates steroid hormones in the liver and kidneys. Mineralocorticoid-like activity, thereby potentiating aldosterone. Useful adrenal tonic that helps with adrenal insufficiency (exhaustion), including Addison's disease	1-2 g root t.i.d. or 250-500 mg extract t.i.d. Should be used with caution in patients with high blood pressure
Withania somnifera (Ashwagandha)	Tonic for debility, exhaustion, emaciation, memory loss, muscle weakness, overwork, and insomnia. Capable of normalizing cortisol levels, whether they are too high or too low. Beneficial in both the "resistance" and "exhaustion" phases of adrenal fatigue	1-6 g q.d. in whole herb or capsule form
Oplopanax horridus (Devil's Club Root)	Notable blood sugar balancing properties, which is particularly useful for people whose energy levels vary considerably throughout the day	1 g q.d.
Polygonum multiflorum (Fo-Ti, Ho Shou Wu)	Prime rejuvenating herb in Chinese medicine. Used to treat dizziness, weakness, and numbness and to support healthy function of the liver and kidneys	1-4 g q.d.
Astragalus membranaceous (Chinese Milk Vetch)	Classic Chinese energy tonic with considerable immune-enhancing properties	2-6 g q.d.
Codonopsis pilosula (Dang Shen)	Used in Chinese medicine for fatigue, weakness, loss of appetite, and vertigo. Western research has demonstrated its strong antioxidant, anti-inflammatory, antispasmodic, and analgesic capabilities	1-6 g q.d. or as tea

Hormone Supplementation: In cases where adrenal insufficiency has been prolonged, there is limited benefit after 2 months of nutritional/lifestyle work, or laboratory values show marked deficiencies of adrenal hormones, a course of the appropriate bio-identical hormone may be indicated.

Adrenal Fatigue Nutraceuticals

Nutrient	Action	Dose
Vitamin C	Supplementation during recovery from adrenal fatigue is indicated Because cortisol is produced under stress, more vitamin C is used Because humans cannot produce vitamin C from glucose (as can most mammals), adequate intake is essential	2-6 g per q.d. Food sources, including pigmented fruits and vegetables, should be encouraged. A mineral ascorbate form is best, taken in divided doses 2-3 times q.d. Higher doses may cause loose stool. Dosage should not be reduced suddenly as this can cause a temporary deficiency.
Pantothenic Acid	Critical for the conversion of glucose into energy Present in high quantities in the adrenal glands and necessary for adrenal hormone	1500 mg q.d.
Vitamin B-Complex	B-complex of vitamins work together to produce adrenal gland hormones	50-100 mg, 2-3 times q.d.
Magnesium	Necessary for energy production, adrenal function, and restful sleep Deficiency is common in adrenal fatigue	400-600 mg q.d. Best taken after 8 p.m. to promote sleep
Calcium	Helps to settle an overactive nervous system and is helpful to counteract stress Helpful in preventing osteoporosis associated with a chronic resistance phase (high cortisol) lifestyle	750-1000 mg q.d.
Potassium	Can be supplemented to counter the mineralocorticoid excess of the resistance phase and promote healthy blood pressure	2-5 g q.d. intake from all sources
Chromium	Helps regulate blood sugar by improving tendency to insulin resistance and reduces cravings for simple carbohydrates	500-1500 mcg q.d.
Phosphatidyl Serine	Promotes calming neurotransmitters and appears to lower excess cortisol in the resistance phase	100 mg, 2-3 times q.d.
Tyrosine	As a precursor to catecholamine neurotransmitters, it is helpful to treat depression and to promote healthy thyroid function	500 mg, 2-3 times q.d.

Hormone Supplements

Hormone	Action	Dose
Adrenal Glandular Extracts (liquid or powder extracts of animal adrenal glands)	Support and enhance adrenal activity by providing essential nutrients in combination with very small amounts of adrenal hormones	250 mg, 1-3 times q.d.
Melatonin	Secreted by the pineal gland, this hormone promotes relaxation and restorative sleep, and is thus useful for those with insomnia or unable to get restorative sleep, especially seen in the resistance phase	3-9 mg at bedtime
DHEA	Adrenal hormone that is an adrenal androgen, precursor to testosterone, and glucocorticoid antagonist. As a glucocorticoid antagonist, useful to compensate for the excess cortisol seen in the resistance phase	5-100 mg q.d. Should be supplemented if shown low on lab testing or if autoimmune disease is an issue
Thyroid Hormones	Shown to normalize adrenal insufficiency itself. However, in more severe forms of hypoadrenalism, thyroid hormone should be used cautiously or avoided in exhaustion phase until the adrenals are supported to reduce risks of tachycardia and anxiety	See chart in "Thyroid Disorder Protocols" for dosages and types of thyroid supplementation
Pregnenolone	Precursor to DHEA	10-30 mg b.i.d.
Cortisol	A course of bio-identical cortisol may be indicated in moderate to severe fatigue	1-12 mg Highest dose on rising, then taper dose at noon and afternoon or evening

Prognosis

- Mild adrenal insufficiency typically responds within weeks with major improvement seen within 2 months.
- Moderate to severe cases may take 6 months to a year to reach 80%-100% improvement, and improvements may be punctuated by symptom recurrences. Patients with longstanding and severe symptoms may not progress beyond 80% recovery.
- If no improvements are seen in 2 months, be sure that all issues have been addressed, including chronic stress, physical exercise, restorative sleep, elimination of food sensitivities, lingering or undiagnosed chronic infections, accumulated body toxins, such as heavy metals, repeated and ongoing workplace or home environmental exposures, and intestinal dysbiosis.

Cautions: The use of adrenal hormones, such as cortisol, can potentially cause anxiety and tachycardia in patients. High doses of DHEA can increase testosterone levels. Botanicals, such as ginseng, can sometimes cause insomnia. Licorice in high doses can cause high blood pressure.

REPRODUCTIVE HORMONE DISORDERS AND NORMAL FUNCTIONAL CHANGES

There are many reproductive disorders that are not mentioned here, but briefly mentioned in the chapter. The scope of this book does not cover gynecology in detail, providing, instead, a basic review of hormonal conditions. This protocol section focuses on the main conditions that are successfully treated with naturopathic medicine.

Male

❑ **Hypogonadism:** Male hypogonadism is the inability of the testes to produce adequate testosterone. It can arise as a result of genetic, environmental, or physiological causes. Conservative estimates reveal that 20% of men may have this condition, but other sources say that the occurrence could be much higher.

Female

❑ **Endometriosis:** Endometriosis is a common and often painful disorder of the female reproductive system. In this condition uterine endometrial tissue becomes implanted outside the uterus, most commonly on the fallopian tubes, ovaries, or the peritoneum.

❑ **PMS:** PMS is a group of symptoms that include mood swings, hypoglycemia (food "cravings"), depression, bloating, and other complaints that occur during the luteal phase of the menstrual cycle.

❑ **PCOS:** Polycystic Ovary Syndrome is a common condition (4% to 10% of American women of reproductive age) that accounts for approximately 8% of anovulation cases. PCOS is used to describe a group of clinical presentations characterized by bilateral polycystic ovaries potentially combined with amenorrhea, anovulation, infertility, insulin resistance, truncal obesity, and hirsutism. Hormone imbalances may include hypothalamus, pituitary, ovarian, adrenal, insulin excess (syndrome X), androgen excess, and prolactin excess.

❑ **Menopause:** The normal cessation of menstruationnormally occurs between 40 and 60 years of age. The initial symptoms may include irregular menstrual cycles, anovulation, and hot flashes. The ovaries diminish their production of progesterone and estrogen.

Associated Conditions

❑ **Autoimmune Conditions:** According to a 2002 study released by the National Institute of Child Health and Human Development, women who have endometriosis are more likely than other women to have disorders in which the immune system attacks the body's own tissues. These include lupus, Sjögren syndrome, rheumatoid arthritis, and multiple sclerosis. The researchers also found that women with endometriosis are more likely to have chronic fatigue syndrome and fibromyalgia —a disease involving pain in the muscles, tendons, and ligaments. Women with endometriosis are more likely to have asthma, allergies, and eczema (a skin condition).

❑ **Hypothyroidism:** An underactive thyroid gland was more common among women with endometriosis. Two thirds of the women reported that relatives also had diagnosed or suspected endometriosis, suggesting the condition may be inherited.

THE HORMONE BALANCE TEST

(Reprinted by permission of John Lee at www.johnleemd.com)

Dr John Lee developed this highly effective questionnaire for diagnosing reproductive hormone disorders in men and women.

Find Out if Your Symptoms Are Due to a Hormonal Imbalance

1. Read carefully through the list of symptoms in each group, and put a check mark next to each symptom that you have. (If you check off the same symptom in more than one group, that's fine.)
2. Go back and count the check marks in each group.

In any group where you have two or more symptoms checked off, there's a good chance that you have the hormone imbalance represented by that group.

3. The more symptoms you check off, the higher the likelihood that you have the hormone imbalance represented by that group. (Some people may have more than one type of hormonal imbalance.)
4. It is recommended that you print these pages and use them as a reference.
5. Go to the "Answers" section at the end of the questionnaire.

HORMONE BALANCE TEST FOR MEN

SYMPTOM GROUP 1

❑ Weight loss	❑ Enlarged breasts	❑ Loss of muscle	❑ Lower stamina
❑ Lower sex drive	❑ Softer erections	❑ Fatigue	❑ Gallbladder problems

Total Boxes Checked _____
(If you have checked two or more boxes in this group, turn to "Answers" to find out what type of hormonal imbalance you may have.)

SYMPTOM GROUP 2

❑ Hair loss	❑ Headaches	❑ Prostate enlargement	❑ Breast enlargement
❑ Irritability	❑ Weight gain	❑ Puffiness/bloating	

Total Boxes Checked _____
(If you have checked two or more boxes in this group, turn to "Answers" to find out what type of hormonal imbalance you may have.)

HORMONE BALANCE TEST FOR WOMEN

SYMPTOM GROUP 1

❑ PMS	❑ Insomnia	❑ Early miscarriage	❑ Painful and/or lumpy breasts
❑ Unexplained weight gain	❑ Cyclical headaches	❑ Anxiety	❑ Infertility

Total Boxes Checked _____
(If you have checked two or more boxes in this group, turn to "Answers" to find out what type of hormonal imbalance you may have.)

HORMONE BALANCE TEST FOR WOMEN CONTINUED

SYMPTOM GROUP 2

- ❏ Vaginal dryness
- ❏ Night sweats
- ❏ Painful intercourse
- ❏ Memory problems

- ❏ Bladder infections
- ❏ Lethargic depression
- ❏ Hot flashes

Total Boxes Checked _____
(If you have checked two or more boxes in this group, turn to "Answers" to find out what type of hormonal imbalance you may have.)

SYMPTOM GROUP 3

- ❏ Puffiness and bloating
- ❏ Cervical dysplasia (abnormal pap smear)
- ❏ Rapid weight gain
- ❏ Breast tenderness

- ❏ Mood swings
- ❏ Heavy bleeding
- ❏ Anxious depression
- ❏ Migraine headaches

- ❏ Insomnia
- ❏ Foggy thinking
- ❏ Red flush on face
- ❏ Gallbladder problems

- ❏ Weepiness

Total Boxes Checked _____
(If you have checked two or more boxes in this group, turn to "Answers" to find out what type of hormonal imbalance you may have.)

SYMPTOM GROUP 4

A combination of the symptoms in #1 and #3

Total Boxes Checked _____
(If you have checked two or more boxes in this group, turn to "Answers" to find out what type of hormonal imbalance you may have.)

SYMPTOM GROUP 5

- ❏ Acne
- ❏ Polycystic ovary syndrome (PCOS)
- ❏ Excessive hair on the face and arms
- ❏ Hypoglycemia and/or unstable blood sugar

- ❏ Thinning hair on the head
- ❏ Infertility
- ❏ Ovarian cysts
- ❏ Mid-cycle pain

Total Boxes Checked _____
(If you have checked two or more boxes in this group, turn to "Answers" to find out what type of hormonal

SYMPTOM GROUP 6

- ❏ Debilitating fatigue
- ❏ Unstable blood sugar
- ❏ Foggy thinking
- ❏ Low blood pressure

- ❏ Thin and/or dry skin
- ❏ Intolerance to exercise
- ❏ Brown spots on face

Total Boxes Checked _____
(If you have checked two or more boxes in this group, turn to"Answers" to find out what type of hormonal imbalance you may have.)

Answers

Men

1. **Symptom Group 1**

 Testosterone deficiency: This is most common in men over the age of 50 and can be remedied with special nutritional supplements; increased muscle-building exercise; and supplemental hormones, including DHEA, androstenedione, and (natural) testosterone. It is recommended that you get a saliva hormone test to find out which hormone would be best for you.

2. **Symptom Group 2**

 Excess estrogen: In men, excess estrogen can be balanced with one of the male hormones and changes in diet and lifestyle.

Women:

1. **Symptom Group 1**

 Progesterone deficiency: This is the most common hormone imbalance among women of all ages. You may need to change your diet, get off of synthetic hormones (including birth control pills), and use some progesterone cream. (This is explained in detail in Dr Lee's books, *What Your Doctor May Not Tell You About Menopause* and *What Your Doctor May Not Tell You About PREMenopause*)

2. **Symptom Group 2**

 Estrogen deficiency: This hormone imbalance is most common in menopausal women; especially if you are petite and/or slim. You may need to make some special changes to your diet; take some women's herbs; and some women may even need a little bit of natural estrogen (about one-tenth the dose prescribed by most doctors).

3. **Symptom Group 3**

 Excess estrogen: In women, this is most often solved by getting off of the conventional synthetic hormones most often prescribed by doctors for menopausal women.

4. **Symptom Group 4**

 Estrogen dominance: This is caused when you don't have enough progesterone to balance the effects of estrogen. Thus, you can have low estrogen, but if you have even lower progesterone, you can have symptoms of estrogen dominance. Many women between the ages of 40 and 50 suffer from estrogen dominance.

5. **Symptom Group 5**

 Excess androgens (male hormones): This is most often caused by too much sugar and simple carbohydrates in the diet.

6. **Symptom Group 6**

 Cortisol deficiency: This is caused by tired adrenals, which is usually caused by chronic stress. If you're trying to juggle a job and a family, chances are good you have tired adrenals.

MALE HYPOGONADISM

Signs and Symptoms

If onset is before 12 weeks, inadequate differentiation of the external genitalia may occur. This can range from mild hypospadia to fully developed female external genitalia. Prepubertal deficiency results in inadequate secondary sexual development (voice, muscle, pubic/axilla hair, small penis/scrotum etc). Postpubertal deficiency results in decreased libido, infertility, impotence, and decreased muscle mass. Osteopenia, sparse body hair, gynecomastia, may also be present.

Medical History

Causes of Hypogonadism

❏ Pituitary tumors
❏ Congenital
❏ Cryptorchidism
❏ Chronic/systemic illness
❏ Surgery
❏ Chemotherapy
❏ Premature aging
❏ Testicular or pituitary trauma
❏ Stress
❏ Klinefelter's syndrome
❏ Autoimmune damage
❏ Tobacco, alcohol and cannabis
❏ Sleep apnea
❏ Excessive heat
❏ Obesity
❏ Hypercortisolism
❏ Medications

Physical Examination

Exam will reveal often loss of muscle mass and obesity.

Laboratory Tests

- ❖ Serum testosterone (free and protein bound) levels as well as serum LH, FSH, PRL, and DHEA are indicated

- ❖ A semen analysis provides a measure of seminiferous tubular function.

Therapeutics

Clinical Nutrition
Diet: Eating foods high in zinc, such as pumpkin seeds, is beneficial.

Hypogonadism Botanicals and Nutraceuticals

Herb/Nutrient	Indication/Action	Dose
Zinc (picolinate, citrate)	Zinc deficiency is associated with male hypogonadism and zinc supplementation increases serum testosterone in marginal deficiency states	20-100 mg q.d. (with 2-4 mg copper if using long term)
Vitamin C	Improves sperm quality, detoxifies heavy metals	500 mg q.d. up to bowel tolerance
Arginine	Improves circulation to testes, erectile function, and sperm motility and count[i]	4-6 g q.d.
Coenzyme Q10	Improves mitochondrial function, improves fertility/sperm motility and count[ii]	30-180 mg q.d.
Panax ginseng (root)	Increases testosterone levels[iii], supports adrenal gland function	4-6 g root q.d. or 200 mg t.i.d .of 5% ginsenosides extract
Tribulus terrestris (Puncture Vine)	Increases testosterone by up to 30%[iv]	750-1500 mg q.d.
DHEA	Testosterone precursor produced by the adrenal glands	25-50 mg q.d.
Testosterone (bio-identical)	Transdermal to the scrotum	50-100 mg q.d.

Prognosis

Many forms of testicular failure are irreversible. However, androgen replacement is effective in reversing symptoms, though it may not restore fertility. Naturopathic approaches are very effective for functional low androgens and can improve sperm motility and quantity.

POLYCYSTIC OVARY SYNDROME

Signs and Symptoms

❏ Typically, patients present with amenorrhea and hirsutism

❏ Overweight or obese. A waist/hip ratio of 0.8 or greater is common

❏ However, they may also have irregular, profuse bleeding, and be of normal weight with no signs of hirsutism

❏ Infertility, metrorrhagia, and menorrhagia are also common complaints

Medical History

❏ PCOS may begin gradually in puberty and worsen with time

❏ There is an associated increased risk of cardiovascular disease, dyslipidemia, insulin resistance, reproductive system cancers, and acanthosis nigricans

❏ Thyroid disorders, adrenal hypercortisolism, and ovarian cancer must be ruled out

Laboratory Tests

❏ LH levels are typically elevated with relatively low FSH, although both may be in the normal range

❏ Serum androgen levels (testosterone, androstenedione, DHEA) are typically elevated

❏ Pelvic ultrasound may reveal many 2-6 mm follicular cysts

Therapeutics

Improving insulin resistance is important to any PCOS treatment protocol. Therefore, the treatment protocols for metabolic syndrome (hyperinsulinemia) are also relevant to PCOS.

PCOS Botanicals and Nutraceuticals

Herb/Nutrient	Indication/Action	Dose
Vitamin B-6 (Pyridoxal-5-Phosphate)	Necessary for dopamine synthesis and to inhibit prolactin synthesis	50-100 mg q.d.
Calcium/Vitamin D	Helps reset and balance menstrual cycle	1000 mg q.d. calcium; 400 IU vitamin D (higher doses have been studied)
Vitex agnus castus (Chaste Berry)	Inhibits PRL	180-240 mg q.d. of standardized extract
GLA	Inhibits PRL	200-300 mg q.d.
Serenoa repens (Saw Palmetto)	Reduces virilization by inhibiting conversion of testosterone to DHT	160-320 mg q.d. of 90% fatty acid extract
D-chiro-inositol	Improves the insulin resistance found in PCOS and lowers serum androgens	1200 mg q.d.

Clinical Nutrition

Diet: Eating foods with low a glycemic index is essential. Eating a tablespoon of omega oil can be beneficial in balancing the often-associated high insulin levels.

Lifestyle

Aerobic exercise, 30 minutes minimum three times a week, with obese patients can also be beneficial in decreasing the insulin levels.

Prognosis

With proper diagnosis and treatment, most PCOS symptoms can be adequately controlled or eliminated. Patients should be monitored for endometrial cancer, blood glucose levels, LDL cholesterol, and triglycerides. Restoration of fertility is likely in most patients.

ENDOMETRIOSIS

Signs and Symptoms

❑ Pelvic pain and/or low back pain associated with menses is common, although even severe endometriosis can by asymptomatic.
❑ Lesions on the large bowel may cause pain with defecation, abdominal bloating, or rectal bleeding with menses.
❑ Nausea, vomiting, and other digestive complaints are possible.
❑ Bladder lesions may cause painful urination.
❑ Prolonged or excessive menstrual bleeding may lead to anemia.
❑ Infertility is an associated complaint.

Medical History

❑ There is evidence of a familial inheritance pattern, so family history of endometriosis is relevant.
❑ Exposure to environmental xenoestrogens have been linked to the development of this condition.
❑ Pelvic inflammatory disease, ectopic pregnancy, ovarian cancer, uterine fibroids, and colon cancer are differential diagnoses.

Laboratory Tests

❑ Hormone testing for imbalances of estrogen/progesterone.
❑ Laparoscopy is needed to confirm the diagnosis.
❑ Food/environmental sensitivity testing (ELISA) and digestive function (comprehensive stool analysis) may point to immune stressors that correspond to the immune imbalance theory of endometriosis.
❑ Liver detoxification profile testing may point to liver dysfunction as an etiology.

Endometriosis Botanicals and Nutraceuticals

Herb/Nutrient	Indication/Action	Dose
Vitamin B-6 (Pyridoxal-5-Phosphate)	Cofactor for estrogen metabolism in the liver	50-100 mg q.d.
Magnesium	Reduces muscle cramping and is a cofactor in estrogen metabolism	500 mg q.d.
Crataegus oxycantha (Hawthorne Berry)	Improves circulation to the pelvic area and supports blood vessel integrity	1/4-1/2 tsp solid extract t.i.d.

Endometriosis Botanicals and Nutraceuticals continued...

Herb/Nutrient	Indication/Action	Dose
Vitex agnus castus (Chasteberry)	Well studied progesterogenic effects useful if estrogen/progesterone ratio is elevated	180-240 mg q.d. of standardized extract
GLA	Stimulates PG1 that is anti-inflammatory	200-300 mg q.d.
Indole-3-Carbinole (I3C)	Assists the liver in metabolizing estrogens	300 mg q.d.
Taraxacum officinalis (Dandelion Root)	One of many possible herb or part of an herbal formula for liver detoxification	500 mg t.i.d.
Bio-identical Progesterone Cream	Corrects imbalance of estrogen/progesterone ratio	1/4 -1/2 tsp transdermal cream beginning after ovulation until period begins (day 15 to day 28)

Prognosis

Women experience a wide variety of responses to naturopathic therapy. Responses range from complete resolution of symptoms to no relief and further progression of the disease. Most women do get some relief of symptoms if they exist.

PREMENSTRUAL SYNDROME (PMS)

Signs and Symptoms

- ❏ Abdominal bloating
- ❏ Menorrhagia
- ❏ Anxiety
- ❏ Moodiness
- ❏ Brain fog
- ❏ Headaches
- ❏ Palpitations
- ❏ Cravings
- ❏ Insomnia
- ❏ Poor memory
- ❏ Depression
- ❏ Irritability
- ❏ Weight gain
- ❏ Emotional lability
- ❏ Mastalgia
- ❏ Swollen extremities

Medical History

- ❏ A history of alcohol intolerance, oral contraceptive intolerance, postpartum depression, toxemia of pregnancy, alcohol abuse, and drug addiction is found more often in individuals with PMS.
- ❏ Differential diagnosis includes pelvic inflammatory disease (PID), endometriosis, ovarian cysts, depression/bipolar, hyperprolactinemia, hypothyroidism, fibrocystic breast disease, and fibromyalgia.

Physical Examination

- ❏ Physical exam including pelvic exam and pap smear.
- ❏ A basal body temperature chart with concomitant symptoms may be helpful in evaluating the hormonal cycle.

Laboratory Tests

❑ Hormone tests, including LH, FSH, Estradiol, TSH, and progesterone.

Therapeutics

PMS Botanicals and Nutraceuticals

Herb/Nutrient	Indication/Action	Dose
Vitamin B-6 (Pyridoxal-5-Phosphate)	Cofactor for estrogen metabolism in the liver	50-100 mg q.d.
Magnesium	Reduces muscle cramping and is a cofactor in estrogen metabolism	500 mg q.d.
Calcium	Improves mood, fluid retention, food cravings and cramping	1000 mg q.d.
Vitex agnus castus (Chasteberry)	Well studied progesterogenic effects for PMS	180-240 mg q.d. of standardized extract
GLA	Stimulates PG1 that benefits PMS	200-300 mg q.d.
Indole-3-Carbinole (I3C)	Assists the liver in metabolizing estrogens	300 mg q.d.
Angelica sinensis (Dong Quai)	Reduces cramping, breast tenderness, relaxes smooth muscle	500 mg 1-2 time q.d. Typically used before period (day 21 to day 28)
Bio-identical Progesterone Cream	Corrects imbalance of estrogen/progesterone ratio	1/4-1/2 tsp transdermal cream beginning after ovulation until period begins (day 15 to day 28)

Prognosis

Almost all women can expect symptom improvement with naturopathic therapies for PMS.

MENOPAUSE

Signs and Symptoms

❑ Irregular menstrual period
❑ Vasomotor instability (hot flashes, night sweats)
❑ Emotional lability
❑ Osteoporosis
❑ Insomnia
❑ Cardiac dysrhythmias/tachycardia
❑ Dyslipidemia
❑ Atrophic vaginitis
❑ Cystitis

❑ Stress incontinence
❑ Poor concentration
❑ Low libido
❑ Arthralgia
❑ Depression
❑ Skin and hair changes (acne, wrinkling, facial hair growth, hair loss on scalp)
❑ Poor Memory
❑ Fatigue

Medical History

❑ The family and patient history should be evaluated for breast cancer, stroke, uterine cancer, ovarian cancer, colon cancer, osteoporosis, and heart disease.
❑ Rule out other conditions or pharmaceuticals that can cause amenorrhea or mimic menopausal symptoms, such as:
 • High levels of intense aerobic exercise or physical training
 • Stress which results in adrenal hypofunction

• Pregnancy
• Eating disorders
• Surgeries that affect ovarian function
• Thyroid disorders
• Pharmaceutical agents that affect estrogen levels or cause vasomotor symptoms
• Immune disorders/chronic infections that cause night sweats
• Psychological conditions, such as panic attacks

Laboratory Tests

❑ Serum hormone testing for FSH is standard, as it increases 10-20 times at the onset of menopause.
❑ Serum LH increases approximately three times and can also be tested.
❑ Other hormone tests include thyroid (TSH), adrenals (cortisol, DHEA), estrogen (E2), progesterone, and testosterone.
❑ In terms of prevention, serum lipids, stress electrocardiography, bone density, and urine calcium balance can be assessed.

Therapeutics

Clinical Nutrition

Diet: High amounts of soy products, such as tofu or soy milk, can be beneficial.

Menopause Botanicals and Nutraceuticals

Herb/Nutrient	Indication/Action	Dose
Soy Protein	Reduces hot flashes, increases bone density, improves lipid profiles, inhibits cancer	Up to 60 g q.d. Caution if thyroid low or food allergies to soy
Vitamin E (mixed tocopherols)	Reduces hot flashes	800-1200 IU q.d.
Cimicifuga racemosa (Black Cohosh)	Reduces hot flashes, palpitations, insomnia, and depression	40-80 mg, 1-2 times q.d.
Vitex agnus castus (Chasteberry)	Reduces hot flashes, progesterogenic	160-240 mg of standard extract
Leonurus cardiaca (Motherwort)	Reduces heart palpitations and anxiety	200 mg, 3 times q.d.
Bio-identical Progesterone Cream	Reduces hot flashes and other symptoms and may assist in bone density	Minimal dose to relieve symptoms and protect uterus if estrogens used (100 mg progesterone for each 1 mg E2 replaced)
Bio-identical Estrogens Triest or Biest	Very efficient at relieving menopausal symptoms	Minimum dose to relieve symptoms (approximately 2.0-5.0 mg total estrogens)
Bio-identical Testosterone	Improves libido	Minimum dose to relieve symptoms

Prognosis

The majority of women can successfully manage menopausal symptoms with non-hormonal naturopathic treatments. For the small percentage of women who require some form of hormonal treatment, bio-identical hormone replacement is usually effective.

ENDOCRINE DRUG AND HERB INTERACTIONS

BLOOD SUGAR METABOLISM
Diabetes Drugs
- **Biguanides:** Metformin (Glucophage)
- **Sulphonylureas:** acetohexamide (Dymelor), chlorpropamide (Diabinese, Glucamide), glimepiride (Amaryl), glipizide (Glucotrol), glyburide (DiaBeta, Glynase, Micronase), tolazamide (Tolinase), tolbutamide (Orinase)
- **Insulin**
- **Glucagon**

Herb-Drug Interactions
- **Ephedrine:** Ephedrine and also the plant *Ephedra sinica* (Ma huang) may decrease insulin effectiveness, thereby increasing hyperglycemia.
- **Lithium:** with the use of sulfonylureas may increase the risk of hypoglycemia.
- **Digoxin:** combined with Glucophage has the ability to compete for renal tubular transport, causing an increase in plasma Glucophage.

Drug-Induced Nutritional Deficiencies
- **CoQ10 deficiency:** can be caused by the use of sulphonylurea drugs, glyburide, acetohexamide (Dymelor) and tolazamide (Tolinase). Extended use of these drugs can cause cardiac symptoms.
- **Vitamin B-12 deficiency:** induced neuropathy can be caused by the use of biguanides, such as Phenformin.

Nutritional Effects on Blood Sugar
- **Biotin:** may help insulin work better in some cases. Some studies have implied that its mild hypoglycemic effect can be independent of insulin as well.
- **Alcohol:** may exert an increased hypoglycemic response when taking sulphonylureas.
- **Chocolate, coffee, cola nut, *Ephedra sinica*, black tea, liberal use of rosemary leaves:** can increase hyperglycemia.
- **Fiber, magnesium hydroxide:** may increase the chance of hypoglycemia.
- **Niacin:** can increase blood sugar.
- **Vitamin E:** may cause glycosylated hemoglobin levels to appear better than they are.

LIPIDS METABOLISM
Lipids Drugs
- **Bile acid-binding resins:** cholestyramine (Questran, Cholybar), colestipol (Colestid).
- **HMG-CoA reductase inhibitors:** Lovastatin (Mevacor), simvastatin (Zocor), pravastatin (Pravachol), fluvastatin (lEscol)
Other: clofibrate, probucol

Drug Interactions
- **Niacin:** with HMG-CoA reductase inhibitors increases the likelihood of rhabdomyolysis and myopathy.

Drug-Induced Nutritional Deficiencies
- **Bile acid resins carotene levels, calcium, vitamin D, A, K , E, dietary fats, and iron:** for example, the drug probucol (Lorelco) lowers not only beta carotene levels but other antioxidants, such as lycopene.
- **CoQ10 production:** inhibited by HMG-CoA reductase inhibitors. 100 mg of Coq10 supplementation per day can offset this side effect.
- **Folic acid deficiency:** linked to the use of bile acid resins.
- **Folic acid, and vitamin B-12:** decreased by cholesterol and lipid lowering drugs.

THYROID METABOLISM
Thyroid Drugs
- **Levothyroxine sodium (T4):** Levothroid, Synthroid, Levoxyl
- **Liothyronine sodium (T3):** Cytomel
- **Thyroid USP:** Armour thyroid, Westhroid, Thyroid Strong

Drug Interactions
- **Cardiac glycosides (such as digitalis glycosides):** become reduced when taking thyroid hormone replacement.
- **Thyroxine:** is less bioavailable when consumed with iron.
- *Lycopus virginicus*: inhibits both the conversion of T4 to T3 in the liver as well as inhibits TSH.

- **Lithium:** may result in a necessary increase in thyroid hormone supplementation.
- **Coumadin:** is 50% to 400% more effective in patients taking thyroid supplementation. Untreated hypothyroid patients need higher dose of Coumadin.

ADRENAL METABOLISM
Adrenal Drugs

- **Aerosols:** beclomethasone, dexamethasone, tri-amcinolone, etc.
- **Topical applications:** alclometasone, amcinonide, methyl prednisone, betamethasone, etc.
- **Oral and parenteral:** methasone. Cortisone, dexamethasone, hydrocortisone, methyl prednisone, hydrocortisone, etc.

Drug Interactions

- **Ephedrine:** a compound found in *Ephedra sinica* has been shown to decrease the half-life of dexamethasone.
- **Antacids:** decreases oral corticosteroids effectiveness.
- **Calcium:** supplementation may overcome corticosteroid-induced osteoporosis.

Drug-Induced Nutritional Deficiencies
- **Folic Acid, Potassium, Vitamin B-6, Vitamin B-12, Vitamin D:** all depleted by the use of corticosteroids.

FEMALE HORMONE METABOLISM
- **Estrogen Drugs:** Chlorotrianisene, conjugated estrogens, dienestrol, diethelstilbuterol, estradiol, estrone, Estropipate, ethinyl estradiol, quinestrol

Drug Interactions
- **Caffeine:** may decrease the effectiveness of birth control pills.
- **Calcium and copper:** absorption is increased with oral estrogen therapy.

Drug-Induced Deficiencies
- **Folic Acid, Vitamin B-6, Vitamin B-12, Vitamin E:** may decrease while taking estrogen therapy.

SELECTED CLINICAL STUDIES AND LITERATURE REVIEWS

The following clinical studies, research papers, literature reviews, and scientific articles are written on a wide variety of subjects pertaining to endocrinology from a naturopathic perspective. These works are written by a wide variety of authors from different medical traditions, ranging from a doctor of Ayurvedic medicine at Banaras Hindu University in India, to a professor of endocrinology at the University of Southern California at Los Angeles, including pioneering medical research scientists and doctors, such as Dr Abram Hoffer, Dr John Lee, and Dr Alan Gaby.

Some of these articles reflect a different approach to endocrinology than what traditional textbooks have taught us. It might prove to be inspiring to realize that many more endocrine conditions can be treated successfully when addressing the root cause. We trust the challenging work of these authors will encourage others to conduct their own research into the causes and treatments for endocrine disorders. If nothing else, these studies, papers, reviews, and articles will provoke fruitful debate.

Insulin Resistance: Lifestyle and Nutritional Interventions
by Gregory S. Kelly (ND), Associate Editor, *Alternative Medicine Review*

(Reprinted from Alternative Medicine Review, *2000;5(2):109-32, by permission of Thorne Research, Inc.*
Copyright©2000, Thorne Research, Inc. All rights reserved)

ABSTRACT
Insulin resistance appears to be a common feature and a possible contributing factor to several frequent health problems, including diabetes mellitus type 2, polycystic ovary disease, dyslipidemia, hypertension, cardiovascular disease, sleep apnea, certain hormone-sensitive cancers, and obesity. Modifiable factors thought to contribute to insulin resistance include diet, exercise, smoking, and stress. Lifestyle intervention to address these factors appears to be a critical component of any therapeutic approach. The role of nutritional and botanical substances in the management of insulin resistance requires further elaboration; however, available information suggests some substances are capable of positively influencing insulin resistance. Minerals, such as magnesium, calcium, potassium, zinc, chromium, and vanadium, appear to have associations with insulin resistance or its management. Amino acids, including L-carnitine, taurine, and L-arginine, might also play a role in the reversal of insulin resistance. Other nutrients, including glutathione, coenzyme Q10, and lipoic acid, also appear to have therapeutic potential. Research on herbal medicines for the treatment of insulin resistance is limited; however, silymarin produced positive results in diabetic patients with alcoholic cirrhosis, and *Inula racemosa* potentate insulin sensitivity in an animal model.

INTRODUCTION
Estimates suggest that in Westernized countries 25% to 35% of the population have a degree of insulin resistance and the health consequences associated with this metabolic derangement.[1] Insulin resistance means, in its simplest sense, that the ability of insulin to dispose of glucose in the liver, skeletal muscle, and other peripheral tissues is compromised. From a quantitative standpoint, skeletal muscle is presumed to have the greatest impact on whole-body glucose disposal, and hence on insulin resistance.

Higher fasting and post-glucose loading insulin levels, as well as a decreased responsiveness of tissue to the insulin driven clearance of this glucose from the bloodstream, usually characterize insulin resistance. Insulin resistance seems to be a common feature and a possible contributing factor to several frequent health problems, including type 2 diabetes mellitus,[2] polycystic ovary disease,[3-5] dyslipidemia,[6] hypertension,[7-8] cardiovascular disease,[9-13] sleep apnea,[14] certain hormone-sensitive cancers,[2,15,16] and obesity.[17-20]

Obesity appears to be predictably accompanied by insulin resistance, with the degree of insulin resistance often in direct proportion to the amount of visceral body fat. This relationship holds across age and sex boundaries.[18,21] Although obesity correlates with insulin resistance, it appears the distribution of body fat might be an even more specific marker. Central or abdominal obesity has been reported to have such a close association with insulin resistance that it is often now viewed as a clinical marker for this metabolic dysregulation.[17] Because of the relationship between central adiposity and insulin resistance and because of the correlation between insulin resistance and increased cardiovascular disease risk, it has been suggested that health care providers should begin using waist measurements as a public health tool in screening for high-risk candidates for cardiovascular disease.[22]

Table 1: Some Metabolic Associations with Insulin Resistance
- Leptin resistance [23,24]
- Dyslipidemia [6]
- Elevated lipoprotein (a) levels [25]
- Elevated homocysteine [25]
- High triglycerides [26]
- Impaired glucose transport system of skeletal muscle (GLUT-4) [1]
- Hypercortisolism [27]
- Decreased DHEA [28]
- Low growth hormone levels [29]
- Increased lipogenesis (production of fat) and decreased beta oxidation (burning of fat) [30,31]
- Increased TNFa [32]
- Hemostatic dysfunction including indreased thrombosis, high fibrogen levels, and tendency to platelet aggregation [33]
- Increased blood pressure [7,8]
- Increased oxidative stress [34]

A clustering of metabolic problems associated with insulin resistance, including elevated plasma glucose, lipid regulation problems (elevated triglycerides, increased small low-density lipoproteins, and decreased high-density lipoproteins), high blood pressure, a prothrombic state, and obesity (especially central obesity) occurs commonly together. (Table 1) This combination is referred to as either "The Metabolic Syndrome" or "Syndrome X." Research suggests this cluster of metabolic disorders seems to interact to promote the development of type 2 diabetes, atherosclerosis, and cardiovascular disease. And, while insulin resistance might lie at the heart of the problem, all of these metabolic disorders appear to be closely related and can, together or independently, contribute to health problems.[6,17] Many overweight individuals have either components of or the entire cluster of symptoms associated with this syndrome.[21]

LIFESTYLE MODIFICATIONS AND INSULIN RESISTANCE

The stark reality is that a majority of people with this metabolic problem developed insulin resistance as a result of a lifetime of cumulative poor choices. Factors thought to contribute to insulin resistance include diet, exercise, smoking, and stress. Although there are certainly genetic factors contributing to this metabolic state, since the above factors are all modifiable to a greater or lesser degree, insulin resistance is potentially preventable. Even among those members of the population with a genetic propensity for this metabolic challenge, it appears appropriate lifestyle choices play a large part in its manifestation and reversal.

Diet

The ideal diet for modifying insulin resistance should reduce body weight, decrease fat while sparing muscle tissue, and improve insulin sensitivity. While it is relatively simple to find agreement within the literature on these general points, agreement on the design of an ideal diet to accomplish these goals is far from universal. Some of the factors to consider when designing a diet for an individual with insulin resistance include age, underlying disease or metabolic conditions, activity level, vegetable content of the diet, and types of dietary fat and carbohydrates consumed. Epidemiological evidence suggests increased consumption of saturated and total fat and decreased intake of fiber are associated with insulin resistance as well.[35-37]

Research is also supportive of the benefits of diets high in certain types of fiber for promoting improved post-prandial glucose and insulin responses in normal individuals and in individuals with type 2 diabetes, dyslipidemia, and insulin resistance. The types of dietary fiber that appear to be most significant with respect to insulin resistance include oat fiber and guar gum, while psyllium has produced mixed results.[38-48]

Guar gum has received the most attention as an intervention aimed at managing insulin resistance. While evidence is quite supportive of the potential for this fiber, when added to test meals, to contribute to significant reductions in post-prandial glucose and insulin responses,[45] its effect on long-term improvement in insulin resistance is equivocal and might vary among patient populations.

Landin et al conducted a double blind, placebo-controlled trial to test the effect of guar gum on insulin sensitivity. Twenty-five healthy, non-obese, middle-aged men were given either 10 g of guar gum or an equivalent dose of a placebo three times daily for 6 weeks. The findings indicated that in this population guar gum was capable of decreasing fasting blood glucose and improving insulin sensitivity; however, fasting plasma insulin levels were unchanged. Other metabolic parameters, all of which decreased by the administration of guar gum in this trial, included cholesterol, triglycerides, and systolic blood pressure.[46]

Tagliaferro et al investigated the use of guar gum as an addition to a diabetic diet in order to evaluate its impact on blood sugar parameters. They provided 4 g of guar gum twice daily to ten type 2 diabetic subjects. At the end of the treatment period, they reported a decrease in fasting insulin levels and a decrease in insulin resistance.[47]

Unfortunately, in the only study that provided guar gum to obese individuals (obesity defined as greater than 50% overweight), no improvement in insulin resistance was noted. In this study, Cavallo-Perin et al administered 4 g of guar gum twice daily to nine obese individuals for 6 weeks. Six individuals subsequently had their dose increased to 8 g twice daily for a 3-month interval. Based on before and after evaluations, guar gum added to the diet was unable to significantly alter fasting glucose, glucose utilization, or insulin sensitivity.[48]

While high fiber diets seems to be prudent, simply advocating low-fat diets might not be the best suggestion for all insulin resistant subjects. Research indicates the type of fat consumed might be an important consideration. While available information suggests a diet lower in saturated fats might be an advantage, evidence also suggests diets rich in monounsaturated fats might be of benefit, particularly for type 2 diabetic people with insulin resistance.

A diet higher in monounsaturated fat appeared to provide an advantage over a fiber-rich, high-carbohydrate, low-fat diet on body fat distribution among type 2 diabetic subjects. The diet higher in monounsaturated fat generated proportional body fat loss from both upper and lower body. In contrast, the fiber-rich, high-carbohydrate, low-fat diet resulted in a disproportionate loss of lower-body fat, worsening the ratio between upper and lower body fat distribution.[49] Since evidence supports the association between obesity, abdominal body fat distribution, and insulin resistance, and because among obese men loss of weight and a decrease in the waist-hip ratio are closely associated with improved insulin sensitivity,[50] the diet higher in monounsaturated fat seems to have produced a more favorable impact on metabolism.

Parillo *et al* randomly assigned ten people with type 2 diabetes to a 15-day period of either a high-monounsaturated/low-fat diet (40% carbohydrate, 40% fat, 20% protein, and 24 g of fiber) or a low-monounsaturated/high-carbohydrate diet (60% carbohydrate, 20% fat, 20% protein, and 24 g of fiber). Their results suggested the high-monounsaturated/low-carbohydrate diet had a more significant impact on improving insulin sensitivity.[51]

Garg *et al* studied the effects of two isocaloric diets on insulin sensitivity in subjects with type 2 diabetes. All subjects were randomly assigned to receive either a high carbohydrate diet (60% of calories from carbohydrate) or a low-carbohydrate diet (35% of calories from carbohydrate) for 21 days, and then crossed over to the other diet for an additional 21 days. Both diets were matched for fiber content (25 g/d) and were low in saturated fatty acids. The low-carbohydrate diet was rich in monounsaturated fatty acids. Mean peripheral insulin-mediated glucose disposal was slightly higher on the diet with lower carbohydrate and higher monounsaturated fatty acid content.[52] It appears that for some, if not all, subjects with insulin resistance, a suggestion to follow a low-fat/high-carbohydrate diet, even if this is a high-fiber diet, should be weighed against the cost of sacrificing monounsaturated fats.

Some research has called into question the wisdom of recommending low-fat, high-carbohydrate diets.[53-55] Evidence suggests the macronutrient composition of the diet might play an important role in fat deposition,[56] and so might consequently influence insulin resistance. Several authors, after reviewing available scientific evidence, have suggested that low-fat, high-carbohydrate diets might contribute to metabolic problems, and certainly do not appear to be capable of reversing insulin resistance, obesity, or Syndrome X.[57-58]

While it is difficult to specify an exact percentage of the diet that should be comprised of carbohydrates, research suggests a diet containing excessive amounts of carbohydrates may contribute to insulin resistance. Similarly, evidence suggests that lowering the percent of the diet consisting of carbohydrates can reverse insulin resistance and positively impact the metabolic profile associated with insulin resistance to some degree. Further complicating the issue of an appropriate percent of carbohydrates to consume might be such factors as the form of the carbohydrates (simple versus complex), health of the subject, age of the subject, fiber content of the diet, other types and quantities of macronutrients consumed, and physical activity levels.

High-carbohydrate, high-fiber diets certainly appear to improve peripheral tissue insulin sensitivity in healthy young and old individuals.[59,60] However, this is often not the population of insulin resistant subjects most in need of dietary intervention. Among insulin resistant subjects with type 2 diabetes and obesity, similar results might not be the norm.

Hoffman *et al* studied the short-term effects of modifying the diet in favor of a high-fiber/high-carbohydrate diet (81 g of fiber and 68% of calories from carbohydrates) in seven very obese subjects with type 2 diabetes. Pre-intervention baseline diets consisted of 28 g of fiber and 42% carbohydrates. As a control group, five non-obese subjects without diabetes were observed. Reported results suggest this dietary modification was unable to decrease insulin resistance in this patient population.[61]

Golay *et al* compared the effects of two low-calorie diets of similar caloric value, but differing in carbohydrate content (25% versus 45% of calories from carbohydrates) for 12 weeks. Although both diets resulted in improvement, the fasting blood insulin decreased more markedly with the 25% carbohydrate diet compared to the 45% carbohydrate diet. The researchers also found a slightly greater degree of average weight loss (10.2 kg with the 25% carbohydrate diet versus 8.6 kg with the 45% carbohydrate diet), and adipose tissue loss (8.1 kg with the 25% carbohydrate diet versus 7.1 kg with the 45% carbohydrate diet) among individuals following the lower carbohydrate diet. However, the lower carbohydrate diet also resulted in a greater average loss of lean body mass (2.2 kg with the 25% carbohydrate diet versus 1.4 kg with the 45% carbohydrate diet).[63] Loss of muscle tissue might not be metabolically desirable when trying to decrease insulin resistance, making the accelerated loss of lean muscle mass observed with the lower carbohydrate diet a potential concern.

As an example of the power of varying the relative amounts of macronutrients (in this study proteins and carbohydrates) in a weight loss diet, Skov *et al* held fat constant at 30% of calories, and placed individuals on either a diet consisting of 12% protein and 58% carbohydrates, or 25% protein and 45% carbohydrates. The trial lasted 6 months and the researchers reported that weight loss was almost double in the higher protein diet (8.9 kg versus 5.1 kg). They also found fat loss was higher in the higher protein group (7.6 kg versus 4.3 kg), and that the higher protein diet had a much more substantial ability to reduce triglycerides.[63] The researchers did not monitor insulin resistance, although the higher protein diet generated more positive metabolic changes in areas associated with insulin resistance.

Piatti *et al* also conducted a weight loss trial. They held the percent of calories from fat constant and modified the relative percent of calories from protein and carbohydrates. The two diets the researchers utilized in this study had the following composition: 45% protein, 35% carbohydrate, and 20% fat; or 20% protein, 60% carbohydrate, and 20% fat. Although diet modifications only lasted 21 days and both diets induced a similar decrease in body weight and fat mass, the higher carbohydrate diet resulted in a greater loss in lean body mass.[64] Since it is not desirable to lose muscle tissue when trying to correct insulin resistance, this evidence suggests a higher protein diet might be the more preferable alternative.

There is also evidence that the amount and range of carotenoid-like pigments in an individual's blood is inversely related to fasting serum insulin levels,[65] suggesting a diet low in vegetables might contribute to insulin resistance. Epidemiological evidence does not support a role of dietary vitamins E or C consumption having a significant association with insulin sensitivity.[66-67] Diets higher in vitamin A, on the other hand, have shown an inverse relationship with insulin resistance. Dietary micronutrient deficiencies might also promote insulin resistance. Chief among these deficiencies appear to be minerals, including calcium, magnesium, potassium, chromium, vanadium, and zinc.[68-74]

Intake of sodium, either too high or two low, appears to impact negatively insulin sensitivity. Evidence presented by Donovan *et al* is suggestive of high sodium intake possibly exacerbating insulin resistance.[75] At the other extreme, salt restriction also appears to increase insulin resistance for most individuals. While moderate dietary sodium reduction may lower blood pressure without a distinct adverse effect on glucose metabolism in subjects with primary hypertension,[76] it appears that salt restriction does not improve insulin resistance in hypertensive subjects.[77] In fact, available evidence seems to be in agreement that severe reduction of salt intake may contribute to an increased serum lipid and insulin levels, and a deterioration of insulin sensitivity in both healthy volunteers and patients with hypertension.[76,78,79] Evidence even suggests moderate salt restriction can aggravate both existing systemic and vascular insulin resistance.[79]

Cigarette Smoking and Use of Nicotine-Containing Products

Researchers found chronic cigarette smokers were likely to be insulin resistant, hyperinsulinemic, and dyslipidemic when compared with matched groups of non-smokers.[80] A further study demonstrated chronic cigarette smoking markedly aggravated insulin resistance in patients with type 2 diabetes.[81] While abstaining from nicotine completely has been found to appear to improve insulin resistance, smoking cessation methods that rely on other forms of nicotine replacement appear to decrease insulin sensitivity.

In order to determine the effect of nicotine-containing chewing gum, Eliasson *et al* compared insulin sensitivity in 20 healthy, non-obese, middle-aged men who were long-term users to 20 matched-control subjects who did not use nicotine. Their findings suggested the long-term use of nicotine-containing chewing gum was associated with insulin resistance, and the degree of insulin resistance was correlated to the extent of nicotine used.[82] Assali *et al* also reported that nicotine replacement therapy resulted in a decrease in insulin sensitivity.[83]

Exercise

Exercise may be the single most important lifestyle factor for both preventing and reversing insulin resistance. Kelley and Goodpaster, after reviewing currently published clinical trial data, concluded that physical activity can reduce insulin resistance and improve glucose intolerance among obese individuals.[31] Ivy came to a similar conclusion about the positive benefits of exercise training on insulin resistance among individuals with type 2 diabetes.[84] Lehmann *et al* also reported regular physical exercise resulted in a significant amelioration of cardiovascular risk factors, including insulin resistance, associated with Syndrome X and diabetes.[85]

Among its many benefits, exercise, independent of changes in energy intake, body composition, and exercise-induced fat burning, actually increases the rate and amount of fat oxidation while at rest.[86] Exercise training results in a preferential loss of abdominal

body fat and reverses the loss of muscle mass associated with insulin resistance, providing the single most important intervention for changes in body composition.[85,87] Exercise improves insulin sensitivity in skeletal muscles and fat tissue, reducing both fasting blood sugar and insulin levels. Findings demonstrate that consistent exercise training, even without accompanying improvements in body composition, improve peripheral insulin activity in subjects with impaired glucose tolerance.[88] A study also demonstrated the skeletal muscle glycogen transport system improved substantially with exercise.[88]

Even an exercise routine as simple as incorporating brisk walking four times weekly dramatically improves endurance fitness, decreases body fat stores, tends to reduce food consumption, and decreases insulin resistance.[89-90] Based on available evidence, it is likely an optimal program for improving insulin sensitivity might, in addition to an aerobic component like walking, aim even more specifically to deplete selectively body fat while maintaining or building lean tissue by incorporating resistance training.[91-93]

The benefits of exercise on insulin resistance appear to hold consistently across all age groups and both sexes. In a study of obese children, Ferguson *et al* demonstrated that 4 months of exercise training improved insulin resistance and other metabolic factors associated with Syndrome X. These benefits were subsequently lost when the children became less active.[94] Research is in agreement that there is no age limit to extracting the insulin sensitizing effects of exercise among men.[87,92,95] Available research also demonstrates that postmenopausal women can improve insulin resistance through consistent appropriate exercise.[91]

Although exercise is a critical intervention to address insulin resistance, the combination of dietary modifications with exercise is probably an even more effective strategy. While studies on the combined effects of diet and exercise with respect to insulin resistance are unavailable, evidence has demonstrated the combination is much more effective at promoting weight loss than either intervention alone.[1,96-98]

Stress

While the role of stress in the development of insulin resistance is still equivocal, it appears that stress and the physiological response to stress is a hurdle that might interfere with efforts to improve insulin sensitivity. Acute stress is clearly associated with a severe, yet reversible, form of insulin resistance. Raikkonen *et al*, after studying psychosocial stress and insulin resistance, concluded that stress should be considered

Table 2: Some Possible Lifestyle Contributors to Insulin Resistance

- High fat diet
- Very low fat diet
- Low protein diet
- Deficiency of essential fatty acids, especially omega 3 oils as found in fish
- High carbohydrate diet
- High glycemic diet
- Refined sugars and starches
- Excessively high or low salt intake
- Low fiber intake
- Micronutrient deficiencies (such as calcium, magnesium, chromium, vanadium, zinc, carotenoids, and vitamin A)
- Low intake of vegetables
- Lack of exercise or sedentary lifestyle
- High stress
- Use of nicotine-containing products

in any attempt to understand the pathogenesis of insulin resistance.[100] Nilsson et al similarly found psychosocial stress might be associated with insulin resistance.[101]

While researchers speculate that glucocorticoids, such as the stress hormone cortisol, might contribute to insulin resistance because of their tendency to oppose the actions of insulin,[102] the nature of cortisol's impact on insulin resistance is unclear. From a physiological perspective, both cortisol and the catecholamine stress hormones are capable of elevating blood sugar, and Goldstein *et al* reported that chronic elevation of cortisol resulted in increased plasma insulin levels.[103] Evidence also suggests that consistently elevated levels of cortisol greatly inhibit non-hepatic glucose utilization (the ability of muscle tissue, for example, to use glucose for energy).[103-104]

Leptin is a hormone secreted by adipose tissue. Higher leptin levels appear to act on the hypothalamus to decrease body fat, increase thermogenesis, and promote satiety. However, evidence indicates that, as the percent of body fat increases, even high levels of leptin are unable to adequately stimulate these metabolic responses, suggesting that obesity is commonly characterized by a state of leptin resistance.[105] Evidence also suggests the amount of leptin found in the blood directly correlates with insulin levels and with insulin resistance. In effect, leptin levels decrease in parallel with insulin, and leptin resistance decreases as a person becomes more sensitive to insulin.[23,24,106] While more research is needed to clarify the exact nature of the relationship between

insulin resistance and leptin resistance, these two metabolic disturbances consistently appear together.

Stress, secondary to cortisol production, also may impact insulin resistance directly or indirectly through interaction with leptin. In animals, evidence suggests cortisol is a primary factor in preventing leptin from increasing thermogenesis and decreasing appetite and body fat. In humans, it appears that cortisol impacts leptin and its activity as well. While more research is required, available evidence indicates cortisol might be capable of both increasing leptin levels and inhibiting the action of leptin, thereby promoting a state of leptin resistance.[107-109] See Table 2 for a summary of lifestyle contributions to insulin resistance.

NUTRITIONAL INTERVENTIONS: SUPPLEMENTATION

The role of nutritional and botanical substances in the management of insulin resistance requires further elaboration; however, available information suggests some substances positively influence insulin resistance. Minerals, including magnesium, calcium, potassium, zinc, chromium, and vanadium, appear to have associations with insulin resistance or its management. Amino acids, including L-carnitine, taurine, and L-arginine, also might play a role in the reversal of insulin resistance. Additional nutrients, such as glutathione, coenzyme Q10, and lipoic acid, appear to have therapeutic potential. Research on herbal medicines for the treatment of insulin resistance is limited; however, silymarin produced positive results in diabetic patients with alcoholic cirrhosis, and *Inula racemosa* appears to potentiate insulin sensitivity in an animal model.

Minerals
Magnesium
Available research suggests an association between magnesium deficiency and insulin resistance. In two patient populations normally associated with insulin resistance, overweight and type 2 diabetic individuals, magnesium deficiency is a relatively common occurrence.[69-70] Depletion of intracellular free magnesium has also been found to be a characteristic feature of insulin resistance among subjects with essential hypertension.[110]

Nadler *et al* reported a decrease in insulin sensitivity with magnesium deficiency in all subjects studied.[111] Humphries *et al* reported a clear association between the lowest consumption of dietary magnesium and the highest degree of insulin resistance among non-diabetic subjects.[112] Dominguez *et al* confirmed this observation, finding that among both normotensive

and hypertensive subjects, a higher magnesium level corresponded to a greater degree of sensitivity to insulin.[110] Looking at this association from another perspective, research indicated an infusion of insulin lowered the ability to accumulate intracellular magnesium, and this response to insulin might be even more exaggerated among individuals with higher degrees of insulin resistance.[113] Lefebvre *et al*, in their evaluation of magnesium's role in glucose metabolism, concluded, "magnesium deficiency results in impaired insulin secretion while magnesium replacement restores insulin secretion. Furthermore, experimental magnesium deficiency reduces tissue sensitivity to insulin."[114]

In efforts to clarify the relationship between insulin resistance and magnesium, several research groups have examined the effects of magnesium supplementation and glucose handling. Paolisso *et al* conducted a double-blind, randomized, crossover study to test the impact of magnesium supplementation on, among other factors, insulin resistance in elderly individuals. They provided subjects with 4.5 g magnesium daily for 4 weeks, which resulted in a significant increase in erythrocyte magnesium concentrations. This intervention also resulted in an improvement in insulin sensitivity, and this improvement correlated with the improved magnesium status.[115] Unfortunately, similar improvements in glucose control were not found in a study of magnesium supplementation in people with type 2 diabetes. While Eibl *et al* showed that oral magnesium supplementation (30 mmol/day) for 3 months resulted in a significant improvement in plasma magnesium levels, this improvement was not sustained following discontinuation of magnesium, and no significant changes in the metabolic control of blood sugar were observed.[116]

Calcium
While information on calcium supplementation and insulin resistance is limited, it appears, at least in some patient populations, administration of calcium might generate positive outcomes. Sanchez *et al* investigated the impact of calcium supplementation on insulin resistance in 20 non-diabetic, hypertensive subjects. All subjects were placed on standardized diets consisting of approximately 500 mg dietary calcium per day for four weeks. Following this period, 1500 mg either calcium or placebo were given daily in a randomized, double-blind fashion for 8 weeks. Following the intervention period, treated patients had decreased fasting plasma insulin levels and a significant increase in insulin sensitivity.[68]

Potassium

A potassium-depleted diet was found to lead to insulin resistance at post-receptor sites, a resistance that was reversed when potassium was resupplied.[71] Currently, no information is available on potassium supplementation under other circumstances; however, this mineral appears to have a close association with insulin resistance and merits future investigation.

Zinc

Preliminary evidence suggests a relationship between zinc deficiency and the response to insulin. In human subjects, information contained in an abstract of an untranslated Japanese research article implied a clinical correlation between low zinc levels and insulin resistance.[74] The prevalence of several of the diseases or metabolic dysfunctions associated with insulin resistance are also much more common among individuals consuming low zinc diets (Table 3).[117]

Table 3: Conditions Associated with both Low Zinc Diets and Insulin Resistance
- Cardiovascular disease
- Diabetes Type 2
- Hypertension
- Dyslipidemia
- Hypertriglyceridemia
- Impaired glucose tolerance

Chromium

Animal experiments have shown that a deficiency in chromium can result in insulin resistance.[118-119] Evidence also suggests diet-induced insulin resistance in experimental animals can be improved by chromium.[120] In humans, there also seems to be an association between insulin resistance and chromium status.[121]

Morris *et al* suggested a compromised ability to retain chromium by individuals with type 2 diabetes might contribute to the insulin resistance found in this population. Compared with healthy controls, these researchers found 33% lower mean plasma levels of chromium and 100% higher urine values, suggesting a disruption in the ability to sustain appropriate chromium status.[122] Morris *et al* demonstrated a reduction in fasting plasma chromium levels and an increase in urinary elimination of chromium followed an infusion of glucose and the resultant insulin surge in healthy individuals. Based on their experiments, it appeared the elevated insulin levels were impacting chromium status.[123] Evidence also suggests

that individuals consuming diets with the lowest amounts of chromium tend to have disruptions in glucose and insulin regulation.[72]

While available evidence seems to clearly indicate a role for chromium in glucose metabolism, and an interaction between chromium status and insulin resistance, chromium's therapeutic role is equivocal. Several forms of chromium have been studied with respect to glucose metabolism; however, studies of chromium supplementation and its impact on insulin resistance are much more limited. Controversy exists as to which supplemental form of chromium is preferable; and, regarding insulin resistance, this controversy is likely to continue until well-designed comparative studies are conducted in humans.

Chromium complexed with nicotinic acid appeared to have a modest effect on glucose metabolism in subjects with type 2 diabetes. However, this form of chromium has yet to be specifically studied regarding insulin resistance in humans. Similarly, glucose tolerance factor (GTF) chromium-rich brewer's yeast has yet to be studied with respect to insulin resistance, but has been shown to impact some aspects of glucose metabolism in elderly subjects.[125] Chromium chloride appears to influence glucose and insulin levels in healthy adult men with evidence of insulin resistance in a manner suggestive of an improvement in insulin sensitivity.[126]

Chromium picolinate also appears to have the potential to influence insulin resistance positively under some circumstances. Anderson *et al* reported a chromium-induced improvement in both glucose tolerance and circulating insulin among non-diabetic individuals with moderate post-glucose challenge hyperglycemia. The experimental group received 200 mcg chromium picolinate daily. Observed changes in glucose and insulin levels following the intervention period were suggestive of increased tissue sensitivity to insulin.[127]

Anderson *et al* also investigated the effect of chromium picolinate supplementation as a sole intervention on parameters of glucose metabolism among type 2 diabetic patients. One hundred and eighty men and women were randomly assigned to groups receiving either a placebo, 100 mcg chromium picolinate twice daily, or 500 mcg chromium picolinate twice daily. During the trial, subjects continued all medications and were instructed to sustain their normal eating and lifestyle habits. Fasting glucose, 2-hour glucose levels, and fasting and 2-hour insulin values decreased significantly during the 4-month study in both groups receiving the supplementary chromium, suggestive of an improvement in insulin resistance.[128]

However, not all studies on chromium picolinate administration and its impact on glucose and insulin response have yielded positive results. Lee *et al* conducted a prospective, double-blind, placebo-controlled, crossover study to determine the effect of chromium picolinate on individuals with type 2 diabetes.[129] Although triglycerides were improved, no statistical difference was noted between control and chromium-treated subjects with respect to measured parameters of glucose control at the conclusion of this six-month study. Although these researchers did not measure insulin resistance, the lack of effect on measured parameters suggests it is unlikely tissue sensitivity to insulin was dramatically altered.

Joseph *et al* found no added benefit of chromium picolinate supplementation when it was provided in addition to resistance training. In this study, 32 moderately overweight men and women were observed in order to determine the effect of 12 weeks of resistance training on parameters of glucose metabolism, with or without chromium picolinate supplementation (924 mcg per day). Their results suggested the expected resistance training enhancement of insulin sensitivity; however, the subjects with and without chromium picolinate had no significant difference in any parameter measured,[130] suggesting any effect chromium picolinate supplementation might have on insulin resistance is either inconsequential in combination with or vanishes with resistance training.

Vanadyl Sulfate

Vanadium, as vanadyl sulfate, is a trace mineral associated with sugar regulation. It is believed to regulate fasting blood sugar levels and improve receptor sensitivity to insulin.[73] Based on available research, vanadyl sulfate appears to be a useful intervention for type 2 diabetic individuals with insulin resistance.

Boden *et al* conducted a single-blind, placebo-controlled study of the effect of vanadyl sulfate on eight male and female subjects with type 2 diabetes. Treated subjects received 50 mg vanadyl sulfate twice daily for 4 weeks, followed by a 4-week placebo phase. Modest improvements in fasting glucose and hepatic insulin resistance followed the treatment period and were sustained throughout the placebo period.[73]

Halberstam *et al* provided 100 mg vanadyl sulfate daily for 3 weeks to moderately obese type 2 diabetic and non-diabetic subjects. They observed a decrease in fasting plasma glucose and a significant improvement in insulin sensitivity in the type 2 diabetic subjects; however, no change was observed in the obese non-diabetic subjects. The authors concluded that at this dose vanadyl sulfate was capable of improving insulin sensitivity in type 2 diabetic subjects but was unable to alter insulin sensitivity among obese, non-diabetics.[131]

Cohen *et al* also examined the effect of vanadyl sulfate (100 mg per day) in type 2 diabetes following a 3-week intervention period. Measurement of fasting plasma glucose and insulin-mediated glucose disposal during pre- and post-treatment periods suggested a beneficial effect of vanadyl sulfate on improving both hepatic and peripheral insulin sensitivity. These effects were sustained for up to 2 weeks after the vanadyl sulfate was discontinued.[132]

Vitamins
Biotin

In experimental models of type 2 diabetes, biotin lowered post-prandial glucose levels, improved insulin response to a glucose load, and decreased insulin resistance.[133] Although biotin has not been evaluated in humans for its effect on insulin resistance, this vitamin has demonstrated an ability to improve glucose metabolism in humans on dialysis and with type 2 diabetes,[134] thus warranting future investigation.

Vitamin E

Clinical studies on vitamin E in insulin sensitivity have been conflicting. In a somewhat surprising finding, Skrha *et al* reported supplementation with vitamin E might actually worsen insulin status in some patient populations. Vitamin E (600 mg daily) was given for 3 months to 11 obese individuals with type 2 diabetes. They found that vitamin E resulted in a decrease in both glucose disposal rate and number of insulin receptors on erythrocytes.[135] However, Barbagallo *et al* reported an improvement in insulin sensitivity among hypertensive patients following a 4-week double-blind, randomized study of vitamin E administration (600 mg/d). The results demonstrated a significant improvement in whole-body glucose disposal subsequent to vitamin E treatment.[136]

Amino Acids
L-Carnitine

Administration of L-carnitine holds potential to improve insulin sensitivity. In a study evaluating the effect of parenteral administration of L-carnitine (either 2 or 4 g per day) on metabolic parameters subsequent to post surgical-stress, Heller *et al* concluded that carnitine administration was capable of reducing the associated trend toward insulin resistance.[137] Gunal *et al* also reported a single intravenous dose of L-carnitine (one gram) had a positive effect on insulin sensitivity in patients with chronic renal failure.[138]

Mingrone *et al* found a two-hour infusion of L-carnitine administered to patients with type 2 diabetes created at least a short-term improvement in insulin sensitivity by enhancing whole-body glucose uptake and increasing glucose storage. They observed a similar positive metabolic effect in normal subjects.[139]

Taurine

The effectiveness of taurine supplementation on human cases of insulin resistance has yet to be documented; however, preliminary experimental evidence from animal models is intriguing. Anuradha *et al* reported that adding taurine to the diet of fructose-fed rats moderated the fructose-induced exaggerated glucose levels and hyperinsulinemia.[140] Nakaya *et al* noted a similar positive effect of taurine on insulin sensitivity in a rat model of type 2 diabetes. In this study, administration of taurine resulted in significantly less abdominal fat accumulation, hyperglycemia, and insulin resistance.[141] While it is impossible to extrapolate these results to human subjects, this research does suggest taurine is a nutritional intervention that merits further investigation.

L-Arginine

Although additional research is required, arginine is another amino acid with a potential therapeutic role in the management of insulin resistance. In children with thalassemia major, serum insulin concentrations were significantly lower 30 minutes after arginine infusion. Conversely, arginine-stimulated glucagon secretions increased significantly. Wascher *et al* conducted a more specific study to determine the effect of a low-dose of L-arginine administered intravenously on insulin sensitivity in healthy, obese, and type 2 diabetic subjects. L-arginine (0.52 mg/kg/min) restored the impaired insulin-mediated vasodilation observed in patients with obesity and type 2 diabetes and improved insulin sensitivity in all three groups studied.[143]

Other Supplements
Glutathione

Individuals with type 2 diabetes appear to have abnormal intracellular reduced glutathione (GSH) redox status.[144] Evidence also suggests whole-body glucose disposal is associated with intracellular GSH redox status.[138] In order to assess the impact of GSH on insulin sensitivity, De Matta *et al* administered glutathione (1.35 g x m2/min) intravenously to 10 subjects with type 2 diabetes and 10 healthy subjects for one hour and repeated this protocol one week later. Both groups experienced increased glucose uptake,

suggesting enhanced insulin sensitivity, and an improved intracellular GSH redox status.[144]

Fish Oils

While fish oils, rich in omega-3 essential fatty acids (omega 3 EFAs), improve insulin resistance in animal models, their effect in humans has been equivocal.[145] Available human research has shown a range of outcomes regarding insulin metabolism ranging from some improvement to no change to deterioration of glycemic control in one study.

Bhathena *et al* fed 40 healthy men diets providing 40% of calories from fat. During the fish oil intervention period, the men received 15 gm/day fish oil concentrate for the full 10 weeks of the trial and 200 mg vitamin E for the last 8 weeks. Compared with the placebo period (15 gm/day mixed fat and 25 mg/day vitamin E), the intervention resulted in decreased insulin,[146] suggesting the possibility that insulin resistance had improved.

In two trials of fish oil supplementation in people with type 2 diabetes, similar results were not obtained. Borkman *et al* investigated the effects of fish oil administration in individuals with mild type 2 diabetes. They fed 10 subjects a standard diabetic diet throughout their trial and, using a double-blind crossover design, provided either 10 g fish oil concentrate (30% omega 3 EFAs) daily, or 10 g safflower oil daily over separate 3-week periods. They found no change in either fasting serum insulin levels or insulin sensitivity. They also observed a 14% increase in fasting blood glucose following the fish oil intervention, suggesting a possible adverse effect on glycemic control, at least in this patient population.[147]

Rivellese *et al* also conducted a randomized double-blind, placebo-controlled trial of fish oil as an intervention for individuals with type 2 diabetes. The treatment group received 2.7 g/day eicosapentaenoic plus docosahexaenoic acid for two months, followed by 1.7 g/day for four additional months. During the trial, diet and hypoglycemic drugs remained unchanged. Although supplementation resulted in an improvement in some parameters associated with cardiovascular risk, no significant difference in blood glucose control or insulin sensitivity was observed between the fish oil and placebo groups. While the investigators found no deterioration of blood glucose control, this dose of fish oils was unable to modify insulin resistance in this patient population.[148]

Coenzyme Q10

Coenzyme Q10 (CoQ10) is a promising nutritional intervention for insulin resistance, at least among

subjects with hypertension. Singh *et al* conducted an 8-week randomized, double-blind trial comparing the use of a water soluble form of CoQ10 (60 mg twice daily) to a vitamin B complex in 59 hypertensive patients. Their results indicated CoQ10 at this dose lowered glucose and fasting insulin levels, suggesting possible improved insulin resistance. CoQ10 supplementation also resulted in improvements in blood pressure, lipid profiles, and blood levels of the antioxidant vitamins A, C, E, and beta carotene. Measured parameters associated with oxidative stress decreased with CoQ10 supplementation. The only observed changes in the group taking the B-vitamin complex were increases in vitamin C and beta carotene.[149]

a-Lipoic Acid

a-Lipoic acid has been shown to improve insulin resistance in a variety of animal models.[150-151] Experimental trials have also provided evidence that lipoic acid might be useful in the treatment of insulin resistance in humans under some circumstances.

Clinical studies have described an increase of insulin sensitivity after both single infusion and short-term parenteral administration of lipoic acid. At a single parenteral dose of 1000 mg, Jacobs *et al* reported lipoic acid resulted in a significant increase in insulin-stimulated glucose disposal among subjects with type 2 diabetes, increasing the metabolic clearance rate for glucose by about 50%.[152] Jacobs *et al*, in a subsequent uncontrolled trial, administered a daily infusion of lipoic acid (500 mg/500 ml NaCl, 0.9%) to 20 subjects with type 2 diabetes for 10 days. Following the treatment period, an approximately 30% increase in insulin-stimulated glucose disposal was observed.[153]

Results also suggest oral administration of a-lipoic acid can improve insulin sensitivity in patients with diabetes. Jacob *et al* investigated the effect of a four-week placebo-controlled, multicenter pilot study to determine the effectiveness of oral treatment with lipoic acid on insulin sensitivity in people with type 2 diabetes. Seventy-four patients were randomized to either placebo or active treatment consisting of lipoic acid in doses of either 600 mg once daily, twice daily, or three times daily. Prior to treatment, all four groups had comparable degrees of hyperglycemia and insulin sensitivity. While not all treated subjects experienced improvements, a mean increase of 27% in insulin-stimulated glucose disposal was observed among subjects receiving supplemental lipoic acid. However, no statistical differences in insulin sensitivity appeared among subjects receiving the higher doses of lipoic acid, suggesting the lack of a dose-dependent response above 600 mg, and that an optimal dose is 600 mg daily or lower.[154]

In another study, Konrad *et al* evaluated the effect of a-lipoic acid on insulin sensitivity and glucose metabolism in lean and obese individuals with type 2 diabetes. Subjects were given an oral dose of 600 mg lipoic acid twice daily for 4 weeks. Both groups had improvements in measured aspects of glucose metabolism suggestive of an enhanced effectiveness of supplementation on insulin sensitivity.[155]

BOTANICALS

An antioxidant flavonoid component of *Silybum marianum* (milk thistle), silymarin appears to offer potential for improving insulin resistance, at least under some clinical circumstances. Velussi *et al* conducted a study to determine whether long-term treatment with silymarin was effective in reducing lipid peroxidation and insulin resistance in diabetic patients with alcoholic cirrhosis. In addition to standard treatment, 30 subjects were given 600 mg silymarin daily, while a matched control group received standard therapy alone. Treated subjects exhibited a significant decrease in fasting blood glucose, mean daily blood glucose, daily glucosuria, and fasting insulin levels noticeable after four months of therapy. Subjects in the silymarin group were also able to lower their exogenous insulin requirements. During the same period of time, the control group had worsening fasting insulin levels and a stabilized insulin need.[156]

It is likely other herbal medicines might have therapeutic potential for modifying insulin resistance. As an example, research indicated that *Inula racemosa* improved glucose metabolism in experimental animals, and that this activity was probably secondary to potentiation of insulin sensitivity in peripheral tissues.[157] More research is required to determine if any of the plant medicines currently used in diabetes management will play an eventual therapeutic role in insulin resistance.

CONCLUSION

A great deal more research is required to determine an ideal approach to both prevention and reversal of insulin resistance. Since lifestyle factors play such a prominent role in insulin resistance, modifying potential contributing habits should be a priority in the management of insulin resistance. Minerals, such as magnesium, calcium, potassium, zinc, chromium, and vanadium, appear to have association with insulin resistance or its management. Amino acids, including L-carnitine, taurine, and L-arginine, might also play a role in the reversal of insulin resistance. Other nutrients, including glutathione, coenzyme Q10, and lipoic acid, also appear to have therapeutic potential.

Research on herbal medicines for the treatment of insulin resistance is limited; however, silymarin has produced positive results in diabetic patients with alcoholic cirrhosis, and *Inula racemosa* potentiated insulin sensitivity in an animal model.

Based on available research, ideal protocols for reversing insulin resistance should take into account existing complicating factors, such as type 2 diabetes, hypertension, obesity, cirrhosis, or dialysis. In other words, the ideal regimen for reversing insulin resistance might likely vary for an individual with type 2 diabetes and a non-diabetic obese individual. For a summary of protocols for various subgroups of people with insulin resistance see Tables 4, 5, 6, 7.

Table 4: Hypertension and Insulin Resistance: Interventions

Intervention	Dose	Comments
Fiber	Increase	In general, higher fiber diets associated with improved insulin resistance.
Saturated Fat	Decrease	In general, high saturated fat diets associated with worsening of insulin resistance.
Vegetables	Increase	In general, evidence suggests high blood levels of carotenoids inversely associated with fasting insulin
Vitamin A-rich foods	Increase	Diets higher in vitamin A have shown an inverse relationship with insulin resistance.
Salt Intake	Low-Moderate	Salt avoidance and high salt intake might worsen insulin resistance.
Nicotine Containing Products	Decrease	Use of nicotine-containing products associated with worsening of insulin resistance.
Exercise	Increase	Exercise is critical for preventing and reversing insulin resistance.
Stress	Decrease	Acute stress associated with insulin resistance. Chronic psychosocial stress probable association with insulin resistance.
Magnesium	Not Studied	Higher magnesium level corresponds to a greater degree of sensitivity to insulin.
Calcium	1500 mg/d	Improved insulin sensitivity.
Potassium	Not Studied	Diet inducing potassium depletion results in a resistance to insulin action.
Vitamin E	600 mg/d	Improved insulin sensitivity.
CoQ10	60 mg b.i.d.	Improvements suggestive of increased insulin sensitivity.

Table 5: Obesity and Insulin Resistance: Interventions

Intervention	Dose	Comments
Fiber	Increase	In general, higher fiber diets associated with improved insulin resistance.
Guar Gum	NA	Unable to alter insulin sensitivity at either 4 or 8 grams b.i.d.
Saturated Fat	Decrease	In general, high saturated fat diets associated with worsening of insulin resistance.
Monounsaturated Fats	Increase	Not studied in obese subjects but among type 2 diabetic subjects it promotes weight loss and improvement in waist/hip ratio.
Vegetables	Increase	In general, evidence suggests high blood levels of carotenoids inversely associated with fasting insulin.
Vitamin A-rich foods	Increase	Diets higher in vitamin A have shown an inverse relationship with insulin resistance.
Salt Intake	Moderate	Extremes of salt intake (low or high) appear to worsen insulin resistance.
Nicotine-Containing Products	Decrease	Use of nicotine-containing products associated with worsening of insulin resistance.
Exercise	Increase	Exercise is critical for preventing and reversing insulin resistance.
Stress	Decrease	Acute stress associated with insulin resistance. Chronic psychosocial stress probable association with insulin resistance.
Magnesium	To correct deficiency	Deficiency likely.
Potassium	Not Studied	Diet inducing potassium depletion results in a resistance to insulin action.
Zinc	Not Studied	Association between low zinc levels and insulin resistance.
Chromium Picolinate	NA	Resistance training-enhanced insulin sensitivity; however, chromium picolinate (924 mcg/d) showed no ability to add to these positive effects.
L-arginine	Unknown	I.V. administration improves insulin sensitivity, but oral dosage and chronic administration unstudied.
Lipoic acid	600 mg/d	Improved insulin sensitivity in obese type 2 diabetic subjects.

Table 6: Type 2 Diabetes and Insulin Resistance: Interventions

Intervention	Dose	Comments
Fiber	Increase	In general, higher fiber diets associated with improved insulin resistance.
Guar Gum	4 g b.i.d.	Improves insulin sensitivity. Decreases fasting insulin levels.
Saturated Fat	Decrease	In general, high saturated fat diets associated with worsening of insulin resistance.
Monounsaturated Fats	Increase	Improves insulin sensitivity.
Vegetables	Increase	In general, evidence suggests high blood levels of carotenoids inversely associated with fasting insulin.
Vitamin A-rich foods	Increase	Diets higher in vitamin A have shown an inverse relationship with insulin resistance.
Salt Intake	Moderate	Extremes of salt intake (low or high) appear to worsen insulin resistance.
Nicotine-Containing Products	Decrease	Use of nicotine-containing products associated with worsening of insulin resistance.
Exercise	Increase	Exercise is critical for preventing and reversing insulin resistance.
Stress	Decrease	Acute stress associated with insulin resistance. Chronic psychosocial stress probable association with insulin resistance.
Magnesium	To correct deficiency	Deficiency likely, but replenishment unlikely to improve insulin resistance.
Potassium	Not Studied	Diet inducing potassium depletion results in a resistance to insulin action.
Zinc	Not Studied	Association between low zinc levels and insulin resistance.
Chromium Picolinate	200-500 mcg b.i.d.	Mixed results reported.
Vanadyl Sulfate	100 mg/d	Improves insulin sensitivity.
Vitamin E.	NA	Vitamin E (600 mg/d) resulted in a decrease in the glucose disposal rate suggesting a worsening of insulin resistance.
L-carnitine	Unknown	I.V. infusion improves insulin sensitivity, but oral dosage and chronic administration unstudied.
L-arginine	Unknown	I.V. administration improves insulin sensitivity, but oral dosage and chronic administration unstudied.
Lipoic acid	600 mg/d	Improved insulin sensitivity.

Table 7: Healthy (non-obese and non-diabetic) Subjects with Insulin Resistance: Interventions

Intervention	Dose	Comments
Fiber	Increase	In general, higher fiber diets associated with improved insulin resistance.
Guar Gum	10 g t.i.d.	Improves insulin sensitivity.
Saturated Fat	Decrease	In general, high saturated fat diets associated with worsening of insulin resistance.
Vegetables	Increase	In general, evidence suggests high blood levels of carotenoids inversely associated with fasting insulin.
Vitamin A-rich foods	Increase	Diets higher in vitamin A have shown an inverse relationship with insulin resistance.
Salt Intake	Moderate	Extremes of salt intake (low or high) appear to worsen insulin resistance.
Nicotine-Containing Products	Decrease	Use of nicotine-containing products associated with worsening of insulin resistance.
Exercise	Increase	Exercise is critical for preventing and reversing insulin resistance.
Stress	Decrease	Acute stress associated with insulin resistance. Chronic psychosocial stress probable association with insulin resistance.
Magnesium	4.5 g per day	Improved insulin sensitivity. Note: this very high dose would likely act as a cathartic.
Potassium	Not Studied	Diet inducing potassium depletion results in a resistance to insulin action.
Zinc	Not Studied	Association between low zinc levels and insulin resistance.
Chromium Picolinate	200 mcg b.i.d.	Observed changes suggestive of improved insulin sensitivity.
L-carnitine	Unknown	I.V. infusion improves insulin sensitivity, but oral dosage and chronic administration unstudied.
L-arginine	Unknown	I.V. administration improves insulin sensitivity, but oral dosage and chronic administration unstudied.
Glutathione	Unknown	I.V. adminisration improves insulin sensitivity.

References

1. Grimm JJ. Interaction of physical activity and diet: Implications for insulin-glucose dynamics. Public Health Nutr 1999;2:363-68.

2. Moore MA, Park CB, Tsuda H. Implications of the hyperinsulinaemia-diabetes-cancer link for preventive efforts. Eur J Cancer Prev 1998;7:89-107.

3. Arthur LS, Selvakumar R, Seshadri MS, Seshadri L. Hyperinsulinemia in polycystic ovary disease. J Reprod Med 1999;44:783-87.

4. Pugeat M, Ducluzeau PH. Insulin resistance, polycystic ovary syndrome and metformin. Drugs 1999;58:41-46.

5. Baranowska B, Radzikowska M, Wasilewska-Dziubinska E, et al. Neuropeptide Y, leptin, galanin and insulin in women with polycystic ovary syndrome. Gynecol Endocrinol 1999;13:344-51.

6. Kotake H, Oikawa S. Syndrome X. Nippon Rinsho 1999;57:622-26. [Article in Japanese]

7. Watanabe K, Sekiya M, Tsuruoka T, et al. Relationship between insulin resistance and cardiac sympathetic nervous function in essential hypertension. J Hypertens 1999;17:1161-68.

8. Lender D, Arauz-Pacheco C, Adams-Huet B, Raskin P. Essential hypertension is associated with decreased insulin clearance and insulin resistance. Hypertension 1997;29:111-14.

9. Stubbs PJ, Alaghband-Zadeh J, Laycock JF, et al. Significance of an index of insulin resistance on admission in non-diabetic patients with acute coronary syndromes. Heart 1999;82:443-47.

10. Lempiainen P, Mykkanen L, Pyorala K, et al. Insulin resistance syndrome predicts coronary heart disease events in elderly nondiabetic men. Circulation 1999;100:123-28.

11. Misra A, Reddy RB, Reddy KS, et al. Clustering of impaired glucose tolerance, hyperinsulinemia and dyslipidemia in young north Indian patients with coronary heart disease: a preliminary case-control study. Indian Heart J 1999;51:275-80.

12. Davis CL, Gutt M, Llabre MM, et al. History of gestational diabetes, insulin resistance and coronary risk. J Diabetes Complications 1999;13:216-23.

13. Despres JP, Lamarche B, Mauriege P, et al. Hyperinsulinemia as an independent risk factor for ischemic heart disease. N Engl J Med 1996;334:952-57.

14. Tiihonen M, Partinen M, Narvanen S. The severity of obstructive sleep apnoea is associated with insulin resistance. J Sleep Res 1993;2:56-61.

15. Pujol P, Galtier-Dereure F, Bringer J. Obesity and breast cancer risk. Hum Reprod 1997;12:116-25.

16. Stoll BA. Essential fatty acids, insulin resistance, and breast cancer risk. Nutr Cancer 1998;31:72-77.

17. Grundy SM. Hypertriglyceridemia, insulin resistance, and the metabolic syndrome. Am J Cardiol 1999;83:25F-29F.

18. Belfiore F, Iannello S. Insulin resistance in obesity: Metabolic mechanisms and measurement methods. Mol Genet Metab 1998;65:121-28.

19. Samaras K, Nguyen TV, Jenkins AB, et al. Clustering of insulin resistance, total and central abdominal fat: Same genes or same environment? Twin Res 1999;2:218-25.

20. Benzi L, Ciccarone AM, Cecchetti P, et al. Intracellular hyperinsulinism: A metabolic characteristic of obesity with and without type 2 diabetes: intracellular insulin in obesity and type 2 diabetes. Diabetes Res Clin Pract 1999;46: 231-37.

21. Rosskamp R. Hormonal findings in obese children. A review. Klin Padiatr 1987;199:253-59. [Article in German]

22. Okosun IS, Cooper RS, Prewitt TE, Rotimi CN. The relation of central adiposity to components of the insulin resistance syndrome in a biracial US population sample. Ethn Dis 1999;9:218-29.

23. Donahue RP, Prineas RJ, Donahue RD, et al. Is fasting leptin associated with insulin resistance among nondiabetic individuals? The Miami Community Health Study. Diabetes Care 1999;22:1092-96.

24. Malmstrom R, Taskinen MR, Karonen SL, Yki-Jarvinen H. Insulin increases plasma leptin concentrations in normal subjects and patients with NIDDM. Diabetologia 1996;39:993-96.

25. Hrnciar J, Gabor D, Hrnciarova M, et al. Relation between cytokines (TNF-alpha, IL-1 and 6) and homocysteine in android obesity and the phenomenon of insulin resistance syndromes. Vnitr Lek 1999;45:11-16. [Article in Slovak]

26. Baldeweg SE, Golay A, Natali A, et al. Insulin resistance, lipid and fatty acid concentrations in 867 healthy Europeans. Eur J Clin Invest 2000;30:45-52.

27. Fossati P, Fontaine P. Endocrine and metabolic consequences of massive obesity. Rev Prat 1993;43:1935-39. [Article in French]

28. Nestler JE, Clore JN, Blackard WG. Dehydroepiandrosterone: the "missing link" between hyperinsulinemia and atherosclerosis? FASEB J 1992;6:3073-75.

29. Scacchi M, Pincelli AI, Cavagnini F. Growth hormone in obesity. Int J Obes Relat Metab Disord 1999;23:260-71.

30. Simoneau JA, Veerkamp JH, Turcotte LP, Kelley DE. Markers of capacity to utilize fatty acids in human skeletal muscle: relation to insulin resistance and obesity and effects of weight loss. FASEB J 1999;13:2051-60.

31. Kelley DE, Goodpaster B, Wing RR, Simoneau JA. Skeletal muscle fatty acid metabolism in association with insulin resistance, obesity, and weight loss. Am J Physiol 1999;277:E1130-E1141.

32. Tsigos C, Kyrou I, Chala E, et al. Circulating tumor necrosis factor alpha concentrations are higher in abdominal versus peripheral obesity. Metabolism 1999;48:1332-35.

33. Agewall S. Insulin sensitivity and haemostatic factors in men at high and low cardiovascular risk. The Risk Factor Intervention Study Group. J Intern Med 1999;246:489-95.

34. Paolisso G, Tagliamonte MR, Rizzo MR, et al. Oxidative stress and advancing age: Results in healthy centenarians. J Am Geriatr Soc 1998;46:833-38.

35. Marshall JA, Bessesen DH, Hamman RF. High saturated fat and low starch and fibre are associated with hyperinsulinaemia in a non-diabetic population: The San Luis Valley Diabetes Study. Diabetologia 1997;40:430-38.

36. Lovejoy J, DiGirolamo M. Habitual dietary intake and insulin sensitivity in lean and obese adults. Am J Clin Nutr 1992;55:1174-79.

37. Maron DJ, Fair JM, Haskell WL. Saturated fat intake and insulin resistance in men with coronary artery disease. The Stanford Coronary Risk Intervention Project Investigators and Staff. Circulation 1991;84:2020-27.

38. Frape DL, Jones AM. Chronic and postprandial responses of plasma insulin, glucose and lipids in volunteers given dietary fibre supplements. Br J Nutr 1995;73:733-51.

39. Pick ME, Hawrysh ZJ, Gee MI, et al. Oat bran concentrate bread products improve long-term control of diabetes: a pilot study. J Am Diet Assoc 1996;96:1254-61.

40. Braaten JT, Scott FW, Wood PJ, et al. High beta-glucan oat bran and oat gum reduce postprandial blood glucose and insulin in subjects with and without type 2 diabetes. Diabet Med 1994;11:312-18.

41. Hallfrisch J, Scholfield DJ, Behall KM. Diets containing soluble oat extracts improve glucose and insulin responses of moderately hypercholesterolemic men and women. Am J Clin Nutr 1995;61:379-84.

42. Tappy L, Gugolz E, Wursch P. Effects of breakfast cereals containing various amounts of beta-glucan fibers on plasma glucose and insulin responses in NIDDM subjects. Diabetes Care 1996;19:831-34.

43. Rodriguez-Moran M, Guerrero-Romero F, Lazcano-Burciaga G. Lipid- and glucose-lowering efficacy of plantago psyllium in type II diabetes. J Diabetes Complications 1998;12:273-78.

44. Frati Munari AC, Benitez Pinto W, Raul Ariza Andraca C, Casarrubias M. Lowering glycemic index of food by acarbose and Plantago psyllium mucilage. Arch Med Res 1998;29:137-41

45. Fairchild RM, Ellis PR, Byrne AJ, et al. A new breakfast cereal containing guar gum reduces postprandial plasma glucose and insulin concentrations in normal-weight human subjects. Br J Nutr 1996;76:63-73.

46. Landin K, Holm G, Tengborn L, Smith U. Guar gum improves insulin sensitivity, blood lipids, blood pressure, and fibrinolysis in healthy men. Am J Clin Nutr 1992;56:1061-65.

47. Tagliaferro V, Cassader M, Bozzo C, et al. Moderate guar-gum addition to usual diet improves peripheral sensitivity to insulin and lipaemic profile in NIDDM. Diabetes Metab 1985;11:380-85.

48. Cavallo-Perin P, Bruno A, Nuccio P, et al. Dietary guar gum supplementation does not modify insulin resistance in gross obesity. Acta Diabetol Lat 1985;22:139-42.

49. Walker KZ, O'Dea K, Johnson L, et al. Body fat distribution and non-insulin-dependent diabetes: Comparison of a fiber-rich, high-carbohydrate, low-fat (23%) diet and a 35% fat diet high in monounsaturated fat. Am J Clin Nutr 1996;63:254-60.

50. Sonnichsen AC, Richter WO, Schwandt P. Benefit from hypocaloric diet in obese men depends on the extent of weight-loss regarding cholesterol, and on a simultaneous change in body fat distribution regarding insulin sensitivity and glucose tolerance. Metabolism 1992;41:1035-39.

51. Parillo M, Rivellese AA, Ciardullo AV, et al. A high-monounsaturated-fat/low-carbohydrate diet improves peripheral insulin sensitivity in non-insulin-dependent diabetic patients. Metabolism 1992;41:1373-78.

52. Garg A, Grundy SM, Unger RH. Comparison of effects of high and low carbohydrate diets on plasma lipoproteins and insulin sensitivity in patients with mild NIDDM. Diabetes 1992;41:1278-85.

53. Jeppersen J, Schaaf P, Jones C, et al. Effects of low-fat, high-carbohydrate diets on risk factors for ischaemic heart disease in postmenopausal women. Am J Clin Nutr 1997;65:1027-33.

54. Frost G, Leeds G, Trew R, et al. Insulin sensitivity in women at risk of coronary heart disease and the effect of a low glycemic diet. Metabolism 1998;47:1245-51.

55. Wolever TM, Jenkins DJ, Vuksan V, et al. Beneficial effect of low-glycemic index diet in overweight NIDDM subjects. Diabetes Care 1992;15:562-64.

56. Miller WC, Lindeman AK, Wallace J, Niederpruem M. Diet composition, energy intake, and exercise in relation to body fat in men and women. Am J Clin Nutr 1990;52:426-30.

57. Reavan GM. Do high carbohydrate diets prevent the development or attenuate the manifestations (or both) of syndrome X? A viewpoint strongly against. Curr Opin Lipidol 1997;8:23-27.

58. Mathers JC, Daly ME. Dietary carbohydrates and insulin sensitivity. Curr Opin Clin Nutr Metab Care 1998;1:553-57.

59. Fukagawa NK, Anderson JW, Hageman G, et al. High-carbohydrate, high-fiber diets increase peripheral insulin sensitivity in healthy young and old adults. Am J Clin Nutr 1990;52:524-28.

60. Chen M, Bergman RN, Porte D Jr. Insulin resistance and beta-cell dysfunction in aging: the importance of dietary carbohydrate. J Clin Endocrinol Metab 1988;67:951-57.

61. Hoffman CR, Fineberg SE, Howey DC, et al. Short-term effects of a high-fiber, high-carbohydrate diet in very obese diabetic individuals. Diabetes Care 1982;5:605-11.

62. Golay A, Eigenheer C, Morel Y, et al. Weight-loss with low or high carbohydrate diet? Int J Obes Relat Metab Disord 1996;20:1067-72.

63. Skov AR, Toubro S, Ronn B, et al. Randomized trial on protein vs carbohydrate in ad libitum fat reduced diet for the treatment of obesity. Int J Obes Relat Metab Disord 1999;23:528-36.

64. Piatti PM, Monti F, Fermo I, et al. Hypocaloric high-

protein diet improves glucose oxidation and spares lean body mass: comparison to hypocaloric high-carbohydrate diet. Metabolism 1994;43:1481-87.

65. Ford ES, Will JC, Bowman BA, Narayan KMV. Diabetes mellitus and serum carotenoids: findings from the third national health and nutrition examination survey. Am J epidemiol 1999;149:168-76.

66. Sanchez-Lugo L, Mayer-Davis EJ, Howard G, et al. Insulin sensitivity and intake of vitamins E and C in African American, Hispanic, and non-Hispanic white men and women: The Insulin Resistance and Atherosclerosis Study (IRAS). Am J Clin Nutr 1997;66:1224-31.

67. Facchini F, Coulston AM, Reaven GM. Relation between dietary vitamin intake and resistance to insulin-mediated glucose disposal in healthy volunteers. Am J Clin Nutr 1996;63:946-49.

68. Sanchez M, de la Sierra A, Coca A, et al. Oral calcium supplementation reduces intraplatelet free calcium concentration and insulin resistance in essential hypertensive patients. Hypertension 1997;29:531-36.

69. Hua H, Gonzales J, Rude RK. Magnesium transport induced ex vivo by a pharmacological dose of insulin is impaired in non-insulin-dependent diabetes mellitus. Magnes Res 1995;8:359-66.

70. Lima M de L, Cruz T, Pousada JC, et al. The effect of magnesium supplementation in increasing doses on the control of type 2 diabetes. Diabetes Care 1998;21:682-86.

71. Norbiato G, Bevilacqua M, Meroni R, et al. Effects of potassium supplementation on insulin binding and insulin action in human obesity: protein-modified fast and refeeding. Eur J Clin Invest 1984;14:414-19.

72. Anderson RA, Polansky MM, Bryden NA, Canary JJ. Supplemental-chromium effects on glucose, insulin, glucagon, and urinary chromium losses in subjects consuming controlled low-chromium diets. Am J Clin Nutr 1991;54:909-16.

73. Boden G, Chen X, Ruiz J, et al. Effects of vanadyl sulfate on carbohydrate and lipid metabolism in patients with non-insulin-dependent diabetes mellitus. Metabolism 1996;45:1130-35.

74. Chen MD, Lin PY, Lin WH. Investigation of the relationships between zinc and obesity. Kao Hsiung I Hsueh Ko Hsueh Tsa Chih 1991;7:628-34. [Article in Japanese]

75. Donovan DS, Solomon CG, Seely EW, et al. Effect of sodium intake on insulin sensitivity. Am J Physiol 1993;264:E730-E734.

76. Gomi T, Shibuya Y, Sakurai J, et al. Strict dietary sodium reduction worsens insulin sensitivity by increasing sympathetic nervous activity in patients with primary hypertension. Am J Hypertens 1998;11:1048-55.

77. Dengel DR, Hogikyan RV, Brown MD, et al. Insulin sensitivity is associated with blood pressure response to sodium in older hypertensives. Am J Physiol 1998;274:E403-E409.

78. Fliser D, Fode P, Arnold U, et al. The effect of dietary salt on insulin sensitivity. Eur J Clin Invest 1995;25:39-43.

79. Feldman RD, Schmidt ND. Moderate dietary salt restriction increases vascular and systemic insulin resistance. Am J Hypertens 1999;12:643-47.

80. Facchini FS, Hollenbeck CB, Jeppersen J, et al. Insulin resistance and cigarette smoking. Lancet 1992;339:1128-30.

81. Targher G, Alberiche M, Zenere MB, et al. Cigarette smoking and insulin resistance in patients with non-insulin-dependent diabetes mellitus. J Clin Endocrinol Metab 1997;82:3619-24.

82. Eliasson B, Taskinen MR, Smith U. Long-term use of nicotine gum is associated with hyperinsulinemia and insulin resistance. Circulation 1996;94:878-81.

83. Assali AR, Beigel Y, Schreibman R, et al. Weight gain and insulin resistance during nicotine replacement therapy. Clin Cardiol 1999;22:357-60.

84. Ivy JL. Role of exercise training in the prevention and treatment of insulin resistance and non-insulin-dependent-diabetes mellitus. Sports Med 1997;24:321-36.

85. Lehmann R, Vokac A, Niedermann K, et al. Loss of abdominal fat and improvement of the cardiovascular risk profile by regular moderate exercise training in patients with NIDDM. Diabetologia 1995;38:1313-19.

86. Calles-Escandon J, Goran MI, O'Connell M, et al. Exercise increases fat oxidation at rest unrelated to changes in energy balance or lipolysis. Am J Physiol 1996;270:E1009-E1014.

87. Horber FF, Kohler SA, Lippuner K, Jaeger P. Effect of regular physical training on age-associated alteration of body composition in men. Eur J Clin Invest 1996;26:279-85.

88. Hughes VA, Fiatarone MA, Fielding RA, et al. Exercise increases muscle GLUT-4 levels and insulin action in subjects with impaired glucose tolerance. Am J Physiol 1993;264:E855-E862.

89. Aldred HE, Hardman AE, Taylor S. Influence of 12 weeks of training by brisk walking on postprandial lipemia and insulinemia in sedentary middle-aged women. Metabolism 1995;44:390-97.

90. Leon AS, Conrad J, Hunninghake DB, Serfass R. Effects of a vigorous walking program on body composition, and carbohydrate and lipid metabolism of obese young men. Am J Clin Nutr 1979;32:1776-87.

91. Ryan AS, Pratley RE, Goldberg AP, Elahi D. Resistive training increases insulin action in postmenopausal women. J Gerontol A Biol Sci Med Sci 1996;51:M199-M205.

92. Miller JP, Pratley RE, Goldberg AP, et al. Strength training increases insulin action in healthy 50- to 65-yr-old men. J Appl Physiol 1994;77:1122-27.

93. Walberg JL. Aerobic exercise and resistance weight-training during weight reduction. Implications for obese persons and athletes. Sports Med 1989;7:343-56.

94. Ferguson MA, Gutin B, Le NA, et al. Effects of exercise training and its cessation on components of the insulin resistance syndrome in obese children. Int J Obes Relat Metab Disord 1999;23:889-95.

95. Coon PJ, Bleecker ER, Drinkwater DT, et al. Effects of

body composition and exercise capacity on glucose tolerance, insulin, and lipoprotein lipids in healthy older men: A cross-sectional and longitudinal intervention study. Metabolism 1989;38:1201-09.

96. Racette SB, Schoeller DA, Kushner RF, et al. Effects of aerobic exercise and dietary carbohydrate on energy expenditure and body composition during weight reduction in obese women. Am J Clin Nutr 1995;61:486-94.

97. Wing RR, Venditti E, Jakicic JM, et al. Lifestyle intervention in overweight individuals with a family history of diabetes. Diabetes Care 1998;21:350-59.

98. Agurs-Collins TD, Kumanyika SK, Ten Have TR, Adams-Campbell LL. A randomized controlled trial of weight reduction and exercise for diabetes management in older African-American subjects. Diabetes Care 1997;20:1503-11.

99. Brandi LS, Santoro D, Natali A, et al. Insulin resistance of stress: sites and mechanisms. Clin Sci (Colch) 1993;85:525-35.

100. Raikkonen K, Keltikangas-Jarvinen L, Adlercreutz H, Hautanen A. Psychosocial stress and the insulin resistance syndrome. Metabolism 1996;45:1533-38.

101. Nilsson PM, Moller L, Solstad K. Adverse effects of psychosocial stress on gonadal function and insulin levels in middle-aged males. J Intern Med 1995;237:479-86.

102. Friedman TC, Mastorakos G, Newman TD, et al. Carbohydrate and lipid metabolism in endogenous hypercortisolism: shared features with metabolic syndrome X and NIDDM. Endocr J 1996;43:645-55.

103. Goldstein RE, Wasserman DH, McGuinness OP, et al. Effects of chronic elevation in plasma cortisol on hepatic carbohydrate metabolism. Am J Physiol 1993;264:E119-E127.

104. Dinneen S, Alzaid A, Miles J, Rizza R. Metabolic effects of the nocturnal rise in cortisol on carbohydrate metabolism in normal humans. J Clin Invest 1993;92:2283-90.

105. Hamann A, Matthaei S. Regulation of energy balance by leptin. Exp Clin Endocrinol Diabetes 1996;104:293-300.

106. Havel PJ, Kasim-Karakas S, Mueller W, et al. Relationship of plasma leptin to plasma insulin and adiposity in normal weight and overweight women: Effects of dietary fat content and sustained weight loss. J Clin Endocrinol Metab 1996;81:4406-13.

107. Zakrzewska KE, Cusin I, Sainsbury A, et al. Glucocorticoids as counterregulatory hormones of leptin: Toward an understanding of leptin resistance. Diabetes 1997;46:717-19.

108. Zakrzewska KE, Cusin I, Stricker-Krongrad A, et al. Induction of obesity and hyperleptinemia by central glucocorticoid infusion in the rat. Diabetes 1999;48:365-70.

109. Berneis K, Vosmeer S, Keller U. Effects of glucocorticoids and of growth hormone on serum leptin concentrations in man. Eur J Endocrinol 1996;663-65.

110. Dominguez LJ, Barbagallo M, Sowers JR, Resnick LM. Magnesium responsiveness to insulin and insulin-like growth factor I in erythrocytes from normotensive and hypertensive subjects. J Clin Endocrinol Metab 1998;83:4402-07.

111. Nadler JL, Buchanan T, Natarajan R, et al. Magnesium deficiency produces insulin resistance and increased thromboxane synthesis. Hypertension 1993;21:1024-29.

112. Humphries S, Kushner H, Falkner B. Low dietary magnesium is associated with insulin resistance in a sample of young, nondiabetic Black Americans. Am J Hypertens 1999;12:747-56.

113. Paolisso G, Ravussin E. Intracellular magnesium and insulin resistance: results in Pima Indians and Caucasians. J Clin Endocrinol Metab 1995;80:1382-85.

114. Lefebvre PJ, Paolisso G, Scheen AJ. Magnesium and glucose metabolism. Therapie 1994;49:1-7.

115. Paolisso G, Sgambato S, Gambardella A, et al. Daily magnesium supplements improve glucose handling in elderly subjects. Am J Clin Nutr 1992;55:1161-67.

116. Eibl NL, Kopp HP, Nowak HR, et al. Hypomagnesemia in type II diabetes: Effect of a 3-month replacement therapy. Diabetes Care 1995;18:188-192.

117. Singh RB, Niaz MA, Rastogi SS, et al. Current zinc intake and risk of diabetes and coronary artery disease and factors associated with insulin resistance in rural and urban populations of North India. J Am Coll Nutr 1998;17:564-70.

118. Striffler JS, Polansky MM, Anderson RA. Overproduction of insulin in the chromium-deficient rat. Metabolism 1999;48:1063-68.

119. Striffler JS, Law JS, Polansky MM, et al. Chromium improves insulin response to glucose in rats. Metabolism 1995;44:1314-20.

120. Striffler JS, Polansky MM, Anderson RA. Dietary chromium decreases insulin resistance in rats fed a high-fat, mineral-imbalanced diet. Metabolism 1998;47:396-400.

121. Fulop T Jr, Nagy JT, Worum I, et al. Glucose intolerance and insulin resistance with aging: Studies on insulin receptors and post-receptor events. Arch Gerontol Geriatr 1987;6:107-115.

122. Morris BW, MacNeil S, Hardisty CA, et al. Chromium homeostasis in patients with type II (NIDDM) diabetes. J Trace Elem Med Biol 1999;13:57-61.

123. Morris BW, MacNeil S, Stanley K, et al. The inter-relationship between insulin and chromium in hyperinsulinaemic euglycaemic clamps in healthy volunteers. J Endocrinol 1993;139:339-45.

124. Thomas VL, Gropper SS. Effect of chromium nicotinic acid supplementation on selected cardiovascular disease risk factors. Biol Trace Elem Res 1996;55:297-305.

125. Offenbacher EG, Pi-Sunyer FX. Beneficial effect of chromium-rich yeast on glucose tolerance and blood lipids in elderly subjects. Diabetes 1980;29:919-25.

126. Riales R, Albrink MJ. Effect of chromium chloride supplementation on glucose tolerance and serum lipids including high-density lipoprotein of adult men. Am J Clin Nutr 1981;34:2670-78.

127. Anderson RA, Polansky MM, Bryden NA, Canary JJ. Supplemental-chromium effects on glucose, insulin, glucagon, and urinary chromium losses in subjects con-

suming controlled low-chromium diets. Am J Clin Nutr 1991;54:909-16.

128. Anderson RA, Cheng N, Bryden NA, et al. Elevated intakes of supplemental chromium improve glucose and insulin variables in individuals with type 2 diabetes. Diabetes 1997;46:1786-91.

129. Lee NA, Reasner CA. Beneficial effect of chromium supplementation on serum triglyceride levels in NIDDM. Diabetes Care 1994;17:1449-52.

130. Joseph LJ, Farrell PA, Davey SL, et al. Effect of resistance training with or without chromium picolinate supplementation on glucose metabolism in older men and women. Metabolism 1999;48:546-53.

131. Halberstam M, Cohen N, Shlimovich P, et al. Oral vanadyl sulfate improves insulin sensitivity in NIDDM but not in obese nondiabetic subjects. Diabetes 1996;45:659-66.

132. Cohen N, Halberstam M, Shlimovich P, et al. Oral vanadyl sulfate improves hepatic and peripheral insulin sensitivity in patients with non-insulin-dependent diabetes mellitus. J Clin Invest 1995;95:2501-09.

133. Reddi A, DeAngelis B, Frank O, et al. Biotin supplementation improves glucose and insulin tolerances in genetically diabetic KK mice. Life Sci 1988;42:1323-30.

134. Koutsikos D, Fourtounas C, Kapetanaki A, et al. Oral glucose tolerance test after high-dose i.v. biotin administration in normoglucemic hemodialysis patients. Ren Fail 1996;18:131-37.

135. Skrha J, Sindelka G, Kvasnicka J, Hilgertova J. Insulin action and fibrinolysis influenced by vitamin E in obese type 2 diabetes mellitus. Diabetes Res Clin Pract 1999;44:27-33.

136. Barbagallo M, Dominguez LJ, Tagliamonte MR, et al. Effects of vitamin E and glutathione on glucose metabolism: role of magnesium. Hypertension 1999;34:1002-06.

137. Heller W, Musil HE, Gaebel G, et al. Effect of L-carnitine on post-stress metabolism in surgical patients. Infusionsther Klin Ernahr 1986;13:268-76. [Article in German]

138. Gunal AI, Celiker H, Donder E, Gunal SY. The effect of L-carnitine on insulin resistance in hemodialysed patients with chronic renal failure. J Nephrol 1999;12:38-40.

139. Mingrone G, Greco AV, Capristo E, et al. L-carnitine improves glucose disposal in type 2 diabetic patients. J Am Coll Nutr 1999;18:77-82.

140. Anuradha CV, Balakrishnan SD. Taurine attenuates hypertension and improves insulin sensitivity in the fructose-fed rat, an animal model of insulin resistance. Can J Physiol Pharmacol 1999;77:749-54.

141. Nakaya Y, Minami A, Harada N, et al. Taurine improves insulin sensitivity in the Otsuka Long-Evans Tokushima fatty rat, a model of spontaneous type 2 diabetes. Am J Clin Nutr 2000;71:54-58.

142. Soliman AT, el Banna N, alSalmi I, Asfour M. Insulin and glucagon responses to provocation with glucose and arginine in prepubertal children with thalassemia major before and after long-term blood transfusion. J Trop Pediatr 1996;42:291-96.

143. Wascher TC, Graier WF, Dittrich P, et al. Effects of

low-dose L-arginine on insulin-mediated vasodilatation and insulin sensitivity. Eur J Clin Invest 1997;27:690-95.

144. De Mattia G, Bravi MC, Laurenti O, et al. Influence of reduced glutathione infusion on glucose metabolism in patients with non-insulin-dependent diabetes mellitus. Metabolism 1998;47:993-97.

145. Luo J, Rizkalla SW, Boillot J, et al. Dietary (n-3) polyunsaturated fatty acids improve adipocyte insulin action and glucose metabolism in insulin resistant rats: Relation to membrane fatty acids. J Nutr 1996;126:1951-58.

146. Bhathena SJ, Berlin E, Judd JT, et al. Effects of omega 3 fatty acids and vitamin E on hormones involved in carbohydrate and lipid metabolism in men. Am J Clin Nutr 1991;54:684-88.

147. Borkman M, Chisholm DJ, Furler SM, et al. Effects of fish oil supplementation on glucose and lipid metabolism in NIDDM. Diabetes 1989;38:1314-19.

148. Rivellese AA, Maffettone A, Iovine C, et al. Long-term effects of fish oil on insulin resistance and plasma lipoproteins in NIDDM patients with hypertriglyceridemia. Diabetes Care 1996;19:1207-13.

149. Singh RB, Niaz MA, Rastogi SS, et al. Effect of hydrosoluble coenzyme Q10 on blood pressures and insulin resistance in hypertensive patients with coronary artery disease. J Hum Hypertens 1999;13:203-08.

150. Jacob S, Streeper RS, Fogt DL, et al. The antioxidant alpha-lipoic acid enhances insulin-stimulated glucose metabolism in insulin-resistant rat skeletal muscle. Diabetes 1996;45:1024-29.

151. Streeper RS, Henriksen EJ, Jacob S, et al. Differential effects of lipoic acid stereoisomers on glucose metabolism in insulin-resistant skeletal muscle. Am J Physiol 1997;273:E185-E191.

152. Jacob S, Henriksen EJ, Schiemann AL, et al. Enhancement of glucose disposal in patients with type 2 diabetes by alpha-lipoic acid. Arzneimittelforschung 1995;45:872-74.

153. Jacob S, Henriksen EJ, Tritschler HJ, et al. Improvement of insulin-stimulated glucose-disposal in type 2 diabetes after repeated parenteral administration of thioctic acid. Exp Clin Endocrinol Diabetes 1996;104:284-88.

154. Jacob S, Ruus P, Hermann R, et al. Oral administration of RAC-alpha-lipoic acid modulates insulin sensitivity in patients with type-2 diabetes mellitus: A placebo-controlled pilot trial. Free Radic Biol Med 1999;27:309-14.

155. Konrad T, Vicini P, Kusterer K, et al. alpha-Lipoic acid treatment decreases serum lactate and pyruvate concentrations and improves glucose effectiveness in lean and obese patients with type 2 diabetes. Diabetes Care 1999;22:280-87.

156. Velussi M, Cernigoi AM, De Monte A, et al. Long-term (12 months) treatment with an anti-oxidant drug (silymarin) is effective on hyperinsulinemia, exogenous insulin need and malondialdehyde levels in cirrhotic diabetic patients. J Hepatol 1997;26:871-79.

157. Tripathi YB, Chaturvedi P. Assessment of endocrine response of Inula racemosa in relation to glucose homeostasis in rats. Indian J Exp Biol 1995;33:686-89.

Hair Mineral Levels and Their Correlation with Abnormal Glucose Tolerance

by Zoltan Rona (MD) and George M. Tamari (PhD), President of Anamol Laboratory

(Reprinted from Anamol Laboratory by permission of the authors)

ABSTRACT

Sixty percent of the ambulatory patients with the following problems — allergies, hypoglycemia, weight problems, anemia, CVD, stomach ulcers, psychological problems, fatigue, hyperlipidemia, loss of memory, headaches, hypertension, migraines, thyroid problems, and backaches — had abnormal Glucose Tolerance Test (GTT), according to the criteria of Alan Nitler, MD.

All patients with elevated hair tissue levels of calcium and magnesium, or calcium alone have abnormal GTT. Mineral deficiencies and the presence of toxic elements were established.

A biochemical working hypothesis is proposed in an attempt to explain the physiological process leading to the breakdown of normal energy production and to the development of metabolic acidosis.

STUDY

Considerable attention has been directed to the provision of generous amounts of dietary calcium during the growth years of young people, but curiously little emphasis has been placed on maintaining an optimal intake of this ion during adult years. Animal nutritionalists have devoted considerable effort to determine the amount of dietary calcium necessary to achieve maximum growth and development. Interestingly, the currently recommended amounts of dietary calcium for livestock, laboratory animals, and pets constitute a much greater proportion of the diet of these animals than is recommended for man.[1,2] This disparity may be because animal nutritionists have been interested in achieving maximum development, whereas most of the investigations of man have been designed to determine the *minimum* amount of calcium required to achieve a state in which loss from the body does not exceed intake.[2]

Loss of bone, or osteoporosis, can occur for different reasons, and in all of these osteoporotic states, the concentration of calcium in serum remains normal.[3] For this reason, we attempted to establish levels of calcium and other elements in the tissues where most of the metabolic processes are taking place at the mitochondrial level. Hair was chosen as a source for measuring tissue mineral levels because it is easily available, the short term variations are averaged out, it is an inert and chemically homogenous substance, the concentration of most trace elements are relatively high in hair as compared to the rest of the body, especially blood,[4] and the specimens can be collected more quickly and easily than specimens of blood, urine, or any other tissue.

The wet-ashed hair digests were analyzed using an Inductively Coupled Argon Plasma (I.C.A.P.) Emission Spectrophotometer at Anamol Laboratories, Canada.

Ambulatory patients with normal blood chemistry were chosen for this study. Six-hour Glucose Tolerance Test and Hair Tissue Mineral Analysis were performed on all of these patients. In evaluating the GTT, the five criteria for the interpretation of the 6-hour GTT by Alan Nittler, M.D., were used,[5] namely:

- The blood glucose level must rise to the half-hour and on up the one-hour level.
- The percentage differential between the fasting and the lowest sugar levels must not exceed 20%.
- There must be no levels lower than the normal low level established for the test used.
- The drop from the high point to the low should be about 50 mg.
- The one-hour level must be at least 50% greater than the fasting level.

In Table I, are listed the complaints of patients having elevated levels of calcium and magnesium or calcium alone. In many cases there was a combination of two or three complaints associated with the elevated mineral levels.

The majority of complaints were: allergies, hypoglycemia, weight problems (including impaired subclinical thyroid function), psychological problems, and fatigue. There were some quantitative differences between the two groups in case of weight problems, psychological disorders, fatigue, and headaches.

Table II indicates the GTT of the different patient groups in general (1), the group with elevated Ca and Mg (2), and elevated CA alone (30), taking the sex distribution into consideration:

- All the patients with complaints from unknown etiology, namely 118, 71 have abnormal GTT, or 60%. In this 60%, 82% were female and 18% were male.
- Among the 31 patients with elevated Ca and Mg, *all* 31 had abnormal GTT, or 100%. This being 81% female compared to 19% male.
- Of the 32 patients with elevated levels of calcium, all 32 (100%) had abnormal GTT; 62% female versus 38% male.
- It seems that the previous group is under much more pronounced influence of the endocrine system than the group with elevated calcium alone.

Table III provides the breakdown of the abnormal GTTs according to the five criteria of Dr Nittler and the mineral imbalances and the presence of toxic minerals in each category.

The nature of biological studies carries a certain disadvantage. It is – if not impossible – very hard to produce the conditions under which one can observe influence of an isolated factor. As in Table III, the analysis of levels of calcium and magnesium as it is related to the well-being of patients is complicated by the fact that deficiencies of other elements have a very recognized contribution to the general energy production, and in the biosynthesis of the many essential enzyme-systems and their products.

- 39% of the cases were deficient in chromium and zinc levels, and 63% showed deficiency in manganese.
- Copper levels in 51% of the patients were abnormal; 23% showed low levels versus 28% with elevated tissue levels.
- Sodium levels in 10% and potassium in 13% of the cases indicated levels outside the reference range, indicating some adrenal problems.
- 25% of the study group indicated the presence of toxic metals, like aluminum (21%), mercury (3%), and cadmium (1%).
- Many of the patients with elevated Ca/Mg or Ca have elevated blood lactate.

Table 1: Patients Complaints vs Tissue Levels of Calcium and Magnesium

Patient's Complaints	Symptoms associated with elevated tissue levels of	
	Calcium and Magnesium in hundred cases	Calcium
Allergies	41	39
Hypoglycemia	22	23
Weight problems	16	8
Anemia	3	-
Heart disease	3	3
Stomach ulcer	6	6
Psychological problems	28	45
Fatigue	13	23
Hyperlipidemia	-	3
Loss of memory	-	3
Headaches	3	13
Hypertension	9	10
Migraines	6	3
Thyroid problems	6	13
Backaches	3	10

Table 2: GTT, Sex Distribution vs Tissue Levels of Calcium and Magnesium

	No.	Abnormal No.	GTT* %	Sex distribution Female	Male %
Patients with complaints-unknown etiology	118	71	60	82	18
Patients with elevated hair tissue Ca and Mg	31	31	100	81	19
Patients with elevated hair tissue Ca	32	32	100	62	38

Table 3: Abnormal GTTs Categorized according to Nittler's Criteria

Five criteria for abnormal GTT	N° of cases	SEX	Ca,Mg	Ca	Cr	Zn	Mn	Cu	Na	K	Toxic Elements
1,2,3,4,5	5	F	2▲	3▲	-	▲▼	▼	2▲2▼	▼	2▼1▲	4 Al
1,2,3,5	9	F	1▲	8▲	6▼	4▼	6▼	2▼	▲▼	▲▼	2 Al
1,2,3,4	4	3F 1M	1▲	2▲▼	2▼	2▼▲	2▼	▲▼	-	-	2 Al,1 Hg
1,3,4,5	2	F	2▲	-	▼	2▼	▼	▼	-	-	1 Hg
2,3,4	5	2F 3M	3▲	2▲	▼	▲	4▼	3▲2▼	3▼	3▼	--
1,4,5	13	12F 1M	7▲	6▲	2▼	6▼	8▼	4▲2▼	2▼	2▼	2 Al,1Cd
1,3,4	2	1F 1M	▲	▲	▼	▼	▼	-	-	-	--
1,2,4	2	1F 1M	2▲	-	▼	-	2▼	-	▲	-	1 Al
1,2,3	1	F	-	▲	▼	▼	▼	-	-	-	--
1,3,5	2	F	▲	▲	2▼	-	2▼	▲	▼	▼	1 Al
2,4	1	M	-	1▲	-	▼	▼	-	-	-	--
3,4	5	3F 2M	▲2▼	2▲	3▼	-	3▼	3▼▲	-	-	--
2,3	1	M	-	▲	▼	-	▼	-	▼	▼	--
1,3	1	F	-	▲	▼	-	▼	-	-	-	--
1,2	1	F	▲	-	-	-	▼	-	-	-	--
1,5	6	5F 1M	4▲	2▲	3▼	▼	2▼	3▲▼	▼	▼	3 Al
1,4	3	F	3▲	-	3▼	2▼	3▼	▲▼	-	-	--
4,5	2	F	▲	▲	▼	▼	▼	▲▼	-	-	--
1	3	2F 1M	-	3▲	▼	▼	▼	▲	▲	-	--
4	3	F	▲	2▲	2▼	2▼	2▼	-	▲	-	--

DISCUSSION

The breakdown (oxidation) of glucose is an important step in the body's energy production. The first part, from the conversion of the six carbon chain molecule of glucose to a three carbon containing moiety, is done in the process called glycolysis under anaerobic conditions. This three carbon moiety usually is pyruvate, which then is utilized in the Krebs of Citric Acid Cycle, where it is oxidized to CO_2 and water (Fig. 1). The heat produced in this process is captured in high-energy phosphate bonds (ADP Æ ATP). About eight energy rich phosphate bonds are produced in the phase of glycolysis (21%) and 30 in the Citric Acid Cycle (79%).[6]

In the concept of today's chemistry, oxidation can take place in the absence of oxygen, and it will be carried out by single electron transport from one atom to another atom, or one molecule to another molecule. This process is supported by the so-called <<Electron-transport>> System,[7] consisting of different dehydrogenases and of enzyme systems in which the co-enzymes are able to form a ketoenol structure, C=O C-OH (Fig. 2 and 3), like in co-enzymes Q, ubiquinone, flavoprotein, riboflavin, nicotinamide, nicotinamide adenine dinucleotide (NAD), and ascorbic acid/tocopherol in combination with other oxidation-reduction systems. See Figure 1.

Deficiency in these nutrients (nutritional, stress-related, etc.) may cause a disturbance in the electron transfer and may produce anaerobic conditions. If anaerobic conditions prevail, the reoxidation of NADH through the respiratory chain to oxygen is prevented. Pyruvate, which is the normal end product of glycolysis under aerobic conditions, is reduced under anaerobic conditions by the NADH to lactate, the reaction being catalyzed by lactate deydrogenase. The re-oxidation of NADH via lactate formation allows glycolysis to proceed in the absence of oxygen by regenerating sufficient NADH+. Thus, tissues that can function under hypoxic circumstances tend to produce lactate.[8]

Under these conditions, however, the intake of food will produce 21% of the energy (anaerobic glycolysis) with the expected feeling of fatigue in general and disturbances in brain function because glycogen stores of the brain are very small; hence, a minute-to-minute supply of blood glucose is particularly important to the nervous system.[3]

Under hypoxic condition, impairment of brain function can be expected. The same condition will result in lowering the intracellular pH level to a degree that is not compatible with normal cellular function.

In this case, the homeostatic mechanism might take over, attempting to neutralize the accumulated acid (lactic) via salt formation. Would this working hypothesis be right, an intracellular increase of alkali minerals like calcium, magnesium, sodium and/or potassium could be expected.

There is supporting information in the study of F.N. Pitts on "The Biochemistry of Anxiety," where he proposed "that anxiety symptoms may have a common determining biochemical and mechanism involving the complexing of ionized *calcium* at the surface of excitable membranes by lactate ion produced intracellularly,"[9] See Figure 2.

Another avenue in which the abnormal breakdown of glucose may occur is in the case when, exposed to *extreme stress* for a longer period of time, as a result the endocrine system may work sluggishly. The bio-feed-back mechanism is deteriorating, and, as a result, there may be an overproduction and later an under-production of certain hormones controlling the carbohydrate metabolism. This may lead to an impaired GTT, on one hand, and in an increased production of lactate, on the other hand.

"The increased incidence of osteoporosis with age," as it is postulated by Wachman *et al*, "may present in part, the result of a life long utilization of the buffering capacity of the basic salts of bone for the constant assault against pH homeostasis. The loss of as little as 2 meq of calcium per day would, over a decade, assuming a total body content of 1 kg, account for a 15% loss of inorganic bone mass in an average individual."[10]

An alternative pathway for the intracellular accumulation of calcium is suggested by the work of Michael A. Kaliner of the National Institute of Allergy and Infectious Diseases and K. Frank Austen of the Harvard Medical School.[11] The sequence of events in the allergic process somehow modifies the structure of the mast cell's outer membrane. The membrane becomes permeable to calcium ions. Calcium enters the cell and activates the enzyme phospholipase A_2, which promotes the further metabolism of phosphatidyl choline to form lysophosphatidyl choline and arachidonic acid. See Figure 3.

The entry of calcium ions also activates enzymes that release energy and promotes the assembly in the cell of cable-like microtubules and the contraction of thread-like microfilaments. These contractile structures cause the granules to move the cell membrane, fuse with it and disgorge their contents: histamine, heparin, serotonin, and chemical factors that activate blood platelets and attract eosinophils and also phagocytic cells. Each of these mediators contributes in its own way to the allergic reaction.

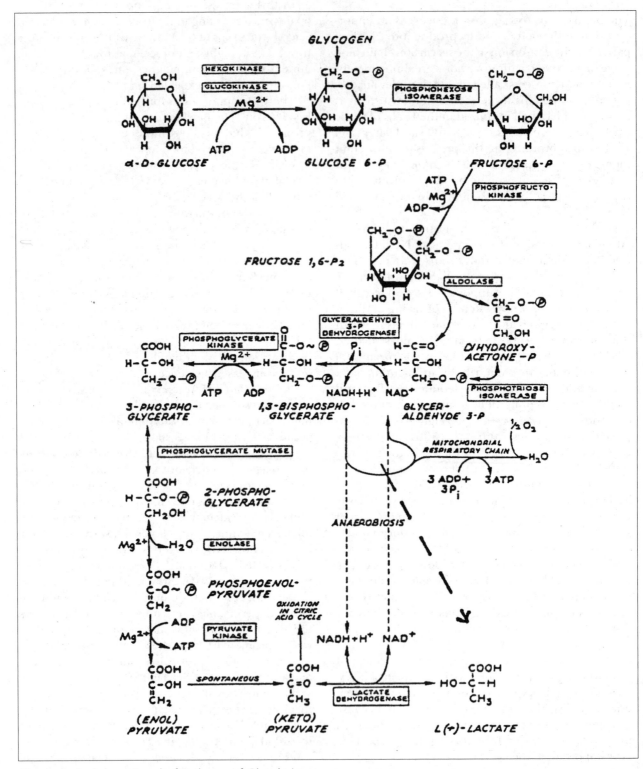

Figure 1: Embden-Meyerhof Pathway of Glycolysis

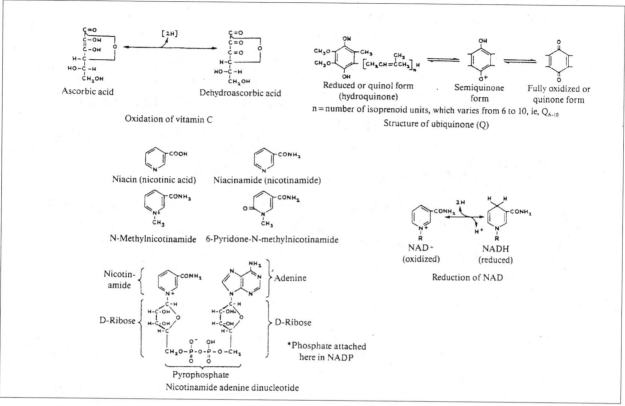

Figure 2: Niacin and Related Deriatives

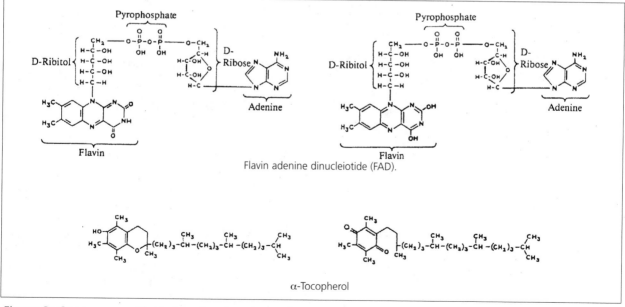

Figure 3: Coenzymes with Hydroquinone-quinone Structure

Therefore, the intracellular deposition of calcium may serve as an indicator of the possible presence of some allergic reaction. Further specific tests are recommended for confirmation.

References

1. National Academy of Sciences. Nutrient requirements of domestic animals. No. 1-10. Washington, DC: National Academy of Sciences, 1972.

2. National Academy of Sciences. Recommended dietary allowances. 8th ed. Washington, DC: National Academy of Sciences, 1974: 82.

3. Thomas, Jr. WC and Howard JE. Disorders of calcium metabolism. Nutrition and Food 1978;(3):150.

4. Underwood, EJ. Trace elements in human and animal nutrition. London, UK: Academic Press, 1977.

5. Philpott WH, et al. Brain Allergies. New Canaan, CT: Keats Publishing, Inc., 1980.

6. Harrison TR, et al. Principles of Internal Medicine. Tokyo: McGraw-Hill Kagokusha, Ltd., 1977.

7. Ziegler E. The Redox Potential of the blood in vivo and in vitro. Springfield, IL: Charles C. Thomas, 1965:13.

8. Harper HA, et al. Review of Physiological Chemistry. Los Altos, CA: Lange Medical Publications, 1979:298.

9. Pitts, Jr. FN. The biochemistry of anxiety. NEJM 1967;277: 69-75.

10. Wachman A, et al. Diet and osteoporosis. The Lancet 1968 May 4:958-59.

11. Kaliner M, et al. Journal of Immunology 1974;112: 664-74.

Effect of Yogic Practices and Pterocarpus Extract on Insulin Dependent Diabetics

J.K. Ojha (MD), H.S. Bajpat (MD), and R.M. Shettiwar (MD), Department of Dravyaguna Medicine and Yoga Sadhana Kendra, Institute of Medical Sciences Banaras Hindu University

(Reprinted by permission of Gujarat Ayurved University)

SUMMARY

Twenty-five patients (4F, 21M) of juvenile onset diabetes were included in the study. After withdrawal of insulin, mean fasting blood glucose (B.G.) was 210 mg%, and P.P.B.G. 577 mg%. Patients were divided into three groups. Gr. I was put on 12 different yogic practices. Gr. II was given Pterocarpus water-soluble extract in divided doses. Gr. III was given combined treatment of yogic practices and Pterocarpus extract three times a day. Blood glucose estimations were done once a week for 4 weeks. Of the cases, 80% were well controlled along with subjective improvement and a sense of well being. Statistical analysis showed a significant improvement after therapy.

INTRODUCTION

Physical exercises and yogic practices have been advocated in the management of diabetes mellitus in the traditional system of medicine since the days of Charaka, the foremost ayurvedic physician and scientist of the ancient period around 2000 B.C.[1] Suhruta (2000 B.C.) has also suggested that a diabetic individual should walk at least 4 miles a day.[2] Celsus (30 B.C. to 50 A. D.) also made a reference to beneficial effects of physical exercise in the management of diabetes mellitus, and in the pre-insulin era, exercise became an established part of diabetic therapy.[3]

Even with the spectacular advances in the management of diabetes mellitus in the present century, exercise has been recommended as an important component for the control of hyperglycemia, both in the insulin dependent and the non-insulin dependent diabetics.[4-7] However, uncontrolled exercise in an insulin treated diabetic may precipitate hypoglycemia or may lead to keto-acidosis if the exogenous insulin is omitted.[8-9] Shortly after the availability of insulin, Lawrence, Burger, and Kramer suggested potentiation of the hypoglycemic effects of insulin by exercise. Further, the insulin requirement has been found to be reduced with regular physical exercise. These effects have been suggested to be due to changes in the insulin receptors or the counter regulatory hormones.[12-13]

The present work was undertaken to study the effect of certain yogic exercises, either alone or in combination with an indigenous plant extracts, on the blood sugar and neurohumors levels in insulin dependent diabetics.

MATERIALS AND METHODS

Thirty insulin dependent diabetics (IDD) were selected from the Diabetic Clinic of the University Hospital. The diagnosis of IDD was made on the basis of clinical profile, age of onset of disease, and the insulin dependency. The diabetic state was confirmed either by oral glucose tolerance test or after the fasting and 2 hours post-prandial blood sugar levels.

The patients' age ranged from 14 years to 30 years, and the duration of diabetes was between 3 to 4 years. Of the 30 patients studied, 20 were males and 10 were females. The weight range of the patients was from 28 to 40 kg, and the average height was between 126 cm and 156 cm.

The patients were on insulin for about 2 to 3 years. None of the patients had evidences of keto-acidosis or any major diabetic complications.

The patients were taken off their insulin therapy and were put on placebo and dietary therapy for about a week or 10 days. The fasting and 2 hours post-prandial blood sugar values as well as plasma neurohormones were estimated. The patients were then categorized in three groups (Group I, II, and III), consisting of 10 patients in each.

Group I patients were put on the following 12 different yogic practices under direct supervision of one of the investigators:

- Yogamudra
- Haasana
- Mayurasana
- Marsyasana
- Samangasana
- Ardha Matsenetrayasana
- Bhujangasana
- Pammitanasana
- Shayasana
- Padmasana
- Uttanpandasana
- Naukasana

Group II patients were given water-soluble extract of an indigenous plant *Pterocarpus marsupium* in the doses of 3 ounces per day in three divided dosages. The drug extract for the 24 hours drug dosages was prepared from 100 to 200 g of the coarse powder obtained from the hard wood of the plant. The water-soluble extract was prepared in the traditional pre-scribed way of the ancient system of medicine. The hard wood of the *Pterocarpus marsupium* was obtained from the forests of Madhya Pradesh.

Group III patients were given the plant extract along with the yogic exercises.

The patients were evaluated every week for a period of 4 weeks. The fasting and 2 hours post-prandial blood sugar and the neurohormones were estimated.

OBSERVATIONS

Of the 30 diabetics studied, the majority was in the age group of 21 to 25 years. There were 20 males and 10 females. The average weight and height of the patients in the different age groups ranged from 28 to 40 kg and from 126 to 156 cm, respectively (Table 1,2,3,4).

Effect of Therapy

The fasting and post-prandial blood sugars before and after treatment for each of the three treatment groups are given in the Tables 2-4. The pretreatment mean fasting blood sugar in Group 1 (Yoga only) was 175 ± 5.3, in Group II (Pterocarpus only) it was 169 ± 5.8, and in the Group III (Pterocarpus + Yoga) it was 163.0 ± 19.4 mg percent. The pre-treatment 2 hours post-prandial mean blood sugar values in the three treatment groups were 358.0 ± 5.2, 299.0 ± 7.07 and 293.3 ± 6.8 mg percent, respectively. After the therapy, the mean fasting and post-prandial blood sugar values were 160.0 ± 2.0, 105 ± 5.5, 90.0 ± 5.9 and 300.0 ± 4.0, 197.0 ± 4.5 and 160.0 ± 6.8 mg percent, respectively. There were highly significant improvement both in the fasting and post-prandial blood sugar levels in the Pterocarpus and Pterocarpus and yoga treated groups. In the yoga-treated group, some decrease in the blood sugar values were also noted but it was nei-ther statistically significant nor controlled.

In the traditional Ayurvedic system of medicine a triangular approach consisting of diet, drug, and yoga exercise has been advocated for the proper and

Table 1: Age, Sex, Height and Weight Distribution of Patients

Age in Yrs.	Total No. of Pts.	Males	Females	Mean. height (cms.)	Mean. weight (kg.)
11-15	2	2	-	126.0	28.0
16-20	5	5	-	126.0	32.0
21-25	14	10	4	125.0	35.0
26-30	9	3	6	156.0	40.0

Table 2: Effect of Yoga alone on Blood Sugar Levels

S. No.	Pts. name	Pre-treatment blood. Sugar mg.%		Post-treatment blood Sugar mg.%	
		fasting	post prandial	fasting	post prandial
1.	B.	170.0	350.0	165.0	295.0
2.	G.S.	180.0	355.0	164.0	297.0
3.	L.C.	177.0	364.0	158.0	305.0
4.	R.K.	168.0	357.0	155.0	307.0
5.	A.S.	169.0	358.0	159.0	298.0
6.	P.U.	165.0	360/0	161.0	304.0
7.	R.K.	175.0	362.0	160.0	301.0
8.	K.N.	177.0	350.0	163.0	267.0
9.	P.	180.0	359.0	159.0	301.0
10.	L.	170.0	365.0	156.0	295.0
Mean±S.D.		173 ± 5.3	358 ± 5.2	160.0 ± 2.0	300.00 ± 4.0
Significance t			2.08		25.8
p			> 0.05		< 0.01

balanced treatment of diabetes mellitus. Charak-Samhita and others have mentioned the beneficial effect of exercises in the management of diabetes in the pre-insulin era. Even with the advent of insulin and other oral hypoglycemic drugs, exercises are of paramount importance in the control of hyperglycemia. In the present study, there was a significant decrease in the mean blood sugar (both fasting and 2 hours post-prandial) levels in the diabetics who were either on yogic exercises alone or were on the drug and the exercises. The degree of fall in blood sugar level was greater in the group who were treated with the

drug (*Pterocarpus marsupium*) and the yogic exercises.

It has been suggested that with the exercises the hypoglycemic effect of insulin gets potentiated, insulin requirement diminishes and there is increase in insulin receptors as well. Further, during the exercise, consumption of glucose by muscles increases to 40 times of the basal values.[14-15] There is increased utilization of FFA, ketone bodies, and glycogen in the liver. It has also been suggested that there are changes in other regulatory neurohormones during exercise, but in the present study there was no change in the levels of the neurohormones before and after the therapy.

Table 3: Effect of Pterocarpus Marsupium on Blood Sugar Levels

S. No.	Pts. name	Pre-treatment blood Sugar mg.%		Post-treatment blood Sugar mg.%	
		Fasting	post prandial	fasting	post prandial
1.	B.	165.0	300.0	104.0	190.0
2.	L.P.	160.0	304.0	107.0	195.0
3.	M.D	170.0	290.0	100.0	192.0
4.	S.P.	174.0	296.0	94.0	197.0
5.	L.D.	168.0	297.0	108.0	200.0
6.	U.S.	169.0	299.0	109.0	200.0
7.	R.N.	178.0	307.0	110.0	205.0
8.	K.	170.0	282.0	110.0	193.0
9.	U.D.	161.0	300.0	110.0	192.0
10.	K.D.	175.0	295.0	99.0	199.0
Mean±S.D.		169.0±5.8	299.0±7.07	105.0±5.5	197.0±4.5
Significance t			25.6		39.0
p			< 0.001		< 0.001

Table 4: Effect of Pterocarpus Marsupium and Yoga on Blood Sugar Levels

S. No.	Pts. name	Pre-treatment blood Sugar (mg.%)		Post-treatment blood Sugar (mg.%)	
		Fasting	post prandial	fasting	post prandial
1.	H.	160.0	300.0	88.0	160.0
2.	A.S.	162.0	286.0	84.0	154.0
3.	N.B.	170.0	286.0	82.0	158.0
4.	L.R.	104.0	305.0	96.0	168.0
5.	S.N.	103.0	290.0	90.0	151.0
6.	L.P.	159.0	295.0	99.0	165.0
7.	B.B.	160.0	286.0	86.0	169.0
8	U.P.	169.0	301.0	97.0	150.0
9.	S.R.	158.0	288.0	93.0	167.0
10.	B.N.	165.0	290.0	85.0	85.0
Mean±S.D. 160.0±6.8		163.0±19.4	293.0±6.8	90.0±5.92	
Significance t			11.40		42.7
p			< 0.05		< 0.001

References

1. Charak. Bombay, India: Nirnaya Sagar Press, 1941:448.

2. Sushruta Samhita. Translated and edited by Kaviraj Kunja Lal Bhishagratna. Varanasi, India: Vidya Vilas Press, 1963:361, 387.

3. Von Noorden C. Die Zuckerkrankheit und ihre Behandlung. Berlin, Germany: Hirschwald, 1917:498.

4. Berger M, Bercht Old P, Cuppers HJ, et al. Metabolic and hormonal effects of muscular exercises in juvenile type diabetic. Dibetologia 1977;13:355.

5. Berchtold P, Berger M, Cuppers HJ, et al. Nonglucoregulatory hormones (T4, T3, rT3, TSH, Testosterone) during physical exercise in juvenile type diabetic. Horm. Me. Res. 1978;10:269.

6. Lawrence RD. The effect of exercise on insulin action in diabetes. Br. Med. J. 1926;1:648.

7. Burger M and Kramer H. Hber die durch Muskelarbeit hervorgerufene steigerung der insulin wirkung anf den Blutzucker ge halt bein normalien und gestorten kohlenhydrasoff weehsee und ihre prakische und theoretische Badentung. Klin. Wochenschr 1928;7:745.

8. Vranic M, Kawamori R, and Wrenchall GA. Mechanism of exercise induced hypoglycaemia in depancreatised insulin-treated dogs. Diabetes (suppl. I) 1974;23:353.

9. Kawanori, R. and Vranic, M. Mechanism of exercise induced hypoglycaemia in depancreatized dogs maintained on long-acting insulin. J. Clin. Invest. 1977:59:331.

10. Marble A and Smith RM. Exercise in diabetes mellitus. Ann. Int. Med. 1936;58:577.

11. Hetzel, K.L. and Long C.N.H. The metabolism of the diabetic-individual during and after muscular exercise. Proc. Roy. Soc. London 1926; Ser. B 99:279.

12. Vranic M and Berger M. Exercise and diabetes mellitus. Diabetes 1979;28:147.

13. Klacho DM, Lie TH, Cunningham, EJ, et al. Blood glucose levels during waking in normal and diabetic subjects. Diabetes 1972;27:68.

14. Wahren J, Felig P, Ahlong G, and Jorfeldt J. Glucose metroboni during leg exercise in man. J. Clin. Invest. 1971;50:2715.

15. Felig P and Wahren J. Fuel homeostasis in exercise. N. Eng. J. Med. 1975;293:1078.

Hypoglycemic Response of C. tamala in Diabetes

Hari M. Chandola (MD) and Surendra N. Tripathi (MD), Department of Kayachikitsa,
Institute of Medical Sciences, Banaras Hindu University

(Reprinted by permission of Gujarat Ayurved University)

SUMMARY

A series of 32 cases of diabetes mellitus were selected. Powder of *C. tamala* was administered in the dose of 2 t.s.f. 4 times a day for a period of one month. Fasting blood sugar (FBS) was estimated before and after the treatment. Average FBS before was 153.4 mg% and after treatment 112.6 mg%. (p<0.001). To evaluate the effect of the drug on glucose load in diabetics, a series of 25 patients were treated and fasting as well as P P blood sugars were estimated before and after one-month treatment. Fall in P P blood sugar was statistically significant. In order to assess the immediate hypoglycemic response of the drug, 20 g of the same was administered after collection of fasting blood sample in a small series of seven diabetics and four blood samples were collected at 30 minute intervals after feeding the drug. Plasma insulin and blood glucose were estimated. There was a rise in plasma insulin and corresponding fall in blood sugar.

INTRODUCTION

Diabetes mellitus is no more a simple disease of insulin deficiency; rather, it is being recognized as a syndrome — i.e., a group of diseases with different etiology having common clinical features.[1] With the progression of disease the same patient may develop different pathological features,[2-3] and is likely to respond in a entirely different pattern with the same drug. In the early stage, the patient may be insulin independent,[4] responding well with known hypoglycemic agents, but at later stage, the same patient cannot be managed without insulin therapy as he becomes insulin dependent. Thus, there is a scope of several types of drugs for different types of diabetes mellitus patients and in different stages of progression. Hence, there is a wide scope to develop new hypoglycemic drugs and to find out their modes of action, so that it may be categorized for specific uses.

The syndrome of diabetes mellitus has been largely covered in Indian medicine under the heading of Prameha. The ancient Indian physicians have tried to advance their views regarding the etiology, pathogenesis, and the treatment of this disease in a great detail. Many herbal and herbomineral drugs have been also recommended. *C. tamala* is also one of them,[5] and it has been reported to have hypoglycemic response in experimental studies and preliminary clinical studies.[6,7,8,9]

In this study, effect of *C. tamala* powder has been assessed in diabetes mellitus patients, and the assessment has been done by estimation of fasting and post prandial blood sugar before and after treatment. Simultaneously, the immediate effect of *C. tamala* on blood sugar cum plasma insulin has been also observed.

MATERIALS AND METHODS
Preparation and administration of drug and doses

Leaves of *C. tamala*, a popular kitchen spice, were dried, pulverized, and filtered through a fine mesh and packed in 100 g plastic packets. Patients were advised to take orally two heaping teaspoons of above powder four times a day, half an hour before breakfast, lunch, tea and dinner, for one month.

Selection of cases

Only the G.T.T. proved cases of maturity onset diabetes were selected for this study from a specialty clinic of Kayachikitsa. Preferably, those cases were selected who had not developed any major complications.

Study groups and assessment of results

A series of 32 G.T.T. provided cases of maturity onset diabetes was selected and treated for one month with the powder of *C. tamala* as mentioned above. They were allowed to continue with an 1800-calorie diet with restriction of sugar, potato, and rice. Fasting blood sugar was estimated again after treatment, and the fall in blood sugar after treatment was recorded. A series of 8 patients of diabetes mellitus was selected for control study and was kept on the same diet as in the treated group, and the blood sugar was estimated before and after one month. No drug was administered during this period. Difference in blood sugar level was statistically analyzed.

A series of 25 G.T.T. proved cases of diabetes mellitus was selected. Their fasting, as well as two post prandial blood sugar samples at one hourly interval after 100 g oral glucose load, were collected for estimation

of blood sugar. They were treated for one month, and again glucose tolerance test was repeated. The difference in blood sugar levels at different points was compared and statistically analyzed.

A series of 7 G. T. T. proved patients of diabetes mellitus of maturity onset type was selected. Their fasting blood samples were collected for the estimation of blood sugar and plasma insulin. After one oral administration of 20 g powder of *C. tamala*, four blood samples were collected at 30 minute intervals up to 2 hours for the estimation of blood sugar and plasma insulin by radioimmunoassay technique.[10] The kit for the insulin assay was procured from Bhabha Atomic Research Centre, Trombay, Bombay.

RESULTS

Powder of *C. tamala* was well tolerated by all the patients in the above dose. No side reactions or toxicity could be observed. In short, the therapy was acceptable.

It is evident from Table 1 and Figure 1 (showing the results of study No. 1) that all the patients had abnormal fasting blood sugar with the mean of 153.44 mg%. Thus, they seem to be only mild and moderate cases of diabetes mellitus. After one month of treatment with *C. tamala* powder, the mean fasting blood sugar was reduced to 112.65 mg%, which was almost within normal limits. On statistical analysis, the difference in fasting blood sugar level is highly significant (p< 0.001). On the other hand, the control group receiving identical diet instead of fall in blood sugar there is a minor rise, which is statistically significant (p< 0.01). Thus, it may be inferred from this clinical study that *C. tamala* is an effective hypoglycemic agent for mild and moderate degree of diabetics. The fall in blood sugar is about 26.5%.

Table 2 and Figure 2 show that there is definite fall in blood sugar values at all points and the difference is statistically significant (P<0.001). The fasting blood sugar has come down to 103.51 mg%, which is within the physiological range.

However, the postprandial blood sugar reading after one hour is 206.89 mg%, which is slightly higher than normal. Of course the mean second postprandial sample is 170.59 mg%, which is below the renal threshold value.

When the immediate effect of *C. tamala* powder on fasting blood sugar vis-à-vis plasma insulin was estimated to evaluate the mode of hypoglycemic response, it was observed that along with fall in blood sugar level there is corresponding rise in plasma insulin, as shown in Table 3 and Figure 3. The mean fasting blood sugar in this group was 166.28 mg%.

Gradually, it has fallen down to 122.28 mg% at the end of the second hr (p<0.01). Simultaneously, the plasma insulin, which was 8 mu/ml in fasting sample, has gone up to 31 mu/ ml in the second hr.

DISCUSSION

In this study, an attempt has been made to establish the role of *C. tamala* as a hypoglycemic agent in the patients of diabetes mellitus. To achieve this object, three study groups have been designed. In study No. 1, the effect of *C. tamala* has been studied on fasting blood sugar with encouraging results. The mean difference is about 40.79 mg% and the effect is statistically significant (P<0.001).

In second study group, the effect of *C. tamala* has been studied on fasting as well as on postprandial samples to assess how far this drug is capable of modulating the challenge of glucose load. Again, this study has established that apart from its effect on fasting blood sugar, it lowers down the blood sugar level after glucose load. Thus, the efficacy of the drug seems to be more important and its use in the management of diabetes mellitus becomes more genuine.

The hypoglycemic action of *C. tamala* after one month treatment has been compared with the result of the diet control with 1800 calories, which has been recommended for both the treated and control groups. The study has revealed that this degree of diet control has no role in the control of blood sugar in the patients with diabetes mellitus. The blood sugar has been reduced only in few cases, and in the rest of the cases there is a rise in blood sugar values. Thus, the hypoglycemic action of the drug is highly suggestive. Of course, a double blind study is essential to exclude unforeseen factors including psychosomatic. Hence, the third study group has been designed to see the immediate effect of *C. tamala* on fasting blood sugar. It is interesting that after the oral administration of the drug, the fall in blood sugar has started within 30 minutes and it went on increasing up to 2 hours. The fall in blood sugar was significant to all points (P <0.01).

The reduction in blood sugar is possible in many ways. The drug may interfere with the digestion and absorption of sugar from gastrointestinal tract. It may enhance the shunting of glucose from blood stream to the tissues, particularly muscle tissue, or it may help the entry of glucose in the cells by virtue of its action on the cell membrane, or it may increase the body metabolism leading to combustion of glucose in the Krebs cycle at the level of mitochondria. Insulin is supposed to be the key hormone in carbohydrate metabolism. It helps in glycogenesis, as well as in permeation

Table 1: Effect of *C. tamala* on Fasting Blood Sugar Before and After One Month Treatment in Patients of Diabetes Mellitus

S. No.	Group	Before treatment Mean blood sugar (mg%)	After treatment Mean blood sugar (mg%)	Difference (mg%) (Mean±SE)
1.	Treated	153.44	112.65	40.79±4.35 (p < 0.001)
		Treated with diet control alone		
2.	Control	156.37	164.12	7.75±12.06 (p < 0.01)

Table 2: Effect of *C. tamala* of Fasting and Post Prandial Blood Sugar Before and After One Month Treatment in Patients of Diabetes Mellitus

	Fasting blood sugar (mg%) Mean±SE	Post prandial blood sugar (mg%) Mean±SE	
		1 hr.	2 hr.
Before Treatment	144.84	258.64	236.15
After Treatment	103.51	206.89	170.59
Difference	41.33±5.548 (p < 0.001*)	51.75±11.78 (p < 0.001*)	65.55±7.27 (p < 0.001*)

*Highly significant

Table 3: Immediate Effect of *C. tamala* on Fasting Blood Sugar Cum Plasma Insulin within Two Hours Treatment in Patients of Diabetes Mellitus

	Fasting blood sugar (Mean)	Blood sugars after drug administration (Mean±SE)			
		1/2 hr	1 hr.	1 1/2 hr.	2 hr.
Blood sugar (mg%)	166.28	157.28	145.57	130.42	122.28
Difference (before & after treatment		9±2.21 p < 0.01	20.71±6.46 p < 0.02	35.85±8.41 p < 0.01	44±10.28 p < 0.01
Plasma insulin (_u/ml)	8.0		16.83		31.0

Figure 1: Immediate effect of *C. tamala* on fasting blood sugar cum plasma insulin within two hours treatment in 7 patients of diabetes mellitus

Figure 2: Effect of *C. tamala* on fasting and P.P. blood sugar before and after one month treatment in 23 patients of diabetes mellitus

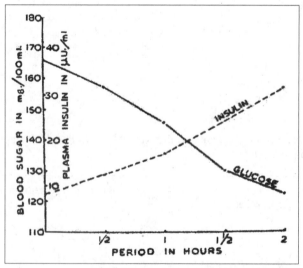

Figure 3: Immediate effect of *C. tamala* on fasting blood sugar cum plasma insulin within two hours treatment in 7 patients of diabetes mellitus

of glucose from the capillaries to the cells, by acting on cell membrane. Drugs like sulphonylureas and biguanides act as insulin promoters leading to release of endogenous insulin. The drug-like phenformin helps in shunting the blood sugar from blood to the tissues and this action is known as 'insulin like'.

The action of *C. tamala* may be either of the two: i.e., it may be promoting the insulin secretion or the action may be insulin-like. In order to pinpoint this action of *C. tamala* on insulin and glucose, the immediate effect of the drug has been assessed on plasma insulin and blood glucose in fasting cases for a period of 2 hours. Gradual fall in the blood glucose has been recorded. Mean fasting blood sugar was 166.28 mg%, with the mean plasma insulin 8 mu/ml, but gradually the blood sugar level has fallen to 122.28 mg% at the end of 2 hours, with a rise of plasma insulin to 31 mu/ml. Thus, the rise of plasma insulin has been demonstrated with the fall of blood sugar in the same sample after the administration of powder of *C. tamala* for 2 hours. It may be inferred from these studies that the drug *C. tamala* may have a role to play with the release of insulin from the cells of islets of Langerhans. Of course, further studies in-vitro and in-vivo have to be designed to trace the exact mode of action of the drug. Instead of using the crude drug, different fractions of the drug and active principles may also be used for the purpose of study and trial.

Acknowledgment
We are thankful to the previous work of Dr B.C. Singh, Dr R.S. Singh, and Dr A.N. Chaddha.

References

1. Notkins AL. The causes of diabetes, Scien Am Jour. 1979;241:56.

2. Alberti KGMM, et al. The role of hormones in the pathogenesis of severe diabetic ketoacidosis: Implication for treatment. In: Diabetes, ed. J.S. Bajaj. Amsterdam, The Netherlands: Excerpta Medica,1977:367.

3. Berson SA and Yalow RS. Insulin antagonists, insulin antibodies and insulin resistance, Am J. Med. 1958;25:155.

4. Foa P, Bajaj JS, and Naomi F. Glucagon: Its role in physiology and clinical medicine. New York, NY: Springer Verlag, 1977.

5. Charak Samhita. Premeha Chikitsadhyaya. Commentary by KN Shastri and GN Chasturvedi Varanasi, India: Chowkhamba Vidya Bhavan, 1970:241

6. Chadda AN. Clinical and experimental studies on Prameha (diabetes mellitus) with special reference to oral hypoglycemic action of C. tamala, D. Ay M. thesis, B.H.U, 1973.

7. Chandola HM Correlation of Prameha with diabetes mellitus and evaluation of the response of C. tamala on glucose and insulin metabolism, M.D. (Ay.) thesis, B.H.U., 1979.

8. Singh BC.Clinical and experimental studies on aetiopathogenesis and management of Prameha with Madhwasava. D. Ay. M. thesis, B.H.U., 1972.

9. Singh RS. Clinical and experimental studies on oral hypoglycemic (Pramehaghna) drugs of Indian medicine, D. Ay. M. thesis, B.H.U., 1972.

10. Herbert V, Lau KS, Gottlieb CW, Bleicher SJ. Coated charcoal immunoassay of insulin, J. Clin. Endocr. 1965;25:1375.

The Role of Psychosomatic Constitution (Prakriti) in the Progression and Prognosis of Diabetes Mellitus and Response to Treatment

H.M. Chandola (MD), S.N. Tripathi (MD),
and K.N. Udupa (MD), Banaras Hindu University, State Ayurvedic College

(*Reprinted from* Alternative Medicine *1985;1(2), by permission of Gujarat Ayurved University*)

ABSTRACT

This study deals with the application of Ayurvedic principles to the treatment of diabetes mellitus. The concept of Prameha in Ayurveda is so close to diabetes mellitus that Prameha can almost be accepted as a synonym of diabetes mellitus. The three major types of Prameha – Kaphaja, Pittaja, and Vataja – can be treated as three stages of the same disease, which is comparable to chemical, acute, and chronic states of diabetes mellitus. The role of psychosomatic constitution in the progress on the prognosis of Pramahar has been emphasized in Ayurveda. Broadly defined, constitution can be of three types: Vataja, Puttaja, and Kaphaja. It is also similar to the constitutional typology of Sheldon. Anthropological, physiological, psychosocial, and biochemical parameters have been adopted to the study of the constitution in normal as well as in a series of 42 diabetic subjects: Vataja (16), Kaphaja (10), and Pittaja (17). Correlation studies have been performed on the duration of the disease, blood sugar, plasma insulin, and neurohumors. It has been observed that progression is quick in Vataja, medium in Puttaja, and slow in Kaphaja constitution. The response of treatment varies with *C. tamla, Inula racemosa*, Chandra-prabhavati, and Diabenese, depending upon the constitution and the stages of the disease. On this basis, a stepped care treatment has been proposed.

INTRODUCTION

Growing clinical and epidemiological evidence shows that the incidence of diabetes mellitus, whether insulin dependent or non-insulin dependent, varies from country to country and also within the same country, depending to a great extent on racial and environmental factors. Anthropological studies have shown a correlation between diabetes and the constitution,[1] and a correlation between the color of the skin and some genetic factors in relation to diabetes have also been reported.[2,3] Similarly it has also been observed that the requirement of insulin and oral hypoglycemic drugs varies from one group to another, and explanations have been put forward. Variation in insulin requirement has also been reported in the same patient, particularly in the morning (pre-breakfast) and during the night hours,

within a 24-hour period.[4] Low- and high-dose insulin therapy schedule is still under consideration. In our opinion, this state of affairs prevails because a holistic approach is lacking.

On the other hand, the approach of Ayurveda is an integrated one, which takes into account the psychosomatic constitution; biometriological parameters; and chronobiological and physiological doshic rhythms *vis-à-vis* the pathological state of the body.[5]

It is surprising that what is being claimed as recently discovered has already been emphasized in the ancient literature of Ayurveda. Seven types of body constitutions have been described: Vataja, Pittaja, Kaphaja, Vatapittaja, Patakaphaja, Vatakaphaja, and Samdoshaja. Similarly, 20 types of Prameha (diabetic syndrome), Kaphaja (10), Pittaja (6), and Vataja (4) have been suggested. The progression and prognosis of this disease have been described as being correlated with the type of constitution and variety of disease. For example, the Kapahaja type of Prameha occurring in a person having Kaphaja constitution is supposed to progress slowly and the prognosis is better.

It is interesting to record that body constitution is thought to be irreversible and is said to have genetic background.[6] On the other hand, Kaphaja, Pittaja, and Vataja types of diseases seem to be the stages of the same disease. The patient from a Kaphaja state of progression passes to the Paittika stage and, ultimately, to the Vataja stage. In the Vataja stage, the prognosis becomes poorer and there is rapid deterioration of health.

MATERIALS AND METHODS
Study of constitution in diabetics and control group

For this study, 42 GTT-proved diabetes mellitus patients were selected and their constitution was evaluated. Seven types of psychosomatic constitutions have been described in Ayurveda, as mentioned earlier. Of course, these seven types are the variations of the three major types: Vataja, Pittaja, and Kaphaja. Therefore, the patients were classified into three groups on the basis of predominance of the clinical features of each dosha.

The basic features of the three constitutions were further classified into three categories: (1)

anthroscopic, (2) physiological, and (3) psychosocial. In the anthroscopic examination, body-build, complexion, prominence of veins and tendons, eyes, teeth, eye-brows, joints, etc. were examined. Appetite, thirst, dietary habits, sexual potency, and tolerance to heat and cold, etc. were studied in the physiological examination. The psychosocial examination included enquiry into sociopsychological traits, such as piousness, courage and boldness, memory, grasping power, calmness of mind, and psychic nobility. Detailed information regarding these traits was collected in a proforma.

Anthropometric examination was subsequently carried out on the diabetic patients and on the control group. Height, body weight, and tibial and biachromial standing height were measured. Body surface area, ponderal index (height-weight ratio), and tibial and biachromial standing height index were calculated. A study of certain neurohumors (acetylaholine,[7] catecholamines,[8] and histamine[9]) was also done. Further, plasma cortisol[10] and insulin levels were estimated in blood samples of the fasting diabetic patients.

In order to compare the findings with the control, a series of 30 normal healthy individuals was selected and all the investigations above were repeated. They had Vitika, Paittika, and Kaphaja constitutions – 10 in each group.

Study of the progression of diabetes

It is an established fact that there is a natural progression of diabetes mellitus with the duration of illness. On the basis of our previous observations, there is a rise in blood sugar with the progression of the disease.[11] The diabetic patients were divided into three groups depending on blood sugar level. Group I fasting blood sugar was <140 mg%; Group II was between 140-250 mg%; and Group III was >250 mg%. These were correlated with Kaphaja, Pittaja, and Vataja stages/types of Prameha. A statistical correlation study was carried out with duration of illness and fasting blood sugar, insulin, neurohumors, and body weight. The correlation of the progression of disease was also done on the basis of the body constitution.

Study of the response of treatment: Clinical trial

C. tamala,[12,13] Inula racemosa, Chandra-prabhavati, and Diabenese were selected for the study of response of the treatment. The patients were kept on an 1800-calorie diet.

Statistical analysis of the blood sugar values was carried out before and after the treatment in all groups.

The percentage fall in the blood sugar values was also normal at various points. A powder from the leaves of C. tamala (Tejpatra) was given to 6 diabetic patients, the dose being 1-2 teaspoons 30 minutes before breakfast, lunch, and dinner, depending upon the severity of the disease. Powder of Inula racemosa was administered 1 teaspoon 30 minutes before breakfast, lunch, and dinner to 18 diabetic patients. Chandra-prabhavati, an Ayurvedic preparation, was administered in 37 diabetics in the dose of two pills, three times a day. Modern oral antidiabetic therapy (Diabenese) was given to 19 diabetic patients according to the severity of the disease. The response of treatment of each drug was analyzed according to constitution and stages of the disease.

OBSERVATIONS AND RESULTS
Pattern of constituation in diabetic patients (Prameha)

It is a general belief that Kapha is predominant in Prameha (diabetes). One may be tempted to infer that patients having a Kaphaja constitution may mostly be affected by this disease. But this is contrary to our observations. In this series of diabetic patients, 16 patients had Vatika, 17 Paittika, and only 9 had Kaphaja constitutions.

The statement of a particular constitution in an individual is only to indicate the predominance of a particular Dosha in him from birth because the constitution is said to be genetically decided. Hence, it does not mean that characteristics of other doshas are not present in them. The comparative score of Vatika, Paittika, and Kaphaja features present in each group has been reviewed.

In Vatika, Paittika, and Kaphaja constitutions the scores of respective Doshas should be high and the same has been observed. Vatika score is 63.09±12.74 in Vatika constitution; Paittika score is 63.41±15.62 in Paittika constitution; and Kaphaja score is 65.11±12.52 in Kaphaja constitution. Regarding the second predominance of Doshic features, Paittika score is high as compared to Kaphaja in Vatika constitution, whereas Kaphaja score is high as compared to Vatika score in Paittika constitution, and Paittika score is high as compared to Vatika score in Kaphaja constitution. This trend seems to have some logical bearing because predominance of Vatika score is not possible in Kaphaja nor in Paittika constitutions because both Kapha and Pitta are Snigdha. Of course, there is a degree of difference. Similarly, in Vatika constitution, the predominance of Kaphaja score cannot be over Pitta because Kapha is more Snigdha as compared to Pitta.

It is obvious from this study that anthroscopic

features are more important for deciding the constitution (Prakriti). For example, in Vatika constitution, the Vatika score is 63.06±12.74; among them, the contribution of anthroscopic score is 44.06±12.31. Similarly, in Paittika constitution, the Paittika score is 63.41±15.62, whereas the anthroscopic score is 44.41±12.85, and in Kaphaja constitution Kaphaja score is 65.11± 12.52, with 40.55±9.16 anthroscopic scores. Thus, the range of anthroscopic score is between 40.55 and 44.41, which is a decisive factor for deciding the constitution of an individual.

On anthropometric examination of the diabetics, the height-weight ratio (ponderal index) was observed to be at a maximum in Vataja (45.25±3.20) and a minimum in Kaphaja constitution (41.64±5.43). On the other hand, the pattern is reversed with respect to the body surface area. It is a minimum in Vataja (1.462±0.143m^2) and a maximum in Kaphaja constitutions (1.625±0.119m^2). In general, people having a Kaphaja constitution are bulky as compared to Vataja and Pittaja constitutions; conversely people of Vatika consitutiosn have the least bulk. The same pattern has also been observed in normal subjects having no disease because the parameters of constitution have a tendency not to change.

The study of neurohumors in normal, healthy individuals reveals that the level of acetylcholine is at a maximum in Vataja (1.07±0.176 mg/ml) and a minimum in Kaphaja constitution (3.638±0.169 mg/ml). On the other hand, catecholamine levels are high in Paittika constitution (8.403±1.32 ng/ml) as compared to others. But the plasma cortisol is at a maximum in Pittaja (22.38±1.33 mg%) and a minimum in Kaphaja constitutions (16.82±1.859 mg%). Histamine is at a maximum in Kaphaja (0.100±0.035 mg/ml) and a minimum in Vataja constitutions (0.037±0.011 mg/ml). The findings are in conformity with the observations of previous studies.[14]

This is not true in the diabetic state — the pattern of the neurohumors is quite different among diabetic patients in general and constitution-wise in particular. Irrespective of the constitutions the average levels of acetylcholine, catecholamines, cortisol and histamine are high.

Thus, it is obvious that in diabetics the level of neurohumors is governed more by the disease phenomenon rather than the constitution. Hence, it cannot be an index of constitution in the diseased subjects in general and diabetics in particular. However, the variation in neurohumoral level is quite significant in patients of different constitutions. It shows the susceptibility of the involvement of different neurohumoral derangement in different types of constitutions.

The plasma insulin level of the diabetics and the normal individuals was examined. It was found to be 9.38±2.398 mU/ml in Vatika, 10.80±3.465 mU/ml in Paittika and 11.42±3.608 mU/ml in Kaphaja constitutions of the control group. But in the diabetic patients of Vatika constitution it is 8.625±5.343 mU/ml and in Paittika constitution the insulin level is 9.175±5.058 mU/ml. But in Kaphaja constitution it is quite the reverse: 18.44±10.70 mU/ml, i.e. hyperinsulinism.

As regards the blood sugar level in different constitutions of diabetic patients, it was observed that body constitution plays an important role. On the basis of fasting blood sugar level, severe hyperglycaemia was observed in Vatika (251.26±133.45 mg%), moderate in Paittika (185.44±92.72 mg%), and mild in Kaphaja constitutions (73.77±68.43 mg%). The same increasing pattern was observed in first- and second-hour postprandial blood glucose curve.

Progression of diabetes mellitus (Prameha)

It has been established that diabetes mellitus progresses with the duration of illness and is marked by rising blood sugar level. Definite stages have been identified that have different clinical features. The first stage is chemical diabetes (Kaphaja Prameha), the second is acute diabetes (Pittaja prameha), and the third is chronic diabetes (Vataja prameha). Hence, in this series some of the physical, biochemical, and clinical features have been studied in relation to the duration of illness.

Blood sugar. The blood sugar level has been observed to be advancing with the duration of illness among the patients. In early diabetics (Kaphaja Prameha – 14 patients) the average duration of diabetes being only 4.32±3.47 years with mild hyperglycaemia (102.07±23.15 mg%), while the patients of acute diabetes (Pittaja Prameha, 16 patients) had moderate hyperglycemia (145±28.39 mg%) with an average duration of disease of 5.50±5.24 years, and that of chronic diabetics (Vataja Prameha, 12 patients) had severe hyperglycemia (348.98±81.99 mg%) with the average duration 9.08±9.34 years.

Body weight. The body weight has been observed to be maximum in Kaphaja Prameha (56.85±10.66 kg) medium in Pittaja (55.81±11.26 kg) and it is minimum in Vatika stage (49.25±9.71 kg).

Insulin. The plasma insulin level is 12.65±10.9 mU/ml in early diabetes, 11.06±5.07 mU/ml in acute and 8.81±5.79 mU/ml in chronic diabetics, while in normal healthy individual it is 10.53±3.21 mU/ml. It

shows the gradual deficiencies of insulin in different stages of diabetes mellitus (Prameha).

Neurohumors. The study of neurohumors shows that acetylcholine, catecholamines, histamines, and cortisol are high in diabetes. In normal persons acetylocholine is .086±0.308 mg/ml, while in early diabetics it is 0.956±0.375 mg/ml, in acute diabetics 1.077±0.484 mg/ml and in chronic diabetics it is 0.935±0.494 mg/ml. The level of catecholamines is also increased in general and stagewise in particular. It is maximum in acute stage (14.22±8.273 ng/ml), medium in early diabetics (13.09±5.419 ng/ml) and in chronic diabetics it is 11.082±4.825 ng/ml. It has been reported only 7.824±1.297 ng/ml in the normal subjects. The plasma cortisol is 19.99±3.74 mg% in the control subjects, while the level of plasma cortisol is maximum in acute stage (39.553±23.20 mg%), 32.55±13.926 mg% in early diabetics and 25.79±11.55 mg%in chronic diabetics. Thus, the level of acetylcholine, catecholamines, and cortisol has been observed maximum in acute diabetes (Pittaja Prameha) and lowest in the chronic diabetes (Vataja Prameha), though it is towards the higher side as compared to the normal. Blood histamine is maximum in chronic state (Vataja Prameha) of disease (0.161±0.060 mg/ml) and minimum in that of early (Kaphaja Prameha) state (0.099±0.050 mg/ml). Thus, with the advancing blood sugar level, histamine also goes high. It was raised in all the stages of diabetes as compared to the control.

Clinical features. The incidence of classical clinical features of diabetes mellitus — polyuria, polydipsia and polyphagia — were found to be at a maximum in the patients of Vatika Prameha. Polyuria was the highest in the patients of Vatika Pramaha (66.66%), medium in Paittika (31.25%), and lowest in the patients of Kaphaja Prameha (14.28%). The incidence of Polydipsia was 7.14% in Kaphaja, 18.75% in Pittaja, and 58.33% in Vataja stages. Similarly polyphagia was noted to be at a maximum in Vatika (16.66%) and a minimum in Kaphaja-type of Prameha (7.14%). The complaint of general weakness was also reported by most of the patients who suffered from Vatika Prameha (66.6%) and fewer from Kaphaja (21.42%). Burning in hands and feet was reported by the patients having Kaphaja (21.42%) and Pittaja Prameha (25%). Constipation and loose motion were also reported by some patients. The incidence of constipation was 16.66% in Vatika and 14.28% in Kaphaja Prameha, while loose motion was more common in Kaphaja stage (21.42%) followed by Vataja (16.66%). Some patients of Vatika Prameha (16.66%) also complained

about pain and itching in the genitalia. Thus, the percentage of clinical symptoms is more prominent in Vatika stage, followed by Pittaja and the Kaphaja stages of disease.

The incidence of complications was observed in all the three groups. Most patients of Vatika Prameha (33.33%) suffered from diabetic carbuncle, while no patient of Kaphaja Prameha reported this complication. Neuropathy was found in 42.85% patients of Kaphaja type, 33.33% in the patients of Vatika type, and 25% in the patients of Paittika type. Greater number of patients of Pittaja Prameha suffered from diabetic nephropathy and retinopathy (25% each).

Progression of diabetes mellitus (Prameha) with body constitution

The blood sugar level, as well as duration of illness, are capable of explaining the Doshic state in a diabetic. Hence, correlation of the duration of illness as well as the blood sugar level has been attempted in different types of constitution. Neurohumoral states and body weight have also been correlated side by side.

Blood sugar. In a total of 42 diabetes mellitus patients, the average duration of illness was found to be 6.13±6.412 years, with fasting blood sugar 208.019±109.469 mg% (r=0.271) and 330.838±145.109% mg% in post-prandial analysis (r=0.364). This data shows the rising blood sugar pattern with the advancement of duration of the disease. But according to their body constitution, in the patients having Vatika constitution, the average fasting blood sugar is found to be 251.26±133.45 mg%, with the average duration of illness 7.40±7.97 years having no correlation between duration of illness and blood sugar values (r=0.101). In Paittika constitution, the average fasting sugar is 185.44±92.72 mg% with the average duration 4.6±4.95 years and the correlation is significantly positive (r=0.471). In the patients having Kaphaja constitution, the average fasting sugar is 173.77±68.43 mg%, with the duration of disease 6.66±5.85 years. Data shows slow progression of disease in Kaphaja constitution, in which, with the advancing duration, rise in blood sugar is not so rapid and the r value is only 0.381 which is insignificant (P>0.05).

Body weight. In the 42 diabetic patients with the average duration of illness 6.13 years the mean body weight was 54.857±10.618 kg (r=-0.140). But the r value is not found to be significant. But on constitutional analysis, the average body weight was found to be 46.87±10.22 in Vatika, 56.17±5.57 in Paittika, and

66.55±5.87 kg in the patients of Kaphaja constitution. It is toward the lower side in the first two groups and on the higher side in the later group. But r value is –0.365 in the patients having Kaphaja constitution which is insignificant.

Insulin. The average plasma insulin level was reported to be 10.95±7.65 mU/ml in the 42 diabetic patients. With the increasing duration of illness, a falling pattern in the insulin value has been reported (r=-0.368) and this correlation is found to be significant ($P<0.05$). With advancing duration, a fall in insulin level is reported in all the constitutional groups, but it is significant in the patients of Vatika (8.625±5.343 mU/ml, r=-0.72), and Paittika (9.175±5.058 mU/ml, r=-0.487) constitutions. In the patients having Kaphaja constitution (18.44±10.70 mU/ml) the r value is only –0.155 though the average duration of illness is 6.66 years.

Neurohumors. In the group of patients of acetylcholine level was found to be 0.996±0.447 mg/ml (r=0.202), catecholamine 12.95±6.501mg/ml (r=-0.047; cortisol 33.288±18.062 mg% (r=-0.135), and histamine 0.139±0.057 mg/ml (r=0.172), with the average duration of illness 6.13±6.412 years. On constitutional analysis it was observed that with the advancement of the duration of disease, acetylcholine is high in Vatika constitution 1.055±0.545 mg/ml (r=0.415), and low in Kaphaja constitution 0.941±0.38 mg/ml (r=-0.374). There is a trend of decreasing catecholamine values in all the three groups with the advancing duration of illness, though it is very high as compared to the control. In Vatika constitution (10.246±3.687 ng/ml) the r value is –0.51 ($P<0.05$), -0.094 in Paittika (15.97±8.43 ng/ml), and –0.063 in Kaphaja constitutions (12.044±3.73 ng/ml) of the diabetic patients. There is similar descending pattern of the plasma cortisol values with the advancing progression and the correlation is towards the negative side, though it is insignificant. Blood histamine is 0.122±0.055 in Vatika (r=0.22), 0.144±0.064 in Paittika (r=0.10), and 0.160±0.041 mg/ml in Kaphaja constitutions (r=0.43). But the correlation between the duration of illness and these values is not found to be significant.

Response to Treatment

C. tamala: Thirty-six diabetics of the maturity onset type were treated with *C. tamala*. Before treatment the average blood sugar level was: fasting 154.477±57.638 mg%, 1 h PP 261.727±62.046 mg%, 2h PP 250.077±82.496 mg%. After the treatment it was: 114.775±42.574, 209.261±59.13 and 188.691±71.663 mg% at fasting,

1 h PP and 2 h PP, respectively. Thus, there was 25.7% fall at fasting, 11.901% at 1 h PP and 29.334% fall at 2 h PP level.

When this result was analysed on the basis of constitution, the best response with this drug was observed to be in Kaphaja constitution as the observed blood sugar level was: fasting, before treatment (BT) 117.346±32.108 mg%, after treatment (AT) 88.4±16.984 mg%; 1 h BT 229.966±52.224 mg%, AT 172.266±42.575 mg% and 2 h BT 207.626±53.047 mg%, AT 135.093±42.944 mg%. Thus, there was 24.667% fall at fasting, 25.887% at 1 h and 48.722% fall at 2 h PP level. Iin Paittika constitution the response of treatment was moderate as the observed blood sugar level was: fasting BT 137.8±26.058 mg%, AT 109±15.275 mg%, 1 h BT 242.01±33.227 mg%, AT 207.77±36.852 mg% and 2 h BT 237.38±47.782 mg%, AT 187.05±46.553 mg%. Thus, there was 20.899% fall at fasting, 5.22% at 1 h and 21.62% fall at 2 h PP level. In Vatika Constitution the response was poor as the observed blood sugar level was: fasting BT 220.272±49.65 mg%, AT 155.445±53.528 mg%; 1 h BT 322.963±51.333 mg%, AT 261.063±58.909 mg% and 2 h BT 348.963±67.054 mg%, AT 263.272±54.882 mg%. Thus there was 29.43% fall at fasting, -2.851% at 1 h and 16.211% at 2h PP level.

Inula racemosa. Eighteen diabetic patients of maturity onset type were treated with *Inula racemosa*. The average blood sugar level before treatment was: fasting 157.833±64.161 mg%, 1 h 284.944±89.743 mg%, 2 h 306.944±82.416 mg%, and after the treatment it was: 118.633±49.686 mg%, 226.944±71.958 mg%, and 243.222±75.691 mg% at fasting, 1 h and 2 h PP, respectively. Thus, there was 24.836% fall at fasting, 14.791% at 1 h and 1.446% fall at 2 h PP level.

When this result was analysed on the basis of constitution, the best response with this drug was observed to be in Kaphaja constitution as the observed blood sugar level was: fasting BT 118.5±18.063 mg%, AT 90.901±15.749 mg%; 1 h BT 236.166±57.946, AT 184.333±24.357 mg% and 2 h BT 259.666±47.622 mg%, AT 191.166±48.917 mg%. Thus, there was 23.29% fall at fasting, 20.596% at 1 h and 28.973% fall at 2 h PP level. In Paittika constitution, the response of treatment was moderate as the observed blood sugar level was: fasting BT 121.833±30.235 mg%, AT 96.33±12.971 mg%; 1 h BT 231.66±55.662 mg%, AT 193.5±28.055 mg% and 2 h BT 274.5±76.602 mg%, AT 225.00±42.426 mg%. Thus, there was 20.93% fall at fasting, 11.532% at 1 h and 15.72% fall at 2 h PP level. In Vatika constitution, the response was poor as the observed blood sugar level· was: fasting BT

233.166±50.34 mg%, AT 168.666±58.769 mg%; 1 h BT 387.0±46.553 mg%, AT 303±75.905 mg% and 2 h BT: 386.666±58.195 mg%, AT 313.5±75.561 mg%. Thus there was 27.662% fall at fasting, 12.678% at 1 h and 5.646% fall at 2 h PP level.

Chandra-prabhavati. Thirty-seven patients of the maturity onset type of diabetes mellitus were treated with Chandra-prabhavati, an Ayurvedic preparation. Before treatment the average blood sugar level was: fasting 183.972±61.867 mg%, 1 h PP 272.02±61.77 mg%, 2 h PP 251.459±62.845 mg% and after the treatment it was: 146.945±49.323 mg%, 223.864±58.622 mg% and 205.32±63.173 mg% at fasting, 1 h PP and 2 h PPm respectively. Thusm there was 20.126% fall at fasting, 12.646% at 1 h and 13.496% fall at 2 h PP level.

When this result was analysed on the basis of constitution, the best response with this drug was observed to be in Kaphaja constitution as the observed blood sugar level was: fasting, BT 139.133±37.576 mg%, AT 109.4±17.565 mg%; 1 h BT 241.266±49.24 mg%, AT 178.533±23.838 mg% and 2 h BT 216.533±52.331 mg%, AT 150.266±26.028 mg%. Thus, there was 21.37% fall at fasting, 32.31% a 1 h and 47.201% fall at 2 h PP level. In Paittika constitution the response of treatment was moderate as the observed blood sugar level was: fasting BT 195.3±43.492 mg%, AT 167.7±49.288 mg%, 1 h BT 283.2±65.184 mg%, AT 238.1±53.296 mg% and 2 h BT 256.5±50.334 mg%, AT 222.3±49.835 mg%. Thus, there was 14.132% fall at fasting, 19.908% at 1 h and 10.784% fall at 2 h PP level. In Vatika constitution, the response was poor as the observed blood sugar level was: fasting BT 230.583±62.875 mg% AT 176.583±48.057 mg%; 1 h BT 301.166±59.96 mg%, AT 268.66±54.986 mg% and 2 h BT 290.916±63.106 mg%, AT 260±50.098 mg%. Thus, there was 23.41% fall at fasting, -30.46% at 1 h and −38.259% at 2 h PP level.

Diabenese. Nineteen diabetic patients of maturity onset type were treated with Diabenese – a modern oral hypoglcemic drug. The average blood sugar level before treatment was: fasting 189.263±92.065 mg%, 1 h 292.105±107.891 mg%, 2 h 320.052±88.476 mg% and after the treatment it was: 139.736±65.897 mg%, 207.347±56.702 mg% and 229.736±65.488 mg% at fasting, 1 and 2 h PP, respectively. Thus, there was 26.168% fall at fasting, 34.258% at 1 h and 31.186% fall at 2 h PP level.

When this result was analysed on the basis of constitution, the best response with this drug was observed to be in the Paittika constitution, as the observed blood sugar level was: fasting, BT 210.5±28.994 mg%, AT 87.5±20.432 mg%, 1 h BT 204±55.411 mg%, AT 169.5±35.931 mg% and 2 h BT 251±69.128 mg%, AT 177.5±70.625 mg%. Thus, there was 20.814% fall at fasting, 12.299% at 1 h and 35.943% fall at 2 h PP level. In Kaphaja constitution, the response of treatment was moderate as the observed blood sugar level was: fasting BT 165.33±40.177 mg%, AT 123.166±34.446 mg%; 1 h BT 280.66±55.12 mg%, AT 184.66±36.258 mg% and 2 h BT 294.66±37.813 mg%, AT 213.5±19.118 mg%. Thus, there was 25.502% fall at fasting, 46.521% at 1 h and 30.155% at 2 h PP level. In Vatika constitution, the response was poor as the observed blood sugar level was: fasting BT 277.285±86.987 mg%, AT 198.714±68.04 mg%, 1 h BT 377.714±115.86 mg%, AT 259.228±48.857 mg% and 2 h BT 401±72.477 mg%, AT 288.482±37.335 mg%. Thus there was 28.335% fall at fasting, 39.743 at 1 h and 27.282% fall at 2 h PP level.

The drug response was also analysed on the basis of the stages of the disease (types of Prameha).

C. tamala. The best response with this drug was observed to be in Kaphaja Prameha (early diabetics) as the observed blood sugar level was: fasting BT 114.185±19.032 mg%, AT 93.95±17.37 mg%; 1 h PP BT 221.755±40.089 mg%, AT 181.535±46.951 mg% and 2 h PP BT 209.51±42.631 mg%, AT 146.445±50.14 mg%. Thus, there was 17.72 % fall at fasting, 18.578% at 1 h and 44.93% at 2 h PP level. In the patients of Pittaja Prameha (acute diabetics), the response to the treatment was moderate as the observed blood sugar level was: fasting BT 170.35±21.008 mg%, AT 109.99±25.213 mg%, 1 h BT 289.81±37.327 mg%, AT 211.45±36.766 mg% and 2 h BT 274.2±50.53 mg%, AT 205.64±36.749 mg%. Thus there was 35.432% fall at fasting, 15.067% at 1 h and 7.896% fall at 2 h PP level. In Vataja Prameha (chronic diabetics), the response was poor as the observed blood sugar level was: fasting BT 262.33±11.29 mg%, AT 192.166±37.806 mg%; 1 h BT 348.166±37.392 mg%, AT 298.033±33.514 mg% and 2 h BT 399.1±48.216 mg%, AT 301.266±32.31 mg%. Thus, there was 26.746% fall at fasting, 23.33% at 1 h and 20.228% fall at 2 h PP level.

Inula racemosa. The best response with this drug was observed to be in Kaphaja Premeha as the observed blood sugar level was: fasting BT 108.44±12.59 mg%, AT 87.156±8.165 mg%; 1 h BT 212.77±45.016 mg%, AT 179.33±19.104 mg% and 2 h BT 247.22±43.702 mg%, AT 199.66±44.415 mg%. Thus, there was 19.627% fall at fasting, 11.649% at 1 h and 18.923% fall at 2 h PP level. In the patients of Pittaja Pramaha, the response of treatment was moderate as the blood

sugar level was: fasting BT 193.125±38.731 mg%, AT 135.125±32.58 mg%; 1 h BT 351.75±59.629 mg%, AT 265.125±73.582 mg% and 2 h BT 358.75±67.06 mg%, AT 273.125±69.741 mg%. Thus, there was 30.032% fall at fasting, 18.045% at 1 h and 16.679% fall at 2 h PP level. In Vataja Prameha, the response was poor as the observed blood sugar level was: fasting BT 320 mg%, AT 270 mg%, 1 h BT 400 mg%, AT 350 mg% and 2 h BT 430 mg%, AT 396 mg%.

Chandra-prabhavati. The best response with this drug was observed to be in Kaphaja Prameha as the observed blood sugar level was: fasting BT 118.538±12.79 mg%, AT 105.461±14.015 mg%; 1 h BT 216.384±25.349 mg%, AT 181.23±27.319 mg% and 2 h BT 195.692±33.434 mg%, AT 156.461±38.365 mg%. Thus, there was 11.93% fall at fasting, 22.56%at 1 h and 33.897% fall at 2 h PP level. In the patients of Pittaja Prameha, the response of treatment was moderate as the observed blood sugar level was: fasting BT 194.529±24.075 mg%, AT 149±31.99 mg%; 1 h BT 284.352±49.554 mg%, AT 225.47±49.927 mg% and 2 h BT 258.176±37.273 mg%, AT 211.176±53.525 mg%. Thus, there was a 23.404% fall at fasting, 14.865% at 1 h and 2.31% fall at 2 h PP level. In the patients of Vataja Pramehsa, the response was poor as the observed blood sugar level was: fasting BT 279.857±27.81 mg%, AT 219±40.95 mg%; 1 h BT 345.428±40.442 mg%, AT 299.142±43.846 mg% and 2 h BT 38.714±44.813 mg%, AT 281.857±35.46 mg%. Thus there was 21.745% fall at fasting, -22.22% at 1h and −6.79% fall at 2 h PP level.

Diabenese. The best response with this drug was observed to be in Kaphaja Prameha as the observed blood sugar level was: fasting BT 112±25.55 mg%, AT 86.875±17.512 mg%; 1 h BT 198.25±49.088 mg%, AT 169.875±30.93 mg% and 2 h BT 250.5±59.134 mg%, AT 183.875±61.519 mg%. Thus, there was 22.43% fall at fasting, 3.768% fall at 1 h and 29.96% fall at 2 h PP level, while in patients of Pittaja Prameha the response of treatment was moderate as the observed blood sugar level was: fasting BT 189.166±38.192 mg%, AT 136.5±29.527 mg%, 1 h BT 319±67.09 mg%, AT 195.5±37.114 mg% and 2 h BT 321±40.37 mg%; 1 h BT 229.166±28.357 mg%. Thus, there was 27.84% fall at fasting 54.557% at 1 h and 29.714% fall at 2 h PP level. In the patients of Vataja Prameha, the response was poor as the observed blood sugar level was: fasting BT 313±63.478 mg%, AT 228.2±50.281 mg%, 1 h BT 410±80.389 mg%, AT 281.52±34.286 mg% and 2 h BT 430.2±47.193 mg%, AT 303.8±24.641 mg%. Thus there was 27.09% fall at fasting, 45.03 at 1 h and 35.49% fall at 2 h PP level.

DISCUSSION

In this study the time-honored hypothesis of Indian medicine has been tested. According to this system of medicine, the constitution of an individual plays an important role in the progression and prognosis of diseases in general and diabetes mellitus (Prameha) in particular. Similarly,in the proper treatment and desired result, consideration of Prakriti (constitution), Vikrati (pathological changes), Sara (strength of the systems), Samhanan (compactness of body), Pramana (proportionate relation of different organs), Satmya (homologation), Satva (mental state), Ahara (intake and digestive capacity), Vyayama (body power), and Vaya (age) has been suggested.

On the basis of predominance of Doshas, three types of constitution — Vataja, Pittaja and Kaphaja — have been identified. These types greatly resemble the three types of constitutions described by Sheldon. In Sheldon *et al*, the system of somatotyping the different somatotypes are determined by the varying expression in the individual organism of three bodily components of structure, namely endomorphy, mesomorphy, and ectomorphy.[15]

Sheldon further recognizes three types of temperament, namely viscerotonia, somatotonia, and cerebrotonia.[16] These are equivalents of the three morphological components, respectively. An attempt has been made to observe the clinical features of the three constitutions into three groups: (i) anthroscopic, (ii) psychological, and (iii) psychosocial. In anthroscopic examination, body-build, complexion, prominence of veins and tendons, eyes, teeth, eyebrows and joint, etc. were included. In physiological examination, appetite, thirst, dietary habits, sexual potency, and tolerance to heat and cold, etc. were studied. Psychological traits like piousness, courage and boldness, memory, grasping power, calmness of mind and psychic nobility were included in psychosocial examination. Further, to develop few quantitative parameters for study of constitution anthropometric and biochemical indices have been adopted.

In this study of subjects having Vatika constitution, the height-weight ratio (ponderal index) was observed to be maximum (44.98±1.83) with minimum body surface area (1.538±0.052 m^2). The level of acetylcholine was found to be at maximum (1.07±0.17 mg/ml) and the histamine at a minimum ((0.037±0.011 mg/ml). In Kaphaja constitution, the body surface area was found to be at a maximum (1.56±0.156m^2), while the ponderal index was at a minimum (38.81±1.988). The level of histamine was found to be at a maximum (0.100±0.035 mg/ml) and the acetylcholine at a minimum (0.638±0.169 mg/ml) in this constitution. In

Paittika constitution, the level of acetylcholine and histamine was observed to be in between the level found in Vatika and Kaphaja constitutions. However, the level of catecholamines (8.403±1.32 ng/ml and plasma cortisol (12.38±1.33 mg%) was found to be highest in this group.

In order to elicit the susceptibility of the disease in a particular constitution, the same has been examined in patients of diabetes mellitus. In this series, the maximum number of the patients was of Paittika constitutions was 40.48%, while Vatika and Kaphaja were 38.09% and 21.43%, respectively. This is contrary to the general perception that Kaphaja constitution patients have a greater tendency to develop diabetes mellitus. In Paittika constitution, plasma catecholamines and cortisol have been found to be highest. Both of these are glycogenolytic in nature; they are established diabetogens. Thus, the susceptibility of this group of patients to diabetes seems to be logical.

Pattern of neurohumors in diabetics is similar to that in healthy people as far as each constitution is concerned. But on the average the level of all the neurohumors, particularly of catecholamines and plasma cortisol, is high in all cases, irrespective of the types of constitutions. Therefore, neurohumors are likely to have definite relation with the causation and precipitation of diabetes.

Prameha (diabetes) has been classified to be of three major types in Ayurveda: Kaphaja, Pittaja, and Vataja. But these classifications are not strict. There is a direct reference in Ayurveda that all types of Prameha in due time, particularly if not managed properly, lead to a particular stage (Madhumeha), which is characterized by severe hyperglycaemia, sever glycosuria, and acetonuria.[17,18] This indicates the concept of progression of the illness with the advancing duration. On this basis three stages of Prameha have been identified: Kaphaja, Pittaja, and Vataja. These are almost similar to the concept of chemical, acute and chronic stages of diabetes.[19] Arbitrarily, three ranges of blood sugar levels — mild (<140 mg%), moderate (140-250 mg%) and severe (>250%) — have been proposed to be symbolic of the Kaphaja, Pittaja, and Vataja stages, mentioned above.[20] This has been used here also.

An attempt has been made to correlate the duration of illness with blood sugar and plasma insulin level in all the 42 diabetic patients in general and constitution-wise in particular. There is a trend of rising blood sugar with advancing the duration both at fasting (P<0.1) and post-prandial level (P<0.05) in general. But this progression is rapid in Paittika constitution as a positive correlation (P<0.05). The progression is slow in the patients having Kaphaja constitution as the correlation is not found to be significant (P >0.05). Blood sugar level has been observed to be very high in Vatika constitution from the very initial stage of diabetes (Fig.1).

A significant fall in insulin level has been observed among the diabetics in general (P<0.05). But the fall in plasma insulin level is much faster in Vatika constitution (P<0.01) and is comparatively much slower in Paittika (P<0.05) and Kaphaja (P>0.05) constitutions. Thus, the progression of diabetes mellitus has been observed to be much faster among the patients of Vatika (asthenic) group, while in Paittika constitutions it is moderate and is very slow in Kaphaja (obese) constitutions. In the patients of Vatika (asthenic) constitutions, the Vatika stage (insulin dependent diabetes) is arrived at quickly, and in the Paittika constitution (high adrenergic activities) the acute stage is arrived at quickly. In Kaphaja constitution (obese), Kaphaja stage (non-insulin dependent diabetes) is maintained steadily for a long time.

Regarding the response to treatment it has been observed that C. tamala, Inula racemosa, and Chandraprabhavati have the best hypoglycemic response in the diabetics having Kaphaja constitution as well as the Kaphaja stage. The good effect of diabenese is noticed both in Kaphaja and Pittaja consitution, as well as the stages of disease. The response is comparatively better in the Paittika group. The response of both of these drugs is poor in the Vataja stage as well as in the patients having Vataja constitutions. It is because of different mode of action of the drugs. In an advanced stage, the patient becomes insulin dependent and the replacement therapy has to be used as last resort. On the other hand, in the Kaphaja constitution or in Kaphaja stage, where the plasma insulin is likely to be higher than norma,l there is no indication either of giving insulin from outside nor of an oral hypoglycaemic agent, which are insulin promotors. Hence, in this stage Ayurvedic herbomineral drugs are best indicated. In the Paittika stage, there is a relatively high catecholamine and plasma cortisol level. To counteract this, drugs have to be used that will reduce the adrenergic activity as well as the use of insulin promoters may also be required.

Thus, on this basis we suggest a stepped care treatment of diabetes mellitus. In the initial stages, the patient should be managed with herbomineral drugs of indigenous medicine having different modes of action. Failing that, in the second stage, oral hypoglycemics should be added. In the terminal stage, insulin therapy has to be used. But in the growth onset type of diabetes, insulin therapy has to be adopted from the very beginning.

References

1. Stern MP, Gaskill SP, Hazude HP, Gardner LI, and Hoffner SM. Does obesity explain excess prevalence of diabetes among Mexican Americans? Result of the San Antonio Heart Study. *Diabetologia* 1983;24:272-77.

2. Lytt L, et al. Prevalence of diabetes in Mexican Americans; relationship to percent of gene pool derived from native American sources. Diabetes 1984;33:86-92.

3. Relethford JH and Lees FC. Admixture and skin colour in the transplanted Tlaxcaltecen population of Saltillo, Mexico. Am. J. Phys. Anthropol. 1981;56:259-67.

4. Donald A, et al. Relative roles of insulin clearance and insulin sensitivity in the prebreakfast increase in insulin requirement in insulin dependent diabetic patients. Diabetes 1984;33.

5. Herbert V, et al. Coated charcoal immune assay of insulin. J. Clin. Endocr. 1965;25:1375.

6. Sushruta. Sushruta samhita, Sharir Asthama. Chapter 4, Sholka 62.

7. Pandey HP, Singh RH, and Udupa KN. An improved method for biological assay of erythrocyte acetylcholine. D.A.J. Exp. Biol. 1975;13:327-38.

8. Griffith JC, Leung FYT, and McDonald TJ. Fluorometric determination of plasma catecholamine-normal human E & ME levels. Clin Chim. Acta. 1970;30:395.

9. Shore PA, Buckhalter A, and Cohn VH. A method for the fluorometric assay of histamine in tissue. J. Pharm. Expt. Ther. 1952;127:102-86.

10. Matingly D. A simple fluorometric method for the estimations of free 11 hydrocorticoids in human plasma. J. Clin. Pathol. 1962;15:374.

11. Chandola HM and Tripathy SN. Clinical and biochemical correlation of different stages of diabetes mellitus with different doshic types of Prameha. *J.R.A.S.* 1980:1:259-64.

12. Chandola HM, Tripathy SN, and Udupa KN. Effect of *C. tamala* on plasma insulin vis-à-vis blood sugar in patients of diabetes mellitus. J.R.A.S. 1980;1:345-57.

13. Chandola HM, Tripathy SN, and Udupa KN. Hypoglycemic response of *C. tamala* in patients of maturity onset (insulin independent) diabetes. J.R.A.S. 1980;1:275-90.

14. Singh RH, Singh MB, and Udupa KN. A study of tridosa as neurohumors. J.R.A.S. 1980;1: 1-20.

15. Sheldon WH., Stevens SS, and Tucker WB. The Varieties of Human Physique. New York, NY: Harper, 1940.

16. Sheldon WH. The Varieties of Human Temperament. New York, NY: Harper, 1942.

17. Chandola, HM and Tripathy SN. Diagnosis of 20 subtypes of Prameha based on physical and chemical examination of urine in proved cases of diabetes mellitus. J.R.A.S. 1980;1:224-38.

18. Tripathi SN and Singh VK. Concept of Prameha (diabetes mellitus) in Indian medicine. Nagarjuna 1972;15:58-67.

19. Camerin-Davalos RA. Prevention of diabetes mellitus. *Med. Cl. of North America* 1965;48: S65.

20. Charaka. Charaka Samhita, Sutra Asthana. Chapter 10, Sholka 11.

THYROID METABOLISM DISORDERS

Peripheral Metabolism of Thyroid Hormones: A Review

by Gregory S. Kelly (ND), Associate Editor, *Alternative Medicine Review*

(Reprinted from Alternative Medicine Review, *2000;5(4):306-33, by permission of Thorne Research, Inc.*

ABSTRACT

Peripheral metabolism of thyroid hormones is a critical component of the impact these hormones have on intracellular function. Thyroid hormones can be metabolized in peripheral tissue by deiodination, conjugation, deamination, and decarboxylation enzyme reactions. Therefore, alterations in these metabolic pathways might significantly impact the quantity of specific thyroid hormone metabolites influencing function at the cellular level. Available evidence also suggests that, under some circumstances, the activity of hepatic antioxidant enzyme systems and lipid peroxidation might influence the peripheral metabolism of thyroid hormones. Several syndromes, such as "euthyroid sick syndrome" and "low T3 syndrome," have been classified within the medical literature. The common feature of these disorders is a low level of circulating T3, with generally normal to slightly elevated blood T4 levels and either normal or slightly suppressed TSH levels. This pattern of altered thyroid hormone levels is generally agreed to be a result of impairment in extra-thyroidal peripheral metabolism. Hepatic and renal pathology, as well as catabolic states such as those induced subsequent to severe injury, illness, or trauma result in consistent shifts in the thyroid hormone profile, secondary to their impact on peripheral enzyme pathways. Lifestyle factors, such as stress, caloric restriction, and exercise, influence peripheral metabolism of thyroid hormones. Exposure to toxic metals, chemical poisons, and several drugs can also influence the peripheral fate of thyroid hormones. While the role of vitamins, minerals, and botanical extracts in thyroid hormone metabolism requires further elucidation, current evidence supports a role for selenium in the hepatic 5'-deiodination enzyme.

INTRODUCTION

Peripheral metabolism of thyroid hormones is a critical component of the impact these hormones have on intracellular function. Primary hypothyroidism, which manifests as elevated thyroid stimulating hormone (TSH) and low T4 levels, and secondary hypothyroidism, manifesting as a combination of low T4 levels and low TSH secondary to pituitary dysfunction, are both well defined. However, perturbations in thyroid hormone levels secondary to alterations in peripheral metabolism have received far less clinical attention. Several syndromes, such as "euthyroid sick syndrome" (ESS) and "low T3 syndrome," have been classified within the medical literature. The common feature of these disorders is a low level of circulating T3, with generally normal to slightly elevated blood T4 levels, and either normal or slightly suppressed TSH levels. This pattern of altered thyroid hormones is now generally agreed to be a result of impairment in extra-thyroidal peripheral metabolism.

The liver and, to a lesser degree, the kidneys play a dominant, although often under-discussed role in the metabolism of thyroid hormones. The majority of the most metabolically active thyroid hormone, 3,5,3'-triiodothyronine (T3) (Figure 1), is generated in peripheral tissue. Similarly, the preponderance of its competitive inhibitor, 3,3',5'-triiodothyronine (rT3; reverse T3) (Figure 1), is generated outside the thyroid gland. Further transformations to T2 and T1 isomers also occur almost exclusively in peripheral tissue. These transformations are all catalyzed by deiodination enzymes that remove iodine atoms from the inner tyrosyl or outer phenolic benzene rings. This stepwise deiodination is the major route of thyroid hormone metabolism and results in both active and inactive metabolites.[1]

A second pathway of thyroid hormone metabolism involves the conjugation of the phenolic hydroxyl group of the outer phenolic ring with sulfate or glucuronic acid. These conjugation reactions occur primarily in the liver, and to a lesser degree in the kidney, and result in biotransformation of T4 and T3. The resultant metabolites are primed for elimination and are considered relatively inactive. It is thought that partially deiodinated thyroid hormone metabolites are preferred substrates for these conjugation reactions.[2,3]

Thyroid hormones can also undergo deamination and decarboxylase reactions in the liver, resulting in the formation of so-called acetic acid analogues. These reactions occur at the alanine side-chain of the inner tyrosyl ring. Although these analogues are thought to be metabolically active, little is known about the quantities produced or their contribution to hormone activity in animals or humans.[1]

Note 1: Conjugation reactions occur at the hyroxy (HO⁻) group.

Note 2: Decarboxylation and deamination reactions occur at the alanine side chain.

$$^{-}CH_2\text{-}CH \begin{cases} NH_2 \\ COOH \end{cases}$$

Note 3: 5′ Deanimation occurs at the outer phenolic ring.

Note 4: 5 Deiodination occurs at the innter tyrosyl ring.

Figure 1: Structures of T4, T3, and rT3

Figure 2: Structure of T2 Isomers

The role of lipid peroxidation and other antioxidant enzyme systems has also received some attention with respect to thyroid hormone metabolism. Currently, the contribution of these metabolic pathways to thyroid hormone metabolism is not clear in humans; however, the current associations in animal models will be discussed.

REVIEW OF THYROID HORMONES

The thyroid gland, in response to stimulation by TSH, produces 3,5,3',5'-tetratiodothyronine (T4) (Figure 1), T3, and rT3. The synthesis of these hormones requires the amino acid tyrosine and the trace mineral iodine. Within the cells of the thyroid gland, iodide is oxidized to iodine by hydrogen peroxide, a reaction termed the "organification" of iodide. Iodine then binds to the number 3 position in the tyrosyl ring in a reaction catalyzed by thyroid peroxidase enzyme, a reaction yielding 3-monoiodotyrosine (MIT). A subsequent addition of another iodine to the number 5 position of the tyrosyl residue on MIT creates 3,5-diiodotyrosine (DIT). T4 is created by the condensation or coupling of two DIT molecules. Within the thyroid, smaller amounts of DIT can also condense with MIT to form either T3 or rT3.

Completed thyroid hormones consist of two benzene rings. An inner tyrosyl ring, often also called the alpha ring, and an outer phenolic or beta ring. After the thyroid hormones are formed, lysosomal proteases sever T4 (as well as any T3 or rT3 formed) from the thyroglobulin molecule, and the hormones are released into circulation. At the cellular level, the activity of thyroid hormones is mediated by interactions with nuclear T3 receptors. Metabolic effects of thyroid hormones result when the hormones occupy specific receptors, evoking subsequent effects on intracellular gene expression. It is estimated a cell needs 5-7 times more T4 to bind to the nuclear receptors to have a physiological effect comparable to T3.[4]

The biosynthetic processes resulting in generation of thyroid hormones within the thyroid gland are controlled by feedback mechanisms within the hypothalamic-pituitary-thyroid axis. The hypothalamus produces thyroid releasing hormone (TRH) that stimulates the pituitary to release TSH, thus signaling the thyroid gland to upregulate its synthetic machinery.

Although T4, T3, and rT3 are generated within the thyroid gland, T4 is quantitatively the major secretory product. All T4 found in circulation is generated in the thyroid unless exogenously administered. Production of T3 and rT3 within the thyroid is relegated to very small quantities and is not considered significant compared to peripheral production.[1-3]

When T4 is released from the thyroid, it is primarily in a bound form with thyroid binding globulin (TBG), with lesser amounts bound to thyroxine-binding prealbumin (TBPA). It is estimated that only 0.03-0.05 percent of T4 within the circulatory system is in a free or unbound form; this unbound T4 is called free-T4 (fT4). In peripheral tissues, T4 is either converted to T3 or rT3, or eliminated by conjugation, deamination, or decarboxylation reactions. It is estimated that more than 70% of T4 produced in the thyroid is eventually deiodinated in peripheral tissues, either at the outer phenolic ring to form T3 or at the inner tyrosyl ring to form rT3.[2]

T3 is considered to be the most metabolically active thyroid hormone. Although some T3 is produced in the thyroid, approximately 80% to 85% is generated outside the thyroid, primarily by conversion of T4 in the liver and kidneys.[5,6] The pituitary and nervous system are capable of converting T4 to T3, so are not reliant on T3 produced in the liver or kidney. Within the liver and kidney, the enzyme responsible for peripheral production of T3 is a selenium-dependent enzyme called 5'-deiodinase. This enzyme removes iodine from T4's outer phenolic ring.

Similar to T4, the majority of circulating T3 is in a bound form; however, TBPA and albumin (not TBG) are the binding molecules with highest affinity for T3. The free form of T3 (fT3) found in circulation is more than an order of magnitude greater than fT4, with estimates suggesting fT3 is approximately 8% to 10% of circulating T3.[1]

Small amounts of rT3 are made within the thyroid; however, peripheral generation from T4 is estimated to account for 95% of all rT3 produced. The enzyme responsible for this conversion is 5-deiodinase and is not believed to be dependent on selenium for its activity. This enzyme acts on the non-phenolic ring of T4 (the inner tyrosyl ring) to produce the hormonally inactive rT3. Under normal conditions, 45% to 50% of the daily production of T4 is transformed into rT3. Substantial individual variation in these percentages can be found secondary to a range of environmental, lifestyle, and physiological influences. Although an adequate understanding of the metabolic role of rT3 is somewhat limited, it is thought to be devoid of hormonal activity and to act as the major competitive inhibitor of T3 activity at the cellular level.[1] Experimental data also suggests rT3 has inhibitory activity on 5'-deiodinase, suggesting it might also directly interfere with the generation of T3 from T4.

Further degradation of rT3 and T3 results in the formation of several distinct diiodothyroxines:

3,5-diiodothyronine (3,5-T2), 3,3'-diiodothyronine (3,3'-T2), and 3',5'-diiodothyronine (3',5'-T2) (Figure 2).

Although the metabolic role of the T2 isomers is poorly understood and the absolute contribution of these hormones to physiological function in humans is unclear, experimental data raises doubts whether the various effects of thyroid hormones in different tissues can all be attributed to T3. The isomer 3,5-T2 has selective thyromimetic activity and has an ability to suppress TSH levels.[7] In animals, the 3,3'-T2 and 3,5-T2 isomers induce a dose-dependent increase in resting metabolic rate (RMR), an increase accompanied by a parallel increase in the oxidative capacity of metabolically active tissues such as liver, skeletal muscle, brown adipose tissue, and heart. In these experiments, 3,5-T2 exerted its greatest stimulatory effect on brown adipose tissue (BAT), while 3,3'-T2 had its greatest effect on muscle oxidative capacity. Although T3 is generally considered to be the metabolically active thyroid hormone, in contrast to these T2 isomers, T3 has only a small metabolic and oxidative effect on skeletal muscle and no significant stimulatory effect in heart and BAT, irrespective of dose.[8,9] (See Table 1 for a summary of T2 isomer activity.)

Alterations in serum concentrations of 3,3'-T2 have been reported for humans under certain conditions. As a rule this isomer declines significantly with advancing age. Hyperthyroidism is characterized by an expected increase and hypothyroidism with a decrease in 3,3'-T2 concentrations.[10] Of the T2 isomers, 3,5-T2 is presumed to be the most metabolically active and can only be formed from further deiodination of T3 by 3'-deiodinase. The isomer 3,3'-T2 can be formed from the deiodination of either T3 by 5-deiodinase or from rT3 through the same 5'-deiodinase enzyme responsible for the formation of T3 from T4. rT3 can also be degraded to an inactive isomer, 3',5'-T2, by a 3-deiodinase enzyme.

Alterations in Peripheral Metabolism: The "Euthyroid Sick Syndrome" and "Low T3 Syndrome"

"Euthyroid sick syndrome" (ESS) and "low T3 syndrome" are often used synonymously to describe non-thyroidal illness characterized by low circulating T3 and fT3 levels despite normal thyroid gland function. In both of these syndromes, T4 levels are generally normal (although occasionally they will be slightly elevated), fT4 is normal, and TSH is either normal or slightly suppressed.

Slight differences are implied by these two overlapping terms. In the strictest sense, ESS refers to a condition of normal thyroid gland activity with a reduced peripheral 5'-deiodination of T4 to T3 related to hepatic or renal disease. In ESS, a reciprocal increase in rT3 is a consistent finding. Although a similar pattern of thyroid hormones is found in "low T3 syndrome," technically this term does not imply any underlying illness or pathology. Despite the technical differences, both ESS and low T3 syndrome are used interchangeably to describe a situation characterized by lowered T3 levels with normal thyroid gland activity.[11]

Both syndromes are thought to be a result of impaired or decreased peripheral conversion of T4 to T3; however, either an increased conversion of T4 to rT3, and/or a decrease in the ability to degrade rT3 could result in ESS or low T3 syndrome. Since the formation of T3 from T4 and the degradation of rT3 both require 5'-deiodinase, an impairment in the function of this enzyme would result in a decreased ability to form T3 and a reduced ability to further deiodinate rT3.

Many non-thyroidal illnesses are associated with the pattern of thyroid hormones found in these syndromes. ESS is more prevalent with aging, and in an elderly population undergoing surgery for acute medical conditions, ESS has been associated with longer hospital stays and higher post-operative death rates.[12]

Laboratory abnormalities have been observed in ESS, including high cortisol and epinephrine levels;[12,13] low serum albumin levels among the elderly;[12] and a compromised selenium status associated with both ESS and low T3 syndrome.[16,17]

Alterations in cytokine profiles appear to have a strong association with ESS.[12,18-20] A correlation between increased rT3 and elevated levels of interleukin-6 (IL-6) has been reported in elderly patients undergoing emergency surgery.[12] Elevated levels of IL-6, tumor necrosis factor-alpha (TNF-a), and interferon-alpha (IFN-a) have also been reported to have a strong association with the reduced T3 and increased rT3 found under stressful conditions.[19,20] Administration of IL-6 to healthy subjects results in a thyroid hormone profile similar to ESS and low T3 syndrome: T3 levels are decreased, rT3 levels are increased, and TSH levels are slightly suppressed. IL-6 administration also results in a significant increase in cortisol levels, so it is unclear whether this cytokine or the elevation in cortisol contributed to the alteration in thyroid hormone levels.[21] Because of these observations, it has been suggested these cytokines might act to impair hepatic type I 5'-monodeiodination;[19,20] however, any absolute role in the regulation

Table 1: Summary of T2 Isomer Activity

Isomer	Derived from	Action	Human/animal data
3,5-T2	T3	Suppresses TSH	Animal
3, 3'-T2	T3 and/or rT3	Greatest increase in RMR in muscle	Animal
	Declines with age	Human	
	Decreased in Hypothyroid	Human	
	Increased in Hyperthyroid	Human	
3', 5'-T2	rT3	Inactive	

Table 2: Summary of Deiodinase Enzymes

Isoform	Location	Activity	Cofactor	Impact
Type I deiodinase	Liver, kidney, Skeletal muscle	5'-deiodination	Selenium	increases T3 degrades rT3
		5-deiodination	none identified	increases rT3 degrades T3
Type II deiodinase	Brain, pituitary, BAT	5'-deiodination	none identified	increases T3 Degrades rT3
Type III deiodinase	CNS	5-deiodination	none identified	increases rT3 Degrades T3

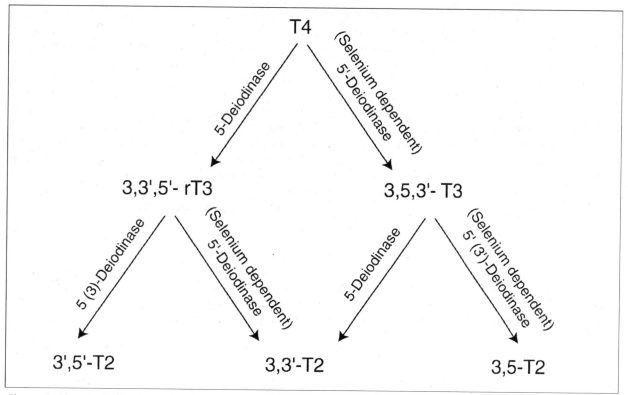

Figure 3: Liver Deiodination of Thyroid Hormones

of the enzyme systems responsible for peripheral metabolism of thyroid hormones by the various cytokines awaits clarification.

Metabolic Pathways Influencing Thyroid Hormone Peripheral Metabolism

As the liver and, to a lesser extent, the kidneys have primary influence on the circulating levels of thyroid hormone metabolites, the health and function of these organs play a critical and under-appreciated role in thyroid hormone function.[22] Deiodination of T4 to form T3 or rT3 and the subsequent disposal of rT3 occurs in the liver and kidneys. The deiodination enzymes are also responsible for formation and elimination of T2 and T1 isomers. Conjugation reactions utilizing glucuronidation, or sulfation pathways leading to the irreversible elimination of thyroid hormones are also primarily mediated by liver microsomal enzyme activity. Available evidence suggests that, under some circumstances, the activity of hepatic antioxidant enzyme systems and lipid peroxidation might influence the peripheral metabolism of thyroid hormones. Hepatic decarboxylation and deamination enzyme reactions are also capable of influencing the formation and elimination of specific thyroid hormone metabolites.

Deiodination

Tissue-specific deiodination of thyroid hormones determines, to a large degree, the fate of these hormones. The majority of the activation of the prohormone T4 to the more metabolically active T3 occurs through non-thyroidal deiodination. The inactivation of T3 to T2 isomers, the inactivation of T4 to yield rT3, and the eventual degradation of rT3 to T2 isomers are also catalyzed by the deiodinase family of enzymes. This stepwise removal of iodine from the benzene ring of the inner tyrosyl and outer phenolic benzene ring is currently thought to be the major route of peripheral thyroid hormone metabolism.

Currently, three deiodinase families are recognized and are termed isoforms type I, II, and III (Table 2). These three families differ in terms of their tissue distribution, reaction kinetics, efficiency of substrate utilization, and sensitivity to inhibitors. Type I deiodinase is the major enzyme in the liver, kidneys, and skeletal muscle; it can carry out both 5'- and 5-deiodination of T4 to produce either T3 or rT3. [2] Type I 5'-deiodinase is a selenium-dependent enzyme, with selenocysteine at the active site of the enzyme; however, type I 5-deiodinase enzyme does not require selenium for activity. Type II enzyme is the major deiodinase in the brain, pituitary, and brown adipose tissue.

This isoform appears to carry out only 5'-deiodination; however, unlike type I 5'-deiodinase, this enzyme does not require selenium for its activity. Since tissue equipped with type II isoforms are relatively independent of circulating T3 for their metabolic demands, type II 5'-deiodinase is particularly important for providing the T3 required to stimulate the pituitary to synthesize and secrete TSH. Type III deiodinase isoform is also found in the central nervous system and catalyzes the 5-deiodination of T4, resulting in generation of rT3.[1-3,23,24]

Bioactivity of thyroid hormone is determined to a large extent by the hepatic monodeiodination of the prohormone T4. The best-characterized activities of the liver with respect to thyroid hormone metabolism involve deiodinase reactions. Within the liver, type I deiodinase activity may either result in formation of T3, subsequent to the removal of an iodine from the outer phenolic ring by a selenium-dependent hepatic 5'-deiodinase enzyme, or it can remove iodine from the inner tyrosyl ring by 5-deiodinase resulting in the formation of rT3.

The same 5'-deiodinase is responsible for degradation of rT3 and subsequent formation of 3,3'-T2. Of the T2 isomers, 3,5-T2 is presumed to be the most metabolically active and can only be formed from further deiodination of T3 by 3'-deiodinase. The isomer 3,3'-T2 appears to have some metabolic activity in specific tissues and can be formed from the deiodination of either T3 by 5-deiodinase, or from rT3 through the same 5'-deiodinase enzyme responsible for the formation of T3 from T4. Further degradation of rT3 can also be achieved by 3-deiodinase resulting in the formation of an inactive metabolite, 3',5'-T2. (See Figure 3 for a summary of liver deiodination of thyroid hormones.)

In a very simplified sense, T3 and rT3 levels are reciprocally related due to the influence 5'-deiodination has on their formation and degradation, respectively. Current evidence suggests the reciprocal increase in rT3 and decrease in T3 found in many conditions and circumstances shown in Table 3 is primarily a result of an alteration in the 5'-deiodination pathway. This alteration results in a simultaneous decrease in the production of T3 and a decrease in the degradation of rT3.[1] The net result is a decrease in T3 and an increase in rT3 in circulation.

It is generally accepted that type I 5'-deiodinase has higher affinity for rT3 than it does for T4.[5,25] Because of this, enzyme saturation will shift metabolic pathways away from the generation of T3 and toward the elimination of rT3. Inhibition of the hepatic type I 5'-deiodinase enzyme, whether due to selenium deficiency

or some other influence, might also act in a similar manner, preferentially degrading rT3 to 3,3'-T2 at the expense of the generation of T3 from T4. Kinetic data from experimental models suggest 5-deiodinase has a substrate preference for T3 inactivation over T4 conversion to rT3.[5]

Changes in 5'-deiodination occur in a number of situations, such as stress, poor nutrition, illness, selenium deficiency, and drug therapy. Toxic metals such as cadmium, mercury, and lead, have been associated with impaired hepatic 5'-deiodination in animal models.[26-29] Results suggest free radicals are also involved in inhibition of 5'-monodeiodinase activity; however, a positive relationship between total sulfhydryl group availability and 5'-monodeiodinase activity in the presence of free radical scavengers has been observed.[30] In the course of chronic liver disease such as hepatic cirrhosis, alterations in hepatic deiodination resulting in increased rT3 and a simultaneous decrease in T3 levels have also been observed.[31]

Glucuronidation

Enzyme activity can be modulated by numerous foreign compounds, such as common chemicals and drugs.[35] Many of these enzyme inducers can increase the glucuronidation of T4, resulting in a decrease of serum T4 and a subsequent increase in TSH.[36] Animal models suggest these glucuronidation-inducing drugs and toxins act to preferentially eliminate T4 and rT3, with limited effect on T3 indices.[37]

Some of the compounds known to increase T4 glucuronidation in animal models, resulting in decreased serum concentrations of T4, include phenobarbital,[34] chlorinated paraffins,[38] polychlorinated biphenyl,[37] hexachlorobenzene,[32,39] 3-methylcholanthrene,[32-37] 3,3',4,4'-tetrachlorobiphenyl,[32] tetrachloro-p-dioxin,[32] and clofibrate.[32] The latter five compounds also substantially increase rT3 glucuronidation activity.[32]

The impact of these compounds on glucuronidation of thyroid hormones in animals has generally been followed for only short-term exposure; hence, the long-term consequences of exposure on thyroid hormone metabolism are currently unknown. In animals, glucuronidation is a major thyroid hormone metabolism pathway; however, there are species- and gender-dependent variations in glucuronidation enzyme activity and specificity for thyroid hormones.[33,40] Therefore, it is unclear to what extent animal kinetic data is relevant to humans.

Sulfation

Since it strongly facilitates the degradation of thyroid hormone by type I hepatic deiodinase enzymes, sulfation is an intriguing, although poorly understood, pathway for thyroid hormone metabolism. Based on kinetic data, a substrate preference of 3,3'-T2 > rT3 > T3 > T4 has been postulated.[41]

Sulfation of the phenolic hydroxyl group blocks the outer ring deiodination of T4 to T3, while it strongly stimulates the inner ring deiodination of both T4 to rT3 and T3 to T2.[42] Since the net affect of activation of the sulfation pathway appears to preferentially inhibit the formation of T3 and increase its degradation, and since it can catalyze the degradation of T4 to rT3, it would seem capable of potentially exerting a profound effect on thyroid hormone metabolites.

Specific drugs and environmental toxins have been shown to influence the sulfotransferase activity responsible for thyroid hormone metabolism. As examples, hydroxylated metabolites of polychlorinated biphenyls[43] and phenol derivatives are potent inhibitors of thyroid hormone sulfotransferase activity.[44,45]

While the role of most nutrients on sulfation of thyroid hormones is unknown, in rats, selenium deficiency significantly increases the mean serum concentrations of sulfated T4, T3, and rT3 (T4S, T3S, rT3S) secondary to reduction in 5'-deiodinase activity.[46]

Similar to glucuronidation, the preponderance of information available on the sulfation of thyroid hormones was taken from animal experiments; however, since even among rats, species- and gender-dependent differences in sulfation have been observed,[45,47] the absolute relevance of animal models to humans is questionable. Current data supports a perspective that, under normal circumstances, sulfation is not as important a mechanism for T3 disposal in humans as it is in rats, possibly suggesting differences in kinetics substrate preference.[48]

In humans, evidence suggests that in healthy subjects the role of sulfation of T3 is probably insignificant since serum T3S is virtually undetectable.[49] However, this process is increased by drugs which inhibit type I deiodinase activity; making elimination of T3 by sulfation a more important metabolic pathway under these circumstances.[50]

Evidence also indicates the sulfation pathway for T4 increases substantially following exogenous T4 therapy in premenopausal women. Although only low T4S levels are detectable in serum both pre- and post-T4 treatment, urinary T4S values increase significantly. However, unlike T4, significant increases in both serum and urine T3S levels are observed following T4 therapy.

Antioxidant Enzyme Systems and Lipid Peroxidation

As mentioned, the roles of lipid peroxidation and antioxidant enzyme systems have also received some attention with respect to thyroid hormone metabolism. An association between hepatic lipid peroxidation and peripheral conversion of T4 to T3 has been observed in animal experiments. This has led some researchers to speculate that changes in antioxidant status might influence functional aspects of thyroid hormone metabolism. Because of the liver's role in thyroid hormone metabolism, it is quite possible this might be compromised if the liver is subjected to chemicals/toxins.

Exposure to toxic metals such as cadmium or lead can result in an alteration in peripheral metabolism of thyroid hormones. A substantial reduction in T3 without any significant alteration of serum T4 concentrations has consistently been observed in animal models.[26-28] Activity of hepatic 5'-deiodinase has decreased by as much as 90% subsequent to exposure to toxic metals.[26-28] Antioxidant enzyme systems, including superoxide dismutase[26,28] and catalase,[28] are also reduced subsequent to exposure. Coupled with the decline in T3 and hepatic 5'-deiodinase activity and the impairment in antioxidant enzyme systems, a concomitant increase in lipid peroxidation by as much as 200% has also been reported.[26-28] This has led researchers to conclude that heavy metal-induced alterations in antioxidant enzyme systems and lipid peroxidation might lead to dysfunction in membrane integrity and that an intact membrane structure might be critical for optimal 5'-deiodinase activity.

Carbon tetrachloride poisoning induces significant alterations in the hepatic antioxidant enzyme systems with a resultant elevation of lipid peroxidation. Levels of T3 are significantly lowered subsequent to carbon tetrachloride exposure.[51]

Associations between hepatic antioxidant enzyme system activity, lipid peroxidation, and peripheral conversion of T4 to T3 in animal models secondary to administration of specific botanical extracts suggest a possible interaction between this aspect of liver function and thyroid hormone metabolism.[51-54] Currently, the contribution of these metabolic pathways to thyroid hormone metabolism is not clear in humans.

Acetic Acid Analogues

Thyroid hormones can undergo deamination and decarboxylase reactions in the liver resulting in the formation of so-called acetic acid analogues of thyroid hormones. These reactions occur at the alanine side-chain of the inner tyrosyl ring. Although these analogues are thought to be metabolically active, little is known about the quantities produced or their contribution to hormone activity in animals or humans.

The effects of tetraiodothyroacetic and triiodothyroacetic acids on thyroid function have been investigated in euthyroid and hyperthyroid subjects. At a sufficient dose, triiodothyroacetic and tetraiodothyroacetic acids can cause a significant reduction in serum T3.[55]

Although 3,3',5-triiodothyroacetic acid (triac), the acetic acid analogue of T3, is bound at least twice as avidly to nuclear receptors as T3, it has limited potency in human peripheral tissues because of its short half-life.[56] Triac, when administered exogenously at high doses, suppresses endogenous thyroid hormone secretion, as evidenced by decreased T4, fT4, fT3 and rT3 levels.[57,58] Triac also temporarily suppresses serum TSH concentrations However, even high doses of triac did not change basal metabolic rate, an expected effect of thyroid hormones.[57,60] Triac appears to induce hepatic 5'-deiodinase with about the same activity as T3,[61] and with a markedly stronger effect than treatment with T4.[62]

In human liver, both triac and tetraiodothyroacetic acid are conjugated by glucuronidated reactions about 1500 and 200 times faster than T3 and T4, respectively. This preference of conjugation reactions for the acetic acid analogues might partially explain their short half-life in the body.[56]

Lifestyle Factors Influencing Peripheral Conversion of Thyroid Hormones

Specific lifestyle factors can have a significant impact on peripheral metabolism of thyroid hormones. In addition to these factors, a number of physiological and pathological events perturb the deiodination pathway, leading to a decrease in T3 peripheral genesis and reciprocal changes in the circulating level of T3 (which decreases) and rT3 (which increases). The biological effects resulting from these changes are not currently completely understood but are potentially important in the body's adjustment to stressful or catabolic states. Several of these circumstances are listed in Table 3.

Table 3: Lifestyle, Environmental, and Pathological Events Associated with Alterations in Peripheral Conversion ff Thyroid Hormones (decreased T3 and increased rT3)

- Aging [12]
- Burns/thermal injury [63]
- Caloric restriction and fasting [64-66]
- Chemical exposure +
- Cold exposure [68]
- Chronic alcohol intake [69]
- Free radical load [30]
- Hemorrhagic shock [70]
- Insulin-dependent diabetes mellitus [71]
- Liver disease [31]
- Kidney disease [72,73]
- Severe or systemic illness [75]
- Severe injury [76]
- Stress [77]
- Surgery [15,78-80]
- Toxic metal exposure [36-29]

Several drugs have been associated with alterations in thyroid hormone metabolites. These drugs and their effects on T3 and rT3 are summarized in Table 4.

In addition to the circumstances and drugs listed in Table 3 and Table 4, elevations in cortisol,[13,14] catecholamines,[15] and some cytokines (IL-6, TNF-a, and IFN-a),[18-20] and low serum albumin levels[12] have been associated with ESS or low T3 syndrome.

Elevated Cortisol and Stress

In virtually any type of situation characterized by increased endogenous secretion of cortisol, a predictable pattern of altered thyroid hormone metabolism occurs. The generalized pattern is characterized by a trend toward lowered TSH production and a blunted TSH response to TRH, a decline in T3, and an increase in rT3.[13,14,67,75-79,86] Even changes in serum cortisol levels within the normal range can cause significant alterations in thyroid hormone parameters.[87]

Dexamethasone-induced increase in corticosteroids has been found to reduce T3 and increase rT3, probably as a result of impaired 5'-deiodination.[81] When endogenous hypersecretion of cortisol was induced by ACTH, T4 to T3 monodeiodination decreased, T4 to rT3 conversion increased, and TSH decreased due to blunting of TRH response.[14,86] Among critically ill men, low levels of fT4, T4, and T3 and elevated levels of rT3 and cortisol have been consistent findings. It has been suggested that high levels of cortisol might be responsible for the altered T4 peripheral metabolism to T3 and rT3 in these patients.[76]

While evidence is limited, it appears a relative deficiency in cortisol might have the opposite effect on thyroid hormone values. Observation of patients with chronic ACTH deficiency with low and normal cortisol levels indicated that thyroid hormone values were influenced during the periods of cortisol deficiency. The pattern emerged as follows: T4 was lower, T3 was higher, and rT3 decreased significantly. The observed changes led the researchers to hypothesize there might be "increased peripheral conversion of T4 to T3 during cortisol deficiency."[88]

Since cortisol appears capable of influencing thyroid hormone metabolism, it would make sense that stress, no matter how induced, might have a similar effect. This appears to be the case based on available evidence. People subjected to cold exposure-induced stress responded with an increase in serum rT3.[68] Examination anxiety is commonly used to measure the stress response. Twenty-two male and 27 female medical students were monitored before and after an academic examination. Both male and female students

Table 4: Drugs Associated with Altered Thyroid Hormone Metabolism

Drug (use/class)	T3	rT3
Dexamethasone (corticosteroid)[81]	decrease	increase
Propylthiouracil (thiourylene) [82]	decrease	increase
Iopanic acid (radiographic contrast agent) [83]	decrease	increase
Sodium Ipodate (radiographic contrast agent) [84]	decrease	increase
Amiodarone (antiarrhythmic/antianginal) [85]	decrease	increase

experienced an increase in rT3 levels on examination days. Although the reason is unclear, the increase among female students was substantially higher than observed in the male students.[77]

Since the stress response is non-specific in nature and can be elicited or exacerbated by a range of external or internal factors, it is not surprising to see other variables induce similar functional influences on thyroid hormone parameters. An expected derangement in cortisol and thyroid hormone parameters was reported among soldiers exposed to chemical weapons containing sulfur mustard. These individuals responded with a predictable increase in cortisol concentrations that did not normalize until the fifth week following the chemical insult. Concomitant with the sulfur mustard-induced impact on cortisol, both fT4 and fT3 decreased while rT3 increased. Similar to cortisol values, serum thyroid concentrations did not normalize until the fifth week after exposure.[67]

Researchers reported a connection between stress of surgery and derangement in thyroid hormone values. Post-surgical decreases in serum T3 and fT3 values and increase in serum rT3 values suggest altered peripheral conversion. Surgery-induced hypersecretion of cortisol was also observed.[78-79]

Combining several stressful situations appears to have a synergistic and dramatic effect on altering thyroid hormone metabolism. Military cadets subjected to a combination of sleep deprivation, calorie deficiency, and intense physical activity during a training exercise demonstrated significant and lasting changes in endocrine function. Cortisol levels increased along with abolition of circadian rhythm. In parallel with this increase, T4, fT4, and T3 consistently declined. While T4 and fT4 returned to normal levels within 4-5 days following the cessation of the training exercise, T3 and fT3 remained depressed.[89]

Calorie Restriction
Calorie restriction and energy expenditure appear to be capable of substantially influencing thyroid hormone peripheral conversion. There is a wide range of variation between individuals, with factors like genetics, obesity, and gender, as well as macronutrient content of the hypocaloric diet likely intermingling to influence response. Nutritional status and caloric expenditure influences thyroid function centrally at the level of TSH secretion, at the level of monodeiodination, and possibly elsewhere.

Since an increase of rT3 is found at the expense of T3 during caloric restriction, it is possible the hepatic peripheral pathways play a substantial role in metabolic control during energy balance. It appears the fasting-induced increase in rT3 might be a result of increased production of and decreased clearance of this metabolite.[90] The increase in T4 and rT3 seen with caloric restriction might also be influenced by the duration of energy restriction. Evidence suggests that, when caloric restriction is longer than three weeks, T4 and rT3 levels return to normal values.[91]

The ratio of T3/rT3 was found to be extremely sensitive to the balance between intake and expenditure of energy. In men, serum thyroid hormones were sensitive to marginal changes in energy intake and expenditure. A marginally negative (-15%) energy balance shifted the ratios of T4/T3 and T3/rT3 in a manner suggestive of impaired peripheral conversion.[64]

A hypocaloric, low carbohydrate diet consisting of 800 kcal daily for four days resulted in a striking decrease in both T3 and fT3 and an increase in rT3. However, the percentage of calories available as carbohydrates influenced the set point, below which alterations in thyroid peripheral metabolism were significantly impacted. In a study of obese individuals, an energy-restricted diet consisting of 800 kcal with greater than 200 kcal as carbohydrates, sustained higher T3 levels. When carbohydrate content of the diet dipped below 200 kcal, T3 levels fell substantially. Irrespective of carbohydrate content of the diet, when caloric content of the diet dropped to 600 kcal/day, T3 levels were compromised. Reverse T3 was not significantly influenced by carbohydrate content of the diet and seemed to be most impacted by caloric content.[91] Similarly, in non-obese subjects, T3 levels decreased and rT3 levels increased when carbohydrate intake was dramatically reduced.[92] Overall, it appears both calorie and carbohydrate restriction can negatively impact thyroid hormone metabolism.

Fasting also exerts a powerful influence on peripheral metabolism of thyroid hormones, and studies suggest mild elevations in endogenous cortisol levels might be partly responsible.[87] Following a 30-hour fast, healthy male subjects experienced a decrease in serum TSH levels with a concurrent disruption of its rhythm. Fasting serum T3 levels were significantly lower than in the non-fasting state, while rT3 levels increased during fasting.[66] Although the decline in TSH could be partially responsible for the observed decline in T3 concentrations, the increase in rT3 clearly demonstrates an alteration in peripheral metabolism of T4. Even after re-feeding, although TSH tended to increase and rT3 to decrease slightly, these values remained perturbed when compared with values observed prior to fasting.[66]

The effect of a longer period of total energy deprivation produced a similar alteration in thyroid

hormone metabolism. Following 10 days of fasting, marked reductions in serum levels of T3 and increases in rT3 were found in healthy male subjects; reductions of blood levels of TSH and gradual increases in the blood levels of cortisol were also observed.[93] Fasting for 31 +/- 10 days also decreased T3 and increased rT3 in obese subjects. Although introduction of an 800 kcal diet following the fasting period increased T3, this amount of calories did not influence the fasting-induced elevations in rT3.[94]

Ketones generated from calorie deprivation did not appear to have a suppressive effect on T3 generation and hepatic type I 5'-deiodinase activity.[95,96] It is not clear whether ketones would have a similar impact in a calorie-sufficient diet.

The role of calories and energy balance might also influence peripheral thyroid hormone metabolism under circumstances of increased caloric consumption. Although on a low-calorie diet elimination of rT3 by 5'-deiodination is decreased, the clearance of rT3 by 5'-deiodination was actually increased with a high calorie diet. An increase in the clearance rate of 3,5-T2 was also found during high calorie consumption.[97] It was not clear to the researchers whether the reported increase in deiodination of rT3 associated with an increase in calories has any substantial metabolic advantages, since it appeared to be at the expense of alternate rT3 disposal pathways.[97]

Exercise

While the role of a hypocaloric diet in producing alterations in thyroid hormones has been consistently demonstrated, the role of exercise in thyroid hormone metabolism is slightly ambiguous, with factors such as prior conditioning making it difficult to predict the influence of exercise. In one study, untrained subjects experienced reductions in cortisol and rT3, and an increase in T3 after exercise. However, trained subjects had an increase in cortisol and rT3 and a decrease in T3 with exercise; concentrations of T4 were unchanged in both groups.[98] The confounding results of thyroid hormone levels seen following exercise might be mediated by elevated cortisol levels; however, additional research is required to establish this connection.

Compelling evidence also suggests that, if exercise-related energy expenditure exceeds calories consumed, a low T3 syndrome may be induced. In female athletes, four days of low energy availability reduced T3, fT3, increased rT3, and slightly increased T4. Since an adequate amount of the prohormone T4 was available throughout the study, an alteration in the peripheral metabolism of T4 was likely. The increase in rT3 and decrease in T3 are consistent with a

decreased activity of hepatic 5'-deiodinase activity, since this enzyme is responsible for the production of T3 and the clearance of rT3. These alterations in thyroid hormones could be prevented solely by increasing dietary caloric consumption without any alteration in the quantity or intensity of exercise.[96,99]

Sleep Deprivation

Short-term sleep deprivation can influence thyroid hormone metabolism. The effects of sleep deprivation appear to be both centrally and peripherally mediated. The reported pattern of thyroid hormone response to a night of sleep deprivation included significant increases in T4, fT4, T3, and rT3. This pattern was observed in individuals diagnosed with depression,[100] as well as among healthy, physically fit males and females.[101] The implications of these changes and the impact of longer-term sleep deprivation on peripheral metabolism of thyroid hormones have not been established.

Alcohol Intake

In animal models, ethanol intake was associated with impaired hepatic 5'-deiodination.[102] Among patients with alcohol-induced liver cirrhosis, low T3 and T4, elevated rT3, and normal TSH values have been observed. In these subjects an abolished circadian rhythm and elevated cortisol levels have frequently been observed.[69] While extreme alcohol-induced liver damage is apparently detrimental to the peripheral modulation of thyroid hormones, it is unclear whether moderate alcohol intake has an impact.

Nutrients with Potential Influence on Thyroid Hormone Metabolism: Trace Minerals

Iodine: It is estimated the thyroid gland must capture approximately 60 mcg iodide (the ionic form of iodine) daily to ensure an adequate supply for thyroid hormone synthesis.[103] Because of the critical role of iodine in this synthetic process, this trace mineral has received the most attention historically with respect to thyroid disorders; however, available evidence does not suggest a role for iodine in peripheral metabolism of thyroid hormones. In fact, it has been demonstrated the decreases in T3 and fT3 and increase in rT3 subsequent to a low carbohydrate, 800 calorie diet cannot be corrected by iodine supplementation.[65]

Selenium: Since selenium, as selenocysteine, is a cofactor for type I hepatic 5'-deiodinase, this trace mineral has received the most attention with respect to peripheral metabolism of thyroid hormones. If selenium

were deficient, the deiodinase activity would theoretically be impaired, resulting in a decreased ability to deiodinate T4 to T3 and a decreased ability to degrade rT3.

In animal experiments, deficiencies of selenium were associated with impaired type I 5'-deiodinase activity in the liver and kidney and reduced T3 levels.[104,105] In an animal model a 47% reduction in the activity of this deiodinase enzyme has been reported secondary to selenium-deficiency.[106] The 20-fold increase in deiodinase activity secondary to acute cold exposure in rats was impaired in selenium deficiency.[107] Conversely, administration of selenium completely reversed the effects of its deficiency on thyroid-hormone metabolism in animals.[104]

Low T3 syndrome and ESS have been correlated with a decrease in serum selenium.[16,17] Evidence suggests a strong linear association between lower T3/T4 ratios and reduced selenium status, even among individuals considered to be euthyroid based on standard laboratory parameters. This association is particularly strong in older subjects and is thought to be a result of impaired peripheral conversion.[108,109] An inverse relationship between T3 and breast cancer associated with decreased selenium status has been reported (although plasma T4 and TSH concentration were similar in cases and controls).[110] This combination of factors strongly suggests that low T3 is secondary to the expected perturbation in T4 conversion to T3 expected in selenium deficiency.

Among individuals with acute renal failure, a reduction of circulating thyroid hormone concentrations without evidence of primary or secondary hypothyroidism frequently occurs. The changes in thyroid hormone concentrations may be due to a compromised peripheral conversion in the kidneys and liver. Current evidence also suggests that, in patients with multiple organ failure, plasma selenium concentrations are substantially reduced compared to normal controls.[72] It is not clear whether selenium supplementation would prove therapeutically beneficial under these circumstances.

Selenium administration has been found to positively influence metabolism of thyroid hormones under certain circumstances. Selenium supplementation (1 mcg/kg/day for 3 weeks) decreased rT3 levels in subjects with phenylketonuria and a low selenium status. In a prospective, randomized clinical trial of 24 critically-ill patients, an expected diminished fT3 level was observed in all patients prior to selenium supplementation. Following parenteral selenium supplementation (sodium selenite 500 mcg twice daily during week 1, 500 mcg daily during week 2, and 100 mcg three times daily during week 3) a gradual restoration of fT3 was observed.[112] A double-blind, placebo-controlled trial of selenium supplementation among elderly euthyroid subjects resulted in an improvement of selenium indices, a decrease in T4, and a trend toward normalization of the T3/T4 ratio in selenium-treated subjects.[109]

Sodium selenite therapy administered to cystic fibrosis patients resulted in a significant increase in selenium status and a parallel increase in serum T3. A highly significant decrease in the serum T4/T3-ratio was also observed in these individuals subsequent to selenium administration, suggesting improved peripheral T4 to T3 conversion.[113]

Available animal and human evidence strongly supports a relationship between altered thyroid hormone metabolism and selenium deficiency, although evidence also suggests high intakes of selenium might exert a detrimental influence on thyroid hormone metabolism. In animals fed a diet supplemented with high amounts of selenium (600 or 3,000 mcg/kg), serum T3 concentrations are actually reduced by 50 percent, while T4 and fT4 remain unaffected when compared to animals fed a selenium-adequate diet.[114] Although human subjects exposed to high dietary levels of selenium typically have normal levels of fT4, fT3 and TSH, a significant inverse correlation has been found between fT3 and selenium. Some researchers have hypothesized the activity of hepatic type I iodothyronine 5'-deiodinase might become depressed after a high dietary intake of selenium,[115] suggesting a safe level of dietary selenium at or below 500 mcg daily.[115]

Zinc: The role of zinc in thyroid hormone peripheral metabolism is still being elucidated; however, preliminary evidence suggests this nutrient might play an important role. In animal experiments, zinc deficiency, although having no impact on T4 concentrations, resulted in an approximately 30-percent decrease in levels of serum T3 and fT4. The activity of type I 5'-deiodinase was also reduced by 67% in zinc-deficient animals.[106] Inhibition of conversion of T4 to T3 was similarly demonstrated in an independent animal experiment.[116]

In humans, zinc supplementation reestablished normal thyroid function in hypothyroid disabled patients treated with anticonvulsants. In a study 9 of 13 subjects with low free T3 and normal T4 had mild to moderate zinc deficiency. After oral supplementation with zinc sulfate (4-10 mg/kg body weight for 12 months), levels of serum fT3 and T3 normalized, serum rT3 decreased, and the TRH-induced TSH reaction normalized.[117]

This study suggests zinc status influences peripheral metabolism of thyroid hormones. Since zinc is not a cofactor in hepatic type I-deiodinase enzyme, the nature of zinc's influence on aspects of peripheral metabolism in animals and humans remains unclear.

Nutrients with Potential Influence on Thyroid Hormone Metabolism: Vitamins

Niacin: Evidence suggests niacin supplementation can influence thyroid hormone levels in at least some individuals. One author reported cytopenia and hypothyroxinemia with a concomitant decrease in thyroxine-binding globulin in two patients receiving niacin. All thyroid function tests returned to normal after niacin supplementation was discontinued.[118]

The impact of sustained supplementation with niacin (mean daily dose of 2.6 g for an average duration of 1.3 years) was observed in one female and four male subjects with hyperlipidemia. Before and after thyroid function studies revealed significant decreases in serum levels of T4, T3, and TBG, with no significant alterations in fT4 and TSH levels. Discontinuation of niacin resulted in a return to pretreatment levels of these parameters of thyroid function.[119]

While results suggest niacin can influence serum thyroid hormone concentrations, it is currently not known whether this is a centrally-mediated result, a direct result of a decrease in TBG, or a niacin-induced alteration in some aspect of peripheral conversion. However, since TSH was unaltered, evidence suggests an influence outside the hypothalamic-pituitary-thyroid axis.

Vitamin B-12: In animals, a tissue vitamin B-12 deficiency was associated with a slight reduction of type I 5'-deiodinase activity in liver and with a significant reduction of the T3 level in serum.[120] Studies in human subjects have not been conducted; however, it is possible that a vitamin B12 deficiency might provoke a similar detrimental influence on peripheral activation of T3 from T4.

Lipoic Acid: Lipoic acid appears to influence the metabolic fate of T4 when co-administered with T4 therapy. Administration of T4 for 22 days resulted in a substantial increase in serum T3 concentrations; however, when lipoic acid was given in conjunction with T4 therapy for nine days a 56% suppression of the expected T4-induced increase in generation of T3 was observed (although T3 levels were elevated above control levels). Continuous supplementation of lipoic acid during T4 treatment resulted in a continued lower production of T3 than would have been expected from T4 therapy.[121]

While the authors suggest lipoic acid might exert an influence on peripheral tissue deiodinase activity, it is also possible this nutrient might have influenced conjugation reactions. It is currently not known whether lipoic acid supplementation influences thyroid hormone metabolism in normal individuals who are not receiving T4 therapy. Since it is usually not a therapeutic advantage to decrease peripheral activation of T3 subsequent to T4 therapy, use of this supplement in hypothyroid patients receiving exogenous hormone therapy should be approached with caution.

Antioxidant Vitamins: E and C: Administration of toxic metals such as cadmium chloride or lead have resulted in reductions in T3 and hepatic 5'-deiodianse activity, with virtually no alteration of T4 levels,[26-28] suggesting the observed alterations are mediated through impaired peripheral metabolism. After exposure to heavy metals, decreases in a variety of hepatic antioxidant enzyme systems and concomitant increases in lipid peroxidation have been observed.[26-28]

In an attempt to determine whether antioxidants such as vitamins E or C might be capable of preventing heavy-metal induced perturbation in thyroid hormones, lipid peroxidation, and hepatic antioxidant enzyme systems, several intervention studies were conducted in animals. Available evidence suggests vitamins C and E had no effect on thyroid hormone levels, antioxidant enzyme systems, and lipid peroxidation under normal circumstances; however, these nutrients were able to partially restore thyroid function to normal in cadmium- or lead-intoxicated animals.[26-28]

Vitamin E at a dose of 5 mg/kg of body weight on alternate days sustained hepatic 5'-deiodinase activity, partially prevented increases in lipid peroxidation, and improved cadmium-induced decreases in T3. Simultaneous administration of vitamin E (5 mg/kg body weight) with lead maintained T3 levels and hepatic 5'-deiodinase activity within normal levels, and partially prevented increased lipid peroxidation and alterations in antioxidant enzyme systems.[28]

Ascorbic acid has also been shown to be effective in preventing cadmium-induced decreases in T3 and hepatic 5'-deiodination. Administration of this antioxidant is thought to function in a manner similar to vitamin E since it was able to act as an antioxidant buffer against lead-induced increased lipid peroxidation.[27]

Since vitamins E and C appear to influence hepatic 5'-deiodination positively only under circumstances associated with increased lipid peroxidation and decreased liver antioxidant-enzyme activity, they have potential therapeutic application.

Botanicals with Potential Influence on Thyroid Hormone Metabolism

An adequate understanding of the influence of botanical extracts on thyroid hormone metabolism and function is lacking for human subjects. However, under experimental conditions in animal models, botanical preparations are known to influence the metabolic fate of thyroid hormones. One of the primary axes of influence for most plants studied appears to be through alterations in peripheral conversion and hepatic antioxidant enzyme systems, although plant extracts may affect other avenues of thyroid hormone metabolism. For example, plants such as *Lithospermum officinale* and *Lycopus europaeus* exert some influence on the hypothalamic-pituitary-thyroid axis.[122]

Several plants appear to be capable of influencing peripheral conversion of thyroid hormones in a manner consistent with decreasing the conversion of T4 to T3, or in effect inducing a low T3-like syndrome. An abstract from an untranslated Chinese article found four plants (Aconite, Cinnamon, Cistanches, and Epimedium) used in Traditional Chinese Medicine (TCM) when administered independently or in combination, reduced plasma T3 concentrations; the mechanism for this effect was unclear.[123] Animal experiments indicated that after oral administration of an ethanolic extract of Lycopus europaeus, T3 levels were decreased and remained low for a period of more than 24 hours. Although reductions of T4 and TSH were also reported, since reductions in T4 tended to occur substantially after the observed reductions in T3, this finding was presumably as a consequence of reduced peripheral T4 deiodination.[124] Similar to *Lycopus europaeus*, *Lithospermum officinale* appeared to inhibit peripheral T4-deiodination.[125] Administration of an aqueous extract from the leaf of *Moringa oleifera* (horseradish tree) to female animals resulted in a decrease in T3 and a concomitant increase in T4, suggestive of an inhibitory effect on peripheral conversion. In male rats no significant changes were observed subsequent to administration of the extract.[126] Animal evidence found fenugreek seed extract impaired peripheral conversion of thyroid hormones. Administration of 0.11 g/kg body weight daily for 15 days to male mice and rats resulted in a significant decrease in serum T3, with a concomitant increase in T4 levels. Hepatic lipid peroxidation was unchanged, suggesting the observed impairment in peripheral conversion was not peroxidation-mediated.[127]

The effects of *Withania somnifera* (ashwagandha) root extract (1.4 g/kg) in the regulation of thyroid function with special reference to type-I iodothyronine 5'-monodeiodinase activity in mice liver have been investigated. Increases in T3 and T4 concentrations were observed; however, hepatic iodothyronine 5'-monodeiodinase activity did not change significantly. In this same experiment, ashwagandha root extract reduced hepatic lipid peroxidation and increased the activity of the superoxide dismutase and catalase antioxidant enzyme systems.[54] In a subsequent animal experiment, daily administration of a similar dose of ashwagandha root extract to female mice resulted in an increase exclusively in T4 concentrations, with no alterations observed in T3 levels. The root extract's effect of decreasing hepatic lipid peroxidation and increasing the activity of antioxidant enzyme systems was again observed in this experiment.[53] These findings seem to suggest the effect of this plant on thyroid hormone levels is independent of increasing 5'-deiodinase activity.

Administration of an extract of *Bauhinia purpurea* bark extract (2.5 mg/kg body wt.) resulted in significant increases in serum T3 and T4 in female mice. This plant also demonstrated antiperoxidative effects as indicated by a decrease in hepatic lipid peroxidation and an increase in the activity of antioxidant enzyme systems.[53] *Commiphora muku* (gugulu) also impacted thyroid hormone conversion in animal models. While administration of 0.2 g/kg body weight for 15 days produced no significant change in serum T4 levels, serum T3 concentrations were increased. Since a concomitant decrease in lipid peroxidation was observed in the liver, the authors suggested the increased peripheral generation of T3 might be mediated by this plant's antiperoxidative effects.[53]

Liv-52, a proprietary herbal formulation consisting of a variety of herbs from the Ayurvedic medical tradition (Table 5), has been found to ameliorate carbon tetrachloride-induced alterations in thyroid hormone levels and liver antioxidant enzyme system activities. Carbon tetrachloride administration results in a decrease in the levels of T3 found in circulation and a profound disruption in hepatic antioxidant enzyme system activity and a concomitant increase in the amount of lipid peroxidation. These effects are believed to be secondary to the severe liver damage this compound causes. When rats were co-administered Liv-52 in combination with carbon tetrachloride, T3 levels were slightly decreased but were sustained within normal levels. A similar positive trend was seen in the case of lipid peroxidation and liver antioxidant enzyme systems with Liv-52 treatment.[51]

Animal evidence suggests a potential dose-dependent dual action of *Piper betel* (betel leaf) on thyroid hormone metabolism. Betel leaf extract at a dose of

Table 5: Ayurvedic Herbal Formulation

- Caparis spinosa
- Chicoium intybus
- Solanum nigrum
- Cassia occidentalis
- Terminalia arjuna
- Achillea millefolium
- Tamarix gallica

0.10 g/kg daily for 15 days decreased serum T4 and increased serum T3 concentrations. A concomitant decrease in hepatic lipid peroxidation was observed, suggesting the potential for a peroxidation-mediated effect on increased peripheral deiodination. However, at a dose of either 0.8 or 2.0 g/kg daily for the same interval of time, an opposite effect was observed. At these higher doses, T4 and hepatic lipid peroxidase were increased and hepatic catalase and super oxide dismutase antioxidant enzyme systems and T3 concentrations decreased.[128] This observed dose-dependent, bi-directional impact of betel leaf opens a Pandora's box of questions regarding other botanicals and the potential for dose-dependent differences in their influences on thyroid hormone metabolism.

As mentioned in the discussion of selenium, acute renal failure has been associated with a reduction of circulating thyroid hormones.[72] Decreased thyroid hormone levels have also been reported in patients with chronic glomerulonephritis. Commentary in an untranslated abstract utilizing Fu shen Decoction, a combination of herbs from TCM, is suggestive of a benefit of this combination for individuals with chronic glomerulonephritis. Administration of this herbal combination apparently increased both T3 and T4 levels; however, levels remained lower than those of healthy individuals.[73] Although the primary herb in this combination is likely to be Poria (Fu shen is the Chinese name given to Poria), the other herbal ingredients, ratio of specific herbal constituents, dose, method and duration of administration are not specified in the abstract.

Potential Influence of Soy on Thyroid Hormone Metabolism

The effect of soy products on thyroid hormone function and metabolism in humans is still being researched; however, animal evidence is suggestive of an impact on aspects of peripheral conversion. In animal experiments soy protein elevated plasma T4 concentrations.[129,130] This may have been due to an increased glandular production of thyroid hormones or to an elevation of T4 subsequent to inhibition of the peripheral conversion of T4 to T3. Considering the latter, evidence has demonstrated that consumption by animals of roasted soy beans can result in reduced plasma T3, possibly because of an effect on peripheral T4 deiodination.[131] Findings also indicated T3 was higher among casein-fed animals and lower among animals fed an equivalent amount of soy protein concentrate. Soy protein consumption also was found to contribute to age-related alterations in thyroid hormone in animals. These alterations included a decline in T4, fT4, T3, and 2,3'-T2 and an increase in rT3.[132]

The animal study findings indicate soy protein consumption might be capable of generating a thyroid hormone profile similar to that found in low T3 syndrome and ESS; in other words, soy protein consumption might cause a shift in thyroid hormone profiles toward unchanged or increased T4 and rT3 at the expense of T3 production. Human data with respect to the possible influence of soy products on peripheral conversion is currently lacking. However, a diet high in soy isoflavones (128 mg/day) has been reported to induce a modest decrease in fT3 levels during the early follicular phase of the cycle in premenopausal women.[133] Whether the soy is affecting peripheral metabolism or increasing binding to TBPA, albumin, or TBG is unclear.

The effects of 30 grams of soybeans fed daily for 1-3 months to 37 healthy adults were investigated. Soybean consumption resulted in a significant increase in TSH levels, although levels remained within normal limits. Other measured parameters of thyroid function were unchanged; however, hypometabolic symptoms suggestive of a functional thyroid hormone deficiency (malaise, constipation, sleepiness) and goiters appeared in half the subjects who consumed soybeans for three months. Symptoms disappeared one month after cessation of soybean ingestion.[134]

While research has not determined the exact effect of soy products and soy isoflavones on the peripheral metabolic fate of thyroid hormones, excessive soy consumption might be best approached cautiously among subjects with suspected impairment of peripheral metabolic pathways.

Potential Influence of Flavonoids on Thyroid Hormone Metabolism

Flavonoids, both naturally occurring and synthetic derivatives, have the potential to disrupt thyroid hormone metabolism in vitro. Synthetic flavonoid derivatives have been shown to decrease serum T4 concentrations and inhibit both the conversion of T4

to T3 and the metabolic clearance of rT3 by the selenium-dependent type I 5'-deiodinase.[2,135,136] Naturally occurring flavonoids appear to have a similar inhibitory effect. Of the naturally occurring flavonoids, luteolin was the most active inhibitor of 5'-deiodinase activity when tested in vitro; however, quercetin, myricetin, and flavonoids with chalcone, aurone and flavone structures have also been shown to have in vitro inhibitory activity.[2,137]

It is not known whether similar effects occur in vivo or whether, if such effects do occur, they are restricted to specific flavonoid compounds or dosages. Since isolated or concentrated flavonoids are increasingly utilized as therapeutic interventions, more research on the potential influence of these substances on thyroid hormone metabolism is desirable.

CONCLUSION

Thyroid hormones are metabolized in peripheral tissues by conjugation, deamination, decarboxylation, and a cascade of monodeiodination enzyme reactions. With the exception of deiodination reactions, the current contribution of these pathways to health and disease is relatively poorly understood.

Since conjugation reactions appear to be influenced by exposure to some pharmacological and environmental influences, as well as the quantity of available thyroid hormones, it is quite possible that alterations in activity of sulfation and glucuronidation pathways will influence the specific thyroid hormone metabolites available at the cellular level. Overall, very little is known about how derangements in these pathways might influence an individual at a functional level. Nutrient and lifestyle interactions with these metabolic pathways with respect to thyroid hormone metabolic fate have not been determined.

While certain acetic analogues of the thyroid hormones appear to have limited thyromimetic activity, the overall contribution of deamination and decarboxylase reactions to cellular function in health and disease are poorly understood. Currently, no data is available to determine a role of nutritional status and lifestyle factors for these enzyme pathways with respect to the metabolic fate of thyroid hormones.

The influence of deiodination enzyme reactions with respect to thyroid hormone metabolism are relatively well understood. In addition to liver disease, a wide range of variables can have an effect on thyroid hormone function secondary to their impact on peripheral conversion. These include aspects such as excessive stress and high levels of the stress hormone cortisol, caloric restriction, excessive physical activity, exposure to chemicals, surgery, injury, and systemic illness.

Since type I 5'-deiodinase processes both T4 to T3 and rT3 to 3,3'-T2, it is possible to deplete the enzyme, interfering with the conversion of T4 to T3 and the degradation of rT3. This potential mechanism might explain the observed derangement of thyroid hormones following chronic stress or after a sufficiently large acute stress. In effect, thyroid hormone conversion gets stuck in this cycle with elimination of the excess rT3 at the expense of T3 formation becoming a self-perpetuating problem. The role of the deiodinase enzymes in the formation and elimination of the T2 isomers, particularly since some of these isomers appear to have capability for metabolic activity independent of T3, might also play an important metabolic role in some tissues.

Hepatic antioxidant enzyme systems and lipid peroxidation have shown a consistent association with peripheral metabolism of thyroid hormones in animal models. Exposure to environmental toxins and drugs can influence these pathways. Many vitamin, mineral, and nutritional cofactors, as well as many botanical extracts can also influence the activity of these antioxidant enzymes. Although information in human subjects is currently unavailable, it is possible that many of the routinely utilized supplements might exert an influence on these enzyme systems under specific circumstances.

Because of its role as a cofactor for type I 5'-deiodinase, selenium's influence on deiodination is the best characterized of any nutrient. While a selenium deficiency does not seem to result in a decrease in the production of T4 or T3 within the thyroid gland, deficiency substantially alters the conversion of T4 to T3 in peripheral tissues such as the liver and kidney. This is generally accompanied by reduced T3 and an increased rT3 in the circulation. Zinc deficiency appears to strongly inhibit type I 5'-deiodinase in animal models; however, the mechanism for this effect is not understood and it is currently not clear if a similar role for zinc exists in humans. The absolute role of other nutritional and botanical agents is still not characterized; however, available data suggests some supplements might have a potential to influence deiodination in specific individuals under some circumstances.

It currently is not clear whether ESS and low T3 syndrome represent protective physiological mechanisms, or are in themselves a damaging maladaptive response. It is certainly possible these syndromes are reflective of an adaptation to stress which acts to protect the body against exaggerated catabolism. However, nutritional approaches to thyroid disorders should not only consider the nutrients and substances that

can alter thyroid hormone synthesis within the gland, but also nutrients and factors which might influence the peripheral conversion of thyroid hormones.

References

1. Robbins J. Factors altering thyroid hormone metabolism. Environ Health Perspect 1981;38:65-70.

2. Kohrle J, Spanka M, Irmscher K, Hesch RD. Flavonoid effects on transport, metabolism and action of thyroid hormones. Prog Clin Biol Res 1988;280:323-40.

3. Visser TJ. Pathways of thyroid hormone metabolism. Acta Med Austriaca 1996;23:10-16.

4. Kohrle J. Thyroid hormone deiodinases–a selenoenzyme family acting as gate keepers to thyroid hormone action. Acta Med Austriaca 1996;23:17-30.

5. Chopra IJ. An assessment of daily production and significance of thyroidal secretion of 3,3',5' triiodithyronine (reverse T3) in man. J Clin Invest 1976:58:32-40.

6. Utiger R. Decreased extrathyroidal triiodothyronine production in non-thyroidal illness: benefit or harm? Am J Med 1980;69:807-10.

7. Ball SG, Sokolov J, Chin W. 3,5-Diiodo-Lthyronine (T2) has selective thyromimetic effects in vivo and in vitro. J Mol Endocrinol 1997;19:137-47.

8. Lanni A, Moreno M, Lombardi A, Goglia F. Calorigenic effect of diiodothyronines in the rat. J Physiol (Lond) 1996;494:831-37.

9. Horst C, Rokos H, Seitz HJ. Rapid stimulationof hepatic oxygen consumption by 3,5-di-iodo-L-thyronine. Biochem J 1989;261:945-50.

10. Pinna G, Hiedra L, Meinhold H, et al. 3,3'-Diiodothyronine concentrations in the sera of patients with nonthyroidal illnesses and braintumors and of healthy subjects during acute stress. J Clin Endocrinol Metab 1998;83:3071-77.

11. Kaptein EM, Grieb DA, Spencer CA, et al. Thyroxine metabolism in the low thyroxine state of critical nonthyroidal illnesses. J Clin Endocrinol Metab 1981;53:764-71.

12. Girvent M, Maestro S, Hernandez R, et al. Euthyroid sick syndrome, associated endocrine abnormalities, and outcome in elderly patients undergoing emergency operation. Surgery 1998;123:560-67.

13. Rubello D, Sonino N, Casara D, et al. Acute and chronic effects of high glucocorticoid levels on hypothalamic-pituitary-thyroid axis in man. J Endocrinol Invest 1992;15:437-41.

14. Banos C, Tako J, Salamon F, et al. Effect of ACTH-stimulated glucocorticoid hypersecretion on the serum concentrations of thyroxinebinding globulin, thyroxine, triiodothyronine, reverse triiodothyronine and on the TSHresponse to TRH. Acta Med Acad Sci Hung 1979;36:381-94.

15. Rutberg H, Hakanson E, Anderberg B, et al. Thyroid hormones, catecholamine and cortisol concentrations after upper abdominal surgery. Acta Chir Scand 1984;150:273.

16. Van Lente F, Daher R. Plasma selenium concentrations in patients with euthyroid sick syndrome. Clin Chem 1992;38:1885-88.

17. Berger MM, Lemarchand-Beraud T, Cavadini C, Chiolero R. Relations between the selenium status and the low T3 syndrome after major trauma. Intensive Care Med 1996;22:575-81.

18. Goichot B, Sapin R, Schlienger JL. Euthyroid sick syndrome: recent physiopathologic findings. Rev Med Interne 1998;19:640-48. [Article in French]

19. Boelen A, Platvoetter-Schiphorst MC, Wiersinga WM. Association between serum interleukin-6 and serum 3,5,3'-triiodo-thyronine in nonthyroidal illness. J Clin Endocrinol Metab 1993;77:1695-99.

20. Bartelena L, Brogioni S, Grasso L, et al. Relationship of the increased serum interleukin-6 concentration to changes of thyroidal function in nonthyroidal illness. J Endocrinol Invest 1994;17:269-74.

21. Torpy DJ, Tsigos C, Lotsikas AJ, et al. Acute and delayed effects of a single-dose injection of interleukin-6 on thyroid function in healthy humans. Metabolism 1998;47:1289-93.

22. Ohnhaus EE, Studer H. A link between liver microsomal enzyme activity and thyroid hormone metabolism in man. Br J Clin Pharmacol 1983;15:71-76.

23. St Germain DL, Galton VA. The deiodinase family of selenoproteins. Thyroid 1997;7:655-68.

24. Beckett GJ, Arthur JR. Hormone-nuclear receptor interactions in health and disease. The iodothyronine deiodinases and 5'-deiodination. Baillieres Clin Endocrinol Metab 1994;8:285-304.

25. Moreno M, Berry MJ, Horst C, et al. Activation and inactivation of thyroid hormone by type I iodothyronine deiodinase. FEBS Lett1994;344:143-46.

26. Gupta P, Kar A. Cadmium induced thyroid dysfunction in chicken: hepatic type I iodothyronine 5'-monodeiodinase activity and role of lipid peroxidation. Comp Biochem Physiol C Pharmacol Toxicol Endocrinol 1999;123:39-44.

27. Gupta P, Kar A. Role of ascorbic acid in cadmium-induced thyroid dysfunction and lipid peroxidation. J Appl Toxicol 1998;18:317-20.

28. Chaurasia SS, Kar A. Protective effects of vitamin E against lead-induced deterioration of membrane associated type-I iodothyronine 5'-monodeiodinase (5'D-I) activity in male mice. Toxicology 1997;124:203-09.

29. Barregard L, Lindstedt G, Schutz A, Sallsten G. Endocrine function in mercury exposed chloralkali workers. Occup Environ Med 1994;51:536-40.

30. Brzezinska-Slebodzinska E, Pietras B. The protective role of some antioxidants and scavengers on the free radicals-induced inhibition of the liver iodothyronine 5'-monodeiodinase activity and thiols content. J Physiol Pharmacol 1997;48:451-59.

31. Gallo V, Rabbia F, Petrino R, et al. Liver and thyroid gland. Physiopathologic and clinical relationships. Recenti Prog Med 1990;81:351-55. [Article in Italian]

32. Visser TJ, Kaptein E, van Toor H, et al. Glucuronidation of thyroid hormone in rat liver: Effects of in vivo treatment with microsomal enzyme inducers and in vitro assay conditions. Endocrinology 1993;133:2177-86.

33. Visser TJ, Kaptein E, van Raaij JA, et al. Multiple UDP-glucuronyltransferases for the glucuronidation of thyroid hormone with preference for 3,3',5'-triiodothyronine (reverse T3). FEBS Lett 1993;315:65-68.

34. McClain RM. The significance of hepatic microsomal enzyme induction and altered thyroid function in rats: Implications for thyroid gland neoplasia. Toxicol Pathol 1989;17:294-306.

35. Gueraud F, Paris A. Glucuronidation: A dual control. Gen Pharmacol 1998;31:683-688.

36. Hood A, Klaassen CD. Differential effects of microsomal enzyme inducers on in vitro thyroxine (t(4)) and triiodothyronine (t(3)) glucuronidation. Toxicol Sci 2000;55:78-84.

37. Barter RA, Klaassen CD. Reduction of thyroid hormone levels and alteration of thyroid function by four representative UDPglucuronosyltransferase inducers in rats. Toxicol Appl Pharmacol 1994;128:9-17.

38. Wyatt I, Coutts CT, Elcombe CR. The effect of chlorinated paraffins on hepatic enzymes and thyroid hormones. Toxicology 1993;77:81-90.

39. van Raaij JA, Kaptein E, Visser TJ, van den Berg KJ. Increased glucuronidation of thyroid hormone in hexachlorobenzene-treated rats. Biochem Pharmacol 1993;45:627-31.

40. Visser TJ, van Haasteren GA, Linkels E, et al. Gender-specific changes in thyroid hormoneglucuronidating enzymes in rat liver during short-term fasting and long-term food restriction. Eur J Endocrinol 1996;135:489-97.

41. Kester MH, Kaptein E, Roest TJ, et al. Characterization of human iodothyronine sulfotransferases. J Clin Endocrinol Metab 1999;84:1357-64.

42. Visser TJ. Role of sulfation in thyroid hormone metabolism. Chem Biol Interact 1994;92:293-303.

43. Schuur AG, Brouwer A, Bergman A, et al. Inhibition of thyroid hormone sulfation by hydroxylated metabolites of polychlorinated biphenyls. Chem Biol Interact 1998;109:293-97.

44. Visser TJ, Kaptein E, Glatt H, et al. Characterization of thyroid hormone sulfotransferases. Chem Biol Interact 1998;109:279-91 .

45. Gong DW, Murayama N, Yamazoe Y, Kato R. Hepatic triiodothyronine sulfation and its regulation by growth hormone and triiodothyronine in rats. J Biochem (Tokyo) 1992;112:112-16.

46. Wu SY, Huang WS, Chopra IJ, et al. Sulfation pathway of thyroid hormone metabolism in selenium-deficient male rats. Am J Physiol 1995;268:E572-E579.

47. Kaptein E, van Haasteren GA, Linkels E, et al. Characterization of iodothyronine sulfotransferase activity in rat liver. Endocrinology 1997;138:5136-43.

48. Eelkman Rooda SJ, Kaptein E, Visser TJ. Serum triiodothyronine sulfate in man measured by radioimmunoassay. J Clin Endocrinol Metab 1989;69:552-56.

49. Huang WS, Cherng SC, Wang CH, et al. Increased urinary thyroxine sulfate excretion in thyroxine therapy. Endocr J 1997;44:467-72.

50. Huang WS, Kuo SW, Chen WL, et al. Increased urinary excretion of sulfated 3,5,3'-triiodothyronine in patients with nodular goiters receiving suppressive thyroxine therapy. Thyroid 1996;6:91-96.

51. Dhawan D, Goel A. Hepatoprotective effects of Liv-52 and its indirect influence on the regulation of thyroid hormones in rat liver toxicity induced by carbon tetrachloride. Res Exp Med (Berl) 1994;194:203-15.

52. Panda S, Kar A. Gugulu (Commiphora mukul) induces triiodothyronine production: Possible involvement of lipid peroxidation. Life Sci 1999;65:PL137-141.

53. Panda S, Kar A. Withania somnifera and Bauhinia purpurea in the regulation of circulating thyroid hormone concentrations in female mice. J Ethnopharmacol 1999;67:233-39.

54. Panda S, Kar A. Changes in thyroid hormone concentrations after administration of ashwagandha root extract to adult male mice. J Pharm Pharmacol 1998;50:1065-68.

55. Burger AG, Engler D, Sakoloff C, Staeheli V. The effects of tetraiodothyroacetic and triiodothyroacetic acids on thyroid function in euthyroid and hyperthyroid subjects. Acta Endocrinol (Copenh) 1979;92:455-67.

56. Moreno M, Kaptein E, Goglia F, Visser TJ. Rapid glucuronidation of tri- and tetraiodothyroacetic acid to ester glucuronides in human liver and to ether glucuronides in rat liver. Endocrinology 1994;135:1004-09.

57. Bracco D, Morin O, Schutz Y, et al. Comparison of the metabolic and endocrine effects of 3,5,3'-triiodothyroacetic acid and thyroxine. J Clin Endocrinol Metab 1993;77:221-28.

58. Beck-Peccoz P, Sartorio A, De Medici C, et al. Dissociated thyromimetic effects of 3, 5, 3'-triiodothyroacetic acid (TRIAC) at the pituitary and peripheral tissue levels. J Endocrinol Invest 1988;11:113-18.

59. Ueda S, Takamatsu J, Fukata S, et al. Differences in response of thyrotropin to 3,5,3'-triiodothyronine and 3,5,3'-triiodothyroacetic acid in patients with resistance to thyroid hormone. Thyroid 1996;6:563-70.

60. Lind P, Langsteger W, Koltringer P, Eber O. 3,5,3'-Triiodothyroacetic acid (TRIAC) effects on pituitary thyroid

regulation and on peripheral tissue parameters. Nuklearmedizin 1989;28:217-20.

61. Liang H, Juge-Aubry CE, O'Connell M,Burger AG. Organ-specific effects of 3,5,3'-triiodothyroacetic acid in rats. Eur J Endocrinol 1997;137:537-44.

62. Juge-Aubry CE, Morin O, Pernin AT, et al. Long-lasting effects of Triac and thyroxine on the control of thyrotropin and hepatic deiodinase type I. Eur J Endocrinol1995;132:751-58.

63. Becjer RA, Wilmore DC, Goodwin CW, et al. Plasma norepinephrine, epinephrine, and thyroid hormone interactions in severely burned patients. Arch Surg 1980;115:439.

64. Garrel DR, Todd KS, Pugeat MM, Calloway DH. Hormonal changes in normal men under marginally negative energy balance. Am J Clin Nutr 1984;39:930-36.

65. Reinhardt W, Holtermann D, Benker G, et al. Effect of small doses of iodine on thyroid function during caloric restriction in normal subjects. Horm Res 1993;39:132-37.

66. Hugues JN, Burger AG, Pekary AE, Hershman JM. Rapid adaptations of serum thyrotrophin, triiodothyronine and reverse triiodothyronine levels to short-term starvation and refeeding. Acta Endocrinol (Copenh) 1984;105:194-99.

67. Azizi F, Amini M, Arbab P. Time course of changes in free thyroid indices, rT3, TSH, cortisol and ACTH following exposure to sulfur mustard. Exp Clin Endocrinol 1993;101:303-06.

68. McCormack PD, Thomas J, Malik M, Staschen CM. Cold stress, reverse T3 and lymphocyte function. Alaska Med 1998;40:55-62.

69. Keck E, Degner FL, Schlaghecke R. Alcohol and endocrinologic homeostasis. Z Gastroenterol 1988;26:39-46. [Article in German]

70. Vitek V, Shatney CH. Thyroid hormone alterations in patients with shock and injury. Injury 1987;18:336.

71. Radetti G, Paganini C, Gentili L, et al. Alteredadrenal and thyroid function in children with insulin-dependent diabetes mellitus. Acta Diabetol 1994;31:138-40.

72. Makropoulos W, Heintz B, Stefanidis I. Selenium deficiency and thyroid function in acute renal failure. Ren Fail 1997;19:129-36.

73. Han MX, Wang YP. Effect of fushen decoction on thyroid hormone in chronic glomerulonephritis of both spleen and kidney-yang deficiency patients. Chung Kuo Chung Hsi I Chieh Ho Tsa Chih 1993;13:155-57,133.[Article in Chinese]

74. Kaptein EM, Weiner JM, Robinson WJ, et al. Relationship of altered thyroid hormone indices to survival in nonthyroidal illnesses. Clin Endocrinol 1982;16:565.

75. Ben Haim S, Kahana L, Bentur Y, et al. Effect of metoclopramide—a dopaminergic blocker and endogenous cortisol on TSH secretion in critically ill men. Acta Endocrinol (Copenh)1985;109:70-75.

76. Bugaresti JM, Tator CH, Silverberg JD, et al. Changes in thyroid hormones, thyroid stimulating hormone and cortisol in acute spinal cord injury. Paraplegia 1992;30:401-09.

77. Johansson G, Laakso ML, Karonen SL, Peder M. Examination stress affects plasma levels of TSH and thyroid hormones differently in females and males. Psychosom Med 1987;49:390-96.

78. Juma AH, Ardawi MS, Baksh TM, Serafi AA.Alterations in thyroid hormones, cortisol, and catecholamine concentration in patients after orthopedic surgery. J Surg Res 1991;50:129-34.

79. Arunabh, Sarda AK, Karmarkar MG. Changes in thyroid hormones in surgical trauma. J Postgrad Med 1992;38:117-18.

80. Burr WA, Griffiths RS, Black EG, et al. Serumtriodothyronine and reverse thriiodothyronine concentrations after surgical operations.Lancet 1976;2:1277.

81. Chopra IJ, Williams DE, Orgiazzi J, Solomon DH. Opposite effects of dexamethasone on serum concentrations of rT3 and T3. J Clin Endocrinol Metab 1975;41:911.

82. Saberi M, Sterling F, Utiger R. Reduction of extrathyroidal triiodothyronine production by propylthiouracil in man. J Clin Invest 1975;55:218.

83. Burgi W, Wimptheimer C, Burger A, et al. Changes of circulating thyroxine, triiodothyronine, and reverse triiodothyronine after radiographic contrast agents. J Clin Endocrinol Metab 1976;43:1203.

84. Burger A, Dinichert D, Nicod P, et al. Effect of amiodarone on serum T3, rT3, T4, and thyrotropin. A drug influencing peripheral metabolism of thyroid hormone. J Clin Invest 1976;58:255.

85. Wiersinga WM. Propranolol and thyroid hormone metabolism. Thyroid 1991;1:273-77.

86. Grubeck-Loebenstein B, Vierhapper H,Waldhausl W, Nowotny P. Thyroid function in adrenocortical insufficiency during withdrawal and re-administration of glucocorticoid substitution. Acta Endocrinol (Copenh) 1983;103:254-58.

87. Samuels MH, McDaniel PA. Thyrotropin levels during hydrocortisone infusions that mimic fasting-induced cortisol elevations: a clinical research center study. J Clin Endocrinol Metab 1997;82:3700-04.

88. Comtois R, Hebert J, Soucy JP. Increase in T3 levels during hypocorticism in patients with chronic secondary adrenocortical insufficiency. Acta Endocrinol (Copenh) 1992;126:319-24.

89. Opstad K. Circadian rhythm of hormones is extinguished during prolonged physical stress, sleep and energy deficiency in young men. Eur J Endocrinol 1994;131:56-66.

90. Suda AK, Pittman CS, Shimizu T, Chambers JB Jr. The production and metabolism of 3', 5, 3' triodithyronine and 3, 3', 5' triiodothyronine in normal and fasting subjects. J Clin Endocrinol Metab 1978;47:1311-18.

91. O'Brian JT, Bybee DE, Burman KD, et al. Thyroid hormone homeostasis in states of relative caloric deprivation. Metabolism 1980;29:721-27.

92. Serog P, Apfelbaum M, Autisser N, et al. Effects of slimming and composition of diets on VO2 and thyroid hormones in healthy subjects. Am J Clin Nutr 1982;35:24-35.

93. Palmblad J, Levi L, Burger A, et al. Effects of total energy withdrawal (fasting) on the levels of growth hormone, thyrotropin, cortisol, adrenaline, noradrenaline, T4, T3, and rT3 in healthy males. Acta Med Scand 1977;201:15-22.

94. Scriba PC, Bauer M, Emmert D, et al. Effects of obesity, total fasting and re alimentation on L-thyroxine (T4), 3,5,3'-L-triiodothyronine (T3), 3,3',5'-L-triiodothyronine (rT3), thyroxine binding globulin (TBG), cortisol, thyrotrophin, cortisol binding globulin (CBG), transferrin, alpha 2-haptoglobin and complement C'3 in serum. Acta Endocrinol (Copenh) 1979;91:629-43.

95. Pasquali R, Baraldi P, Biso F, et al. Relationship betwwen iodothyronine peripheral metabolism and ketone bodies during hypocaloric dietary manipulations. J Endocrinol Invest 1983;6:81-89.

96. Loucks AB, Callister R. Induction and prevention of low-T3 syndrome in exercising women. Am J Physiol 1993;264:R924-R930.

97. Burger AG, O'Connell M, Scheidegger K, et al. Monodeiodination of triiodothyronine and reverse triiodothyronine during low and high calorie diets. J Clin Endocrinol Metab1987;65:829-35.

98. Limanova Z, Sonka J, Kratochvil O, et al. Effects of exercise on serum cortisol and thyroid hormones. Exp Clin Endocrinol 1983;81:308-14.

99. Loucks AB, Heath EM. Induction of low-T3 syndrome in exercising women occurs at a threshold of energy availability. Am J Physiol 1994;266:R817-R823.

100. Baumgartner A, Riemann D, Berger M. Neuroendocrinological investigations during sleep deprivation in depression. II. Longitudinal measurement of thyrotropin, TH, cortisol, prolactin, GH, and LH during sleep and sleep deprivation. Biol Psychiatry 1990;28:569-87.

101. Radomski MW, Hart LE, Goodman JM, Plyley MJ. Aerobic fitness and hormonal responses to prolonged sleep deprivation and sustained mental work. Aviat Space Environ Med 1992;63:101-06.

102. Langer P, Foldes O, Gschendtova K. Effect of ethanol and linoleic acid on changes in biliary excretion of iodothyronines possibly related to thyroxine deiodination in rat liver. Horm Metab Res 1988;20:218-20.

103. Clugston GA, Hetzel BS. Iodine. In: Hils ME, Olson JA, Shike M, eds. Modern Nutrition in Health and Disease. Philadelphia: Lea and Febig; 1994;252-63.

104. Beckett GJ, MacDougall DA, Nicol F, Arthur JR. Inhibition of type I and type II iodothyronine deiodinase activity in rat liver, kidney, and brain produced by selenium deficiency. Biochem J 1989;259:887-92.

105. Arthur JR, Nicol F, Beckett GJ. Selenium deficiency, thyroid hormone metabolism, and thyroid hormone deiodinases. Am J Clin Nutr 1993;57:236S-239S.

106. Kralik A, Eder K, Kirchgessner M. Influence of zinc and selenium deficiency on parameters relating to thyroid hormone metabolism. Horm Metab Res 1996;28:223-26.

107. Arthur JR, Nicol F, Beckett GJ, Trayhurn P. Impairment of iodothyronine 5'-deiodinase activity in brown adipose tissue and its acute stimulation in cold by selenium deficiency. Can J Physiol Pharmacol 1991;69:782-85.

108. Olivieri O, Girelli D, Stanzial AM, et al. Selenium, zinc, and thyroid hormones in healthy subjects: low T3/T4 ratio in the elderly is related to impaired selenium status. Biol Trace Elem Res 1996;51:31-41.

109. Olivieri O, Girelli D, Azzini M, et al. Low selenium status in the elderly influences thyroid hormones. Clin Sci (Colch) 1995;89:637-42.

110. Strain JJ, Bokje E, van't Veer P, et al. Thyroid hormones and selenium status in breast cancer. Nutr Cancer 1997;27:48-52.

111. Calomme M, Vanderpas J, Francois B, et al. Effects of selenium supplementation on thyroid hormone metabolism in phenylketonuria subjects on a phenylalanine restricted diet. Biol Trace Elem Res 1995;47:349-53.

112. Lehmann C, Egerer K, Weber M, et al. Effect of selenium administration on various laboratory parameters of patients at risk for sepsis syndrome. Med Klin 1997;92:14-16. [Article in German]

113. Kauf E, Dawczynski H, Jahreis G, et al. Sodium selenite therapy and thyroid-hormone status in cystic fibrosis and congenital hypothyroidism. Biol Trace Elem Res 1994;40:247-53.

114. Eder K, Kralik A, Kirchgessner M. Effect on metabolism of thyroid hormones in deficient to subtoxic selenium supply levels. Z Ernahrungswiss 1995;34:277-83. [Article in German]

115. Bratter P, Negretti de Bratter VE. Influence of high dietary selenium intake on the thyroid hormone level in human serum. J Trace Elem Med Biol 1996;10:163-66.

116. Fujimoto S, Indo Y, Higashi A, et al. Conversion of thyroxine into tri-iodothyronine in zinc deficient rat liver. J Pediatr Gastroenterol Nutr 1986;5:799-805.

117. Nishiyama S, Futagoishi-Suginohara Y, Matsukura M, et al. Zinc supplementation alters thyroid hormone metabolism in disabled patients with zinc deficiency. J Am Coll Nutr 1994;13:62-67.

118. O'Brien T, Silverberg JD, Nguyen TT. Nicotinic acid-induced toxicity associated with cytopenia and decreased levels of thyroxinebinding globulin. Mayo Clin Proc 1992;67:465-68.

119. Shakir KM, Kroll S, Aprill BS, et al. Nicotinic acid decreases serum thyroid hormone levels while maintaining a euthyroid state. Mayo Clin Proc 1995;70:556-58.

120. Stangl GI, Schwarz FJ, Kirchgessner M. Cobalt defi-

ciency effects on trace elements, hormones and enzymes involved in energy metabolism of cattle. Int J Vitam Nutr Res 1999;69:120-26.

121. Segermann J, Hotze A, Ulrich H, Rao GS. Effect of alpha-lipoic acid on the peripheral conversion of thyroxine to triiodothyronine and on serum lipid-, protein- and glucose levels. Arzneimittelforschung 1991;41:1294-98.

122. Auf'mkolk M, Ingbar JC, Kubota K, et al. Extracts and auto-oxidized constituents of certain plants inhibit the receptor-binding andthe biological activity of Graves' immunoglobulins. Endocrinology 1985;116:1687-93.

123. Kuang AK, Chen JL, Chen MD. Effects ofyang-restoring herb medicines on the levels of plasma corticosterone, testosterone andtriiodothyronine. Chung Hsi I Chieh Ho Tsa Chih 1989;9:737-78, 710. [Article in Chinese]

124. Winterhoff H, Gumbinger HG, Vahlensieck U, et al. Endocrine effects of Lycopus europaeus L. following oral application. Arzneimittelforschung 1994;44:41-45.

125. Winterhoff H, Sourgens H, Kemper FH. Antihormonal effects of plant extracts. Pharmacodynamic effects of Lithospermum officinale on the thyroid gland of rats; comparison with the effects of iodide. Horm Metab Res 1983;15:503-07.

126. Tahiliani P, Kar A. Role of moringa oleifera leaf extract in the regulation of thyroid hormone status in adult male and female rats. Pharmacol Res 2000;41:319-23.

127. Panda S, Tahiliani P, Kar A. Inhibition of triiodothyronine production by fenugreek seed extract in mice and rats. Pharmacol Res 1999;40:405-09.

128. Panda S, Kar A. Dual role of betel leaf extract on thyroid function in male mice. Pharmacol Res 1998;38:493-96.

129. Forsythe WA 3rd. Soy protein, thyroid regulation and cholesterol metabolism. J Nutr 1995;125:619S-623S.

130. Potter SM, Pertile J, Berber-Jimenez MD. Soy protein concentrate and isolated soy protein similarly lower blood serum cholesterol but differently affect thyroid hormones in hamsters. J Nutr 1996;126:2007-11.

131. Rumsey TS, Elsasser TH, Kahl S. Roasted soybeans and an estrogenic growth promoter affect the thyroid status of beef steers. J Nutr 1997;127:352-58.

132. Mitsuma T, Ito Y, Hirooka Y, et al. The effectsof soybean diet on thyroid hormone and thyrotropin levels in aging rats. Endocr Regul 1998;32:183-86.

133. Duncan AM, Merz BE, Xu X, et al. Soy isoflavones exert modest hormonal effects in premenopausal women. J Clin Endocrinol Metab 1999;84:192-97.

134. Ishizuki Y, Hirooka Y, Murata Y, Togashi K. The effects on the thyroid gland of soybeans administered experimentally in healthy subjects. Nippon Naibunpi Gakkai Zasshi 1991;67:622-29. [Article in Japanese]

135. Kohrle J. The trace components–selenium and flavonoids–affect iodothyronine deiodinases, thyroid hormone transport and TSH regulation. Acta Med Austriaca 1992;19:S13-S17.

136. Spanka M, Hesch RD, Irmscher K, Kohrle J. 5'-Deiodination in rat hepatocytes: effects of specific flavonoid inhibitors. Endocrinology 1990;126:1660-67.

137. Spanka M, Koehrle J, Irmscher K, Hesch RD. Flavonoids specifically inhibit iodothyroninedeiodinase in rat hepatocytes. Prog Clin Biol Res 1988;280:341-44.

Orthoiodosupplementation: Iodine Sufficiency of the Whole Human Body

Guy E. Abraham (MD), Former Professor of Obstetrics, Gynecology and Endocrinology at The UCLA of School of Medicine, Jorge D. Flechas (MD), and John C. Hakala (R.Ph)

(Reprinted by permission of the authors)

I. INTRODUCTION

The essential trace element iodine (I) is the only one required for and in the synthesis of hormones. These I-containing hormones are involved in embryogenesis, differentiation, cognitive development, growth, metabolism, and maintenance of body temperature. I is highly concentrated in one organ, the thyroid gland, which becomes visibly enlarged when there is a deficiency of that element. It is the most deficient trace element in the world, with an acknowledged third of mankind functioning below optimal level due to its deficiency.[1] Low intake of I is the world's leading cause of intellectual deficiency.[2] Yet, as unbelievable as it may sound, this essential element has suffered from total neglect regarding the amount of it required by the human body for optimal health. In 1930, Thompson *et al* wrote: "The normal daily requirement of the body for iodine has never been determined."[3] This statement is still true today, more than 70 years later.

At the Children's Summit held in 1990, the United Nations and heads of state assembled for that occasion pledged to eliminate I deficiency by the year 2000. Commenting on this meeting, John T. Dunn stated in 1993, "The goal is technically feasible, but many obstacles must be overcome before it is realized."[4] In the list of obstacles, no mention was made of the greatest obstacle of them all: our total ignorance regarding sufficiency of the whole human body for I. It is obvious that I deficiency has been equated with the simple goiter, cretinism, and I-deficiency disorders related to its role in thyroidal physiology. Supplementation was considered adequate if such amounts prevented cretinism, simple goiter, and symptoms of hypothyroidism.[1,2,4] The assumption that the only role of I was as an essential element for the synthesis of T_3 and T_4 has became a dogma. With the advent of sensitive assays, thyroid stimulating hormones (TSH) was promoted to queen of tests for thyroid functions,[5] and I was forgotten altogether as irrelevant to the point where most endocrinologists and other medical practitioners do not request a single test for urine I concentration during their whole medical career.

II. IODOPHOBIA AND MISINFORMATION ABOUT IODINE

It is ubiquitous: the fear of using or recommending I (Iodophobia) and misinformation about I are found in books written by laypersons; in books written by physicians for laypersons; and in articles and books written by physicians for physicians. These views influence a large segment of practicing endocrinologists. For example, it is widely held that "high dietary iodine content in some areas of the world has resulted in a rise in the prevalence of thyroiditis and thyroid cancer."[6,7,8,9] However, the mainland Japanese consume a daily average of 4.6 g of seaweed and they are one of the healthiest people on earth.[10,11,12,22,23] The same endocrinologist claims, "To function normally, the thyroid requires 150 micrograms a day... In the United States, iodine consumption ranges between 300 and 700 micrograms a day." However, the last comprehensive nutritional survey (NHANES III 1988-1994) revealed that the median urine I concentration was 145 ug/L; furthermore, 15% of the U.S. adult female population suffered from I deficiency (urine I less than 50 ug/L).[2] That is, 1 out of every 7 female patients walking into a doctor's office, almost the same risk ratio for breast cancer in our population, that is 1 in 8.[63]

Let's summarize the misinformation about I and set out the facts:

Misinformation #1: I deficiency is a thing of the past.
Fact #1: The last National Nutritional Survey (NHANES III 1988-1994) revealed that 15% of the U.S. adult female population suffered from I deficiency, defined as urine I level below 50 ug/L,[2] which is a very low level by any standard.

Misinformation #2: High consumption of iodized salt prevents I deficiency.
Fact #2: Iodized salt contains 74 ug I/gm salt. The purpose of iodization of salt was to prevent goiter and cretinism, not for optimal level of I required by the human body. For example, to ingest the amount of I needed to control FDB — 5 mg I/day — you need to consume 68 gm of salt.[19] To reach levels of I ingested by mainland Japanese, a population with a very low

prevalence of cancer of the female reproductive organs, you need 168 gm of salt.

Misinformation #3: You may be getting too much I if you live near a coast.
Fact #3: Kung *et al* after investigating I deficiency in Hong Kong, concluded: "Our experience in Hong Kong has shown that it is not safe to assume that iodine insufficiency does not exist in coastal regions."

Misinformation #4: Too much I from coastal areas is harmful to the thyroid.
Fact #4: From the study just mentioned, coastal areas do not even supply enough I to prevent I deficiency.

This kind of misinformation may have serious consequences. With this high prevalence of I deficiency, urine I levels in the initial screening of simple goiter is justified. Without the information on urine I levels, the physician will most likely prescribe thyroid hormones to the I-deficient patient.

Hintze *et al* compared the response of patients with simple goiter to administration of I at 400 ug/day and to the administration of T4 at 150 ug/day for a period of 8 months and 4 months after cessation of therapy.[8] The results definitely favor I over T4. There was a similar suppression of the size of the thyroid gland with I and with T4. This suppression persisted 4 months after discontinuation of I; whereas the mean thyroid volume in the group receiving T4, returned to pre-T4 level 4 months after stopping T4 administration. The authors concluded: "Our data clearly shows that iodine alone…is at least equally as effective for goiter reduction as levothyroxine alone and offers the further benefit of a sustained effect after cessation of therapy."

Of greater concern, however, is the possibility that I-deficient women are more prone to breast cancer, and that depriving them of I is not in their best interest. Based on an extensive review of breast cancer epidemiological studies, R.A. Wiseman came to the following conclusions: 92% to 96% of breast cancer cases are sporadic; there is a single cause for the majority of cases; the causative agent is deficiency of a micronutrient that is depleted by a high fat diet; if such an agent is detected, intervention studies with supplementation should lead to a decline in the incidence of breast cancer.[9] It is the opinion of several investigators that this protective micronutrient is the essential element I.[14,16,19,20,54] Demographic surveys of Japan and Iceland revealed that both countries have a relatively high intake of I and low incidences of simple endemic goiter and breast cancer, whereas in Mexico and Thailand the reverse is observed: a high

incidence of both endemic goiter and breast cancer.[10] Thomas *et al* have demonstrated a significant and inverse correlation between I intake and the incidence of breast, endometrial, and ovarian cancer in various geographical areas.[11,12] Thyroid volume measured by ultrasonometry and expressed as ml is significantly larger in Irish women with breast cancer than controls with mean values of 12.9 ± 1.2 in controls and 20.4 ± 1.0 in women with breast cancer.[13] Intervention studies in female rats by Eskin are very suggestive of a facilitating role of I deficiency on the carcinogenic effect of estrogens, and a protective role of I by maintaining normality of breast tissues.[14-16]

The administration of thyroid hormones to I-deficient women may increase further their risk for breast cancer. In a group of women undergoing mammography for screening purposes, the incidence of breast cancer was twice as high in women receiving thyroid medications for hypothyroidism (most likely induced by I deficiency) than women not on thyroid supplement.[17] The mean incidences were 6.2% in controls and 12.1% in women on thyroid hormones. The incidence of breast cancer was twice as high in women on thyroid hormones for more than 15 years (19.5%) compared to those on thyroid hormones for 5 years (10%).

Backwinkel and Jackson have presented as evidence against the association between I deficiency and breast cancer the fact that in the state of Michigan, between 1924 and 1951, the prevalence of goiter decreased markedly from 38.6% to 1.4%, but no detectable change was observed in the prevalence of breast cancer during that same interval of time.[18] These authors are making the assumption that the amount of I required to control goiter is the same as that required for protection against breast cancer. Ghent *et al* and Eskin have estimated, based on their studies, that in both women and female rats, the amount of I required for protection against breast cancer and fibrocystic disease of the breast (FDB) is at least 20 to 40 times the amount required for control of goiter.[19,20]

Medical textbooks written for physicians contain the same iodophobia and misinformation about I. When I is incorporated into a drug, that drug gets all the credit for the good effects and I is blamed for the side effects. Although there are several I-containing drugs used by physicians for various medical condition,[21] we will just cover one of these drugs, from information supplied by Roti and Vagenakis in the latest review on I excess.[21] Amiodarone is a benzofuranic derivative containing 75 mg I per 200 mg tablet. It is widely used for the long-term treatment of cardiac arrhythmia. It is long acting with 100 days half-life and

releases 9 mg I daily in patients ingesting the recommended amount. In the United States, Amiodarone induces hypothyroidism in 20% of patients ingesting it. The authors of that review blamed I for the hypothyroidism, although no study has been performed with daily administration of 9 mg of inorganic I in a similar group of patients. It would not be surprising if inorganic I alone in equivalent amount resulted in the same beneficial effects without the side effects, among them, destructive thyroiditis, which require large doses of glucocorticoids, and, in some cases, thyroidectomy. Actually, there is a large population consuming close to 100 times the RDA almost daily, the Japanese living in Japan. According to the Japanese Ministry of Health, the average daily consumption of seaweed by mainland Japanese is 4.6 g.[2] At an average of 0.3% I in seaweed (range 0.08-0.45%),[22] that would compute to an average daily intake of 13.8 mg I. Overall, the Japanese living in Japan are among the healthiest people in the world, based on cancer statistics.[23] They have one of the lowest incidence of I-deficiency goiter and hypothyroidism.[10]

In the same review on I excess, published in a textbook read by most endocrinologists, and therefore influencing the national trend in the management of thyroid disorders, there is a subsection with the title "Iodine as a Pathogen."[21] This essential trace element is thus given the attribute of a pathogen. Commenting on the latest nutritional survey (NHANES III), the authors stated that this trend of decreasing I intake has resulted in a lower percentage of the U.S. population consuming excess I, defining excess I intake as urine I levels above 500 ug/L (0.5 mg/L): "This trend in iodine consumption has also resulted in a decline in the percentage of the population with excessive iodine intake (>500 ug/L) from 27.8% in the 1971 to 1974 survey to 5.3% in the 1988 to 1994 survey." With this iodophobic mentality, a cut off point of 0.5 mg I/L of urine has been arbitrarily chosen for excess I intake. What is considered excess I by these authors represents 3% of the average daily I intake by mainland Japanese, a population with a very low incidence of cancer of the female reproduction organs.[11,12] This attitude toward I may play an important role in the high incidence of cancer of the female reproductive organs in our population. It would be of interest to compare the prevalence of breast cancer with urine I levels from data available in the last two National Nutritional Surveys.

Currently, the average daily intake of I by the U.S. population is 100 times less than the amount consumed by the mainland Japanese. In the 1960s, I-containing dough conditioners increased the average

daily I intake more than 4 times the RDA.[24] One slice of bread contained the full RDA of 150 ug. The risk for breast cancer in our population was then 1 in 20.[63] Over the last two decades, food processors started using bromine, a goitrogen,[25] instead of I in the bread making process. The risk for breast cancer now is 1 in 8, and it is increasing at 1% per year.[63] The rationale for replacing I with a goitrogen in a population already I deficient is not clear, but definitely not logical and against common sense. In rats on a diet with the rat RDA for I (3 ug), adding thiocyanate, a goitrogen, at 25 mg/day, caused hypothyroidism.[26] Increasing I intake to 80 times rat RDA prevented this effect. In humans, that would be the equivalent of 12 mg I/day.

It is likely that a large percentage of patients receiving T4 for hypothyroidism are I deficient. This I deficiency is worsened by the goitrogens they are exposed to. Prescribing T4 to them increases further their risk for breast cancer.[17] What these patients really need is a supply of I large enough to create I sufficiency and to neutralize the effect of most of these goitrogens. Based on the studies of Lakshmy et al in rats, that amount of I would correspond to the level of I consumed by mainland Japanese.[26]

For those who trust the food processors to meet their nutritional needs, the last significant source of I is table salt, which contains 74 ug I per gm of NaCl. An editorial in the February 2002 issue of the *Journal of Clinical Endocrinology and Metabolism* exhorted the USA and Canada to decrease the amount of I in table salt by one half: "Most other countries use 20-40 PPM as iodine, and the United States and Canada should consider lowering the level of fortification to this range." [27] This recommended low level of I fortification between 20-40 PPM had no significant effect on urine I levels and size of goiters in published studies from Germany and Hungary.[28,29] Essentially, this amount of I was designed to give a false sense of I sufficiency but to really be ineffective. It is ironic that the title of this editorial is: "Guarding our Nation's Thyroid Health."

III. REQUIREMENT OF THE THYROID GLAND FOR I

After reviewing the available information in published studies designed to assess the effect of various amounts of I on thyroid physiology, it was possible to arrive at a tentative range of intake that would result in sufficiency of the thyroid gland for that element.

With the availability of radioactive isotopes of I and improved understanding of I metabolism, it became obvious that the thyroid gland concentrates this trace element more than two orders of magnitude,

compared to most other organs and tissues. The percent of radioiodide uptake by the thyroid gland correlated inversely with the amount of I ingested.[30] In areas of severe endemic goiter, it was above 80%.[31] The % uptake decreases progressively with increased intake of I, and at RDA levels (150 ug), the % uptake was maintained between 20% and 30%.[24]

In the 1960s I added to bread increased the average daily intake 4-5 times RDA levels, with a concomitant decrease in % uptake below 20%.[24,32] During the Cold War years, the threat of nuclear attack and radioactive fallout became a topic of national interest.[33] Attempts were made to estimate the amount of I required to suppress maximally radioiodide uptake by the thyroid.[34,37] It is of interest to note that these studies were not performed to assess the requirement of the human body for I, but as a crisis management in case of fallout of radioisotopes of I during a nuclear attack or accident. However, we will use these data to assist us in pinpointing the optimal requirement of the human body for I.

The ranges of % radioiodide uptake by the thyroid gland from some selected publications are displayed in Table I. The goal of this selection was to cover a wide range of I intake, from severe goiter to intake of excess I. From the publications by Karmarker et al,[31] three areas were selected, representing severe (<25 ug I/day), moderate (25-50 ug/day), and mild (51-100 ug/day) I deficiency. Moving up into the RDA range, the two studies of Pittman et al show in two groups of normal subjects results before and after I was added to bread at a level of 150 ug I/slice of bread.[24] The mean I intake in the two groups was 2/3 and 4 to 5 times RDA levels.

Going up in the scale of I intake, Saxena et al were the first to attempt a systematic study of the effect of increasing I intake on the % uptake of radioiodide by the thyroid gland in order to find the minimum oral dose of I for maximum suppression of radioactive I uptake by the thyroid gland.[34] These researchers used 63 euthyroid children as subjects, and they express the amount of I ingested as mg I/m^2/day. The range of I intake covered was from 0.1 to 2.5 mg/m^2/day, which would correspond to a range of 0.2 to 5 mg I in the adult. At 0.1 mg, the % uptake varied from 20% to 30%. On a semilogarythmic graph, there was a linear relationship between the log of I intake and % thyroid uptake of radioiodide. This linearity persisted up to 1.5 mg/m^2/day, where the % uptake seems to reach a plateau at 5% uptake with oral doses of I up to 2.5 mg/m^2/day. Because of the apparent leveling off at 5% thyroidal uptake at 1.5 mg/m^2/day (equivalent to 3 mg I in adults), Saxena et al concluded that

this % represented maximum suppression of radioiodide uptake by the thyroid gland.

Six years later, Cuddihy observed a 4% radioiodide uptake when 10 mg I was ingested.[35] Hamilton and Soley in 1940 were able to achieve a mean % uptake of 3.5% when 14 mg I was mixed with the radioactive tracer.[36] In 1980, Sternthal et al used amounts of I from 10 mg to 100 mg/day.[37] At 10 mg, they confirm the 4% uptake observed by Cuddihy, and they were able to achieve near maximum suppression (0.6% radioiodide uptake by the thyroid gland) with a daily I intake of 100 mg.

If these data are plotted on a semilogarithm graph, with % radioiodine uptake on the y-axis and the logarithm of the amount of I ingested on the x-axis, four slopes and ranges are observed (Fig. 1). By extending the first two slopes A and B to the point where their extensions cross the x-axis at zero % uptake, we can estimate the amount of I required for sufficiency of these two "pools" of I. Slope A crosses the x-axis at 0.27 mg and slope B, at 6 mg I. The range of intake covering slope A could be called the RDA range, or the goiter control range, since no more uptake of radioactive I was required at .27 mg, which is the upper limit (0.3 mg) of the RDA for control of goiter under all physiological conditions.[1]

Slope A is very steep and, therefore, represents a range of I intake where the I-trapping mechanism of the thyroid gland is very inefficient. Within the linear portion of that range, that is, with intake of I less than 100 ug/day, extrathyroidal tissues would be able to compete effectively with the thyroid for available I. To be discussed latter, the mammary glands possess an I-trapping system similar to that of the thyroid and have certain requirements for I to maintain normality. The larger breast in women would retain more I than the breast in men, and there would be less I available for the I-trapping of the thyroid gland. This would result in a greater incidence and prevalence of thyroid dysfunctions in women than in men, mainly in areas of marginal I intake. Indeed, the prevalence of goiter in endemic areas is six times higher in pubertal girls than pubertal boys.[38] Subclinical and overt hypo- and hyperthyroidism are more common in women than in men.[39,40] The physiological approach in these cases would be to treat them with I supplementation in optimal amounts, not thyroid hormones and antithyroid drugs.

Returning now to Fig. 1, slope B corresponds to I sufficiency of the thyroid gland, and represents a range where the efficiency of the I-trapping mechanism by the thyroid is markedly improved over slope A, which is steeper and, therefore, less efficient. Slope

Figure 1: Percent 24 hr uptake of radioiodide by the thyroid gland with increasing intake of I.

Figure 2: Percent 24 hr uptake of radioiodide and computed uptake of 1/2 hr by the thyroid gland, following intake of increasing amount of I.

Table 1: Percent uptake of radioiodide by the thyroid gland and amount of iodide retained by the thyroid gland in response to increasing intake of stable iodide (all values below are means)

Intake mg I/day	Thyroidal Radioiodide Uptake (percent)	Amount of iodide retained by the thyroid gland (ug/day)	References
0.02	84.7		Karmarkar et al Am. J. Clin. Nut 27:96-103, 1974
0.03	68.7		"
0.76	42.4		"
0.11	28.6	31.8	Pitman et al N. Engl. J. Med 280:1431-1434, 1969
0.68	15.4	105	"
3.0	5.0	150	Saxena et al Science 138:430-431, 1962
10.0	4.0	400	Sternthal et al
14	3.5	490	Hamilton, J.G. and Soley, M.H. Am. J. Physical 131:135-43, 1940
15	1.9	285	"
30	1.6	480	"
50	1.2	600	"
100	0.6	600	"

B starts at 0.1 mg, the upper limit for mild deficiency, and extends to 6 mg, theoretically, the optimal I intake for sufficiency of the thyroid gland. Slope C is almost horizontal, representing a range of I between 3 mg and 14 mg. The thyroid gland possesses maximal efficiency of the I-trapping mechanism over the range of I intake in slope C. Slope D from 15 mg to 100 mg of iodide could be called the saturation range. In order to refine further the optimal range of I intake, Fig. 2 displays the range of I intake from 0.1 to 100 mg.

The amount of I retained by the thyroid gland was also plotted for each intake levels. The amount retained was computed by multiplying the amount of I ingested by the % uptake of radioiodine by the thyroid gland. The 6 mg point is of interest because not only is it the crossing point of slope B at zero radioiodide uptake on the x-axis, but it also represents the 50% saturation point of the I trapping system of the thyroid gland. A system in a state of dynamic equilibrium would be the most stable at midpoint between the two extremes, that is at 50% saturation. The RDA for I corresponds to 5% saturation of the I-trapping mechanism of the thyroid gland, a very unstable position, predisposing to both hypo- and hyperthyroidism. The intake of 14 mg was the maximum amount that did not trigger the autoregulatory mechanism of the thyroid gland. This amount may represent the upper limit of I required for sufficiency of the whole human body. At 15 mg intake, the thyroid gland downregulates the efficiency of the I trapping in an attempt to bring down the amount of I retained to 50% saturation (Fig. 2). Above 15 mg intake, the efficiency of the trapping mechanism increases markedly with greater intake of I to reach saturation at 50 mg intake and 0.6 mg/24 hr of trapped I by the thyroid gland (Fig. 2).

Searching the literature, we found evidence supporting the amount observed in our calculation regarding the saturation of the I trapping by the normal thyroid, that is 0.6 mg/day. For example, Wagner et al observed in an euthyroid subject who received increasing amount of iodide that the maximum trapping of I by the thyroid was 50 ug/2 hrs.[41] This value multiplied by 12 = 600 ug/24 hr. Fisher et al observed in 20 normal subjects receiving different amounts of I, that the computed I accumulation/day by the thyroid gland was highest in 2 subjects with values of 608 and 613 ug/24 hr.[42]

Regarding the optimal I intake of 6 mg/day for sufficiency of the thyroid gland, there are some very interesting observations reported by various investigators, with 6 mg mentioned in connection with various physiological parameters of thyroid function. With optimal intake of I, thyroid functions would be the most stable under adverse conditions, maintaining homeostasis when pathological conditions tend to destabilize homeostasis in both directions, toward hypo- and hyperactivity of the thyroid gland. Therefore, the optimal intake of I for thyroid sufficiency should have the greatest effect in restoring normal functions under both conditions. The amount 6 mg/day happens to be the daily intake of I that gave the maximum reduction in basal metabolism toward the normal range in most cases of Grave's disease (hyperthyroidism).[3]

First, let us describe the form of I used in these studies. The Lugol solution contains 5% iodine and 10% potassium iodide.[43] It has been available since 1829 when it was introduced by French physician Jean Lugol, and was used extensively in medical practice during the early part of the 20th century. The recommended intake for I supplementation at that time was 2 drops/day corresponding to 12.5 mg I. This recommendation was still mentioned in the 19th Edition of Remington's *Science and Practice of Pharmacy*, published in 1995.[43] As quoted by Ghent et al, in 1928 an autopsy series reported a 3% incidence of FDB, whereas in a 1973 autopsy report, the incidence of FDB increased markedly to 89%.[19] Is it possible that the very low 3% incidence of FDB reported in the pre-RDA early 1900s was due to the widespread use of the Lugol solution available then from local apothecaries; and the recently reported 89% incidence of FDB is due to a trend of decreasing I consumption, with such decreased levels still within RDA limits for I, therefore giving a false sense of I sufficiency.[2]

The American physician H.S. Plummer was the first in 1923 to use Lugol solution pre- and post-operatively in his management of Graves'. disease.[44] He postulated that the hyperthyroidism of Graves' disease was due to I deficiency and that the high mortality rate associated with the post-operative recovery period could be controlled with I administration pre- and post-operatively. By administering 20 to 30 drops of Lugol pre-operatively and 10 drops post-operatively, he reported zero mortality rate. His procedure became widely used both in the USA and abroad. In 1930, a systematic study was performed by Thompson et al in patients with Graves' disease, using a wide range of I intake from Lugol solution, that is from 1/5 drop to 30 drops/day.[3] In 17 hospitalized patients and in 23 outpatients, one drop of Lugol gave the maximum reduction in basal metabolism toward the normal range in the majority of the patients, following a period of bed rest. One drop of Lugol contains a total of 6.25 mg, with 40% iodine and 60% iodide as the potassium salt.

Koutras *et al* administered increasing amounts of iodide from 0.1 to 0.8 mg to normal subjects over a period of 12 weeks and measured the quantity of I retained by the thyroid gland before an equilibrium with the new plasma inorganic I was reached.[45] With all the doses administered, a total of 6-7 mg I was accumulated by the thyroid gland over a period of weeks before equilibrium was reached. Again, around 6 mg was the amount observed under those physiological manipulations. These authors stated: "From our evidence it appears that, with all the doses we used, the thyroid took up about 6 to 7 mg of iodine before an equilibrium with the new PII (Plasma Inorganic I) was reached. It is of some interest that this is approximately the amount of the intrathyroidal exchangeable iodine."

Based on the above observations and the data displayed in Fig. 2, we would like to propose that the optimal daily intake for I sufficiency of the thyroid gland is 6 mg, with a minimum of 3 mg, Saxena's minimal daily amount.[34]

IV. REQUIREMENT OF THE EXTRATHYROIDAL TISSUES FOR I

In 1954, Berson and Yalow postulated that following initial clearance of an administered dose of radioiodine, the major portion of the radioiodine in the body is distributed between 2 compartments, the thyroidal and extra thyroidal organic I pools which are in dynamic equilibrium.[46] The results obtained from an elegant experimental design revealed that the total exchangeable organic I pool ranged from 7 to 13 mg. The total organic pool of I observed in Berson and Yalow's study may correspond to the range of I intake required daily for I sufficiency of the whole human body. The upper limit of 13 mg I is amazingly close to the upper limit of 14 mg observed in slope C (Fig. 2), the maximum intake of I that will not trigger downregulation of the I-trapping mechanism of the thyroid gland.

The amount of I required by the human body for optimal health would not be expected to trigger downregulation of the I trapping system of the thyroid gland. We are proposing that the upper limit of the requirement of the whole human body for I would be 14 mg. If 6 mg I is the optimal amount needed for the thyroid gland, the extra-thyroidal tissues need the difference, that is 14 mg – 6 mg = 8 mg.

Although several extrathyroidal organs and tissues have the capability to concentrate and organify I,[47-49] the most compelling evidence for an extra thyroidal function of I is its effects on the mammary gland. Eskin *et al* have published the results of their extensive and excellent studies on the rat model of FDB and breast cancer. Showing the importance of iodine as an essential element for breast normality and for protection against FDB and breast cancer.[14-16,19,20] The amount of I required for breast normality in the female rats was equivalent, based on body weight, to the amounts required clinically to improve signs and symptoms of FDB. That amount of I was 0.1 mg I/kg body weight/day. For a 50 kg woman, that daily amount would compute to 5 mg I.

Of interest is the findings of Eskin *et al* that the thyroid gland preferentially concentrates iodide whereas the mammary gland favors iodine.[20] In the I-deficient female rats, histological abnormalities of the mammary gland were corrected more completely and in a larger number of rats treated with iodine than iodide given orally at equivalent doses. This would suggest that iodine is not reduced to iodide during intestinal absorption.

Recent textbooks of endocrinology continue the tradition of the past, reaffirming that iodine is reduced to iodide prior to absorption in the intestinal tract, referring to a study by Cohn, published in 1932, using segments of the gastrointestinal tract of dogs, washed clean of all food particles prior to the application of I in the lumen.[50] However, Thrall and Bull observed that in both fasted and fed rats, the thyroid gland and the skin contained significantly more I when rats were fed with iodide than with iodine; whereas the stomach walls and stomach contents had a significantly greater level of I in iodine-fed rats than iodide-fed animals.[51] Peripheral levels of inorganic I were different with different patterns when rats were fed with these 2 forms of I. The authors concluded: "These data lead us to question the view that iodide and iodine are essentially interchangeable." Based on the above findings, I supplementation should contain both iodine for the mammary tissue and iodide for the thyroid gland.

The mammary glands can effectively compete with the thyroid gland for peripheral I. Eskin *et al* measured the 24 hr. radioiodide uptake in 57 clinically normal breasts, and in 8 clinically abnormal breasts.[52] The mean \pm SD % uptake was 6.9 \pm 0.46% in the normal breasts and 12.5 \pm 1% in abnormal breasts. These means were statistically significant at p <0.005. Considering that these measurements are representative of a single breast and a woman has two breasts, the % uptake per patient is twice these amounts. This brings the 24 hr. radioiodide uptake by the mammary glands of a woman in the same range as the 24 hr. radioiodide uptake by the thyroid gland. The higher % uptake in the abnormal breasts suggests that the

abnormal breasts were more I deficient than normal breasts. As previously discussed, endemic goiter is six times more common in pubertal girls than pubertal boys.[38] This suggests that in areas of marginal I supply, the larger breast of pubertal girls, with greater I requirement, would leave less I available for thyroid uptake than in pubertal boys, and the expected outcome would be a greater prevalence of goiter in pubertal girls than boys. The presence of simple goiter in a female patient is an indication of I deficiency of both the thyroid and mammary glands. Treating such patients with T4 instead of I supplementation is non physiological and increases their risk of breast cancer [17].

Beside the greater risk for breast cancer in I-deficient women, there is convincing evidence that I deficiency also increases the risk of thyroid cancer. It is common knowledge that simple goiter due to I-deficiency, if left without I supplementation, will progress to nodular goiter with some of these nodules becoming cancerous.[30] Since simple goiter is more common in women than in men, I-deficiency will eventually result in a greater prevalence of thyroid nodules in women and subsequently a greater incidence and prevalence of thyroid cancer. Therefore, it is not surprising that with the decreasing trend of I consumption by the population, there is a marked increase in thyroid nodules resulting in 19,500 new cases of thyroid cancer in 2001, with 14,900 cases in women.[1,2]

An editorial in the May 2002 issue of the *Journal of Clinical Endocrinology and Metabolism* called this increased incidence of thyroid nodules "an epidemic," but made no mention of I deficiency as a possible cause for this so-called epidemic, although the connection is very obvious.[53] It is a national tragedy that such preventable diseases continue to rise in our population as I deficiency becomes more prevalent and self-appointed experts continue to spread iodophobic misinformation. The guardians of our nation's thyroid should be more concerned about supplying the optimal requirement of the human body for I to the population; and less zealous in their crusade to eliminate I from our food supply.

V. REQUIREMENT OF THE HUMAN BODY FOR I

So far, the optimal daily requirement for I has been estimated at 6 mg of iodide for the thyroid gland and 5 mg of iodine for the mammary glands. The adrenal glands may also require adequate levels of I for normal function. A recent study of female rats exposed to noise stress revealed a decreased adaptability to stress when these rats were placed on an I-deficient diet. There was an attenuation of the pituitary-adrenal-axis to stress that persisted after functional recovery of the pituitary-thyroid-axis. Therefore, this effect of I on the adrenal response to stress is totally independent of thyroid hormones.

Certain roles of I in maintaining well-being and protecting against infections, degenerative diseases, and cancer may not involve its action on specific organs and tissues. Instead, such properties of I, affecting every cell in the human body, may depend on its concentration in biological fluids. Derry has reviewed some beneficial properties of I: the antimicrobial effect of I in organs capable of concentrating it to reach effective I levels; the apoptotic property of I in the body's surveillance mechanism against abnormal cells; the ability of I to trigger differentiation, moving the cell cycle away from the undifferentiated characteristic of breast cancer, for that matter, of all cancer.[54] Besides, as a halogen and because of its large size, I has the ability to markedly enhance the excited singlet to triplet radiationless transition.[55] Reactive oxygen species, causing damage to DNA and other macromolecules, are usually excited singlets with a high energy content released rapidly, and characterized by fluorescence, whereas the corresponding triplet state contains lower energy levels that are released slowly, expressed as phosphorescence. Such an effect of I would depend on its concentration in biological fluids.

Using a rudimentary phosphoroscope, Szent-Gyorgy was able, 50 years ago, to demonstrate this effect of I on the singlet Æ triplet radiationless transition, at a concentration of 10^{-5} M.[56] It is likely that this effect would persist at 10^{-6} M, which would correspond to a serum I level of 12.7 ug/100 ml. Such a level is easily achieved with I intake in the range consumed by mainland Japanese. This effect of I would markedly decrease the oxidative burden of the body, having a beneficial impact upon degenerative diseases and cancer. Protection of the thyroid from radioiodine fall out in cases of nuclear attack and accident would benefit from the recommended daily intake of I, discussed above. The equivalent of 2 drops of Lugol solution (12.5 mg I) daily would maintain a low radioiodine uptake by the thyroid gland (3% to 4%). Since the greatest damage to the thyroid occurs during the first few hours of radiation exposure, this recommended level of I would serve as a prevention in cases of unexpected exposure.[57]

Collective experience may have played a role in the choice of 2 drops of Lugol daily for I supplementation.[43] Amazingly, 0.1 ml (2 drops) of Lugol contains 5 mg iodine and 7.5 mg iodide as the potassium salt,

the near perfect total amount of I and ratio of iodine over iodide, for sufficiency of the thyroid and mammary glands. This amount of Lugol solution would then represent an ideal form of 'orthoiodosupplementation'.

Based on the above criteria for I sufficiency of the whole human body, the mainland Japanese represent the only population in the world consuming adequate amounts of I. Thyroid function is higher in normal Japanese woman, a low risk population for breast cancer, than in normal British women, who are at high risk for breast cancer.[11] When five different ethnic groups living in Hawaii were compared with British women and mainland Japanese women, the latter showed the highest serum levels of Free T3. There was a significant and inverse correlation ($p<0.001$) between serum Free T4 and the incidence of breast cancer in these 7 groups with mainland Japanese women showing the lowest incidence.[11,12] Since T4 therapy in I-deficient women increased their risk for breast cancer,[17] the significant correlation between serum Free T4 and breast cancer is not necessarily indicative of a protective role of T4. Instead, this correlation may point to the higher I levels in Japanese women, expressed as increased thyroid function.

Prasad *et al* reported significantly lower serum T4 and higher serum T3 levels in 40 women with histologically confirmed breast cancer, compared to 10 normal controls.[58] Although these authors did not measure urine I levels in those cases, the pattern they reported in women with breast cancer is typical of I deficiency: increased T3 levels and lower T4 levels to compensate for the limited availability of I.[30]

VI. PHYSICIAN-SUPERVISED ORTHOIODOSUPPLEMENTATION

Based on the information previously discussed, the optimal daily I intake for I sufficiency of the whole human body would be equivalent to 2 drops of Lugol solution. In the United States the initial implementation of I supplementation at this level would require medical supervision. Administration of I in liquid solution is not very accurate, may stain clothing, has an unpleasant taste, and causes gastric irritation. We decided to use a precisely quantified tablet form containing 5 mg iodine and 7.5 mg iodide as the potassium salt. To prevent gastric irritation, the iodine/iodide preparation was absorbed unto a colloidal silica excipient; and to eliminate the unpleasant taste of iodine, the tablets were coated with a thin film of pharmaceutical glaze.

Our preliminary experience with I supplementation at 12.5 mg/day confirmed the findings of Ghent *et al* regarding subjective and objective improvements of FDB following I supplementation.[19] Our findings in three patients with Polycystic Ovarian Syndrome (PCOS) confirmed the positive response observed following supplementation with 10 to 20 mg of potassium iodide by Russian investigators 40 years ago.[62] Prior to I supplementation, those PCOS patients were oligomenorrheic, menstruating one or twice a year. Following I supplementation for 3 months, they resumed normal monthly cycles. In two patients with subclinical hypothyroidism and elevated TSH levels, I supplementation suppressed TSH levels markedly in both cases. In one patient, serum TSH level was 7.8 mIU/L pre-supplementation and 1.7 mIU/L 3 months post I supplementation. In the other patient, TSH level was 21.5 mIU/L before and 11.9 mIU/L after 3 months of I supplementation.

Surprisingly, this program improved the symptoms of tremor and restless legs, two symptoms usually present in neurologic cretinism.[59] There was some evidence of improved T3 receptor responsiveness, reflected by a decreased need for T3 in some patients previously receiving this hormone. One female patient with normal size and echo pattern of the thyroid gland required 45 ug T3 to maintain clinical euthyroidism. Following I supplementation at 12.5 mg/day, she was able to titrate her daily dose of T3 down to 7.5 ug during the first month of I supplementation. Previously, missing 1 or 2 days of T3 elicited symptoms. She noticed that now she can remain asymptomatic without T3 for 1 week. TSH levels in this patient were below detection limits prior to I supplementation. Over the last 12 months on I supplementation, TSH levels are maintained between 1 and 2.5 mIU/L. The calculated T3 secretion rate by the normal thyroid gland varies between 4.6 and 8.3 ug/day. Therefore, with adequate supply of endogenous or exogenous T4, the daily need for exogenous T4 should not exceed 8.3 ug to maintain clinical euthyroidism. Is it possible that the large number of patients currently on supraphysiologic levels of T3 to maintain clinical euthyroidism are in reality I deficient by our definition of I sufficiency of the whole human body? Could it be that all they need is orthoiodosupplementation?

Eskin and Ghent have observed a modulating role of I at levels of 0.1 mg/kg body weight/day in the response of mammary tissue to estrogens.[14-16,19] We have some evidence of improved T3 receptor function in female patients receiving 12.5 mg I/day. T3 and steroid hormones share the same superfamily of receptors for hydrophobic small molecules.[60] Clur has postulated that iodination of thyrosine residues in the hydrophobic portion of these receptors normalized

their response to the corresponding hormones.[61] Optimal intake of I, in amounts two orders of magnitude greater than I levels needed for goiter control, may be required for iodination of these receptors. Our observation has important clinical implications. If optimal intake of I reduces the need for exogenous T3, one would expect the same effect of I supplementation on endogenous T3. I intake below optimal levels would result in clinical hypothyroidism in the presence of normal levels of thyroid hormones because of decreased T3 receptor function. If this common condition is due to iodine deficiency, the proper treatment would then be orthoiodosupplementation.

References

1. Anonymous. Editorial: What's happening to our iodine? J. Clinical Endocrinology and Metabolism 1998;33:3398-3400.

2. Hollowell J, Staehling N, Hannon W, Flanders D, Gunter E, Maberly G. Iodine nutrition in the United States. Trends and public health implications: Iodine excretion data from National Health and Nutrition Examination Surveys I and III (1971-1974 and 1988-1994) J. Clinical Endocrinology and Metabolism 1998;83:3401-08.

3. Thompson WO, Brailey AG, Thompson PK, et al. The Range of effective iodine dosage in exophthalmic goiter. Arch. Int. Med. 1930;45:261-81.

4. Dunn J. Iodine Supplementation and the Prevention of Cretinism. Annals of the New York Academy of Sciences 1993;678:158-68.

5. Utiger RD. Thyrotoxicosis, Hypothyroidism, and the Painful Thyroid. In: Endocrinology & Metabolism, Felig P and Frohman LA (eds.) New York, NY: McGraw-Hill, 2001:275.

6. Arem R. The Thyroid Solution. New York, NY: Ballantine Publishing Group, 1999.

7. Harach R and Williams ED. Thyroid cancer and thyroiditis in the goitrous region of Salta, Argentina, before and after iodine prophylaxis Clin Endocrinol 1995;43:701-706.

8. Hintze G, Emrich D, Kobberling J. Treatment of endemic goitre due to iodine deficiency with iodine, levothyroxine or both: results of a multicentre trial. European Journal of Clinical Investigation 1989;19:527-34.

9. Wiseman R. Breast cancer hypothesis: A single cause for the majority of cases. J Epid Comm Health 2000;54:851-58.

10. Finley JW and Bogardus GM. Breast cancer and thyroid disease. Quart. Rev. Surg. Obstet. Gynec. 1960;17:139-47.

11. Thomas BS, Bulbrook RD, Russell MJ, et al. Thyroid function in early breast cancer Enrop. J. Cancer Clin. Oncol. 1983;19:1213-19.

12. Thomas BS, Bulbrook, RD, Goodman MJ. Thyroid function and the incidence of breast cancer in Hawaiian, British and Japanese women Int. J. Cancer 1986;38:325-29.

13. Smyth P. Thyroid disease and breast cancer. J. Endo. Int. 1993;16:396-401.

14. Eskin B, Bartuska D, Dunn M, Jacob G, Dratman M. Mammary gland dysplasia in iodine deficiency. JAMA 1967;200:115-19.

15. Eskin B. Iodine metabolism and breast cancer. Trans. New York Acad. of Sciences 1970;32:911-47.

16. Eskin B. Iodine and mammary cancer. Adv. Exp. Med. Biol. 1977;91:293-304.

17. Ghandrakant C, Kapdim MD, Wolfe JN. Breast cancer: Relationship to thyroid supplements for hypothyroidism. JAMA 1976;238:1124.

18. Backwinkel K and Jackson AS. Some features of breast cancer and thyroid deficiency. Cancer 1964;17:1174-76.

19. Ghent W, Eskin B, Low D, Hill L. Iodine replacement in fibrocystic disease of the breast. Can. J. Surg. 1993;36:453-60.

20. Eskin B, Grotkowski CE, Connolly CP, et al. Different tissue responses for iodine and iodide in rat thyroid and mammary glands. Biological Trace Element Research 1995;49:9-19.

21. Roti E and Vagenakis AG. Effect of excess iodide: Clinical aspects. In: Werner and Ingbar's The Thyroid. Braverman LE and Utiger R-D (eds.) New York, NY: Lippincott, 2000:316-29.

22. Nagataki S, Shizume K, Nakao K. Thyroid function in chronic excess iodide ingestion: Comparison of thyroidal absolute iodine uptake and degradation of thyroxine in euthyroid Japanese subjects. J. Clin Endo 1967:27:638-47.

23. Waterhouse J, Shanmvgakatnam K, et al. Cancer incidence in five continents. Lyons, France: LARC Scientific Publications, International Agency for Research on Cancer, 1982.

24. Pittman J, et al. Thyroidal radioiodine uptake. N. Engl. J. Med. 1969;280:1431-34.

25. Mizukami Y, Funaki N, Hashimoto T, et al. Histologic features of thyroid gland in a patient with bromide-induced hypothyroidism. Am. J. Clin. Pathol. 1988;89:802-05.

26. Lakshmy P, Rao S, Sesikeran B, et al. Iodine metabolism in response to goitrogen induced altered thyroid status under conditions of moderate and high intake of iodine. Hormone & Metabolic Res. 1995;27:450-54.

27. Editorial: Guarding our nation's thyroid health. The Journal of Clinical Endocrinology & Metabolism 2002;87:486-88.

28. Gutekunst R, Smolarch H, Hasenpusch U. Goitre epidemiology: thyroid volume, iodine excretion, thyroglobulin and thyrotropin in Germany and Sweden. Acta Endocrinologica 1986;112:494-501.

29. Merovi E, Molner I, Jukab A, et al. Prevalence of iodine deficiency and goitre during pregnancy in east Hungary. European Journal of Endocrinology 2000;143:479-83.

30. Delange FM. Iodine deficiency. In Werner and Ingbar's The Thyroid. Braverman LE and Utiger R-D (eds.). New York, NY: Lippincott, 2000:295-329.

31. Karmarkar MC, Deo MG, Kochupillar N. Pathophysiology of Himalayan endemic goiter. Am. J. of Clinical Nutr 1974;27:96-103.

32. Wartofsky L and Ingbar SH. Estimation of the rate of release of non-thyroixine iodine from the thyroid glands of normal subjects and patients with thyroitoxicosis. J. Clin. Endo. 1971;33:488-500.

33. Becker DV and Zanzonico P. Potassium iodide for thyroid blockade in a reactor accident: Administrative policies that govern its use. Thyroid 1997;7:193-97.

34. Saxena KM, Chapman EM, Pryles CV. Minimal dosage of iodide required to suppress uptake of Iodine-131 by normal thyroid. Science 1962;138:430-31.

35. Cuddihy RG. Thyroidal Iodine-131 uptake, turnover and blocking in adults and adolescents. Health Physics 1996;12:1021-25.

36. Hamilton JG and Soley MH. Studies in iodine metabolism of the thyroid gland in situ by the use of radio-iodine in normal subjects and in patients with various types of goiter. Am. J. Physiol. 1940;131:135-43.

37. Sternthal E, Lipworth L, Stanley B, et al. Suppression of thyroid radioiodine uptake by various doses of stable iodide. N. Engl. J. Med. 1980;303:1083-88.

38. Marine D and Kimball BS. The prevention of simple goiter in man. J. Lab Clin Med. 1917;3:40-48.

39. Wiersinga WM. Subclinical hypothyroidism and hyperthyroidism. I. Prevalence and clinical relevance. Netherlands J. Med. 1995;46:197-204.

40. Vanderpump PJ, Tunbridge WM, French, N. The incidence of thyroid disorders in the community: A twenty-year follow-up of the Whickham Survey. Med. Endo 1990;43:55-66.

41. Wagner Jr. HN, Nelp WB, Dowling JH. Use of neutron activation analysis for studying stable iodide uptake. Thyroid. J. Clin. Invest. 1961;40:1984-92.

42. Fisher DA, Oddie TH, Eppersonn D. Effect of increased dietary iodide on thyroid accumulation and secretion in euthyroid Arkansas subjects. J. Clin. Endocr. 1965;25:1580-90.

43. Gennaro AR. Remington: The Science and Practice of Pharmacy. 19th ed. New York, NY: Mack Publishing Co, 1967.

44. Plummer HS. Results of administering iodine to patients having exophthalmic goiter. JAMA 1923;80:1955.

45. Koutras DA, Alexander WD, Harden R, et al. Effect of small iodine supplements on thyroid function in normal individuals. J. Clin. Endocr. 1964;24:857-62.

46. Berson SA and Yalow RS. Quantitative aspects of iodine metabolism. The exchangeable organic iodine pool, and the rates of thyroidal secretion, peripheral degradation and fecal excretion of endogenously synthesized organically bound iodine. J. Clin. Invest. 1954;33:1533-52.

47. Freinkel N and Ingbar S. The metabolism of I by surviving slices of rat mammary tissue. Endo, 1956;58:51-56.

48. Schiff L, Stevens CD, Molle WE, Steinberg H, Kumpe C, Stewart P. Gastric (and salivary) excretion of radioiodine in man (Preliminary Report). J. Nat. Can. Inst. 1947;7:349-56.

49. Banerjee R, Bose A, Chakraborty T De S, Datta A. Peroxidase-catalysed iodotyrosine formation in dispersed cell of mouse extrathyroidal tissues. J. Endocr. 1985;106:159-65.

50. Cohn B. Absorption of compound solution of iodine from the gastro-intestinal tract. Arch Intern Med, 1932;49:950-56.

51. Thrall K and Bull RJ. Differences in the distribution of iodine and iodide in the Sprague-Dawley rat fundamental. Applied Toxicology 1990;15:75-81.

52. Eskin BA, Parker JA, Bassett JG, et al. Human breast uptake of radioactive iodine. OB-GYN 1974;44:398-402.

53. Editorial: Nonpalpable thyroid nodules – Managing an epidemic. J. Clin. Endo & Metabolism 2002;87:1938-40.

54. Derry D. Breast cancer and iodine. Victoria, BC: Trafford Publishing, 2001:92.

55. Kasha M. Collisional perturbation of spin-orbital coupling and the mechanism of fluorescence quenching: A visual demonstration of the perturbation. The Journal of Chemical Physics 1952; 20:71-74.

56. Szent-Gyorgyi A. Bioenergetics. New York, NY: Academic Press, 1957:113.

57. Zanzonico PB and Becker DV. Effects of time of administration and dietary iodine levels on potassium iodide (KI) blockade of thyroid irradiation by [131]I from radioactive fallout. Health Physics Journal 2000;78:660-68.

58. Prasad GC, Singh AK, Raj R. Pineal-thyroid relationship in breast cancer. Indian Journal of Cancer 1988;22:108-13.

59. Delange FM. Endemic cretinism. In: Werner and Ingbar's The Thyroid. Braverman LE and Utiger R-D (eds.). New York, NY: Lippincott, 2000:743-51.

60. Evans RM. The steroid and thyroid hormone receptor superfamily. Science 1988;240:889.

61. Clur A. DI-Iodothyronine as part of the oestradiol and catechol oestrogen receptor – The role of iodine, thyroid hormones and melatonin in the aetiology of breast cancer. Med Hypothesis 1988;27:303-11.

62. Vishnyakova VV and Murav'yeva NL. On the treatment of dyshormonal hyperplasia of mammary glands. Vestn Akad Med Navk SSSR 1966;21:19-22.

63. Epstein SS and Steinman D. Breast cancer prevention program. New York, NY: Macmillan, 1998:5.

Treatment for Thyroid Diseases with Chinese Herbal Medicine

Subhuti Dharmananda (PhD), Director, Institute for Traditional Medicine, Portland, Oregon
(Reprinted by permission of the author)

INTRODUCTION

Thyroid disease is common in China, and it is frequently treated by herbal medicine or a combination of herbs and drugs. Positive response is a common outcome: the aggregate "cure" rate for hyperthyroidism reported in more than a dozen studies involving more than 700 patients is 42%, with most other patients well-managed even after cessation of the therapy. By "cure," it is meant that the primary hyperthyroid symptoms are removed and that the laboratory measures (such as T3 and T4 levels and iodine uptake) are in the normal range. Clearly, it is not meant that there is any change in the underlying genetic propensity for autoimmunity, nor is it suggested that the immunologic memory of the T-cells is altered. Rather, the initiating factors for autoimmune attack appear to be diminished and, as shown in two studies, circulating antibodies against thyroid tissue are reduced. Follow-up studies of patients claimed to be cured during these treatment programs indicates persistence of the favorable outcome.

ORIENTAL MEDICAL APPROACH

Until the past 50 years, thyroid disease could not be definitively diagnosed in China; rather, Chinese doctors could only detect a certain set of symptoms to be treated and could palpate any moderate or large nodules in the area of the thyroid gland. Now, objective measures, such as altered levels of thyroid hormone, can give a clue as to the site of the disease and can further elucidate the influence of various therapeutic measures that might be applied.

While treatments for both hyperthyroidism and hypothyroidism have been reported in the literature, the main thrust of clinical trials has been with hyperthyroidism. The treatments vary somewhat from one study to the next, but there are certain consistent features that will be described here on the basis of reports for hyperthyroid treatments only.

First, there is a strong reliance on materials from the sea, mainly oyster shell (included in 12 of 18 clinical trials using a basic formula), seaweeds (laminaria, and sargassum, used in nearly half the clinical trials), and somewhat less frequent use of clam shells, arca shells, or pumice. While these materials, especially the seaweeds, would obviously be helpful for iodine-deficiency goiter, they are now often used for Graves' disease and thyroid adenoma. Iodine is not known to have an impact on chronic (autoimmune-based) thyroid disease, though it is employed as a temporary remedy in cases of thyroid storm (physiologic crisis resulting from thyroid hormone excess). The continued use of the sea materials may be unnecessary for modern thyroid diseases, and, indeed, two studies producing satisfactory results in treatment of hyperthyroidism contain none of these materials.[2,21] However, the sea materials may contain components other than iodine that benefit patients with hyperthyroidism. Their initial use was no doubt associated both with the experiential knowledge that consumption of sea materials resolved many cases of goiter and also by the theoretical concept that salty materials would soften and remove masses. Thyroid nodules often occur even in cases of non-iodine-deficiency hyperthyroidism.

The two trials reported in the Chinese literature that failed to include sea materials in the herb combination had unusually long treatment times (6 months to one year for most patients of one study, and one and a half years for the patients in the other study) compared to trials that included sea materials. In the recent book, *Practical Traditional Chinese Medicine and Pharmacology Clinical Experiences,* formulas are presented for treatment of hyperthyroidism according to differential diagnosis: all five of the listed formulas contained seaweeds or seashells or both. Thus, current thinking about hyperthyroidism emphasizes these materials. Oyster shell and other shells not only resolve masses, but also help to calm liver wind, thought to be responsible for some hyperthyroid symptoms, such as trembling, and they astringe excessive perspiration, another common symptom.

Several other phlegm-resolving agents are used to remove the thyroid mass, such as pinellia, fritillaria (zhebeimu), sinapis, huangyaozi (*Dioscorea bulbifera*), and various types of citrus (e.g., chenpi, juhong, and zhiqiao). Masses and nodules are often described by Chinese doctors in terms of entangled qi, accumulated phlegm, and static blood. Because of the site of the nodules (just over the lungs), the fact that the nodules are usually not painful, and the soft quality of the

swellings (except in cases of thyroid tumor), they are traditionally described as being primarily phlegm masses. Both the sea materials and the items mentioned here from land plants are thought to treat such masses effectively. Fritillaria, used also in the treatment of a wide variety of tumors, is the most commonly selected phlegm-resolving item for hyperthyroidism aside from oyster shell. In addition, many of the therapies for hyperthyroidism contain prunella, an herb used to resolve entangled qi. The citruses likewise help resolve qi stagnation and phlegm accumulation, and bupleurum and/or cyperus are sometimes included in the treatments for regulating the qi.

A few doctors include therapeutic substances for static blood in formulas aimed at removing thyroid nodules. The main herbs used are zedoaria and sparganium; these would also be relied upon for treatment of abdominal masses, such as uterine myoma. Salvia, cnidium, and/or peony (white peony), which are less powerful blood-vitalizing agents, are sometimes used instead of, or in addition to, these two principal herbs. Blood-vitalizing herbs are especially indicated when the thyroid mass is quite firm; this is a characteristic of thyroid tumors, which can also cause hyperthyroidism (toxic adenoma).

Hyperthyroidism is thought by some doctors to start with an excess fire syndrome, which later becomes yin-deficiency fire. Therefore, fire-purging herbs are used, especially in the early stages of the disease process. Prunella is the most frequently selected one, used in more than half the clinical trials that rely on a basic formula. Peony, raw rehmannia, and scrophularia are also commonly used. Other fire purging herbs recommended include moutan, gentiana, gypsum, scute, anemarrhena, and gardenia.

Several hyperthyroid symptoms, such as heart palpitation, general hyperactivity (psychological and physical), excessive perspiration, heightened appetite, aversion to heat, and, in more severe cases, wasting of the muscles, are characteristic of a yin deficiency syndrome. Therefore, Chinese doctors prescribe raw rehmannia and scrophularia (herbs that purge fire and nourish yin) plus ophiopogon and/or adenophora. In some cases, lycium fruit and/or tang-kuei may be used in conjunction with one or more of these other agents to nourish liver blood and thereby control liver fire. To calm the agitation, sedative herbs such as zizyphus, succinum, dragon bone (or dragon teeth), and polygonum stem are used. Magnetite or hematite may be added as sedatives and to treat exophthalmos. Tribulus is used as an antispasmodic that is beneficial to the eyes; it may be combined with lycium fruit to nourish the liver. Cinnabar is employed by some

Chinese doctors as a sedative but is not recommended for use by Western practitioners.

Many doctors prescribe some spleen qi tonics to normalize overall body functions and to avoid generation of phlegm from spleen dampness. Astragalus, codonopsis, atractylodes, hoelen, and licorice are the materials most often used. Astragalus is the preferred item, though it is often selected, as are the other qi tonics, as an optional ingredient rather than a standard item, to be used for those patients showing obvious signs of qi deficiency. Typically, hyperthyroid formulas contain only one or two qi tonic herbs that do not constitute the bulk of the formula.

A typical treatment, with a formula somewhat larger than others, but comprised of the commonly used components, is *Jia Kang Wan* .[7] It contains oyster shell, sargassum, laminaria, prunella, citrus (juhong), pinellia, fritillaria, and huangyaozi-ingredients for resolving nodules; it also contains succinum and cinnabar as sedatives, and hoelen and licorice to benefit the spleen. The herbs are powdered, formed into large honey pills weighing 15 grams, and taken in the dosage of one pill twice daily for 45 to 90 days. It was reported that 65 of 125 patients so treated were cured, a rather high rate (52%).

Another typical example is *Pingyin Fufang,*[16] which contains oyster shell, arca shell, prunella, fritillaria, blue citrus, sparganium, and zedoaria to resolve the thyroid nodules; scrophularia, raw rehmannia, peony, and moutan to clear heat and nourish yin; plus tang-kuei, dragon bone, hoelen, and cornus. The herbs were decocted "in typical amounts" (the total dosage is 150 g or more of crude herb per day) and given for a cycle of 30 days, which might be repeated once or twice if necessary to obtain adequate response. The cure rate was 38 of 110 patients (35%), somewhat low compared to the overall outcome of the various clinical trials, but because of the short treatment time (usually just 30 days), the results are impressive.

A Japanese doctor, relying on approved herb formulas (those sanctioned by the Health Ministry of Japan) reported good response of hyperthyroidism in several patients from Bupleurum and Dragon Bone Combination and from Baked Licorice Combination.[25] The former contains herbs found in many of the modern hyperthyroid treatments, such as oyster shell, dragon bone, pinellia, bupleurum, and hoelen, while the latter also contains some ingredients in common with the modern therapies, including raw rehmannia, ophiopogon, and licorice. Other treatments mentioned by Japanese doctors are described later in the section on Kanpo medicine.

In sum, Chinese doctors obtain clinically useful

results from the application of formulas that have the primary function of resolving masses, with additional herbs to clear heat and nourish yin.

Causes from the Oriental Perspective

While Western doctors seek a cause of autoimmune-induced thyroid disease in a combination of genetic determinants and viral initiators, Chinese doctors have attributed the cause of the disorder primarily to emotional disturbance. In the case of hyperthyroidism, the following have been mentioned in the Chinese literature:[24]

* Disturbance of qi by sorrow and anger. Liver and spleen qi become disharmonious, and, as a result, moist sputum coagulates to form a goiter. The swelling in the neck should be one of the first noted symptoms when this is the primary cause.

* Heart fire. The disorder is often marked by highly agitated emotional condition. Fright, dreaminess, mania, panic, and other distress that may cause insomnia, excessive talking, or heart palpitations belong to this category. Heart fire is often associated with heart yin deficiency. The skin in the area of the thyroid may become discolored (purple).

* Extreme anger may produce liver fire, which dries yin and blood. The vessels surrounding the thyroid may bulge.

* External factors: geography plays a part (iodine deficiency, goiterogenic foods dominant in local crops, or some toxin in the environment induces thyroid disease). Drinking "sandy water" or being exposed to "mountain vapor" have been said to cause the disease, but such explanations are no longer relied on.

The first cause, qi disturbance, is most frequently cited. A weakening of the stomach and spleen qi (which may be the result of emotional factors or dietary influences) produces turbid and moist substances; these are raised to the thyroid area by the stimulus of excessive liver qi (most often the result of emotional stimulus).

There will thus be swelling in the neck and protrusion of the eyes. Or, to put events in a different order, as described in *Comprehensive Guide to Chinese Herbal Medicine*:

When [hyperthyroidism is] due to long-term depression or sudden psychic trauma, the liver no longer properly regulates the flow of vital energy and blood, liver qi stagnates, and fails to transport fluids. The fluids accumulate and transform into phlegm, which then obstructs the neck with qi and gradually induces goiter. Lingering [pathologic] liver qi transforms into fire, which is manifested in fidgeting and irritability. If the fire consumes body fluids and stomach yin, the resulting yin deficiency produces heat. Even though this heat overstimulates the appetite, the patient still loses weight. If the spleen is impaired, it will be unable to transport or transform nutrients, thereby giving rise to diarrhea, gauntness, and lassitude. If heart yin is deficient [a result of lack of transported nutrients], palpitation or severe palpitation with fear, fidgeting, insomnia, and profuse sweating can be observed. ...

In the discussion of a clinical trial involving 98 patients,[21] the authors present the following explanation:

The etiology of hyperthyroidism involves chiefly the deficiency of genuine qi and insufficiency of kidney fluid. Insufficiency of water leads to excessive heat, which in turn harms the vital energy. Excessive heat also hurts yin, and impairment of yin again affects yang. The excessive heat of the hyperthyroid patient often involves the three internal organs of heart, liver, and stomach. Excessive heat in the heart is manifested by palpitations and forgetfulness. Excessive heat in the liver gives rise to irritability and tremor. Excessive heat in the stomach leads to polyphagia. The impairment of yin that affects yang in the hyperthyroid patient is represented by the damage of spleen yang. Deficiency of spleen yang causes indigestion and loose stool, and produces wet phlegm, which goes up to the neck to cause the enlarged thyroid or nodules, or goes to the eyes to induce exophthalmos. In treatment of this disease, main emphasis should be on replenishment of vital energy. Once the yang of vital energy is replenished, yin will grow to calm down the excessive heat.

An initial problem of deficiency is also described by another experienced doctor.[31] According to his observation of patients with hyperthyroidism, yin deficiency of the liver and kidney is a dominant cause of the disease, though it is sometimes caused by yin deficiency of the heart and kidney or deficiency of qi and yin. The yin deficiency can lead to a coexisting yang deficiency.

He therefore recommends nourishing the kidney, removing heat from the liver, softening the thyroid mass, and (if necessary) restoring the qi and yang.

From these explanations (see also the explanation given under the section on acupuncture therapy), it should be evident that there is not complete agreement on the initiation of the disease. There is general agreement, however, that ultimately the yin is damaged and must be replenished and that the thyroid swelling, due to a phlegm excess, must be resolved.

In one clinical report on hyperthyroidism,[16] investigators determined that the likely causative factors for the 110 patients were: fright, depression, and mental irritability in 84 cases (76.3%), infections in 12 cases, extreme fatigue in 9 cases, and congenital problems in 6 cases. The 26 remaining cases were of undetermined causality. The main cause — emotional distress —has an effect of disturbing the qi.

Single Herb Remedies

Single-herb remedies for hyperthyroidism do not follow the rules of traditional Chinese herb prescribing in addressing the underlying or symptomatic problems. There are three examples mentioned in clinical trials or individual case reports.

The immunosuppresive herb tripterygium (shanhaiteng), which has effects comparable to corticosteroids, was used in at least one study of hyperthyroidism.[1] When used alone or with the Western drug tapazole (methimazole), virtually all patients were said to have their symptoms remitted. Interestingly, corticosteroid therapy is not a common method of treatment in the U.S. Tripterygium is considered, by Chinese doctors, to be somewhat safer and more effective than corticosteroids, but because of its potential toxicity even in small doses, the herb is not imported into the U.S. and is not available for use by Western practitioners. Chinese doctors use it for a wide range of autoimmune diseases, especially rheumatoid arthritis (the variety *leigongteng* is used).

Fagopyrum (suanqiaomai) was used in another study.[3] The whole plant (rather than the fruits typically used in Chinese medicine) was combined only with a small amount of poultry trachea (0.5%), decocted and made into tablets. With two grams of herb extract in each tablet, they were taken in the amount of 15 to 16 tablets daily (thus about 30 grams of crude herb equivalent) for 45 to 60 days. This method was claimed to cure 41 of 90 patients (45%), a rate comparable to that obtained with the complex formulas; another 44 patients had some degree of improvement. Fagopyrum is in the same plant family (Polygonaceae) as polygonum stem, used to treat

agitation caused by hyperthyroidism. The plant contains glycosides and flavonoids, but the mechanism of action for hyperthyroidism has not been determined. According to the clinical report, in using this remedy during a 3-year period, the doctors found it safe and reliable. No toxicity was revealed upon examination of liver function, potassium and sodium levels, and blood sugar.

The herb huangyaozi is a common ingredient in formulas for hyperthyroidism, and it has been used in individual cases as a sole ingredient. In *Practical Traditional Chinese Medicine and Pharmacology Clinical Experiences*, a method of using the herb is described: the rhizome is crushed into small pieces and soaked in wine (300 g rhizome per 1500 ml wine), put into a sealed jar, and heated over a very low fire for 4 hours, then stored in ice water for one week. The patient is then instructed to drink 10 ml of the liquor six times daily, but not before bed (total daily dose equal to about 12 g huangyaozi). This is indicated in the book as applicable to thyroid adenoma. This herb, like other Dioscorea species, is rich in steroidal compounds. However, it also contains diosbulbins (diterpene lactones) that may have an influence on the thyroid adenoma. An herb with similar lactones, brucea, is used in cancer therapy. Huangyaozi must be used with some caution, however, as it has been reported to cause toxic hepatitis when used in large amounts. Ingestion of decoctions containing 15 to 21 g for 30 days or 12 to15 g for 45 days were reported to be sufficient to cause toxic hepatitis, with some symptoms appearing in as little as two weeks [39]. At 30 g daily, 7 days of administration could cause toxic hepatitis. Therefore, the dose of this herb should not exceed 12 g per day and liver enzymes should be checked monthly if prolonged therapy that includes this herb is undertaken.

Dosage and Duration of Treatment
Complex Formulas

For purposes of analysis, nine studies, which each involved a minimum of 50 patients, were analyzed to determine the influence of method of administration, dosage, and duration of treatment.

Four studies used decoctions only. In a 1986 study using Yiqiyangyin decoction,[21] treatment time was 6 months to one year for most of the patients (treatment is terminated when the patients are obviously cured or when it is obviously not helping); however, 12 of the 98 patients were treated for up to 3 years. A high dosage decoction, with about 150 g per day, was used. The claimed cure rate was 62%. In another study,[4] with a dosage of about 120 g per day in decoction,

treatment time was one of 5 months and the claimed cure rate was 42%. Another report described a decoction with a dosage of about 180 g per day used for one to four months;[16] it yielded a claimed effective rate of 34.5%. A heavily modified Bupleurum and Dragon Bone Combination, taken once daily in decoction form with 215 grams/day, produced marked improvement in 50% of the patients with 1 to 3 months of therapy, but no claim of cures.

One study used either decoctions or dried decoction in tablet form.[5] The decoction had a dose of 90 g per day, taken one time per day, and the tablets had a similar dose (after concentration), but were taken in a divided dose three times per day. The cure rate was rather low (12.1%) with 3 months of treatment time, though the rate of "marked improvement" was substantial at 38%.

Two studies used a mix of decoctions and powdered herbs. In one, the decoction was always given first, with a dosage of about 110 g per day, administered until the disease improved somewhat, but then followed-up by powdering the herbs and taking them as pills (18 g per day).[6] The treatment time was not clearly stated, but appeared to be 3 months or more, with a cure rate of 47%. In the other, herbs were either given as a decoction (about 100 g per day) or made into a powder and consumed with warm water.[13] The treatment time was 3 to 6 months and the claimed cure rate was 20%. No distinction was made in the reported outcome between the two methods of herb preparation.

Two studies used powdered herbs only, in pill form. In a study cited earlier, two large pills were taken daily for 45 to 90 days, and the cure rate was 52%.[7] Given the short duration of therapy, the cure rate is remarkably high. Also, the amount of herb materials used, about 30 g per day (includes binder of 30% to 50% by weight) was far lower that the amounts used for decoctions. In the other, patients received 10 g of herbs per pill (probably includes binder weight), two to three pills per day.[10] The duration of therapy was not stated; a cure was indicated for only 16% of the patients, though the rates for marked improvement were substantial (36%).

In these nine studies, the treatment times varied from one month to more than one year, but the typical treatment time was about 3 months (a review of the Chinese literature reveals that this duration is common for treatment of chronic ailments involving autoimmunity). The treatments were administered mainly as decoctions or large pills or both (not at the same time, however). The decoctions had a range of 90 to 210 g per day of dosage, with a highly variable cure rate, from zero to over 60%. The pills had a

dosage range of 18 to 30 g per day. Two of the studies that utilized pills (made from powdered herbs, combined with honey, and then chewed and swallowed) — one initiated with decoctions and using pills for the remainder — had relatively high success rates (around 50% cure) with moderate duration of treatment (about 3 months). In the third study using pills with a cure rate of only 16%, the criteria for participation by most of the patients was a long duration of the disease with failure of Western drugs to control it.

On the basis of this small sampling, it would seem reasonable to use powdered herbs prepared in a convenient form in a dosage of about 20 g per day for a period of 3 months. This would conserve resources (using about 15% as much herb material as in a decoction), maximize convenience (no cooking of the herbs or drinking a strong tasting tea on a daily basis), and provide a reasonable trial time. As an example, using easy-to-swallow tableted herbs (700 mg herb/tablet), the dosage recommended in the studies would correspond to the use of 9 to 10 tablets each time, three times daily. Using instead bulk powdered herbs swallowed by the spoonful with water, this would correspond to about a tablespoon of powder twice daily.

However, in order to be able to vary the formulation according to individual needs, the use of decoctions or dried single herb extracts may be indicated for part or all of the treatment. In such cases, about 6 to 15 g of each ingredient (crude herb) with 10 to 15 ingredients per formula is made in decoction form, often divided into two doses per day, and administered as needed. About 18 to 27 g of dried extracts, taken in two or three divided doses, would be expected to provide comparable effects.

It should be noted that when consuming herb powders or pills, astragalus, or ho-shou-wu may cause digestive problems for some individuals at the higher dosage levels. This is because astragalus contains large amounts of polysaccharides and ho-shou-wu contains emodin glycosides. If problems were to occur, they would likely be gas and abdominal bloating and mushy or loose stool. When consuming herbs in decoction form, the sea materials and the bitter fire-purging herbs may cause nausea or vomiting in some sensitive individuals. Also, hyperthyroid patients should allow the herb tea to cool somewhat before consuming it. An experienced physician, reporting in the book *Treatment of Knotty Diseases*, has cautioned that herbs should be administered in small portions at frequent intervals rather than single large doses. In most of the studies, two dosages per day were suggested, but a three-times-per-day schedule would not be inconvenient with tablets or dried extracts.

FORMULA MODIFICATION FOR HYPERTHYROIDISM

Relatively rapid relief of symptoms, within the first 30 to 90 days of treatment, is observed in most patients consuming Chinese herb formulas. While essentially complete remission is indicated in just under half of the patients, alleviation of the majority of symptoms occurs in most of the remaining patients. In order to obtain such high rates of symptom relief, basic herb formulas may be modified by adding one or more ingredients to address specific symptoms or symptom complexes. Below are some examples obtained from examination of the literature. If an ingredient to be added is already present in the base formula, then the dosage may be increased. Not all items in any list of additions need be included. When two symptoms occur together, one or more of the ingredients indicated for each of the symptoms may be added to the base formula.

Symptoms

Exophthalmos: celosia seed, chrysanthemum, and plantago; or vitex, leonurus fruit, and cassia; or prunella, dandelion, chrysanthemum, lycium fruit, celosia, and tribulus; or magnetite, lycium fruit, lycium bark, and tribulus

Heart Palpitations and Insomnia: polygonum stem, hematite, zizyphus, mother of pearl

Palpitations Alone: dragon teeth, succinum, and polygala

Tachycardia: zizyphus and dragon bone or dragon teeth; may also add Sophora

Insomnia Only: dragon teeth and oyster shell or zizyphus, albizzia flower, and campsis

Goiter: cremastra and oyster shell or add fritillaria, prunella, and huangyaozi

Persistent Goiter: smilax, pleione, oyster shell, fritillaria, turtle shell, sparganium, and anteater scale

Sore Throat, Fever: lily, lonicera, polygonum (yuzhu), rehmannia, raw, and scrophularia

Thirst: gypsum, anemarrhena, and trichosanthes root (remove pinellia if present)

Liver Swelling, Jaundice: curcuma, salvia, turtle shell, capillaris, alisma, gardenia, polyporus

Depression: bupleurum, peony, and uncaria; or bupleurum, curcuma, and fushou

Excessive Appetite: gypsum and Anemarrhena

Hand Tremor: antelope horn, tang-kuei, chaenomeles, and scorpion.

Syndromes

Liver Fire: gentiana, prunella, and uncaria or gentiana and rehmannia, raw, or gentiana and gardenia

Qi Deficiency: codonopsis, astragalus, Atractylodes

Qi/Yin Deficiency: astragalus and pseudostellaria

Qi/Blood Deficiency: codonopsis, atractylodes, polygonatum, dioscorea, astragalus, millettia, and lycium

Qi Stagnation: cyperus, chih-ko, and curcuma

Qi Stagnation with Excess Phlegm: clam shell and prunella

Spleen Deficiency: codonopsis, dioscorea, and alisma, remove yin tonics

Phlegm Excess: arisaema and perilla stem, or fritillaria and citrus

Liver/Kidney Yin Deficiency: anemarrhena and phellodendron

Yin Deficiency, With Fire: rehmannia, raw, adenophora, ophiopogon, and turtle shell

Blood Stasis: zedoaria and sparganium, or peony, salvia, and persica

Heart Fire: coptis

Accompanying Diseases

Diabetes: trichosanthes root, anemarrhena, gypsum, pueraria, raw rehmannia, and Dioscorea

Sjogren's Syndrome: ophiopogon, adenophora, trichosanthes root, linum, gelatin

Dr. Zelin Chen points out that for exophthalmos, a treatment superior to using the eye-benefiting herbs mentioned above would be to remove dampness and phlegm that congests the eyes, using Hoelen Five

Herb Formula minus cinnamon twig or Hoelen and Areca Combination.[40] In a clinical report, the physicians commented that immunosuppresive agents were always necessary in the treatment of cases involving exophthalmos.[2]

HYPOTHYROIDISM

The treatment of hypothyroidism is infrequently mentioned in Chinese literature and is not a common subject of clinical studies. This may result from a less frequent diagnosis of the disorder, since the fatigue, water retention, and chills characteristic of hypothyroidism are standard symptoms belonging to traditional categories such as qi and yang deficiency. These conditions usually do not present immediate need for Western medical attention as might occur with the irregular heart rate of hyperthyroidism. The relatively infrequent reporting may also result from a lower incidence of the disease in China.

Patients with Hashimoto's thyroiditis have reduced responsiveness to TSH. The disease can spontaneously remit, and this change can be detected, even while thyroxine replacement therapy continues, by testing for TSH responsiveness. In one evaluation, about 24% of patients were seen to experience spontaneous remission, though no remissions were found among patients with diffuse goiter.[29]

The basic herbal treatment for hypothyroidism is to administer qi and yang tonics. For example, 19 cases of hypothyroidism of various causes (10 due to thyroid operation or irradiation in the treatment of hyperthyroidism, three were chronic lymphatic thyroiditis, 6 due to unknown causes) were treated for 2 to 4 months with a thyroid tablet containing codonopsis and astragalus to tonify qi, and epimedium, curculigo, and cuscuta to tonify yang (with cooked rehmannia to balance the yin and yang).[32] The patients received either herbs alone or herbs with thyroxine. A control group received thyroxine alone. The Chinese herbs improved clinical symptoms, reduced cholesterol and thyroid-stimulating hormone levels, and increased T3 and T4. The addition of thyroxine (at 60 mg per day) gave even better results. A similar prescription, adding psoralea in the standard formula, and aconite and cinnamon twig for more severe cases, was given to seven patients with hypothyroidism, and it was claimed that all patients showed improvement with 2 to 3 months of treatment.[14]. Five of the patients took a small dosage of thyroxine.

In a study of 22 patients with hypothyroidism, 19 of the cases were caused by thyroid treatments (radioactive iodine, surgery, antithyroid drugs).[22] A decoction of aconite, cinnamon bark, ginseng, astragalus, lycium fruit, epimedium, deer antler, psoralea, morinda, salvia, atractylodes, and hoelen was given. Thyroxine tablets were also provided as needed during the treatment period. After 2 months of therapy, of the 22 patients, 17 had their clinical symptoms eliminated, and the T3, T4, and TSH returned to normal levels, while the other five patients showed partial improvement in both symptoms and laboratory values. In one patient cured by this treatment, a follow-up visit after five years showed that she remained healthy.

Five patients with lymphatic thyroiditis were treated with a combination of astragalus and codonopsis (30 g each) to tonify qi, aconite, cinnamon bark, curculigo, and epimedium (9 to 12 g each) to tonify yang, and lycium fruit plus coix.[50] The decoction of herbs, modified as necessary to treat symptoms such as indigestion with diarrhea or constipation, was taken in two divided doses daily for two to three months. The mean body weight of the patients declined from 63 kg to 60 kg, the heart rate increased from 66 to 75 per minute, and cholesterol dropped from 260 to 202. T3 and T4 values increased markedly, while TSH declined.

Six patients treated with a high dose decoction of licorice (10 g) and ginseng (8 g, reduced to 6 g after the first month) for three months, using thyroxine in reducing amounts from the beginning to the end of the treatment program, showed good results.[28] Four patients had basal metabolic rate, T3, and T4 return to normal or near normal values and improved symptoms which persisted after the treatment ended; two others improved while on the herbs but within one year of stopping the therapy the symptoms returned and could be controlled by using the decoction again.

As reported in *Recent Advances in Chinese Herbal Drugs*, an evaluation of patients with kidney yang deficiency syndrome who were not classified as suffering from hypothyroidism but were rather suffering from chronic bronchitis revealed a decreased level of T3 and T4 (average values of 102 and 8.2 respectively). Both chronic bronchitis patients not having kidney yang deficiency and normal adults had comparable levels of these hormones (147 and 9.3 respectively). When the kidney yang deficiency patients were treated for five months using a kidney tonic prescription (ingredients not specified), T3 levels increased (average 164; slightly higher than normal). Thus, kidney yang deficiency may be directly associated with hypothalamus-pituitary-thyroid function which is affected by corrective herbal therapies.

In contrast to the hyperthyroid treatments, herbs for dispersing phlegm and resolving masses are generally

not included for hypothyroid cases, and instead the focus is on tonification therapy.

A somewhat different approach has been used in two studies, in which tonics are still an important aspect of the treatment but qi and blood regulating herbs are also used. This method was applied in the treatment of 133 patients with Hashimoto's thyroiditis.[34] A combination of cyperus, saussurea, cnidium, curcuma, and bupleurum was modified by adding one of two tonic prescriptions: polygonatum, dioscorea, moutan, hoelen, and lycium for qi and blood deficiency patients and Rehmannia Eight Formula for yang deficiency patients. By taking the powdered herbs in pill form for 1 to 5 months, 29% were cured.

In another study, 38 patients with Hashimoto's thyroiditis were treated with codonopsis (or ginseng), plus pinellia, hoelen, and licorice to tonify qi and normalize the digestion, and citrus, blue citrus, salvia, and red peony to regulate qi and blood.[51] Patients still showing hyperthyroid symptoms were additionally given the yin nourishing combination of asparagus, ophiopogon, rehmannia, and schizandra, while those showing hypothyroid symptoms were given the yang tonifying combination of cinnamon twig, deer antler, and epimedium. In the event that a thyroid nodules existed (four cases), sparganium and zedoaria would be given. A control group with 20 patients were treated with standard thyroid drugs. Treatment time was 6 months. Among the group treated with Chinese herbs, 55% of those with hyperthyroid conditions and 93% of those with hypothyroid conditions had normal thyroid levels following treatment. There was no significant difference between this outcome and the results of using Western medicine in the control group.

It is not evident from these two studies that the addition of qi and blood regulating herbs enhanced the outcome of treatment compared to relying primarily on qi and yang tonic herbs alone. Among the several studies of hypothyroid treatment, it does appear that longer treatment times produce better effects.

Long-Term Follow-up
A one year follow-up to a study of Jiakangling administered for 3 months, either alone or with Western medication (thiamazole or propranolol), revealed that 85.2% of those treated with herbs only and 90% of those treated with herbs and drugs maintained the improvements that had been attained during the treatment period.[5] In a study of senile hyperthyroidism, a typical case was presented in which 30 days of decoction was consumed and a follow-up visit one year later showed no recurrence.[19] In 45 cases of hyperthyroidism said to be cured by an astragalus-based

formula (Yiqiyangyin Tang), recurrence was noted in only two cases.[21] Follow-up duration was from less than 6 months to 4 years (12 cases under 6 months and 33 cases from 6 months to 4 years).

In the study of herb treatments for hyperthyroidism, in which exophthalmos was a symptom, a follow-up 4 years later showed no recurrence of the initial condition.[12] Forty cases of hyperthyroidism treated with herbs for an average of 67 days yielded 24 cures and the remaining 16 either markedly improved or somewhat improved. One year later, the therapeutic benefits remained stable.[35]

Individual cases mentioned in the reports describing various treatments for hyperthyroid or hypothyroid conditions suggested that 1- to 5-year follow-up demonstrated continued relief, but that a few individuals might experience a relapse that could be treated effectively by applying again the original treatment. From those studies involving longer-term treatment at the outset, it was evident that symptom improvement might be attained early, but continued administration of herbs was essential to further improve or maintain that effect.

Thyroid Tumor
The most common thyroid tumor is thyroid adenoma. It occurs somewhat more frequently in women than men, manifests as a "rock hard" lump or group of lumps on the thyroid, and either leaves thyroid function unaffected or generates a hyperthyroid condition because of the excess growth of thyroid tissue (called toxic adenoma).

Thyroid tumors, like other types of tumors treated by Chinese doctors, are addressed with a wide range of herb formulas. Some examples cited in the Chinese literature published during 1981 to 1986 (formulas cited in *An Illustrated Guide to Antineoplastic Chinese Herbal Medicine*) are given below.

Luffa Decoction: luffa (30 g), prunella (30 g), licorice (10 g). [An abstract of the research article was also published in *Abstracts of Chinese Medicine*]. This formula was given to 30 patients with thyroid adenoma, in the form of decoction, in two divided doses daily for 2 to 3 months. It was claimed that 70% were cured, 20% improved, and 10% failed to respond.

Xiao Ying Tang: prunella (12 g), laminaria and sargassum (12 g each), sparganium (12 g), pumice (20 g), tang-kuei (10 g), peony (10 g), fritillaria (10 g), and bupleurum (10 g).

Huangyaozi Decoction: huangyaozi (15 g), sargassum (12 g), laminaria (20 g), fritillaria (10 g), prunella

(10 g), oyster shell (30 g), pumice (30 g), citrus (6 g), and blue citrus (6 g).

Thyroid Tumor Formula: oyster shell (30 g), prunella (20 g), polygonum stem (20 g), adenophora (20 g), acorus (15 g), curcuma (15 g), bupleurum (10 g), sparganium (10 g), and zedoaria (10 g)

Jia Liu Wan: prunella (30 g), tang-kuei (30 g), mother of pearl (30 g), oyster shell (30 g), laminaria (15 g), and salvia (15 g). Mixed as powder, made into pills and consumed 9 g b.i.d.. For benign nodular goiter.

With the exception of Luffa Decoction, the above formulas do not differ in any significant way from the formulas used to treat hyperthyroidism, though herbs for treating the secondary effects of hyperthyroidism (e.g., insomnia, heart palpitations) are generally not present when treating the adenomas. Herbs for resolving a "phlegm mass" dominate. Sea materials are present in nearly every one, and prunella is a major ingredient in every prescription. Information about the effectiveness of the above formulas was not immediately available except for that of the Luffa Decoction, for which a high level of cure was claimed. It should be noted that both decoctions (70-150 g per day) and powders made into pills (18 g per day) were used for the purpose of treating thyroid tumors.

A large number of additional formulas of similar nature, prepared in decoction and powder form, are presented in *Treating Cancer with Chinese Herbs.* Some examples are:

Bao Jin San: pig or sheep thyroid glands (10 pairs), sargassum (60 g), laminaria (60 g), clove (6 g), succinum (6 g), saussurea (6 g), musk (3 g), pearl powder (15 g). The ingredients are dried, powdered, and taken in the dose of 1.5 g each time, b.i.d..

Wu Ying Fang: laminaria (30 g), sargassum (60 g), venus shells (60 g), pinellia (9 g), usnea (9 g), rice paper (9 g), ampelopsis (9 g), asarum (3 g), cucumeroides (3 g), gentiana (3 g), made into decoction.

Unnamed Formula 1: prunella (30 g), huangyaozi (12 g), sargassum (12 g), laminaria (12 g), scrophularia (12 g), earthworm (12 g), and fritillaria (9 g). Taken as a decoction.

Unnamed Formula 2: equal amounts of sargassum, sea univalve, venus shells, cuttlebone, laminaria, gentiana, and aristolochia root. Grind into powder, make pills. Daily dosage is 9 g.

Ying Jie San: fried wheat (1.2 g), usnea (3 g), pinellia (3 g), fritillaria (3 g), sargassum (3 g), gentiana (3 g), venus shells (3 g), rice paper (3 g), laminaria (3 g), and alum (3 g). Grind to powder, take 3 g each time, 3 times daily, with wine.

Like the previously listed prescriptions, these all contain sea materials, and the formulas are made either as high dosage decoctions or pills (in this case, the dosage of the pills is smaller). However, prunella is an ingredient in only one of the five prescriptions, and it is also absent from many other formulas mentioned in this source.

In the book *Anticancer Medicinal Herbs*, formulas for thyroid tumors include:

Thyroid Adenoma Formula: prunella (20 g), polygonum stem (20 g), oyster shell (30 g), *huangyaozi* (9 g), curcuma (15 g), acorus (15 g), adenophora (15 g), bupleurum (10 g), sparganium (10 g), zedoaria (10 g).

Thyroid Cyst Formula: prunella (60 g), salvia (24 g), trichosanthes fruit rind (24 g), laminaria (24 g), sargassum (24 g), cyperus (24 g), iphigenia (24 g), bupleurum (15 g), red peony (18 g), peony (18 g). As follow-up, two ounces each of lean pork and prunella are simmered together and taken every day for some time to reinforce the curative effect.

Thyroid Tumor Formula: solidago (15 g), scutellaria (12 g), kalimera (12 g), lysimachia (24 g). This formula was tried for 53 cases of thyroid tumor and 28 of them were said to be cured after taking the formula for one year.

The above formulas are given by decoction. A formula made into pills for thyroid adenoma is produced by combining 50 g each of sparganium, chih-ko, curcuma, tang-kuei, salvia, peony, blue citrus, sinapis, and anteater scales, plus 100 g each of sargassum, laminaria, and prunella, and 150 g each of zedoaria, dandelion, and oyster shell, plus 25 g of carthamus. This is taken in pills, about 18 g per day.

Differential diagnosis and treatment of thyroid tumors is described in the book *Cancer Treatment with Fu Zheng Pei Ben Principle.* The diagnostic categories are stagnation of phlegm and ying type (cold) mass, yin deficiency and blood stasis type, and qi and blood deficiency type. In each case, a formula is prescribed which contains herbs characteristic of those for treating any thyroid mass (not necessarily a tumor; there are no added anticancer agents). According to the author, "except for undifferentiated carcinoma, the

prognosis for thyroid cancer is good." Using a combination of Western therapies (including surgery as necessary) and Chinese herbs, the 5-year survival rate is 78% to 95%, depending on the cancer type (but only 12.5% to 20% for the undifferentiated type).

Kanpo Methods for Thyroid Diseases
The characteristic of modern Kanpo is prescription of herb formulas that are included in the national registry and covered by health insurance. There are about 200 such prescriptions.

For hyperthyroidism, the following have been suggested:

- Baked Licorice Combination
- Bupleurum and Dragon Bone Combination
- Bupleurum and Peony Formula
- Bupleurum, Cinnamon, and Ginger Combination
- Pinellia and Magnolia Combination plus Cinnamon, Licorice, Oyster Shell, and Dragon Bone Combination
- Pinellia and Licorice Combination

Baked Licorice Combination is often given along with a second formula, such as Cinnamon and Hoelen Formula, Bupleurum and Cinnamon Combination, Minor Bupleurum Combination, or Bupleurum and Schizonepeta Combination. Of the formulas cited above, Baked Licorice Combination serves as the main yin-nourishing formula, the bupleurum formulas clear liver fire and disperse stagnant qi, and the pinellia formulas resolve phlegm. Cinnamon twig, an ingredient in several of the formulas (including Baked Licorice Combination), is said to settle rising heat and is therefore useful in some heat syndromes (especially for deficient patients), despite its warming and stimulating quality. Baked Licorice Combination was also reported to be successful in treating a case of goiter complicated by Sjogren's syndrome, another autoimmune disease; treatment time until all symptoms were resolved was 17 months.[36]

Dr Keisetsu Otsuka described a case of hyperthyroidism in his book *30 Years of Kanpo*. He treated a 38-year-old man with Grave's disease, using Pinellia and Magnolia Combination with Cinnamon, Licorice, Oyster Shell, and Dragon Bone Combination. The patient, who had obviously swollen thyroid, slightly protruding eyes, and a pulse rate of 120 at the beginning of treatment, felt better after only one week and had almost completely recovered in 6 months use of the formulas.

For hypothyroidism, the following have been suggested:

- Ginseng and Astragalus Combination
- Ginseng and Ginger Combination
- Tang-kuei and Peony Formula
- Tang-kuei, Evodia, and Ginger Combination
- Vitality Combination

These are all tonic prescriptions that enhance function of the stomach and spleen, nourish the blood, and stimulate circulation. Ginseng, aconite, and/or atractylodes are included in these formulations.

Professor Shigeru Ariji at the Institute of Oriental Medicine of Kinki University reported on a case of myxedema.[37] Treatment consisted of Vitality Combination extracts (10 g per day), and Ginseng and Astragalus Combination extracts (10 g per day), corresponding roughly to a decoction of the two formulas with a dosage of 90 g per day. Within 2 weeks there was alleviation of subjective symptoms, and substantial improvement in objective symptoms within three months. She was able to resume normal lifestyle within 6 months.

The level of effectiveness of these formulas has not been reported on the basis of large clinical trials as has been done in China. However, unlike the treatments described by Chinese doctors, none of the formulas listed here were designed specifically for the treatment of thyroid diseases; rather, existing formulas for treatment of other ailments were matched up to symptom complexes characteristic of the patients with thyroid diseases. Thyroid cancers were not mentioned in the general Kanpo literature.

Traditional Chinese Herb Formulas Used in China
Chinese physicians sometimes rely on the use of traditional formulas in a manner similar to Kanpo practitioners. The formulas are most often provided in the form of decoctions or pills made from powdered herbs rather than dried extracts, and slight modifications are made in many cases. The practice of selecting traditional formulas in China has no limitations related to government approval. In *Formulas and Strategies*, formulas mentioned to be useful for hyperthyroidism include three kidney nourishing formulas, Rehmannia Six Formula, Tortoise Shell Formula (Da Bu Yin Wan), and Curculigo and Epimedium Combination (Two Immortals); a yin nourishing formula for stomach deficiency (Zeng Ye Tang, comprised of scrophularia, ophiopogon, and raw rehmannia), Jade Screen Powder, an anti-scrophula pill (Xiao Luo Wan, made of scrophularia, oyster shell, and fritillaria), and a fire-purging formula, Dang Gui Liu Huang Tang.

Two formulas used in Kanpo, Baked Licorice Combination and Bupleurum and Dragon Bone Combination, are also suggested for hyperthyroidism in this source. The Sargassum Jade Pot Decoction (Hai Zao Yu Hu Tang), rich in seaweeds, is suggested for simple goiter, hyperthyroidism, and benign thyroid tumors. A small clinical study of a modified version of this formula with six patients was said to result in five patients cured and one markedly improved. In the treatment of hypothyroidism, Vitality Combination and Aconite and G.L. Combination (Si Ni Tang) were suggested. Both of these formulas contain aconite and dried ginger.

Pharmacological Investigations

If, in fact, most of the patients participating in the clinical trials suffer from an autoimmune disease, the question may be raised-how are they cured? Western medical researchers currently regard such ailments as manageable by appropriate immunosuppressive techniques, but incurable.

Virtually all formulas used for treating hyperthyroidism contain either seashells or seaweeds or both. Their role in treating autoimmunity has not established — for example, they are not used for diabetes, lupus, scleroderma, multiple sclerosis, or myastenia gravis. In those disorders, a few prescriptions contain tortoise shell as a yin tonic, but it would seem that sea materials are not essential to treating autoimmunity. In one study of hyperthyroidism, with no sea materials used, it was claimed that over 62% of those treated were cured, with a low incidence of relapse even years after the therapy was ceased.[21] The sea materials might play some role in regulating the thyroid hormones beyond their provision of iodine, and may reduce the duration of treatment necessary to gain satisfactory results. The mechanism of action would have to involve some inhibition of nodules or swellings. The same sea materials are used for tumors, cysts, fatty accumulations, and lymphatic nodules. By removing the thyroid nodules, they would reduce hyperthyroidism.

In addition, virtually all formulas used for hyperthyroidism contain some saponin components. Examples are fritillaria, pinellia, huangyaozi, and ophiopogon. Also, some of the symptom-alleviating herbs contain such components, notably bupleurum and zizyphus. However, in some studies with relatively high cure rates, the proportion of saponin-containing ingredients in the formulations is rather small and may be insufficient to provide an explanation of the clinical effects obtained. Essential oils in prunella, the citruses, and cyperus might contribute some curative effects for which the pharmacology is not yet established.

Ingredients found in treatments for hyperthyroidism that are common to other autoimmune disorders are astragalus, codonopsis, ophiopogon, rehmannia, scrophularia, bupleurum, citrus, salvia, peony, moutan, lycium fruit, and licorice. It should be noted that the majority of these herbs are attributed with some tonic actions, and many of them clear heat. Chinese studies of immune responses, using hemolytic plaque formation as a criterion, have shown that yin-nourishing, qi-regulating, and blood-vitalizing formulas can reduce immunologic attacks, such as those characteristic of autoimmunity and transplant rejection.[38] A yang-nourishing formula enhanced immune responses. In terms of treatment of hyper- and hypo-thyroidism, the former is usually treated with yin-nourishing formulas and the latter with yang-nourishing formulas, even though autoimmunity may be involved with both. The pharmacologic impact of the different types of herb formula might explain, in part, why apparently less satisfactory results have been obtained in treating hypothyroidism. In animal models with induced hyper- or hypothyroid conditions, it was shown that a mixture of rehmannia and polygonatum (yuzhu) reduced T3 and T4 levels in the hyperthyroid animals, while a mixture of either cinnamon bark and aconite or cistanche and epimedium increased T3 and T4 in hypothyroid animals.[49]

Recent Japanese investigations have shown that phenolic glycosides, such as acetoside in rehmannia can inhibit the immune attack of cells.[48] A decoction of rehmannia was reported to produce remarkable therapeutic effects in most patients with rheumatic and rheumatoid arthritis that were treated in one Chinese study mentioned in *Modern Study and Application of Materia Medica*. Since arthritis inflammation is due to excessive antibody production and attack of joint tissue, this response may be due to selective immune suppression. A decoction of raw rehmannia proved effective in the treatment of eczema and neurodermatitis when used intermittently in very high doses (90 grams per day). Gentiana has been shown to inhibit antibody formation. Both rehmannia and gentiana inhibit formaldehyde-induced inflammation in rat paws. Scrophularia, a close relative of rehmannia used in several hyperthyroid prescriptions, has glycosides similar to those found in rehmannia.

Feng Guoping and his colleagues at the Department of Pharmacology, Shanghai Second Medical College, studied the effects of two ingredients used for treating deficiency patients, rehmannia and tortoise shell, on renal adrenoreceptors.[41] In laboratory rats, they showed that these herbs prevented the

increase in renal beta-adrenoreceptors that occurs with hyperthyroidism. Their experimental results were deemed solid basis for the use of yin tonics for correcting hypersensitivity of the sympathetic nervous system. Anemarrhena had a receptor-lowering action similar to that of rehmannia. Since adrenoreceptors influence nervous system functioning, it is possible that the use of these herbs in formulas can help regulate the system that has been adversely influenced by autoimmune attack.

It has long been known that consumption of vegetables in the Brassica family can inhibit thyroid function. Rabbits fed on a cabbage diet develop goiter, due to content of sulfaguanidine. A Chinese herb from this plant family, sinapis (mustard seed), is sometimes used in hyperthyroid formulas because of its phlegm-resolving quality. Another seed, raphanus (radish seed), has been shown to influence iodotyrosine content of the thyroid gland, suggesting disruption of thyroxin synthesis when the herb is fed to rats for a long period of time. Related experiments show that the formula Tan Yin Wan markedly inhibited the iodine uptake of the thyroid gland in both mice and rats, thus inhibiting overall thyroid function.[42] *Tan Yin Wan* contains atractylodes (red and white), raphanus, sinapis, perilla fruit, cinnamon bark, aconite, and dry ginger. It is of interest to note that this is a warming, yang-nourishing prescription similar to those used for hypothyroidism, except for the content of raphanus and sinapis that are used in resolving phlegm-masses.

Khatamines, amphetamine analogues found in the herb *Catha edulis*, produce an increase in metabolism that is at least partially mediated by thyroid stimulation.[43] Ephedra, contained in the Chinese herb ma-huang, has a similar chemical structure and a similar ability to enhance metabolism. Therefore, ma-huang preparations may help increase thyroid function in patients with hypothyroid function. Dr S. I. Esner, at the Capital District Bariatric Clinic in New York, has been using a ma-huang extract preparation for increasing brown adipose tissue thermogenesis for weight loss; he reported that patients with chronic fatigue symptoms obtain relief by using this herb extract.[44] This may be through the thyroid stimulation.

Ginseng has been shown to exert at least part of its effects via the pituitary gland. Since ginseng activities include promotion of DNA, RNA, and protein synthesis, enhancement of energy metabolism, and oxygen utilization, it is possible that the pituitary activity leads to enhanced thyroid activity, finally promoting the metabolic changes. Ginseng is a component of many of the hypothyroid formulas. Licorice also strongly influences hormone balance and may play a role in enhancing metabolism through regulation of the pituitary and adrenal cortex.

Gossypol, a Chinese drug derived from the cotton plant used to inhibit male fertility (as a birth control method) and to treat female gynecological disorders including endometriosis, reduces serum levels of T3 and T4 and increases TSH.[32] Side effects of this widely used drug, such as fatigue, muscle weakness, and diminished sexual function, may be secondary effects of hypothyroidism induced by the drug. It may thus have some application in treating hyperthyroidism.

Iodine Controversy in Hyperthyroid Treatment

Three articles and one brief report reviewed in preparation of this paper mentioned avoidance of iodine-containing herbs and foods in the treatment of hyperthyroidism. In one paper, on differential treatment of hyperthyroidism, the author states that "because in some patients after taking Laminaria and Ecklonia the thyroid becomes suddenly enlarged and other hyperthyroid symptoms become more serious, the iodine-containing herbs were not recommended in the treatment for those patients."[17] In a brief letter in the *Sichuan Journal of TCM*, it is pointed out that formulas with iodine-containing herbs are frequently prescribed for hyperthyroidism, but "modern medicine has realized that to apply iodides for the treatment of hyperthyroidism can sometimes induce ill effects. When there is a case of hyperthyroidism, uptake of radioiodine is typically stimulated. Ingesting iodides would produce a higher concentration of iodine in the thyroid, which temporarily inhibits the synthesis of thyroid hormone. At the same time, iodides can also inhibit the release of thyroid hormone, which then accumulates in the thyroid. In this situation, the course of treatment would be increased, the dosage would need to be larger, and the remission rate would be worsened. Long-term use of iodine-containing agents may cause hyper- or hypothyroidism. Iodine use should be limited to preparatory treatment before surgery or to dangerous conditions (e.g., thyroid storm)."[20]

In the third article, about dietary therapy for hyperthyroidism prepared by California acupuncturist Heidi Middlebrooks, patients are told to avoid iodide-containing foods because iodine provides "the substrate for increased thyroxine production which, over the long term, may delay or counteract the effectiveness of herbal therapy (TCM) or antithyroid therapy (Western medicine), and indeed may precipitate an acute thyroid crisis."[45] No supporting research was mentioned in making this statement. In a brief report

Symptom Responses

In an evaluation of symptoms for 110 hyperthyroid patients,[16] the most common symptoms and the response to a particular treatment (the herb formula Pingyin Fufang) were:

Symptoms	# of Cases	Eliminated	Alleviated	No Change
Palpitation	105	87	18	0
Shortness of breath	95	84	9	2
Aversion to heat	91	79	12	0
Excessive appetite	89	87	2	0
Shaking (hand)	88	71	9	8
Brachial artery murmur	88	79	9	0
Emaciation	87	75	9	3
Insomnia	78	66	10	2
Tremor (fingers)	78	57	12	9
Anxiety	74	68	4	2

There were only about 18 individuals who did not experience elimination of one of these symptoms. In another study,[10] in which specific symptoms were outlined with 50 patients, the main conditions were:

Symptoms	# of Cases	Eliminated	Alleviated	No Change
Fatigue	50	36	10	4
Palpitation	48	32	11	5
Neck swelling	47	27	17	3
Quickly angered	47	28	10	9
Aversion to heat	46	28	16	2
Insomnia	39	25	11	3
Excessive appetite	34	30	4	0
Irregular menstruation	29	20	0	9
Low fever	25	24	1	0
Loose stool	16	10	6	0

This study did not have as strong results as the previous one in terms of symptom relief. A symptom of concern to Western practitioners, exophthalmos, was reported in this study to have affected only 14 of the patients, of which seven were resolved and four more got better, while three were unchanged.

In a clinical evaluation that focused on treatment of exophthalmos,[12] there were three formulas that could be selected, one for liver fire and phlegm wetness, one for liver and kidney yin deficiency, and one for excessive liver fire. In the treatment of 12 patients, it was reported that five of the cases were markedly improved and the other seven were somewhat improved. At the same time, other symptoms were improved with similar frequency, such as palpitation, aversion to heat, excessive perspiration, excessive appetite, anxiety, and insomnia.

by California acupuncturist Ron Golden, based on his experience visiting a hospital in Guanzhou, an opinion by the doctors was relayed: "in cases of hyperthyroidism, one wanted to avoid using any of the seaweeds since they contained too much iodine."[46] In a sample case study from the hospital, neither seaweeds nor seashells were included.

Thus, these authors consider iodine, in any amount, to be of potential harm by worsening hyperthyroidism in some patients and interfering with the cure. In contrast, more than a dozen clinical trials using iodine-containing ingredients claim a high level of positive responses. Other clinicians relaying their personal experiences recommend formulas that contain seaweeds. Also, traditional Chinese dietary therapy for hyperthyroidism usually is based on consuming sea materials (nonetheless, it should be remembered that in earlier times, most goiter was due to iodine deficiency). Thus, the controversy remains unresolved.

Clearly, if consumption of an iodine-containing herb prescription appears to make the hyperthyroid syndrome worse, then a non iodine-containing prescription should be tried as an alternative. However, unless the attending physician regards modest levels

of iodine, as might be ingested in herb teas or common dietary items, to be a risk factor, it appears that the weight of opinion is that sea materials are an acceptable part of traditional Chinese therapy.

Laboratory Measurements and the Impact of Chinese Herbal Therapy

The following are standard laboratory measures of thyroid disease:

T3 and T4: Levels are elevated in hyperthyroid and reduced in hypothyroidism, and this measure is a defining feature of the diseases. One of the methods of determining duration of treatment with Chinese herbs is to monitor this parameter and stop treatment only when the values are normalized. Hyperthyroid treatment with Chinese herbs may have a duration as short as one month, or as long as 3 years.

Iodine Uptake: Radioactive iodine is utilized to allow monitoring of uptake, by measurement of radioactive emissions at the neck in the region of the thyroid gland. In general, iodine uptake is increased in hyperthyroid cases, due in part to the larger amount of thyroid tissue and the higher production of the iodine-based T3 and T4, and iodine uptake is reduced in hypothyroidism. Clinical values for iodine uptake usually keep pace with those for T3 and T4 production.

MCA (a.k.a. MSA) and TGA: Antibodies to the thyroid gland circulating in the plasma. The level of these antibodies is reduced by immune-suppressing therapies (e.g., tripterygium extract tablets) and has been shown to be reduced by moxibustion (in treatment of Hashimoto's thyroiditis), but these are not altered by administration of thyroxine or by other therapies that do not have an effect on the immune system. MCA and TGA are probably not altered in cases of thyroid tumor.

BMR: Basal metabolic rate is raised in hyperthyroid cases and lowered in hypothyroid cases. Since metabolic rate is influenced by T3 and T4 levels, the BMR measurement closely follows the T3 and T4 measures.

cAMP and cGMP: In hyperthyroid cases, cAMP is elevated and cGMP is reduced; the reverse situation exists with hypothyroid cases. Since cyclic nucleotides are directly involved in metabolism, changes in BMR and changes in cAMP/cGMP ratios should be parallel.

TSH: Thyroid-stimulating hormone is released from the pituitary in a feedback loop with T3/T4 levels in normal individuals. TSH levels are usually reduced in hyperthyroidism and elevated in hypothyroidism.

Several of the clinical reports provided detailed analysis of laboratory measures, while a few simply classified patient responses according to success or failure in restoring "normal values" for those items assayed. The following are offered as examples of changes in measured parameters, using average values for the clinical study group before and after the therapeutic program.

Treatment of hyperthyroidism with tripterygium tablets:[1]

T3	363 before	185 after
T3	16.5 before	10.7 after
TGA	46.7 before	14.6 after
MSA	38.3 before	10.0 after

Treatment of hyperthyroidism with Jiakangling herb tablets or decoction:[5]

T3	425 before	339 after
T3	23.6 before	18.3 after

Treatment of hypothyroidism with astragalus-based formula:[14]

cAMP	14.7 before	22.5 after
cGMP	7.92 before	5.43 after

Treatment of hyperthyroidism with rehmannia-based formula:[14]

cAMP	42.8 before	21.45 after
cGMP	4.68 before	6.35 after
BMR	41.8 before	16.28 after
TSH	16.28 before	7.55 after

Traditional Diagnostic Indicators

According to *The Essence and Scientific Background of Tongue Diagnosis*, hyperthyroidism consistently produces a cardinal red tongue appearance, while hypothyroidism produces a pale tongue appearance. This is believed to be a direct reflection of changes in basal metabolic rate, which influences blood circulation to the tongue. In the absence of other diseases, the tongue coating should be white, though denuded red tongues are seen in some cases of hyperthyroidism. While a white coating occurs in early stage of

disease caused by external pathogens, it has been noted in cases of thyroid adenoma and other thyroid diseases. The tongue may be trembling in hyperthyroid cases and flaccid in hypothyroid cases.

The pulse in hyperthyroid cases can be expected to be rapid, irregular, and knotty. In hypothyroid cases, it is expected to be slow, soft, and deep. Both the tongue appearance and the pulse should be responsive to successful therapies since the alteration in metabolic rate will influence these parameters.

Acupuncture/Moxibustion

Acupuncture is not frequently listed as a treatment for thyroid disorders, but a few suggestions have appeared in the literature.

The Comprehensive Guide To Chinese Herbal Medicine mentions the following as "common points" for hyperthyroidism:

❖ *naohui* (TB13)
❖ *zusanli* (ST36)
❖ *tianding* (LI17)
❖ *hegu* (LI4)
❖ *tianrong* (SI17)
❖ *tiantu* (CV22)

The Treatment of Knotty Diseases with Chinese Acupuncture and Chinese Herbal Medicine lists the following for "senile hyperthyroidism":

❖ *guanyuan* (CV4)
❖ *shenshu* (BL23)
❖ *mingmen* (GV4)

The above with reinforcing method; those below with reducing technique:

❖ *yongquan* (KI1)
❖ *shuidao* (ST28)
❖ *feishu* (BL13)
❖ *chize* (LU5)
❖ *xingjian* (LV2)

This source also lists moxa points: *guanyuan* (CV4), *qihai* (CV6), *mingmen* (GV4), and *shenshu* (BL23) for cases of impairment of yin affecting yang.

According to *Modern Clinic Necessities for Acupuncture and Moxibustion*, acupuncture therapy could resolve the symptoms in 25% of patients. Recommended needling points included *pingyin* and *qiyin* (near CV22) as primary points, and *neiguan* (PC6), *jianshi* (PC5), and *zusanli* (ST36) as secondary points. For exophthalmos, upper *tianzhu* (BL10) and *fengchi*

(GB20) are added (with needling to direct sensation to the eye region). Three to five points are selected with a qi-promoting technique to be used at the *pingyin* point and reducing method to be used at the *qiyin* point. Needle retention is for 30 minutes, done once or twice daily. Of 129 patients treated by this method, symptoms were controlled in 34 cases (26%).

Moxibustion is applied to the main points *dazhu* (BL11), *fengmen* (BL12), *feishu* (BL13), *fengfu* (GV16), *dazhui* (GV14) and *shengzhu* (GV12). Secondary points are *neiguan* (PC6), *jianshi* (PC5), *taixi* (KI13), *zaohai* (KI16), *Fuliu* (KI17), and *sanyinjiao* (SP6). Two to three of the main points and a similar number of secondary points are treated once daily with seven small moxa cones at each point.

A clinical study of acupuncture treatment for benign thyroid nodules (thyroid adenoma, nodular goiter, or cystic goiter, but not thyroid carcinoma or thyroiditis) revealed a long-term effective rate of 90% in resolving the nodules.[47] Sixty-five patients were treated by applying six to eight needles surrounding a nodule and one directed at the center of the nodule (not intending to penetrate the nodule, however). Strong stimulation was applied for 20 minutes. In addition, *tianzhu* (BL10), *dazhu* (BL11), *neiguan* (PC6), and *qugu* (KI2) were needled every other day but with needles withdrawn after the needling sensation (*deqi*) was felt. Nearly half of the individuals were cured (measured by palpation of the neck and by ultrasonography), and most of the remaining individuals showed marked improvement.

In a clinical study of moxibustion in the treatment of Hashimoto's thyroiditis,[23] points selected were in two groups, the first consisting of *dazhui* (GV14), *shenshu* (BL23), and *mingmen* (GV4), and the second consisting of *shenzhong* (CV6), *zhongwan* (CV12), and *guanyuan* (CV4). These two sets were alternated from one visit to the next and treatments were given every other day for 20 treatments (10 each set). Moxa was done with cones on top of cakes of processed aconite (*fuzi*). It was reported that the moxibustion treatments reduced serum TGA and MCA (indicating change in the autoimmune process), the total serum T3 and T4 showed a marked increase, and the TSH showed a decrease. The clinical symptoms of hypothyroidism were alleviated. A control group of patients receiving thyroxine showed no change in autoimmunity.

The basic disorder of hyperthyroidism, with suggested treatment strategies, is presented in the book *Acupuncture Cases from China*. It is said that hyperthyroidism "is related to emotional factors, kidney yin deficiency, fatigue, or congenital weakness. The liver is in charge of purging and discharging. It likes movement

and dislikes stagnation. When it is affected by emotional factors the functional qi stagnates. Stagnation of liver qi can transform into fire, which in turn can impair the yin. When the yin is impaired, deficiency fire agitates inside, impairing the heart in the upper heater and the kidney in the lower heater. If this condition lasts for a long time, the yin of the heart, liver, and kidney are consumed, and they act on each other, depleting each other further. The disease is caused by deficiency but its symptoms are excess. The cause is deficiency fire and the symptoms are exuberant fire. Heat in the heart transforms to the stomach, accelerating metabolism and causing hunger. At the same time, heat in the stomach and liver condenses the essence in the yang ming channel into phlegm. Phlegm and qi rise to the neck to form goiter, the swollen thyroid. When the phlegm gets to the liver channel and lodges in the eyes, it causes bulging eyes." To treat this condition, one may use the following points: *jianshi* (PC5) and *shenmen* (HT7) to purge the heat in the heart, relieve heat in the liver, and nourish the stomach. When the heat in the heart is purged, the fire does not burn the metal, so the metal can control the wood. Also, *taixi* (KI3) and *fuliu* (KI7) are used to nourish kidney yin. When the water is full it nourishes the liver. Finally, *shuitu* (ST10) clears the channel qi of the stomach and removes stasis of phlegm in the neck. A female patient suffering from hyperthyroidism for more than two years was treated following this methodology. Needling was done every other day for 9 weeks (with some changes in the selection of points after three and six weeks), at which time she was considered cured; there was no relapse for 6 months of follow-up.

SUMMARY AND CONCLUSION

Thyroid diseases can be cured or controlled in most patients, according to Chinese reports published during the past 12 years. For those who are cured, relapse is relatively rare during a period of up to 5 years following treatment. Among those who are not cured but show symptomatic improvement, usually with accompanying changes in blood parameters, continued use of herbs, alone or with Western drugs, is necessary. In those cases, it appears that Chinese herbs provide better results than using drugs alone. Only a small number of individuals fail to respond to the Oriental therapies.

There is a clear pattern of herb selection for treatment of thyroid diseases. When thyroid nodules or swellings are present, phlegm-resolving herbs are used. Other herbs are selected for treatment of specific syndromes or symptoms. Hyperthyroid cases are treated with yin nourishing and/or fire purging herbs while hypothyroid cases are treated with qi and yang tonifying herbs.

The number of different herbs commonly used by Chinese doctors for treatment of thyroid diseases is relatively small, thus making selection based on accumulated Chinese experience, but applied to new cases, relatively easy. Acupuncture and moxibustion point selection may include local treatment plus a focus on treating the stomach and spleen meridians, the governing and bladder vessels along the back, and the kidney and conception vessels along the front.

The dosage of herbs used in Chinese clinical trials showing effective treatment of thyroid diseases is higher than commonly used by Western practitioners but comparable to those used in treating other chronic ailments. Powdered herbs in pill form are consumed in the amount of 18 to 30 grams per day, while decoctions are consumed in the amount of about 90 to 210 grams per day. Duration of therapy typically ranges from 6 weeks to 6 months, though some patients require more than a year of treatment to obtain satisfactory resolution of symptoms.

Western drugs used in conjunction with Chinese herbs help to resolve symptoms during the treatment period and appear to enhance the overall effects of the therapy towards attaining a cure or major resolution of the disease. Acupuncture and moxibustion also improve the effects of Chinese herb therapy, though their impact on total duration of treatment has not been ascertained. From a single study with moxibustion, it appears this technique can provide rapid relief for hypothyroid cases.

The mechanism of action of the Chinese herb therapies for thyroid diseases, as expressed in Western pharmacology terms, remains unknown. Clearly, some of the herb ingredients used in the complex formulas regulate the hormone system and/or the antibody attack that causes changes in thyroid function. There is some controversy about using iodine-rich materials (mainly seaweeds) in making Chinese herb formulas, but it appears that in most cases there is no problem in utilizing such materials.

The continued use of surgical thyroidectomy and iodine-irradiation of the thyroid gland to remove thyroid activity in hyperthyroid patients may be deemed a last resort rather than a standard method of therapy if Chinese medicine is incorporated into the health-care system. This can reduce the health problems encountered by Graves' disease patients and also reduce the cost of life-long health care.

References

Note: References 1-20, 22-23, and 49-51 were published in Chinese; a translation of portions of the original text was made by Dr Fu Kezhi, and the translated materials were consulted for the purpose of preparing this paper. The other references were published in English. Book references, mentioned by title in this article, are listed at the end.

Articles referred to by number in the text:

1. Qu Zhijin and Zhou Liang. Hyperthyroidism treated with Shanhaitang Pian. Journal of Traditional Chinese Medicine 1989;30(8).

2. Chen Zhimin, Huang Shuhua, et al. Fufang Baijiezi used to heal 54 cases of hyperthyroidism. Chinese Journal of Integrated Traditional and Western Medicine 1988;8(7).

3. Dong Zemin and Zhang Zaolian. Observation of curative effects of Jia Kang Pian for the treatment of 90 cases of hyperthyroidism. Guangxi Journal of Traditional Chinese Medicine 1988;11(4).

4. Hu Daihuai, Xia Duhung, and Luo Jijie. Clinical observation of 60 cases of hyperthyroidism treated with a modified Jia Kang Fang. Journal of Hunan College of Traditional Chinese Medicine 1989;9(1).

5. Liu Cuirong, Li Jianming, et al. Observation on curative effect of Jia Kang Ling for the treatment of hyperthyroid disorders. Chinese Journal of Integrated Traditional and Western Medicine 1988;8(12).

6. Qu Zhuqiu, Lu Xiuluan, et al. Clinical observation on 60 cases of hyperthyroidism treated with Jia Kang Jian. Journal of Traditional Chinese Medicine 1987;28(2).

7. Zhang Suzhi. 152 cases of hyperthyroidism treated with Jia Kang Wan. Heilongjiang Journal of Traditional Chinese Medicine 1987;1.

8. Yu Jixian. 100 cases of hyperthyroidism treated with modified Bupleurum and Dragon Bone Decoction. Journal of Hunan College of Traditional Chinese Medicine 1986;6(2).

9. Fu Qingchen. Hyperthyroidism accompanying anemia treated with Jaiwei Guipi Wan. Journal of Traditional Chinese Medicine 1984;25(10).

10. Zhang Zhenyan. 50 cases of hyperthyroidism treated with Jia Kang Wan. Beijing Journal of Traditional Chinese Medicine 1983;2.

11. Jiang Liji and Jiang Yunxiang. Jiawei Sili San used to treat hyperthyroidism. Shanghai Journal of Traditional Chinese Medicine 1982;1.

12. Zhang Kaizhen, Lin Zhezhang, et al. Clinical observation of 12 cases of hyperthyroid malignant exopthalmos treated with integrated traditional and Western medicine. Journal of Traditional Chinese Medicine 1982;23(1).

13. Liu Jing, Yin Jian, et al. Hyperthyroidism treated with Shuanghai Xiaoying Tang: A clinical observation of 60 cases. Sichuan Medical Journal 1982;3(5).

14. Kuang Ankun, Din Tin, et al. Clinical observation of hypo- and hyper-thyroidism treated with traditional Chinese medicine and changes of plasma cyclonucleotides. Journal of Traditional Chinese Medicine 1980;21(11).

15. Yu Yunpu, Wang Jian, et al. Clinical observation of 50 cases of hyperthyroidism treated with Fufang Jiakang Gao. Zhejiang Journal of Traditional Chinese Medicine 1980;15(8).

16. Yuan Wenxue. Observation on curative effect of Pinyin Fufang in treating 110 cases of hyperthyroidism. Middle Medical Journal 1980;3.

17. Li Weifan and Zhang Guiliang. An experience of treating hyperthyroidism by differentiation of syndromes according to traditional Chinese medicine. Middle Medical Journal 1980;3.

18. Li Yingquan. Jiawei Haizao Yuhu Tang used to heal hyperthyroidism. Hunan Medical Journal 1980;1.

19. Zhang Jueren. A special formula for senile patients in treating hyperthyroidism. Journal of Traditional Chinese Medicine 1990;31(3).

20. Gao Hongchun. Seaweeds should not be applied for the treatment of hyperthyroidism. Sichuan Journal of Traditional Chinese Medicine 1988;7.

21. Xia Shaonong, Xu Zhizhang, and Zhang Zhihong. Hyperthyroidism treated with Yiqi Yangyin decoction. Journal of Traditional Chinese Medicine [English] 1986;5(2).

22. Li Changdu and Li Peili. Treatment of hypothyroidism with Chinese herbs. Journal of Guiyang Traditional Chinese Medicine College 1990;1.

23. Hu Guosheng, et al. A clinical study of treating Hashimoto's thyroiditis by moxibustion. Journal of Traditional Chinese Medicine [English] 1987;7(2).

24. Hsu Hong-yen. Chinese herb therapy for hyperthyroidism. Bulletin of the Oriental Healing Arts Institute 1983;8(3).

25. Kikutani Toyohiko. Clinical research on hyperthyroidism. Bulletin of the Oriental Healing Arts Institute 1984;9(6).

26. Abe Hiroko and Kodashima Shukuo. Pharmacological actions of crude drugs and Chinese herbal drugs-especially concerning their action mechanisms. Oriental Healing Arts International Bulletin 1986;11(7).

27. Kuang An-kun, et al. The relationship between the therapeutic effect of TCM on primary hypothyroidism and nuclear T3 receptors in lymphocytes. Chinese Journal of Integrated Traditional and Western Medicine 1988;8(11).

28. Huang Zhixin, et al. Observation on curative effect of Licorice and Ginseng Decoction plus a small dose of thyroxine tablet in treating hypothyroidism. Clinical Medicine 1989;9(4).

29. Takasu N, et al. Test for recovery from hypothyroidism during thyroxine therapy in Hashimoto's thyroiditis. The Lancet 1990;336.

30. Chen MD, et al. Influence of Yang-restoring herb medicines upon metabolism of thyroid hormone in normal rats and a drug administration schedule. Chinese Journal of Integrated Traditional and Western Medicine 1989;9(2).

31. Li Wenqi, et al. Effects of gossypol on thyroid function in man. Reproduction and Contraception 1989;9(3).

32. Kuang Ankun, et al. Observation on curative effects of Chinese herb and Western drug therapies for primary hypothyroidism. Chinese Journal of Traditional and Western Medicine 1988;8(2).

33. Li Wen-qi, et al. Effects of gossypol on thyroid and gonadal endocrinology in male subjects. Medicine and Pharmacy of Yunnan 1989;10(3).

34. Wang Ziyou and Zhang Haifa. Treatment of 133 cases of chronic lymphocytic thyroiditis. Liaoning Journal of Traditional Chinese Medicine 1989;13(11).

35. Shen Yuming. Treatment of 40 cases of hyperthyroidism. Shanghai Journal of Traditional Chinese Medicine 1987;2.

36. Terutane Yamada. The Chinese herbal treatment of Sjögren's syndrome and subacute myelo-opticoneuropathy (SMON) disease. Oriental Healing Arts International Bulletin 1987;12(7).

37. Hsu, Hong-yen. Applications of Chinese herb formulas and scientific research: Ginseng and astragalus combination. International Journal of Oriental Medicine 1991;16(3).

38. Su Xiangfu, et al. Effect of yin-nourishing and blood-activating recipes on antibody formation in animals. Journal of Traditional Chinese Medicine 1984;4(2).

39. Feng Jianhua, Report of 2 cases of toxic hepatitis induced by Dioscorea bulbifera. Shandong Journal of Traditional Chinese Medicine 1989;8(2).

40. Chen Zelin. Personal communication, 1992.

41. ACTA Acadamiae Medicinae Secondae Shanghai 1985;5(2).

42. Makhkamov GM, et al. Chemical Abstracts 1966;64(14532).

43. Islam MW, et al. Effect of khatamines and their enantiomers on plasma triiodothyronine and thyronxine levels in normal Wistar rats. American Journal of Chinese Medicine 1990;18(1-2).

44. Esner SI. Personal communication, 1991.

45. Middlebrooks H. TCM nutritional therapy for hyperthyroidism. Journal of the American College of Traditional Chinese Medicine 1989;7(4).

46. Golden, R. Clinical experience at Guangzhou Hospital for Traditional Chinese Medicine. Journal of the American College of Traditional Chinese Medicine 1989;7(1-2).

47. Guo Xiaozong, et al. Acupuncture treatment of benign thyroid nodules: Clinical observation of 65 cases, Journal of Traditional Chinese Medicine [English] 1984;4(4).

48. Hiroshi Sasaki, et al. Immunosuppresive principles of Rehmannia glutinosa. Planta Medica 1989;55.

49. Zhang Jiaqing and Zhao Ming. Animal experiments of Chinese herbs in treating hypothyroid model rat. Chinese Journal of Integrated Traditional and Western Medicine 1991;11(2).

50. Kuang Ankun, et al. Effect of traditional Chinese medicine on primary hypothyroidism in relation to nuclear T3 receptors in lymphocytes. Chinese Journal of Integrated Traditional and Western Medicine 1988;8(11).

51. Chen Zhichai and Xu Ziyin. Clinical observation on Fuzhen Xiaoyin formula applied to treat 38 cases of autoimmune thyroiditis. Chinese Journal of Integrated Traditional and Western Medicine 1992;12(10).

Books referred to in the text by title:

Bensky D and Barolet R. Formulas and Strategies, Seattle, WA: Eastland Press, 1990.

Chang Hson-mou and But Pui-hay. Pharmacology and Applications of Chinese Materia Medica, 2 vol. Singapore: World Scientific, 1986.

Chen Jirui, ed. Recent Advances in Chinese Herbal Drugs. Beijing, China: Science Press, 1991.

Chen Zelin and Chen Meifang. The Essence and Scientific Background of Tongue Diagnosis. Long Beach, CA: Oriental Healing Arts Institute, 1989.

Chen Zelin and Chen Meifang. Comprehensive Guide to Chinese Herbal Medicine. Long Beach, CA: Oriental Healing Arts Institute, 1991.

Hsu, Hong-yen. Treating Cancer with Chinese Herbs. Long Beach, CA: Oriental Healing Arts Institute, 1990.

Kikutani Toyohiko. Combined Use of Western Therapies and Chinese Medicine. Long Beach, CA: Oriental Healing Arts Institute, 1987.

Shang Xianmin, et al. Practical Traditional Chinese Medicine and Pharmacology Clinical Experiences. Beijing, China: New World Press, 1990.

Shao Nianfang, compiler. The Treatment of Knotty Diseases with Chinese Acupuncture and Chinese Herbal Medicine. Jinan, China: Shandong Science and Technology Press, 1990.

Zhang Ren and Dong Zhi Lin. Modern Clinic Necessities for Acupuncture and Moxibustion. Beijing, China: China Ocean Press, 1990.

Ou Ming, et al. An Illustrated Guide to Antineoplastic Chinese Herbal Medicine. Hong Kong: Commercial Press, 1990.

Wang Qi and Dong Zhi Lin. Modern Clinic Necessities for Traditional Chinese Medicine. Beijing, China: China Ocean Press, 1990.

Dong Zhi Lin and Yu Shu Fang, Modern Study and Application of Materia Medica, Beijing, China: China Ocean Press, 1990.

Keisetsu Otsuka. 30 Years of Kanpo. Long Beach, CA: Oriental Healing Arts Institute, 1984.

Zhang Dengbu. Acupuncture Cases from China. London: Churchill Livingstone, 1994.

Pan Mingji. Cancer Treatment with Fu Zheng Pei Ben Principle. Fujian, China: Fujian Science and Technology Publishing House, 1988.

Thyroid Function and Dysfunction

by Ryan Drum (PhD, AHG), Adjunct Professor, Bastyr University

(Reprinted by permission of Gaia Herbal Symposium)

INTRODUCTION

Thyroid dysfunction is epidemic in North America. One in ten adult American women have been diagnosed with thyroid disorders, and some endocrinologists suggest that as many as 25% of adult American women are presenting with clinically detectable thyroid dysfunction. Health practitioners in Canada, Saudi Arabia, and Ireland report a similar increase in female thyroid disorders. Most veterinarians in small animal practice are seeing thyroid problems in cats and dogs increase up to 40%. Cats tend to be hyperthyroid, while dogs tend to be hypothyroid.

What has happened? Are healthcare practitioners becoming more aware of the many facets of thyroid dysfunction presentations? Has something happened in the environment that is responsible for the apparent great increase in clinical and subclinical thyroid dysfunction?

THYROID DILEMMA

In my clinical practice, I have been perplexed by the recent rapid increase in patients presenting with both diagnosed and probable thyroid dysfunction (90% female). Just for a reality check, I went back to my old (1967) *Robbins' Pathology* to see if he had anything to say about frequency of thyroid presentations: "Diseases of the thyroid, while not common in clinical practice, are nonetheless of great importance because most are amenable to medical or surgical management." Robbins' hopeful prognosis for thyroid case management might bring bitter responses from the millions of women who have experienced surgical or radiation ablation removal of their thyroids only to have many or most of their presenting symptoms and others return with a vengeance. The patient help phone lines at the Thyroid Foundation of America are flooded with thousands of calls from women wondering, "how come I feel awful again?" Currently, TFA endocrinologists are actively trying to improve this situation.

Worldwide, thyroid dysfunction is a probable risk factor for 1 to 1.5 billion people (WHO figures), usually considered due to simple iodine deficiency, presenting as goiter (at least 200 million), complex mental retardation from fetal and neonate iodine deficiency (iodine deficiency causes more mental retardation worldwide than all other causes combined), and physical deformities (at least 20 million). Low dietary iodine is also associated with increased rates and risk for breast, endometrial, and ovarian cancer; the cause is probably gonadotropin stimulation with a resulting hyperestrogenic state characterized by relatively high production of estrogen and estradiol.

However, the claim has been made for almost 80 years that North Americans are getting plenty of dietary iodine due to the ubiquitous use of iodized salt. Other sources of dietary iodine came from flour products and dairy products. Iodates were used as dough conditioners because they improve the cross-linking in gluten molecules and also act as mild antiseptics and mold retardants. In the dairy industry, iodine is used as disinfectant in teat dips in commercial machine-milking operations, with some iodine solution potentially dripping into the milk instead of large quantities of topical microbes. Stainless steel equipment is also washed with strong iodine solutions for sterilization. Despite these dietary sources of iodine, people still continue to get obvious low-iodine goiters, though the situation is much improved from the 1915-1919 years, for example, when the number one cause of recruit rejection for military service was overt goiter.

Rather than add more iodine to the diet, some endocrinologists have suggested that Americans are getting too much iodine and that increases in the incidence of autoimmune thyroid disease, namely Hashimoto's hypothyroiditis and Graves' disease (hyperthyroidism), parallel increased dietary iodine intake. Our high iodine intake, especially during the years 1940 to 1990, may be responsible for the high incidence of thyroid dysfunction currently presenting. The efforts to reduce dietary iodine have been overly effective, with recent surveys of food products and consumption indicating that the American diet may be borderline deficient in iodine intake, down from 500-800 ug in 1980 to about 135 ug in 1995.

The North American thyroid dysfunction picture is, therefore, not simple. Rather than just simple iodine deficiency or excess, it is the thyroid gland itself that seems to be failing.

THYROID GLAND CHALLENGES

The largest of the endocrine glands, the one-half to one-ounce thyroid gland is almost twice as large in women on average as in men. Its overt function seems to be to manufacture, store, and release, under strict controls, thyroid hormones, mostly thyroxin (T4) and triiodothyronine (T3), in about a 4:1 ration. The two main iodine-bearing thyroid gland hormones are T4 (65% iodine) and T3 (59% iodine). In very low iodine intake situations, the T4:T3 ratio is reversed to 1:4. The thyroid is a dynamic gland, as Robbins explains: "From the physiologic standpoint, the thyroid gland is one of the most sensitive organs in the body. It responds to many stimuli and is in a constant state of adaptation. ... During puberty, pregnancy, and physiological stress from any source, the thyroid gland increases in size and becomes more active functionally. Changes in size and activity may be observed during a normal menstrual cycle. This extreme functional changeability is manifest as transient hyperplasia of thyroidal epithelium (follicular cells) changing (to tall, columnar). When stress abates, involution obtains and normal follicular cell shape (roughly spherical) and function resume." Increasingly, in our environment, the thyroid is forced to adapt to new stimuli and stresses, sometimes successfully, other times not.

Situational iodine deficiency regularly occurs in modern Americans as a result of both dietary peculiarities and the chronic use of fluoridated, chlorinated, bromated water supplies, internally and externally. Fluorine, chlorine, and bromine are all more chemically reactive than iodine; when in the body, they all tend to disrupt stable iodine molecules, displacing the iodine and causing its excretion. When experimental rats are fed high-bromine diets, the bromine enters their respective thyroid glands and replaces the iodine already there; the proportion of bromine in the thyroid glands of those rats is directly proportional to the amount of bromine in their diet.

We can lose iodine from these aggressive halides; our bodies have no known mechanisms for dealing with relatively large amounts of fluorides, chlorine, and bromine, since these substances are normally too reactive to be available in the so-called natural environment; our exposure is totally modern. Gaseous chlorine is regularly released from shower and tub water freshly drawn from water supply taps. We are exposed to bromine in pesticides, dough conditioners, and disinfectants for water in hot tubs and commercial spas. I recommend showering with the window open; I recommend bathing in tubs filled with the hottest water and allowed to out- gas while

they cool to bearable temperature. Reduce your exposure to iodine-robbing halides for optimal thyroid health.

In addition, aspirin and other related salicylates, as well as anticoagulants like Warfarin (di-Coumerol), increase iodine excretion and can induce mild hypothyroidism. Always inquire of mild hypothyroid patients about aspirin and anticoagulant use.

Compounding these environmental challenges to the thyroid gland is the impact of the atomic age. Since 1945 every human has been repeatedly dusted with radioactive fallout from both acknowledged and unacknowledged nuclear explosions, nuclear power plant disasters, and, most insidious of all, the steady release of radioactive Iodine-131 from all nuclear weapons facilities and all nuclear power plants. The government-sponsored nuclear industry has released experimental quantities of radioactive iodine, cesium, and strontium into the atmosphere. Continual exposure to this incidental I-131 may be the origin of most current thyroid disorders.

It takes about 18 minutes for all the blood in the body to pass through the thyroid gland; it is the most thoroughly vascularized of all the endocrine glands. Most of our respective bodies are iodine conservative: we can absorb it through our skin in minutes when painted on. I have had participants demonstrate transdermal movement of iodine absorbed from clothing through the skin. Iodine is easily absorbed from the intestines in efficiencies up to 98% in very low-iodine diets. The radioactive iodine we are all breathing and eating is released in bursts as a product of nuclear fission, usually within legally allowable amounts. These allowed amounts are calculated on a per day basis rather than as high-amount bursts or episodes. This helps perpetuate the myth that the allowable releases are no health hazard. The episodic rather than regular release of I-131 means we get big hits and then none at all, especially in milk and milk products.

The reason that I-131 is so dangerous is that it has a relatively short half-life of about 8 days; this means it has a radiogenic life of about 60 days, and then the amount remaining is probably biologically insignificant. Although this short half-life is touted as a great thing for patients and incidental accumulators of I-131, the short half-life means that most I-131 taken into the body will decay in the body rather than being excreted. Rather than occurring over a relatively long time, the short half-life means a lot of radioactive decay of I-131 within the thyroid gland, releasing unavoidably molecular-destructive gamma radiation to nearby cell molecules. There is no safe dosage of gamma radiation inside cells. Therapeutically, I-131

is fed to patients to fry their thyroids with gamma radiation, released by radioactive decay of I-131.

Our bodies tend to be iodine aggressive in absorption and iodine conservative in excretion. If we are at all iodine deficient, we will readily take in radioactive I-131 and deposit it in our thyroid glands just as we do with non-radioactive I-127. If we have a full, ongoing whole-body complement of I-127, our bodies tend to not take up any I-131.

The major health problems from the Chernobyl nuclear disaster on or about 26 April 1986 are related to the releases of radioactive I-131 into the atmosphere and onto the soils, surface waters, plants, animals, and cities within 1000 miles of the Chernobyl site. Within 5 years, large increases in thyroid disorders of all sorts began to occur, directly attributable to Chernobyl I-131 releases. The worst is still developing since we know that the cancer rates from short-term radiation exposure tend to peak 20 to 30 years after a particular release episode.

Women are particularly at risk due to environmental agents depleting iodine reserves and other agents exposing them to radioactive I-131. After the thyroid gland, the distal portions of the human mammary glands are the heaviest users/concentrators of iodine in tissue. Iodine is readily incorporated into the tissues surrounding the mammary nipples and is essential for the maintenance of healthy functioning breast tissue. The radioactive decay of I-131 in breast tissue may be a significant factor in the initiation and progression of both breast cancer and some types of breast nodules. Iodine also concentrates in the salivary glands and gonads. Salivary gland cancer and testicular cancer (especially in men over 25, a relatively recent phenomenon) and ovarian cancer are all increasing in actual numbers. Radioactive I-131 decay may be a significant contributing factor.

Other tissues in the body, particularly the liver, can greatly influence the accessibility of T4 to body cells. For T4 to be physiologically active, it must first be converted to T3. This conversion is accomplished primarily by 5' deiodinase in the liver. This enzyme requires selenium as its cationic enzymatic cofactor, which suggests that chronic selenium deficiency may present as hypothyroidism due to reduced T4 to T3 conversion. The thyroid test for TSH and T4 will not reveal this, and, as a result, unnecessary thyroid medication may be prescribed. In an associated consideration, mercury in the body tends to quell or cripple selenium in enzymes. This means that chronic or even possible acute mercury poisoning can present as hypothyroidism. We all have steadily increasing body burdens of mercury from both our foods and water. A test for

selenium and mercury is indicated in cases of obvious hypothyroid signs and symptoms with normal range TSH and T4.

Isoflavones, such as genistein and equol, are inhibitors of thyroid peroxidase, the thyroid follicle enzyme that makes T4 and T3. This inhibition may generate goiters, hypothyroidism, and autoimmune thyroiditis. Since isoflavones are being touted as cancer preventatives, especially for breast and prostate cancers, their addition to non-soya foods may create further thyroid challenges. Isoflavones already available in soya foods may depress thyroid function through TPO inhibition.

Another challenge to thyroid function is the situation with rT3 (reverse T3). It is not reversed at all but instead is produced when the 5'iodine on the interior benzene ring is removed by 5-deiodinase, instead of the 5' iodine on the exterior site. rT3 is nearly inert, and especially so as a thyroid hormone. It has an extremely short half-life in the body of a few hours; it is rapidly excreted via the liver. In our bodies normally, T4 converts to T3 at about 40% and to rT3 at about 45%. This is most curious in an otherwise innately metabolically conservative biological system. The rT3 mechanism is a way of regulating T3 and reducing the likelihood of incipient hyperthyroidism, while maintaining the capacity to boost T3 production as a situation may demand. The body can also decrease T3 production on demand: fasting, acute trauma, chronic illness, and grief all tend to increase rT3 production and decrease T3 production.

A decrease in T3 tends to mean a slower metabolism, less appetite, slower protein replacement, and much less energy on demand for spontaneous kinetics. A relatively high rT3 and low T3 is often accompanied by a relatively low body temperature (less than 97.5°F) as measured in the axillaries before rising in the morning; this low armpit temperature reading is often used as a simple test for hypothyroidism, since body temperature is tightly controlled by metabolic rate and that metabolic rate — the rate at which fuel is converted to heat and kinetics — is controlled by T3. A shortage of T3 means lower body temperature and possibly death if prolonged. The relatively high production of rT3 compared to T3 is sometimes referred to as Wilsons temperature syndrome, and is clinically treated with T3 until a normal body temperature is "captured" and maintained.

There is not yet a positive consensus about either the efficacy or desirability of T3 therapy. It is certainly indicated in life-threatening situations and maybe in other cases. The temporary low body resting temperature and accompanying low T3 may indicate

physiological grieving and/or the need to slow down, get quiet, meditate, rest, regroup one's life resources, and correct faulty attitudes or behaviors to more health-positive ones. In the trauma response, low T3 and high rT3 function to keep the body still calm to slow or prevent further trauma through activity. Up to a year of prolonged low T3 and or low T4 production might be a genetically programmed requirement for health renewal in a long-lived primate, such as ourselves (remember that chimpanzees have lived well past 65 years in captivity), so that we can remain healthy for up to 120 years.

A further challenge to healthy thyroid function is exposure to X-rays. Between 2 and 8 million North Americans (the exact numbers will never be known due to poor record-keeping) in the era from 1930 to 1980 were deliberately medically treated with X-rays to the head and chest, for a wide range of presenting conditions, including scalp ringworm, asthma, chronic bronchitis, tonsillitis, acne, and neonate respiratory problems. The thyroid glands of the respective patients received pathologically significant amounts of powerful ionizing radiation. These treatments have caused over 10,000 of cases of thyroid cancers, which develop 10 to 40 years after the medical exposures, with a peak incidence between 20 and 30 years after the episodes, and many as a million cases of other thyroid structural deformities, including nodular goiters (at least 27% of all children and adolescents irradiated). Treatment prognosis is mixed, with thyroidectomy usually recommended with subsequent lifelong obligatory thyroid replacement therapy.

Seaweed Treatments

Our best source of biological iodine and our best protection against thyroid disruption is to body-load with iodine contained in iodine-rich whole raw seaweeds as regular daily consumption. If our bodies have an ongoing full complement of I-127, we can better resist taking in incidental I-131. This means that eating seaweeds regularly in the diet, especially the big northern kelps, to provide both dietary iodine and protection against the ongoing I-131 hazards.

No land plants are a reliable natural source of iodine. Garlic grown near the sea often has relatively high amounts of biological iodine. Besides garlic, root crops, such as turnips, carrots, potatoes, parsnips, and sweet potatoes, are plant sources of iodine. However, the best natural source of biological iodine is seaweed. Any seaweed contains more available dietary iodine than any land plant. The seaweeds with the most available iodine are the giant kelps of the northern hemisphere. The highest concentrations of iodine occurs in Icelandic kelp (8000 ppm), Norwegian kelp (4000 ppm), and Maine and California kelp (1000-2000 ppm). The seaweeds with the least amounts of iodine are nori (about 15 ppm) and sargassum (about 30-40 ppm). The amounts of iodine in land plants can be greatly increased by fertilizing food plants with seaweeds applied directly to the soil as topical mulch or tilled into the soil.

The complexity of many thyroid dysfunction cases precludes a simple set of all-purpose formulas. Each thyroid patient has a unique thyroid presentation. I try to compose an individualized functional treatment plan for each, using a few basic methods. Diet and behavior modification also are very important in thyroid case management. What follows are some of my treatment approaches and some general guidelines and notes:

Treatment Guideline 1: Rather uncomplicated seaweed therapy seems to help relieve many of the presenting symptoms of thyroid dysfunction. Some of the results are very likely from whole body remineralization (especially potassium, zinc, calcium, magnesium, manganese, chromium, selenium, and vanadium), in addition to thyroid gland aid from both sustained regular reliable dietary sources of biomolecular iodine and from thyroxin-like molecules present in marine algae, both the large edible seaweeds and their almost ubiquitous epiphytic micro-algae, predominantly the silica-walled diatoms. Seaweeds provide ample supplies of most of the essential trace elements required for adequate enzyme functioning throughout the body but especially in the liver and endocrine glands.

Treatment Guideline 2: Regular biomolecular seaweed iodine consumption is more than just thyroid food: it can also protect the thyroid gland from potential resident I-131-induced molecular disruption and cell death when the thyroid gland is fully iodized with I-127. The fear of eating seaweed that might be contaminated with I-131 is easily mitigated by allowing the seaweed to be stored for 50 days prior to dietary consumption; this will give enough time for most (99%) of any I-131 to decay radioactively.

A simple folk test for iodine deficiency or at least aggressive iodine uptake is to paint a 2-inch diameter round patch of USP Tincture of Iodine (strong or mild) on a soft skin area, such as the inner upper arm, the inside of the elbow, the inner thigh, or the lateral abdomen between the lowest rib and the top of the hip. If you are iodine deficient, the patch will disappear in less than 2 hours, sometimes as quickly as 20 minutes; if it fades in 2 to 4 hours, you may just be

momentarily iodine needy. If it persists for more than 4 hours, you are probably iodine sufficient. Iodine deficiency seems to predispose to thyroid malignancy; this could explain the apparent thyroid cancer distribution 'fans' downwind of nuclear facilities in previous 'goiter belt' areas. This test is of course easier to use with Caucasians and may not offer sufficient color contrast in brown-skinned people.

Treatment Guideline 3: Many patients with underactive thyroid glands complain of a sense of "coldness" or feeling cold all of the time; often they are over-dressed for warmth according to thyronormal people's standards. They may also present a low basal body resting temperature, as measured by taking their armpit temperature before rising in the morning. (Remember to shake down the thermometer the night before). Other symptoms may include sluggishness, gradual weight gain, and mild depression. For these patients, add 5 to 10 g of several different whole seaweeds to the daily diet; that is, 5 to 10 g total weight per day, not 5 to 10 g of each seaweed. I usually suggest a mix of 2 parts brown algae (all kelps, Fucus, Sargassum, Hijiki) to one part red seaweed (Dulse, Nori, Irish moss, Gracillaria). The mixed seaweeds can be eaten in soups and salads or easily powdered and sprinkled onto or into any food. I recommend doing this for at least 60 days, about two lunar cycles or at least two menstrual cycles; watch for any changes in signs and symptoms and any change in average daily basal temperature.

Note that patients can have a normal 98.6°F temperature and still feel cold and also present many of the signs and symptoms of functional hypothyroidism. Do not insist that all hypothyroid patients must have abnormally low basal resting temperatures. If no symptoms improve or the temperature remains low (less than 98.6°F), continue seaweeds and request a TSH and T4 test. If TSH and T4 tests indicate low circulating thyroxin levels, continue seaweeds for another 2 months. It may take the thyroid that long to respond positively to continual regular presentation of adequate dietary iodine. Powdered whole seaweed may be much more effective than flakes, pieces, or granules. The powdered seaweed is best added to food immediately prior to eating; do not cook the seaweed for best results.

All corticosteroids tend to depress thyroid function. Before trying to fix the thyroid, be sure to inquire about both internal and topical steroid use, including Prednisone and topical creams. These, as well as salicylates and anticoagulants, can aggravate existing mild hypothyroidism.

Treatment Guideline 4: Partial thyroidectomy cases can be helped by regular continual dietary consumption of 3-5 g of whole seaweeds three to four times a week. By whole seaweed I mean untreated raw dried seaweed, in pieces or powder, not reconstructed flakes or granules.

Treatment Guideline 5: Patients with thyroid glands on thyroid replacement hormone (animal or synthetic) can respond favorably to replacing part or all their entire extrinsic hormone requirement by adding dietary Fucus in 3 to 5 g daily doses, carefully and slowly. Fucus spp. has been the thyroid folk remedy of choice for at least 5000 years. The best candidates are women who seek a less hazardous treatment than synthetic hormone (after reading variously that prolonged use of synthetic thyroid hormone increases risk for heart disease, osteoporosis, and adverse interactions with many prescribed drugs, particularly corticosteroids and antidepressants). Fucus spp. contains di-iodotyrosine (iodogogoric acid) or DIT. Two DIT molecules are coupled in the follicular lumina of the thyroid gland by a condensing esterification reaction organized by thyroid peroxidase (TPO). This means that Fucus provides easy-to-use-prefabricated thyroxine (T4) halves for a boost to weary thyroid glands, almost as good as T4. European thalassotherapists claim that hot Fucus seaweed baths in seawater provide transdermal iodine; perhaps hot Fucus baths also provide transdermal DIT.

The best results with Fucus therapy are obtained with women who were diagnosed with sluggish thyroid glands and who are or were on low or minimal maintenance replacement hormone dosages. They may remark that they miss, forget, or avoid taking their thyroid medication for several days with no obvious negative short-term sequelae; others claim to have just stopped taking their medication. I do not recommend stopping thyroid medication totally at once. Thyroxin is essential for human life and all animal life; it has a long half-life in the body of a week or more, so that a false impression of non-dependency can obtain for up to 2 months before severe or even acute hypothyroidism can manifest, potentially fatal.

Even though I personally do not recommend it, women regularly stop taking their thyroid replacement hormone, even after years of regularly and faithfully taking their medication. In many cases, their respective thyroid glands resume thyroxine production after a 2- to 3-month lag time with many of the signs and symptoms of hypothyroidism presenting while their thyroid glands move out of inactivity. This complete cessation of taking thyroid replacement can

only be successful in patients who have a potentially functioning thyroid gland. Those who have had surgical or radiation removal of their thyroid glands must take thyroid hormone medication containing thyroxine to stay alive.

Fucus can be easily added to the diet as small pieces, powdered Fucus in capsules, or freeze-dried powder in capsules. The actual Fucus is much more effective than extracts. A nice note is that Fucus spp are the most abundant intertidal brown seaweeds in the northern hemisphere. This is of especial interest to those patients who might be trading one dependency for another, as seems to be the case for some. A year's supply can be gathered in an hour or less and easily dried in a food dehydrator or in hot sun for 10 to 12 hours and then in a food dehydrator until completely crunchy dry. Fucus dries down about 6 to 1 (six pounds of wet Fucus dry down to about one pound). It has a modest storage life of 8 to 12 months in completely airtight containers stored in the dark at 50°F. A year's supply at 4 g per day is slightly more than 3 pounds dry. Encapsulated Fucus is available from Naturespirit Herbs, Oregon's Wild Harvest, and Eclectic Institute.

Treatment Guideline 6: Aggressive attempts to replace thyroid replacement hormone with Fucus involve halving the dose of medication each week for 4 weeks while adding 3 to 5 g of dried Fucus to the diet daily from the beginning and continuing indefinitely. If low thyroid symptoms appear, return to lowest thyroid hormone maintenance level and try skipping medication every other day for a week, then for every other 2 days, then 3 days, etc. The intent is to establish the lowest possible maintenance dosage by patient self-evaluation and/or to determine if replacement hormones can be eliminated when the patient ingests a regular reliable supply of both biomolecular iodine and DIT. Thoughtful, careful patient self-monitoring is essential for successful treatment.

Treatment Guideline 7: A more conservative replacement schedule is similar to the aggressive approach, except that the time intervals are one month instead of one week, and the Fucus addition is in one gram increments, beginning with one gram of Fucus the first month of attempting to halve the replacement hormone dosage, and increasing the amount of Fucus by a gram each succeeding month to 5 g per day. The conservative schedule is urged with anxious patients and primary caregivers.

There is some concern that excess (undefined) kelp (species either unknown or not mentioned) consumption may induce hypothyroidism. It seems possible.

The likely explanation is an individual's extreme sensitivity to dietary iodine: Icelandic kelp can contain up to 8000 ppm iodine; Norwegian kelp can contain up to 4000 ppm iodine. Most kelps contain 500 to 1500 ppm iodine.

The only definitive study I have seen is a report from Hokkaido, Japan, where study subjects, at a rate of 8% to 10% of total study participants, presented with iodine-induced goiter from the consumption of large amounts of one or more Laminaria species (Kombu) of large kelps, known to be rich (more than 1000 ppm) in available iodine. Reduction of both total dietary iodine and/or dietary Kombu led to complete remission of all goiters. The apparent iodine-induced goiters did not affect normal thyroid functioning in any participants. Two women in the study did not care if they had goiters and refused to reduce their Kombu intake. Note that the Japanese have the world's highest known dietary intake of both sea vegetables and iodine.

Reduction or elimination of seaweeds from the diet is indicated for at least a month in cases of both hyperthyroidism and hypothyroidism, to ascertain if excess dietary iodine is a contributing factor to a disease condition. Other dietary iodine sources, particularly dairy and flour products, should also be reduced and or eliminated during the same time period. Some individuals do seem to be very dietarily iodine-extraction efficient and iodine sensitive simultaneously.

Case History

A 35-year-old female patient (two children) presented with a rapidly growing thyroid nodule, which seemed to arise with no overt cause. The nodule was not firm but cystic. Once it had stabilized, a fine needle aspirant sample was collected; the cyst was apparently totally benign. Synthetic thyroid hormone was suggested to promote the nodule's shrinkage. The patient refused. Almost 4 years after the nodule stabilized, the woman began taking 3 to 5 g per day of powdered Fucus and Nereocystis kelp, mixed. After 6 months, the nodule had completely disappeared. The woman continues to take some maintenance dosages several times a week.

Graves' Disease

Unlike Hashimoto's hypothyroiditis, Graves' disease seems very amenable to successful herbal intervention and control. The three main herbs used are *Melissa officinalis* (lemon balm), *Lycopus virginiana* (bugleweed), and *Leonuris cardiaca* (motherwort) in descending order of strength and apparent thyrosuppressive efficacy.

Melissa officinalis, in particular, when delivered in measured doses as tincture, tea, or, less exactly, freshly extracted juice from a wheatgrass juicer, stops TSH from binding to its thyroid receptor sites, slows or even quells the uptake of iodine by the active transport sites on thyroid cell surfaces, suppresses the iodination of tyrosine residues in the follicular lumina by TPO, and appears to also impede stored thyroid hormone release from the thyroid gland. The results can be especially rewarding. My personal preference is to have hyperthyroid patients grow and harvest their own lemon balm and also to prepare their own medicine. It grows abundantly in all except xeric habitats with sufficient water and a little shade. It will over-winter in pots. The freshly expressed juice can be frozen. I do not know if freeze-dried Melissa products are effective.

A critical point for herbal treatment of Graves' is the active and aware participation of the patient in monitoring both symptoms and their respective body responses to herbal treatment. Melissa has a fine reputation as a calming herb and it may be that the calming action is not as a nervine, but as a very effective thyrosuppressant. I do not have data on the proportions of T4:T3, or T3:rT3 in Melissa treatment of Graves'. The possibility of potential overmedication with Melissa, a temporary hypothyroidism, exists, but I have no known cases to report.

Lycopus virginiana, apparently both American species and the European one, are effective in slowing down TSH adherence to its rightful cell surface receptors and the uptake of iodine by thyroid cells. It does not seem as quick as Melissa. Ruth Dreier, one of my former apprentices, reported in the 1994 *Journal of the Northeast Herbal Association* about her long and arduous but eventually successful efforts to slow and stop progressive Graves' using tea, tincture, and fresh plant material of *Lycopus virginiana*. She found the tea and tincture to be more effective than the fresh plant material, which suggests to me that some type of molecular cleavage or rearrangement is necessary for effective use of Lycopus as a thyrosuppressive. She also used severe dietary restrictions and careful self-monitoring of her symptoms, using the tincture as a sort of quick-fix medication.

Some of the purported almost-narcotic effects of *Leonuris cardiaca* as a somnambulant may be due to thyrosuppressive activity.

I usually also recommend small (1-2 g) daily dosages of Fucus in hyperthyroidism since some dietary iodine is needed for basic body functions.

Contemporary British Columbia coastal natives drink a strong tea (decoction) of devil's club (*Oplopanax horridum*) root and stem bark to cure hyperthyroidism. I do not know the dosages or the duration of the treatment. I predict that a correlation exists between devil's club's type II diabetes remediation and its successful thyrosuppression. The post-consumption devil's club lethargy may be thyrosuppression at the TRH hypothalamic level rather than direct action on the thyroid gland.

Case History

A 47-year-old female was diagnosed with Graves' disease based on blood tests ordered by an endocrinologist she had been referred to by her family doctor. She was first alerted to the likelihood of thyroid dysfunction by her usual pedicurist who noted the recently greatly-thickened skin on her feet. The patient also presented feeling hot all of the time, with increased sweating, heat intolerance, insomnia, huge appetite, hyperactivity, fatigue, heart palpitations, manual tremor, and eye irritation — all Graves' hyperthyroid symptoms. Her tests were TSH < 0.03 (normal range is 0.5-3.5) and T4 224 (normal range 65-165). A family health and emotional crisis generated acute worry and anxiety.

The endocrinologist offered her three therapeutic choices: surgical thyroid gland removal, use of thyrosuppressive drugs, or radioactive iodine burning of the thyroid gland out of existence. None of these were acceptable, so she went to see a naturopath-acupuncturist and began taking tinctures of bugleweed, Siberian ginseng, motherwort, lemon balm, and, later, hawthorn in addition to acupuncture treatments. In 5 months, her T4 had declined a bit to 198, but her TSH remained essentially nothing at <0.03. She started a homeopathic constitutional remedy (Pulsatilla 30).

A few weeks later, I recommended she begin taking a green drink of freshly blended lemon balm (*Melissa officinalis*) in daily doses of 2-3 liquid ounces with food in addition to her tinctures and homeopathic remedy. In 3 months her T4 was 50% lower at 113, but her TSH was still<0.03. She continued the treatment plan for another 5 months until her THS and T4 were in the normal range. She stopped all herbs and the homeopathic remedy, and her endocrinologist declared her cured.

A cautionary note: Patients with undiagnosed Graves' disease may become hyperthyroid from absorption of increased dietary or topical iodine.

Maude Grieve, in her extensive section on nettles, discusses, somewhat cryptically, the use of powdered nettle seeds as a treatment for goiter. There is no easy access to corroborating references or a case history. I know of only one anecdotal report where a young woman claimed to have cured her goiter with nettle seeds. It was not at all clear as to what type of goiter was treated.

Diet: Hypothyroidism does not respond to any particular herbs that I know of, in either a hopeful or remedial manner. Seaweed therapy with a strong fresh green vegetable diet, particularly chickweed, dandelion, parsley, spinach, and beet greens, seems to be the best. Brassicas are probably best kept to a minimum because of their known goitrogenic activity.

I usually recommend reduction to little or no flour products in an effort to reduce erratic iodine intake and to reduce bromine intake, as well as reduce the hyperglycemia that often accompanies the eating of flour products and simple sugars. It is also recommended to eliminate sugars except in fresh fruit. All non-organic meat and meat products are contraindicated since xenoestrogens can disrupt thyroid function just as intrinsic estrogens generated by the patient's body can. I usually suggest elimination of all dairy products, except unsalted organic butter, to further reduce exposure to growth hormones and iodine and unwanted tetracycline residues. I usually recommend eating avocados, organic eggs, and sardines to provide quality fats to keep bile flowing and wasted thyroid hormones moving out of the liver.

Dietary Blood and Blood Products: All blood will contain some thyroid binding globulin-bound thyroid hormone. The consumption of red meat will always provide small but significant sources of extrinsic thyroid hormone and, at the least, some dietary iodine. In areas of endemic goiter (for example, continental Eurasia), blood products, such as blood sausage, are regularly consumed. The blood from slaughtered animals is carefully caught when the animals are bled. Blood pudding and blood sausages are still regularly served in traditional Irish breakfasts and are regularly available in meat shops throughout Great Britain, the European Union, and eastern Europe. Blood pudding and blood sausage are folk treatments for fatigue and sluggishness. I assume that T4 is the active constituent after iron.

In his privately published memoir, *Of Desert Plants and Peoples*, Sam Hicks writes about the use of fresh deer blood by indigenous peoples in the Sonoran Desert to treat what reads like hypothyroidism. The dosages were about a pint or more of fresh deer blood biweekly or monthly, just about right for time-release T4. For meat-eating patients, I definitely prescribe bloody organic meat and organic blood sausage. For hypothyroid patients, blood can be caught from home-grown and slaughtered animals known to have no growth hormones or pesticide exposure.

References for Further Reading

1. Arem R. The Thyroid Solution. New York, NY: Ballantine, 1999.

2. Barnes B and Galton L. Hypothyroidism: The Unsuspected Illness. New York, NY: Harper and Row, 1976.

3. Bergner P. The Healing Power of Minerals, Rocklin, CA: Prima, 1997.

4. Budd M. Why Am I So Tired? New York, NY: Thorsons, 2000.

5. Colburn T, Dumanoski D, Myers J. Our Stolen Future. New York, NY: Penguin, 1996.

6. Ditkoff B and Lo Gerfo P. The Thyroid Guide. Hanover, NH: University Press of New England, 2000.

7. Grieve MA. Modern Herbal. Vol. 2. New York, NY: Dover Reprint, 1971:578.

8. Greenspan FS and Strewler FJ. Basic and Clinical Endocrinology. Philadelphia, PA: Saunders College, 1997.

9. Hamburger J. The Thyroid Gland. Southfield, MI: J. Hamburger, 1991.

10. National Women's Health Report. Thyroid Disorders and Women's Health 2000 Oct;22(5).

11. Oschman J L. Energy Medicine: The Scientific Basis. Edinburgh, Scotland: Churchill Livingstone, 2000.

12. Pert C. The Molecules of Emotion. New York, NY: Scribners, 1997.

13. Pert C, Dreher X, Ruff M. The psychosomatic network: Foundations of mind-body medicine. Alternative Therapies 1998;4(4):30-41.

14. Robbins S. Pathology. Place: Publisher, 1967.

15. Rosenthal S. The Thyroid Sourcebook. Philadelphia, PA: Saunders, 1996.

16. Schecter S. Fighting Radiation and Chemical Pollutants. Portland, OR: Book Publishing Co., 1997.

17. Shannon S. Diet for the Atomic Age. New York, NY: Crown, 1993.

18. Shomon M. Living Well With Hypothyroidism. New York, NY: Avon, 2000.

19. Surks M. The Thyroid Book. Self-published, 1999.

20. thyroidnews@onelist.com (Online thyroid resources).

21. Wichtl M and Bissett HG. Herbal Drugs & Pharmaceuticals. Portland, OR: Book Publishing Co., 1994:329-32.

22.Wilson D. A Doctor's Manual for Wilson's Syndrome. Muskega, FL: Muskega Medical Publisher, 1995.

23. Wood LC, Cooper DS, Ridgway EC. Your Thyroid. New York, NY: Lavoisier, 1995.

Dopamine, Noradrenalin and Adrenalin Metabolism to Methylated or Chrome Indole Derivatives: Two Pathways or One?

By Abram Hoffer (MD, PhD)

(Reprinted from The Journal of Orthomolecular Medicine *by permission)*

INTRODUCTION

Indoles and their derivatives, the melanins, are among the most important compounds in the body, and perhaps the most neglected.[1] This is not because they are uninteresting – they are very reactive, are present in every cell, and may be involved in most reactions in the body. Barr summarized the data, from which he concluded melanins were the organizing molecules that control growth and development and continuing function of the body.[1] Perhaps they have been neglected because they are so common. We can hardly avoid seeing our own and everyone else's melanin. More likely melanins have been neglected because they are too stable, while their immediate precursors are too unstable. Chemists did not have the techniques, skills, or patience to work with either the precursors or the final polymers. Simple indoles are derived from dopamine, noradrenalin, and adrenalin. These oxidized indoles – dopachrome, noradrenochrome, adrenochrome, and adrenolutin – are very reactive, as are all free radicals. Before they can be extracted from body fluids they will have to be trapped or stabilized by converting them into stable compounds. Adrenochrome forms a stable derivative with semicarbazone. In fact, the first workers who attempted to repeat our adrenochrome psychological studies, not knowing the difference between adrenochrome-semicarbazide and adrenochrome, and not knowing where to obtain adrenochrome, used the stable derivative that is not an hallucinogen. On the contrary, it has very mild anti-anxiety properties.[2,3] Naturally, they did not find it to be an hallucinogen. Until these stable derivatives are isolated, the proof of their presence exists in the extraction of another class of stable derivatives, the melanins.

The sympathomimetic amines and their chrome indole derivatives are involved in the schizophrenias, in coronary disease, in aging, in some neurological diseases, such as Parkinsonism, and perhaps the organization and control of life itself.

Research scientists in fields other than psychiatry are leading the field.[4,5] Research dermatologists interested in skin pigment and its diseases have been the pioneers in determining the structure and precursors of melanin. A few clinicians have become excited about the connection between arrhythmias and adrenochrome metabolism, but psychiatric interest remains very low. It was killed by two main factors: one political, one scientific. After NIMH, Washington, took a hostile attitude toward the Adrenochrome Hypothesis, it became clear to American investigators there would be little point in applying for grants. One of the major directors of research was advised personally during an on-site visit he could expect no funds unless he changed the direction of his research.

Scientifically, two lines of evidence were used to discredit the adrenochrome work. It was claimed it was not an hallucinogen because Rinkel, Hyde and Solomon had found adrenochrome semicarbazide not to be an hallucinogen. All the positive studies, including the double-blind studies in Czechoslovakia, were ignored. It was further claimed that all the adrenalin was metabolized by other pathways, leaving none to be oxidized into adrenochrome. In one "devastating" study using crude tracer techniques, it was proven that up to 120% of the adrenalin was accounted for by non indolic compounds.

In this report I will review briefly the history of the Adrenochrome Hypothesis of schizophrenia and show how it led to a number of interesting developments in medicine and psychiatry.

ADRENOCHROME HYPOTHESIS

In 1952, Humphry Osmond joined me in Saskatchewan, bringing with him the observations he and John Smythies had made.[6] They had compared the experiences induced in normal subjects by mescaline with the experiences schizophrenia induced in its victims. There were many remarkable similarities and, of course, differences. They realized that if a molecule as simple in structure as mescaline could produce an experience which mimicked something as complex as schizophrenia, a similar compound produced in the body could be the schizophrenic toxin. Using somewhat similar reasoning, Osmond and I induced non schizophrenic subjects to excrete a mauve factor when given LSD. Later, the same factor was identified as kryptopyrrole,[7,8] and a rapid screening method was developed by Sohler, Hosztynska, and Pfeiffer.[9] Pfeiffer, Sohler, Jenney, and Iliev described the syndrome

pyroluria[10] (which Hoffer, Osmond, and Mahon had termed malvaria[11,12,13,14,15,16,17]) and its treatment with large doses of pyridoxine and zinc. Kryptopyrrole is toxic.[18,19]

Mescalin is a methylated derivative of a phenylethylamine similar to adrenalin. Adrenalin became even more likely as a source when one of their subjects reported that deteriorated (discolored) adrenalin which had had inhaled for his asthma induced a mescaline type experience in him. They suggested that methylated derivatives of adrenalin played a role in the genesis of schizophrenia. This idea was brilliant, for it immediately provided a guide to the search for the elusive toxin. Until then (and since), most biochemists had devoted their research to examining body fluids of schizophrenics to find anything that could sort out patients from controls. The odds of finding such a substance from the thousands present in the body were and are very low.

But in 1952, the idea was too far in advance of biochemical technology. There were no methods for measuring these methylated derivatives, and none were being sought because it was "known" that methylation could not take place in the body.

The Osmond-Smythies hypothesis pointed toward methylated derivatives as a general class. With Osmond, I began to examine the literature for all known hallucinogens; fortunately, there were few: d-lysergic acid diethylamide, ibogaine and harmine, all indoles, mescaline, which was an amine which could be indolized, and pink adrenalin, whose structure remained unknown to us. Soon after, Prof. D. Hutcheon, a pharmacologist, joined the Saskatchewan Committee on Schizophrenia Research. He told us it was adrenochrome. Of the five hallucinogens, four were indoles and the fifth might become an indole. We now had another guideline. Search the body for an hallucinogen, an indole derived from adrenalin. Was it andrenochrome, adrenolutin, or one or more of their derivatives?[20]

From the beginning, the idea aroused an inordinate amount of rage among our psychiatric colleagues. Our first grant request from Ottawa was vetoed by Canada's three most distinguished chairmen of departments of psychiatry. They were overruled by an outside referee, Prof. Nolan D.C. Lewis of Columbia University.

The adrenochrome hypothesis directed our attention to three main research areas. If the predictions derived from the hypothesis were confirmed, this would provide support for the hypothesis. Naturally, adrenochrome or its derivatives must be formed in the body, either only in schizophrenics, which would make this disease unique, or in everyone but to a greater degree in schizophrenics. It would also follow that adrenochrome would be hallucinogenic. Finally, it would follow that reversing the reaction, i.e. preventing the formation of adrenochrome, would be therapeutic.

To examine the first idea we assembled a small team of chemists led by Dr R.A. Heacock.[21,22] We discovered how to synthesize crystalline adrenochrome that was stable at room temperature and also its derivative, crystalline adrenolutin. Our group was the first to have available pure adrenochrome, but we were not able to isolate and crystallize it from body fluids. In our book, *The Hallucinogens* (Hoffer and Osmond, 1967), we summarized the evidence that showed all the conditions essential for the formation of adrenochrome were present.[23] These include the substrate, the catecholamines, the enzymes and catalysts necessary for oxidation, and the products of oxidation, the melanins. These are chrome indole polymers.

Recently, Hegedus, Kuttab, Altschule, and Nayak demonstrated the presence of a particular type of melanin, rheomelanin, in serum.[24] It is made from adrenochrome. Most melanins are made from tyrosine and require the enzyme tyrosinase. However, reddish neuromelanins are present in the brain even in albinos. They are found in areas of the brain rich in noradrenalin, adrenalin, dopamine, and serotonin. These chrome indoles may also be formed from aldehydes formed by amine oxidase. These amines may be metabolized by three pathways, but the chrome indoles may come from any one of these pathways. A deficiency of amine oxidase or a surplus of amines would force the amines more directly into the indole pathway. Areas richest in these amines would be most apt to accumulate neuromalinins.

Serotonin interacts with catecholamines and may modulate the oxidation of adrenalin to adrenchrome. VanderWende and Johnson reported that substantia nigra and caudate nucleus were high in dopamine and serotonin.[25] Dopamine is in the soluble fraction and serotonin is bound. An excessive release of or failure to bind serotonin would lead to a reduction in formation of melanin. Less melanin is found in Parkinsonism disease. When the concentration of serotonin is lower than the concentration of adrenalin, adrenochrome formation is accelerated. When the ratio is reversed, oxidation is inhibited. VanderWende and Johnson point out both must be measured.[26] The ratio is critical. At normal ratios no adrenochrome is formed. When too little serotonin is present, formation of adrenochrome is accelerated.

The amount of amine oxidized to aminochromes is

less important than the time during which oxidation occurs. Even a slight conversion will be pathological if long continued and if detoxifying measures are defective. The ratio of amount formed to amount inactivated is critical. If the body lacks antioxidants (free radical scavengers), more adrenochrome will be formed. Increased quantities of melanin would accumulate in all areas where melanin is normally deposited and in some where it is not. Hair and skin should be darker, and in many schizophrenics this darkening is quite evident. One of my female patients deposited a yellow-brown pigment in her fingernails and toenails. As she recovered, a clear area appeared in every nail as new, normal nails grew. The demarcation between distal discolored nail and proximal clean nail was the same in every nail. Deposition of melanin had stopped simultaneously in each nail. Chronic schizophrenics do not develop gray hair as often and do develop pigment in their skin as do pellagrins, especially when treated with chlorpromazine, in sun-exposed areas. The relation of pigment in schizophrenic brains relative to normal brains is not known.

A small number of schizophrenics treated with vitamin B-3 go through a phase when melanin is deposited in their skin, particularly in the flexor surfaces. It resembles an old suntan, which begins to fade. The discoloration of skin is not pathological. Parsons also saw this in a few patients treated with niacin for hypercholesterolemia.[27] He described it as a localized, velvety thickening and tanning of the skin. It is not acanthosis nigricans, a term used by Lipton et al,[28] who erroneously concluded this after misreading a paper published by Wittenborn, Weber, and Brown.[29] The discolored skin is easily removed by gently rubbing the wet skin. It leaves normal skin underneath. It proves excess melanin is deposited in skin, primarily in schizophrenics. No cases were reported by the coronary study on thousands of patients.

Modern scientists investigating melanin no longer dispute its source. Barr, in his thorough review of the evidence, concluded the melanins play a unique and most important role in growth and development.[1] Others are convinced adrenochrome plays a most important role in heart function.[30,31,32] Old age pigment accumulates in heart muscle at a rate of $1/2$ % of the cell volume per decade, and older people may contain 10% of pigment by volume in their cells.[33] Others discuss the oxidative pathways of catecholamines in the formation of neuromelanins and cytotoxic quinines.[34,35] Dopamine and 6 hydroxydopamine are toxic after they are converted into their chrome indoles.

Melanin is a remarkably versatile substance; for example, it is a very efficient photon absorbing molecule that responds also to sound. This is why it is present in skin, eyes, and the inner ear. Maybe this is how the day/night light ratio controls mood in some cyclothymic individuals. It is a free radical scavenger binding organic and metallic molecules. Metals bound to melanin as hair and skin are shed, much as deciduous trees eliminate unwanted minerals by dropping their leaves. It is an organizing substance present at ever stage from the oocyte into the highly pigmented neural crest from which it is dispersed to the central nervous system and the autonomic nervous system. In the growing rat, neuromelanin reaches a stable adult level in 30 days, while dopamine and noradrenalin increase from day 1 to day 60. Neuromelanin is not a metabolic waste-basket.

There are three types of melanin: (1) eumelanins, derived from tyrosine, black-brown in color as seen in skin; (2) neuromelanin, derived from catecholamines, from serotonin and from melatonin; and (3) phaemelanins, which contain cysteine and gluthathione and are red, yellow, green, blue or violet.

The oxidizing enzymes are tyrosinase, peroxidase, and monoamine oxidase. The latter deaminates amines and indole amines to aldehydes, which form melanins. Auto-oxidation also occurs, catalyzed by copper and iron. The type of melanin varies with the site. In substantia nigra, dopamine is the major source. In the locus coeruleus, noradrenalin, and in the diffuse brain stem raphe system, serotonin is the chief precursor. These melanins are found in strategic, highly functional areas of the brain. I am puzzled how theorists who support the dopamine hypothesis of schizophrenia can ignore one of the most important and most toxic metabolites, dopachrome, and its melanin.

Absolute proof of a substance is present in the body is to extract that substance and to prove it is identical with a synthetic substance of know structure, or to convert it in the body into a stable derivative which can be crystallized and identified. The body has, in fact, carried out the second step and whenever we extract melanin we are proving the presence of adrenochrome in the body, even if it has a transient life.

Hegedus and Altschule, in a series of reports, concluded that adrenalin, adrenochrome, and adrenolutin incubated in blood formed rheomelanins and hemolyzed erythrocytes.[36,37,38] They concluded the indole pathway was available in blood, and, even more, that erythrocytes from schizophrenics were abnormally susceptible to the hemolytic effect of rheomelanins or precursors formed from aminochromes. Blood contains cells that metabolize adrenalin to adrenochrome as the major pathway.

Matthews, Hallett, Henderson and Campbell reported that over 80% of the adrenalin was oxidized to adrenochrome by polymorphonuclear leukocytes stimulated by latex beads or by the peptide N formyl-metleuphe.[39] Oxidation began in 5 minutes and continued for 4 hours. This was the favored pathway over amine oxidase and catechol O methyltransferase. They also found that serum from patients drawn after myocardial infarction induced more oxidation than control serum. This provides a cellular mechanism for adrenochronme formation in inflammatory conditions. Perhaps the oxidized catecholamine free radicals are use to destroy bacteria. Adrenochrome is also an antimitotic poison.

It is likely the proportion of catecholamines converted to aminochromes varies enormously from 1% to 2% to over 80%, depending upon the tissues where this oxidation occurs. In the synapse, this oxidation is dangerous, as quinines, an intermediate, are toxic. Liang, Plotsky and Adams found that 6 hydroxy dopamine reacts with central nervous system tissue in vivo to form paraquinone.[40] Tse, McCreery and Adams reported catecholamines were oxidized in vitro using conditions comparable to human brain,[41] and Cheng suggested that paraquinone from 6 hydroxy dopamine was an important toxin causing destruction of neural tissue.[42] Is adrenochrome formation a way of removing more toxic paraquinones? It is possible the aminochromes, once formed, increase the formation of more by inhibiting catechol O methyl transferase.[43]

The adrenalin/adrenochrome pathway has become an important are for study in heart disease. Yates, Beamish and Dhalla, Beamish, Dhillon, Sinsal and Dhalla, and Yates, Taam, Sinsal, Beamish and Dhalla showed adrenochrome is partly responsible for myocardial necrosis and failure following massive injection of adrenalin.[44,30,45] Sulfinpyrazone (Anturan) was reported by the Anturan Reinfarction Trail investigators to decrease cardiac mortality after the first infarction. It does so by abolishing adrenochrome induce arrhythmias.

Altieri and Inchiosa reported adrenochrome was a potent inhibitor of myosin, actomyosin and myofibrillar ATPase at physiological levels and pH.[46] There was no effect on cerebral cortex ATPase. It is formed in smooth muscle and is part of the mechanism by which adrenalin relaxes certain smooth muscles.

Wortsman, Frank and Cryer recorded extraordinarily high plasma levels of adrenalin in patients resuscitated from cardiac arrest.[47] Adrenalin levels rose 300 times while noradrenalin rose 10 times. Increases also occur in hypoglycemia and hemorrhagic shock.

The exact connection between schizophrenia and oxidized catecholamine metabolites has not been studied. It is unlikely they are specific to schizophrenia, most likely due to a combination of factors, such as a deficiency of reducing substances or antioxidants, an excess of oxidizing metals or enzymes, and an overload of catecholamines. The increased amount of adrenochrome and like substances cannot be detoxified fast enough, leading to an accumulation of adrenochrome and its metabolites. One does not even need to postulate higher concentrations of adrenochrome will be found. The increased amount of adrenochrome may be removed or destroyed just as quickly, leaving damaged molecules or an accumulation of its metabolites such as melanin. The oxidation of activated adrenalin at the synapse will destroy the receptors. This is why dopamine is toxic. If dopamine were stabilized so it could not be oxidized to dopachrome, it is doubtful that it would destroy neuron receptors. The destruction occurs by the interaction between the oxidized aminochrome and the chemicals on the surface of the receptors. Walaas and Walaas have shown that the oxidation of adrenalin to adrenochrome is accelerated in synapses when there is a deficiency of vitamin B-3 as nicotinamide adenine dinucleotide.[49]

Niacin is a broad-spectrum hypocholesterolemic substance that decreases cholesterol,[50] triglycerides, low density and very low density lipoprotein cholesterol, and elevates high density lipoprotein cholesterol. A huge coronary drug study compared five substances: placebo, estrogen, thyroid, clofibrate, and niacin.[51] Patients were treated for 9 years, the study ending in 1976 or so. Niacin, at the end of the study, was superior to the other four treatments, but there was no difference in the death rate. The state of the patients was reexamined beginning in 1982. Recently, Canner reported that niacin decreased the death rate by 11%.[52] Clofibrate and placebo were the same and estrogen and thyroid had increased it and had been discontinued during the original study. What was surprising was this beneficial effect even after treatment was discontinued many years before. In sharp contrast, Dr E. Boyle found that his patients on niacin continually for 10 years after their first coronary suffered only 10% mortality rather than the expected 90%.[53] Niacin could prevent the excessive formation of adrenochrome and would antidote the toxic effect of adrenochrome on myocardial tissue, much as it antagonized the cerebral arrhythmia measured on the electroencephalograph when adrenochrome was given intravenously.

Is Adrenochrome an Hallucinogen?

We have reviewed the evidence that adrenochrome is an hallucinogen.[54,23] This has been established by open clinical studies and by double-blind controlled studies; especially noteworthy are studies by Grof, Vojtechovsky and Horackova ,[55] Vojtechovsky, Grof and Vitek,[56] and Grof, Vojtechovsky, Vitek and Prankova.[57] It is also active in altering animal behavior. We saw this in 1952 when we measured the toxicity of adrenochrome in rats. Weckowicz did his PhD thesis on the effect of adrenochrome on learning in albino rats.[58] It has altered behavior in other animals as well, including spiders, cats, monkeys and pigeons. Taborsky found adrenochrome and adrenolutin reduced the work rate of rats.[59] Anything that blocked the 3 hydroxyl group, such as 5, 6, dihydroxy N methyl indole, removed toxicity.

Adrenochrome produced psychotomimetic reactions that mimicked schizophrenia more closely than does LSD. The usual perceptual changes were illusions but with heavier doses hallucinations were present. Thought disorder was common with loss of insight and paranoid delusions. Depression was very common. When I last took adrenochrome, I was depressed for 2 weeks. I have never been depressed before or since. We concluded adrenochrome was a dangerous hallucinogen. It did not produce any psychedelic reactions and will never be the darling of the streets as was LSD.

There is evidence LSD will not produce its typical effect in the absence of enough adrenochrome. We had given LSD as a treatment to several thousand alcoholics. Our standard initial dose was 200 to 300 micrograms. Yet many alcoholics needed a lot more. In a small series of cases, we gave alcoholics this amount of LSD, and when the only response after 2 hours was increased anxiety, we gave them intravenous adrenochrome. Within 10 minutes, they had the psychedelic reaction we wanted them to have. There were no other changes in the test situation. The most recent reviews are by Heacock and Hoffer.[60]

It is known that up to 25% of patients with Parkinsonism given l-dopa in larger quantities become psychotic, i.e., develop perceptual symptoms and thought disorder. With lower doses, a smaller proportion become psychotic. Graham,[34,61] and Graham, Tiffany, Bell, and Gutknecht[35] are convinced a proportion of catecholamines were oxidized to quinines to aminochromes to neuromelanin. This is so slow that little is found in brain until age 6. 6 hydroxy dopamine is toxic because it is converted to trihydroxyphenylalanine (TOPA), which is converted to aminochrome. Thus, while it benefits the patient by moderating the symptoms, it accelerates the destruction of dopamine receptors. Yaryura-Tobias and Diamond found that niacin protected Parkinsonism cases against the l-dopa psychosis;[62] I have also found this, but it did not help their neurological symptoms. L-dopa decreases the conversion of tryptophan to NAD. Bender, Eall, and Lees found that patients of l-dopa were as low in vitamin B-3 and in its metabolites as were pellagrins.[63]

Adrenochrome increases the arrhythmia normally found in epileptics when measured by the surface EEG, and this is reversed by niacin.[64] It also changes the normal patterns of the depth electroencephalogram, as do mescaline and LSD.[65]

Adrenochrome Hypothesis and Treatment of Schizophrenia

In 1951, there were only three acceptable treatments for schizophrenia: (1) psychotherapy based upon psychoanalysis, which did not work; (2) insulin coma, which was rapidly being displaced by electroconvulsive therapy; and (3) ECT, which aborted many acute psychotic reactions but in the long run did not change the course of the illness very much. There was nothing else on the horizon except a few workers who were investigating steroids, histamine, thyroid, and the newly discovered antihistamines. Pellagraologists had found that a few patients in Southern mental hospitals recovered when given niacin, but they were promptly re-diagnosed pellagrins, thus retaining the sacred principle that only pellagrins responded to vitamin B-3. We confirmed that histamine treatment helped many acute patients, but it was no more practical to use it on a sustaining basis than it was to use insulin coma or ECT for chronic control of psychosis.

Humphry Osmond and I agreed we should base any new treatment on our adrenochrome hypothesis for two reasons. If such a treatment were successful, it would bolster the hypothesis, but much more important, we would have a way of helping our patients. We decided to use compounds that were safe, available, could be taken easily, and would prevent or decrease the oxidation of adrenalin to adrenochrome. This was the first example of antioxidant therapy applied to medicine. We hoped that vitamin B-3 would decrease the production of adrenochrome or prevent its toxic effect on the respiratory enzymes. Adrenochrome was known to be a powerful inhibitor of these enzymes. We also hoped that ascorbic acid, as one of nature's best water-soluble reducing substances, would act in a like manner.

Both vitamins were and are safe and fit our requirements for a treatment that could be taken for a lifetime if necessary. But in order to be effective we

concluded we would have to use doses larger than those already reported, for if smaller doses had been effective this would have been reported. We decided to begin with 3 to 10 grams per day of each vitamin.

A few preliminary studies soon showed these doses were safe and acceptable to patients. Our first pilot study included eight severely ill acute cases, two under my care and six under Dr Osmond's care at a mental hospital. All had not responded to previous treatment. All recovered on these vitamins. I am still surprised. Perhaps in 1952 schizophrenics were not as badly damaged by high-tech nutrition as they are today. Pritchard found no difference in outcome between patients treated before and after tranquilizers were introduced,[66] but Bockoven and Solomon concluded schizophrenics treated between 1947 and 1952 had a better long-term outlook than patients treated with tranquilizers between 1967 and 1972.[67] They concluded, "psychotropic drugs may not be indispensable to the success of community-based mental health services and that their extended use in aftercare may prolong the social dependency of many discharged patients." They were, in fact, made as dependent then as they are now on tranquilizers alone. It is impossible to function normally in any activity requiring energy, initiative and concentration on tranquilizers alone. Would you allow a heavily tranquilized surgeon to operate on your heart? Two factors have made the outcome worse: (1) malnutrition and (2) tranquilizers alone.

We started a double dummy experiment to test our ideas. These experiments had been done in England but had not yet come across to North America. In fact, the first report in North America that tranquilizers were helpful in the treatment of manic states were open clinical experiments. According to modern clinical scientific dogma, these results should not have been published, should not have been read, and should not have been believed because they were anecdotal – that evil way of making observations. Yet H. Lehmann became the North American pioneer in introducing tranquilizers because of one anecdotal report. Thank God double-blind theorists did not exist then. By the time we finished our experiment, it had become "double blind," overthrowing the British term "double dummy."

In our experiment, the addition of 3 g per day of either niacin or niacinamide to the treatment then available doubled the one-year cure rate of acute patients from the placebo rate of 35% to 70%. Three more double-blind controlled experiments gave us similar results. We also found and reported in 1955 that chronic patients did not respond to vitamin B-3,

even in doses of 10 g per day.[17,68,69,70,71,23] Our method was described by Clancy, Hoffer, Lucy, Osmond, Smythies and Stefaniuk.[72]

Our main conclusions were:
1. That acute patients doubled their one-year recovery rate.
2. That chronic patients did not.

These findings have been confirmed by every study reported since then. Thus, the Montreal group using only chronic patients labeled newly admitted obtained mixed results. Generally, they did not respond, but they ignored evidence of improvement. The New Jersey studies were also mixed. The initial report on chronic patients was negative. However, Dr J. Wittenborn later reviewed his data, pulled out 24 patients who were chronic, less ill, and found that compared to placebo, 70% had responded — i.e., double the placebo rate.[73] Every psychiatrist since 1960 has been able to find similar responses, provided they took the pains to follow the basic treatment protocols. So far I have not known any psychiatrists who, having used the nutritional approach for at least one year, have given it up, in spite of massive harassment by local, state, and national psychiatric establishments. There is one exception – a Northeastern psychiatrist gave up all use of vitamins after 6 months because, if he had not, he would have lost his hospital privileges and his practice. He, in the end, merely lost his self-respect, for in his sign-off letter to me he bemoaned the fact he was not permitted to treat his schizophrenic patients in the most efficacious way.

Vitamin therapy is advancing very quickly because it works, even when there are no drug companies to push it, and arrayed against it are all the establishment organizations, including nutritionists, psychiatrists, psychologists, and social workers. Our main support has come from the thousands of families hit by schizophrenia who have compared results when their relatives were on tranquilizers only and then treated more effectively with orthomolecular therapy. Politics, not science, has inhibited the advance of orthomolecular therapy, and it is politics as practiced by our patients that will force you eventually to become orthomolecular psychiatrists. Until then, our poor schizophrenics will be treated in tranquilizer institutions or condemned to the streets, while the wealthy will be able to seek out orthomolecular hospitals and practitioners and be given their chance for recovery.

Treatment today is much more than vitamin B-3 and ascorbic acid, even though these two vitamins remain basic components. Treatment today is to our original treatment as a Japanese Cressida is to a Model T. Ford. This does not mean the Adrenochrome

Hypothesis is proved, but it does provide further support; it is a viable theory and must continue to be examined.

CONCLUSION

The Adrenochrome Hypothesis has been tested experimentally by a large number of scientists since it was first reported in 1952 in New York before the Dementia Praecox committee of the Scottish Rites Masons. Three major sub-hypotheses have been confirmed; it is made in the body, it is an hallucinogen and its antidotes are therapeutic for schizophrenia. What must still be done is to determine how schizophrenics and normals differ in the way they deal with the catecholamine/aminochrome pathways.

Schizophrenia is a syndrome.[73,74,75] The Adrenochrome Hypothesis may account for the final clinical picture, but the abnormal changes are triggered by a number of factors, such as cerebral allergies, vitamin dependencies and deficiencies, and so on. The essential fatty acids[76,77] and the prostaglandins[78,79] are involved. One day all these factors will be examined and co-related so that we will have a clear picture of what happens when a person becomes schizophrenic.[60]

All three known pathways by which the catecholamines are metabolized play a role in the body. What we must know is how they are related to each other and what factors direct these pathways.

References

1. Barr FE, Saloma JS, Buchele NJ. Melanin: The organizing molecule. Medical Hypothesis 1983;11:1-140.

2. Rinkel M, Hyde RW, Solomon, HC. Experimental psychiatry III: A chemical concept of psychosis. Dis. Nerv. System 1954;15:257-6.

3. Rinkel M and Solomon HC. Chemical theories of psychosis. J. Clin. Exp. Psychopathology 1957;18:323-34.

4. Mason, HS. Comparative biochemistry of the phenolase complex. Advances in Enzymology 1955;16:105-84.

5. Mason HS. Structure of melanins. In: Pigment Cell Biology, Gordon M (ed.) New York, NY: Academic Press, 1959.

6. Osmond H and Smythies J. Schizophrenia: A new approach. J. Ment. Sci. 1953;98:309-15.

7. Irvine D, Bayne W, Miyashita H. Identification of kryptopyrrole in human urine and its relation to psychosis. Nature 1969;224: 811-13.

8. Sohler A, Beck R, Noval JJ. Mauve factor re-identified as 2, 4-dimethyl-3-ethylpyrrole and its sedative effect on the CNS. Nature 1970;228:1318-20.

9. Sohler A, Holsztynska E, Pfeiffer CC. A rapid screening test for pyroluria: Useful in distinguishing a schizophrenic subpopulation. J. Ortho. Psychiatry 1974;3:273-79.

10. Pfieffer CC, Sohler A, Jenney MS, Iliev V. Treatment of pyroluric schizophrenias (malvaria) with large doses of pyridoxine and a dietary supplement of zinc. J. Applied Nutrition 1974;26:21-28.

11. Hoffer A. The presence of malvaria in some mentally retarded children. Amer. J. Ment. Def. 1965;67:430-32.

12. Hoffer A. A comparison of psychiatric inpatients and outpatients and malvaria. Inter. J. Neuropsychiat. 1965;1:430-32, 1965.

13. Hoffer A. Quantification of malvaria. Int. J. Neuropsychiat. 1966;2:559-61.

14. Hoffer A and Mahon M. The presence of unidentified substances in the urine of psychiatric patients. J. Neuropsychiat. 1961;2:331-62.

15. Hoffer A and Osmond H. A card sort test helpful in making psychiatric diagnosis. J. Neuropsychiatry 1961;2:306-30.

16. Hoffer A and Osmond H. The relationship between an unknown factor (US) in urine of subjects and HOD test results. J. Neuropsychiatry 1960;2:363-68.

17. Hoffer A and Osmond H. OFFER, A. Malvaria: A new psychiatric disease. Acta Psychiatrica Scand. 1963:39:335-66.

18. Walker JL. Neurobiological and behavioral toxicity of kryptopyrrole in the rat. Pharmacology, Biochemistry and Behavior 1975;3:243-50.

19. Wetterberg GL. Pharmacological and toxic effects of kryptopyrrole in mice. Orthomolecular Psychiatry 1972;1:141-44.

20. Hoffer A, Osmond H, Smythies J. Schizophrenia: A new approach. II Results of a year's research. J. Ment. Sc. 1954;100:29-45.

21. Heacock RA. The chemistry of adrenochrome and related compounds. Chem. Reviews 1959;59:181-237.

22. Heacock RA. The aminochroemes. Advances in Heterocyclic Chem. 1965;5:205-90.

23. Hoffer A and Osmond H. The Hallucinogens. New York, NY: Academic Press, 1967.

24. Hegedus ZL, Kuttabl SH, Altschule MD, Nayak U. Isolation of melanin from human plasma lipofuscin. Arch. Internationales de Physiologie et de Biochemie 1981;89:393-98.

25. Vanderwende C and Johnson JC. Interaction of serotonin with the catecholamines II Activation and inhibition of adrenochrome formation. Biochem. Pharm. 1970;19:2001-07.

26. Vanderwende C and Johnson JC. Interaction of serotonin with the catecholamines I Inhibition of dopamine with norepinephrine oxidation. Biochem. Pharmacology 1970;19:1991-2000.

27. Parsons WB. Nicotinic acid in hyperlipidemia: Clinical guidelines in the use of a broad spectrum lipid reducing agent. Internal Med. 1974;9:13-24.

28. Lipton M. Task Force Report #7. Megavitamin and Orthomolecular Therapy in Psychiatry. Washington, DC: American Psychiatric Association, 1973.

29. Wittenborn JR, Weber ESP, Brown M. Niacin in the long-term treatment of schizophrenia. Arch. Gen. Psychiatry 1973;28:308-15.

30. Beamish RE, Dhillon KS, Sincal PK, Dhalla NS. Protective effect of sulfinpyrazone against catecholamine metabolite adrenochrome-induced arrhythmias. Am Heart J. 1981;102:149-52.

31. Karamazyn M, Beamish RE, Fliesel L.Dhalla NS. Adrenochrome induced coronary artery constriction in the rat heart. J. Pharmacol. Exp. Ther., 1981:219:225-30.

32. Sinsal PK, Yates JC, Beamish RE, Dhalla NS. Influence of reducing agents on adrenocrome induced changes in the heart. Arch. Pathol. Lab. Med. 1981;105:664-69.

33. Stehler B, Mark D, Mildwan A, Gee, M. Linear accumulation of heart age pigment. Gerontology Branch, NHI, and Baltimore City Hospitals, Fed. Proc. 18, March 1959.

34. Graham DG. Oxidative pathways for catecholamines in the genesis of neuromelanin and cytotoxic quinines. Molecular Pharmacology 1978;14:633-43.

35. Grham DG, Tiffany SM, Bell WR, Gutknecht WF. Autoxidation versus covalent binding of quiniones as the mechanism of toxicity of dopamine, 6-hydroxy-dopamine and related compounds toward C1300 neuroblastoma cells in vitro. Molecular Pharmacology 1978;14 644-53.

36. Hegedus ZL and Altschule MD. Aminochromes III. Transformation of epinephrine, adrenochrome and adrenolutin into plasma-soluble melanins during incubation in human blood plasma. Arch. Biochem. Biophys. 1968;126:388-92.

37. Hegedus ZL and Altschule MD. Aminochromes IV. Hemolysis associated with the transformation of ephinephrine, adrenochrome and adrenolutin into rheomelanin human whole blood. Arch. Int. Pharmacodyn. Ther. 1970;186:39-47.

38. Hegedus ZL and Altschule MD. Aminochromes V. Excessive hemolysis associated with the formation of rheomelanins during incubation of adrenochrome and adrenolutin in the bloods of chronic schizophrenic patients. Arch. Int. Pharmacodyn. Ther. 1970;186:48-53.

39. Matthews SB, Hallett MB, Henderson AH, Campbell AK. The adrenochrome pathway. A potential catabolic route for adrenaline metabolism in inflammatory disease. Myocardiology 1985;6:367-81.

40. Liang YO, Plotsky PM, Adams RN. Isolation and identification of an in vivo reaction product of 6-hydroxy-dopamine. J. Med. Chem. 1977;20:581-83.

41. Tse DC, McGreery RL, Adams RN. Potential oxidative pathways of brain catecholamines. J. Med. Chem. 1976;19:37-40.

42. Cheng AC. Synthesis and physiochemical and neuro-toxicity studies of 1-(4- substituted – 2, 5-dihydroxyphenyl) –2-aminoethane analogues of 6-hydroxydopamine. J.Med. Chem. 1984;27: 513-20.

43. Borchardt RT Catechol O-methyltransferase: A model to study the mechanism of 6 hydroxy dopamine interaction with proteins. Chemical Tools in Catecholamine Research. 1975;1:33-40.

44.Yates JC, Beamish RE, Dhalla NS. Ventricular dysfunction and necrosis produced by adrenochrome metabolite of epinephrine: Relation of pathogenesis of catcholamine cardiomyopathy. Am. Heart J. 1981;102:210-21.

45. Yates JD, Taam GM, Sinsal PK, Beamish RE, Dhalla NS. Protection against adrenochrome-induced myocardial damage by various pharmacological interventions. Br. J. Exp. Pathol. 1980;61:242-55.

46. Altieiri RJ and Inchiosa MA. Concentration-dependent inhibition of myosin ATPase by an indole metabolite of epinephrine. Life Science 1980;26:1523-34.

47. Wortsman J, Frank S, Cryer PE. Adrenomedullary response to maximal stress in humans. Am. J. Med. 1984;77:779-84.

48. Walaas E. Catecholamines as substrates for ceruloplasmin. In: Molecular Basis of Some Aspects of Mental Activity. Walaas O (ed.). New York, NY: Academic Press, 1967:2:167-74.

49. Walaas E and Walaas O. Oxidation of reduced phosphorpyridine nucleotides by p-phenylenediamines, catecholamines and serotonin in the presence of ceruloplasmin. Arch. Biochem. 1961;95:151-62.

50. Altschul R, Hoffer A, Stephen JD. Influence of nicotinic acid on serum cholesterol in man. Arch. Biochem. & Biophysics 1955;54:558-59.

51. Coronary Drug Project Research Group. The coronary drug project: Clofibrate and niacin in coronary disease. JAMA 1975;231:360-81.

52. Canner PL Link niacin to longevity after an M.I. Abstract. J. American College Cardiology 1985;5:442.

53. Boyle E. The Vitamin B-3 therapy. A second communication to AA's physicians. Ed. Bill Wilson. 1968.

54. Hoffer A. The effect of adrenochrome and adrenolutin on the behavior of animals and the psychology of man. Int. Rev. of Neurobiology 1962;4:307-71.

55. Grof S, Vojtechovsky M, Horackova E. Poruchy asociativniho myslent pri ruznyuch experimentalnich psychozach. Activitas Nervosa Superior 1961;3:216-17.

56. Vojtechovsky M, Grof S, Vitek V.: A clinical and experimental study of the central effects of adrenochrome. Czech. Psychiat. 1962;58:383-93.

57. Grof S, Vojtechovsky M, Vitek V, Prankova S. Clinical and experimental study of central effects of adrenochrome. J. Neuropsychiatry 1963;5:33-50.

58. Weckowicz TE. The effect of adrenochrome on learning in albino rats. Ph.D. Thesis, University of Saskatchewan. Saskatoon, Saskatchewan, Canada, 1962.

59. Taborsky RG. Indoxyl derivatives: Potential psychotropic metabolites. Int. J. Neuropharmacol. 1968;7:483-86.

60. Hoffer A. The adrenochrome hypothesis of schizophrenia revisited. J. Orthomolecular Psychiatry 1981;10: 90-118.

61. Graham DG. On the origin and significance of neuromelanin. Arch. Path. and Lab. Med. 1979;103:359-62.

62. Yaryura-Tobias JA and Diamond B. Levodopa-nicotinic acid interaction in psychiatric patients. Schizophrenia 1971; 3:177-80.

63. Bender DA, Eall CJ, Lees AJ. Niacin depletion in Parkinsonian patients treated with l-dopa, benzerazide and carbidopa. Clin. Science 1979; 56: 89-93.

64. Szatmari A, Hoffer A, Schneider R. The effect of adrenochrome and niacin on the electroencephalogram of epileptics. Am. J. Psychiat. 1955;3:603-16.

65. Schwarz BE, Sem-Jacobsen CW, Petersen MC. Effects of mescaline, LSD-25 and adrenochrome on depth electrograms in men. AMA Arch. Neur. Psychiatry 1956;75 579-87.

66. Pritchard M. Prognosis of schizophrenia before and after pharmacotherapy. British J. of Psychiatry 1967;113:1345-59.

67. Bockoven JS and Solomon HC. Comparison of two five-year follow-up studies: 1947-1952 and 1967 to 1972. Am. J. Psychiatry 1975;132:796-801.

68. Hoffer A and Osmond H. Treatment of schizophrenia with nicotinic acid – a ten year follow-up. Acta Psychiatrica Scand. 40:171-89.

69. Hoffer A and Osmond H. How to Live with Schizophrenia. New York, NY: University Books, Inc., 1966, 1978.

70. Hoffer A, Osmond H, Callbeck MJ, Kahan I. Treatment of Schizophrenia with nicotinic acid and nicotinamide. J. Clin. Exper. Psychopath. 1957;18:131-58.

71. Clancy J, Hoffer A, Lucy J, Osmond H, Smythies J, Stefaniuk B. Design and planning in psychiatric research as illustrated by the Weyburn Chronic Nucleotide Project. Bull. Ment. Clinic 1954;18:147-53.

72. Wittenborn JR. A search for responders to niacin supplementation. Arch. Gen. Psychiatry 1974;31:547-52.

73. Osmond H and Hoffer A. Massive niacin treatment in schizophrenia. Review of a nine-year study. The Lancet 1962;1:316-20.

74. Osmond H and Hoffer A. Schizophrenia and suicide. J. of Schizophrenia 1967;1:54-64.

75. Osmond H and Hoffer A. Schizophrenia and suicide. J. Orthomolecular Psychiatry 1978;7: 57-67.

76. Rudin O. The major psychoses and neuroses as Omega-3 essential fatty acid deficiency syndrome: Substrate pellagra. Biol. Psychiatry 1981;16: 837-50.

77. Rudin DO. The dominant diseases of modernized societies as Omega-3 essential fatty acid deficiency syndrome: Substrate beri-beri. Medical Hypotheses 1982;8:17-47.

78. Horrobin DF. Schizophrenia as a prostaglandin deficiency disease. The Lancet 1977;1:936-37.

79. Horrobin DF. Schizophrenia: Reconciliation of the dopamine, prostaglandin and opioid concepts and the role of the pineal. The Lancet 1979;1:529-30.

Dehydroepiandrosterone: Biological Effects and Clinical Significance

By Alan R. Gaby (MD)

(Reprinted from Alternative Medicine Review *1996;1(2):60-69, by permission of Thorne Research, Inc.*

ABSTRACT

Dehydroepiandrosterone (DHEA) is a steroid hormone secreted in greater quantity by the adrenal glands than any other adrenal steroid. For many years, scientists assumed that DHEA merely functioned as a reservoir upon which the body could draw to produce other hormones, such as estrogen and testosterone. However, the recent identification of DHEA receptors in the liver, kidney, and testes of rats strongly suggests that DHEA may have specific physiologic actions of its own. Circulating levels of DHEA decline progressively with age; this age-related decline does not occur with any of the other adrenal steroids. Epidemiologic evidence indicates that higher DHEA levels are associated with increased longevity and prevention of heart disease and cancer, suggesting that some of the manifestations of aging may be caused by DHEA deficiency.

Animal and laboratory data indicate that administration of DHEA may prevent obesity, diabetes, cancer (breast, colon and liver), and heart disease; enhance the functioning of the immune system; and prolong life. In humans, evidence exists that DHEA might be associated with autoimmune diseases, such as lupus, rheumatoid arthritis, and multiple sclerosis; chronic fatigue syndrome; acquired immunodeficiency syndrome (AIDS); allergic disorders; osteoporosis; and Alzheimer's disease. Although administration of DHEA appears to be safe, its long-term effects are unknown, and it is possible that adverse consequences will become evident with chronic use. It is, therefore, important that this hormone be used with care and that practitioners err on the side of caution when contemplating DHEA supplementation.

INTRODUCTION

Dehydroepiandrosterone (DHEA) (see Figure 1) is a steroid hormone secreted by the adrenal glands and to a lesser extent by the testes and ovaries. First identified in 1934, DHEA was subsequently shown to be produced in greater quantity than any other adrenal steroid. However, although circulating levels of DHEA and its ester DHEA-sulfate (DHEA-S) are 20 times higher than those of any other adrenal steroid, the function of DHEA in the body was, until recently, unknown. Since DHEA can be converted into other hormones, including estrogen and testosterone, scientists assumed that DHEA is merely a "buffer hormone;" i.e., a reservoir upon which the body can draw to produce the other hormones (see Figure 2). However, the recent identification of DHEA receptors in the liver, kidney, and testes of rats strongly suggests that DHEA has specific physiologic actions of its own.[1]

During the past several years, there has been a great deal of interest in DHEA as a possible anti-aging hormone and as a potential treatment for a wide array of medical conditions. This interest has been sparked by two different lines of evidence. First, circulating levels of DHEA decline progressively with age; the levels in 70-year-old individuals are only about 20% as high as those in young adults. This age-related decline does not occur with any of the other adrenal steroids. Furthermore, epidemiologic evidence suggests that higher DHEA levels are associated with increased longevity and prevention of heart disease and cancer. It has, therefore, been suggested that some of the manifestations of aging may be caused by DHEA deficiency.

Second, numerous animal studies have shown that administration of DHEA prevents obesity, diabetes, cancer, and heart disease; enhances the functioning of the immune system; and prolongs life.[2] Since most of these studies were done in rodents, which have little circulating DHEA, it is not clear whether the results have relevance to human health. However, a growing body of human research, combined with the intriguing observations of innovative clinicians, suggests that DHEA may indeed have value in the treatment of various medical conditions. If this hormone can be convincingly shown to retard the aging process and to fight certain diseases, then DHEA therapy will be recognized as a major breakthrough in clinical medicine.

DHEA AS AN "ANTI-AGING" HORMONE

Preliminary results in mice suggest that DHEA might retard the aging process. Animals treated with this hormone looked younger, had glossier coats, and less gray hair than control animals.[3]

Figure 1: Structure of Dehydroepiandrosterone (DHEA)

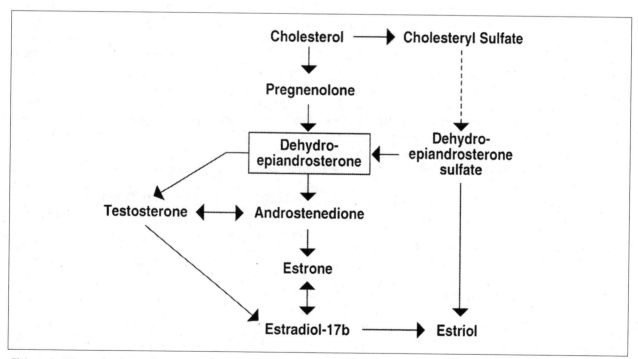

Figure 2: Biosynthetic Pathways of Dehydroepiandrosterone (DHEA) and Its Metabolites

In a recent study, 30 individuals between the ages of 40 and 70 years received 50 mg per day of DHEA or a placebo, each for 3 months, in double-blind crossover fashion. During DHEA treatment, a remarkable increase in physical and psychological well-being was reported by 67% of the men and 84% of the women. There was no change in libido and no side effects were seen.[4]

In my experience, elderly patients who suffer from weakness, muscle wasting, tremulousness, fatigue, depression, declining memory, and other signs of aging frequently have serum DHEA-S levels near or below the lower limit of normal. Treatment with DHEA (usually 5-10 mg per day for women and 10-20 mg per day for men) often results in improved mood, energy, memory, appetite, and skin color, sometimes after as little as 2 weeks. With continued treatment, the benefits may become even more pronounced and muscle wasting may be partially reversed.

Cancer Prevention

Administration of DHEA inhibited tumor formation in a strain of mice that develops spontaneous breast cancer.[5] DHEA also has been shown to prevent chemically-induced colon and liver cancers, as well as skin papillomas in mice.[6,7,8] Premenopausal women with breast cancer had significantly lower plasma levels of DHEA than age-matched controls without breast cancer, whereas postmenopausal women with breast cancer had significantly higher DHEA levels than age-matched controls.[9] In another study, women with DHEA levels in the highest tertile were 60% less likely to develop breast cancer than were women in the lowest tertile.[10] In a prospective case-control study, serum DHEA and DHEA-S levels were significantly lower in individuals who subsequently developed bladder cancer than in those who did not.[11]

These findings suggest that DHEA has anti-cancer activity and that low DHEA levels might be a risk factor for cancer. However, additional research must be done before guidelines can be developed regarding DHEA therapy and cancer. The observation that some postmenopausal women with breast cancer have elevated DHEA levels, and the fact that DHEA is converted in part to estrogen and testosterone should be cause for concern. It is not known whether the possible anti-cancer effects of DHEA might be stronger than the prostate cancer-promoting effects of additional testosterone or the breast cancer-promoting effects of additional estrogen. Until those questions can be answered, DHEA therapy should be approached with caution in patients who are at risk for developing hormone-dependent cancers.

Effects on Immune Function

DHEA exerts a number of different effects on the immune system. Some of these effects appear to result from the anti-glucocorticoid actions of DHEA. For example, in mice DHEA antagonized the suppressive effects of dexamethasone on lymphocyte proliferation and prevented glucocorticoid-induced thymic involution.[12,13] Administration of DHEA also has been shown to preserve immune competence in burned mice, an effect that extends beyond its anti-glucocorticoid action.[14,15] Administration of DHEA also protected against acute lethal infections with coxsackie virus B4 and herpes simplex type 2 encephalitis in mice. DHEA appeared to act by preventing the suppression of immune competence caused by the viral infections.[16]

DHEA has also been shown to influence immune function in humans. In a double-blind study, administration of 50 mg per day of DHEA to postmenopausal women (mean age, 56.1 years) produced a two-fold increase in natural killer cell activity and a 6% decrease in the proportion of helper T cells.[17] While the increase in natural killer cell activity might be expected to enhance immune surveillance against cancer and viral infections, the decline in helper T cells could have adverse consequences. On the other hand, since DHEA is known to mediate T cell responses,[18] the decline in helper T cells merely could be a reflection of enhanced T cell function. Although the implications of these changes in immune function are not entirely clear, it should be noted that 50 mg per day of DHEA has been shown to produce supraphysiologic serum levels in postmenopausal women.[19] Lower doses may therefore be more appropriate and might result in more clear-cut improvements in immune function.

Treatment of Autoimmune Diseases

The potential value of DHEA as a treatment for autoimmune disease was suggested by the observation that DHEA reduced the severity of renal damage in the NZB x NZW mouse, an animal model of spontaneous lupus. A clinical trial was therefore performed with ten women suffering from mild or moderate systemic lupus erythematosus (SLE).[20] Each patient received 200 mg per day of DHEA for 3 to 6 months. Eight of the 10 patients reported improvements in overall well-being, fatigue, energy, and/or other symptoms. For the group as a whole there was significant improvement in the physician's overall assessment of disease activity. After 3 months, the average prednisone requirement had decreased from 14.5 to 9.4 mg per day. Of three patients with significant

proteinuria, two showed marked reductions and one a modest reduction in protein excretion. There was no significant correlation between changes in serum DHEA or DHEA-S levels and clinical response. In addition, pre-treatment levels of these hormones did not predict clinical response. Side effects were limited to mild or moderate acneiform dermatitis and mild hirsutism.

Administration of relatively large doses of DHEA has also been reported to increase stamina and improve the sense of well-being in patients with multiple sclerosis.[21]

During the past 5 years, a number of practitioners have been prescribing DHEA for patients with autoimmune disease. Pre-treatment plasma levels of DHEA or DHEA-S are usually below normal in patients receiving prednisone or related drugs, because these medications cause adrenal suppression. However, in my experience, DHEA-S levels are also frequently low in patients with autoimmune disease who are not receiving corticosteroids.

I have treated a 76-year-old female patient with rheumatoid arthritis who was being maintained on 5 mg per day of prednisone. After taking 10 mg per day of DHEA for several weeks, her joint symptoms improved and she was able to wean off the prednisone. Another woman with poorly controlled dermatomyositis had marked clinical improvement and was able to reduce her prednisone by 50% after receiving 10 mg of DHEA, twice a day. A female patient with a 3-year history of persistent bleeding due to inflammatory bowel disease reported no further bleeding after taking 15 mg per day of DHEA. Two other women with SLE had clinical improvements with DHEA. However, low doses were not effective in these cases; results became apparent only after the dose was increased to around 100 mg per day or more.

Lamson has given DHEA to six patients with ulcerative colitis that had failed to respond to a combination of conventional therapy and nutritional treatments. In all six cases, the bleeding, diarrhea, and overall condition improved.[22]

Some patients with chronic fatigue syndrome (CFS) have also improved clinically with DHEA therapy. However, since cortisol deficiency appears to be the primary problem in some patients with CFS and, since DHEA can antagonize the effects of cortisol, DHEA therapy might actually cause some patients with CFS to worsen. It is important, therefore, to measure both DHEA and cortisol levels before treating CFS patients with DHEA.

Acquired Immunodeficiency Syndrome

Preliminary evidence suggests that DHEA might play a role in acquired immunodeficiency syndrome (AIDS). In one study, DHEA inhibited the replication of HIV, the virus believed to cause AIDS.[23] In addition, DHEA has been shown to enhance the immune response to viral infections. Furthermore, DHEA levels are low in people infected with HIV and these levels decline even more as the disease progresses to full-blown AIDS.[24] In a study of 108 HIV-infected men with marginally low helper T-cell counts (between 200 and 499), those with serum DHEA levels below normal were 2.34 times more likely to progress to AIDS than were men with normal DHEA levels.[25] These studies suggest that DHEA deficiency might be one of the factors contributing to immune system failure in HIV-infected patients.

To date, only one clinical trial has tested the effect of giving DHEA to HIV-infected patients. Although DHEA did not improve CD4 counts or serum p24 antigen levels,[26] the dosage used (750-2,250 mg per day) seems excessively large, possibly beyond the "therapeutic window" in which DHEA exerts its beneficial effects. The concept of a therapeutic window clearly has been demonstrated for cortisol (the other major adrenal steroid). For example, cortisol is known to enhance immune function at physiologic levels. However, both a deficiency and an excess of cortisol result in impaired immune function. Future trials of DHEA in HIV-infected patients should therefore use lower doses, perhaps 50-200 mg/day.

Allergic Disorders

Eight patients with severe attacks of hereditary angioedema were treated with 37 or 74 mg per day of DHEA-S (equivalent to 25 or 50 mg, respectively, of DHEA) every 1 to 3 days, for 3 to 29 months. DHEA-S treatment resulted in a dramatic clinical improvement in all eight patients.[27]

Practitioners who use DHEA have observed that treatment sometimes reduces the severity of food or chemical allergies. I have seen several patients with multiple chemical sensitivities who responded to physiologic doses of DHEA (5-15 mg per day for women, 10-30 mg per day for men). However, it is difficult to predict which patients will improve.

Subnormal serum levels of DHEA-S are common in asthmatics. DHEA deficiency might result, in part, from corticosteroid-induced adrenal suppression. However, low levels of DHEA-S were also found in 21% of asthmatics who were not taking steroids.[28] DHEA deficiency may also result from long-term administration of inhaled corticosteroids. In a study

of 36 post-menopausal asthmatic women, those who were receiving at least 1 mg per day of beclomethasone dipropionate had nearly a 50% reduction in serum DHEA levels, compared with women who were not receiving the drug. Apparently, inhaled corticosteroids are absorbed in amounts sufficient to cause some degree of adrenal suppression.[29]

I have seen two female patients with long-standing asthma who had clinical improvement after receiving 10 mg per day of DHEA. In one of these patients, chronic nasal polyps also disappeared, much to the surprise of her otolaryngologist.

Obesity

Administration of DHEA prevented the development of obesity in genetically obese mice.[30] However, studies in humans have so far failed to demonstrate a role for DHEA in the treatment of obesity.

Cardiovascular Disease

Administration of DHEA reduced the severity of atherosclerosis in cholesterol-fed rabbits.[31] DHEA-S also has been shown to have digitalis-like activity, accounting for 62-100% of the total plasma digitalis-like factors in 11 healthy adults.[32]

Mean plasma DHEA-S levels were significantly lower in men with a history of heart disease than in men without such a history. In men with no history of heart disease at baseline, a low plasma DHEA-S level (less than 140 mcg/dl) was associated with a more than three-fold increase in the age-adjusted risk of death from cardiovascular disease.[33] Similar findings have been reported by others,[34] although another epidemiologic investigation found only a modest protective effect of DHEA.[35]

In women, no inverse association was found between DHEA-S levels and cardiovascular disease. In fact, cardiovascular death rates were highest in women in the upper tertile of DHEA-S levels and lowest in women in the middle tertile (a U-shaped distribution).[36]

Osteoporosis

At the time of menopause, the amount of DHEA manufactured by the ovaries declines. And, even though the ovaries are not the major source of DHEA, serum DHEA levels decline by more than 60% after menopause.[37]

The possible relationship between DHEA deficiency and osteoporosis was suggested by a study of women with Addison's disease (adrenal failure). In these patients, the onset of menopause was followed by an unusually rapid rate of bone loss. This accelerated bone loss was associated with marked reductions in plasma concentrations of DHEA and testosterone (94% and 63% lower, respectively, than those of healthy post-menopausal women).[38] These findings suggest that DHEA and/or testosterone is essential for the maintenance of bone mass in post-menopausal women.

In another study, bone mineral density was measured at the lumbar spine, hip, and radius in 105 women, aged 45-69. Fifty women had normal measurements, whereas 55 had low bone density. The average serum DHEA-S level was 60% lower in the women with low bone density than in those with normal bones. Women with low DHEA values were 40 times more likely to have osteoporosis than were women with normal DHEA levels. In contrast, there was no relationship between estrogen levels and bone density.[39] In a group of post-menopausal women, there was a significant positive correlation between bone mineral content of the distal radius and ulna and age-adjusted serum DHEA levels.[40]

There are several mechanisms by which DHEA might prevent osteoporosis. First, one of the breakdown products of DHEA, a compound called 5-androstene-3ß, 17ß-diol, is known to bind strongly to estrogen receptors. Therefore, DHEA, like estrogen, might exert an inhibitory effect on bone resorption. Second, there is evidence that androgens (a class of hormones that includes DHEA and testosterone) stimulate bone formation and calcium absorption.[41] Third, the partial conversion of DHEA to estrogen and testosterone would be expected to provide additional protection against bone loss.

I often recommend low doses of DHEA (usually 5-10 mg per day) for postmenopausal women whose serum DHEA-S levels are near or below the lower limit of normal. In some cases, DHEA relieves symptoms such as hot flashes that are usually attributed to estrogen deficiency. A combination of DHEA and identical to-natural progesterone (usually given as a topical cream) may be more effective against hot flashes than either treatment alone.

Dementia

In one study, intracerebroventricular administration of DHEA or DHEA-S improved the results of certain memory tests in mice.[42] Some investigators have found low levels of DHEA in patients with Alzheimer's disease.[43] However, others have failed to confirm those observations.[44] In a small, uncontrolled trial, administration of DHEA appeared to produce modest improvements in cognition and behavior in a group of male patients with Alzheimer's disease.[45]

Diabetes

Administration of 0.4% DHEA in the diet reversed hyperglycemia, preserved beta-cell function, and increased insulin sensitivity in genetically diabetic mice.[46] Although DHEA has been reported to ameliorate insulin resistance in one patient with diabetes,[47] very large doses of DHEA (1,600 mg/day for 28 days) caused mild abnormalities of glucose metabolism.[48] The role of DHEA in the over all management of diabetes, therefore, remains unclear.

Toxicity of DHEA

For a steroid hormone, DHEA appears to be relatively safe. Administration of 1,600 mg per day for 28 days to healthy volunteers resulted in some degree of insulin resistance, but no other significant side effects occurred. In the SLE studies, 200 mg per day given for a number of months was well tolerated, with the exception of mild to moderate acne and occasional mild hirsutism.

Addition of 0.6% DHEA to the diet of rats reduced body weight and enhanced the development of chemically-induced pre-neoplastic pancreatic lesions.[49] Although that dose of DHEA is extremely large (the equivalent human dose would be approximately 2,000 mg per day), this report indicates that DHEA is by no means innocuous and, therefore, it should be used with caution.

USING DHEA WISELY AND SAFELY

As this review suggests, DHEA shows promise for preventing age-related decline and as a treatment for certain diseases. Innovative practitioners, therefore, have begun prescribing DHEA for their patients and the public is becoming increasingly interested in this purported "anti-aging pill."

Although DHEA appears to be safe, its long-term effects are unknown. It is possible that adverse consequences will become evident with chronic use. It is, therefore, important that we use this hormone with care and err on the side of caution. Although some practitioners are routinely prescribing 50 mg per day for healthy women and 100 mg per day for healthy men, those doses may be supraphysiologic, raising legitimate concerns about the long-term safety of such dosages.

Unlike hydrocortisone (cortisol), for which the physiologic replacement dose is known, it is not clear what the physiologic dose of DHEA is. However, it may be lower than many practitioners believe. I have treated one patient with severe adrenal insufficiency who had a clear response to 15 mg per day of DHEA. She experienced marked clinical improvement at that dose, and her serum level of DHEA-S increased from barely detectable to well above the lower limit

of normal. Another female patient with a history of bilateral adrenalectomy reported marked symptom relief with DHEA doses as low as 5-10 mg per day.

In my practice, I usually prescribe 5-15 mg per day for women and 10-30 mg per day for men. Many patients have obvious improvements with these doses. With some patients who have not improved, I have prescribed larger doses, but in most cases, the larger doses were not helpful either. The one exception has been patients with lupus or other autoimmune diseases, who sometimes needed as much as 100 mg per day or more to obtain benefit. I typically prescribe DHEA in capsule form, in a base of hydroxymethylcellulose. In most cases, I recommend twice-a-day dosing, usually morning and evening.

Although serum measurements of DHEA and DHEA-S are available through most laboratories, it is not clear how closely one should rely on these measurements; nor is it clear whether DHEA or DHEA-S is the more reliable test. The normal range for DHEA-S as listed by my local laboratory is 350-4,300 ng/ml for women and 800-5,600 ng/ml for men. Many older individuals have values near or below the lower limit of normal. However, I prefer not to use an age-adjusted reference range (as published by some labs), since it seems that the age-related decline in serum DHEA-S is undesirable.

When DHEA therapy appears to be clinically indicated, I will consider treating a woman whose DHEA-S level is below 600 ng/ml and a man whose level is below 1,200 ng/ml. There are as yet no data on what constitutes an optimum serum level. Consequently, I continue to err on the side of caution by using low doses of DHEA.

There are also no data available concerning long-term administration of DHEA. While lifetime replacement therapy seems appropriate for patients with age-related DHEA deficiency, other patients should be assessed on a case-by-case basis.

I have found that about 10% of patients who are taking thyroid hormone develop symptoms of thyrotoxicosis after starting DHEA therapy. That observation is consistent with a report that DHEA potentiates the action of thyroid hormones.[50] Symptoms of thyroid over-treatment responded to a reduction in the thyroid-hormone dosage, and patients reported that they felt better on DHEA plus lower-dose thyroid hormone than they did on thyroid hormone alone.

In conclusion, DHEA appears to be one of the major therapeutic advances of the past 20 years. However, this powerful hormone must be utilized with caution in order to maximize its benefits and minimize its risks.

References

1. Kalimi M, Regelson W. Physicochemical characterization of [3H]DHEA binding in rat liver. Biochem Biophys Res Commun 1988;156:22-29.

2. Nestler JE. DHEA: a coming of age. Ann NY Acad Sci 1995;774:ix-xi.

3. Anonymous. Antiobesity drug may counter aging. Science News 1981;19(3):39.

4. Yen SSC, et al. Replacement of DHEA in aging men and women. Potential remedial effects. Ann NY Acad Sci 1995;774:128-42.

5. Schwartz AG. Inhibition of spontaneous breast cancer formation in female C3H (A vy/a) mice by long-term treatment with dehydroepiandrosterone. Cancer Res 1979;39:1129-32.

6. Nyce JW, et al. Inhibition on 1,2-dimethylhydrazine-induced colon tumorigenesis in Balb/c mice by dehydroepiandrosterone. Carcinogenesis 1984;5:57-62.

7. Mayer D, et al. Modulation of liver carcinogenesis by dehydroepiandrosterone. In Kalimi M, Regelson W. The Biological Role of Dehydroepiandrosterone. New York: de Gruyter, 1990:361-85.

8. Pashko L, et al. Dehydroepiandrosterone (DHEA) and 3-beta-methylandrost-5-en-17-one: inhibitors of 7,12-dimethylbenz[a]anthracene (DMBA)-initiated and 12-O-tetradecanoylphorbol-13-acetate (TPA)-promoted skin papilloma formation in mice. Carcinogenesis 1984;5:463-66.

9. Zumoff B, et al. Abnormal 24-hr mean plasma concentrations of dehydroisoandrosterone and dehydroisoandrosterone sulfate in women with primary operable breast cancer. Cancer Res 1981;41:3360-63.

10. Helzlsouer KJ, et al. Relationship of prediagnostic serum levels of dehydroepiandrosterone and dehydroepiandrosterone sulfate to the risk of developing premenopausal breast cancer. Cancer Res 1992;52:1-4.

11. Gordon GB, et al. Serum levels of dehydroepiandrosterone and its sulfate and the risk of developing bladder cancer. Cancer Res 1991;51:1366-69.

12. Blauer KL, et al. Dehydroepiandrosterone antagonizes the suppressive effects of dexamethasone on lymphocyte proliferation. Endocrinology 1991;129:3174-79.

13. May M, et al. Protection from glucocorticoid induced thymic involution by dehydroepiandrosterone. Life Sci 1990;46:1627-31.

14. Araneo BA, et al. Administration of dehydroepiandrosterone to burned mice preserves normal immunologic competence. Arch Surg 1993;128:318-25.

15. Araneo B, Daynes R. Dehydroepiandrosterone functions as more than an antiglucocorticoid in preserving immunocompetence after thermal injury. Endocrinology 1995;136:393-401.

16. Loria RM, et al. Protection against acute lethal viral infections with the native steroid dehydroepiandrosterone (DHEA). J Med Virol 1988;26:301-14.

17. Casson PR, et al. Oral dehydroepiandrosterone in physiologic doses modulates immune function in post-menopausal women. Am J Obstet Gynecol 1993;169:1536-39.

18. Regelson W, et al. Dehydroepiandrosterone (DHEA) - the "mother steroid." I. Immunologic action. Ann NY Acad Sci 1994;719:553-63.

19. Casson PR, et al. Replacement of dehydroepiandrosterone enhances T-lymphocyte insulin binding in post-menopausal women. Fertil Steril 1995;63:1027-31.

20. Van Vollenhoven RF, et al. An open study of dehydroepiandrosterone in systemic lupus erythematosus. Arthritis Rheum 1994;37:1305-10.

21. Calabrese VP, et al. Dehydroepiandrosterone in multiple sclerosis: positive effects on the fatigue syndrome in a non-randomized study. In Kalimi M, Regelson W. The Biological Role of Dehydroepiandrosterone. New York: de Gruyter, New York, 1990: 95-100.

22. Dr. Davis Lamson. Personal communication.

23. Henderson E, et al. Dehydroepiandrosterone (DHEA) and synthetic DHEA analogs are modest inhibitors of HIV-1 IIIB replication. AIDS Research and Human Retroviruses 1992;8:625-31.

24. Merril CR, et al. Reduced plasma dehydroepiandrosterone concentrations in HIV infection and Alzheimer's disease. In Kalimi M, Regelson W. The Biological Role of Dehydroepiandrosterone. New York: de Gruyter, 1990:101-105.

25. Jacobson MA, et al. Decreased serum dehydroepiandrosterone is associated with an increased progression of human immunodeficiency virus infection in men with CD4 cell counts of 200-499. J Infect Dis 1991;164:864-68.

26. Dyner TS, et al. An open-label dose-escalation trial of oral dehydroepiandrosterone tolerance and pharmacokinetics in patients with HIV disease. J Acquired Immune Deficiency Syndromes 1993;6:459-65.

27. Koo E, et al. Effect of dehydroepiandrosterone on hereditary angioedema. Klin Wochenschr 1983;61:715-17.

28. Dunn PJ, et al. Dehydroepiandrosterone sulphate concentrations in asthmatic patients: pilot study. NZ Med J 1984;97:405-408.

29. Smith BJ, et al. Does beclomethasone dipropionate suppress dehydroepiandrosterone sulphate in postmenopausal women? Aust NZJ Med 1994;24:396-401.

30. Cleary MP, et al. Effect of dehydroepiandrosterone on growth in lean and obese Zucker rats. J Nutr 1984;114:1242-51.

31. Gordon GB, et al. Reduction of atherosclerosis by administration of dehydroepiandrosterone. J Clin Invest 1988;82:712-20.

32. Vasdev S, et al. Dehydroepiandrosterone sulfate as a digitalis like factor in plasma of healthy human adults. Res Commun Chem Pathol Pharmacol 1985;49:387-99.

33. Barrett-Connor E, et al. A prospective study of dehydroepiandrosterone sulfate, mortality, and cardiovascular disease. N Engl J Med 1986;315:1519-24.

34. Mitchell LE, et al. Evidence for an association between dehydroepiandrosterone sulfate and nonfatal, premature myocardial infarction in males. Circulation 1994;89:89-93.

35. Newcomer LM, et al. Dehydroepiandrosterone sulfate and the risk of myocardial infarction in US male physicians: a prospective study. Am J Epidemiol 1994;140:870-75.

36. Barrett-Connor E, Khaw K-T. Absence of an inverse relation of dehydroepiandrosterone sulfate with cardiovascular mortality in postmenopausal women. N Engl J Med 1987;317:711.

37. Monroe SE, Menon KMJ. Changes in reproductive hormone secretion during the climacteric and post-menopausal periods. Clin Obstet Gynecol 1977;20:113-22.

38. Devogelaer JP, et al. Bone mineral density in Addison's disease: evidence for an effect of adrenal androgens on bone mass. Br Med J 1987;294:798-800.

39. Szathmari M, et al. Dehydroepiandrosterone sulphate and bone mineral density. Osteoporosis Int 1994;4:84-88.

40. Brody S, et al. Adrenal steroids in post-menopausal women: Relation to obesity and to bone mineral content. Maturitas 1987;9:25-32.

41. Taelman P, et al. Persistence of increased bone resorption and possible role of dehydroepiandrosterone as a bone metabolism determinant in osteoporotic women in late post-menopause. Maturitas 1989;11:65-73.

42. Flood JF, et al. Memory-enhancing effects in male mice of pregnenolone and steroids metabolically derived from it. Proc Natl Acad Sci 1992;89:1567-71.

43. Sunderland T, et al. Reduced plasma dehydroepiandrosterone concentrations in Alzheimer's disease. Lancet 1989;2:570.

44. Leblhuber F, et al. Dehydroepiandrosterone sulphate in Alzheimer's disease. Lancet 1990;336:449.

45. Schneider LS, et al. Plasma dehydroepiandrosterone sulfate in Alzheimer's disease. Biol Psychiatry 1992;31:205-208.

46. Coleman DL, et al. Therapeutic effects of dehydroepiandrosterone (DHEA) in diabetic mice. Diabetes 1982;31:830-33.

47. Buffington CK, et al. Case report: amelioration of insulin resistance in diabetes with dehydroepiandrosterone. Am J Med Sci 1993;306:320-24.

48. Mortola JF, Yen SSC. The effects of oral dehydroepiandrosterone on endocrinemetabolic parameters in postmenopausal women. J Clin Endocrinol Metab 1990;71:696-704.

49. Tagliaferro AR, et al. Enhancement of pancreatic carcinogenesis by dehydroepiandrosterone. Adv Exp Med Biol 1992;322:119-29.

50. McIntosh MK, Berdanier CD. Influence of dehydroepiandrosterone (DHEA) on the thyroid hormone status of BHE/cdb rats. J Nutr Biochem 1992;3:194-99.

Environmental Chemicals and Endocrinology

Paul Goettlich, President of mindfully.org

(Reprinted by permission of the author)

ENDOCRINE DISRUPTORS

Endocrine disruptors are man-made synthetic chemicals and natural phytoestrogens (naturally occurring plant-derived estrogen, a hormone) that interfere with the endocrine systems of humans and animals by mimicking, blocking, and/or interfering in some manner with the natural instructions of hormones to cells. The resulting disruption creates many problems with physical development, sex, reproduction, brain development, behavior, temperature regulation, and more. Other names for endocrine disruptors (EDs) are hormone mimics and hormone copycats. The bodies of animals and humans depend upon a complexly integrated and timed series of events, of which the delivery of hormones to various organs is vital. When the delivery timing and/or amount of a hormone is upset, the results can be devastating and permanent.

The most insidious of the EDs are man-made synthetic chemicals. We are routinely exposed to them in most areas of our daily lives at home, work, and play. Known and suspected EDs come in things we have been led to believe have been thoroughly tested for the safety of our health and environment. These types of products include cosmetics, sunscreens, perfumes, soaps, detergents, solvents, dental sealants, pharmaceuticals, such as birth control pills, clear plastic baby bottles, and some water bottles. The list also includes many chemicals in plastics, such as PVC, polystyrene (a.k.a. Styrofoam), and others, and pesticides, such as Monsanto's Roundup and many others. A few heavy metals are included — arsenic, cadmium, lead, mercury. Other known EDs are the 209 PCBs (polychlorinated biphenyls), 75 dioxins, and 135 furans. The creation can be intentional and/or as byproducts of industrial processes, such as the production of paper that uses chlorine bleaching, as well as the incineration of chlorine containing products, such as PVC burned in incinerators, residential backyard barrels, or accidentally in residential fires.

PVC is made into toys, teethers, clothing, raincoats, shoes, and building products, such as windows, siding, roofing, and flooring. Other uses are for hospital blood bags, IV bags, tubing, and other medical devices. Polystyrene, another ED, is made into food containers for meats, fish, cheeses, yogurt, foam and clear clamshell containers, foam and rigid plates, clear bakery containers, packaging "peanuts", foam packaging, audio cassette housings, CD cases, and disposable cutlery. Other specific EDs are oil refining, burning coal and oil for energy, all car and truck exhaust, and cigarette smoke.

Endocrine Disruptors

Persistent Organohalogens: dioxins and furans, PBBs, PCBs, hexachlorobenzene, octachlorostyrene, pentachlorophenol

Pesticides: 2,4,5-T, 2,4-D, alachlor, aldicarb, d-trans allethrin, amitrole, atrazine, benomyl, beta-HCH, carbaryl, chlordane, chlozolinate, -cyhalothrin, cis-nonachlor, cypermethrin, DBCP, DDT, DDT metabolites, dicofol, dieldrin, endosulfan, esfenvalerate, ethylparathion, fenvalerate, h-epoxide, heptachlor, iprodione, kelthane, kepone, ketoconazole, lindane, linurone, malathion, mancozeb, maneb, methomyl, methoxychlor, metiram, metribuzin, mirex, nitrofen, oxychlordane, permethrin, procymidone, sumithrin, synthetic pyrethroids, toxaphene, trans-nonachlor, tributyltin oxide, trifluralin, vinclozolin, zineb, ziram

Phthalates: Di-ethylhexyl phthalate (DEHP), Butyl benzyl phthalate (BBP), Di-n-butyl phthalate (DBP), Di-n-pentyl phthalate (DPP), Di-hexyl phthalate (DHP), Di-propyl phthalate (DprP), Dicyclohexyl phthalate (DCHP), Diethyl phthalate (DEP)

Other: Penta- to Nonyl-Phenols, Bisphenol A, Bisphenol F, Styrene dimers and trimers, Benzo(a)pyrene, ethane dimethane, sulphonate, tris-4-(chlorophenyl), methane, tris-4-(chlorophenyl), methanol, Benzophenone, N-butyl benzene, 4-nitrotoluene, 2,4-dichlo-rophenol, Cyanazine, Diethylhexyl adipate

Metals: arsenic, cadmium, lead, mercury

Pharmaceuticals: drug estrogens — birth control pills, DES, cimetidine

More EDs: ordinary household products (breakdown products of detergents and associated surfactants, including nonylphenol and octylphenol)

Some Health Effects of Endocrine Disruptors

- Birth defects
- Immunological disorders
- Reduced physical stamina
- Enlarges prostate and cancer
- Decreases in gross and fine eye-hand coordination
- Neurologic disorders
- Early uberty in young girls
- Genital birth defects (hypospadias and cryptorchidism)
- Developmental, behavior, and mood disorders: angers, inattention
- Decreased mental capacity
- Reduced motor skills
- Endometriosis
- Cancers: breast, colon, vaginal, cervix, testicular, brain, nervous system
- Diabetes mellitus
- Non-Hodgkin's lymphoma
- Reduced sperm counts
- Propensity to violence
- Intellectual retardation

Manufacturers of these chemicals know their dangers through their own research. Countless scientists and organizations have also warned them for many years. Not only do they refuse to test them adequately before marketing them, but also they have organized action groups spending many millions of dollars on public media campaigns to misinform us. Profit is the sole reason.

Chemical manufacturers claim that the scientists who urge caution with regards to EDs are but hysterical sensationalists. Something they like to scare us with is that ending production of these toxic chemicals would take jobs away from people. They also say that because only animal tests have been done, no proof exists that humans are being affected as other animals are. But through studies of industrial workers' health and accidents enough has been learned to strongly implicate EDs. When industry gets really scared they debunk any negative claim as being "junk science."

The estrogenic properties of bisphenol-A (BPA) was known as early as 1936, yet children now have their teeth coated with plastic containing BPA. The ADA denies any problem and goes on coating teeth. Food and drink cans are lined with it. Some plastic baby bottles contain it and other plasticizers. In April 1999, *Consumer Reports* Special Report advised parents to dispose of soft vinyl teethers and toys that infants sometimes suck or chew, and all clear, shiny plastic baby bottles, unless the manufacturer tells you they're not made of polycarbonate, which leaches BPA. They also advised them to replace the bottles with those made of glass or an opaque, less-shiny plastic (the plastic bottles are often colored). Shortly thereafter, in conjunction with American Council on Health and Science (ACSH), an industry-funded front group, family doctor C. Everett Koop strongly stated that there is no problem. His press release stated that polycarbonate bottles are safe and that the public should not listen to the "junk science" of the people that brought us the alar scare. Not only was alar proven to be as toxic as claimed, but Koop's argument in favor of polycarbonate bottles is wrought with contradictions.

The government doesn't test chemicals for safety. Nor do they regulate by the scientific standards that are possible today. Old regulations and laws govern the production and use of most chemicals and products on the market today. Each attempt at legislation is usually thwarted by industry.

The Endocrine Disruptors Screening and Testing Advisory Committee (EDSTAC), which convened between 1997 and 1998, was established to advise the EPA on a strategy for screening and testing new and existing chemicals for their potential to disrupt endocrine functions in humans and wildlife. Some of the EDSTAC recommendations are that EPA considers screening and testing 87,000 chemicals, to address environmental impacts, and focus on both human and ecological health. Sadly, Congress grossly underfunded the EPA for this project, and it hasn't a hope of progressing. In 1998, a rough estimate of its cost was $50 million, but EPA got only $3.2 million in fiscal year 1999. Industry has not offered to pay for any testing in spite of the fact that these highly suspect chemicals are all industry-produced.

Pesticides are a good example of regulations that were written — in complete disregard for public health— with only industry profits in mind. Without any testing at all, many pesticides are "grandfathered in," or approved for use because they were created before regulations. Pesticide testing is done by manufacturers and/or paid for by manufacturers. Even then, they are not tested as the final product sold in stores or to farmers. Only the "active ingredient' of a pesticide is tested, not its "inert ingredients," which can be as much as 99.99% of the product. Inerts can be significantly more toxic than the actives. The mixture of active and inerts can have a synergistic effect of multiplying the toxicity many times beyond that of each part. Many inerts are on restricted use lists, but as part of a "registered" pesticide they are permitted. To be registered means only that they are registered

and guarantees no safety or testing. The definition of "active" ingredient is that which is not inert. In order to protect industry profits, most inerts are proprietary, meaning that consumers do not have the right to know. The government administration is working hard at reducing our right to know.

Under the present risk assessment regulatory scheme, industry is allowed to produce potentially damaging chemicals until absolute proof of human harm exists. Presently, chemicals are regulated by risk assessment, which dictates how many people it is acceptable to kill before a chemical is restricted or banned. Chemicals are innocent until proven guilty. According to the well-established scientific method, scientists can support a hypothesis, but never absolutely prove it. Therefore, industry's demand of absolute proof that EDs can injure humans at extremely low levels is not possible. It is right that scientists observe the rules of scientific method in order to maintain standardization, but our policy makers should only be guided by it, not controlled by it.

Policy makers must consider the consequences of not taking action protective of public health. Action is similar to inaction in that both are intentional decisions with somewhat predictable outcomes. A chemical should be considered guilty until proven innocent, putting the burden of proof on the manufacturer rather than on the public. Safety testing should be completely independent of the manufacturer.

Since enough evidence of harm to humans, animals, and the environment already exists, many scientists have insisted that the "Precautionary Principle" be employed, which states: "When an activity raises threats to the environment or human health, precautionary measures should be taken, even if some cause-and-effect relationships are not fully established scientifically. In this context, the proponent of an activity, rather than the public, should bear the burden of proof." Key elements of the principle include taking precaution in the face of scientific uncertainty; exploring alternatives to possibly harmful actions; placing the burden of proof on proponents of an activity rather than on victims or potential victims of the activity; and using democratic processes to carry out and enforce the principle-including the public right to informed consent.

To make a blanket statement, short paper, or even a book that would cover all that you need to do to avoid endocrine disruptors would be an arduous task. Purchase less, consume less, waste less. Unlearn the lessons taught to us by industry and just use less. Always question yourself before buying, "Do I really need this product?" If you really need it, then ask,

"What can I use that's less toxic?"

Next, considering that our protective agencies are not what they claim to be, everyone must educate themselves on the environmental hazards that are right in their own homes. Industry prefers to keep us all ignorant of the harm caused by the many products we use. The products of concern are found in every area of our houses and properties. They range from cleaning products, paints and glues, lawn care products, and pet supplies to auto products, art supplies, cosmetics and foods. Especially vulnerable to these toxic products are the unborn, those in the womb, and those yet to come. Below is a list of things to do. Don't be overwhelmed by it. Take it one step at a time.

Don't smoke or drink alcohol.
Especially when pregnant! It can cause permanent damage to you and the unborn child.

Don't use lawn chemicals or any pesticides.
Especially when pregnant! Don't even think of being near them. Lawns are healthier without them.

Don't use makeup, hair sprays & coloring products or nail polish.
Especially when pregnant! Enjoy your own body and not the image that the media says you should want.

Avoid using strong chemicals, glues, paints, nail polish and remover, floor & carpet cleaners.
Get rid of all those name brands and use earth friendly products sparingly. If you must use chemicals, then wear industrial quality, gloves, eye protection and a mask with filters approved for each chemical being used. Once again … Definitely NOT when your pregnant!

Don't heat food or eat hot food in plastic containers, even the ones frozen dinners now come in. This includes Teflon coated cookware.
Chemicals from the plastic can be ingested with the food and could cause great problems for the unborn and you.

Purchase fresh organic produce, meats and milk free from rBGH
rBGH is a hormone to increase milk production in cows. It causes mastitis requiring lots of antibiotics in cows that can be passed on to humans, which in turn, can create new incurable diseases. Buy produce at your local farmers' market or join a buying club. Purchase local organic produce in season. Vegetarians have far fewer endocrine disruptors found in their

blood than people that consume meat. This is because incinerators that are as near as your back yard or as far away as thousands of miles release dioxin into the air when they burn chlorine containing materials like PVC plastic or pesticides. The dioxin falls on the grass that cows and cattle eat and accumulates in their fat and milk. Because of their longer life, dioxin accumulation is more critical in milk cows and beef cattle than chickens or other animals. Being at the top of the food chain, humans accumulate even more dioxin in their blood than the animals they eat. Taking that one step further, infants are at an even higher plane of the food chain because they consume the milk of their mothers'. While this is a major health concern, recent studies have shown that it is still better to breast feed than any of the alternatives.

Use fewer processed, prepackaged foods whenever possible.

Eat more fresh food, you'll get more nutritional value from your diet. And you'll be sure of what's in it!

Avoid canned goods unless absolutely a must.

The nutritional value is lower and some of the interior can coatings are toxic.

Avoid products with hydrogenated, partially hydrogenated fats and oelestra (a synthetic fat substitute).

While these types of fats and fat substitute are not currently thought to be EDs, they are found in snack foods or processed foods and can be bad for your health.

Don't stay in places that smell of chemicals.

Get out quickly. Don't wait to ask if the smell is safe. Probably the people around you know even less.

In general, substitute natural products for synthetic products whenever possible.

That's not an easy task. I've tried it myself. Do it one step at a time. Don't overwhelm yourself. Maybe pick out one thing a month to switch over to a more natural product. Seek out the metal, wooden, ceramic, and glass cook wear like your grandmother had. There are a lot of people that have been injured by synthetic chemicals during their production, use, disposal and/or by just being in the wrong place at the wrong time. Protect our future generations by making it your business to be one of the well-informed people.

References for Further Reading

1. Kaufman, RH, Adam E, Hatch EE, Noller K, Herbst A, Palmer JR, Hoover RN. Continued follow-up of pregnancy outcomes in diethylstilbestrol-exposed offspring. Obstetrics & Gynecology 2000;96(4):483-89.

2. Walsh LP, et al. Roundup inhibits steroidogenesis by disrupting steroidogenic acute regulatory (StAR) protein expression. Environmental Health Perspectives 2000;108(8).

3. Colborn T, et al. Hormones: Chemical Messengers That Work in Parts per Trillion. In: Our Stolen Future, New York, NY: Penguin, 1996 .

4. Mulvihill K. Agricultural pesticides linked to fetal death. Reuters Health 2001 Feb 13.

5. Brown D. Herbicides, diabetes linked in new study. Washington Post 2000 Oct 12.

6. Weisglas-Kuperus N, et al. Immunologic effects of background exposure to polychlorinated biphenyls and dioxins in Dutch preschool children. Environmental Health Perspectives 2000 Dec; 108(12).

7. Toloken S. Plastics possible culprits in early puberty. Plastics News 2001 Feb 12.

8. Colón I, et al. Identification of phthalate esters in the serum of young Puerto Rican girls with premature breast development. Environmental Health Perspectives 2000 Sep;108(9).

9. Legler JM, et al. Brain and other central nervous system cancers: Recent trends in incidence and mortality. Journal of the National Cancer Institute 199;.91(16):1382-90.

10. Buckley JD, et al. Pesticide exposures in children with non-Hodgkin lymphoma. Cancer 2000;89(11).

11. Anon. Child's exposure to pesticides hikes lymphoma risk. UniSci 2000 Nov 30.

12. Guillette EA, et al. An anthropological approach to the evaluation of preschool children exposed to pesticides in Mexico. Environmental Health Perspectives 1998 Jun;106(6).

13. Weidner IS, et al. Cryptorchidism and hypospadias in sons of gardeners and farmers. Environmental Health Perspectives 1998 Dec;106(12).

14. Gupta C. Reproductive malformation of the male offspring following maternal exposure to estrogenic chemicals. Proceedings of the Society for Experimental Biology and Medicine 2000 Jun;224:61-68.

15. Anon. Orange triggers infertility rising in Vietnam. XINHUA via NewsEdge Corporation 2001 Jan 12.

16. Anon. IDRC study shows high exposure to insecticides affects mental capacity. Learning Disabilities Association of Canada 2001 Feb 6.

17. Schmidt CW. Poisoning young minds. Environmental Health Perspectives 1999 Jun;107(6).

"Trade Secrets": The Latest in a Long Line of Conspiracies Charges

Samuel S. Epstein (MD), Chairman of the Cancer Prevention Coalition and Professor of
Environmental and Occupational Medicine, University of Illinois School of Public Health, Chicago

(Reprinted from SOURCE — Cancer Prevention Coalition — March 23, 2001, by permission)

Bill Moyers is to be warmly commended for his program "Trade Secrets." This PBS Special documents the chemical industry's conspiracy in denying information on the grave cancer risks to hundreds of thousands of workers manufacturing the potent carcinogen vinyl chloride (VC) and its polyvinyl chloride (PVC) product. As newsworthy is the fact that there is a decades-long track record of numerous such conspiracies involving a wide range of industries and chemicals, besides VC.

These conspiracies have resulted in an escalation in the incidence and mortality of cancer and chronic disease, among workers and the general public unknowingly exposed to toxics and carcinogens in the workplace, air, water and consumer products— food, household products, and cosmetics, and toiletries. This misconduct involves negligence, manipulation, suppression, distortion and destruction of health and environmental data by mainstream industries, their consultants and trade associations, notably the Chemical Manufacturers Association (CMA). These practices are so frequent as to preclude dismissal as exceptional aberrations and, in many instances, arguably rise to the level of criminality as illustrated below:

- Suppression of evidence from the early 1960s on the toxicity of VC by Dow Chemical, and on its carcinogenicity from 1970 by the VC/PVC industry and the CMA. Based on these findings, a blue ribbon committee of the American Association for the Advancement of Science charged in 1976 that: "Because of the suppression of these data (by the CMA), tens of thousands of workers were exposed without warning to toxic concentrations of VC."

- Suppression of evidence since the 1930s on the hazards of asbestos and asbestosis and lung cancer, by Johns-Manville and Raybestos-Manhattan, besides the Metropolitan Life Insurance Company. This information was detailed in industry documents dubbed the "Asbestos Pentagon Papers," released at 1978 Congressional Hearings.

- Suppression by Rohm and Haas of information, known since 1962 but not released until 1971, on the potent carcinogenicity of the resin bischloromethylether. This resulted in deaths from lung cancer of some 50 men, many non-smokers and under the age of 50.

- Suppression of carcinogenicity data on organochlorine pesticides: Aldrin/Dieldrin, by Shell Chemical Company since 1962; Chlordane/Heptachlor, by Velsicol Chemical Company since 1959; and Kepone, by Allied Chemical Company since the early 1960s.

- Falsification in the early 1970s of test data on the drug Aldactone and artificial sweetener Aspartame by Hazleton Laboratories under contract to G.D. Searle Company.

- Falsification and manipulation by Monsanto since the 1960s of data on dioxin and its contamination of products, including the herbicide Agent Orange, designed to block occupational exposure claims and tightening of federal regulations. This evidence was detailed in 1990 by Environmental Protection Agency's Office of Criminal Investigation which charged Monsanto with a "long pattern of fraud" and with reporting "false information" to the Agency.

- Fraudulent claims by Monsanto since 1985 that genetically engineered (rBGH) milk is indistinguishable from natural milk. These claims persist despite contrary evidence. Monsanto's reckless marketing in 1976 of plastic Coke bottles made from acrylonitrile, a chemical closely related to VC, prior to its testing for carcinogenicity and migration into the Coke. The bottles were subsequently banned after acrylonitrile was found to be a potent carcinogen contaminating the Coke.

- Destruction of epidemiological data on ethyleneimine and other chemicals by Dow and DuPont. This was admitted at 1973 Department

of Labor Advisory Committee meetings in response to challenges to produce data on whose basis industry had falsely claimed that these chemicals were not carcinogens.

- Destruction of test data on drugs, food additives, and pesticides as admitted in 1977 by Industrial Biotest Laboratories, under contract to major chemical industries.

- Failure of the mainstream cosmetics and toiletry industries to warn of the wide range of avoidable carcinogenic ingredients, contaminants, and precursors in their products used by the great majority of the U.S. population over virtually their lifetimes. (For supporting documentation of the above charges, see the author's: Testimony on White Collar Crime, H.R. 4973, before the Subcommittee on Crime of the House Judiciary Committee, 12/13/79; The Politics of Cancer, 1979; and The Politics of Cancer, Revisited, 1998.)

Hopefully, the public and the media will be outraged by this long-standing evidence of recklessness and conspiracies, graphically reinforced by Moyers' program. The public and the media should finally hold industry accountable and demand urgent investigation and radical reform of current industry practices besides governmental unresponsiveness.

The Moyers' program has already galvanized formation of a coalition of grassroots citizen groups, "Coming Clean," to demand more responsible and open industry practices, including phasing out the use and manufacture of toxic chemicals.

Criticism should also be directed to the multibillion dollar cancer establishment — the National Cancer Institute and American Cancer Society — for their failure to warn Congress, regulatory agencies, and the general public of the scientific evidence on the permeation of the totality of the environment with often persistent industrial carcinogens, thus precluding corrective legislation and regulation, besides denying workers and the public of their inalienable right-to-know.

Yoga, Healing, and Endocrinology

By Sarika Tandon (BA, BS, Student of Yoga)

(Reprinted by permission of the author)

INTRODUCTION

We have all met people who emanate composure, balance, and health. They are calm, yet energetic, disciplined, yet joyful. They seem balanced, deal with stress well, and have healthy bodies and peaceful minds. These people, through self-mastery, have achieved a certain degree of inner peace. Yoga is a system of philosophy and conduct that cultivates this peace and, through it, health.

Yoga stems from a holistic tradition that can be traced back over 5,000 years to the South Asian subcontinent. Literally translated from Sanskrit, yoga means 'union' or 'joining' and is sometimes referred to as a 'science of life'. The purpose of Yoga, in its purest sense, is spiritual liberation. Traditional yogic practices include prayer, meditation, physical exercises, breathing exercises, diet, hygiene, and benevolent action. The benefits of proper yoga practice fall in the categories of physical, emotional, mental, and spiritual health. From the traditional Vedic perspective, from which yogic practices have grown, these aspects of health are inextricably linked.

The word 'Yoga' evokes many images, ranging from the Hindu ascetic lying on a bed of nails to the lean, muscular Westerner twisted in complex acrobatic positions requiring strength, flexibility, and agility. The focus of most Western practitioners has been on the breath exercises (pranayama) and the physical postures (asanas) of the yogic tradition. In the past 50 years, yoga has become a popular practice in the West. The popularity of yoga is increasing as more and more people discover the benefits of the practice on their health and well-being. In a survey of 2055 adults in the United States, it was found that 7.5% had used yoga at least once in their lifetime, and 3.8% had used it within the past year; 90% of those who had practiced yoga felt that it was very or somewhat helpful.[1] How exactly yoga works to improve health is not completely understood. Scientists and yoga practitioners often have different explanations as to why yoga is beneficial to health. Experienced teachers and practitioners of yoga would argue that these benefits are due in most part to a strengthened connection between mind, body, spirit, and emotion.

As we realize the profound connection between thoughts, emotions, body chemistry –and, therefore, disease — it becomes clear that people need a holistic system of health maintenance that not only provides the proper corrective and restorative medicines, but also addresses the mental and emotional stress that underlies and precipitates weakness in the body. Yoga is an effective tool because it addresses the various aspects of a person, not just their body, but their mind, emotions, and spirit.

In a study of the physiological and psychological effects of Hatha Yoga in healthy women, members of a yoga group showed psychological benefits expressed in the personality inventory as higher life satisfaction, lower excitability, aggressiveness, emotionality and somatic complaints.[2]

Yogic Anatomy

Just as traditional Chinese medicine is based on certain central principles and the flow of energies, yoga works with the energies in the body to restore systemic balance and enhance vitality. The main life-force energy in yoga is called prana. The prana flows through seven major energetic centers, known as the chakras (literally translated as wheels), and through many smaller channels, called nadis. The seven chakras have physical, emotional, and spiritual properties. The chakras spin clockwise when flowing properly. The bottom three are yang (or external) and the top three are yin (or internal). The heart chakra combines and integrates these opposite forces. All of the chakras are thought to be externalized as endocrine glands.

The root chakra is located at the base of the spine. It governs understanding of the physical dimension. It represents the human's most primitive responses. The fight or flight response and, therefore, the adrenal glands, as well as the kidneys and the spinal column, are governed by the root chakra.

The second chakra, located at the center of the pelvis, is associated with the sexual and reproductive functions of the body. It governs the ovaries and testes. The second chakra is associated with creativity, as well as attitudes in relationships.

The third chakra is located in the solar plexus. It is associated with the pancreas, liver spleen, stomach,

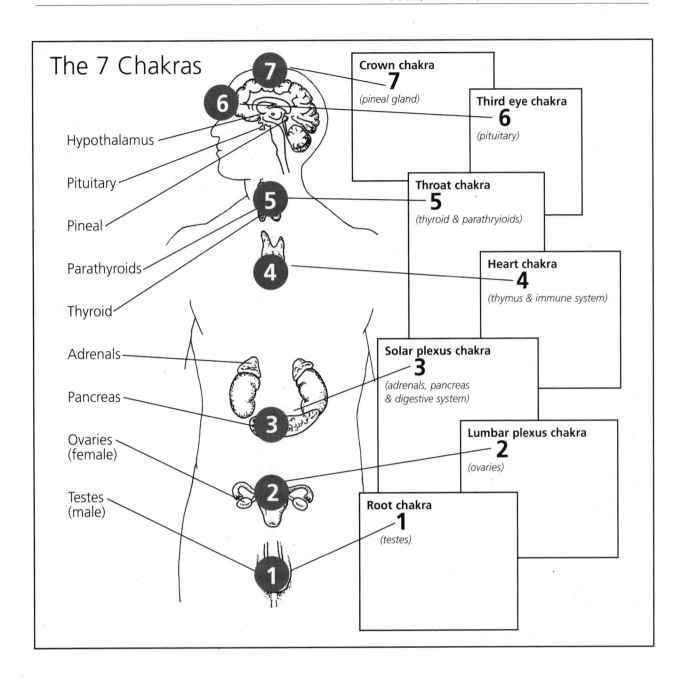

The 7 Chakras

Hypothalamus

Pituitary

Pineal

Parathyroids

Thyroid

Adrenals

Pancreas

Ovaries
(female)

Testes
(male)

Crown chakra
7
(pineal gland)

Third eye chakra
6
(pituitary)

Throat chakra
5
(thyroid & parathryioids)

Heart chakra
4
(thymus & immune system)

Solar plexus chakra
3
*(adrenals, pancreas
& digestive system)*

Lumbar plexus chakra
2
(ovaries)

Root chakra
1
(testes)

gall bladder, and nervous system. In the solar plexus chakra is seated a person's emotional sensitivity and issues of personal power.

The fourth chakra, often called the heart chakra, is located under the center of the sternum. It is externalized as the thymus gland. This chakra governs the heart, blood, and circulatory system, as well as influencing the immune and endocrine systems. This is the chakra that is associated with the experience of love.

The fifth chakra is located in the throat area, externalized by the thyroid gland. It governs the lungs, vocal cords, bronchial apparatus, and metabolism. The throat chakra is the center of expression, communication, and judgment.

The sixth chakra is located in the center of the brow and is often called the third eye. It is externalized by the pituitary gland. This chakra governs the lower brain and nervous system, the ears, the nose, and the left eye. It is the place from which our personality and spiritual nature stems.

The seventh chakra, referred to as the crown chakra, is located at the top of the head. It externalizes as the pineal gland, upper brain, and right eye. This chakra is the place from which a person experiences integration with the divine cosmic forces.

From this brief description of the significance of the chakras, it is clear that the emotions and the physical body are considered to be linked inextricably in the science of yoga.

Yogic Conduct

Yogic philosophy includes a code of moral conduct, which is to aid in the spiritual path and help the yogi to be healthy and peaceful. Yogic rules of conduct require a person to avoid the following: injuring, lying, stealing, attachment to sensual desires, attachment to grievances, immersion in inertia, attachment to self interests, attachment to consumption, and gluttony. Hygiene and moderation in lifestyle are a focus. Traditionally, the practitioner of yoga is encouraged to eat simple unprocessed vegetarian food and to avoid intoxicants of any kind.

It is believed that if a person follows the above guidelines, they will be free from worry and stress. This allows the yogi to cultivate the positive qualities of purity, contentment, austerity, self-study, and dedication to unselfish motives.

Health Benefits

Whether or not a person suffers from disease or sickness, regular yoga practice has shown to be beneficial for health. Yogic postures (asanas) fall into different categories, including inversions, balance poses, relaxation poses, and standing poses. Some are for the purpose of developing strength, some for balance, some for flexibility. Many asanas develop all of these properties but in different proportions. Most asanas are meant to be held for 30 seconds to 5 minutes, depending on a person's stamina and abilities. Pranayama exercises can involve short rapid breaths or long deep breaths. These exercises can involve holding in the breath between inhalation and exhalation, and alternating breath through different nostrils. Asanas and pranayama exercises can be invigorating or relaxing, depending on the specific exercises practiced.

Yoga can increase flexibility of musculoskeletal system, improve circulation, and tone muscles and organs. It also can result in greater strength, as well as improved balance and motor coordination. Breathing exercises increase oxygen supply in blood system and clear passages. Different postures direct blood to certain parts of the body. From the yogic point of view, blood is seen as the carrier of vital fluids that cleanses and revives. After sustained practice, most people feel a greater sense of energy and physical vitality.

Asanas that are specified for certain maladies have been known to decrease physical discomfort and sometimes eliminate physical problems (e.g., back pain and muscle cramping).

Patients with serious conditions should consult an experienced yoga teacher to design a regime that will be beneficial. Some yoga books list which asanas can be used for different illnesses.

Medical research has confirmed that the practice of yoga can affect and in some cases alleviate a variety of health problems, including carpal tunnel syndrome, high blood pressure, osteoarthritis, chronic fatigue, back pain, diabetes, epilepsy, asthma, varicose veins, mental health problems, respiratory disorders, and heart conditions.

Yoga practice was shown to retard coronary atherosclerosis and cause lesion regression, and decrease need for angioplasty and bypass surgery.[1] A study conducted of generally healthy participants of a residential a 3-month yoga and meditation training program looked at effects on cardiovascular risk factors and hormones. Substantial risk factor reduction was found with the use of yoga and a vegetarian diet. Body mass index, total serum and LDL cholesterol, fibrinogen, and blood pressure were significantly reduced, especially in those with elevated levels. Urinary excretion of adrenaline, noradrenaline, dopamine, aldosterone, as well as serum testosterone and luteinizing hormone levels, were reduced, while cortisol excretion increased significantly.[3]

The applications of yoga to endocrinology has been confirmed by recent research. Serum cortisol levels decreased in participants of a study after they had practiced yoga, indicating its positive effects in stress.[4] Yogic meditation was shown to create an acute increase in night-time plasma melatonin levels, indicating its positive effects in the treatment of insomnia.[5]

Yoga and Diabetes

Yoga has been proven to be effective as an adjunctive treatment in controlling diabetes. Changes in blood glucose and glucose tolerance of non-insulin-dependent diabetics (NIDDM) were investigated in another study: 104 out of 149 patients showed a fair to good response to the yoga therapy, with a significant decrease in hyperglycemia.[6] In another study of Type II diabetics, nerve conduction velocity increased in subjects who participated in yoga for 30-40 minutes a day daily for 40 days as opposed to the control group, who experienced decreased nerve function parameters.[7]

CONCLUSION

Yoga practice offers a holistic method for a patient to contribute to their overall health and quality of life. Yoga instruction is available in most communities, often adapted for Western students. It is rare for beginning students to learn in-depth information about the rules or traditions of yoga. As with any treatment or discipline, the benefits can only be obtained if the person practices regularly and follows instructions properly. Yoga works in the long term and often in subtle ways. It is not a panacea for all problems, but a strategy from which people can approach life in a healthy and more whole way. It is important to note that certain asanas and pranayama techniques are contraindicated with some illnesses and conditions. If you are to recommend that a patient begins to practice yoga, it is important that they find a properly trained teacher.

As we realize the profound connection between thoughts, emotions, body chemistry — and, therefore, disease — it becomes clear that people need a holistic system of health maintenance that not only provides the proper corrective and restorative medicines, but also addresses the mental and emotional stress that underlies and precipitates weakness in the body. Yoga is an effective tool because it addresses the various aspects of a person, not just their body, but their mind, emotions, and spirit.

References

1. Saper RB, Eisenberg DM, Davis RB, Culpepper L, Phillips RS. Prevalence and patterns of adult yoga use in the United States: results of a national survey. Alternative Therapies in Health and Medicine. 2004 Mar-Apr;10(2):44-49.

2. Schell FJ, Allolio B, Schonecke OW. Physiological and psychological effects of Hatha-Yoga exercise in healthy women. International Journal of Psychosomatics. 1994;41(1-4):46-52.

3. Schmidt T, Wijga A, Von Zur Muhlen A, Brabant G, Wagner TO. Changes in cardiovascular risk factors and hormones during a comprehensive residential three month kriya yoga training and vegetarian nutrition. Acta physiologica Scandinavica. Supplementum 1997;640:158-62.

4. Kamei T, Toriumi Y, Kimura H, Ohno S, Kumano H, Kimura K. Decrease in serum cortisol during yoga exercise is correlated with alpha wave activation. Perceptual and Motor Skills 2000 Jun; 90(3 Pt 1):1027-32.

5. Tooley GA, Armstrong SM, Norman TR, Sali A. Acute increases in night-time plasma melatonin levels following a period of meditation. Biological Psychology 2000 May;53(1):69-78.

6. Jain SC, Uppal A, Bhatnagar SO, Talukdar B A study of response pattern of non-insulin dependent diabetics to yoga therapy. Diabetes Research and Clinical Practice 1993 Jan;19(1):69-74.

7. Malhotra V, Sigh S, Tandon OP, Madhu SV, Prasad A, Sharma SB. Effect of Yoga asanas on nerve conduction in type 2 diabetes. Indian Journal of Physiology and Pharmacology 2002 Jul;46(3)298-306.

Integrating Vipassana with Naturopathy: Some Experiences

Dr Jay Sanghvi, Nature Cure Hospital, Gujarat, India

(Reprinted by permission of the author)

In this paper, I would like to share some of our experiences at the Nature Cure Centre, Bhuj (Gujarat), in integrating Vipassana meditation with naturopathy.

After working with pure naturopathy for many years and adding Anapana mediation with the nature cure regime, we began advising patients to take a course of Vipassana before admission, during treatment, or after treatment, according to the need. It has been observed over the years that:

- Meditation hastens the healing process.
- The patient's capacity to endure suffering increases.
- Increase in equanimity reduces the agony of incurable patients in the face of imminent death.
- Meditation changes the total outlook toward life and illness.
- In most cases, the role of mind in the genesis of disease becomes evident.
- Patients suffering from many types of incurable diseases are relieved beyond their expectations.
- Patients suffering from mental diseases, such as depression, neurosis, psychosis, and schizophrenia, are also helped when we combine Vipassana with other treatments.
- Patients with chronic renal disease (and even failure), who were on dialysis or who had been advised to have kidney transplants, showed improvement with nature cure and Vipassana.

Before I substantiate the above findings, I would like to give a general picture of our work.

We have been practicing naturopathy in a hospital with 20 beds for the past 22 years. After practicing allopathy for 12 years, we switched over to naturopathy. After 5 years we added Vipassana and Anapana as a part of the therapy. Our three doctors and our staff of 14 people are all Vipassana meditators. We have a separate hall exclusively for meditation, used by the patients, staff, and doctors alike. On an average, about 60% of our patients take a Vipassana course. Now I will substantiate the above findings with some case histories.

1. Meditation hastens the healing process

We observed in asthma, mucouscolitis, ulcerative colitis, hyper-acidity, hypertension, peptic ulcer, and diabete that patients recovered quickly when we added Vipassana or Anapana. We observed that with adding Vipassana, along with the naturopathy treatment, the duration of the stay was reduced and there was faster relief.

We found in 40 cases of asthma that with meditation the recovery was very fast. During acute attacks the patients showed patience, and with their co-operation, they were free from the acute attacks. We could also reduce the medicine in a short time.

I would like to explain one case of a young lady from Bombay, age 25. She had had asthma for 8 years and was undergoing treatment with a bronchodialater and steroids. She was diagnosed to have allergic bronchial asthma. Ultimately, when she developed side-effects from the medicine, her family doctor advised her to try some other alternatives. Then she was admitted in our Centre. After 6 weeks of treatment and Anapana, we sent her for a 10-day Vipassana course. Thereafter, she continued her diet and treatment plan of naturopathy. She came from time to time for check-ups at our Centre. She has been quite well for almost 20 years since then, with no need for medicines. Sometimes she has slight attacks, but she is able to handle these herself. She kept herself under control and became more peaceful and co-operative.

When we practice pure naturopathy, this type of patient takes about 3 months to improve. When combined with meditation, the improvement takes half that period. Several cases of this type have been treated at our Centre.

I will now present some details concerning ulcerative colitis. We have observed about 30 cases. A 50-year-old man from Saurashtra had suffered from ulcerative colitis for 3 years. His diagnosis was confirmed with a barium X-ray and sigmoidoscopy. A well-known gastroenterologist treated him with Salezpyrin, steroids, and vitamins. He got temporary relief, but when he stopped taking medicines, his condition became worse. Ultimately, he came to our Centre. He was having 15 to 20 bowel motions per day with blood and mucous. His haemoglobin level was very low and

his general condition was weak. He could not control his motions and would sometimes even spoil his clothes. After 3 months of treatment, during which he practiced Anapana and took two courses of Vipassana, he was back to normal and is now cultivating the land. He has been coming for regular follow-ups. His haemoglobin level rose to around 12 gm and he now has good bowel control.

We have also observed similar results in many cases of diabetes, hyper-acidity, peptic ulcer, and high blood pressure.

2. The patient's capacity to endure suffering increases

When a patient starts the treatment, he believes his suffering is not going to change. Since the disease is chronic, he is fed up with treatments, loses faith, and often becomes a total wreck, cursing the situation he is in. In this way, he actually multiplies his suffering. Due to all this, he is unable to take the treatment with an open mind. But after learning Vipassana, the total outlook toward life and disease changes. Now he understands: "Oh, this is a good opportunity to reduce my pain and grief." Now he understands his own responsibility. He also realizes that nothing is permanent, that his disease will also change. His pain now becomes a tool to establish equanimity. Hence, he endures the disease with less suffering, instead of multiplying his suffering. The total attitude toward pain and suffering changes.

3. Increase in equanimity reduces the agony of incurable patients in the face of imminent death

As we all are aware, when patients are terminally ill, they and their relatives are passing through a highly stressful and restless period. In their desperation, they often change therapies and try a number of methods to rid themselves of this suffering. In this condition, the patient, as well as his relatives, live in a continual state of insecurity, fear, deep despair, sorrow, and distress. Even in this condition, if the patient uses Vipassana, along with other therapies, the remaining part of his life becomes less agonizing.

There have been a number of cases in which patients had tried different types of treatment, but ultimately came to us. We start treatment with Anapana, and send such persons for a 10-day course of Vipassana. They may not improve physically but they become strong mentally and learn how to develop equanimity.

One example is a 60-year-old gentleman from Bhuj, Gujarat. He was admitted with lung cancer. He had undergone an operation and then remained

under treatment at Tata Cancer Hospital in Bombay for a long time. As the case was hopeless, he was sent to Bhuj, his native place, to pass his remaining time. The patient and his relatives were under great stress and worried a lot. He had himself admitted to our Centre and his treatment started. The main treatment was just Anapana, and within 3 days he began to feel better, with some relief from pain and fear. We could not send him for a Vipassana course, but he did Anapana quite seriously. He died 10 days later fully aware of himself, in a peaceful state of mind.

Another patient was a young 38-year-old electrical engineer from Palanpur, Gujarat. He was admitted in the final stage of renal failure. He was on dialysis at the Kidney Institute but he needed a blood transfusion every time after dialysis. He developed severe anemia and other complications and hence could not undergo dialysis any more. Someone sent him to our Nature Cure Clinic. On admission, his creatinine was 12, blood urea 180, HB 5.8, potassium 5, blood pressure 180/120. He had hiccups and vomiting, severe headache, and puffiness in the face. Urine output was only 200 to 300 ml. We started the treatment with Anapana. After 3 weeks, his creatinine was 8, blood urea 120, HB 9.6, potassium 5, blood pressure 140/100 and urine output was about one liter.

Other symptoms also improved, but still he was worried and stressed, because, being educated, he studied a lot about his disease and ultimately he knew the prognosis. We sent him for a 10-day Vipassana course, and when he returned, he had totally changed his attitude toward his disease. He went for another course later on and continued with Vipassana at home. He died after one year. During this period, he remained cheerful, and he died with peace and awareness.

4. Meditation changes the total outlook toward life and illness

We studied five cases of pseudo muscular atrophy and two cases of Pamphigus Vulgarius. The patients were in the worst possible condition and had lost all hope. We treated them with Anapana, and three were sent for a Vipassana course. All seven cases showed improvement. Clinically, we did not find any physical or pathological change, except for a little improvement for a short time. However, mentally they were totally changed persons.

5. In most cases, the role of mind in the genesis of disease becomes evident

After Vipassana, patients start understanding that most diseases are not really physical — they arise in

the mind and manifest on the body. We have had a number of cases who improved with simple Anapana and a little counseling.

A young married lady of 24 from Rajkot had been vomiting for 8 months. She was treated at various places for peptic ulcer, hyperacidity, gastritis, and worms, but her condition kept deteriorating. She was admitted to our Centre in a very bad condition. On our recommendation, she undertook a Vipassana course. She is absolutely all right now with no medication. We had a regular follow-up, and she is still in touch with us.

This shows how important the role of the mind is when there is any disease. There are many cases we have studied showing that most of the diseases have their root cause in the mind.

6. Patients suffering from many types of incurable diseases were relieved beyond their expectations

There was a man who was diagnosed with ascending neuropathy Gulanbari syndrome. He was admitted in a completely bedridden condition. He could not turn to one side when sleeping, and he could not eat unassisted. We started the diet treatment along with Anapana meditation. Because he was bed-ridden, we could not give him any other treatment, but to our surprise, within a short period of 6 weeks, he was able to sit, take his own food, and move his legs. Within 3 months of his admission, he could walk. We sent him to one of our physician friends, who was surprised to see him walk and make all movements in a normal way. He asked me about this magical recovery. When I told him about Anapana and diet treatment, he was not ready to believe it. We have some other cases with similar amazing results.

7. Patients with chronic renal disease (and even failure), who were on transplants, showed improvement

We have treated many cases of chronic renal failure, and obtained very good results. We observed that if we add Vipassana along with our treatment, the results are more satisfying. Patients easily develop the confidence to go without dialysis. Control of diet becomes easy after Vipassana. In this context, I would like to explain the case of the mother of a well-known doctor of our area. She was diagnosed with chronic renal failure and treated at the Kidney Institute, Nadiad. However, her condition worsened and the doctor advised dialysis. Ultimately, her son brought her to our Centre with high blood pressure, oedema all over of the body, anorexia, with vomiting, breathlessness, and low-grade fever. Her blood urea was 130, creatinine 7.3, HB 9.5, and urine albumin -1+. After one month, her urea was 100, creatinine 5, and HB 1. She was treated as an indoor patient for about 3 months. During this period, she went twice for a 10-day course. After that, she came regularly for follow-up. In her last biochemistry, blood urea was up 70, creatinine was 4, HB 11, and blood pressure was 140/180. Her general condition is now very good. She is cultivating her land and looking after her grandchildren, practicing Vipassana.

Our experience of many years has shown that most diseases are linked with the mind. To cure them, a therapy involving purification of the mind is necessary. It is our conviction that doctors should learn how to practice Vipassana Meditation themselves in order to become good healers.

CCNM
PRESS

CCNM Press is dedicated to publishing college texts, clinical reference materials, consumer health books, and corporate wellness guides in the field of naturopathic medicine to further the advancement of the profession of naturopathic medicine and to teach the principles of healthy living and preventive healthcare, enabling patients to participate in their healing process.

The Principles of Naturopathic Medicine
First, do no harm
Co-operate with the healing power of nature
Address the fundamental causes of disease
Heal the whole person through individualized treatment
Teach the principles of healthy living and preventive medicine

Distribution Partners
Login Brothers Canada, Health Management Books, Coutts Library Service, Nutri-Books, BMS Resources, SCB Distributors, Blackwell North America, Mathews Medical Books, J.A. Majors Company, Rittenhouse Book Distributors, Baker & Taylor Company, Ingram Book Company, NetLibrary.com, amazon.com, amazon.ca.

CCNM Press, 1255 Sheppard Avenue East, Toronto, Ontario, Canada M2K 1E2
Tel. 416-498-1255 Ext. 290 Fax: 416-498-3157
E-mail: ccnmpress@ccnm.edu Website: www.ccnmpress.com

CONTENTS

Preface by Dr Abram Hoffer, MD

PRINCIPLES & PRACTICES OF NATUROPATHIC
Clinical Nutrition

JONATHAN PROUSKY, ND
Preface by ABRAM HOFFER, MD

400 pages, illustrated, 8 x 10 inches
BISAC: MED06000 HEA016000
ISBN 1-897025-04-1 HC $99.95 CDA/USA $79.95

Naturopathic Clinical Practice Series

This series of professional reference books focuses on core CNME diagnostic and management skills taught at naturopathic and other complementary and alternative medical colleges in North America. These books also include practical guides for starting up and managing a naturopathic medical practice, as well as professional development updates for the practicing ND.

Publishing Program:

Naturopathic Medical Standards of Primary Care
Naturopathic Practice Marketing and Management
Naturopathic Diagnostics and Assessment
Naturopathic Parenteral Care
Naturopathic Case Management

Naturopathic Standards of Primary Care

by Shehab El-Hashemy, BSc, MBChB, ND

Based on AMA and CMA guidelines, this book provides core knowledge and practical instruction in the critical skills comprising the repertoire of the primary care physician as outlined by the Board of Directors of Drugless Therapy-Naturopathy (BDDT-N) and examined by the Naturopathic Licensing Examinations (NPLEX-II). Primary care standards govern the systematic process of symptom/sign recognition, cost-effective laboratory investigation, procedural diagnosis, proper follow-up, and case management for naturopathic physicians. These competencies will allow students to proceed to clinical rotations, independent medical practice, or further postgraduate studies.

This book offers a program for mastering essential primary care skills, clinical knowledge, and professional behavior towards oneself, patients and families, colleagues, and the community.

Emphasis is placed on problem-based case studies and small-group learning experiences that simulate actual primary care clinical practice. Ideal not only for students of naturopathic medicine but also for practicing naturopathic doctors in need of a primary care clinical handbook.

Dr Shehab El-Hashemy, BSc, MBChB, ND, is an Associate Professor of Clinical Medicine at The Canadian College of Naturopathic Medicine. He has established a problem-based, objective-structured clinical curriculum for standardizing primary care best-practices. He also teaches physical and clinical diagnosis skills and lectures on urology and men's health topics. Dr El-Hashemy received his medical degree from Cairo University Faculty of Medicine (Egypt) and his naturopathic degree from The Canadian College of Naturopathic Medicine (Ontario). He is also an attending naturopathic physician at Anishnawbe Health Toronto, a publicly funded community health center in downtown Toronto.

CONTENTS

Naturopathic Standards *of* Primary Care

Shehab El-Hashemy, ND

300 pages, clinical handbook format, 5.5 x 8.5 inches,
reinforced binding, tabbed, tables, references,
index BISAC: MED014000 HEA016000
ISBN 1-897025-17-3 SC $89.95 CDA/USA $69.95